RAPHAEL

A. P. OPPÉ

RAPHAEL

Edited with an introduction by Charles Mitchell

ELEK BOOKS

London

1970

© 1970 Paul Elek Productions Ltd
© 1970 Introduction Charles Mitchell
First published by Methuen and Co, London, 1909
Revised edition 1970 by Paul Elek Productions Ltd,
2 All Saints Street, London N.1.

ISBN 0 236 17608 0

Printed in England by
The Garden City Press Limited
Letchworth, Hertfordshire

CONTENTS

LIST OF ILLUSTRATIONS

In the text the colour-plates are referred to by Roman numbers, monochromes of paintings by regular Arabic numbers, and monochromes of drawings by Arabic numbers in italic.

All measurements are in centimetres.

In the 1909 catalogue, now omitted, the qualification 'School' was placed against paintings which were well attested as Raphael's or thoroughly characteristic of his art, but which did not appear to be his in execution or even in complete composition. This has been followed without change in the list below.

In the citing of literature on paintings and drawings the following abbreviations are used:

C.I. E. Camesasca. *Tutta la pittura di Raffaello: i quadri*, 2nd ed., Milan, 1962.

C.II. E. Camesasca. *Tutta la pittura di Raffaello: gli affreschi*. 2nd ed., Milan, 1962.

D. L. Dussler. *Raffael. Kritisches Verzeichnis der Gemälde, Wandbilder und Bildteppiche*, Munich, 1966.

PV. M. Prisco and P. De Vecchi. *L'opera completa di Raffaello*, Milan, 1966.

F.I–VIII. O. Fischel. *Raphaels Zeichnungen*, 8 vols., Berlin, 1913–1941.

F.1898 O. Fischel. *Raphaels Zeichnungen. Versuch einer Kritik*, Strasbourg, 1898.

M. U. Middeldorf. *Raphael's Drawings*, New York, 1945.

S. A. Stix and L. Fröhlich-Bum. *Die Zeichnungen der toskanischen, umbrischen und römischen Schulen (Beschreibender Katalog der Handzeichnungen in der graphischen Sammlung Albertina, III)*, Vienna, 1932.

P. A. E. Popham and J. Wilde. *The Italian Drawings of the XV and XVI Centuries in the Collection of His Majesty the King at Windsor*, London, 1949.

P.II. K. T. Parker. *Catalogue of the Collection of Drawings in the Ashmolean Museum*, vol. II (the Italian schools), Oxford, 1956.

PG. P. Pouncey and J. A. Gere. *Italian Drawings in the Department of Prints and Drawings in the British Museum. Raphael and his Circle*, London, 1962.

COLOUR-PLATES

MONOCHROME ILLUSTRATIONS

34 *The Madonna with St Jerome and St Francis*. Berlin–Dahlem, Gemaeldegalerie.
 Oil on panel. 34 × 29. C.I. 7, D.I. 6, PV. 15

35 *Madonna and Child*. Perugia, Galleria Nazionale dell'Umbria.
 Oil on panel. 53 × 41. C.I.P. 81, PV. 9

36 *The Galitzin Crucifixion*. Washington, National Gallery of Art. Andrew Mellon Collection.
 Oil on panel transferred to canvas. 95 × 30; 101 × 56; 95 × 30. Cf. C. Castellaneta and
 E. Camesasca, *L'opera completa del Perugino*, Milan, 1969, No. 22

37 *Portrait*. Rome, Galleria Borghese.
 Oil on panel (after the restoration of 1911). 45 × 31. C.I. 20, D.I. 114, PV. 27

38 *The Vision of a Knight*. London, National Gallery.
 Oil on panel. 17 × 17. C.I. 44, D.I. 59, PV. 37

39 *The Three Graces*. Chantilly, Musée Condé.
 Oil on panel. 17 × 17. C.I. 45, D.I. 18, PV. 38

40 *St George and the Dragon*. Paris, Louvre.
 Oil on panel. 31 × 27. C.I. 48, D.I. 103, PV. 49

41 *St Michael*. Paris, Louvre.
 Oil on panel. 31 × 27. C.I. 46, D.I. 102, PV. 48

42 Cartoon for 43. Florence, Uffizi.
 Pen and yellow-brown ink on light pencil drawing, pricked. 26·4 × 21·3. F.II. 78

43 *St George and the Dragon*. Washington, National Gallery of Art. Andrew Mellon Collection.
 Oil on panel. 28 × 22. C.I. 62, D.I. 133, PV. 50

44 *The Terranuova Madonna*. Berlin–Dahlem, Gemaeldegalerie.
 Oil on panel. 86 diameter. C.I. 30, D.I. 8, PV. 36

45 Preliminary study for 44. Lille, Musée Wicar.
 Pen and brown ink. 16·7 × 15·7. F.I. 54

46 The *Small Cowper Madonna*. Washington, National Gallery of Art. Widener Collection.
 Oil on panel. 58 × 42. C.I. 43, D.I. 135, PV. 35

47 *The Tempi Madonna*. Munich, Alte Pinakothek.
 Oil on panel. 75 × 52. C.I. 95, D.I. 84, PV. 83

48 The *Large Cowper (Niccolini) Madonna*. 1508. Washington, National Gallery of Art. Andrew
 Mellon Collection.
 Oil on panel. 68 × 47. Signed and dated. C.I. 94, D.I. 132, PV. 82

49 *The Colonna Madonna*. Berlin–Dahlem, Gemaeldegalerie.
 Oil on panel. 77 × 56. C.I. 85, D.I. 9, PV. 77

50 *The Orleans Madonna*. Chantilly, Musée Condé.
 Oil on panel. 29 × 21. C.I. 56, D.I. 19, PV. 60

51 *The Madonna of the Meadow*. Vienna, Kunsthistorisches Museum.
 Oil on panel. 113 × 88. C.I. 67, D.I. 137, PV. 63

52 Study for 51. Chatsworth, Duke of Devonshire.
 Pen and yellow-brown ink. 25 × 19·4. F.III. 117

53 Study for 51. Oxford, Ashmolean Museum.
 Brush in pale brown ink, heightened with body-colour, over metal-point with red chalk,
 faintly squared and pricked. 21·9 × 18. F.III. 118, P.II. 518

75 Study for 69. London, British Museum.
 Pen and brown ink. 21·3 × 32. Original of F.IV. 170

76 Study for 69. London, British Museum.
 Pen and brown ink over traces of black chalk. 33·9 × 24·2. F.IV. 171, PG. 12

77 Developed design for 69. Florence, Uffizi.
 Pen and ink, squared in red chalk. 28·9 × 29·7. F.IV. 175

78 Study after Michelangelo's *St Matthew* (? for 69). Verso of 76. London, British Museum.
 Pen and brown ink. 23 × 31·9. F.IV. 172, PG. 12

79 Study for 69. London, British Museum.
 Pen and brown ink. 25 × 16·9. F.IV. 165, PG. 10

80 Study for 69. Oxford, Ashmolean Museum.
 Pen and brown ink, pricked. 23·2 × 18·5. F.IV. 174, P.II. 525 verso

81 Study for 69. London, British Museum.
 Pen and brown ink with faint underdrawing in black chalk. 30·7 × 20·2. F.IV. 178, PG.11

82 Study for 69. Paris, Fritz Lugt Collection (copyright).
 Pen and dark brown ink. 26 × 18·6. F.IV. 177

83 Study for 69. Oxford, Ashmolean Museum.
 Pen and brown ink over grey chalk outlines with some red chalk (Christ's body), pricked.
 28·2 × 24·6. F.IV. 173, P.II. 532

84 Study for 69. Florence, Uffizi.
 Pen and ink over lead-point. 26·2 × 18·8. F.IV. 176

85 Copy of a lost study for 69. London, British Museum.
 Pen and brown ink. 28·9 × 20·1. F.IV. 179, PG. 39

86 Study for *Charity* in 87. Vienna, Albertina.
 Pen and ink over grey lead-point. 34 × 24. F.IV. 181, S. 51 recto

87 *Faith*, *Charity* and *Hope*. From the predella of the *Entombment*. Rome, Pinacoteca Vaticana.
 Oil on panels. 16 × 44 each. C.I. 78, D.I. 118, PV. 70C

88 Preliminary sketches for 89. Oxford, Ashmolean Museum.
 Pen and brown ink over lead-point. 27·9 × 16·9. F.IV. 204, P.II. 536 verso

89 *St Catherine of Alexandria*. London, National Gallery.
 Oil on panel. 71 × 55. C.I. 89, D.I. 58, PV. 84

90 Copy (?) of a lost study for 89. Chatsworth, Duke of Devonshire.
 Pen and ink. 24·7 × 19·7. F.IV. 206

91 Study for 89 (recto of 88, detail). Oxford, Ashmolean Museum.
 Pen and brown ink over lead-point. 27·9 high. F.IV. 205, P.II. 536 recto, M. 37

92 Cartoon for 89. Paris, Louvre.
 Grey chalk touched with white, pricked. 58·4 × 43·5. F.IV. 207

93 *Raphael's Self-portrait*. Florence, Uffizi.
 Oil on panel. 45 × 33. C.I. 60, D.I. 39, PV. 54

94 *Portrait of Angelo Doni*. Florence, Pitti.
 Oil on panel. 63 × 45. C.I. 68, D.I. 29, PV. 55

95 *Portrait of Maddalena Doni*. Florence, Pitti.
 Oil on panel. 63 × 45. C.I. 70, D.I. 28, PV. 56

120 Developed study for 110. Oxford, Ashmolean Museum.
 Black chalk touched with white chalk. 38·7 × 26·6. F.VI. 296, P.II. 548

121 *The School of Athens.* Stanza della Segnatura.
 Fresco. 770 wide. C.II. 24, D.II. 5, PV. 85J

122 Cartoon for the figures of 121. Milan, Ambrosiana.
 Charcoal and black chalk on pasted up sheets of paper. 280 × 800. F.VI. 313–44

123 Detail of the *School of Athens.*

124 Detail of the *School of Athens.*

125 Study for 121. Oxford, Ashmolean Museum.
 Silver-point, heightened in body-colour, on pale pink ground. 27·8 × 20. F.VII. 307,
 P.II. 550, M. 68

126 Study for 121. Frankfurt a/M, Staedel Institut.
 Silver-point on rose ground. 24·5 × 28·5. F.VII. 306

127 Study for 121. Oxford, Ashmolean Museum.
 Dark red chalk over lead-point. 37·9 × 28·1. F.VII. 309, P.II. 552, M. 69

128 Single sheet of 122.

129 *Parnassus.* Stanza della Segnatura.
 Fresco. 670 wide. Dated 1511. C.II. 42, D.II. 5, PV. 85K

130 Detail of the *Parnassus.*

131 Study for 129. Lille, Musée Wicar.
 Pen and ink. 31·5 × 22·2. F.V. 245, M. 54

132 Detail of the *Parnassus.*

133 Detail of the *Parnassus.*

134 *Alexander the Great depositing the poems of Homer in the tomb of Achilles.* Grisaille below the
 Parnassus.
 Fresco. 180 wide. C.II. 49, D.II. 5, PV. 85M

135 *Fortitude, Prudence* and *Temperance.* Stanza della Segnatura.
 Fresco. 660 wide. Dated 1511. C.II. 50, D.II. 5, PV. 85N

136 *Justinian delivering the Pandects to Tribonianus.*
 Fresco. 220 wide. C.II. 58, D.II. 5, PV. 85 O

137 *Gregory IX delivering the Decretals to St Raymund of Penaforte.*
 Fresco. 220 wide. C.II. 59, D.II. 5, PV. 85P

138 *The Alba Madonna.* Washington, National Gallery. Andrew Mellon Collection.
 Oil on panel transferred to canvas. 95 diameter. C.I. 97, D.I. 131, PV. 90

139 Study for 138. Lille, Musée Wicar.
 Red chalk and pen. 41 × 26·4. F.VIII. 364, M. 53

140 Study for 138 (verso of 139). Lille, Musée Wicar.
 Red chalk. 41 × 26·4. F.VIII. 365

141 Developed study for 138. Vienna, Albertina.
 Pen and wash, heightened in white. 18·6 × 15·8. S. 70

142 Study for 138. Rotterdam, Boymans-van Beuningen Museum.
 Silver-point on cream ground. 11·7 × 10·5. F.VIII. 355

143 *The Aldobrandini-Garvagh Madonna.* London, National Gallery.
 Oil on panel. 38 × 32. C.I. 96, D.I. 60, PV. 87

166 Copy of a preliminary sketch for 164. Stockholm, National Museum.
 Pen and bistre. 32·4 × 23·5

167 Study for 164. Oxford, Ashmolean Museum.
 Red chalk over stylus indentations with black chalk in the draperies. 36·3 × 18·9. P.II. 562, M. 79

168 Study for 164. Vienna, Albertina.
 Red chalk and lead-point. 27·9 × 17·2. S. 72

169 *The Burning of the Borgo.* Stanza dell'Incendio.
 Fresco. 670 wide. C.II. 100, D.II. 5. III, PV. 115A

170 The Stanza dell'Incendio. 1514–17 (School). Rome, Vatican Palace.

171 Study for 169. Vienna, Albertina.
 Red chalk. 30 × 17. F. 1898, 195, S. 75, D.p. 93

172 Workshop study for 169. Vienna, Albertina.
 Red chalk, prepared with stylus, paper washed in grey. 36·5 × 16·1. F. 1898, 190, D.p. 93

173 Workshop study for 169. Vienna, Albertina.
 Red chalk, prepared with stylus, white paper. 33·6 × 25. D.p. 93

174 Workshop study for 169. Oxford, Ashmolean Museum.
 Brush in brown ink heightened with body-colour over black chalk, reinforced with pen and black ink. 39·2 × 15·4. P.II. 652, D.p. 93

175 *The Battle of Ostia.* Stanza dell'Incendio.
 Fresco. 770 wide. C.II. 105, D.II. 5. III, PV. 115B

176 Workshop study for 175 (given by Raphael to Dürer). Vienna, Albertina.
 Red chalk and lead-point. 40·1 × 28·1. S. 74, D.p. 94

177 Copy of a compositional sketch for 175. London, British Museum.
 Pen and brown ink and wash heightened with white, with indented outlines. 41·4 × 63. PG. 49, D.p. 94

178 *The Coronation of Charlemagne.* Stanza dell'Incendio.
 Fresco. 770 wide. C.II. 106, D.II. 5. III, PV. 115C

179 Workshop study for 178. Düsseldorf, Kunstmuseum.
 Red chalk on light paper. 26·1 × 31·9. Budde, *Katalog der Handzeichnungen in der Staatlichen Akademie*, Düsseldorf, 1930, No. 12 recto

180 *The Oath of Leo III.* Stanza dell'Incendio.
 Fresco. 670 wide. Dated 1517. C.II. 106, D.III. 5. II, PV. 115D

181 Workshop study for 180. Haarlem, Teyler Museum (copyright).
 Red chalk on white paper. 8·4 × 6·7

182 *The Miraculous Draught of Fishes.* Cartoon. 1515–16. London, Victoria and Albert Museum (Crown Copyright reserved).
 Sized body colours over charcoal. 360 × 400. C.I. 153, D.III.1a, PV. 116A

183 *The Miraculous Draught of Fishes.* Tapestry. Rome, Pinacoteca Vaticana.
 440 wide (without borders).

184 *The Charge to St Peter.* Cartoon. London, Victoria and Albert Museum (Crown Copyright reserved).
 Sized body colours over charcoal. 345 × 535. C.I. 154, D.III.1b, PV. 116B

2—R

248 *The Madonna del Divin'Amore* (School). Naples, Museo Nazionale di Capodimonte.
 Oil on panel. 138 × 109. C.I. 135, D.I. 89, PV. 140

249 *St Michael* (School). 1518. Paris, Louvre.
 Oil on panel transferred to canvas. 268 × 160. Signed. C.I. 129, D.I. 104, PV. 135

250 *The Visitation* (School). Madrid, Prado.
 Oil on panel transferred to canvas. 200 × 145. Signed. C.I. 137, D.I. 77, PV. 152

251 *St Margaret* (School). Paris, Louvre.
 Oil on panel transferred to canvas. 178 × 122. C.I. p.88, D.I. 101, PV. 138

252 *Lo Spasimo di Sicilia* (School). Madrid, Prado.
 Oil on panel transferred to canvas. 306 × 230. Signed. C.I. 124, D.I. 75, PV. 132

253 The Monteluce *Coronation of the Virgin* (executed by Giulio Romano and Penni). Rome,
 Pinacoteca Vaticana.
 Oil on panel. 354 × 230. D.I. 121, C.I.p. 89, PV. 156

254 *St John the Baptist* (School). Florence, Accademia.
 Oil on canvas. 165 × 147. C.I. p.88, D.I. 27, PV. 144

255 Sebastiano del Piombo. *The Raising of Lazarus*. London, National Gallery.
 Oil on panel transferred to canvas. 380 × 287. Dussler, *Sebastiano del Piombo*, no. 24

256 *The Transfiguration* (partly School). 1518–1520. Rome, Pinacoteca Vaticana.
 Oil on panel. 405 × 278. C.I. 140, D.I. 119, PV. 153

257 Early compositional design (Giulio Romano) for 256. Vienna, Albertina.
 Pen, brush and wash, heightened with white. 40·2 × 27·2. Oberhuber, *Jahrbuch der Berliner Museen*, IV, 1962, fig. 2. On drawings for 256 generally cf. D.pp. 67–9

258 Later compositional design (Penni) for 256. Paris, Louvre.
 Pen and brown ink with brown wash, heightened with white. 41·3 × 27·4. Oberhuber, fig. 4

259 Compositional study (? Raphael) for 256. Chatsworth, Duke of Devonshire.
 Red chalk, squared. 24·6 × 35. Oberhuber, fig. 6

260 Developed compositional study (workshop) for 256. Vienna, Albertina.
 Pen. 54 × 37·7. Oberhuber, fig. 9

261 Study (? Raphael) for 256. Vienna, Albertina.
 Red chalk. 12·6 × 14·4. S. 116, Oberhuber, fig. 8

262 Study (? Raphael) for 256. Amsterdam, Dr J. Q. van Regteren Altena (copyright).
 Charcoal heightened with white. 33 × 24·2. Oberhuber, fig. 16, Hartt, *Giulio Romano*, 1959, no. 30

263 Study (? Raphael) for 256. Chatsworth, Duke of Devonshire.
 Red chalk. 32·9 × 23·2. Oberhuber, fig. 10, D.p. 68

264 Auxiliary cartoon (Raphael) for 256. Chatsworth, Duke of Devonshire.
 Black chalk. 36·3 × 34·6. Oberhuber, fig. 19, D.p. 68

265 Study (? Raphael) for 256. Paris, Louvre.
 Red chalk over lead-point. 34·1 × 22·1. M. 86, D.p. 68

266 Study (Giulio Romano) for 256. Vienna, Albertina.
 Red chalk. 32·2 × 27·5. S. 78, Hartt, no. 29

267 Study (? Raphael) for 256. Paris, Louvre.
 Black chalk heightened with white on brown paper. 26·4 × 19·7. Oberhuber, fig. 14, D.p. 68

ACKNOWLEDGEMENTS

For permission to reproduce works illustrated, thanks are due to owners and institutions as individually listed, the Windsor drawings being reproduced by gracious permission of Her Majesty the Queen.

Certain photographs are reproduced by permission or mediation of other agents, viz: Courtauld Institute, London (Chatsworth drawings 52, 63, 90, 226, 259, 263, 264, 269); Giraudon, Paris (39, 50, 62); Biblioteca Herziana, Rome (198); Mansell, London (35, 37, 60, 67–69, 98, 100, 110, 135, 145, 146, 175, 199, 203–206, 219, 237, 254); Gabinetto Fotografico Nazionale, Rome (163, 164, 197, 207, 209, 231, 235); G. Reinhold, Leipzig-Mölkau (XIII, 227); Scala, Florence (II, III, V-XII, XIV); Giuseppe Tacchini, Città di Castello (13–15, 18); A. Villani, Bologna (240).

INTRODUCTION

P A U L Oppé's *Raphael*, published in 1909 and long out of print, is as original and lively a work as any of his later and better known monographs on English eighteenth century artists—Alexander Cozens, Rowlandson, the Sandbys, Hogarth and the rest. Sixty years of subsequent research and criticism have added a good deal to our knowledge of Raphael, particularly with regard to his drawings and studio procedures, but they have not fundamentally affected the corpus of finished paintings which Oppé confronted with his habitual scepticism, yearning for beauty, and astringent good sense when he wrote his book. The pictures he contemplated sixty years ago (though many of them have since undergone more or less happy restoration) are pretty well the pictures we contemplate today; and Oppé's account of them preserves the freshness of all genuine aesthetic criticism, however seldom it occurs—the perennial freshness, rooted in humane sensibility, of direct response (however conditioned by contemporary culture) by a man who knows and loves art, and can write accurately and beautifully about it, to the productions of a great artist. The purpose of this re-edition of Oppé's *Raphael* is to bring it back into useful circulation at a moment when Raphael's art, after one of its periodical eclipses, is once more becoming an object of close and enthusiastic study; and the aim of this introduction is simply to record how the book came to be written and briefly to indicate where it stood in 1909 and where it stands today.

Oppé came to art-history from the classics, and this early philological training gave nerve and sinew, as well as synthetic grasp, to all his later scholarship in other fields. After school at Charterhouse and a spell, due to ill-health, in New Zealand, he went in 1894, aged sixteen, to St Andrews where he crowned his undergraduate career with his first book, a prize-essay, on *The New Comedy* (St Andrews, 1897). Thence he migrated as an exhibitioner to New College, graduating with firsts in Mods and Greats in 1901, after which he enjoyed a year of intermittent travel in Germany, eastern Europe and Greece—an experience that helped to place all his subsequent studies of native English art in a European perspective and gave a European breadth to his life-long collecting of Old Master drawings. From 1902 to 1904, as assistant to Professor John Burnet, he lectured in Greek at St Andrews, and in 1904–5 he was a lecturer in Ancient History at Edinburgh, where a shared passion for both older and modern art won him the lasting friendship of Professor Baldwin Brown. In 1904 he published a characteristically iconoclastic and elegantly written paper on 'The Chasm at Delphi' in the *Journal of Hellenic Studies*, and bought his first Cotman drawing—a purchase which set one of the main directions of his collection. His career, however, was not to be in universities, though he was later faced more than once with the

possibility of a return to Oxford as an alternative to the London life—and the charms of the Chelsea Embankment—which in his heart he preferred. In 1905, already a regular reviewer of general literature in the London press, he entered the office of the Board of Education, where he remained—except for two periods when he was seconded to the Victoria and Albert Museum (1906–7, and 1910–13 as Deputy Director) and war-service in the Ministry of Munitions—until his retirement in 1938. Nevertheless, during these decades of public service in Whitehall followed by twenty years of leisure among his books and drawings in Cheyne Walk, Oppé achieved as much as any whole-time academic could have done in opening up, almost single-handedly, whole provinces of English art-history, especially in the field of watercolours.

It was Baldwin Brown who in May 1906 proposed Oppé's name for the volume on Raphael in Methuen's new series of 'Classics in Art'; and the agreement was made in June. The task was a formidable one—to compose almost from scratch virtually the first English monograph on Raphael at a time when (as Oppé noted in one of his memoranda) it was 'a mark of cultivation to disparage him'. Oppé's diaries for the next two years show him, with alternate and sometimes internecine feelings of exasperation and enthusiasm, coming to terms with his subject, and struggling to steer a steady course between accurate narrative history and critical appreciation of the paintings, with the constant goal before him of presenting a coherent account of Raphael's development and total pictorial achievement. We watch him during the summer of 1906 nightly settling down, often against the grain, to analyse Müntz and Passavant, and attempting to work out a systematic chronology. 'The early chronology', he exasperatedly concluded, 'is sheer humbug. Three years of Perugino. About fifteen months of Florence. . . . There isn't any'.

Meanwhile he was jotting down tentative general ideas—on form and colour and their decorative qualities, on the distinction between vision and technique, on the supreme importance of expression in Raphael's work—though at moments he doubted Raphael himself. 'There is nothing in Raphael to offend the man in the street. That is his chief fault in the eyes of the man on the first floor'. 'Raphael simply sucked from Leonardo. He may even have collared the types. Leonardo is poignant, Raphael can never be'. Then in September 1906 he made a trip to Italy—to Florence, Arezzo, Urbino, San Sepolcro, Città di Castello, Assisi, Rome, Orvieto, Siena, Milan and home through Paris—to make careful notes in front of the originals. 'A miniature fresco', he commented on the *Ezekiel* in the Pitti; and the same relish for an artistic totality prompted his remark on Michelangelo's Medici Chapel: 'No other works so absolutely occupy their whole surroundings'. 'Raphael', he noted from San Sepolcro, 'wants breadth and majesty in big Madonnas. He has it in the cartoons'. Later he reflected on Piero: 'The Piero Resurrection is grim, ugly and hard, consequently it gives me pleasure. The hardness of it suggests something actual, real and tangible; it suggests structure which is convincing and satisfying. Having come to a basis of form one fancies that one is in the presence of reality of idea. . . . One is so much occupied with the actual plastic qualities of the figures that their meaning escapes one'. And he went on: 'Why is the battle of Constantine less pleasing than Uccello's rubbish or Piero's tin soldiers at Arezzo?' So he prepared himself for Rome and the sight of the Stanza della Segnatura, which he was to make one of the high peaks of his book. 'All is absolutely pagan. Who can distinguish Plato and Aristotle from Peter and Paul? But is this any loss? For a moment Christianity was combined with paganism—there was happiness'. For the Logge, on the other hand, he had no such praise: 'These Bible stories are silly. They only tell a story with some lesson. They are useless for painting'; and this brought him back to 'the subject of the Segnatura'—'I should scarcely have known it had any. But must talk of it'.

2

After Rome he stopped in Orvieto where he remarked on Signorelli's frescoes: 'This is strong meat for weak people. For the strong something less vehement is more effective'—an observation that prompted him immediately to contemplate the other side of the medal in a note on Raphael and Perugino which perhaps summed up his conclusions, so far, on the formation of the early Raphael. 'He caught besides evil habits the smooth softness which is an element of beauty. This is the mock religious feeling of the Umbrians: the gentle ecstasy. Something of this remained with him for ever. It was reinforced and made fuller of character at Florence—Fra Bartolommeo and Leonardo; issued in the Sistine [Madonna] which is the summit of Fra Angelico and Umbrian art. But in order to catch it he must have had it in his nature, and from the first he must have imbibed it from his father who was church painter for the women while Federigo sought out more learned and vivid painters from the North. Timoteo Viti might have given him the first glimpse into the proto-theatrical Bolognese manner, the greater pathos and lifelikeness which ultimately, through him, dominated and killed Italian art. But even after reading Morelli I don't see why Timoteo, so like his later work, is so little like the early. The evidence given by the higher critics never necessitates their conclusions. They form the conclusions on aesthetic grounds and then search for corroborative details'. Thus to scotch Morelli's authoritative revival of the theory that Timoteo Viti was Raphael's master, and to recognise the limitations of mechanistic Morellian criticism at a time when the young Berenson was crusading for its all-conquering virtues, was a bold and acute piece of hard reasoning in face of current fashion.

Early in November Oppé was back in London, low in spirits and dissatisfied with his journey. 'Raphael is no ambition nor love', he recorded, 'but an exercise of thought and duty'. This chimes with one of the last entries in the Italian notebook: 'The sick soul flies to art in order to express what the ordinary world will not allow him to express in action. That is great art. The rest, including Raphael, is mere cookery'. The fact was that he was personally unsettled at the Museum and in his lodgings in St John's Wood, and did not see his way clear to a proper shape for the book. He was not yet ready to write. He apparently hoped at this time to give his argument a strong ideological structure, harping, as he put it, 'round three notes: Unity, Happiness, Pagan Form'. But he was also—as he sat excerpting Crowe and Cavalcaselle and wrestling with Morelli and Fischel—getting more and more involved in problems of connoisseurship; and his Pyrrhonic hackles rose. 'As usual', he wrote, 'I feel more inclined to write a book on the methods of critics than on Raphael. But it will come'. So he hung in the wind's eye until the middle of December, when he started to write and his confidence returned. 'I am going to make the book a glorification of enjoyment'.

The entries in Oppé's diary for the next months show him slogging away at the preliminary drafts of the earlier part of his book, reading in the literature as he went along. Morelli he resented 'for cleverness'; Pungileoni was 'confused stuff' and unreadable; Wölfflin 'intolerable'. Then at the end of the year his French Passavant arrived and his 'head grew clearer'. In January 1907 he found himself 'stuck over Perugino' and 'unable to get the narrative part going. There is nothing to narrate'. However, in February—when he was recalled to Whitehall—his keenness revived. 'New work, movement and excitement are making me very happy. . . . I feel alive, too much so of course, but it's a change'. Writing went on, sometimes fluent, sometimes laboured, but never to his satisfaction, during March. He met Max Beerbohm at the Savile Club (where he usually dined), read Pater's essay on Raphael, which he pronounced 'as bad as his essays on Greek sculpture', and visited the Cooks at Richmond ('. . . . I enjoyed some of the pictures. A superb Sebastiano'). Then on 12 March he made a longer entry in his diary which shows some of the teleological and critical ideas that were to help shape the book

hardening in his mind. 'It occurred on Sunday that every critic should have sufficient sympathy with his man to feel any deviation from his course or ideal. This is Ruskin against the modern connoisseur, but the modern at any rate is bankrupt. The difficulty is when one is asked, if not he, who else? This is true in the case of a really great work like the Velasquez Venus but it is not true of sketches like the Agnew's de Wint, for anyone can catch the superficial aspect and the sentiment; nor of the so-called early Raphaels in Berlin. It is only true when the picture is thorough and studied and it would require a man of many characteristics equal to the original to produce them all. . . . Of course connoisseurship may come in useful. But hands, feet and details never convinced anybody and never suggested anything to anybody. The argument from them is argument by subsidiaries, and is good as secondary evidence. I grow more to see Raphael's Unity, Nobility. The School of Athens is the great work. The wall flies open and another world appears. . . . Decoration, mere line and colour, is a secondary affair; it is part of a picture but no part of the conception. Composition is another matter for it springs from subject. . . . Every atmospheric scheme, conventional colouring, has its technical cause. This is the material side of artistic development but it no more accounts for the pleasure taken in the artistic product than does evolution for man or beast. Every art is folk-art [here speaks the friend of Cecil Sharp who was later to collaborate with him in a book on the dance]; i.e. every artist adds his little variations to the song which the whole people sing or cause to be sung. Raphael could never have painted had he not been a painter's boy'. Next day brought the customary pejorative reaction: 'Raphael going fairly well—a little weak—so's he'.

During April and May of 1907 things continued to go slowly. Oppé was still puzzled and baffled by the conundrums—due to lack of hard documentation—of the Florentine period. 'The Florentine chronology is hopeless. Nor do I really know the contemporary art history', he recorded on 5 April; 'Raphael *is* dull in Florence', he complained on 14 May, 'I am losing my scheme'; and on 24 May he noted: 'I go on writing Raphael, but I am really stuck—marking time. I don't like these Florentine pictures and I'd sooner say very little about them'. His smaller working notebooks, however, reveal a bit more of how his thoughts were running, and how his immediate difficulties of chronology and criticism were beginning to sort themselves out. 'If one removes the Severo till later with Crowe and Cavalcaselle the Florentine period becomes clear. It was not essentially a Florentine period until about 1506. Till then he was mainly Umbrian travelling from Perugia to Urbino and to Florence. It is Vasari who exaggerates Florence'. On the early Madonnas he has a longer note: 'The mere prettiness of Raphael's Madonnas is against them. We suspect that what appeals directly to our senses is on the one hand intellectually, morally and emotionally inferior and on the other less thorough in representation, i.e. less true. Ugliness is always convincing, prettiness suggests the clap trap of the chocolate box, a mere momentary and obvious appeal. We are mistaken because we are not simple enough to connect our immediate sense impressions and desires with our emotional ideals. To a Renaissance man the Virgin was as naturally well favoured in the ordinary sense as a male saint was well formed. Almost all the early art shows this, only they didn't know how to represent either a female or a man's physique and they had a bias towards the conventional and barbarous Madonna. When they became individual each man chose his own style, each giving the Virgin what he liked himself in women. Among all the varieties Raphael found the most humanly satisfying. But he didn't do so until Rome. Before that he was semi-conventional and semi-tentative, mainly Quattrocento. In both however, thanks to Umbria, he was pretty'. In a later entry Oppé returns to his notion of Raphael as a 'painter's boy': 'Raphael learned to paint before he had learned to see. So some speak, even write, before they can think. They feel vaguely the emotional meaning of what they are expressing in imitation of some model, but they do

4

not understand its implications, do not see how it comes about, do not know what it means'. And he concluded: 'Florence is a short unimportant transition period. Raphael didn't show what he had learnt there till he came to the Segnatura'.

Meanwhile Oppé had refreshed himself, during the month of June 1907, with a visit to St Petersburg, Berlin and Dresden with his South Kensington colleague Eric Maclagan. Again he did not sketch in front of the pictures, but wrote out detailed verbal descriptions of them on the spot. His notebook of the journey contains, for example, an elaborate, and by no means wholly laudatory, description of the Sistine Madonna. It makes a marked and characteristic contrast to his nobly modulated eulogy of the painting in the published book. His initial response, on the other hand, to the *St George* in the Hermitage (now in the National Gallery in Washington) was pure enthusiasm: 'All this', he concluded after his long formal description, 'is beside the point; the picture is the soul of chivalry. It is naif and yet thoroughly skilled, learned without losing any freshness. It is the most beautiful Raphael'. This second *Studienreise*, in fact, unlike the previous one of 1906, was an exhilarating cathartic experience—just what Oppé needed at this stage in the composition of his book. It enabled him, while feasting his eyes on originals long familiar in reproduction, to stand back, as it were, from his writing, to simplify and anchor his floating ideas and bring them into sharper focus. 'As for Raphael, with less writing I grow more intent on ideas—Unity'. This was his last remark in the diary before he left for Russia; and a fortnight after his return to London he recorded with relish his impressions of the trip: 'It's a vivid memory, a debauch of pictures. I was so thoroughly excited that even the constant headache disappears from memory. Now I'm here again, beginning to work on Raphael, conscious of how much I have learnt'.

During the next four months—from mid-July to mid-November—Oppé revised the drafts of his earlier chapters and blocked out the remainder of the book to the end. Combined, as it was, with his daily duties at the Board of Education and an increasingly rewarding social life, it was a triumph of intellect, patience and self-discipline. 'Occasional Raphael. . . . Much pleasure and too much hurry', he noted on 31 July; on 15 August: 'I do Raphael every night and if what I write is conventional and stale it is fluent'; on 2 September: 'Raphael every night . . . doesn't go well. . . . I am learning to wait without impatience. Certainly there is no need to struggle'; and a month later: 'I know I could write Raphael like wildfire tonight, but I know equally that to do it would be to poison myself for a week. My head is clear like a burning flame in a heavy block of iron. The heart beats. The world doesn't seem present. The body is insensible. But this is all symptomatic. The cause. Nothing'. Early in October, too, he visted Petworth ('fine and strange') and Oxford, where he 'saw F. H. Bradley at every meal and had a superb day with Zulu [Professor de Zulueta] and Fyfe in the country'; and for a moment— with a sense of his 'divided life' ('Art isn't the greater part of me')—he slowed down with the book. 'Raphael is quite dry', he recorded on 9 October, 'I haven't a thought of it and my mind turns much more easily to office work, as a relief from the other. Of course there is no hurry as Laing [the editor of the 'Classics in Art' series] wrote of the postponement. . . . I'm not really keen to express my ideas, but I have a workman's desire to produce a good consistent piece of work on certain ideas which seem to me true and quite well worth elaborating and saying and, in a lesser degree, quite likely firstly to be useful to England at the present moment and to me personally to have said. Thus, as ever, the pleasureless hard driving workman, the Jew, is uppermost in me. That is wrong. I want emotion, enthusiasm, love. I doubt if the writer, in the middle of his writing, ever feels conscious of these qualities which must certainly be in him if he is to work at all for any other motives but money or

fame. . . . As for love. . . [he added after reflections on family affairs], I have never felt so completely that it is an impossible emotion for me to recover'.

His sails, however, soon filled again. By 20 November he had apparently got to the end of his preliminary draft of the whole book and had begun his final revision of it. 'I have actually written some Raphael revise tonight', he wrote, 'quietly and without arrogance or heat'; and he added: 'A conclusion drafted for Raphael has created the illusion that the book has reached a form'. The same entry also records another visit to Petworth ('where I enjoyed the pictures infinitely more than before'), and it contains a touch of the sort of poetry that is always near the surface, but rarely on it, in Oppé's diaries: 'Today the fog was high and made a beautiful olive green night, wonderful in tone, restful and depressed in colour, unworldly, inhuman yet quieting as though a dream. . .' The following day brought him news from de Zulueta in Oxford that a research fellowship was open at Merton, but he unhesitatingly rejected any ideas of entering for it: 'I want Chelsea Embankment and an active life'.

The final revision of the text as a whole was achieved, by a remarkable feat of concentrated energy, between the end of November 1907 and the end of April 1908. It did not start easily. 'Tonight', Oppé wrote on 3 December, 'absolutely deadly failure. I want to do the end of Raphael's first section—life only [i.e. the present Chapter 1 on the 'Early Years']. I want to show how the blankness of incident shows his character. Not that he was blank himself, not that he merely accepted conventions, but that the absence of all conflict shews absence of limitations, a power of assimilation which leads to universality and at the same time that the early professionalism saved him from sterility. Then to shew the evils of Perugino's influence. It won't go. I can't see why, but my head is muddled, and I can't advance with it. Of course it isn't interesting. I don't want in the least to dwell upon it. It means nothing to me; anyone might write it and I wouldn't be much impressed by the result. So now with the whole of Raphael. But that is work always'. Meanwhile, he had dined with Robin Legge, the music critic, and Miss Valentine Tollemache (whom he was to marry in February 1909), and he noted: 'I have a suspicion she will mean something in my life. . . . We talked of music of which I know nothing'. He also seems to have had ideas, which came to nothing, of sharing lodgings with Geoffrey Scott. On 5 December, however, his pen flowed once more: 'I wrote tonight. Rather rubbish but fluent, and fluency that comes after restriction is often better than it seems'; and the next day he finished his first chapter ('poorly but perhaps adequately. *Chi lo sà?*').

The revision of Chapter 2, on the 'Early Pictures', occupied the next two weeks. 'Dined alone and recasting Raphael, appalled at the connoisseurship difficulties of the early period in which I'm not interested', he recorded on 12 December; and on the following day: 'Pure analysis of method. Theorising in my Raphael revise has gone fairly happily. Goodness knows whether the sequel will be worthy of the proem. But I'm not feeling afraid tonight'. On 17 December—after a visit to Christie's ('. . . a few good paintings and many poor. Most were vulgar XVIII cent. English, showy and empty like bad Peruginos. They catch the undiscriminating who is taught to admire. What then is the difference between them and good works? . . . How is it that I don't tire of art?')—he recorded: 'I could, I think, go on all night writing the inconclusive rubbish about the early paintings that I'm writing now. . . . It is wonderful how badly I am doing it. Of course the early part is the hardest. But I am always bad when face to face with the pictures. Most of them are distasteful to me'; and finally, the chapter apparently finished, he wrote on 19 December: 'Tired but not altogether displeased with Raphael and life in general'.

The end of the year was disturbed by the bother of moving to new lodgings in Hampstead; and

meeting Campbell Dodgson at a music-party just before Christmas sent Oppé away with 'a certainty that my Raphael would be no good because I didn't know enough of the current art world and history'. The move to Hampstead, however, revived his spirits and appetite for work, though January gave him a hard time with what he called 'the impossible chapter'—Chapter 3 of the final book dealing with the chronology of the period 1504–8 that had teased him all along. 'Raphael is the chief thing', he wrote on 16 January, 'I wish I could give it life. I don't know enough to handle my own material. I know too much to deal with it naively'. Still, by 24 January Chapter 3 was sketched out ('It seems good enough. I can't judge and it ought to go ahead but it doesn't'); and all through February 1908 he was struggling with Chapter 4 on 'The Art of the Transition Period'. 'Raphael still sticks', he wrote on 4 February. 'I have given up the summary, partly because of its difficulty and partly because it is impossible to dissever aesthetic from historical criticism. The different elements in appreciation are also elements in the psychology. But the history goes no better'. The chapter was still going 'very stingily' on 5 February: 'It takes longer to revise the chronology than it did to write it and as for criticism I have simply discarded it, meaning either to come back to it or to incorporate it in the end. But there isn't the faintest depression'. And still on 21 February Oppé complained: 'Raphael goes feebly. I have discarded much of my intention and am frankly treating the pictures aesthetically. I find the historic and critical necessarily demands and implies aesthetic consideration. But the failure of the original plan makes the present a poor composition. It would have been better to eschew historical sequence'. Then for two months— March and April—the diary is silent, and Oppé must have recast the last great chapters on Raphael in Rome at a run, for on 29 April he laconically recorded that 'Raphael is gone to the publishers'; whereupon, in jaundiced retrospect, he immediately proceeded to sum up the book's shortcomings: '. . . a mere—no, not a shadow, but a disguised, obscured, muddled version of what I wanted to say. I doubt somehow whether I can improve it. The truth is that anyone can conceive a wonderful book and go some way to achieve it. But all the work is eventually done with haste and disgust and then it requires real knowledge, vivid ideas, great power and experience to make the hurried product in any way representative of one's thoughts. There's a nervousness in beginner's writing as there is in platform speaking or any performance, which makes all the intentions disappear and only the bedrock come uppermost. If that is not valuable in itself, or if the training has not been so good that expression is natural and undisturbed, the result is sheer failure'.

When, after vexatious delays, the book finally appeared in print towards the end of 1909, it showed no signs at all of the pains and self-questionings that Oppé had suffered in the course of its composition. It left his hands faultlessly and elegantly articulated into three pairs of chapters, each pair dealing with the life and works of its respective period, early, transitional or Roman. Distinct in its parts, the book is balanced and unified as a whole, and it is written in a taut, nervous, precise language that combines a fastidious grace with perfect fidelity to the contours of the argument, rising and falling with them. 'I had when I wrote essays', Oppé observed in his diary while in the throes of his final revision, 'even when I did Greek proses, an exaggerated idea of interconnection—of logical sequence, of perfect transitions. But this sense, while it makes writing all but impossible, may perhaps give me the secret of Raphael's greatness. It is the sense of Form'. This in the end—after 'murdering his darlings' and jettisoning so much of the ideological scaffolding with which he started—is exactly what Oppé succeeded in conveying in his book: a sense of Raphael's formal achievement and formal development as a painter.

It is strange, when we remember Oppé's later preoccupation with Old Master drawings, that he should have had so little to say about Raphael as a draughtsman. Partly, perhaps, this was due to the

paucity, at that time, of critically sifted material. J. C. Robinson's catalogue of the Raphael drawings in Oxford, it is true, was available to him in his library; but Fischel's great corpus of the drawings had not yet begun to come out, and Fischel's preliminary catalogue of 1898 was forbiddingly restrictive as to which drawings were to be accepted as Raphael's and which were not. Oppé's decision to confine himself almost exclusively to Raphael's paintings was also perhaps partly dictated by Methuen's, who made most of the plates for the book, no doubt by prior arrangement with the German publisher, from blocks that were used to illustrate Gronau and Rosenberg's *Raphael* in the 'Klassiker der Kunst' series which appeared earlier in 1909. But this was not the fundamental reason for Oppé's exclusion of the drawings. The fundamental reason was that he was concerned to determine, define and evaluate the final and definitive achievement of the most ideal and humane of Renaissance artists. To this end the processes of genesis, such as the drawings would illuminate, were beside the point. What mattered were the finished works; and Raphael's finished works—which provided a 'classic' canon for generations of succeeding artists and amateurs—were, supremely, his paintings.

What was the contribution of the book at the time it was written? Here we must regret that Roger Fry, who told Oppé during the writing that he 'insisted' on reviewing it, gave it no appraisal in the *Burlington Magazine* and only a brief notice (if that is his) in the *Athenaeum*. With respect to the older literature, Oppé was well aware that he was building on the solid foundations laid by Passavant, as he indicates in his bibliography, and for documents he drew heavily on Pungileoni and Campori, while Crowe and Cavalcaselle, though too diffuse for his taste, gave him a good deal in the way of general information and critical opinion of the works. At the same time, in approaching his task, Oppé took up a clear and distinct critical position of his own, which he defined in the introductory paragraph of a pencilled synopsis of the projected argument of the book dating probably from the early months of 1908. 'In history of life and in attribution of pictures effort to be very cautious and to stick to the facts and documents. No picturesque account of his life and no attempt to declare works his or not. Throughout the pictures are considered on their evidence'. These objectives distinguish Oppé's book on the one hand from the antiquarian aims of Eugène Müntz's monograph of 1881 (which he described in his bibliography as 'a picturesque account of Raphael and his times'), and on the other from the attributionist aims of Morelli and Crowe and Cavalcaselle. The book, as it turned out, was indeed very much of its time, especially in its combination of a critical temper with a fundamentally aesthetic approach; and the nearly contemporary writings that immediately invite comparison with it are Berenson's pages on Raphael in his *Central Italian Painters of the Renaissance* (1897) and Wölfflin's in his *Klassische Kunst* (1898). Like Berenson and Wölfflin, Oppé wanted to comprehend Raphael's formal achievement from a thoroughly aesthetic point of view, and he did so in an argument more sceptical than Berenson's and more concentrated than Wölfflin's, and one infused with a controlled passion no less intense than theirs. Where he differed most notably from them was in the way, however reluctantly at first, he progressively underplayed any *a priori* notional categories or criteria that might stand between the pictures and the viewer, and steadily kept his eye and mind on the individual paintings themselves. Berenson and Wölfflin were, and remain, doctrinaire critics; Oppé was an empirical one. It was in the closeness, subtlety and accuracy of his formal descriptions of the great pictures, one by one, that he brought out their individual qualities, and thus—*a posteriori*—demonstrated both the variety and the unity of Raphael's career. Secondly, he differed essentially from his immediate predecessors in his clear separation of the biographical from the artistic evidence, and in the sceptical rigour with which he handled both. The decisiveness with which he cleared away the dead wood in the biography, especially

as regards the pre-Roman period which gave him most trouble, was unique in its time; and he thus released the works themselves for historically well-founded but purely formal and aesthetic appraisal, which became his ultimate and dominant purpose. What emerges by the end of the book is a critically based but quite independently viewed full-length portrait of Raphael the painter.

When we come to consider how Oppé's *Raphael* stands today, after more than half a century of accumulated research, we must draw more radical distinctions. Few younger art-historians will share Oppé's indifference—he was writing at a time when Oscar Wilde, willy-nilly, had changed the whole aesthetic climate—to the problems of subject-matter and iconography that fascinate so many modern students of Renaissance art. Having read and marked, however critically, the studies of Wind, Gutman, Hartt and others, they may well fail to appreciate Oppé's remarks on the ceiling of the Stanza della Segnatura: '. . . these figures, together with their attendant putti, are primarily decorative. Their first object is to fill space pleasantly, and since in those days it was not enough to fill the space with a pleasant pattern, and figures were required, the figures are also decorative and pleasant in their form and bearing. If they do not succeed in conveying the allegorical idea which is stamped upon them by their attributes and inscriptions, they do not in any way contradict it, and they do, at least, so far correspond to the ideas for which they stand that they convey the impression of dignity, grace, and fair proportions, as befits the great branches of intellectual activity which they represent'. This is pure *fin de siècle*; and on Oppé's own principle (already quoted from his diary) that 'composition springs from subject' it is one-sided and inadequate. However little we in fact know for certain, through historical accident, about the prescriptions for Raphael's great figure-programmes and about who actually devised them, it is unquestionable, on the Renaissance evidence we have, that their subject-matter was fundamental to their conception and realisation as finished compositions. Nevertheless, in jumping so deliberately on this side of the fence when it came to the ideal naturalism of High Renaissance art, Oppé was making a clear historical distinction. 'Critics have analysed the picture', he writes of the 'School of Athens', 'to discover hidden intellectual and symbolic meanings in each figure, in each group, in the whole arrangement [a very Whistlerian phrase]. Such criticism has naturally proved its own doom, for it soon found better employment in deciphering the artificial symbols of primitive hieratic art, which were painfully pieced together, and can be as easily resolved into their constituent factors. Raphael's figures are not like these, but are the representation of a world of living and breathing men, who show their characters in the complex forms in which nature clothes qualities of mind, and who are more real than those of the world around because they are more perfect'. Partial and rooted in the outlook and aesthetic of its own time as this judgment is, it is still a salutary caution to piecemeal exegetes who try to unpick the iconography of works of art—especially such humane and classic ones as Raphael's—without proper regard to their total historical and artistic context and purpose. It needs very delicate iconology not to 'murder to dissect'.

This brings us to another obvious distinction between Oppé's treatment of Raphael and that of many later, particularly the more recent, critics. Oppé considered Raphael's life and works more or less in isolation, whereas the tendency of modern criticism is to consider both the artist and his various commissions in their historical and stylistic context. Fischel, for example, in his great monograph (now available in the original German text), gives us a picture—the fruit of a lifetime's enquiry—of Raphael's whole activity as painter, architect, antiquary and papal official in all its many-sided variety; and he sets this in an encompassing artistic and cultural frame which shows where Raphael stood, and how he stood out, in his age. So too on the stylistic side. Ortolani and Freedberg, to

name but two critics of this and the last generation, not only analyse and explicate Raphael's personal style, but show its links with the style and styles of the whole High Renaissance. Similarly with the individual works. The most notable recent advances in our knowledge have been made by scholars aiming at a full historical reconstruction rather than an aesthetic evaluation of the major works. They want to show exactly how they came into being and how they stand in a precise historical and physical setting. Outstanding examples of this approach—to take only a few of many—are Shearman's studies of the Chigi Chapel in S. Maria del Popolo and the Loggia of Psyche in the Farnesina, Biermann's monograph on the Stanze and Putscher's on the Sistine Madonna, Hirst's paper on the Chigi Chapel in S. Maria della Pace, and White's and Shearman's on the tapestries and cartoons—all, incidentally, now having to hand a splendid working tool, denied to Oppé, in Vincenzo Golzio's *Raffaello nei documenti* (1936).

Nevertheless, despite these clear and expected differences between Oppé's book of 1909 and the more modern literature, there is one cardinal point on which Oppé's conclusions and those of the acutest recent critics converge. Oppé, as we have seen, was only occasionally and incidentally concerned with Raphael's drawings because his eye was on the finished paintings; nor was he much concerned with Raphael's studio, since his topic was the man himself. He expressly forebore (p. 91, note 1) to discuss Dollmayr's seminal paper on the subject (Vienna *Jahrbuch*, 1895) as being outside his purpose. Modern criticism, on the other hand, in reconstructing the precise history of individual works, has necessarily been much concerned with their genesis; and this—with the help of Fischel's corpus to which we can now add Popham's, Parker's, Pouncey's and Gere's catalogues—has involved it in close analysis of the drawings of Raphael and his assistants and hence in the reconstruction of his workshop practices and procedures. Berenson in 1897 dismissed the productions of Raphael's school as beneath notice, and until fairly recently there has been a tendency, culminating in Hartt's monograph on Giulio Romano, either to play down Raphael's authorship of much of his late commissions and to assign a large part to his juvenile pupils, or to see a falling off in Raphael's late work, due again to the intervention of his school. However, the result of more recent investigation of the drawings and of the division of labour in Raphael's shop (Shearman, Oberhuber, and others) is to show that Raphael abandoned neither grip nor command despite the press of commissions and duties that overburdened his later years. The stories of Raphael walking the streets of Rome with troops of admiring assistants, which provoked the sneers of Michelangelo and Sebastiano del Piombo, Raphael's would-be rival, are no doubt true. But Raphael's followers were not sycophants: they were a band of brothers. Unlike the *garzoni* of a normal quattro-cento workshop, who were manual executants of their master's stock-in-trade, Raphael's assistants were his intellectual colleagues with whom he discussed and to whom he communicated all his intentions, so that with every proposed change of manner—Raphael like Donatello never did the same thing twice—they could follow his mind as well as his hand. Moreover, they were so well briefed and trained in the elaborate graphic procedures which Raphael had devised for the preparation of a finished work—through sketches, studies and cartoons of all kinds—that they could manually participate at any point in the process and still produce something which, if not everywhere bearing the mark of Raphael's own hand, was thoroughly his throughout in conception and outcome. Thus, to put it concretely, the 'Transfiguration' (which was interrupted by Raphael's death in 1520) and the 'Sala di Costantino' too (which was pretty well all executed after it) are Raphael's own in conception and design. They are no less his inventions than the Stanza della Segnatura or the Sistine Madonna; and they bear witness to the extraordinary acceleration in his powers of invention and stylistic change in the later years of his life. To assume that Raphael did not handle all his own great commissions to the end,

to chop up his later work and parcel it out among his youthful assistants as theirs alone, is logically and historically absurd. These, summarily, are some of the results of more recent study of Raphael's drawings; and they have restored unity to Raphael's career.

Oppé arrived at a similar conclusion by another route. While temperamentally and intellectually averse to the undiscriminating Raphael-worship of the academic tradition and sceptically open to the scientific results of the new Morellian criticism, he refused to be betrayed by the latter into a disruptive mechanistic view of Raphael's achievement. From the start he assumed, or rather empirically discovered, that Raphael's career, from beginning to end, was guided by an intellectual ideal which would give it coherence and unity; and while fully recognising the difference between the handiwork of master and pupil he went where the argument led. Thus as we follow his descriptions of the successive paintings and his positive or negative evaluations of them (for he was always quick to note any deviation from the ideal), we rise from peak to peak: in the Roman period from the Stanza della Segnatura to the Sibyls in S. Maria della Pace, thence to the balancing excellencies of the *Sistine Madonna* and the *Castiglione*, and finally to the height of the *Transfiguration*, which Oppé judged in terms as valid and eye-opening today as they were when he was writing. 'The *Transfiguration* ... should have been the epitome of Raphael's art when freed from the restrictions of fresco technique and the smaller scale of easel paintings. Such indeed it appeared to his contemporaries, but now, through the accident that Raphael's death left it for completion by his pupils, and through the ill effects of time, it stands so much an epitome of all the hostile influences which beset the work of Raphael's later art that more thought and sympathetic reconstruction than is usually given to it in these days must be expended for its true appreciation'. Then Oppé describes the picture with the aim, throughout, of trying to discover the direction of Raphael's mind. This leads him to deplore the way the effects of time on the chiaroscuro have destroyed the unity of the picture. And he goes on: 'It is no wonder that the picture falls now into two distinct halves—and the surprising unity of the conception which was remarked by Goethe has so far vanished that at the first view only the dignity and tenderness of a few heads are apparent in the general disruption of the picture—nor that critics can fasten upon fragments and quarrel over their attribution among Raphael's various pupils without reference for a moment to the spirit and intention of the whole.

'But the unity of the picture [Oppé concluded], once seized by the spectator, becomes the greatest and most resounding note of Raphael's entire achievement. It would be in some respects more appropriate to his genius were his final and consummate work one of those scenes of quiet and general splendour which show his happy temperament in its full expression. The *School of Athens*, the *Sistine Madonna*, and the *Portrait of Castiglione* are therefore in many ways the supreme note of Raphael's achievement. But the *Transfiguration* has its centre in such a scene as this, and there is in the picture, besides, the sense of contrast and concentration and the dramatic employment of light and shade which are no less part of Raphael's full genius.

It remains to specify how the book of 1909 is here re-edited, and to acknowledge my debts. A few misprints and slips (some noted by Oppé in his own copy) are silently corrected; present locations of pictures that have changed homes since 1909 are indicated by slight changes of wording and additions in square brackets; a small number of now inappropriate sentences and footnotes have been recast or omitted; and I have sparingly added a few elucidatory footnotes which are signalled by asterisks. Otherwise, I have made no attempt to alter or postillate Oppé's text and notes: they stand substantially as he presented them in 1909. The original edition contained two appendices, one listing Raphael's

paintings with indications of their then current status as regards ascription and attribution, the other giving a bibliography. The former is now omitted as out-of-date and needless, since Oppé's text does not depend upon it. In its stead I have supplied an index of paintings by present location. The 1909 bibliography is retained with the addition of a select list of subsequent writings on Raphael; and there is a revised index of names. The greatest change has been made in the series of illustrations. Most of the paintings reproduced in 1909 are again reproduced (save for reductions in the cartoons and tapestries and the Logge frescoes whose number outweighed Oppé's discussion of them in the original book) from largely fresh photographs, and again more or less in the order in which they are discussed in the text. To these a selection of colour-plates has been added, along with quite a number of extra illustrations in monochrome. A novel feature of the new edition is the inclusion of a considerable body of drawings, which separately supplement Oppé's text. They have been chosen (and here Dussler's recent catalogue was especially helpful) to provide specimens and groups of drawings—in some cases the bulk of what survives—connected with particular paintings, thus affording material for the study of Raphael's preparatory procedures which does not duplicate the scheme of selection in Dr Middeldorf's *Raphael's Drawings* (1945) or in the two editions (1948 and 1962) of Fischel's monograph, and is not always available in Fischel's scarce corpus. A second novel feature is the brief apparatus attached to the list of illustrations at the beginning of the book. This is meant to direct the reader, if he wishes it, to the up-to-date literature and critical opinion on the pictures Oppé discussed in 1909. The main references here are to the catalogues of Camesasca (1962), Dussler (1966) and De Vecchi (1966).

My chief debt of gratitude is to Miss Armide Oppé for so kindly inviting me to edit her father's book, for giving me much information and practical aid, and for allowing me to read and quote from the diaries and notebooks Oppé was writing while his book was in the making. I also owe warm thanks for generous help of various kinds to Miss Jaynie Anderson, Professors Charles Dempsey and E. H. Gombrich, Mr John Gere and Mr Gregory Martin, Professors Donald Posner and J. Q. van Regteren Altena, and Dr John Shearman; and to Mr Paul Elek, Miss Moira Johnston and Miss Frances Shertzer for many kindnesses while the book was being put together for the press.

C.M.

May 1970

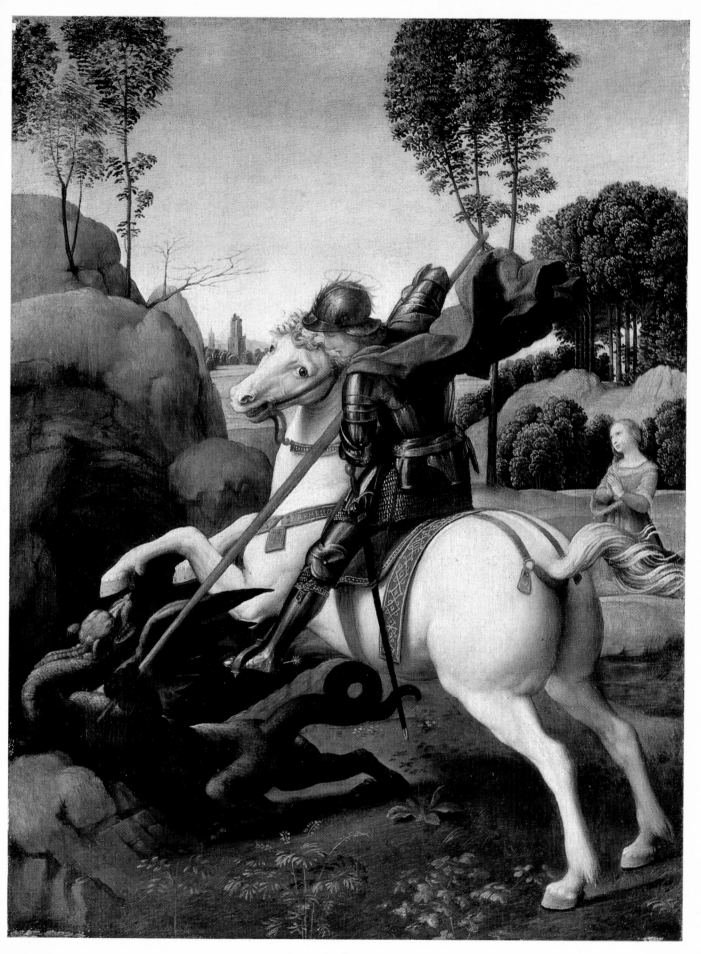

1 *St George*. Washington. 28 × 22.

CHAPTER I

EARLY YEARS

I

RAFFAELLO, the son of Giovanni Santi, painter, of Urbino, was born at the end of March or the beginning of April 1483.[1] Urbino, the town in which he was born, is now an insignificant hill city, remote from the centres of industry and population and famous only for its past. But in the fifteenth century it was a city of the first rank. It lay in a strong position commanding the great road, the Via Flaminia, which had been from ancient days the highway from Rome to the cities of the North, and it was the seat of the Counts of Montefeltro, the greatest of whom, Federigo, claimed to be invincible in war, and was the most renowned of captains in an age when military skill invested its possessor with a real kingship among men. Under Sixtus IV in 1474 Federigo changed his title from Count of Montefeltro to Duke of Urbino, and he built himself a palace on the height which bears the city, making it the model for princely castles in succeeding ages, and filled it, not only with books and treasures of art, but also with a court which long remained unsurpassed for its chivalry and learning. Young men came to him for instruction in the art of warfare and the bearing of a man; they found with him the skill which they sought, and with the strength of a soldier they found the graces of cultivation. The robustness of their life saved the court from sickliness and effeminacy; the love of learning and the arts secured that in the mountain city strength should not degenerate into barbarity.

Raphael was not born in the atmosphere of the noble court. His father, Giovanni, was a painter and a goldsmith, perhaps also an occasional trader in the products of the country. His family could not boast of a drop of noble blood in its veins, although later ages credited him with an illustrious ancestry remounting to one Giulio Sanzio, a kinsman of the most eloquent Roman citizen Tiberio Bacco (presumably Gracco is intended), who earned the name Sanzio *ab agris dividundis*.[2] Giovanni was not even a native of Urbino. His father, Sante, brought him there as a boy, together with his grandfather, Peruzzolo, from a village in the vicinity named Colbordolo, when, in 1450, the rival of Federigo, Sigismondo Malatesta, overran the country and made the city the safest place of residence for the inhabitants.[3] The occurrence in documents of the names of Peruzzolo's father and of his grandfather,

[1] The epitaph by Cardinal Bembo on Raphael's tomb states that he died on 6 April, the day on which he was born. 6 April 1520 was Good Friday. Vasari assumes that the reference is to the ecclesiastic date.

[2] Comolli, *Vita*, 1781, p. 5.

[3] For all documents concerning Raphael's family see Pungileoni, *Giovanni Santi*, 1822; *Raffaello Santi*, 1829; *Timoteo Viti*, 1835 (or more conveniently Passavant, I, App. 1).

which served as patronymics in lieu of a family surname, enables the family to be traced at Colbordolo for two more generations. They seem to have been peasant proprietors; comfortably off, inasmuch as Sante was enabled to purchase property at Urbino, and Giovanni himself speaks of their forced migration as the ruin of his ancestral home. After his arrival in the city Sante amassed enough money by means of the miscellaneous traffic of a country merchant to buy two substantial houses in a good position near the market-place in the centre of the town. He left these with a small fortune to Giovanni, who was his eldest son, and Giovanni became well enough known as the son of Sante to enable him to discard the descriptive title 'da Colbordolo' by which he and his father are distinguished in documents, and to hand the name on as a surname to his son. The name 'di Sante' or 'Santi' became Latinised as 'Sanctius', returned to Italian as 'Sanzio', and in this way the Christian name of his grandfather (and his great-great-grandfather) has become the surname of Raphael, though there is no evidence that he was known during his lifetime by any other name than 'Raphael of Urbino'.

Giovanni's blood did not therefore bring him into any close relation with the rulers of his town; nor yet did his profession, of which he says himself that he adopted it on coming to man's estate when he might have chosen others of greater utility, and that his choice had brought him often into contact with misfortune. His goldsmith's work is unknown. But as a painter, he belonged to a school already too antiquated to satisfy the tastes of Federigo, and, for all his efforts to adopt a more vigorous style, he failed to secure Federigo's patronage. That prince bought pictures by Northern painters such as *The Bath* by Jan van Eyck, and in the decoration of his palace he employed the mysterious Justus of Ghent, one of whose hard and painful pictures is now to be seen upon its walls. Of the Italians he called to Urbino men of the ambitious innovating stamp, such as Piero della Francesca (who twice painted his portrait), Mantegna and Melozzo da Forlì. He asked for stronger colouring, more daring representations of the human form, more violent expressions of passion, more movement and more vigour than Giovanni could have given him. It was more for the monasteries, perhaps more for the women, that Giovanni worked, and his pictures are to be seen in various churches of the region, always Madonnas with the conventional groups of saints and donors, and always showing, for all their excursions into differing styles and their stiffness of execution, a gentleness and sweetness, an easy charm, such as marks the whole range of painting in that century from Umbria and the Marches. He is seen at his highest in the small *Madonna and Child* which is now in the National Gallery, where he succeeds for once in grafting upon his fundamental sweetness a poignancy and a depth of passion which might have entitled him to rank with Federigo's favourites.

Federigo died in 1482. His son Guidobaldo did not emerge from tutelage until 1489 when, only fourteen years of age, he gained his independence by the favour of the Pope, with whom he served against the French. Three years later he married Elizabeth Gonzaga, the daughter of Frederick of Mantua, and from this year dates the establishment of a court which outshone in splendour the ruder court of Federigo, if it has not, indeed, caused the earlier court to shine with light reflected from itself. Giovanni Santi may have received more patronage from Guidobaldo than from his father. But the favour was necessarily short-lived. A letter from Elisabetta to her brother, the Marquis of Mantua, on 12 October 1494, speaks of a portrait commission which Giovanni was to execute in Mantua, but some two months before this date she had announced in a letter to her sister, Isabella of Este, that Giovanni the painter was dead.[1]

The kindly terms in which Elisabetta speaks of Giovanni prove that he was honoured in his humble place. He had not, however, relied upon his painting alone to gain the favour of the young duke. It

[1] Campori, *Notizie*, 1870, pp. 4 and 5.

must have been shortly before his death that he approached Guidobaldo with a modest letter recommending himself to his good offices, and presenting a long poem on the glorious theme of Federigo and his exploits. While Federigo's own courtiers had celebrated their patron in magnificent and cultured language, dedicating to him their graceful Latin poems, or their rhetorical Latin orations, Giovanni entered the lists with a rhyming chronicle in the native Italian tongue. For this solecism he apologises, of course, laying the blame upon the misfortunes of his family and upon the cruel tyranny of art, which, lying upon his shoulders, like the world on Atlas, rendered the burdens of family life doubly hard to bear. But if he cannot speak the tongue of antiquity, he is familiar with its images, as befits one whose book is to lie in the library beneath the effigies of classical poets and orators which Federigo had caused to be painted on the walls. The poem is as full of imitations of the classics and of visions of the pagan gods as it is of echoes of Dante. The twenty-three books chronicling the exploits of the Dukes are prefaced by nine chapters in which Giovanni tells how he lost his way in a dark forest and finds, by the help of Apollo and the Muses, the Temple of Immortality. The shade of Plutarch tells him the names of the heroes of antiquity who pass before him, and, after touching on those of the Middle Ages, he comes to the ancestors of Federigo. The long story of the Duke's campaigns is diversified with short moral reflections and with excursions into subjects of contemporary interest. In the twenty-second book the presence of Federigo at the marriage in Milan of Galeazzo (his brother-in-law) with Bona of Savoy suggests that he had the opportunity to see many pictures. Giovanni dwells upon the theme, and gives not only a review of the great figures in painting up to the date of his poem, but enlarges, à propos of Mantegna, on the virtues of perspective. Thus, the book is an odd medley of the new learning and culture with the spirit of an old-fashioned chronicler. Its composition is good evidence of Giovanni's position in Urbino; it shows him a devoted and humble adherent of a magnificent court. Giovanni must have taken long to compose it. He had it copied in a fair hand with a preface enlarging upon his devotion and upon his difficulties. It is couched in magniloquent language, and after quoting the Caucasus, Hercules and the Lernaean Hydra and Atlas, he mounts to a fine peroration in which Plato appears glorying in three things: that he was born a man, at Athens, and in the days of——: here suddenly the author stops. Possibly the name of the Greek hero had escaped his memory; possibly the comparison between himself and Plato was too bold. He erased the words of the unfinished sentence with a stroke of the pen and wrote 'Finis' above it in the middle of the text. No doubt Guidobaldo would have appreciated the compliment of the dedication. He was probably aware of the composition of the poem; but it does not appear that the book ever reached the ducal library, and it passed into obscurity with its author's death.[1]

Giovanni married one Magia, the daughter of Battista Ciarla, a tradesman of Urbino. Raphael was the third child of their marriage and the only one of four to survive infancy. The imagination of historians has endowed Magia with many virtues, but beyond the fact that Raphael in after life honoured her brother Simone above all his relations, we have nothing but the character of her son to enable us to judge of hers. Legend, fond of contrasting Raphael with Michelangelo, whose foster-mother was famous,[2] discovered the interesting detail that Raphael was suckled by his mother herself. Such little traits are distinctive, but since Vasari, who reports the tale, knew so little of Magia that he mistakes by some ten years the date of her death, no weight can be attached to his evidence. Magia died

[1] Further in Schmarsow, *Giov. Santi der Vater Raphaels*, Berlin, 1887, who quotes a reference from a contemporary poem by Antonio da Mercatello to Giovanni as 'a second Dante'.

[2] Condivi, *Michelangelo*, trs. Holroyd, § lvii.

when Raphael was eight years old. His father married again during the course of the next year the daughter of a goldsmith, Bernardina Parte. Two years later, on 1 August 1494, Giovanni died.

Raphael was only eleven years of age when his father died. The tradition which makes his father the only instructor of his youth besides Perugino is almost contemporary, but it is probably based on ignorance of the true date of Giovanni's death. Certainly it finds little support in actual paintings. The trace of his hand in some of Giovanni's pictures is a mere figment of romance, and the discovery of elaborate parallels between pictures of his and his father's is scarcely less fantastic. But the recent school of critics has gone too far in belittling his father's influence in favour of Timoteo Viti's. In the eighteenth century Mengs[1] fixes upon the age of four years as the right time for a child to begin to learn painting; it is improbable that in the earlier epoch maturer years were thought more suitable. This would give Raphael seven years of instruction under his father; a period long enough not only to form the habits of a lifetime but also permanently to affect a painter's style.

2

The next few years of Raphael's life are the most obscure in all his history. The only facts of which we are certain are that, at any rate by the end of the century, he was working in the studio of Perugino at Perugia, and that ten years after his father's death, in 1504, his earliest dated picture proves that he had mastered all that he could extract from his teacher. So much is evident both from tradition and from his pictures; everything else is mere supposition. Shortly after Raphael's death, and possibly even during his lifetime, it was believed that Giovanni Santi, after giving Raphael his first instruction in painting, placed him under the tuition of Perugino. Vasari represents this event as happening during the lifetime of both Giovanni and Magia. The discovery of the true dates of the death of each renders the account incredible. Documents which destroy all faith in the tradition are not sufficient to establish the true story. It has been discovered that shortly after Giovanni's death a quarrel arose between Bernardina, his youthful widow, and Bartolommeo, Raphael's uncle and guardian. In the legal documents which record the dispute, Raphael appears as an interested party. In 1495, 1497, and 1499, he is mentioned as the ward of Bartolommeo and no hint is given of his absence from Urbino, as would, presumably, have been the case if Vasari's account were true and he had been by this time in Perugia. In May 1500, however, he is expressly described as absent. From this evidence it has been concluded that he remained in Urbino for six years after his father's death and reached Perugia only in 1500. This date, moreover, coincides with the year in which Perugino, after much travel, took up his residence in Perugia, in order to execute the decoration of the Cambio, and when Pinturicchio, Perugino's partner, was also in that town. The combination is seductive. Unfortunately it does not necessarily follow that the omission in the earlier documents to mention Raphael's absence is a proof of his presence at the notary's or in Urbino. He was a minor, and his presence may not have been required, or his absence not have been noted. Nor, as has been pointed out,[2] does the reference to his absence in the document of 1500 necessarily prove his absence from Urbino. As far as the words go—and in dealing with documents the utmost caution is required—nothing is stated but his absence from the court. Finally, although Perugino was certainly very little in Perugia before the year 1500, neither he nor Pinturicchio remained there after that date for more than two years, and it might be held that this period was too

[1] *Lezioni Pratiche di Pittura, Opere*, 1783, II, 228.
[2] See on this point and the documents generally H. Grimm, *Preuss. Jahrb.*, II, 1882, p. 230.

short for Raphael, already a youth of seventeen, to obtain so thorough a mastery of Perugino's methods and to be so much influenced by his manner as his work proves him to have been.

Modern writers at first accepted Vasari's account, adapting it only so far as to allow that Raphael entered the studio of Perugino after his father's death, and that he did so on account of the quarrels between his guardian and his stepmother. They based their view very largely upon the evidence of pictures and drawings which were attributed to Raphael before either the date of his father's death or the record of Perugino's absences from Perugia was known. The more recent view that Raphael remained at Urbino till 1500 was propounded as a paradox by the greatest critic of the last century, Morelli. It is based partly upon the evidence of the documents concerning the quarrel and upon the promise of others which have never been forthcoming, and partly upon a real appreciation of certain differences between Raphael's style in his early years and that of Perugino. This theory required for its completion the discovery of the master who trained Raphael at Urbino during the six years of interval. A document as usual came to the aid of stylistic criticism. In a passage of his diary, dated April 1495, the Bolognese painter Francia stated that his dear Timothy had left him.[1] This is Timoteo Viti, a painter of Urbino, and nothing is more likely than that on leaving Bologna he went home to Urbino. Giovanni Santi's death might afford him a good reason for returning to his native town. Now Viti had been from the days of Vasari placed in the closest connection with Raphael. Some of his pictures and many of his drawings have passed under the name of Raphael. But the connection had generally been explained after Vasari by saying that Timoteo in after life came under Raphael's influence in Rome. Even before Morelli, critics had reversed this supposition and made Viti the master and not the pupil of Raphael.[2] To Morelli he appeared as the great outstanding influence of Raphael's youth, initiating him into the mysteries of art as practised in Francia's school and permanently affecting the direction of his genius. How far the theory may be accepted will be considered before the actual paintings of this period. At present it is sufficient to note that, even though Vasari's account of the relationship of the two men is inaccurate, it would be strange had he omitted to mention so prominent a fact as the six years' tuition of Raphael by Timoteo. It would have been no slur on Raphael's character as an artist if he had been the pupil of Timoteo; and, even if it had been, Vasari was neither so partial to Raphael that he would have omitted to mention it in the account of his life, nor such a stickler for consistency that he would have refused to mention to the credit of Timoteo in his life of that artist a connection which might have been omitted in the life of Raphael himself. Moreover, allowing that Morelli did good service in emphasising a likeness between the works of Viti and Raphael, it by no means follows that the connection occurred during these years. There were other occasions before Raphael went to Rome when he and Timoteo might have met.

The obscurity of the documents baffles any attempt of the critical imagination to reconstruct the details of Raphael's early life. It is mere waste of words to describe his life as a boy in the household of his stepmother and guardian, or to picture him as learning the rudiments of his art from Timoteo Viti or any other painter of Urbino and wandering at will through the mountain town and among the treasures of Guidobaldo's castle, since he may have been at this time in Perugia. It is equally absurd to attempt to watch his progress in the studio of Perugino, since, even if he were there at this date, the master who taught him in Perugino's frequent absence is unknown in name. But, after all, this ignorance is a matter of little importance. Had the adventures of his life during this period been of great moment; had the influences which he underwent marked the direction of his art, tradition, documents, or the

[1] Malvasia, *Felsina Pittrice*, ed. 1844, I, p. 52.
[2] Eastlake's review of Passavant, *Quarterly Review*, 1840 (*Works*, I, p. 211).

pictures themselves would have borne clear witness to their character. As it is, we are in the position in which Vasari and the contemporaries of Raphael found themselves. For us, as for them, the story of his early life resolves itself into an account of Urbino and Perugia; his early influences are his father's and that of the circle of his father, Perugino's and the circle of Perugino, and the exact weight which is to be attached to each cannot be estimated with the slightest approach to accuracy.

Nor is it a matter of great importance how these influences are divided. By the year 1500 at the latest, Raphael was working with Perugino, and, wherever he was working in the years preceding that date, he was still within the range of Perugino's art, drawing from the same sources as produced much of Perugino's work, living among painters whose art Perugino had himself influenced. When he came to Perugino's studio, at whatever date that might be, he was exchanging life in a remote province of Umbrian art for life at its artistic centre. Perugino's qualities were the summation of the definitely Umbrian traditions which had been reinforced by fresh impulses from Florence, through Fra Angelico and Benozzo Gozzoli and in Perugino himself. Many of Perugino's shortcomings were supplied by his partner in the Perugian workshop, Pinturicchio, himself so Umbrian and so near to Perugino that for centuries their principal works were confounded. In a few mannerisms of painting some of the pictures ascribed to the youthful Raphael come nearer to the conventions of other schools, but in all essentials, in their aesthetic qualities, their outlook upon nature, their idea of art, neither these paintings of Raphael nor those of the painters from whom he is supposed in them to have derived depart at all from the Umbrian circle.

Thus, Raphael's transition from Urbino to Perugia was made gentle by the artistic similarities of the two places; so gentle and easy, indeed, that it cannot be dated. The actual cause of the transition is scarcely necessary to seek. Perugino's supremacy in Umbrian art was recognised, for he had raised himself on Umbrian methods to the position of one of the greatest painters in Italy. He had never, as far as is known, come to Urbino in his travels, nor worked nearer to it than at Fano. But he was known to, and sought by, the members of the ruling family of Urbino, and Raphael himself must have heard of him as a boy from his father, who mentions him with honour in his rhyming chronicle, and met him, if Vasari is to be believed, while working at Perugia. Nor, again, is there any great material difference in the outward circumstances of the life which Raphael met with at Perugia from those which he knew at Urbino. Political dissensions and civil warfare were rife in one, while the other was comparatively immune, but the whole story of Italian art shows nothing more remarkable than its apparent independence of these ever-present circumstances. As far as they influenced the art of Perugia, they seem to have affected it by reaction, driving men more and more from the storm of daily life to the contemplation of a reposeful ideal. The struggles of the ruling families were far outside Raphael's purview; victors or vanquished were equally ready to bring commissions into Perugino's workshop. The battles of hired soldiers were indifferent to the true citizens, and therefore, whatever was happening in the streets, Raphael seems to have been occupied in the studio, working at Perugino's drawings, whether the master was present or absent, and sharing his life of a young craftsman with painters of his age, or older, as his friends and sole companions.

3

The blankness of Raphael's record during the first twenty-one years of his life is not a merely negative fact. It gives to the historian as much insight into the man's character as is needed; the

remainder must be told by the pictures themselves. The outstanding fact is that Raphael was purely a painter, born of a painter's family, with no ambitions to adopt another line of life, and with no barriers placed by outward circumstances in the way of his becoming a painter. His life was no more marked by adventure than those of hundreds among his contemporaries who have either left no memory or achieved but moderate success in art. Moreover, his record is free even from such incidents as are recorded of other men whose lives were given to painting alone. There is no tale of unsympathetic relations with masters or with fellow-pupils, of hardships or of unexpected patronage. Everything points to a life of peaceful development, to a character maturing gradually and to a temper which made relations with other men smooth and easy.

The world generally finds a record of rebellion and revolt more sympathetic reading than a tale of peace and conformity. The power and the opportunity to rebel come so seldom and figure so largely in the ordinary man's mind that all his desire for it can only express itself in sympathy with the heroes who have done what he would do. But conformity also has its merits, if they are less exciting to describe. All conflict and rebellion with the powers that are in force have their source in weakness as well as strength, arise as much from incapacity to enjoy the good of existing institutions as from vehement desire to introduce newer and apparently better. Conformity, if it is not merely weak acquiescence but springs from a definite resolve to succeed in a beaten path and from a conviction that what other men do is necessarily not worthless, is a method of advancing towards an ideal not less noble than rebellion. It has, moreover, the greater advantage that every step taken in conformity is a discipline, and that success when achieved is not only due to the efforts and character of the one personality, but also to the acquisition and exercise of the virtues of all those predecessors whose efforts have formed a tradition. The man who has achieved once, through his own value in rebellion, has little impulse to advance farther; the man who succeeds in conformity may, by the exercise of the same virtues, proceed and develop until he absorbs all that is within his power and reaches such perfection as human nature is capable of achieving. Both temperaments have their dangers—in the rebellious the success of opposition may breed mannerism and failure to appreciate the efforts of others; in the conforming the influence of others, mere convention, may choke with idleness the instincts and ideals of the self. Each therefore must be corrected by an infusion of the other so great that only the habit of characterising according to degree enables any really successful genius to be placed in either class.

The astounding development of Raphael's art in the remainder of his short life proves how ready he was to accept and invent new ideas. Such broad-mindedness, unlike the limitation either of revolt or of acquiescence, leads, as a rule, to sterility, since it aims at a perfection too comprehensive to be achieved. It was, therefore, Raphael's luck or a necessity to his development that he should begin in contentment within a narrow sphere. He learnt to paint in his father's studio before he had learnt to exercise his eyes upon nature. His appreciation of nature grew with his appreciation of art, and there was no conflict between the beauty which he saw for himself in outward appearance and the beauty which men had seized and expressed in the pictures which he was taught to paint. Such conflict shows itself either in desperate innovation, in absolute failure, or in eager adoption of some style alien to that of the school in which the painter is apprenticed. Of this there is little sign in Raphael. At no time is his work, as far as it is known, quite without distinctive features of its own, and these features may have been, for all that we can tell, deliberate innovations looming so largely in their creator's eye, that he was unconscious of the general conformity of his work as a whole. But if they were, no external record shows that the innovating spirit showed itself in such material actions as might be expected of it, and the further back the impression which Raphael produced upon men can be traced, the more it appears to have been an

impression of discipleship and acquiescence. Raphael's innovations were unconscious variations upon an accepted theme, the result of looking at nature with eyes, personal enough, but schooled within a definite tradition, and the reason that he could afterwards attain so great a power in a wider field is that his power of representation grew together with his power of vision and his range of imagination, and he learnt the command of his art-methods before he had imagined a field of art too great for him to represent.

In other words, Raphael's strength lay in the fact that he began his life as a professional painter, a man whose trade and business it was to paint pictures, and whose pride to produce an article—to use appropriately enough the language of commerce—which was good of the kind demanded. He was untroubled by preoccupations of the value either of his art as a whole or of the particular form of art which he professed, and whatever his secret ideals may have been, the custom of his profession and the commands of his patrons determined him in the execution of his ideas. In this way he was a typical painter of the fifteenth century, the product of the guilds and confraternities whose trade was modest but joyful, and whose methods were sanctioned by a tradition as strong as the religion which in their innocence they conceived to be closely enwound with their technique. No schooling could be better for a man strong enough ultimately to break loose from its effects and able to regard it as a discipline and not as a whole rule of life. But, as must happen, the virtues of the system are accompanied by no small vices. The school of Perugino, like the schools of all the masters of Italy, lived not only through the execution of masterpieces, but also by the production of countless pictures which are mere echoes of genuine and intelligent work. Virtuosity may have its disadvantages, but it is superior to conventional art in that, its patrons being fewer and its exponents more self-restricted, each work produced is an effort of greater thought. Popularity in art necessarily produces the vulgar picture, a work in which one feature only is exaggerated at the expense of all. Nor is this a mere accident. Art which is based upon notions so widespread that they can be termed popular must necessarily produce works, among others, which contain nothing but the single element which earns them popularity. The galleries of Italy are witnesses that in the strongest epochs the amount of vulgar work was as great as in any other. There is scarcely a painter whose work was not parodied by the cheaper labourers in his studio, and if those of the fifteenth century still retain some charm for the present day as they did for the less critical of their contemporaries while those of a later date are hopelessly out of fashion and unappreciated, the reason lies, of course, in the fact that even the commonest of such reproductions contained a fraction of the essential element which its prototype manifests either for our liking or dislike. But, among all the offenders in this respect, few could equal Raphael's master, Perugino. Achieving his success by the adoption of thorough habits of observation, and by a study such as Perugia had never known before of certain effects of nature and of the human face and form, he soon learnt that his essential charm and sweetness, the appearance of a superhuman blissfulness, could be produced in painting with the minimum of solid pains. He was the first to parody himself, and by the use of a method of transference of drawings which amounts to nothing more than stencilling, he could teach his pupils in their hundreds to produce the ill-composed, ill-coloured, featureless inanities which cover the walls of Umbrian museums. It is said that form can be copied, but feeling never. Nothing can be less true. Feeling can be reproduced by the discovery and repetition of the few central forms until, as in the case of Perugino's imitators, all the aesthetic virtues have disappeared and nothing remains but the primal emotional intention, which stares, like the cat's grin in the children's story, from the picture's frame, and, through the loss of all attendant circumstances, becomes over-potent, oppressive, or in this case, cloying.

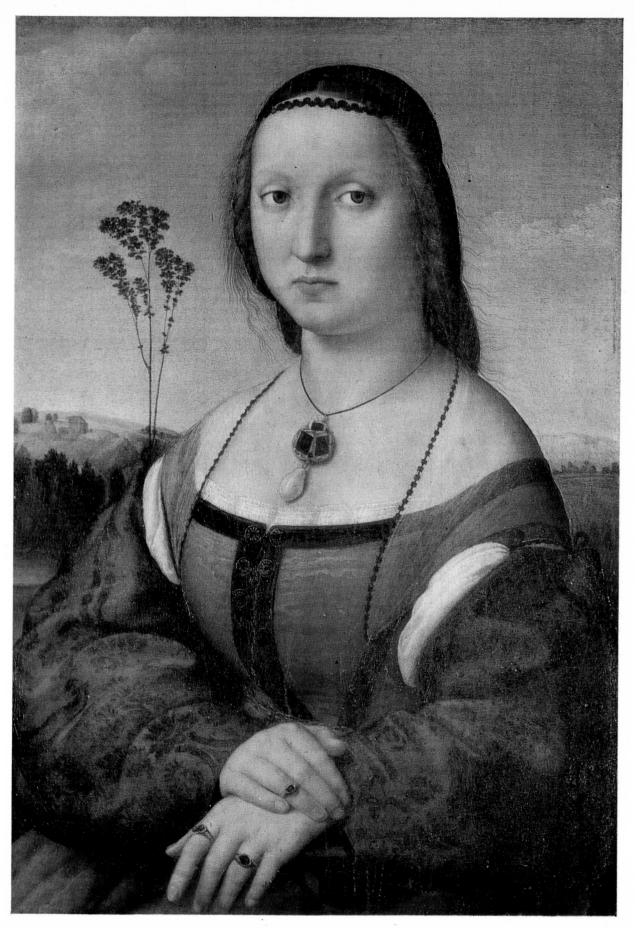

11 *Maddalena Doni*. Florence. 63 × 45.

This is the bad side of the early influences which beset Raphael's life. His training as a craftsman enabled him to keep pace with his ideas, to assimilate and yet to retain a mastery over himself and the influence of others, and this served him in good stead when he had outgrown the ideas of his youth and had a wider imagination for his field. But he gained with his training something of the tradesman's lack of conscience, the necessary professional carelessness, which allows work of admitted inferiority to be put forth as sufficient for the purpose for which it is intended. As far as this tendency resulted in the production of early and transitory work, it was in Raphael's case wholly good. His powers of development were so great that there was never danger that he would rest in contentment with the merely provisional, and, in general, man learns, not by the constant unrealised effort for perfection, but by repeated expressions of the imperfect. But as far as it was a tendency to meet an uncritical demand by the production of imperfect work, its effect was wholly bad, and when it resulted, as it did later in Raphael's life, in the repetition in his studio of the activity which he had seen in Perugino's, and in the manufacture, by hundreds, of works painted and almost wholly invented by pupils, it has done in the end incalculable damage to Raphael's reputation. But, since it must be accepted as a feature in his life, it is as well to recognise that the vice is but the accompaniment of a virtue, and that when it appears most strongly in the days of his maturity this characteristic is no new growth nor sign of decay, either in the life of Raphael or yet in the history of Italian art, but a constant feature in the development of his life and a characteristic which he accepted without question from the example and the tradition handed down by all but the greatest of his predecessors.

EARLY PICTURES

I

IT would be natural to suppose that a better way for the discovery of Raphael's history in his early years, his progress in his art, and his adventures among different influences, might be afforded by an analysis of the pictures themselves than by an examination of documents or of traditions. This is a vain delusion. The works attributed to Raphael by modern critics, whether ascribed to him or not by ancient tradition, fall into certain groups, related among themselves and to each other, and bearing resemblances in different details to works by other artists, but they do not give, either by their intrinsic qualities or by any accidents of dating, any certain grounds for the construction of a sequence. At no time in his history can Raphael's work be found to follow a straight course of progress. No picture before the *Sposalizio* [22] of 1504 bears a date; none is known to have been produced in any circumstances to which a definite date can be assigned. If any such there were, its place in Raphael's history would be established, not by the character of the picture, but by documentary evidence. The pictures themselves exhibit, as in the case of the *St Michael* [41] and the *St George* (Louvre) [40], the most striking divergences of technique among similarities of manner. Moreover, though some of the paintings can be assigned to Raphael with as much certainty as it is reasonable to expect in these matters, many are of disputed authenticity. The disputed pictures, and not the certain, are the most important in all theories concerning the doubtful points of his history. The very characteristics of the doubtful pictures upon which one party bases its theory of dating or of influences are to the others definite proof that the picture is not by Raphael. Thus, any argument from the style of a picture to its date or to the influence under which it is painted, is based upon a vicious circle, in which the authenticity of the picture rests wholly upon a theory of the painter's history, and the theory is proved by a reference to the picture. The drawings are of even less value than the pictures in such an argument as this, because their slighter and more personal nature, while it would, if they were certain to be genuine, throw more light upon the artist's life and circumstances, only gives, in the general uncertainty, more opportunity for variation and confusion.

The series of paintings, which is now generally ascribed to Raphael, is based largely upon theoretical argument of this doubtful description. The group is largely the result of compromise, for it is seldom that the theory of the painter's life used by any critic is not based upon, or largely influenced by, some picture or group of pictures which the particular theorist includes, and others necessarily expunge, from the list. For example, the writers who placed Raphael in the studio of Perugino

immediately after his father's death attributed to him, wholly or in part, a number of drawings and paintings which later critics declare to be entirely the work of his masters. The presence of these works gave probability to their arguments, and now that they have disappeared from the list of his achievements their departure has largely strengthened the force of the theory which excludes them. In their place other works have stepped in which are not universally accepted, and, even if they were, would not be less conjectural. Both parties, in the case of a master like Raphael, can always invoke tradition to support the attribution to him of any likely picture. In such uncertainty the only safe course would be to sweep over a far larger field of possible 'Raphaels' than appears to have been touched by any who have written upon him, and to reconstruct upon an entirely new basis some less prejudiced theory of his personality and development. Another, and perhaps the more practical, method is to accept the compromise of the critics and tradition as a consensus of opinion which points with some probability to the truth, to display the accepted works without prejudice, and to state clearly by a comparison among themselves and with other works the amount of light which they throw upon Raphael's character, and the amount of evidence which they afford for the rival theories. The latter method is adopted in this book. No doubt, it is less attractive than the method which attempts to trace directly the course of the painter's development and to place the extant works in a clear-cut historical sequence; certainly it is more difficult, since the presence of a theory, not only by emphasising certain points in every picture but also by casting a veil upon others, renders the historian's task of selection among the mass of details infinitely easier. But in the present state of knowledge there can be no doubt which of the two methods is the sounder and the more truly critical.

2

The first group of works which are universally accepted as authentic rests upon the evidence of Vasari or upon the signature of the painter. Of course, signatures are easily fabricated, and Vasari, while he is the nearest thing to an eye-witness, was also in a sense a theorist, in so far as he selects and arranges the pictures according to the opinion which he held of Raphael's development. He adduces the *Coronation of the Virgin* as evidence that Raphael's earliest work was all but indistinguishable from that of Perugino, and not unnaturally upon the same grounds the only other works of Raphael's youth which he mentions are formed in something of the same mould. But Vasari's theories are those of men who actually knew Raphael in the flesh. With this caution, therefore, it will be safe to begin the estimate of this period with the group of paintings which Vasari mentions, for not only are they the most certain, but the influence of Perugino which they show is the most obvious and irrefutable of all Raphael's characteristics, and must be fully appreciated before either the divergences which these pictures show, or the pictures which show those characteristics less, are respectively brought under review.

It is only necessary to look upon the *Coronation of the Virgin*[1, *2-8*] to appreciate the obvious truth of Vasari's remark. To analyse in detail the forms and attitudes, the figures and the groupings which recur *ad infinitum* in other paintings from Perugino's studio, whether they represent the same or a different subject, would be tedious and unnecessary. The quiet landscape of a wide valley between wooded hills, the uplifted adoring faces, the gently expressive attitudes or the restrained gaiety of the angels, and the bright simple colouring, are all elements in a scheme which has its basis in a sentiment entirely concordant with Perugino's. No slight divergences in detail can affect the immediacy and certainty of

this impression. Were the picture by Perugino himself it would cause no great alteration in the world's conception of him. But when the analysis of the picture is carried deeper than this, a divergence from Perugino's practice becomes at once evident. The picture is neither purely a 'Coronation of the Virgin', nor yet an 'Assumption', but a combination of the two subjects. Were it the first, the normal arrangement would have required the apostles upon earth to be merely grouped in attitudes of adoration; were it the second, the empty tomb might or might not be present, but the upper part of the picture would be occupied by a representation of the Virgin in glory alone. The picture is thus a combination of two motives with certain features added which belong more strictly to the Ascension of the Christ. There may be historical reasons for this; the existence of a very doubtful sketch[1] has caused critics to conclude that Raphael's conception or his commission[2] changed in the course of his work, and that what was begun as an 'Assumption' ended as a 'Coronation'. There may be hagiographical reasons, for the arrangement is not unique. But whatever other reasons there may be, it is certain that Raphael accepted the finished picture and approved the idea which he had represented, for some years afterwards when he was commissioned by the nuns of Monteluce to paint for them a *Coronation of the Virgin* [253] his sketch embodied the same ideas with only a change in the expression, rendering them more dramatic. With this fact before us, all investigation into the accidents which originated the picture becomes otiose, and it is only necessary to inquire into the reasons which led Raphael to adopt or accept the arrangement. These reasons immediately mark his difference from Perugino. He desired a greater amount of action and a greater variety of life than Perugino showed in his work. The same tendency in him or his school which led to exaggeration of the drama in the Monteluce *Coronation* led him to adopt a dramatic rendering in the earlier picture; nor is it merely the desire for dramatic action, which, for that matter, is scarcely as yet expressed in this picture, since the figures of the apostles taken singly are still but actors formed strictly according to Perugino's precedents. It is a desire for greater drama in the grouping, a search for a motive which will keep the characters together, and at the same time place them in physical relation to each other in such a way that they occupy a definite space. The tomb affords this motive. In the Monteluce picture its miraculous emptiness is the keynote of the scene; here it is almost unremarked by the bystanders. But its presence explains the grouping to the spectator, its position is utilised, and instead of being, as it is in the Peruginian picture of the *Assumption of the Virgin* in Sta Maria Maggiore in Bologna, or the *Resurrection of Christ* in the Vatican, shown at right angles to the observer, its position at an oblique angle gives perspective, and its disappearance among the apostles at once throws them into a group.

This is the central feature of the picture. For the rest, there is a striking mixture of care and of carelessness in the execution. Some of the heads among the apostles are studied and strongly painted with a faithful rendering of structure, others are loose and unskilled reproductions of conventional Peruginesque types. The attitudes of Christ and the Virgin are fresh and free variations upon stock themes, their lightness and absence of particular character recalling the studies from boy models which still exist [2-4]. The angels show in their studied poses and gracefulness the manner of the school, while their heads, rounded and with beady eyes, are of a form which is not traditional. Hands and feet are, save for the feet of the angels, uniformly careless, coarse and without character, drapery falls into heavy folds and the shadows are blackish. The landscape is careful if not remarkable, while the lightness of the half-conventional flowers is fresh and exquisite.

[1] Budapest. Fischel, 1898, No. 32.
[2] Crowe and Cavalcaselle, I, 142, Morelli, *German Galleries*, 323, assume that the picture passed as Perugino's. Contract for its execution without name of painter *ap.* Mariotti, Lett. 238.

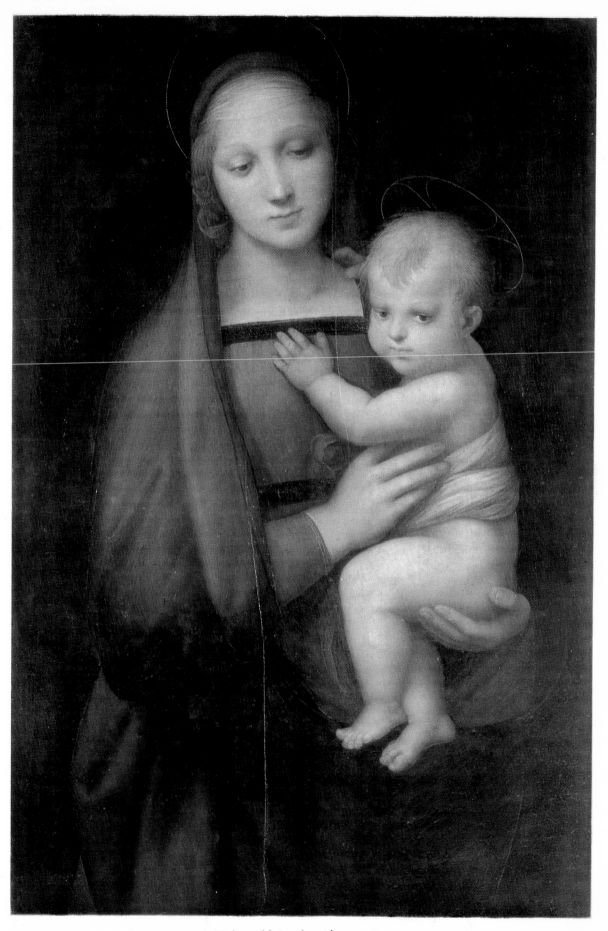

111 *Madonna del Granduca.* Florence. 84 × 55.

Two of the three predella pictures [9], the *Annunciation* and the *Presentation*, follow closely upon pictures by Perugino—the Albani altar-piece (Torlonia Collection, Rome) and the predella to the altar-piece at Fano. The third, the *Adoration*, recalls the more crowded compositions of Florentine painters. The choice of a semi-classical architecture marks an advance upon the Fano predella, but remains within the circle of Perugino's conceptions. A curious feature of the group is that, while the figures and the groupings show more freedom of pose and ease in disposition than do the majority of Perugino's pictures, the heads, at any rate in their present state of preservation, are indistinguishable from the stock productions of his studio.

Inequalities of execution and inconsistencies of type are still more evident in the second picture mentioned by Vasari, the Mond *Crucifixion*[10], painted for a chapel of San Domenico at Città di Castello [and now in the National Gallery in London]. Though inscribed with Raphael's name, RAPHAEL URBINAS, the picture is, in details and arrangement, a *cento* of figures used over and over again in works from Perugino's shop. The composition, unlike that of the *Coronation*, shows no variation from the studio practice. The drawing and modelling, where they are careful, as in the body of Christ, follow closely the model of Perugino's better work; where feeble and characterless, as in the figure of the Magdalene, they are not different from inferior productions by himself or other pupils. Of features peculiar to the picture there is little outstanding save the hard and somewhat gaudy colour which distinguishes this picture from others by Raphael, as much as from Perugino's own work, and the character of the heads. In these the contradiction of the whole period of Raphael's work is emphasised. The Virgin's head is pure and typical Perugino, save that the modelling of the transition from the upturned cheek to the neck is confused. Comparison with the Virgin's head in the *Coronation* shows its difference from a head more characteristic of Raphael. But the young St John and the angels show clearly the beady pupils and brilliant sclerotic in the eyes, the pursed, somewhat protruding but unstructural lip, the tiny unmodelled nose, and the general inadequacy of the features to the expanse of face which are recurrent and typical marks of Raphael's early work. The hands of the Virgin and St Jerome are of the same type as those in the *Coronation*, showing broad square palms and thin fingers, but they are more carefully drawn, while those of the Magdalene and St John are frankly scamped in careless imitation of Peruginesque prototypes. The landscape is rough, the drapery carefully disposed with heavily shaded angular folds, while there is a definite attempt to produce a variegated pattern by means of flowing ribbons.

A second picture of the Crucifixion, the Galitzin triptych from the Hermitage [now in Washington], has also been attributed to Raphael [36]. It shows a Christ whose body, reversed in outline from that of Raphael's, comes nearer to the figure in Perugino's fresco at the Scalzi, and other figures which are as frequent in Perugino's paintings as those in the Mond *Crucifixion*. Hence critics have attributed it to Perugino himself, but its colouring, which is dark and rich (an echo of the colour may be found in the dark grey-blue mantle over a dark red dress with yellow collar in the Magdalene in Raphael's picture), the slender forms of the actors, the brown flesh-colour and the Flemish detail in the flowers of the foreground and the rocks and villages of the landscape remove it as far from Perugino's work as from Raphael's and bring it within a circle of Umbrian pictures whose authorship is as yet undetermined.

The similarities in these two works with Perugino's pictures have joined with tradition in persuading critics to trace Raphael's hand in even more distinctively Peruginesque works. The altar-piece of Pavia now in the National Gallery, the *Assumption* of Vallombrosa (Uffizi), the *Resurrection* of the Vatican, and the San Francesco *Coronation* (Perugia) are some of these. Drawings may be cited in favour of these attributions. A banner at Città di Castello [13-15], painted on one side with a representation of the *Trinity*, on the other with the *Creation of Eve*, is also ascribed by an old tradition to the painter of three

pictures in that town. Again, drawings are used with some effect to establish a veracity of tradition,[1] but the almost obliterated condition of the pictures and the work of a restorer, who has made the heads shine forth in perfect preservation among tattered fragments of pigment, render the discussion purely a matter of documents.* Several predella panels, of which the *St Jerome and the Heretic* from the Cook collection [11], its pendant at Lisbon [12], and the *Preaching of St John* (Ansidei Madonna) [now in Lady Mersey's collection at Pulborough] may be mentioned, have been claimed as Raphael's work without causing conviction. If they are his, they show him in unlucky moments indistinguishable from the mass of his fellow-workers in Perugino's workshop. Two pictures, a *Blessing Christ* at Brescia [16] and a *St Sebastian* at Bergamo [17], which many critics agree in attributing to Raphael, are of greater intrinsic merit. The 'Sebastian' shows a face which is typically Peruginesque, and differs in almost every particular from the heads which in Raphael's pictures show divergence from Perugino's forms. In these pictures it is interesting to note that though they are attributed to Raphael by critics who, *par excellence*, base their judgments upon the characteristics of minor details, the widest divergence is shown in the shape of the hands and fingers. St Sebastian's fingers are long and bony, and are posed in the conventional attitude of dainty clasping, which occurs again and again with fingers of similar shape in pictures of the Madonna, while the Christ shows a broad square palm, and fingers and a thumb which are as fat and as short as St Sebastian's are thin and long. For the attribution of the *St Sebastian* to Raphael very little can be said; but the 'Blessing Christ' has enough points of resemblance with the figures in the Ansidei Madonna to make its attribution to Raphael at that period not improbable.**

Of the two pictures which, besides the Mond *Crucifixion*, Raphael painted for churches in Città di Castello, one, the *Coronation of the Blessed Nicholas of Tolentino*, has now disappeared. Only a late and free copy of the central figure, and a drawing[2] in Lille (attributed to Pinturicchio by important critics), can be used for its reconstruction [18, 21].*** The Saint seems to have been standing in the lower half of the picture, his feet planted upon the writhing figure of Satan. On each side stood angels, while in the upper portion of the picture three figures—the Deity, the Virgin, and a Saint—were represented as holding crowns. The figures seem to have been displayed in a divided architectural frame as was customary in the altar-pieces of saints in glory in which the principal figure occupied a central niche, and the others were placed in appropriate attitudes within separate settings. Their actions together combine to compose a dramatic scene, but no attempt is made to represent the scene as such, and the imagination of the beholder is called upon for the combination of all the elements. This painting varied from such decorative representations only in the pictured action of St Nicholas; but, as far as can be judged, the group can scarcely have been of a pronounced dramatic character. It appears more probable that St Nicholas stood sympathetically above his prostrate foe, charming in his pose and decorative in his outlines, but as little concerned with the meaning of his actions as are the enriched heroes and prophets in Perugino's frescoes upon the walls of the Cambio.[3]

The third picture painted for Città di Castello has suffered better fortune, and it remains, with the *Madonna Connestabile* [30] and the Hermitage [now Washington] *St George*, one of the outstanding works of the early manner. The *Marriage of the Virgin* or *Sposalizio* [22], displayed in the Brera at

[1] Magherini-Graziani, *L'arte a Città di Castello*, 1897, p. 220.

[2] Fischel, 1898, No. 33, see also Oxford, Robinson, *Catalogue* No. 4, p. 111, and App. 18.

[3] For documents dating this picture 1500–1 see Magherini-Graziani, *Storia Patria per l'Umbria*, 1908.

* The banner has recently been cleaned.

** Here in 1930 Oppé pencilled a note in the margin of his copy of the book: 'Inadequate (through lack of sympathy with the Umbrian side)'.

*** Cf. now the surviving fragments in Brescia and Naples [19, 20] and additional drawings listed by Dussler, I, 87.

Milan, bears the date 1504, and is the earliest of Raphael's dated pictures. As much as any of the pictures which have been considered, it remains in its conception within the mental circle of Perugino's studio. Its closest analogy with any picture from the studio of Perugino lies with the picture of the same subject which is now at Caen and has generally been believed to have been painted by Perugino for the Cathedral of Perugia. Mr Berenson claims, however, that this is a work by Lo Spagna of later date than Raphael's.[1] His arguments are not convincing, but as full discussion of them is not possible, no reference can be made to the picture. Nor is it necessary to call it into account. It makes little difference in the estimate of Raphael's power whether he is to be credited with the conversion of an already settled but lifeless scheme into a living picture or the piecing together of old material. All the structural elements of Raphael's picture are contained in the fresco by Perugino of the *Charge to Peter* in the Sistine Chapel, the predella of the *Circumcision* in Fano, and the predella to Raphael's own *Coronation* with the subject of the *Presentation* [9]. The temple and attendant groups occur in all these pictures; the central group with the priest is found in the predellas, while in the *Charge to Peter* the temple is placed at a distance from the actors in a manner identical with that in the *Sposalizio* of Raphael and the picture at Caen. The poses of the two principal actors in the *Sposalizio* are almost identical with those in Raphael's own *Presentation*, while the strange attitude of Joseph's left leg not only occurs in the Virgin of the *Presentation*, but can be traced farther back to a figure in the *Circumcision* at Fano. These and a hundred other parallelisms of detail are too frequent to be worth mentioning if nothing more is desired than to emphasise the obvious resemblance of the picture to others of its family, and they occur over too wide a field to be of value in tracing Raphael's debt to the influence of any particular picture.

Raphael's innovations in this picture, or rather the special variations in the Peruginian tradition which his taste led him to emphasise, are upon the same lines as those noted in the other pictures. His figures show no sign that his conception of the apposite and the beautiful was different from that of Perugino; they are graceful, dainty and charming, somewhat weak in drawing with the weakness that comes of a preference for a particular sentiment over study and realisation, and their attitudes are occasioned by decorative and ornamental rather than dramatic considerations. But within this sphere there is, as there was in the *Coronation* and its predellas, a definite attempt to place the figures upon a basis of observed truth. The peeping maiden, the heads of the priest, Joseph, the Virgin and several of the attendants, and occasional turns of limb and drapery have a freshness and vitality which could only come from the infusion of new observation into the old forms. There is in the central group no little vitality and sentiment in the figures,[2] and far more than this, the grouping of the figures, with its evident intention of breaking up the planes of the picture, tells of Raphael's dissatisfaction with the uniform or sporadic arrangements of Perugino's figures. They are no longer placed in a semicircle; but a cruciform design leads the eye from the foreground to the principal figures and concentrates the interest in the central action. Even the line of the heads—straight and unrelieved in the *Coronation*—is broken in the *Sposalizio*, and a diminution in their size helps with the cruciform arrangement to throw them backwards with some realisation of space. In this respect, however, the *Sposalizio* is less advanced than the *Presentation* predella or the *Vision of St Bernard* of Perugino; for there the grouping and the architecture are skilfully combined, while here the division between the two, and the consequent

[1] *The Study and Criticism of Italian Art*, II, p. 1. The attribution to Lo Spagna is plausible but depends upon an elaborate and rickety structure of this painter's and Perugino's styles: the evidence for assignment to a later date is inadequate, and the effort to find Bolognese character in Raphael's picture unsuccessful.

[2] Note especially the action of the right arm of the Virgin, which is, as Wölfflin (*Renaissance*, tr. Armstrong, p. 80) points out, the reason why the position of the whole group is altered from the traditional arrangement. It is, however, not safe to attribute the invention of this change to Raphael—only less unsafe than to see in it a mark of Bolognese influence.

projection of the main incident into the foreground, bring the picture, almost as much as the Caen altar-piece, into the circle of Peruginesque paintings which are most notable for their complete failure to master the difficulties of composition in space. No actual study of grouping in an open space before a building lies at the bottom of the *Sposalizio*; the two parts of the picture, landscape and figures, remain almost as distinct as the heavenly and earthly spheres in the *Coronation*, and while in each fresh care and fresh observation have left their mark in the sentiment and workmanship of many details, the lack of fusion and combination between the two is a sign that Raphael was still engaged in devising subtle variations upon a conventional and primitive arrangement, and had not wrought the whole into a new and genuine vision of his own. He still saw the scene in terms of preceding pictures, and had not the force to bend his picture into the forms of his own observation and imagination. But the Peruginesque tradition had means for compensating for failure to secure a unity of space and atmosphere, and these Raphael employed to the full. In the first place, the pattern of his lines, both in the figures and the background, is harmonious and interdependent, and, in the second, the height of the horizon, the breadth and openness of the landscape, and, above all, the vision of pure sky through the empty door of the temple give the impression of a spacious atmosphere, which is powerful enough in itself to hide the fact that they are completely separate from the principal composition. In this way Raphael has almost succeeded, in the manner of Perugino, in producing by two efforts an effect which he was as yet incapable of securing in one, but, at the same time, by his modifications in the group and the landscape, he has far surpassed Perugino in creating a group which is concentrated and varied and tends to carry the eye through itself into the space beyond.

In these pictures the influence of Perugino is so predominant that, even though the master was certainly separated from the pupil for two years before the last-mentioned painting was completed, it is difficult, almost superfluous, to trace any other influence but his upon Raphael's manner. Similarities and divergences alike suggest the work of a young and keen observer, who could both seize the advantage of the method which he was being taught, and supplement it by occasional variations and innovations, but remained throughout entirely satisfied with the excellence of the tradition in which he worked. Nor, though the greater concentration and aliveness of the figures remove Raphael's work entirely from the level of the ordinary production of Perugino's, were these elements wanting in the best works of Perugino himself. Even had they been, Pinturicchio, his partner, with as great inequality in his work as Perugino himself showed, exhibited also at times greater mastery in precisely these two qualities. It is therefore unnecessary to suppose that Raphael undertook a journey to Florence before he painted the *Sposalizio*, however possible such a journey might be in itself, and it becomes more than unnecessary, even absurd, to suppose with Messrs Crowe and Cavalcaselle that this journey took place between the execution of the *Coronation* altar-piece and that of its predellas.

3

In the second group of pictures assigned to Raphael during this period the interest passes from the group and the whole figure to the human face. Something of an irregular advance has already been noticed from the all but pure Peruginesque features of the figures in the *Coronation* to the freer and more individual countenances of the *Sposalizio*. The counterpart of that picture in the list of Raphael's Madonnas, the *Madonna del Granduca* [III, 24] now in the Pitti gallery, belongs to a slightly later period, when Raphael was working, at any rate partly, in Florence. Its head, but for the greater finish

in its workmanship, for which the larger scale is quite sufficient explanation, might be that of one of the attendant maidens in the *Sposalizio*, showing the same oval frame, the same eyes under their black-lined lashes, the same straight slight nose, all but unmarked save at the round well-chiselled point and nostrils, and the same small curved upper lip. There is also something of the same slight awkwardness and angularity in the pose of the left arm, and the large long-fingered hands remain. Only the longer and slighter lower lip might tell of a new influence; while the greater simplicity of the attitude shows that the first lesson which Raphael learnt at Florence was that his type of Madonna lay ready to his hand in his portraits of her attendant maidens.

The irregularity of Raphael's advance is shown in the two pictures of the Madonna which alone give certain evidence of the characteristics of his Perugian period. Both the *Madonna Ansidei* [23] and the *Madonna di Sant' Antonio* [26-29] are later than several paintings which must be dealt with, on every ground, together with the pictures of the 'Florentine' period. In some features the *Madonna di Sant' Antonio* definitely betrays the influence of Florentine masters, but in general, both in the types of the heads and the scheme of the groups, these two altar-pieces remain fundamentally Peruginian work, and are not only less advanced than the *Madonna del Granduca*, but even than the *Sposalizio*. This is not only observable in the mechanical grouping, but also in the figures of the Madonna and the Child and in the painting of the faces. The Madonna's head is bent awkwardly and without elasticity upon one side, her face is of an extravagant oval, the eyelids are puffy, the nose and upper lip scarcely indicated, while the cheeks and features are represented without transition and consequently without suggesting in any degree the structure of the head. There is nothing here of the fluidity of painting which existed in the *Madonna del Granduca* or the heads of some of the attendants in the *Sposalizio*; and, similarly, in the affected posture of the hand in the *Ansidei*, the general stiffness of the Madonna in both pictures and the tight and wine-skin-like texture of the infants' bodies, there is nothing to suggest that the painter had already attained the comparative mastery of the two earlier paintings.

These characteristics, however, all attach themselves to a group of pictures of the Madonna which have been attributed to Raphael, and must be, if they are his, works of a period earlier than the *Coronation* and the *Sposalizio*. These pictures have in each case drawings associated with them which are attributed by the majority of critics to his masters Perugino and Pinturicchio. The best authenticated, and probably the latest of this group of pictures is the *Madonna Connestabile* in the Hermitage [30], a little, circular painting of the Madonna and Child set within spandrils with an ornamental pattern.[1] In this the head of the Virgin forms a stepping-stone between those in the *Coronation* and the *Ansidei Madonna*, and the infant closely resembles that in the latter picture. The right hand of the *Connestabile Madonna*, while both it and the left have long and bony fingers, does not exhibit the characteristic affectation, already observed in the *St Sebastian*, of a little finger raised in clasping above the level of the others. This may be due to the fact that as originally designed the right hand held an apple and not a book, but, apart from this, it is characteristic of a greater simplicity in the lines and attitude of the figure than belongs as a rule to Peruginesque paintings. The affectation is strongly marked in two of the three other Madonnas of this period attributed to Raphael in Berlin. In one of these, the *Solly Madonna* [32], it is associated with a more rounded face, and more definite and symmetrical features than those of the Hermitage Madonna; in the other, the *Madonna Diotalevi* [31], with a long and gaunt figure whose face, in its broken curves and elongated ill-fitting features, is an exaggeration, almost a caricature, of the

[1] The pedigree of this picture is less perfect than it is often represented. It has no certain connection with Domenico Alfani, Raphael's friend, and it is referred to in the documents as anonymous, by Perugino and by Raphael indifferently (*Giornale d'Erudizione Artistica Per.*, VI. 77 and 321).

type. The two Infants in this latter picture closely resemble those in the *Madonna di Sant' Antonio*, and further resemblances occur between that picture and the third of the Berlin pictures, the *Madonna and two Saints* [34]. Thus, in spite of immense differences in type and workmanship, there is inter-relation between the whole group, and upon the strength of this, without tradition and without documents, they are all brought into the list of Raphael's work.

If these Madonnas are accepted as Raphael's—and the *Madonna Connestabile*, the *Ansidei* and the *Sant' Antonio* are accredited to him on almost as good grounds as any panel pictures—they show, as do the subject pictures of the first group, a combination of general Peruginesque style with distinctive features of their own. The mood, the arrangement and the colouring, the drawing of the Infants, the landscape, the attitudes of the Madonnas and the general scheme of the pictures, with their softness, subdued feeling, touches of ornament in the dress, and elements of observed nature in the Infants, are all quite sufficient to bring the pictures into the circle of Peruginesque work. There are even the gross inequalities of execution, as shown in the scamped work in the extremities of some of the figures and the tender care and observation in the others, which are characteristic of Perugino himself and of Raphael, together with every member of the studio. If the pictures did not bear on their own faces the association with the work of the studio, it would be enough in order to prove the resemblance to point to the drawings connected with them, which appear to different critics as being by Raphael himself, Perugino or Pinturicchio. But besides these points of similarity, there is a great divergence in no less central a feature than the head of the Madonna. Much as they vary among themselves, and much as they present actual details which are identical with Perugino's practice, these heads show no actual approximation to any of Perugino's forms. Nor are they unsuccessful copies of Perugino. The head of the Madonna in the Mond *Crucifixion* has already been taken as an example of Peruginesque type. It only needs to be compared with these to show the difference between them and a good imitation of the more commonplace of Perugino's types. The head of the Virgin in the *Sposalizio*, which comes near to one of Perugino's most happy figures in the *Vision of St Bernard*—or to that in the Pavia altar-piece—is not the head of any of these paintings. Nor is the head of the Virgin in any of these the characteristic variation from the Peruginesque type which occurs in the angels and the St John of the *Crucifixion*, the angels and certain of the heads in the *Coronation*, and passing through the last attendant maiden on the left, and the youth with the bent rod on the right, of the *Sposalizio* becomes the type of the other attendant maidens in that picture and of the *Madonna del Granduca*. In no case is it the head which recurs in the group of paintings which is next to be considered. It is not Pinturicchio's type nor the type of Raphael's father. Above all, it is not the type of Timoteo Viti, although, had he been Raphael's master for the years before his entry into Perugino's studio, there would be no more likely place to find his influence than in these divergences from Perugino's practice in pictures which, if they are Raphael's, must date from his earliest days in Perugia. The group, therefore, stands almost isolated, and the only close parallel to it that can be found occurs in a picture so obscure and undistinguished that to mention it in connection with Raphael's work is at once to emphasise the multitude of hidden possibilities which must exist in the development and the associations of Raphael's youth. It is a *Madonna and Child* which is now apologetically attributed to Raphael in the gallery at Perugia, and comes from the Convent of the Misericordia in which Perugino had his studio [35]. Coarse and ill-executed, its forms but half-understood, it impresses almost as a parody of the *Madonna Connestabile* and the *Madonna with two Saints*, and yet has variations and touches of independent feeling which mark it as a work with an origin of its own. To assume that it is a copy based upon Raphael's pictures is to give the boy of under twenty-one years too great importance. But if it is an independent work, its existence, like that of the

anonymous drawings connected with the pictures, proves that there were movements and eddies in the circle of Perugino's studio far too complex and subtle for the historian at this date to observe.

These heads of the Madonna are formed on traditional lines, and present less observation of the living model than variation upon a settled scheme. If therefore they fail to show any definite influence besides Perugino's upon the young Raphael, portraits from life are scarcely likely to be better guides. But of the two portraits which are assigned to Raphael at this date, one is given to him by a conjecture of Dr Morelli's [37], as arbitrary as any attribution in the pre-scientific days of art connoisseurship,* and the other is so much ruined by repainting that it is worthless as evidence. The latter, a *Portrait of a Boy*, in the Munich Gallery, is so undistinguished and ugly a work that critics have universally discarded it, and have pronounced its inscription with the name Raphael as a forgery.** It appears, however, both from the condition of the lettering of the inscription and the fact that the letters are carefully drawn in perspective with the buttons upon which they are represented as incised, that it and the buttons are almost the only part of the picture which is in its original state. Nor is it unlikely that the inscription led to the repainting of the picture, as it has led to the production of an early and curious variation of so insignificant a portrait in the Gallery of Hampton Court, in which the lettering proclaims itself as the other does not, a manifest forgery. The other portrait, that in the Borghese Gallery, is a striking work, but it has no more connection with Raphael than can be found in the fact that it came from Urbino, as did two other paintings which are accepted as his, and in its vigour of drawing and expression, in the modelling and comprehension of the skull, it shows features not only far superior to anything that Raphael could produce in his Perugian days, but even to the portraits that are said to have come from him at Florence. Originally it was assumed to be a portrait of Perugino, but, as is known from his portrait in the Cambio, he was already a white-haired, soft-faced old man in the year 1500, when, according to Morelli's own theory, Raphael first came to him in Perugia. Morelli was, therefore, better inspired when he denied the portrait to be of Perugino than in his later view, in which he found in it both a portrait of that painter and a work by Raphael.

4

These two groups of paintings, the large altar-pieces and the smaller Madonnas, show Raphael to be in general the faithful follower of Perugino, refining upon the good qualities of his master, and by no means avoiding his faults, piecing together the elements which he learned at the studio, and making such improvements and variations in detail upon the general scheme as his own powers of observation and his own taste suggested to him. If the pictures show him possessed of a definite personality, it is a personality within a well-marked type, sufficiently individual to have distinguished him, had he died after producing the *Sposalizio*, as one of the very best, if not the best, of the whole school of Perugia, but not independent enough either to cause him to be attached to any other school or to stand entirely by himself. But these pictures were not of such a nature as to give a young man who was anxious to succeed full opportunity for exhibiting the characteristics of his own taste. They are either set pieces or conventional commissions, in which the youth was expected to conform to certain models. There is a third group of paintings ascribed to Raphael and dating from this period; they are paintings of smaller size and with subjects of a less hackneyed nature, and, while they are certainly not careless improvisa-

* The picture was transformed by the removal of much overpainting in 1911.
** C. I. 32; D. I. 86; PV. 39.

tions such as often most reveal the personality of an artist, they are sufficiently intimate to make it a reasonable expectation that they will show more clearly, not only the characteristics which make Raphael's work on the grand scale different from that of his neighbours, but also any marks which might betray the power of other influences than Perugino's.

There are four pictures in this group: the *Vision of a Knight*, in the National Gallery [38], the little *St George* [40] and the *St Michael* [41] in the Louvre, and the *Three Graces* [39], which passed from the collection of Lord Dudley to that of the Duc d'Aumale, at Chantilly. To these must be added the second small picture of *St George* from the Hermitage [now in Washington] [I, 43, *42*] for, though the power exhibited in its execution raises it far above the level of the other works, its conception and many of its details are so closely related with theirs, that, even if the latest possible date for its production be accepted, it belongs essentially and entirely to the group. It is the only picture of the five that can be dated by external evidence, for if it be, as is generally supposed,[1] a commission to Raphael from Guidobaldo of Urbino, and painted as a present for Henry VII of England in return for the gift of the Garter made by that monarch to the Duke, it cannot have been painted later than 1506, when the Count Castiglione, Raphael's friend, came to England with the Duke's presents; but there is reason to believe that it may have been painted some time before this date, as early, even, as 1504.[2] The historical combinations which have been woven round the two pictures in the Louvre are purely fanciful; the *Vision of the Knight* is without a history and without a date, while the *Three Graces*, once connected with the visit to Siena in 1504 which is recorded by Vasari, is now, since that tradition is universally discarded, no less impossible to date than the others.

A common spirit runs through these five pictures and joins them to the other two groups which have been considered. The figures have a quiet reflectiveness, an air of unconsciousness and detachment from their occupations, which even the violence of the dragons in the pictures of the Saints and the horrors of the background in the St Michael are powerless to disturb. St Michael and St George in the Louvre pictures raise their arms mechanically and brandish their weapons without emotion, while, even in the Hermitage picture, St George goes about his business without flourish and without excitement, but in a thorough and determined fashion. The *Three Graces* are posing in a pattern, while the maidens who appear to the sleeping Knight hold out their emblems, but fail by any expression of face or trick of posture to reveal their enigmatic purpose. A preoccupation with line and colour, with the picture itself as a decorative object, a vision of gentle picturesque figures full of softness and tenderness, are the qualities common to these and to the other paintings of Raphael's youth, and they are even more noticeable here than in the religious pictures, because they appear in the representation of scenes in which either great violence or action or a suggestion or definite sensual attractiveness is inherent in the subjects and is actually expressed in the surroundings of the principal figures.

Similarities of drawing also connect the pictures among themselves; indeed, this must necessarily be the case if the total impression conveyed by the pictures is similar. There is a likeness in the method of suggesting the features of the head which shows most clearly, since, being all upon one scale, the same slight touches are used in each case. It is, as it were, a method of shorthand writing, and not only the method, but also the characters are the same. There is in each picture—save the Hermitage *St George*— the same inequality and imperfection in the drawing; the heads and certain of the limbs are adequately suggested and well placed, while the bodies, even when covered with clothes which hide all their forms in ample and decorative lines, are obviously mere approximations and badly understood. The colour,

[1] Claude Phillips, *The Picture Gallery of Charles I*, London, 1896, p. 77.
[2] Schmarsow, *Preuss. Jahrb.*, II, 1882, 254.

soft and harmonious, without—again, save in the Hermitage *St George*, which in this respect, as in the others, sums up all the excellences of, and adds new graces to, the other paintings—rare distinction of unity and glow, differs, of course, according to each subject, but remains essentially the same. There is also—save in the Hermitage picture—an absence of shadow and contrast and a certain monotony of emphasis which belong to the undramatic conception and the inability to give motion to the body; and yet there is an absence, perhaps the most characteristic feature of the whole group, of the merely decorative flourishes which compensate in most fifteenth century pictures for want of unity in the drawing and variety in the action and disposal of the figures. The figures are solid and sober, upon the whole, although here and there, as in the waving skirt of the *St Michael*, the wind and the movement of the body make a dainty play of line.

These characteristics bring the whole group of paintings into closer connection with the *Sposalizio* than with any other of Raphael's early works. Even the faces bear most resemblance to the faces of the maidens in that picture; they are totally different in every one of their suggestive touches from the more characteristically formal type of Perugino's school which is to be found in the *Coronation* predellas. As for the figures themselves, they are not dissimilar in general character from the more careful and fully observed figures in Perugino's religious pictures, but they are poles asunder from the work of Perugino when he was engaged upon similar themes. His *Combat of Love and Chastity*, painted in 1505 for Isabella d'Este, shows elongated and unstable figures, prancing in exaggerated motion, and everywhere ekeing out the want of observation and structure by fantasies of line. Want of solidity and restraint is as much a mark of these figures as solidity and dignity is the mark of Raphael's. Nor are they similar to such works of the Umbrian School as the *Apollo and Marsyas* of the Louvre,* once attributed to Raphael and now credited to Perugino at an early stage. In this picture there is still more studious work, more careful modelling and realisation of bodily structure than in Raphael's pictures, but the forms are lengthy and wiry, the heads are of another character, and all these details, even the landscape, bring the picture into close connection with still another group of which the Galitzin *Crucifixion* is a prominent example.[1]

Here, then, in this array of small pictures, should be the traces of the foreign influences, the un-Peruginesque tendencies which went to build up the young Raphael. But before foreign influences can be traced, some idea of the historical sequence of the pictures among themselves must be arrived at. This raises difficulties at once. The two paintings in the Louvre would appear, from their general character, to be among the earliest; certainly the *St George* would, *a priori*, seem to be many years earlier than that from the Hermitage. But, while they are similar in most respects, so similar that many critics treat them together, their technique is completely different.[2] The *St Michael* would seem to be the earlier of the two, for it is more feebly drawn, and its accessories are, upon the whole, quite childish. But the dragon, both in its attitude and in its modelling, is considerably stronger than that in the Louvre *St George*, and nearer to that in the Hermitage picture. Nor are the others less confusing. The *Vision of a Knight* is generally taken to be the earliest of all, but traces in the heads, and such slight details as the occurrence of a coral necklace, bring it into touch with the picture of the *Three Graces*. With such a beginning the search for outside influences is difficult to continue. There are suggestions in each of the pictures. The *St Michael* with its strange beasts recalls some Flemish painting of the Temptation of St Anthony, the horse in the Louvre *St George* is found to be based upon a drawing of one of the famous horses on the Monte

[1] The resemblance is also noted by Harck, *Repertorium*, XIX, 1896, 418.
[2] Springer, I, 116.
* Castellaneta and Camesasca, *L'opera completa del Perugino*, Milan, 1969, No. 48.

Cavallo at Rome, while that in the Hermitage picture is closely akin to Donatello's relief at Orsan-michele. To these resemblances may be added, more as a *reductio ad absurdum* than as a serious argument, that the background and the maiden in the latter picture are strangely like those in a picture of identical subject, dated 1485, which is inscribed with the name of Bartolommeo Vivarini in Berlin. But these resemblances are sporadic, and serve as the basis of no theory. The theories which have entered as settled truths into most of the text-books and catalogues of Europe are concerned with the *Vision of a Knight* and the *Three Graces*.

5

It is upon the *Vision of the Knight* that Morelli based his theory of the influence of Timoteo Viti upon the young Raphael, strengthening with the marks of style which he found in this picture the flimsy foundations afforded by the entry in Francia's diary, the unfulfilled promise of documentary evidence, and the general untrustworthiness of Vasari's account. He used as arguments for the influence the general character of the heads, the hands and the landscape, and, above all, the resemblance between the female figures and those in two supposed early works of Timoteo Viti, and upon the strength of these characters he dated the picture about 1498, before Raphael entered the studio of Perugino. As for these, the character of the hands is so variable in the early works of Raphael that no use can be made of it as scientific evidence; the character of the landscape might possibly be important, for it is assuredly very different from the landscapes of Perugino, were it certain that the difference is not due to some definite meaning attached to it by the painter, and this certainty cannot be arrived at until the symbolism of this puzzling work has been explained. It is, moreover, very similar to that in a picture by Pinturicchio in which the figure of a knight forms still another link.[1] As for the female figures, while their likeness to Viti's *St Margaret* at Bergamo is not disputed, there is no adequate ground for placing that picture among Viti's early works, and their likeness to the San Vitale of Viti's *Madonna* in the Brera is more than counterbalanced by their and Raphael's general dissimilarity with all the more characteristic features of that work. Moreover, their difference from Perugino's figures is exaggerated. There are maidens with short heavy dresses and bare feet in Perugino's pictures, notably in the *Vision of St Bernard*, the likeness of which to the *Sposalizio* has already been noted, and in the Fano predella of the *Circumcision* (which served as model for Raphael's *Presentation*), and in the *Assumption* at Bologna. The same pictures and many others give precedents for other details of the dress, notably the head-dress of the maiden on the right, which occurs in the *Vision of St Bernard* and again, together with the whole attitude, in the *Circumcision* from which they were borrowed for Raphael's *Presentation*. Even the head-dress of the maiden on the left occurs both in Perugino's and in Raphael's predellas. But, even were the total identity of these two figures with Viti's claimed, and it is not, they can only be used as arguments for the dating and the history of the picture by the total suppression of the third and the most important figure of the group. The higher criticism in art, basing its conclusions at one moment upon the vaguest generalities and at another endeavouring to establish theories by use of isolated details, is full of such suppressions, but none is more amazing than this. It is of minor importance that the Sleeping Knight has a Peruginesque helmet and cuirass (see the *Assumption* of Bologna and the Cambio), although, had they occurred in and not been obtrusively absent from Timoteo Viti's figure of St Vitale, they would, no doubt, have proved indubitable evidence of relationship. But it is more than significant that his

[1] The *Knight of Arringheri* (Siena, Duomo).

whole pose, especially his crossed legs, his hands and his head, is a free version of the two figures to the left of Perugino's *Agony in the Garden*, which is now in the Pitti palace at Florence. In the face of this figure the argument for a pre-Peruginesque Raphael falls to the ground, and it becomes very doubtful that this picture is an early work in the studio of Perugino, executed before the influence of Timoteo Viti had worn off. It is excessively improbable that, after attaining such power in varying and adapting Peruginesque figures, Raphael returned to the slavish and feeble imitation which is observable in the Mond *Crucifixion*. It is not, indeed, inconceivable that this should be the case, nor is it inconceivable that Raphael should return with fuller power to his earlier manner in the *Sposalizio* when freed from Perugino's immediate presence; but, if these theories are conceivable, a hundred other hypotheses are equally probable, and it becomes ludicrous to fix upon any one of them and to treat it as an established fact. Morelli's arguments were of great value in emphasising characteristics in Raphael's work which are not purely Peruginesque, and even more so in pointing out the importance in his history of possible association with artists of the second rank, but when they become, not daring paradoxes and clever surmises, but established dogmas repeated in every catalogue, they are misleading and untrue.

Resemblances in the type of head and figure, and such details of identity as the coral necklace, connect the picture of the *Three Graces* with the *Vision of the Knight*, and they, together with the general dissimilarity with Perugino's work which this picture also shows, are seized upon by the historians who wish to place this picture too at the beginning of Raphael's career before he was dominated by Perugino. A more curious point of detail serves, as does the figure of the Knight in the *Vision*, to bring the picture back again into the Peruginesque circle, though it leaves the question of the date untouched. The Grace to the left of the picture is posed in the characteristic attitude of Perugino's nudes, whether they are figures of Christ or classical figures. It occurs both in the Apollo in the Louvre picture and in the *Blessing Christ* of Brescia, but it is not confined to these two pictures which have been attributed to Raphael, but occurs again and again in figures of Christ, St John, and St Sebastian, and, when masked by drapery, may almost be said to occur in the majority of Peruginesque figures. It is an attitude in which the weight of the body thrown upon one leg protrudes one thigh, while the other thigh is drawn in and the other leg is loosely dragging. The picture is an exercise in this attitude, for each of the figures presents it in a different aspect, and, having mastered it, Raphael, until the end of his days, retained a fondness for it. It is too universal an attitude to call for remark were it not that the lines of the body in the one Grace to the left are identical with Perugino's practice. Besides this point, the inclination of the heads connects the picture with Raphael's Madonnas, while not only something in the features, but also the landscapes and the treatment of the hands bring it into the closest connection with the most certain of that group, the *Connestabile Madonna*. That picture cannot by any trick of criticism be dated earlier than Raphael's arrival at Perugia, or even in his earliest days there.

The way is thus left open to connect this little picture, as was done by critics of the pre-Morellian era, with the visit of Raphael to Siena, which, according to Vasari, took place at the end of his so-called Perugian period. A group of the *Three Graces*, an antique work, now in the Cathedral Museum at Siena, formerly stood in the Library of the Cathedral which is adorned with Pinturicchio's frescoes. Vasari says that Raphael helped Pinturicchio in the decoration of this room, and though he does not mention the *Graces*, it was natural to suppose that the little picture and a drawing of the same subject which is in the Venice sketch-book, were the fruit of visits to Siena. It would be tempting to believe this and to trace the simpler sobriety not only of these figures, but of those in the whole of the group of these paintings to the definite effect of the one visit to Siena and the one introduction to ancient art through a statue which long stood where Raphael saw it. Unfortunately, the arguments of recent

critics, while they have not established their own case, have succeeded in shaking this combination. No one can trace a vestige of Raphael's hand in the frescoes of the Library, although there is a difference of opinion as to the share that Raphael may have had in the composition of the drawings. There is, moreover, considerable doubt as to the date when the statue was placed in the Library, and, further, the group is of such frequent occurrence in ancient works of art that to connect it with the particular version at Siena is a purely arbitrary act of association. Therefore, in this case also, historical certainty is impossible to arrive at; every combination is imaginary, and the only point which is secure is that from some source which must remain unknown a classical influence emanating from a real work of ancient art came upon the young Raphael in his Perugian days, strengthened the influence of what was valuable in Perugino's teaching, corrected its excesses, and at an early date gave Raphael an insight into the possibilities of a greater manner, and brought him before a world of art which he was afterwards to make his own.

Thus, with the exception of the Peruginesque tradition, which shows itself constant through all the variations of all the pictures, no certain influence can be discovered and dated in Raphael's early pictures. They possess no sequence which gives the clue to the dominant effect of other painters. We stand in just the same position as Vasari or Condivi, in whose accounts Raphael passed from the circle of his father to the circle of Perugino. Other elements, Florentine, Bolognese, antique, can be observed, but unless they be placed at the very end of Raphael's Perugian period, when they became merged in the mass of diverse influences which produced the transitional and so-called Florentine manner, they are impossible to assess or date with precision. The mechanical theory which attaches every movement of an artistic mind to definite and external incidents and accidents finds in definite journeys to different places the necessary pegs upon which to hang the various influences. But these are far more possible than is generally allowed by the historians, who write as though every movement of an undistinguished journeyman painter were likely to be recorded. Raphael may have made many journeys to Urbino at any period between his arrival at Perugia and the year 1504, and even Messrs. Crowe and Cavalcaselle are forced to imagine unrecorded journeys to Florence in order to account for the difference between the *Coronation* and its predella. At Urbino he would have found Timoteo Viti, to whom he may have taught far more than he learnt from him, and whose work, notably the *Magdalen* at Gubbio and the *Immaculate Conception* of the Brera, shows far more points of similarity with the 'Florentine' than with the earlier pictures of Raphael. Moreover, the period of Raphael's youth is approaching the time when the higher criticism, which only flourishes among clearly marked and primitive traditions, finds itself face to face with a free and developed art and is necessarily silent. Influences had become already too complex for absolute determination in any given case. Perugino himself had absorbed much from Florence; he gave much to Bologna. To decide in Raphael's case exactly how much he received through Perugino and how much through the original or derivative sources would be a difficult task even if every picture and drawing of Raphael's had been preserved and were every one which is ascribed to him authentic. Nor yet are journeys necessary for the communication of artistic influences. Raphael was accustomed from his earliest youth at Urbino to the sight of pictures of every school and every date, and Perugia had its share of Florentine, perhaps also of Bolognese paintings. Drawings, also, multiplied by pupils and easily carried from one atelier to another, were in those days as great channels of influence as pictures. In Raphael's case they were, perhaps, even greater. In the next period his colouring and painting remain largely Umbrian, while his drawing and conception follow Florentine influence, and give an indication of his character during the Roman period which is entirely wanting in the paintings. In the Perugian period, also, if a drawing of the horse

on Monte Cavallo was the model of the *St George* in the Louvre, there is no reason why a sketch of Donatello's relief should not have inspired the Hermitage *St George*. Other drawings from Donatello's work seem certainly to have had influence upon him.[1] The needs of customers or patrons were also potent factors in determining the character of paintings, and, while these would generally have a restraining and localising effect, they may well occasionally have led to the imitation of a foreign model.[2] With all these possibilities, it is unnecessary to have recourse to the theory of a journey, and arbitrary to construct a definite history in order to account for the existence of influences. In the case of a painter the sight of a single picture or drawing, the memory even of a picture seen once and not remarked at the moment, might mean as much in its artistic influence when joined to a particular mood or to the observation of a particular effect in nature as an association for a short or a long period with men or works. To no more definite causes than these all the variations which Raphael shows from Perugian practice should be ascribed, and in estimating them less weight should be given to the external influence than to the peculiar properties of the artist's mind which, strengthened, if you will, by the example of other men, led him in his early days to find in Perugino himself, and to join with his manner where he did not find it, the qualities of concentration and variety in his groupings, sobriety, a lifelikeness and delicacy in his figures, and in general all the qualities which found but an imperfect field in the Peruginesque manner and led him onwards through other schools into his ultimate perfection. An influence is the work as much of him who feels as of him who exerts it.

[1] See p. 50, and further instances in Gronau, *Aus Raphael's florentinischen Tagen*.

[2] Compare, for an Umbrian example, the commission for Lo Spagna's *Coronation* at Trevi on the model of a Florentine picture at Narni (*Giorn. Erud. Art. Per.*, III, p. 175).

THE TRANSITION PERIOD

I

BETWEEN the years 1504, when Raphael completed the *Sposalizio*, and 1508 or 1509, when he came to Rome, the events of his life are little less obscure than those of his earlier youth. Until he entered the service of the Pope he was entrusted with but two large commissions, the execution of which would fix him for a period of some months to one of the towns in which he resided, and those, the fresco of San Severo in Perugia and the altar-piece of the *Coronation* for the Nuns of Monteluce in that town, he did not complete, and there is no reason recorded for his failure to bring them to completion. There is but the barest mention of his friendships and acquaintances, not the least memory of any adventure or incident in his life, and no evidence at any moment of his presence at any remarkable event of the time. He was in Florence, Perugia and Urbino indifferently, but the documents are not sufficient to prove anything more than the mere fact of his presence at the moment, while Vasari's narrative is too vague and general either to corroborate the documents or to satisfy by itself.

The tale told by Vasari is that about the time of the execution of the *Sposalizio*, while Raphael was at Siena working under Pinturicchio at the frescoes of the library, he met with certain painters of Florence who so inflamed his mind with their accounts of the wonders which Leonardo and Michelangelo had executed in their cartoons for the Signory at Florence that he left his work unfinished, and, at the cost of his interest and comfort, set off for Florence. There he executed a few commissions, until the death of his mother and his father and the consequent family disorders took him back for a time to Urbino. Here and at Perugia, he painted pictures and received commissions but returned to Florence, where, save for one more visit to Perugia, he remained until he was called to Rome.

There is no difficulty in throwing doubts upon the accuracy of Vasari's story. The motive which he gives for the visit to Urbino is obviously a confused memory of events which are now known to have occurred nearly ten years before. The evidence for the journeys to Perugia is clearly nothing more than that which we possess to-day, the dates upon some pictures which were painted in that town. Even Raphael's visit to Siena is more than doubtful and is scarcely borne out by Vasari's own account of Pinturicchio's life.[1] As for the effective entry into Florence as a self-sacrificing enthusiast bent upon a

[1] Springer, I, p. 328, for an analysis of the evidence hostile to the tradition. Schmarsow, *Raffael und Pinturicchio in Siena*, is friendly. Many indications in Raphael's work point to a visit to Siena, if not at this early date. Tradition also brought him to Orvieto (Comolli, note 14).

pilgrimage to the latest great works of art—the tale is too much like the common device which simple historians love of grouping minor events around some famous centre to appear plausible. Vasari cannot have meant that Raphael came to see the actual exhibition of Michelangelo's cartoon, for that event took place in 1506, two years after the completion of the *Sposalizio* and a year after the date upon the fresco of San Severo, with which presumably he was familiar. But Vasari cares nothing for dates, and his whole story is merely a rough sketch.

More plausible evidence for the date of Raphael's arrival in Florence has been found in a letter bearing the date of 1 October 1504, which purports to be an introduction of the young painter to the Gonfaloniere of Florence by Giovanna della Rovere, sister of Guidobaldo, Duke of Urbino. This letter not only affords an excuse for departing from Vasari's narrative in the matter of the exhibition of the cartoons, but it also gives testimony of a visit to Urbino at a time when, for different reasons, such a visit is badly wanted. Unfortunately it is not genuine.[1] It is a small discrepancy that four years later Raphael is found asking for an introduction to the same Soderini. But it is no insignificant matter that the letter makes Giovanna speak of Giovanni Santi as being still alive. This error is in accordance with Vasari's account of Giovanni's death, which would alone be known to a forger, but it has been made manifest by the discovery of the true date. Since this discovery the letter itself has mysteriously disappeared. With it goes the only external evidence dating Raphael's visits to Urbino and Florence, and there is not another document which bears upon Raphael's presence in the latter city until very shortly before he left it for Rome.*

If this document had been genuine it would still not have proved that Raphael definitely severed his connection with Perugia in the year 1504, or took up his residence in Florence with the intention of passing any considerable portion of his life in the town. It would only show that he had paid a visit to a city in which his friend Perugino was already settled, and where he might reasonably expect not only to learn much but also to gain great profit. Such a journey is in itself entirely probable, and does not in any way conflict with the obvious inferences which can be drawn from the next two documents which bear on Raphael's life. These, if they are authentic, would go to show that by the end of the year 1505 Raphael had not manifested any intention of leaving Perugia to take up his residence elsewhere. The first document has received little notice from historians, perhaps because this inference is so clearly to be drawn from it, while they, as a rule, are anxious to bring Raphael as early as possible into Florence. It is an extract from a day-book of the Convent of Monteluce, outside Perugia, and it is dated 29 December 1505. It records how, shortly before that date, the Abbess had conceived the idea of commissioning a picture of the *Coronation of the Virgin* for the high altar of the Chapel, and how, consulting with citizens and holy Fathers, she had found 'the Master' Raphael to be acknowledged the best painter in Perugia and had given him the work. It mentions also a contract made with the painter a few days before the date of the entry and the sum of thirty gold ducats which was paid to him in advance.

Another Perugian document of the same year shows that at this time Raphael undertook another large commission in the town. This is the inscription with the date 1505 upon the fresco painted for the Camaldolite Church of San Severo. The picture was never finished by him, and as the inscription was added in 1521 when Perugino had completed the fresco, it is taken to point rather to the year in which Raphael began the work than that in which he finally left it incomplete.

The Monteluce document, with its explicit reference to Raphael as a painter of Perugia, does more than hint that men looked upon him as a settled institution of the town, and the undertaking of these

[1] Bottari, *Lettere*, I, p. 1. The letter was sold in 1856 in Paris (Passavant, I, 496 n.).

* On the documentation of Raphael's career see now Vincenzo Golzio, *Raffaello nei documenti*, Vatican City, 1936.

commissions shows that he was quite prepared to continue to live there until they were completed. But this evidence of intention is less valuable than the certainty of fact. Neither of these pictures was ever completed. The nuns of Monteluce never received the *Coronation* from Raphael's hand. In 1516 they sent friends to Rome to bind Raphael by a new contract, and only in 1525 did they receive a painting which was executed by Giulio Romano and Francesco Penni.[1] The monks of San Severo were more lucky than the nuns who received at most a drawing from Raphael. For them Raphael painted the upper part of the *Trinity*, apparently at a later date than 1505, but he left the lower part entirely untouched, and, as far as is known, without giving any indication of how it was to be completed. Perugino finally covered the blank space without any reference to the fragment above. Other paintings for Perugia seem to have been similarly delayed, for both the *Madonna di Sant' Antonio*, which carries no date, and the *Ansidei Madonna*, which appears to be dated 1507, bear signs of having been executed some years after they were designed, while the last picture painted for Perugia, the *Entombment*, commissioned by Atalanta Baglioni and dated 1507, is explicitly stated by Vasari to have taken long to paint. The cause of this interruption must clearly be found in pressure of work in Florence. A visit to Urbino or elsewhere may actually have taken him away from Perugia, but it requires the constant work which Florence provided to account for so grave and continued an interruption in the progress of these large commissions. Raphael may have visited Florence more than once before that date, but, from now, Vasari's account must be followed and the centre of his activity be placed in the Tuscan capital. But even then it would be wrong to look upon him as definitely severing his connection with Perugia, or as regarding himself as settled in Florence. He left it without scruple or hesitation when he was called to Rome, and, even during the three years which intervened, the pictures of 1507, which have been mentioned, show that he had still an interest in Perugia. There is even stronger evidence than this in a letter[2] which Raphael wrote to his friend Alfani in Perugia, shortly after the completion of the *Entombment*, for its tone of familiarity and its light reference to men and things prove that he was still on easy terms with men in the town he had left, and that the hundred miles or so between the towns did not constitute so impassable a barrier as is commonly imagined.

Nor did Raphael in any way sever his connection with Urbino. He may have visited it at some date between 1504 and 1506 to paint the little picture of *St George and the Dragon*, which his friend Castiglione took in the latter year as a present from Duke Guidobaldo to King Henry VII of England. Vasari saw in Urbino some pictures which Raphael had painted for the Duke. Could they be identified they would perhaps give the date of the visit and throw no little light upon the development of Raphael's art. In the year 1507, on 11 October, he was in that town entering upon an agreement for the purchase of some land,[3] a fact which, as far as it goes, shows that he was as ready to settle there as elsewhere, though it cannot be concluded from the absence of documents concerning similar transactions at Florence or Perugia that Urbino was the only town in which he held property. His relations with Urbino are, as were those with Perugia, attested by a letter.[4] He wrote on 21 April 1508 to his uncle, his mother's brother, and the letter not only recalls the familiarity which continued to exist between Raphael and his relations till the end of his life, but shows that even at this date Raphael could use his influence at Urbino with a view to obtaining favours at Florence.

[1] For the documents concerning this picture see Passavant, II, 311.
[2] On the back of a drawing in the Wicar collection at Lille (F.I. 161).
[3] Contract given in full by Müntz, *Historiens de Raphael*, App. 1.
[4] Passavant, II, p. 497.

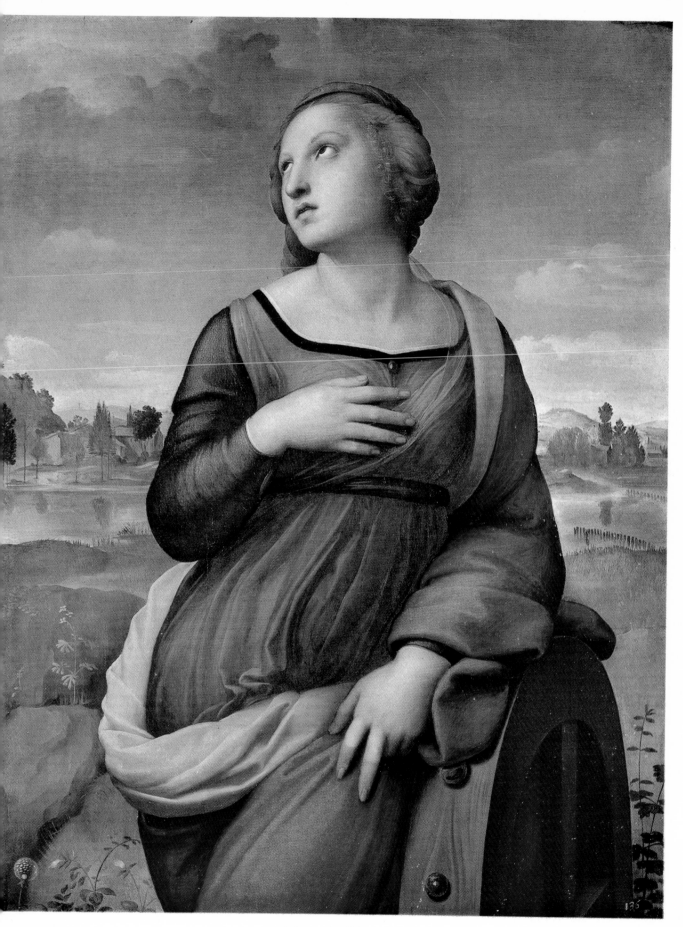

IV *St Catherine*. London. 71 × 55.

2

This is the bare outline of Raphael's life during this period. It is too slender a thread to support any consistent theory of his actions, too bare of personal touches to afford a picture either of himself or of his circle. Apart from the mere fact of his constant travelling, the records tell us little. They show him to have been divided between Florence, Perugia, or Urbino, ignorant in which place his immediate fortune was to be found, and through whom his ultimate life's work would be occasioned. Biographers, who know that he was eventually to reach Rome, and, after spending a brief period there, to die without revisiting his former homes, forget that Raphael had no such knowledge and no such plan. and that his daily life and his future depended solely upon his daily work. He travelled and lived in each of these places in turn, not knowing where his home might be, forming ties in each of them so light, however close they might be in affection, that they have left no mark whatever in his history at this time.

Possibly he was most at home in Perugia, where the choice of the Abbess of Monteluce shows that even by the end of 1505 he had secured a paramount position. There his life would continue to be, as it had been in the days of his apprenticeship, a time of work and of success among a group of mediocre friends. He was so frequently in the town that he could undertake commissions and even begin large works and then vanish, leaving them unfinished, with the expectation of a frequent return. At Perugia, only, he worked for religious bodies, for, in the city of internecine strife between the two ruling families, private life wa neither prosperous nor secure enough for the patronage of artists, and in a somewhat backward civi isation the arts still existed only as the servants of the Church. Certain nobles, such as Atalanta Baglioni and some members of the Ansidei family, gave him commissions, and he executed for them the *Entombment* and the *Ansidei Madonna*, both of which were altar-pieces for chapels. But these were not his friends. Of his friends the only ones concerning whom we have information were his studio companions and fellow-artists. Chief of these was one Domenico Alfani, a painter of mediocre ability or worse, to whom Raphael, then prosperous in Florence, sent a sketch of a Madonna and saints which he worked up into a picture after his manner, as though to show the world the difference between the art of the old school and the new. The letter, written on the back of the sketch in dialect, is full of the casual messages which prove constant intercourse, and is as childish in its request for certain love songs of one Ricciardi as in its appeal to Alfani to get Cesarino to jog the memory of Donna Atalanta Baglioni about the payment of her picture and to secure it in gold. Cesarino appears to have been the goldsmith Rosetti, who, two years afterwards, executed two designs by Raphael for golden shields which were commissioned by Agostino Chigi at Rome. One or two other painters of Perugino's school, Girolamo Genga, himself of Urbino, and Lo Spagna, show by the character and development of their style that they remained in touch with Raphael.

But neither in the number nor in the quality of her painters could Perugia vie with Florence. Throughout the fifteenth century Florence had been the metropolis of art, standing towards Perugia as Perugia stood in relation to Urbino. Even at this moment, when the expulsion of the Medici and the religious revival of Savonarola had checked to a great extent the vigorous output of Florentine art, Florence could hold out to the young painter the inducements of companionship with distinguished friends in all branches of art and of intercourse with cultured patrons and connoisseurs such as had entirely failed him in troubled and priestly Perugia. Moreover, though Vasari is possibly in error in actually tracing Raphael's visit to Florence to the exhibition of Leonardo's and Michelangelo's car-

41

toons, Florence could at this moment boast of the invention of a new development in art, and even if the new spirit in its first great manifestation did not actually serve as the cause for Raphael's arrival, it may well have acted as the chief reason why, having once come, he showed himself more and more disinclined to leave.

3

It is natural for posterity, looking back with its knowledge of Raphael's future eminence, to connect him during his stay in Florence with the two great leaders of Italian art with whose names his is now firmly linked. But, as a matter of fact, there is not a trace in fact or fable of any personal relations at this time between him and either Leonardo or Michelangelo. Vasari knew nothing of any such relations, or he would certainly have dwelt upon them, and it is perhaps with design that he made Raphael's first visit to Florence synchronise with the exhibition of the Signoria cartoons, for after that event both painters left Florence.

It was, however, open to Raphael to meet Leonardo in Umbria, when, as an engineer, he was accompanying Caesar Borgia and inspecting the fortresses. He may also have met him before the summer of 1506 in Florence, but after that only once, for a short time, when Leonardo came to Florence on business. Later they had an opportunity of meeting in Rome. As an old friend and fellow-student of Perugino, Leonardo would have come to him also as a friend, and he might have recalled, if he had ever seen it, the line in his father's poem coupling the two together as equal in age and in love.

Michelangelo left Florence still earlier than Leonardo, in March 1505. When he returned again in April 1506, Raphael may have met him and would have found him angry with the Pope, and angrier still with Raphael's countryman, Bramante, for having caused the project of a noble tomb to be superseded in Julius's mind by the greater conception of a new St Peter's. Unlike Leonardo, Michelangelo was actively hostile to Perugino (doubtless he hated all Umbrians at that time), and his sallies against him were proverbial. But he only stayed until November in Florence, and for the greater part of Raphael's stay there neither of the great masters was present. But even if he did not reach intimacy with either, Raphael could not escape their influence in his art or his life. He lived with the crowd of their pupils and admirers, saw what few paintings of theirs Florence possessed, studied their drawings and heard their precepts, and, when he went to look at the works of the dead masters, he would look at them in the light of the new practice which they had been the first to introduce.

Raphael at Florence was neither the equal nor the companion of these two. He lived more modestly with the lesser lights of the time whom Florence satisfied as it could not satisfy the giants. Apart from them the period seems almost barren. The great leaders of the last generation, Ghirlandaio and Filippino Lippi, were dead; Botticelli had ceased to paint. Perugino, Raphael's own master, had slipped into their place, and only Lorenzo di Credi and Granacci remained with him to bring Raphael into personal contact with the older traditions. There is indeed no tradition to bring Raphael into connection with the former of these, but the latter is specially mentioned by Vasari as having formed, with Raphael, Perugino, Sansovino, the San Gallo and others, a circle of painters and craftsmen which met at the house of an old architect, Baccio. There is no tradition associating Raphael with such of the men of the younger generation as Andrea del Sarto, Franciabigio, Pontormo, or Bugiardini. Vasari only mentions two painters as being Raphael's friends. One was Ridolfo Ghirlandaio, the other Fra Bartolommeo, who, twelve years Raphael's senior, deserves to be classed with the younger generation, because his

style shows him to have been, with Leonardo and Michelangelo, one of the leaders in the new movement in art. He had but recently emerged from his monastic retirement after a fury of Savonarolan piety, and, according to Vasari, he was not too old to learn from Raphael some secrets of perspective while giving him some teaching in the use of colour. Their relations, according to Vasari, were particularly friendly, and it is clear that in his eyes Fra Bartolommeo was the main channel through whom Raphael derived his growing knowledge of the art of Florence.

The modest position which Raphael held during this period is apparent from the fact that a contemporary historian, Albertini,[1] omits all mention of his name in his account of the paintings to be found in Florence. Indeed, even if he had attained such eminence that an opportunity might have been given to him to show his power upon a monumental scale, it is doubtful whether Florence could have given him the occasion. There were no public edifices to decorate, after the fiasco of the Signoria, and Churches no longer had the will to give large commissions. Private citizens could not, or had not the taste, to order the large historical or allegorical decorations which the Medici had commissioned some few years before. The only opportunities that were given to a painter lay in the painting of the Madonna with the Child or a group of saints, which were now required as easel pictures to be part of the furniture of the room and not, as before, as the decorations of a chapel. With such commissions Raphael was busy. The list of his patrons is far too short to account for all the pictures which he painted. Vasari mentions one, Taddeo Taddei, as the chief of Raphael's friends, giving him housing and the hospitality of his table. He was a friend of the scholar Pietro Bembo, afterwards, if not already, Raphael's firm friend, and he frequented Urbino where Raphael, in a letter to his uncle, urges that all respect and hospitality may be shown him by his family. For him Raphael painted two pictures, one of which is more or less probably identified with the *Madonna in the Meadow* [51] at Vienna. Another friend was Lorenzo Nasi. Raphael painted him a Madonna when he married, the *Cardellino*, now in Florence [54]. A third was Angelo Doni, a miserly patrician, according to the legend, who, among other pictures, owned the *Holy Family*, by Michelangelo, which Raphael studied. Raphael painted his portrait [94] and that of Maddalena Strozzi, his wife [II, 95], and if the pictures bearing their names are authentic, the lady was as much an admirer of Leonardo and his portrait of Mona Lisa as her husband of Michelangelo. Other friends and patrons of the time were members of the Canigiani and Dei families, for whom respectively Raphael painted a *Holy Family*, which is identified with a picture at Munich [66], and began—without finishing—the large altar-piece called the *Madonna del Baldacchino*, in the Pitti [60].

4

With these and similar commissions Raphael was kept busy, and, to judge by the letter which he wrote to his uncle Ciarla at the end of his stay in Florence, he was happy. He expected good prices for his works, and was so confident of his powers and reputation that he preferred his paintings to be paid for by valuation after they were painted to naming a fixed price beforehand. He speaks of some man, possibly Giovanni Battista della Palla, who promised him commissions for France as well as Florence. He asks his uncle to use influence with the new Duke Francesco Maria in order to obtain a letter of recommendation from him to the Gonfaloniere of Florence, from whom Raphael desired a favour concerning either the painting of a room or a room to paint in. In all, this letter shows no sign of an intention to leave Florence. But it also shows that Raphael was equally at home in Urbino. He speaks

[1] *Memoriale.* This omission may be set against Tizio's silence regarding any visit of Raphael to Siena.

of a commission which he had received from Giovanna della Rovere, and of the help she may be to him at the moment. He sends his message of condolence upon the death of Duke Guidobaldo, and recommends himself as his old friend and servant, using a phrase which had a definite meaning, to his successor Francesco Maria. There is no suggestion in the letter that Raphael was seeking for commissions—indeed, he definitely asks that the Duke may help him to obtain some favour concerning a painting-room from the Gonfaloniere of Florence; but Raphael can scarcely have been blind to the advantages which he, as a native of Urbino and a friend of the Court, could obtain from that town. The execution of small commissions for the rich men of Florence was scarcely the end of his ambition, and his sketches and his later performances prove that he contemplated work in another method and upon another scale. In those days every painter found his way to the Court of some Italian or foreign Prince, where great designs could be executed, and culture and learning reigned. Raphael was eventually to find his opportunity in Rome, but, in spite of the small evidence of his activity at Urbino, it is not unlikely that before finding it at Rome he came near to it at Urbino. Indeed, if he did not actually attain his opportunity at Urbino he found there his road towards it. Serlio,[1] the architect, states that the Duchess of Urbino was Raphael's first patron, and even if this is rather an obvious and unfounded inference than a statement of fact, it remains true that while Perugia gave Raphael not a single connection or relationship which proved of value in his after-life, and Florence scarcely gave him a friend who recurs in his Roman period, almost all the powerful men who made his way easy for him at Rome were men who are known to have frequented the Duchess's famous Court at Urbino.

The book of Raphael's friend Baldassare Castiglione, called *The Courtier*, is a full picture of the Palace life at Urbino during this period. Elizabeth Gonzaga and her invalid husband gathered together in Federigo's castle a group of wits and statesmen which included all that was best in Italy of the day. It was a microcosm of the world which gathered together at Rome under Pope Leo, without the extravagant luxury and the busy turmoil of the greater city. Among the group which met together on the imagined occasion of Castiglione's dialogue were the most refined and capable of the younger Medici, Julian, the brother of Leo x, Pietro Bembo, scholar and Platonist, the witty Bernardo Divizio da Bibbiena and Louis of Canossa, to mention those only who remained Raphael's friends throughout his life. With Castiglione himself Raphael was always intimate. He painted his portrait once at least, and true and immortal as is the presentment of the writer in Raphael's picture, so in *The Courtier*, with its generous and sober manners, its serious humour, and its ideal of a free and dignified nobility based upon a glorification of the classic world, Castiglione has given no less perfect an expression in words to the ideas which lay at the base of Raphael's art.

But though the book, its actors and the author, seem closely connected with Raphael, it remains true that there is no historical accuracy lying behind the association of the personages in the dialogue. Castiglione refers freely to events which occurred long after some of the principal personages were dead, and there is no reason to believe that any historic occasion is represented as the scene of the book. Moreover, even if such were the case, the absence of Raphael from the list of persons taking part in the dialogue would be enough to disprove any attempt to bring him into immediate connection with the incidents. He is named in the course of the conversation, and named with the utmost honour, but not a suggestion is made that he was a figure familiar to the whole group. Nor can the dates of any of his visits to Urbino be proved beyond the occasion in 1507, when he made a purchase of land. Portraits of the Duke and the Duchess are ascribed to him, and a sketch of Bembo drawn by him at Urbino was seen by the Anonimo in Padua. Vasari credits him with three pictures painted for Guidobaldo, but they

[1] *Regole*, vol. IV, Dedication. He calls her Isabella.

can only be identified with existing pictures by the sheerest guesswork. There is therefore little left but the references to the Duchess and to the new Duke Francesco Maria, which occur in his letter to his uncle, and his known association with men of the group who surrounded the Court, to connect him with the glories of Urbino.

It is thought, however, that a visit to Urbino produced the most intimate of the few memorials of Raphael's first youth, the only portrait of him which, besides the damaged figure in the Vatican fresco of the *School of Athens*, has any claim to be considered genuine. This picture [93], which is now in the gallery of portraits of painters by their own hands at the Uffizi, is said to have come from Urbino, and it represents a youth of Raphael's age towards the beginning of this second period, and is in a style which was his at the time. Considerably damaged, somewhat conventionalised in style, and not by any means remarkable for its strength of drawing, the portrait affords but uncertain evidence of the sitter's character. But such as it is, with its thin and slender oval face, its full lips, fine nose, delicate chin and eyes which are at once quiet and dreamy, the portrait makes it easy to think of the subject as a youth of quiet and imaginative character, too little self-assertive perhaps, and too sensitive to outside suggestions for complete happiness, but with power, restraint and determination, and above all with a mind ever open to embrace a wider and wider horizon of ideals. The face is in repose, the handsome features are left completely to their form for their attraction, and the expression is limited entirely to the gaze of the eyes. Consequently it is, or it appears to be, wanting in the accidents and oddities which speak immediately of definite tendencies of mind and character, and it is empty of the qualities which, because they bring themselves quickly and prominently into opposition or notice, are wrongly identified with the attribute of personality; but it is a face which shows generosity, high-mindedness, courtesy and gentleness, and these, no less than the other qualities, are positive marks of character. The legend which makes the grandson of Sante the embodiment of a hundred saintly virtues has its justification in the portrait, and Leonardo, who blames the majority of painters for allowing their own portraits to appear too constantly in the heads of their imaginary creations, could scarcely have found fault with Raphael, for Nature herself had formed him in the image which others had chosen for their angels and their saints.

THE ART OF THE TRANSITION PERIOD

I

THE influence of Florence upon Raphael's art was neither immediate nor overwhelming. If the documents quoted in the last chapter had not already prepared the way for this conclusion by showing that he was as much at home in Perugia as in Florence, almost as much in Urbino as in either; if Albertini's silence had not shown how little mark he had made on Florence, and how little he was regarded as a Florentine, another document, the earliest piece of criticism passed on Raphael, would be enough to prove that in the eyes of his contemporaries his style was not found to have suffered a complete revolution in the years when he was at work in Florence. In a letter[1] to Michelangelo, written in 1512, Sebastiano del Piombo tells of an interview which he had with Pope Julius II. They talked of painting, for Sebastiano was busy in his friend's interest, and, naturally enough, they touched upon Raphael who, at that moment, was working in the second chamber of the Vatican. 'Look at Raphael', said the Pope, 'and how in this room he has cast aside the manner of Perugino and taken to himself the style of Michelangelo'.

Documents, however, even contemporary criticism, could not bring the least conviction if they were not supported as they are by the evidence of the pictures themselves. It will be seen that the Pope was as wrong in identifying Raphael's manner in the *Expulsion of Heliodorus* with Michelangelo's as he was in describing the *School of Athens* as in the style of Perugino. In both, Raphael was himself, an individual owing much to the example of others, and perhaps less free from the influence of his place and time than many other men of less wide ideals and more powerful limitations, but yet a concrete, complicated soul, impossible to sum up in any phrase or technical comparison. But it is far more wrong, in the analysis of this so-called Florentine period, to seize upon the traces of foreign influence that can be found in details or in general characteristics, and to dwell upon them in words until they assume the aspect of a whole description. In this way the work of any man, artist or thinker, can be resolved into component factors which, while they do not satisfy immediate sympathy, such as is felt by the ordinary reader, or the deeper attention of a thoughtful study, are too quickly confounded by the half-critical and unsympathetic world of connoisseurs with an account of the man as a whole.

Raphael was, even at the date when he painted the *Sposalizio*, too much a master of a definite and

[1] Gaye, *Carteggio*, II, 489.

developed style to fall either at once or completely into a foreign manner. He had learned all that Perugia could teach him in the art of conception and execution, in colour and line, in figure and in space. But, in the natural course of his development, he had begun to advance beyond the range of his contemporaries, and the directions of his advance were already so much in keeping with the tendencies of Florentine art, that it is held by some that their manifestation is a proof of previous acquaintance with Florentine methods. Be this as it may, he only needed further familiarity with the work of other men who were advancing in his direction, to help him to insist upon the qualities which were already growing up in his work, to cause them, instead of being excrescences and mere details in an antiquated and conventional scheme, to become central and dominant in his work, transfusing instead of adorning, and mastering instead of merely attending.

What these qualities were has appeared from the consideration of his earlier work. In his effort to give the qualities of life to his conceptions, and to dwell in his art upon the attractions of the outer world, he had, in the first place, surpassed Perugino in concentration; had, secondly, made advances in his grouping; and, thirdly, something more of space than a mere background in perspective had appeared in his work. These were eventually to become dominant features of his art. But the lessons were not learnt at once. Before he could learn wholly to transmute into the new qualities his conception and representation of such large groups as he had modelled more or less after the manner of the primitives in the *Coronation* or the *Sposalizio*, he had to discover how the same qualities could be expressed in the representation of the single figure, or, at most, of a limited group, and how they could there show themselves as giving an air of life to the human figure by itself before giving it to many in combination. Popular taste, not only in Florence, but at Urbino, helped him in his task. He was forced to relinquish for a time the execution of larger commissions, and to study at every moment, in the living flesh and in the works of sculptors and painters, the one single subject of the Mother and Child. Before a larger grouping he might still have struggled in a vain attempt to conceive the whole in his advanced manner and to represent it in his new language, or, rather, he would have continued to exhibit a gradually increasing number of occasional details thoroughly observed in a general scheme that was conventional and obsolete. In the limited field he was able to work over and over again upon the same ideas until he had gradually formed them into concordance with his intention. It was not even at Florence that Raphael succeeded in reaching full freedom in his representation of the Madonna—it needed the experience gained in larger works to send him back with complete power to the smaller— nor is it to be imagined for a moment that he had any real idea in his various essays in the subject as to what form, in the end, his true conception would take. His work in this period is tentative and unequal, successful sometimes in one field, sometimes in another, and never in giving complete expression to the whole range of which he was obviously capable. He is to be understood best not as one who elaborates his work until it answers to his conception, seeking always to produce in the work of the moment the whole ideal which the subject and the inventor is capable of attaining, but as one who, having the ideal before him, completes and puts forth the approximation which is within reach at the moment. With the first man, the ideal may be ever growing, while the work stands still through the conflict of apparently irreconcilable tendencies, or it may stand still while the work fails to grow into its image; with the second, similarly, the ideal may be ever present while the various works, completed, as needs must, but faintly reproduce its features, or the ideal may grow as each work is finished, and finished fails to satisfy. Raphael is probably to be placed with the second of these groups, for his advance is irregular, and there is no trace of the intense dissatisfaction which accompanies the constrained output of work which is consciously below the level of the man's own knowledge of his desires

and his powers. Nor, from the very first, is there any want of harmony between the advancing and the still retrograde features of his work, as would be the case were the former striving to obtain possession of the whole, the latter merely entering because power was at the moment lacking and outside necessities were urgent. He had the power of entering completely into the spirit of his own conceptions, and this makes his work appear at every moment as though it were immediate and final.

This appearance of finality causes his work to be impossible to date with any approach to accuracy. There are few external indications by which to date his pictures, and he combined together less and more advanced features with such freedom and ease that the few dates which occur fail to indicate periods in his advance, and there is no definitely marked progress in any single detail which is not contradicted by apparently conflicting tendencies in others. This irregularity is best illustrated by an analysis of two works, one of which has already been touched upon in illustration of the Perugian manner, although its date proves it to be posterior to much that is classed as Florentine, while the other is connected with Perugia by the evidence of two drawings.

Of the *Madonna Ansidei* of the National Gallery [23], it is safe to say that it contains nothing which can be definitely described as Florentine, since even the most diligent investigators of foreign influences upon Raphael (Crowe and Cavalcaselle) can discover nothing in it of Tuscan influence save in the colour and the larger scantling of the frame, the height of the Virgin's brows and the better sweep of the Virgin's drapery which, nevertheless, they attribute in the same breath to the hand of an inferior disciple. From the imperfect combination of the figures, with the parallel inclination of their four heads, to the sleek and glass-like surface of the Baby's skin, everything in the picture proclaims the studio of Perugino. The head of the Virgin is hard and conventional, elongated and structureless; the features are merely drawn in, the nose little more than a thin bar, the eyelids heavy and solid, the mouth independent of the cheek and without expression. Like so many Quattrocento heads, it is a mere sketch, impossible to imagine in profile or in any other position, an indication for the imagination of the faithful, no realisation of a physical fact. The rhythm of the head, neck, arm, and hand is angular and contorted; the drapery casual. The Infant Christ is a conglomeration of paunchy curves, as structureless as it is monotonous in surface. The two Saints, St John and St Nicholas, only manage to stand upon their legs because the draperies hide the greater part of their bodies, and the St John is posed with an affectation of the limb which is the strict counterpart of the mechanical ecstasy of his glance.

These are the vices of the Perugian School. The picture also possesses the virtues. A noble architectural setting and a dignified simplicity of line compensate partly for the want of combination in the figures, and show how whole-heartedly Raphael entered into the spirit of his Perugian manner. A fair landscape background and a suggestion of much sky emphasise the air of super-sensuous calm which marks all the figures. There is a greater precision in the drawing of the extremities than is usual in Umbrian pictures of this period, even than is customary with Raphael himself; but the drawing is tight and hard, and while there is a greater care in the modelling of the faces, the attempt to give an air of keenness to the eyes by the brilliance of the pigment, and the character of the contours, prove the simple means by which at this period Raphael tried to give life to his creations.

The *Madonna of Terranuova* in Berlin [44] is, on the other hand, a picture of Perugian origin infinitely modified by Florentine association, and presents so many conflicting features that the assignment of the picture to as early a date as is generally given seems very doubtful. Two drawings, one in Lille perhaps by Raphael himself [45], the other in Berlin by an older master,* exhibit the main group in a characteristically Peruginesque setting, and serve to connect the picture with the now largely discarded style. In

* F., text volume, fig. 61.

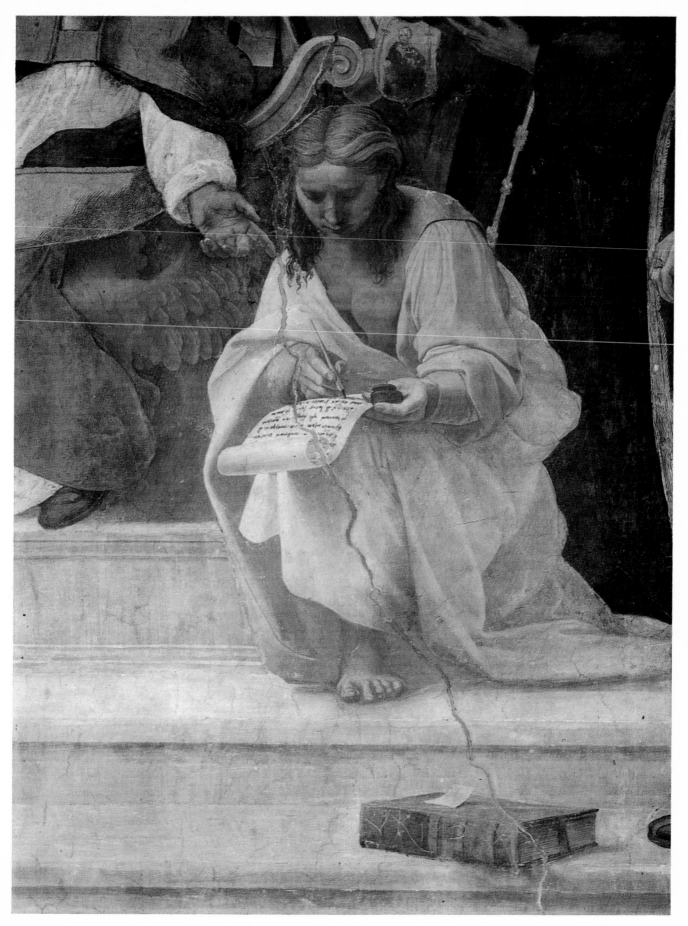

v Detail of the *Disputa*. Vatican.

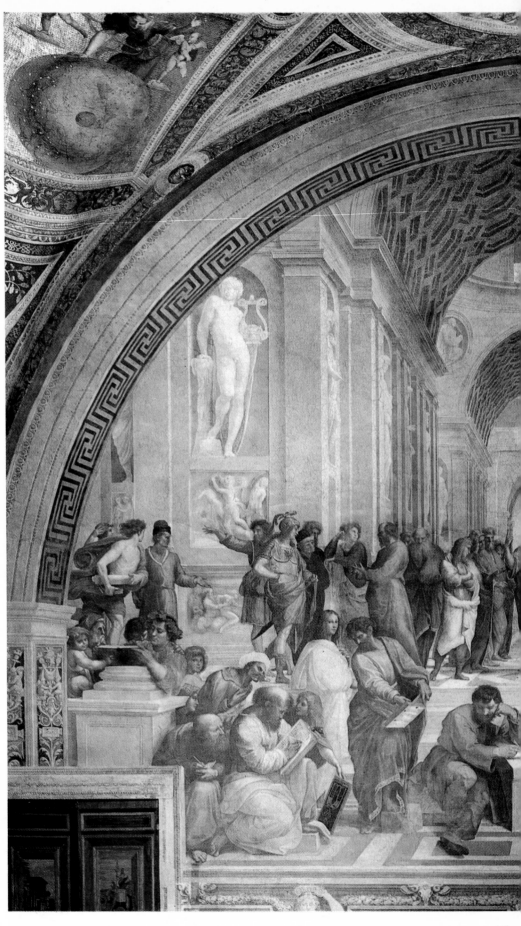

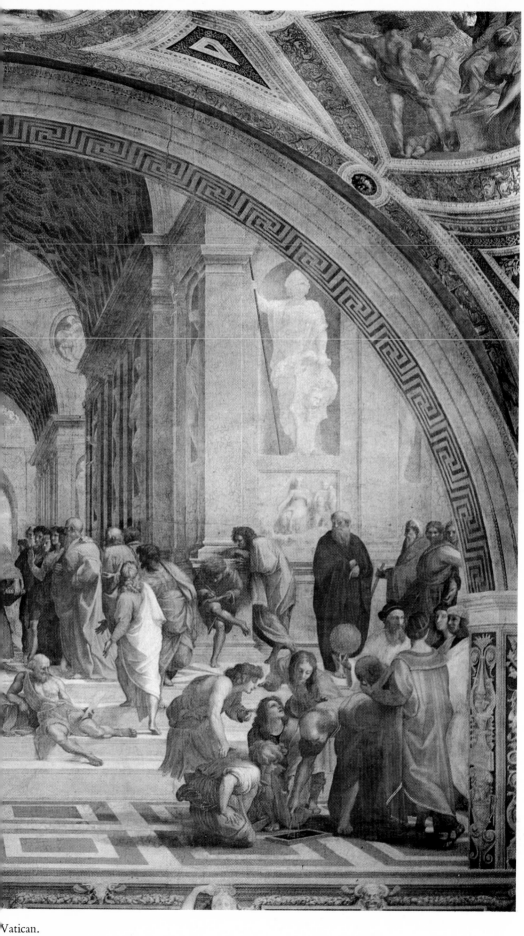

Vatican.

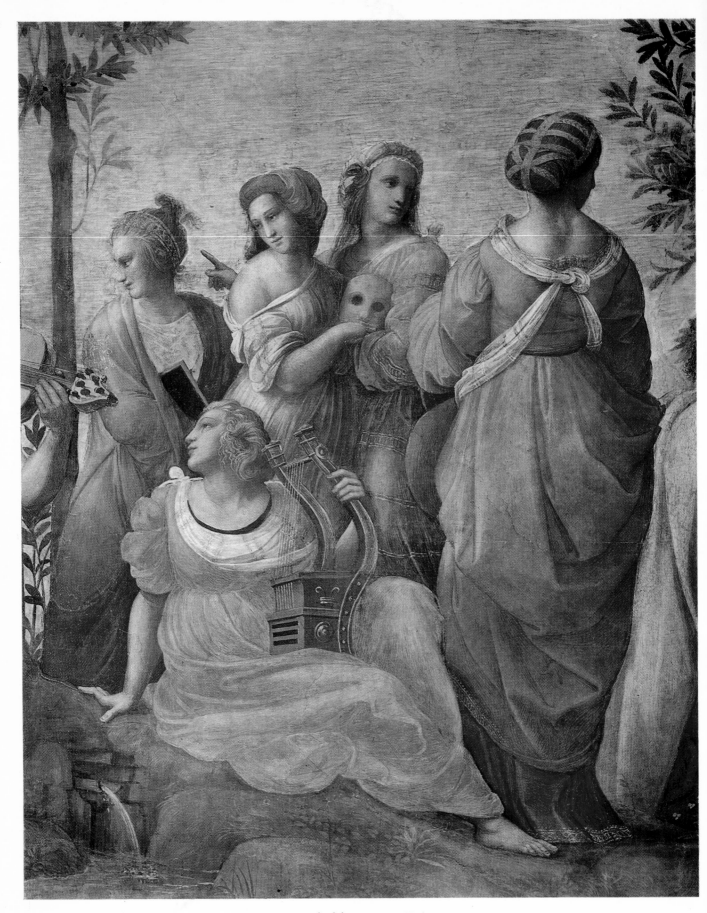

VII Detail of the *Parnassus*. Vatican.

neither of the drawings does the third child occur, but, in both, two heavy and disturbing figures, almost identical with those in another Berlin picture [34], flank the Madonna and the Child. In the painting Raphael has cast them away, converting the group from a mere hieratic congeries into a lighted and airy scheme. He has softened the values and contours of the Virgin's head so that the curve becomes elastic, and while its general form is that of the head in the *Madonna Ansidei*, its structure is realised and its texture reproduced. Still more, the greater delicacy of the drawing converts the inclination of the head from a merely conventional device into a representation of a momentary action, suggesting life and the true grace of the human form in motion. The same spirit runs through the whole group, until it seems as though the unaffected life of the Infant Christ which was already present in the Infants of the *Presentation* and the *Connestabile Madonna*, had penetrated and transfused the Madonna with all her Perugian antecedents, and the St John and the Angel with their still Umbrian forms.

2

In spite, however, of the Perugian drawings, the Perugian tradition in the Madonna and much that is definitely Perugian in the treatment of the drapery, the clever lighting of the Madonna's left arm and hand and the Leonardesque delicacy of that hand—not to mention the unique occurrence in Raphael's work of an attendant child which is a feature borrowed from countless Florentine works—bring the *Terranuova* nearest among Raphael's Madonnas to a Florentine painting. It is filled with a spirit of dainty lightness, an easy delicacy and choiceness of detail, which are far more akin to Florentine art than to the heavy sobriety and the dignified decorativeness of Perugia. But even in his earlier works these characteristics were not absent from Raphael. A hundred tricks of drapery or coiffure occur in his Perugian Madonnas, his angels, and in the attendant figures of maidens in the *Sposalizio*. But in them the lightness is restrained by Perugian dignity. In the *Madonna del Granduca* [III, 24, 25,], as has already been said, one of these seems to have stepped out of her frame and to have become the most well-beloved of all Raphael's earlier Madonnas. In this, as in the *Terranuova Madonna*, a moment's comparison of the Virgin's head with that of the *Madonna Ansidei* shows how far the artist had advanced in his power of treating the surface so as to reproduce the texture of the skin and the structure of the features. The modelling is of the lightest and lighting of the simplest, but the cheek, the mouth and the eyelids show their contours and their dimensions with the easy gradations of the living head. All affectation is gone from the pose, and the Madonna's hands are somewhat large and coarse, but they are displayed, not in order to exhibit their grace, but to perform their business. There is in the *Ansidei Madonna* one touch of unemphasised naturalism in the right hand, which is just shown as tenderly supporting the Infant's back. This characteristic recurs again and again throughout Raphael's pictures of the Madonna, and gives the keynote of their style and charm. But in the *Granduca* this note of simplicity is not unique, but is carried consistently throughout the whole conception. Standing simply and holding the baby gently, the whole figure is as unconscious as the hand.

Much of the quiet dignity of the Perugian Madonna type, the simple flowing lines, the cool, incurious colour and the thoughtful repose of the head and hands recur in the little *Cowper Madonna* [46] from Panshanger [now in Washington]. The Madonna is older than she of the *Granduca*, who is in this respect unique among Raphael's figures. Her face is more fully modelled, her form, uncovered by the mantle, is shown with more amplitude; and the child is more playful. In these features Raphael shows his effort towards the more lively conception of the Florentines, whose Virgins throughout the

century were, with all their suggestions of mysterious character, primarily women and not Mothers of God. It is common to find in Raphael the first of the painters who humanised the Madonna ideal and brought her from Heaven to the world below, but this opinion is largely a survival from an older generation, and is based upon a comparison of his work with that of later painters. It does not represent with truth the actual character of his relation to contemporary art. Florentine work both in painting and in sculpture was a constant exercise in the idealising of the human relationship of maternity, the humanisation of the Madonna Ideal. In their way, also, the Umbrian Quattrocentists had worked in the same direction, only their view of humanity was more dignified and reverent, more remote and unaffected, than the Florentine with its excursions into strange characteristics and its insistence upon accidents of form and feature, its extravagance, even, of face or drapery.

In another Madonna of this period, ruined as it is by restoration, the beginnings of this tendency in Raphael are to be observed. This is the *Madonna Tempi* [47] of Munich, for which a definite Florentine model can be found in one of the little medallions in Donatello's relief of the *Miracle of Rimini* on the high altar of Saint Anthony at Padua.[1] In this picture, perhaps for the first time in Raphael's work, the figures of Mother and Child are brought together in a moment of concentrating action, not merely, as in the other pictures, joined together by a restful pose which exhibited both, but left each figure to some extent independent of the other. Here they are inextricably interwoven by a common and enthralling movement. In the ruined state of the picture it is impossible to judge how far Raphael was successful in imparting the feeling of the moment to the two faces, but it is possible that they never showed to a greater extent than now a complete absorption. The arms, too, are somewhat stiff and nerveless, showing that while he knew enough of bodily forms to give ease to limbs in repose, he could not yet bring them with success into purposeful action. It is still enough for him to weave them into a fair pattern without inspiring them with a sense of their own activity and motion. The Infant's head, shoulders, and arm, and his hanging legs, give the note of life which is missing in the other portions of the picture. Yet, with this inequality, the picture marks an advance, and there is yet another token of a change in taste. Though the mantle of the Virgin, which had disappeared from the *Cowper Madonna*, still covers her head, it is thrown in more ample and flowing folds around her body, giving her something of the majesty of one of Fra Bartolommeo's or Raphael's own later figures, and her sleeve, loose and puckered, occurs here first in Raphael's pictures to show that he was attracted to the freedom and the quaintnesses of Florentine methods of dress. In the *Niccolini* ('large Cowper') *Madonna* from Panshanger [now in Washington], dated 1508 [48], also a picture spoilt by restoration, these playfulnesses of dress are more strongly emphasised, and are coupled with the love of graceful detail in the head-dress and the hair which might be called Verrocchian and Florentine, had it not already appeared in the *Vision of the Knight* and in the *Sposalizio*.

In this picture there occurs, with a new and stronger type of Madonna's head, a marked heroisation of the Infant form, a tendency which, whencesoever it may have been derived, recurs throughout Raphael's later periods. It is to be noted again in the unfinished Madonna called the *Colonna* [49], at Berlin, where it accompanies still another experiment in the Madonna type, a head in so many ways unlike Raphael's usual figures that the conventional hypothesis of the work of assistants has been dragged in as an explanation of the picture. In both of these also there occurs a more remarkable feature. Besides the study of a pattern, which was with Raphael from the first, there is a new field of observation in the disposition of the figures to give the group solidity and mass. Foreshortening and careful drawing are partly responsible for producing this effect (compare the hands holding the book in

[1] *Cf.* Schmarsow, *Donatello*, p. 46, n. 1.

the *Colonna* and *Connestabile* Madonnas), but it is due still more to careful observation of light and shade. In both pictures the Infant's arm, reaching to the breast, with its attendant shadow, gives the keynote which is carried further by a hundred details in drapery and limb, and this note severs the picture completely, not only from Perugian works, but even from early 'Florentine' Madonnas, such as the *Granduca* and the *Niccolini*. This deliberate effort towards obtaining relief marks perhaps the influence of Leonardo, or, joined with the heroisation of the Infant form, that of Michelangelo, but the close-fitting bodice of the Madonna, showing neither sculpturesque nor fluid treatment in the folds and scarcely a suggestion of the form beneath, proves how intermittent and incomplete these influences were in their effect.

The effort towards relief in composition appears also in the *Orleans Madonna* [50]. It is a carefully finished work, remarkable for its adoption and improvement upon a common Florentine convention, that of placing the Madonna within the walls of a room and thus securing effects of light upon the figure which were familiar in life, and, at the same time, fresh in art. It is characteristic of Raphael's mind that this effect, which Leonardo converted into a new means of carrying the Madonna into realms of mystery and poetry, was used by him literally as a method of greater humanisation. It is in keeping with this that while he is still Perugian in the sober dignity, the sweet absorption of the Madonna's face, and he is partly Perugian, partly his later self, in the rapt and serious expression of the Infant's eyes, he has reached in this picture an intensity of communion between the Mother and Child, which was wholly wanting in the *Cowper* Madonnas, but latent in the *Granduca*, and only half-expressed in the *Tempi*. In this picture even the want of success in the drawing of the right hand does not destroy the impression of complete unity of conception, of a single self-contained moment, seized and expressed, which is conveyed through the instinctive coherence of each portion of the body, and is so elusive and so natural in its effect that it is hard to point to any detail, save the position of the Madonna's left hand, as that in which the secret is contained.

3

An analysis of the pictures in which the Madonna and the Infant Christ are the sole figures is sufficient by itself to show the main currents and variations of Raphael's art during this period. But certain characteristics which are visible to the acute observer in these groups are more prominent in pictures where the addition of other features is necessitated by the subject. The next group, the nearest allied to that of the half-figure Madonnas, is formed by three pictures, the *Madonna in the Meadow* of Vienna [51, 52, 53], the *Madonna of the Goldfinch* of the Uffizi [54, 55], and the *Belle Jardinière*, of the Louvre [56, 57], in which the Virgin is represented at full length and the infant Baptist enters as well as the Infant Christ. No pictures of Raphael's, perhaps none in the world, win so quickly and so completely the direct admiration of the simple, of none equally have modern critics so little to say. Traces of foreign influence are to be sought for in them almost in vain. The more delicate and sensitive face of the *Virgin in the Meadow*, and the somewhat choice painting and posture of her hands in this picture suggest the example of Leonardo, and in all three pictures the careful concentration of the lines and the figures, and the effort after simple and easy gradations and delicate refinements of movement, are akin to his practice. But there is no suggestion in any of the paintings of definite imitation of Leonardo's manner. Such influence as he seems to have exerted appears in the drawings assigned to Raphael at this time, in which a method of rapid representation of momentary attitudes in outline, like to Leonardo's, and

quite dissimilar to the careful and even pencil-work of the Umbrian masters, is to be observed. In any case the pictures themselves are not Leonardesque in character; they are, indeed, totally unlike anything either of Florentine or Perugian art of the day. There is no recollection of Leonardo's heavy modelling and of the ivory lights of his *Virgin of the Rocks*, and the other paintings which formed the tradition of Milan, nor is there anything of the dreamy vagueness of the colour in the *Virgin and St Anne*. The figures are placed in the broad upland landscapes of Raphael's youthful associations, and not in the magical country of rock and water which Leonardo had found in Florentine tradition, and by force of his greater art had made his own. The colour is clear and gay, and illumined by the open daylight of Umbria. The theme is that of the central group of either the *Ansidei* or the *Sant' Antonio* Madonnas and their Pinturicchian archetype in the large Ancona in the Perugian Gallery; and the dress of the Madonna, simple and close-fitting, is only one of many indications which attach these works to the more specifically Umbrian period of Raphael's life.

If the influence of Leonardo is to be found, it must have come imperceptibly, freeing the methods of Umbrian painting in Raphael, as it was itself the outcome of a liberating tendency in the mannered and decaying traditions of painting in Florence. In these three pictures of Raphael's the new spirit appears, as in the group which has already been considered, merely as an extension of the pictorial virtues which he had already shown in Perugian pictures. There is no gap in feeling between the tender solicitude of the *Connestabile Madonna* and the sweet seriousness of these three pictures of the Virgin. There is no change in the elemental pictorial conception of smooth, simple lines, which was the natural form for the emotional expression of the central idea, both in these pictures and in the Madonnas of Perugino or of Raphael himself. But these qualities have become more all-pervading, and have ousted entirely the remains of the quaintnesses and merely decorative extravagances with which earlier Umbrian art had dallied heavily enough, and Florence had carried beyond the reach of sanity, through the innate appropriateness of such pictorial features to the choice and precious conceptions which the Florentine loved. This growth of complete and successful simplicity is joined with, and is entirely due to, the newly-won freedom to carry throughout the picture the chief of the great qualities which Raphael had already shown in his early work. In all their variations upon the single theme the three pictures are alike in their exhibition of the consummate power to select and represent the exact attitude in which the apposite motion is most fully expressed by the bodies. This power, which is common to all great painters, Raphael had shown in the *Presentation*, in the *Sposalizio* and in the Hermitage *St George*, but it is not until the date of these pictures that it was strong enough to fashion his whole conception, and enabled him to dispense with every other means of attraction which might render his pictures interesting, but would conflict with, or at any rate not affect, the expression of his central idea.

Even in these pictures there are degrees in his power of conception and execution. In the *Madonna of the Meadow*, and the *Belle Jardinière*, the lower part of the Madonna's figure is heavy and confused, a fault which, in the latter picture, is emphasised by the destruction of the blue pigment with which the mantle is painted. In the *Cardellino*, on the other hand, the Madonna's knee becomes an essential part of the conception, combining with the body of the Infant Christ, as much as her right hand is part of the Baptist, or her left, holding idly the unread book, is an accidental and telling incident in her whole attitude. Similarly, in the *Madonna of the Meadow*, the only figure which is thought out completely in relief is that of the infant Baptist; the Madonna and the Christ form but one plane in the too pyramidal arrangement of the whole group; in the *Belle Jardinière*, the solidity of the form is more definite, and in the *Cardellino* the grouping and the lighting are so subtle that the three figures detach themselves immediately in an intricate and compact mass. With this there occurs an intensification of the drama of

the children's action. They are playing in the *Madonna of the Meadow*; they are lisping some childish history* from one to the other in the *Jardinière*; and in the *Cardellino* a tragedy of prophetic vision, almost too intense, is being enacted. It may seem at first sight that this evidence of thought and fancy is entirely foreign to the evidence of technical skill which is shown in the representation of the figures; and indeed, it might have been possible to say all that was wished in the simple outlines of earlier art. But with outline only the attitude of the body and the expression of the face need over-emphasis in order to convey their meaning; together with the all but complete realisation of the form, these indications of action and character are expressed so subtly and with such an effect of effortlessness that they form at once the whole picture and communicate themselves to the observer without clamouring for his notice.

The sentiment of these pictures expressed in the head, the hands, and the poses of the three figures, reinforced by their colour and by the peaceful sweep of the landscape, is so predominant in its claims to interest that the lack of certain pictorial qualities is not only not felt, but may even have been deliberately intended by the painter. As far as his conception required him to face the problems both of the human figure and of the space to be covered, Raphael has successfully overcome their difficulties. But it remains true that, both as representations of the human figure and as compositions of lines and masses, these three pictures are still restricted by some of the limitations of Perugian Quattrocento art; the composition is an unrelieved pyramid, the symmetry merely lineal and rather negative than arresting, and, except for the accurate observation and the unfailing instinct shown in the posture of the limbs, the possibilities of treatment in the Virgin's body are scarcely seized. It is remarkable of Raphael's versatility that it is not necessary to pass outside the list of his works to find a contrast in every one of these features. A fourth painting of the Madonna with the two children, the unfinished *Esterhazy Madonna* at Budapest [58], is as rich in pictorial qualities and as empty of sentiment as the last group is the reverse. In this picture, more even than in the *Colonna* or the larger *Cowper Madonna*, the centre of interest for the painter is not the sentiment of the Madonna with the divine children, the poetic realisation of the holy story, nor even the sentiment of motherhood in general, but a joy in the life, vigour, variety, and elegance of the human body, and in the decorative quality of line and mass. In comparison with the subtlety and grace in the two half turns of the Madonna's head and shoulders, even the *Madonna of the Cardellino* seems wooden and flat. The sweeping curves of her kneeling body and the easy balance of her whole poise make the seated posture of the other figures appear a mere means of disposing without offence of an awkward mass. The broad, simple flow of her drapery gives both beauty of line and a sculpturesque force, where, in the *Jardinière* and the *Madonna del Prato*, there is but a bulging pile of stuff serving at best only to give dignity to the limbs and a contrast of heavy colour to the high lights of the flesh. In their careful and graceful poses the two Infants cause those in the other pictures to appear haphazard and naturalistic, while the heightening of the landscape background, the simplification of its features, and the more gradual transitions between the foreground and the background bring it and the group of figures into an immediate unity of space. Even more remarkable, though it is but part of the same effect, is the breaking up of the triangular composition, the distribution of the pattern in line and mass over the whole field of the picture from the towers and hill on the horizon to the extreme angle of the Madonna's dress and the toes of St John's right foot. It is as though in this picture everything that had until now remained meaningless, every feature that had been imposed upon the painter by convention or the nature of the subject, had grown suddenly to have a new value and importance of its own. And yet there is no absolute separation between these pictures,

* 'Surely not' (marginal note by Oppé, 1938).

there is enough of the quiet and sober tenderness of the mother, of the serious playfulness of the children in this picture, enough of decorative power and of study of the human form at any rate in the *Cardellino,* to show that this stage is merely an extension of features already present in the last, a necessary step in the development of Raphael's art.

4

It is more than probable that the *Esterhazy Madonna* dates from after Raphael's arrival at Rome, and not, as is generally supposed, from the last years of his stay in Florence, for it seems inconceivable that it should have preceded the stiff and Quattrocento-like figures which were the first to be placed upon the walls of the Vatican. In any case, it reaches a far higher level of decoration, space, and inventiveness than is reached by any pictures of the next two groups, and it seems to pre-suppose a readiness and skill which came through the laborious efforts after unity and concentration which can be traced in them. In these pictures the Madonna with the Child is accompanied by one or more figures of saints. So long as the additional figures were those of saints connected only with the Holy Family by some accident of dedication, Raphael retained the primitive and conventional arrangements, and was enabled to display both in the figure of the Madonna the skill and feeling which he showed in the pictures devoted to her alone, and in the attendant figures his sense of dignity and harmonious line, and the growing power of representing the human body. Two of these pictures, the *Ansidei Madonna* and the *Madonna di Sant' Antonio*, painted for Perugia in the Umbrian style, have already been discussed. The former shows practically nothing that is not purely Umbrian; the latter, in the stronger poses of the male saints and their more ample forms, is taken to prove an acquaintance with the more robust and imposing elements present in Florentine art. Only one other instance of this conception exists in the large altar-piece, the *Madonna of the Baldacchino* [60, 61–63], which Vasari states to have been commissioned at Florence by members of the Dei family and to have been left unfinished on Raphael's departure for Rome. Details such as the flying seraphs, which are identical with those in the fresco in Sta Maria della Pace, the putti at the foot, which are closely paralleled by several in Roman works, and the strictly classic and Roman character of the niche, suggest that the painting was taken with him by Raphael, and only slowly completed. But the whole painting is full of anomalous features of design and technique, and is in too poor a condition of preservation to warrant any certain judgment as to its period or method of composition. It would seem quite possible that the essential elements belong to the Florentine days. The type of the Virgin's head and her draperies belong to the Florentine period, the Infant has affinities in pose and form with those in the *Colonna* and large *Cowper* Madonnas, and the massively draped figures of the saints are but a further step in the direction already shown in the *Sant' Antonio Madonna* and the San Severo fresco. At some time before he painted the upper portion of the *Disputa* fresco he must have conceived and represented the type of apostolic hero which he uses so freely in that picture, and there is no place where he could so readily have met with models for these figures as in Florence, where the frescoes of the Brancacci Chapel were his school as they were of others. Moreover, the picture connects him with one nearer to him in date and feeling than any other Florentine painter. Its resemblances with Fra Bartolommeo's great altar-piece have been noted by every critic, and the complete harmony between the later additions and the earlier portions is not so much an indication that the whole conception is late, as evidence that throughout his life his progress was continuous and gradual. If then the general conception of the picture is Florentine, it marks the highest

point which Raphael had reached in treating conventional grouping with breadth and powerful effect; and it is in its way a parallel to the *Esterhazy Madonna*, showing, not as that picture, the exquisite grace and elegance which he could infuse into a naturalistic scene, but the dignity and monumental grandeur with which he could invest an imaginary and undramatic group.

5

Such conventional groups of the Madonna with attendant saints were not sufficient to satisfy Florentine taste. The strict logic of the moment demanded that this should be the only treatment for a combination of the Holy Family with saints unconnected with them in time, and it is characteristic that Raphael, who henceforth accepted this canon, discarded in the *Terranuova Madonna* the two attendant saints of the Umbrian drawing upon which the picture is based, while they remained in the picture in Berlin which is attributed to his earliest days. Florentine naturalism demanded at this time that if the Virgin was to be accompanied by other figures, these should be the personages with whom she was historically connected, and that the scene represented should be historically conceivable. Thus the family group of the Mother and Child was extended to include St Anne and St Joseph and even St Elizabeth, as the mother of the Baptist, and it is in these pictures that Raphael's development in the art of conceiving a composition based upon an idea can be traced, not in the solitary *Madonna del Baldacchino*, in which his monumental feeling and not his dramatic was given play.

There were two main models for pictures of these subjects in Florence. The first was a version of the *Virgin with the Child and St Anne* by Leonardo; the second was the circular picture of the *Madonna with the Child and St Joseph*, painted by Michelangelo for his and Raphael's common patron Angelo Doni. Both pictures seem to have exerted an influence over Raphael. In the *Madonna with the Lamb* [59], which is now in Madrid (dated 1506 or 1507), St Joseph has replaced St Anne, but the figure of the Child and the pose of the Virgin in the clumsy elegance of her kneeling posture are both derived from Leonardo's picture. The Child alone of all the figures shows throughout observation and ease in expression; St Joseph fails to stand on his feet, his draperies are heavy and meaningless, and they obscure the real power shown in his hands, arms and shoulders. But it is chiefly in the total absence of the flow of line and balance of mass that the picture is remarkable. Everything is agitated and restless; much, as the feet, is ill-placed, and there are little details of unhappy delicacy, as in the drawing of the lamb, which are almost Gothic in their attempt to hide ignorance by playful quaintness. With this there is a rigid pyramidal composition, which, unlike that of the *Madonna del Cardellino*, has no purpose to serve in leading the eye to a central point, and there is barely any play of light and shade such as would harmonise the abruptness of line, and no breadth or vagueness in the painting to smooth the passages of tortured outline.

Nor again in the *Madonna of the Palm* [64] has Raphael achieved complete success in dealing with this group. In it the triangular composition is deliberately broken up and the two figures are contrived to occupy without distortion the greater part. But an empty space in the centre and a somewhat insignificant figure of Christ prevent the concentration of effect from being complete, and there is a dull repetition of attitude in the legs of the two figures and no little flatness in the arrangement of the light. But here, if the composition is not remarkable, grace of line, ease of pose and dignified treatment of drapery reappear in combination with a simple representation of emotion in the actors which recalls the *Madonna of the Meadow* and the paintings of that group. Hard, gay colouring and such details as the

shape of the Infant's head (identical with the *Terranuova* and *Cardellino* Madonnas), to some extent the features of the Virgin, and, entirely, the unbroken and hard line of her bodice, carry the picture into direct relation with that group.

The *Madonna with the Beardless St Joseph* in the Hermitage [65] is a similar experiment, but in the direction, now, of the *Orleans Madonna*. Here the addition of a further figure causes the picture to become so completely a representation of an everyday scene that the ecstatic attitude and expression of the Child has the appearance of a fault in taste. Here, too, there is a total want of decorative connection between Joseph and the Virgin and such lack of subtlety in the lighting and such weakness in the Virgin's head and left arm (not entirely due to the extensive repainting of the picture), that it is hard to believe that this picture is not a pastiche of later date.

The most unsuccessful of all these pictures is the group of *Madonna and Saints* [66] in the Munich collection, which answers to the description given by Vasari of a picture painted by Raphael for Domenico Canigiani in Florence. In this the haphazard composition of the last picture gives place to a triangular arrangement which is formal and uninspired in a way unparalleled in all Raphael's work. Not only are the five figures arranged in a set pyramidal form, but the two inner groups, each of a mother and child, are set over against each other in sheer mathematical balance and formal symmetry. Except for the somewhat close repetition of lines in the legs of the two female figures, the inner relations of the two groups are sufficiently diversified, but the whole is entirely devoid of the air of animation which occurs in all the single Madonna figures and gives to them, however quiet in attitude, a character of life. To add to the unhappy effect, this picture has been almost entirely repainted.

A more congenial arrangement of the family group occurs in the sketch which Raphael sent to his friend Domenico Alfani at Perugia to be worked up into a picture. Here there is complete freedom from artificial arrangement, and the picture is as unlike the conventional grouping of an Umbrian altar-piece as it is different from the deliberate concentration of figures which occurs in Leonardo or Michelangelo. More clearly than in the *Madonna of the Palm* Raphael has here consciously broken up the triangular arrangement which renders the *Madonna of the Lamb* and that called *Canigiani* too formal and wooden; and he has scattered the figures and invented a counterpoise to the principal pyramid. Had he painted the picture himself, it is not impossible that he might have thought it necessary to conform completely with the advanced canons of his day. But, as it is, his sketch was faithfully reproduced by Alfani, and since the attitudes of all the figures are as easy and unforced as the whole composition, both the sketch and the picture remain the solitary examples at this date of an ease in the management of a group which equalled that of his management of the Mother and Child. To vary still further the composition by effects of lighting was still almost as far out of the power of Raphael as it was beyond the reach of Alfani, but in the drawing the breath of life which informs the simple attitude of the Madonna runs through the whole group and foretells, as no picture since the *Sposalizio* had done, the triumphs of easy grouping which were to be displayed on Roman walls.

6

Were the fresco of the Trinity in San Severo [67] completed, it would show, besides a sense of dignity in the figures akin to that of the *Baldacchino*, how far Raphael had advanced in the art of conceiving a scene. But as it is, Raphael's struggles with an elaborate composition are now to be observed alone in the altar-piece representing the *Entombment* [69], which he painted in 1507 for Atalanta

Baglioni in Perugia. It has become a commonplace among modern critics, even the most favourable to Raphael, to find fault with this picture, which was equally universally extolled by older writers. Indeed, the faults of the picture, its cold steel-like colouring of greens and blues, its overcrowded canvas, and its conflicting actions, are only too obvious. From the over-expressed sense of strain in the chief figures the mind naturally passes to an inference that the artist himself is straining. A number of drawings [70-85] showing the subject in different arrangements, and many of them betraying by their overcareful hatching the absence of a definite intention in the painter's mind, are taken to be further evidence that the picture is a work of labour without inspiration, and to justify the modern condemnation of it as a dead thing. Others, with more charity, see in the drawings the work of pupils, and in the painting the traces of assistants' hands. Not a few are ready to accept both hypotheses, although they are mutually destructive. Nor is either satisfactory by itself. Overstrain in the attitude of figures may be a sign of hasty work as of laborious, while, though there is nothing improbable in the hypothesis that the picture was partly painted by assistants—and certainly the drawings are not all genuine—the faults of the picture are not such as can be assigned to pupils. It fails as a composition, for the main group is imperfectly displayed in the frame and in the landscape, and the secondary figures are crowded into the scene outside the main point of vision and inharmoniously in scale. It fails in its colour scheme and in its imperfect lighting. These two faults may be largely due to repainting. It fails in the attitudes of all the figures save the dead Christ, for their limbs are, like their features, too expressive, and they are so definitely posed and so obviously contrived that it is impossible not to feel the painter coming between his idea and its expression.

But all these faults have their origin in Raphael and his circumstances. Possibly, when he received the order, Atalanta Baglioni gave him the lines upon which his picture must be painted. At any rate, the similarity between this *Entombment* and that painted by Perugino for the nuns of Sta Chiara in 1495 [68] shows that from its first conception the younger picture was cast in a traditional mould. While the whole spirit of the figures is different, agony replacing quiet sorrow, the pictorial scheme is identical. The figures are brought into the immediate foreground of the scene, and are placed in precisely the same relations to the landscape as in a picture by Perugino, the composition is on similar lines and the methods of painting are the same. Both Perugino's and Raphael's pictures are like the groups of coloured wooden figures set against a painted background which are common in Italian churches, rather than like human beings in an open space. Nor yet is it necessary to leave Umbria in order to find precedents in the work of Luca Signorelli for Raphael's treatment in just the particulars which show him diverging from Perugino. Upon the top of these fundamental ideas came Florence. With scarcely an influence upon the general scheme, the new ideas of painting possessed the painter in his treatment of the details. The figures become larger and broader in conception, modelled on the lines of antique sculpture. The drapery becomes flowing, the heads more heavily modelled and more strongly featured. A whole figure is seized from a contemporary painting, which is the distance of the poles apart from Perugino's. Nothing but the intrinsic attraction of the figure for Raphael could have caused the introduction of a motive from Michelangelo's Tondo for the woman attending the Madonna. In the other figures there appears the spirit of Florentine fifteenth century work and of Luca Signorelli as it was embodied in Michelangelo's cartoon. But among all these influences Raphael was not happy. He approaches his subjects with timidity, he elaborates the anatomy of the parts without comprehending the structure of the whole, and in the painting of the faces he gives heavy emphasis to feature and to expression because he has not yet attained the freedom and the power required for a complete representation of them as inspired wholes. As a group the picture stands in much the same position as the Doni

57

6—R

heads among portraits, solid and studied effort upon unfamiliar lines, admirable in parts but not yet mastered and directed to a congenial end.

Yet, as the picture stands, it is worthy of more careful appreciation than is given to it in these days. It is historically a work of transition in the history of painting as it is in the art of Raphael. Full of the spirit of the older painting, it is the first extant work in which the new and broader naturalism was allowed to play with the old material. Filippino's decorative flatness is forgotten, and only the genius of Signorelli stands over the picture as of a nobler and simpler forerunner. But Signorelli had not the power to paint these easy surfaces or to model this drapery or these heads. Michelangelo and Leonardo had come between and had given a new conception within which to see the human figure. Later ages, which could not see through the conventions into the intentions of the earlier age, saw in this picture for the first time the virtues which we find in earlier work. To us, the sense of overstrain, which is so far from being a novelty that it is actually a mark of earlier work, appears abhorrent in this picture as it is not in the earlier, because it is accompanied by sufficient naturalism to appear to be, not mere decoration or significant drawing, but actual exaggeration in the pose. The greater the illusion of reality, the more obvious is the fault of overstatement. Raphael does not err in any fault which is not common to most of his predecessors, but in the fact that he made that fault obvious by combining it with virtues which they did not possess.

RAPHAEL AT ROME

FROM his arrival at Rome, Raphael's life is comparatively easy to follow. For a period of some twelve years, from the time that he was about twenty-four years old until his death at the age of thirty-seven, he lived and worked exclusively at Rome. Only one journey is recorded during the period, and though it is impossible that this event was unique, neither it nor any other can have been of great importance. Even this journey was undertaken in the company and the service of the Pope, Leo, for whom, and for whose predecessor Julius, the majority of Raphael's works were executed. A few large commissions and many smaller ones were received from private patrons; but these were men, with few exceptions, in the immediate circle of the Pope. But, beyond the certainty of the material fact that he lived exclusively at Rome, the darkness which surrounds all Raphael's actions—the darkness not of secrecy, but of a prominence too marked to be recorded—is constant. Save for what can be gathered from his pictures, the record of his inner life is quite unknown, and very little of his outward actions can be discovered from the few documents which chance has preserved.

It is not even possible to date with certainty the year of Raphael's arrival in Rome. A letter to the painter Francia bearing the date 1510 is, like the letter which dates his arrival in Florence (see page 39), most probably a forgery.[1] But this forgery, unlike the other, is not based on ignorance, and the date which is ascribed to the letter may be an inference from the known date upon which the first large Roman work was completed and may represent approximately the actual date of his arrival. Nor are the causes which led to his arrival clear. Vasari, searching after his manner for a positive fact as a ground of action, found sufficient reason for his coming in his friendship with Bramante, whom he wrongly declares to have been in some degree his kinsman. It is typical of the general inadequacy of the records of this period that no combination of evidence can be discovered which would succeed in bringing these two together before this moment. Possibly, therefore, Vasari is right, and Bramante supplied the hint that the young painter would be welcome in a city where Popes and nobles were busy with the discovery of antique art and the creation of modern. But there was more to draw Raphael to Rome than Bramante's invitation. Like all other painters of the day he was in search of some patron through whom great works might be commanded. Urbino for some reason failed to supply the want, but Urbino pointed the way to Rome. The great men whom Raphael met at the Court of Guidobaldo were all attached to the Papal service, and the Pope Julius himself was of the family which gave Urbino its rulers. In painting also, the traditions of Umbrian art pointed to Rome as its natural

[1] Malvasia, *Felsina Pittrice*, I, 44. See Minghetti, *Raphael*, p. 66; *Nuova Antologia*, 1883. The signature Raffaelle Sanzio is alone enough to condemn the letter (printed in Passavant, I, 498).

flowering-ground. Melozzo da Forlì and Piero della Francesca, Perugino and Pinturicchio, even Bramante himself had come from Umbria to Rome at the order of the Popes. Nor would Raphael's experiences in Florence fail to corroborate the accounts he might have heard in Umbria. At this moment Florentine sculptors and architects were crowding in the city, and painters, from Michelangelo to his meanest assistant, were finding there their employment. If Raphael visited Siena he would hear no other story. Baldassare Peruzzi, painter and architect, was working in Rome, Sodoma from Lombardy had left Siena for Rome, and the greatest of Sienese patrons, Agostino Chigi, was engaged more busily in building and decorating his Roman house than his home at Siena. It has been well said that there is less reason to ask what led Raphael to Rome than what could have kept him from it. The Via Flaminia would carry every Urbinate straight from his native place to the central city, and everywhere that the Urbinate might travel he would find crowds pressing in the one direction towards which his eyes might have turned from home.

There is no difficulty then in bringing Raphael to Rome. But every obscurity surrounds his first commissions. As they stand now, four rooms upon an upper floor in the Vatican decorated by his own hands, or by his pupils from his designs, remain the chief monument of his activity. It is not easy to think of Raphael with his work at Rome still undone, it is almost impossible to think of him without the completion of the Stanze standing to his record, and without even the conception of the finished work formed in his brain. But these rooms took years to complete; their design was interrupted by the death of the Pope, and their completion by the decoration of the fourth and principal of the rooms— the only one indeed of the four which offered a worthy field to the decorator—was broken off abruptly by the death of Raphael himself. The design of the rooms, the order in which they were painted and the character of the decorations show that there was no single simple commission given to Raphael to adorn them, but that he came, not as the decorator of the Stanze, but as one of many painters who were to be or might be employed side by side in that or any other task.

Hatred of his predecessor drove Julius on his accession in 1507 to prefer the second floor of the Vatican—the upper chambers, as they were called—to the lower, which Pinturicchio had adorned. Whether he found them already decorated, or began at once to have the walls covered with fresco is not certain, for the earlier paintings were afterwards cleared away for Raphael's. The scattered record of payments, dating from 1508 to 1510, to painters who may be these, tell of men whose work is otherwise unknown, or whose work at Rome had otherwise escaped record.[1] The decorations as they stand at present show portions which are clearly not Raphael's work, and can be attributed with much show of reason to Perugino, Sodoma and Baldassare Peruzzi, but whether they are the only remains which were spared in a general destruction or the fragments of incomplete undertakings cannot be decided. In any case they show, and the disposition of Raphael's own decorations shows more clearly, the gradual nature of his task. For three years he worked steadily, and perhaps alone, at the decoration of the first room, which was set apart to be the meeting-place of the Papal Court called the Segnatura,[2] leaving the chamber through which it was approached on either side untouched and adding nothing, changing nothing, in the architectural framework of the rooms. For two more years he worked at the second chamber, suffering this time an interruption in the plan of his decorations to meet the taste of the new Pope, and then he and his assistants spent two more in decorating the room on the other side of the Segnatura. There remained to be completed the largest room of all and the colonnaded loggia

[1] Crowe and Cavalcaselle, II, pp. 12 and 13. Among others Lotto, Sodoma and Bramantino are mentioned.
[2] For this explanation of the name see Klaczko, *Jules II*, p. 215.

without. The latter Raphael designed and decorated in the later years of his life; the former he began to have painted in a new medium of oil, when death carried him off.

The Vatican stanze and loggia did not of course occupy the whole of his energies. Internal evidence would place certain of his pictures of the Madonna during the period of the painting of the Segnatura chamber, but no external evidence corroborates it. In any case, the patrons for whom the works were executed remain unknown. The subjects of the frescoes suggest that as soon as he came to Rome he fell into the society of learned men, poets and writers with whom Urbino had already brought him into contact. Some three sonnets written on the backs of drawings for this room show that he moved in lighter circles, where perhaps he, like Benvenuto Cellini,[1] was made to recite a conventional poem at a lovers' feast. But these are the only records of his life. In 1511, when the chamber of the Segnatura was not yet finished and Pope Julius returned bearded to Rome after his fruitless expedition to Bologna, Raphael painted his portrait. In the same year he stood as security for the Sienese painter, Baldassare Peruzzi, in a transaction between the latter and his landlord regarding the repairs to the house he had rented in the Via del Corso.[2] This document, with its evidence of intimacy between Raphael and the Sienese architect would serve alone to connect Raphael at this date with the rich Sienese banker, Agostino Chigi, who was also Peruzzi's patron. But an earlier document of 10 November 1510 records a payment by Chigi to Raphael's old Perugian friend, Cesarino Rossetti, for the execution of bronze dishes from designs of Raphael's.[3] Chigi was, after the Pope, to be Raphael's most important patron in Rome. In the next year, 1512, his villa in the new quarter across the Tiber—the Farnesina, as it is now called—was completed, and though Vasari ascribes its architecture to Peruzzi, a critic[4] who knows Raphael well would attribute it to him, in design as well as in decoration. Sodoma was also employed by Chigi. Thus a centre of artistic life subsidiary to that of the Papal Court is faintly recorded. Of this circle Sebastiano del Piombo, freshly arrived from Venice, and the engraver, Marc Antonio, seem also to have been members.

The letter from Sebastiano del Piombo to Michelangelo, which has already been quoted, shows the position of Raphael at this period. His work in the Vatican was liable to immediate interruption if some other painter caught the favour of the Pope, and as it stood he had but one chamber finished and another but begun. Good critic of art the Pope might well be, but his judgment might equally well show itself by the choice of different masters for the decoration of the same room. But Raphael maintained his favour with Julius until his death in February 1513, and under his successor Leo his position for the first time was secure.

Leo found Raphael immersed in work. Before the death of Julius a letter from the agent at Rome of Federigo Gonzaga, Duke of Mantua, tells of Raphael's inability to paint a portrait of the Duke through the number of his commissions.[5] Raphael also painted by Julius's orders a portrait of the Duke which is in the chamber of the Vatican where the Pope himself appears.[6] The two portraits might well have been completed from a single sketch, as were perhaps those of Julius himself. Doubtless the death of the Pope caused an interruption to the decoration of the *Heliodorus* chamber, and during this interval it has

[1] *Life*, tr. Symonds, 1888, I, 92. Raphael's sonnets are printed in Passavant, I, App. VII.

[2] Minghetti, p. 111. *Nuova Antologia*, 1883, p. 613.

[3] Fea, *Notizie*, p. 81.

[4] Geymüller, *Raffaello Santi Architetto*, Milan, 1884, p. 24.

[5] Letters of 11 January and 19 February 1513. The portrait was then abandoned owing to Raphael's anxiety on account of the Pope's health. Castiglione in 1521 refers to it as an existing picture. A portrait of the Duke was in the collection of Charles I (Campori, *Notizie*, 1870, pp. 7 and 8).

[6] Documents cited, *L'Arte*, 1903, p. 108.

been supposed that Raphael executed the first large commission for Agostino Chigi, for a letter to Castiglione,[1] which may be dated from the next year, speaks of the *Galatea* [197] as now finished, and refers to the fresco on the walls of the Farnesina palace. Perhaps also about this time the fresco of the *Sibyls* [XII, 164] and *Prophets* in Sta Maria della Pace was begun at Chigi's expense. But both these dates are purely conjectural.

With Leo's accession the busiest period of Raphael's life began. He was confirmed in the commission to complete the *Heliodorus* chamber, altering his designs and his subjects to suit his new patron's wishes, but retaining by his own will or by his patron's the general scheme of subject which makes this room the first of the monuments to Papal glory. The room was completed in 1514, and the chamber on the other side of the Segnatura was given to Raphael to decorate. Thus Leo's arrival forced the pace of Roman life. Nor was it enough to hasten the completion of rooms which doubtless Leo wished to occupy at the earliest possible moment. Another and far greater work was given to Raphael. A few days before Leo's accession Bramante, the architect to whom Julius had entrusted his great scheme of the rebuilding of St Peter's, died, leaving the works barely begun. Within a fortnight of Leo's accession Raphael, who had been the official associate of all Bramante's plans, and the sharer in his ideas, was appointed his successor. This commission was confirmed in August, a salary of 300 ducats being assigned to Raphael,[2] and later, two assistants, Gian Barile and the old and learned scholar Fra Giocondo, were given to Raphael for the work.

Raphael found himself thus suddenly a prince among the artists of Rome. He describes the change in his fortunes, in one of his simple and familiar letters[3] written on 1 July 1514 to his uncle Ciarla, to whom he had written before from Florence. He began with an excuse for not writing earlier on the ground that he had nothing to say, but now even he considered that there were events worthy of communication. He says that he was glad not to have married the girl whom Ciarla had decided upon for him, or any other, because marriage would have stood in his way. At that moment he valued his property in Rome at 3000 ducats, with receipts of 50 scudi. He had his salary as architect of St Peter's, and the new stanza will bring him 1200 ducats. For other works he set his own price. Besides this, the Cardinal of Santa Maria in Portico (Bibbiena) was arranging a marriage between him and his niece; and other ladies, one of whom had a dowry of 5000 scudi and a house worth more than 100 ducats, were no less willing to marry him than the youth of Urbino to wed the nameless lady whom Ciarla had destined for Raphael. As for his uncle's complaints that he was always in Rome, it would be impossible for him to be anywhere else for any time with such a project as St Peter's on hand. It would cost over a million in gold, and the Pope spent 60,000 ducats upon it a year. His associate was an old man who could not live long. Every day the Pope sent for them to discuss the building. The letter ends with messages to the Duke and Duchess, and to one Ridolfo, Raphael's dear and unknown friend.

Together with the third stanza of the Vatican, Raphael appears at this time to have been engaged upon the cartoons for tapestries with which Leo proposed to decorate the Sistine Chapel. Sixtus IV had placed a row of frescoes upon the walls and at the east end; Julius had secured from Michelangelo the painting of the upper wall and ceiling. Leo chose Raphael to design such hangings as would, with their magnificence of colour and design, fitly commemorate the third great Pope of modern Rome. The first payment for these tapestries was made to Raphael on 15 June, 1515.[4] A further onerous mark of

[1] Passavant, App. VII, p. 501. The letter was first printed in Bino's collection, 1582. See Crowe and Cavalcaselle, II, 205.
[2] Passavant, I, p. 505; Fea, *Notizie*, pp. 9 and 13, and documents there quoted.
[3] Passavant, I, p. 499—from Pungileoni, *Raphael Santi*, p. 158.
[4] Fea, *Notizie*, p. 8. Another payment on 20 December 1516 of 134 ducats.

Leo's favour and of his desire that Raphael should be associated with him completely in his favourite pursuits is recorded in a brief of 27 August.[1] By the Pope's order Raphael was commissioned to buy all ancient stones in Rome for the building of St Peter's, and all men were commanded to give him information of every discovery within three days, and forbidden to mutilate any inscribed stones without his leave. Thus he became not only painter and architect-in-chief, but also the first official to watch over the now universal taste in the discovery of antiques.

Private commissions were also given at this time. Isabella d'Este secured a promise of a picture,[2] and, perhaps at this time, an order came from Bologna for the altar-piece of the Chapel of Sta Cecilia in San Giovanni in Monte, which is the only easel painting by Raphael which still remains in the town for which it is known to have been originally painted.[3] Vasari states that he took part in the competition for the façade of San Lorenzo at Florence, but, though he may have visited that town with Leo on his state entry there in 1515, there is no evidence to support the story. He did not accompany Leo upon his further progress, or he would have found himself together with Leonardo and Michelangelo; no doubt, his presence was required in Rome, where, during his absence on 8 November,[4] he bought himself a house for 200 ducats—whether to inhabit or as an investment does not appear.

The incessant activity of the last years of Raphael's life has left its mark even upon the documents. The letters of Bembo to Bibbiena show Raphael as the painter of the scholarly court. In April 1516 he is awaiting orders from Bibbiena for the decoration of a bathroom on the upper floor of the Vatican which was the private apartment of the Cardinal. He had finished some of the pictures which formed the centre of an antique decorative scheme, and was expecting to hear from Bibbiena the subjects for the rest. Probably a delay occurred at this point, and the change in handling which occurs after the third panel may be a sign that Bibbiena responded too slowly with his commands, and, either through his or Raphael's interest flagging, was at a later date put off with a scholar's work. The same letter speaks of portraits of Tebaldeo and Castiglione, members of the same circle, and mentions a portrait of the late Duke, presumably Giuliano dei Medici, which had been painted at an earlier date. Another letter gives also a more intimate touch when it tells of an excursion which Bembo and Castiglione made with Raphael to Tivoli, taking in their company Navagero and Beazzano (whose portraits, now in the Doria Gallery, Raphael must have painted at this time). Scholars and poets were Raphael's friends, and in that day they paid together a homage to the antiquity which was the inspiration of them all.

Another flash of insight is rendered even more intimate by the touch of ridicule which necessarily forms a part of it. The King of Portugal had presented Leo with an elephant, which served to adorn the mock triumph of a poor foolish poet, Barrabal, and is enshrined as carrying him upon his feast-day in the intarsia which stands above a door of the Segnatura Stanza. In 1516 the elephant died, but, seriously or in jest, it had become so popular a hero that a memorial in the shape of a huge tower at the entrance to the Vatican was painted after Raphael's design with Jumbo's likeness, and an inscription was placed upon it naming the Pope's chamberlain as founder of the monument, Leo himself as master of the epoch, and Raphael as the painter. Even the necessary epigram, with a neat antithesis between nature and art, was included in the inscription.[5]

[1] Bembo, *Opere*, XVI, 246.

[2] Letters of Agostino Gonzaga, June 1515, and anonymous, November 1515. An undated letter from Paulucci to Alfonso of Ferrara speaks of a picture for the Signora Marchesana which was only touched when Castiglione was present. Campori, *Notizie*, 1870, pp. 9 and 10.

[3] *Archivio Storico dell' Arte*, VII, 1894, p. 306.

[4] *Ibid.*, II, 248.

[5] Müntz, 1881, p. 421, quoting Cancellieri, *Solenni Possessi dei Sommi Pontefici*, p. 62.

As a contrast to the sumptuousness of Rome, and as a memory of a period which he might well have forgotten, an embassy came in 1516 to Raphael from Perugia, reminding him that the altar-piece which he had promised to the nuns of Monteluce had never been executed.[1] A new contract was drawn up, under which Raphael was engaged to paint the *Coronation* within a year, accepting 120 ducats in gold as the price—only 40 more than were promised to his friend Beato di Giovanni for the frame and the predella. Towards the same date, possibly, he accepted the commission from the Black Monks of Piacenza which produced the *Sistine Madonna* [XIII, 227], painted on canvas for easy transport; but the Cardinal-abbot of Modena who wished Raphael to paint the refectory of his convent was told that he could only leave Rome for an enormous fee even for a short time.[2] Meanwhile he was busily working for Agostino Chigi, if not, as is probable, upon the *Cupid and Psyche* [199–204] frescoes in the Farnesina—no documents exist for the dating of this work—at any rate he was supervising the building and the decoration of the Chigi chapel in Sta Maria del Popolo, for the mosaics in the vault, which were executed from his designs by Luigi de Pace of Venice [206, 209], bear the date of this year.

St Peter's was also occupying his thoughts. On 20 November 1516, Giuliano da San Gallo, his professional associate, died, and Antonio his brother was appointed in his place. Fra Giocondo, the learned old friend who had been appointed to assist him in another way, had died the year before. Too little is known of the history of his activity in this direction to enable any progress to be marked in his designs for the building. But this was not his only architectural work. The Chapel of the Chigi in Sta Maria del Popolo is due to his designs. Vasari attributed to him the erection of the so-called stables at the Farnesina, and various houses at Rome and Florence are said to have been his work.[3] Possibly an adventure in architecture or the external decoration of houses in the great new quarter of Rome brought Raphael into financial contact with the bankers of the Pope, the Porcari brothers, who owed him some 1000 florins, for which eventually they gave him a mortgage on a house.[4] Nor did painting, architecture, and the search for antiquities exhaust Raphael's activity. In this year Leonardo the saddler wrote to his friend Michelangelo that Raphael was busy with a statue of a boy for Peter of Ancona,[5] a new, but in no way a surprising departure, for the now acknowledged master of the arts of Rome.

The next year 1517 shows no abatement in his industry. In June the finishing touches were given to the Camera dell' Incendio, for, on the 6th of that month, he told the agent of the Duke of Ferrara that in two more days that work would be completed, and in July Bembo wrote to Bibbiena in terms of praise of the decorations of the room. In the same month a sum of money (20 ducats) was paid to his pupils for the decoration of the room in front of the *garda roba*, an indefinite description which fails to identify the work.[6] This year or the next saw the completion of the Chigi frescoes, which Leonardo the saddler described in a letter[7] to Michelangelo as even worse than the last paintings in the palace. Possibly the *Ezekiel* [241] in the Pitti Gallery, and the *Bearing of the Cross*, called *Lo Spasimo* [252], painted for his friend the Count of Canossa, were executed in this year. The Governor of Florence,

[1] For documents, see p. 40, n. 1.
[2] Pungileoni, *Raphael Santi*, p. 198.
[3] The most characteristic and best authenticated are the Villa Madama outside Rome and the Villa Pandolfini in Florence.
[4] *Archivio Storico dell' Arte* II, 1889, p. 248.
[5] Gotti, II, 59. A whole literature has sprung up regarding this 'Boy with the Dolphin'. The group in the Hermitage is unremarkable and flat in its execution. The other statue which is attributed to Raphael, the 'Jonah' in the Chigi chapel, might also be described as a boy with a dolphin.
[6] Müntz, 1881, p. 466, n. 1.
[7] 1 January 1518, or, more probably, 1519.

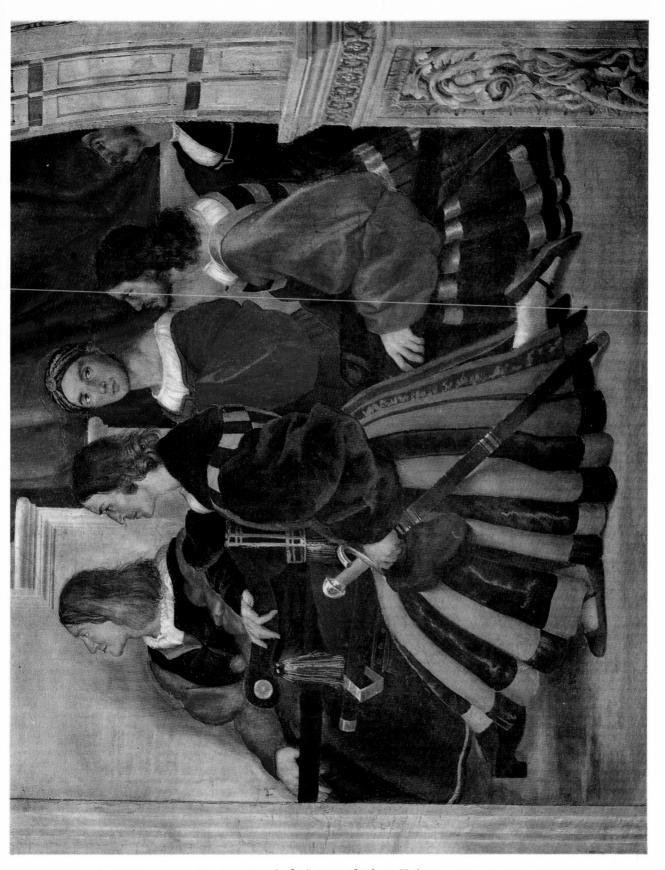

VIII Detail of *The Mass of Bolsena*. Vatican.

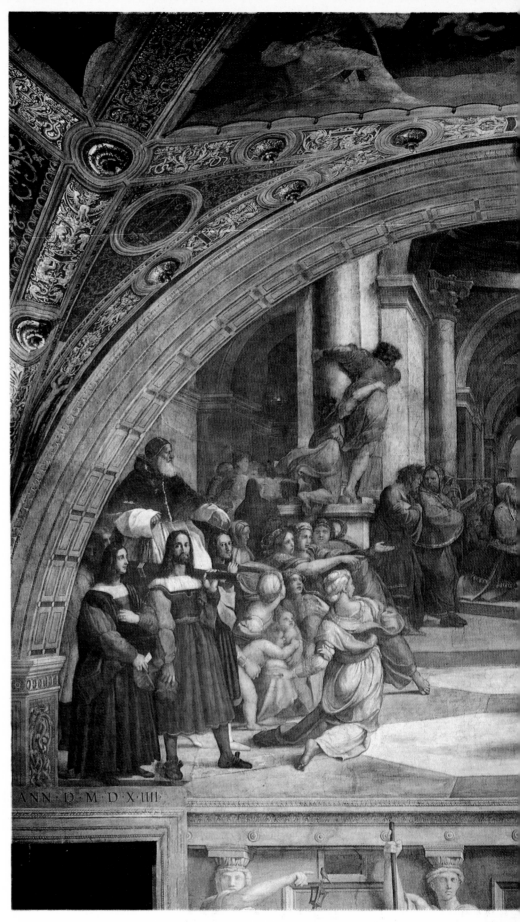

ANN·D·M·D·X·IIII·

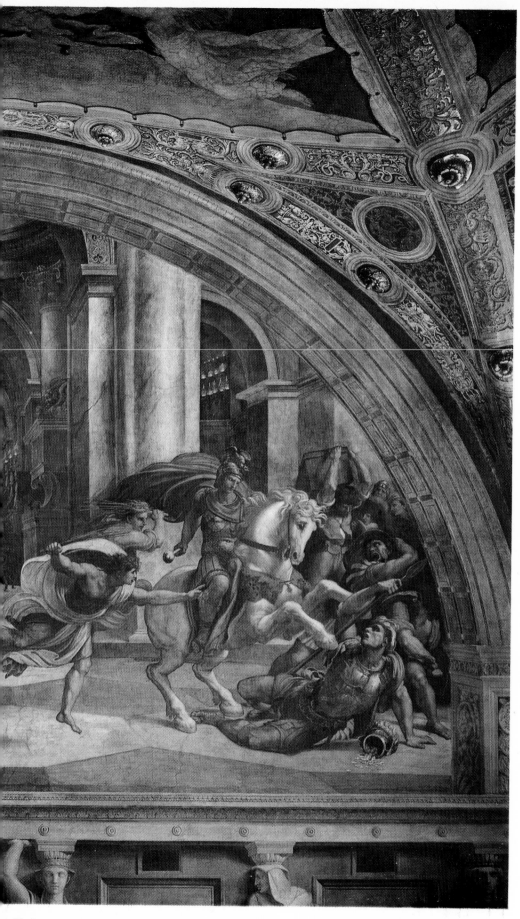

s. Vatican.

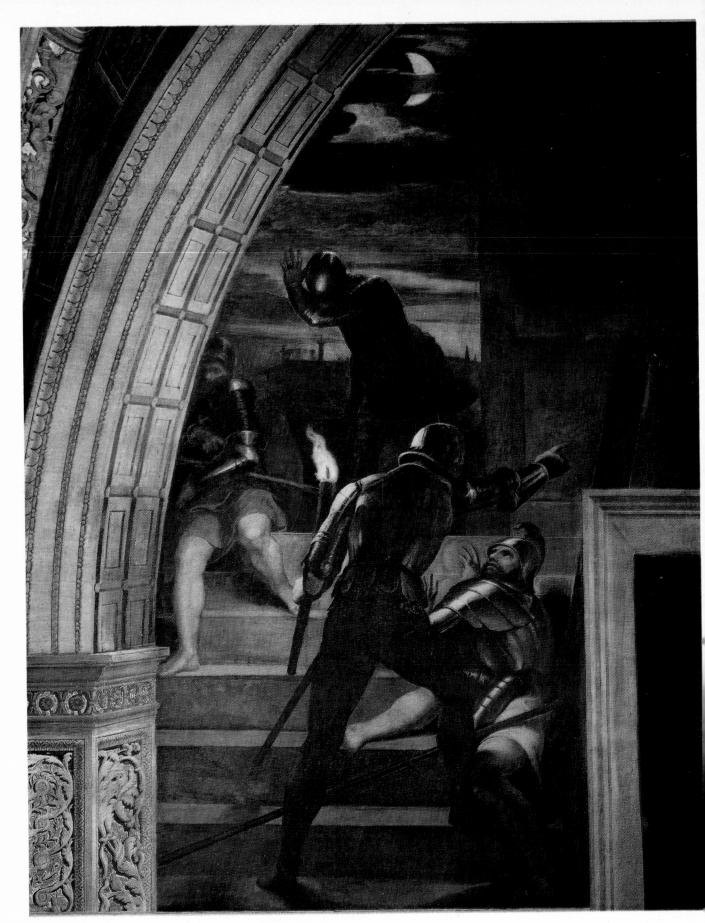

x Detail of *The Release of St Peter*. Vatican.

Goro Gheri, wrote in November to ask Lorenzo dei Medici for some drawing of himself by Raphael or another to serve as a model for a medal.[1]

Of St Peter's this year tells no tale. In the matter of antiquities there is record only of Raphael acting as collector for Alfonso d'Este.[2] But on the side of Raphael's accounts it is recorded that in January he borrowed from Bernardo Bini and his company 150 ducats, which were repaid in April of the following year. In October he bought a large house in the Borgo Nuovo for 3600 ducats. It is of interest that the witnesses to the former transaction were Lorenzo Canigiani of Florence, for whose kinsman Raphael had painted, some ten years before, the Madonna which bears his name, and Tommaso di Andrea Vincidor of Bologna, his friend and pupil.[3]

The next year, 1518, gives the clearest picture of Raphael's activity at Rome. Besides the architecture and the decoration of the Loggia of the Vatican, the latter of which was entirely carried out by pupils under his direction, besides the constant labour of St Peter's, and the care of the antiquities which led to a dispute[4] with the heirs of the owner of a statue, Raphael was engaged on several private commissions. Several of these were given by Lorenzo dei Medici, who, after residence in Rome, where in 1513 he had brought Leonardo da Vinci, was at this time Ambassador at the Court of Francis I. For him,[5] as a present to the king, Raphael began in 1517 the picture of *St Michael Slaying the Dragon* [249], which is now in the Louvre. For twelve months Raphael seems to have had it on hand, only to have it finished eventually, as far as can be judged, by the hands of pupils. For him also Raphael had painted the picture called the large *Holy Family of Francis I*,★ again exporting as his work a picture largely by pupils' hands. Both pictures were finished and left Rome about May 1518, and a correspondence between Lorenzo's agents in France and Rome gives glimpses of the panels as they travelled upon mule-back under the charge of one of Raphael's pupils. Another picture for the French Court was painted under Raphael's directions. This is the half-length picture of Joanna of Aragon, which was sent through Bibbiena at the end of the year as a present to the king, but which Raphael himself acknowledges to be partly the work of one of his aids. Finally, the great picture of the *Transfiguration* [256], which Lorenzo ordered, might have been begun by this time, for the letters of Sebastiano del Piombo to Michelangelo at this date contain remarks which can only be understood as referring to the picture by Raphael in competition with which his own *Raising of Lazarus* [255] was being painted.

In June 1519 Castiglione mentioned with praise the Loggia decorations in a letter to Isabella d'Este.[6] In October Agostino Chigi was dead, his chapel in Sta Maria della Pace finished, that in Sta Maria del Popolo still awaiting the final decorations and its tombs, for which Raphael made sketches of statues. Two papal villas, known as the Magliana and the Madama, were being built in this year and decorated under Raphael's direction. The largest of the rooms of the Vatican must also have been occupying Raphael's attention, but the picture of the *Transfiguration* was put aside for a great part of the year because of Cardinal dei Medici's absence, and the rumour which was set abroad in September that it was shortly to be exhibited seems not to have been founded on fact.

It is not the custom of great princes to reserve their favourite painters for their more legitimate work. To Leo the decorations of his public rooms, even the erection of his most lasting monuments, may not

[1] Gaye, *Carteggio*, II, p. 145.

[2] Campori, *Notizie*, 1863, p. 6.

[3] *Archivio Storico dell' Arte*, II, 1889, pp. 34 and 145.

[4] Pungileoni, *T. Viti*, p. 103.

[5] Gaye, *Carteggio*, II, 146. It is a matter of indifference whether Lorenzo or the Pope is said to have commissioned this gift.

[6] *Il Rafaello*, 20–30 September 1876 (Crowe and Cavalcaselle, II, p. 425).

★ C. I. 130, D.I. 98, PV. 136.

have appeared of more capital importance than the splendid entertainments of a day. It is characteristic of him that he chose to add tapestries resplendent in gold and silver to the decorations of the Sistine Chapel, and part of their attractiveness in his eyes was, no doubt, that they could be detached from the walls and used to give glory to his official pomps. The tale of his celebrations is too long to recount here, nor has chance left a record of Raphael's part therein save in one solitary instance. When, in 1519, Ariosto's comedy, the *Suppositi*, was first performed, Raphael appears as the decorator of the scenery. Placed upon the stage at Rome in rivalry with a play which was also written by another Cardinal, and had recently been played before Isabella d'Este at Mantua, this comedy was attended by the Pope in state with the princes of the church and the leaders of every art in his retinue. It occupied only one day in a series of entertainments which included horse-races, a bull-fight, and another comedy, which, again, was written by an ecclesiastic. Rome was given up to enjoyment, and Raphael had his part in it. His scene-painting is described as consisting of issues and perspectives (*forami di prospettive*), and it appeared behind a comic drop-curtain upon which a buffoon, Fra Mariano, was displayed amidst a quantity of devils. Paulucci, the agent of the Duke of Ferrara, who describes this entertainment in a letter,[1] does not attribute this work to Raphael, but it may well have been his, as was the comic monument to Barrabal. The background of his scenery may have shown the study of perspective and the vistas of buildings which belonged to his care of St Peter's and his interest in ancient Rome. Doubtless the work was not glorious or of eternal worth, but it is a testimony to Raphael's want of false pride, and to his ability to use his gifts readily and without consciousness of their value. It may not require a genius to descend to the level of the common herd, but, among geniuses, he is likely to be the greatest who does not invariably refuse to stoop from his high estate.

The correspondence between the Duke of Ferrara and his agents at Rome, which was published from the archives of Modena by Campori in 1863, gives the only contemporary picture of any protracted negotiations between Raphael and his patrons. Earlier than 1517 the Duke of Ferrara, Alfonso d'Este, husband of Lucrezia Borgia and patron of Titian and Ariosto, had secured a promise from Raphael that he would paint a picture for his palace at Ferrara. On 28 March 1517 the duke's ambassador at Rome, Costabili, Bishop of Adria, tells his master that Raphael is working constantly at a picture for the French king and must postpone the duke's commission. He repeats much the same excuse about the Pope's chamber two days later, at the same time reporting a message from Raphael concerning a commission given him by the duke to use his authority over the ruins of Rome for the purchase of antique works of art. On 6 June, Raphael promised to turn to the duke's commission as soon as he had finished the chamber of the Pope, an event which he anticipated in two days' time. In September Raphael decided to change the subject of the picture. He had chosen, the letter states, the Triumph of Bacchus, and had sent a sketch to the duke, but now, hearing that Pellegrino da Udine was painting the subject for the duke, he refused to proceed with his. Consequently he asked for some other subject. Here the correspondence breaks off, and there is no way of learning whether the duke refuted the story as a mere pretext to postpone the work or suggested some other subject. At any rate, Raphael sent him as a present the cartoon of his fresco, the *Repulse of Attila*, and received fifty ducats in gold as a first payment on account of the—as yet—untouched picture. Yet in December Raphael was still delaying, urging in excuse his many commissions for the Pope and the Cardinals of the Palace. The same pretexts were urged in March 1518, now varied by the story of the *St Michael* which the Pope had ordered as a gift to Francis I, and required to be quickly executed. Otherwise it appears the picture would have been ready by April. Three more letters, not counting one which, dated by its discoverer a

[1] Published with the correspondence summarised below by Campori (*Notizie Inedite di Raffaello di Urbino*, 1863).

year earlier, seems to relate to this matter, speak of his commissions for the Pope and of the 'Holy Family' for the same King, which is now known as the *Large Holy Family of Francis I*. In August Raphael was inaccessible, but the picture (a canvas—*tela*) was said to be begun. On 21 September Raphael still put forward his work for the Pope as an excuse for undertaking no other, but he felt bound to offer a more tangible sign of his good intentions than the constant asseveration that nothing was so near his heart as his work for Alfonso, and he offered him as a present the cartoon of the *St Michael*. The ambassador, somewhat suspicious that the gift was intended as a final repayment of the money advanced, and as a compensation for the non-delivery of the picture commissioned, was not enthusiastic in the acceptance of the gift, but a promise that the picture would be completed by the end of the year reassured him. The cartoon went to Ferrara. The next day the bishop wrote a letter of introduction to the duke for a pupil of Raphael's who was setting out to Venice to buy colours, and told him that the pupil would bring news of Raphael. The duke accepted the cartoon and sent Raphael twenty-five crowns on 10 November to make himself merry at Martinmas. Raphael protested that he had sent the cartoon without idea of payment, but he allowed himself to be overcome, without, at the same time, giving the bishop the opportunity he desired to penetrate into his studios in order to gauge the progress of the long-delayed canvas.

Shortly afterwards Alfonso travelled to Paris, where he saw and admired the portrait of Joanna of Aragon [236]. On 28 December he wrote to his Secretary at Ferrara telling him to command the envoys in Rome to look after the picture and to secure the cartoon of the *Joanna* as a gift from Raphael. On 1 February the bishop wrote that Raphael had given the cartoon and was willing to have it coloured, and that the picture would be ready by the duke's return. A month later the bishop wrote that Raphael had told him that the cartoon of the *Joanna* was drawn by one of his pupils whom he had sent to Naples for the purpose. But this was a mere incident in the negotiations for the great picture which Raphael in February stated to be still delayed.

Soon after this the bishop fell ill and the duke transferred the duty of looking after the picture to Paulucci. His orders were explicit, and truly the blank on the walls of his Camerino was a grievous sore in his eyes. In May and June Raphael made the same excuses to Paulucci as he had to his predecessor, and offered to admit him to his studio. By August the offer had not been carried beyond his words. Nor by September had Paulucci entered the studio, but he heard that the picture was stacked with many others against the wall. But while advising the duke to write with his own hand, he promised to search again in order to see not only the duke's painting, but also the *Transfiguration*, of which rumours had reached him. The second attempt followed soon after, but Raphael pleaded that he was painting a portrait of Baldassare Castiglione, and Paulucci was turned away from the door.

The duke did not accept Paulucci's advice to write a letter himself to Raphael. But he wrote again to press Paulucci to his task, troubling, as the original draft of the letter shows, to change his command that a letter should be written to one that a private conversation should take place. Clearly the duke repented of his disbelief in Paulucci's visit (he probably received the letter of 3 September), but he preferred that no one else should be aware of his complaints, and the threats which he commanded Paulucci to hurl at Raphael no doubt appeared somewhat too violent and too futile to be communicated to the Pope's favourite painter, whose chief offence was that he was constantly working for the Pope. At any rate Paulucci replied that he would first make another trial with his customary gentleness, because men of genius were always somewhat quick-tempered and melancholic. Alfonso answered shortly that Paulucci must do as he was told, and in January he wrote that Raphael was treating him like a vile plebeian, and that the Cardinal del Cibo should be asked to use his influence. Paulucci

complied and was again put off. Raphael was busy with the *Transfiguration*, which, according to Battista Dossi, would be ready at Easter. In March Raphael told the same story, and promised to write to Dossi at Ferrara to make his excuses to the duke. Paulucci undertook to keep him to his word, but a fortnight after he could only write that Raphael was dead.

The further correspondence which shows the duke moving heaven and earth to recover from Raphael's heirs the fifty ducats which he had paid to Raphael at an early stage of the proceedings, throws enough light upon his anger and covetousness, but nothing more on Raphael's character. But the narrative of this transaction illustrates far better than the apocryphal anecdotes of Raphael's pomp and glory at Rome the actual position of the artist. It shows him to have been of so considerable a position that Paulucci felt bound to humour him and wait upon his wishes, and to put off the duke with excuse after excuse rather than convey to Raphael the irate messages which the duke had sent. Even the duke himself, in preferring a verbal message to a letter, shows himself anxious to avoid a public quarrel with an artist of eminence and a favourite of the Pope. But at the same time the correspondence proves Raphael to have been reluctant to alienate a patron who might have been powerful, and merely postponing his obligations towards the duke to the claims of more immediate and pressing friends. The delay in the execution of the picture might be paralleled by a hundred stories of the time, and the whole affair, with its negotiations, its excuses, and, above all, its Martinmas gift, reads so much like a quiet chapter of Cellini's *Memoirs* that it brings Raphael himself nearer in position to Cellini than to the all-powerful courtier that legend has made of him.

Raphael's influence with Lorenzo dei Medici is shown in fragments of two other contemporary correspondences. On two occasions he interceded with the new Duke of Urbino in the affairs of his native town. In February 1518 he pleaded for one M. Antonio di Ser Niccolo, who seems to have been the leader in some revolutionary movement against Lorenzo. Again, in March 1519, he secured that a benefice which had been given by the duke to his chaplain was restored to his own brother, who had a claim to it under the old regime.[1] His relation to Giuliano dei Medici, the Pope's other brother, is shown by the fact that in 1515 he is mentioned as among his *familiares* or chosen court.[2] But these are small matters, and do not go far to contradict the impression caused by the history of his negotiations with Alfonso d'Este.

Paulucci's letters show him immersed in work and frequented by distinguished visitors. No doubt he lived among a crowd of pupils, walking abroad, as he is said to have been described by Michelangelo, like a prince, and no doubt his group of friends and pupils formed so solid a body of common interests that they could be sneered at by Sebastiano del Piombo as 'the Synagogue'. But it is far from this to the scandal told by Vasari that Raphael aimed at the red hat of the Cardinal. Among the crowd of wits and poets upon whom that honour was bestowed it might seem to modern eyes that the favourite painter, architect and antiquarian of the Pope might well aspire to win a place. There is an old tradition which based his aspiration to this honour not upon the devotion of the Pope to the arts but upon the enormous sums which he owed to Raphael. This story is to some extent disproved by the discovery of the documents[3] which show Raphael's receipt of the salary due to him for the work of St Peter's, but it shows what credit was given by Romans to the story, and as a matter of fact, painters, for all their honour, were not held in the same esteem as poets and wits, who could also be useful diplomats and ambassadors. The painter might be employed, as was Raphael, in useful offices about the Court, but he

[1] Documents for these transactions in Gaye, *Carteggio*, II, 146 and 149.
[2] Müntz, 1881, p. 429, quoting a Strozzi document.
[3] Fea, *Notizie*, p. 9.

was not in those days distinguished, as were later Velasquez or Rubens, with confidential affairs of state. His art remained in the eyes of the noble Italian much as was that of the painter or the sculptor for the ancient Greek, not far removed from that of the handicraftsman. Bembo and Bibbiena, Riario and Castiglione, might all be firm friends of Raphael, but in his book *The Courtier* Castiglione put into Bembo's mouth an account and a defence of painting which scarcely exceeds in generosity that made by Aristotle in his *Politics*.

He lived, then, in Rome, his life crowded with his pictures, his architecture and his care of antiquities. He could turn to the design for the stage of a theatre, the execution of a tomb for Isabella d'Este (in the absence of Michelangelo), or even the construction of a chimney which was warranted not to smoke for Alfonso of Ferrara.[1] His pupils crowded round him as the acknowledged chief of painting, and only a few friends of Michelangelo, then absent from Rome, formed a hostile camp, anxious to secure the commissions that were given to him, finding fault with his colouring and his decoration, and even attempting to accuse him of the theft of their designs, or of filching gold from the frames of his pictures. There is little sign that the hostility between him and Michelangelo, which became in later years typical and legendary, was ever actually acute. Raphael's own estimate of Michelangelo is given by the latter's biographer, and is sufficiently generous. 'He thanked God,' he said, 'that he was born in the same days as Michelangelo.' Michelangelo's was less ungrudging. 'Raphael's eminence,' he said, 'was due to his great diligence.'[2] But these words, as has been well said, are, for any one with knowledge of Michelangelo's character, no small proof of his esteem.

The stories of the relations of Raphael with women are equally little attested. Vasari says that he was much given to the society of ladies. It is very likely. He also tells the tale of one woman whom Raphael loved consistently throughout his Roman life, repudiating her, like a good churchman, on his death-bed. So little of Raphael's inner character is known that it is impossible to say whether the story is true or not. In any case, the matter is far too unimportant to be allowed any weight in estimating his character as a whole. The identification of the woman with one Margherita rests on the slenderest evidence. An anonymous manuscript annotation on the margin of a sixteenth century edition of Vasari's *Lives* is its only source, and there are a thousand different reasons why a woman's name is placed in the margin of a book. The description of her as a baker's girl, *Fornarina*, has even less foundation; the identification of houses in Rome as those in which she lived is still more imaginary. Of the many portraits of women which, according to Vasari, Raphael painted, none unfortunately is now known for certain, save that of Joanna of Aragon, though some resemblance to a portrait by Raphael may persist in the *Donna Velata* [234] of the Pitti, and the *Fornarina* [235] of the Barberini Palace, and some echo of a loved face may remain in various pictures of the Madonna or of goddesses. Raphael himself, writing to Castiglione,[3] describes his women's faces as purely ideal, speaking, as was the fashion of the day, in the language of a somewhat misty Platonism, but flesh and blood may have lain behind the ideal image of *Galatea* of which he was at the moment speaking, and the instinct of men and women through three centuries may be right in finding in Raphael's pictures the inspiration of the perfect lover.

In any case, the record of Raphael's love affairs is no more eventful than that of his other life. There was a maiden in Urbino whom his family had selected to be his wife, and Cardinal Bibbiena wished Raphael to marry his niece. Neither plan succeeded. The village maiden remained obscure, the Car-

[1] Campori, *Notizie*, 1870, p. 13; 1863, p. 24.
[2] Condivi, §§ 57, 67.
[3] See p. 62, n. 1.

dinal's niece died before Raphael. Of further history in either affair there is no trace. Probably Raphael married neither because he was too busy. Marriage, as he wrote to his uncle, would only have retarded his career. Leonardo and Michelangelo were both unmarried, and in an age when the most prominent men were clerics a celibate life was the rule rather than the exception.

Work is the dominant note in Raphael's life. There are no adventures of love or politics to give his history a touch of sensational interest. Even his death came to him suddenly amid his many occupations. He was engaged upon his great picture of the *Transfiguration*, upon the building of St Peter's, and upon a fantastic and colossal plan which his passion for antiquities and his new interest in architecture had brought him to undertake. With a recklessness of adventure which tells of his age no less than do his pictures, he had embarked upon a scheme to draw up a plan of ancient Rome, with all its edifices restored and in perspective. It was to be a complete restoration of the ancient city, a recovery of lost glories, and no doubt, a model for the future. No discovery of a new world could have aroused men's enthusiasms to so great a degree; no voyage into unknown seas could have promised a more hopeful Eldorado than this adventure into the glorious past. Cultured Rome awaited the result with greater excitement than they had shown for any mere exhibition of decorative art. They believed that Raphael was possessed, after his fashion, with a sure method to bring the past to life. But death struck down the new Asklepios. On 20 March Raphael promised the Duke of Ferrara the design of his new chimney. On the 24th he leased some land for building purposes from the Canons of St Peter's.[1] At the end of the month he fell ill of a quick fever, and eight days later, on Good Friday, 6 April, he brought his short life of thirty-seven years to a close, and Rome was left to look with sorrow on the unfinished *Transfiguration*, and to mourn the wreck of its hopes to recover the outward aspect of its prime.

His body was buried by his own direction in the Pantheon, at once a Church of the Virgin and the most perfect monument of his beloved antiquity. Gossips discussed his will; poets honoured him with antithetic epitaphs; ambassadors wrote to their princely patrons confronting them once and for all with the vanity of their desire to obtain some work of the favourite painter. His pupils, forming almost a league for the continuance of his traditions, divided his artistic inheritance, but fell asunder into different directions when the guiding hand was lost. The stronger personality of Michelangelo, showing itself more powerful if only by the treble length of his life, resumed its sway over Roman Art. Shortly afterwards Rome itself fell before the barbarian, and, not much later, German soldiers wrote their names upon the frescoes in the Logge and the Stanze of the Vatican. A ridiculous publication was issued purporting to embody Raphael's investigations into ancient Rome; his pictures faded or were destroyed by restoration, and St Peter's was completed by another hand. But enough of his work has remained to make him the most adored painter of three centuries of critics, even those who decried him having from the first lived upon his example and his activity; and his personality, elusive and vague, neither excessive nor careless, but loyal and fresh and young, has become a legend of the beauty and the happiness which his work embodies in itself.

[1] *Gazette des Beaux-Arts*, 1880, I, p. 358.

CHAPTER VI

ROMAN ART

I

WHEN Raphael began to decorate the first of the Pope's chambers in the Vatican, that called the Stanza della Segnatura [98–100], the subjects to be depicted upon the walls and ceiling must have been already chosen, even if it had not already been decided that one man would execute the whole, for they are based upon one idea and follow in a consistent order. In the very centre of the ceiling the arms of an earlier Pope, Nicholas v, surrounded by *putti* on a blue ground, remain from a former scheme, and it is possible that the general arrangement of the decorations follows that of the old. It is composed of medallions and rectangles bound together by gold frames, arabesques and bosses with subjects painted in the chief spaces and in certain of the smaller intervals of decoration [99]. This is a conventional scheme of ceiling decoration modelled no doubt on woodwork, and suggesting by the arrangement and perspective of its lines a heightening of the room. It had been used with great effect by Pinturicchio in Rome before this date, and here in this room it, with the paintings in the smaller panels, is attributed to Sodoma. In the eight principal spaces upon the ceilings, four lunettes near the centre and four rectangles at the springing of the vault, subjects were chosen to illustrate the four great branches of learning—Theology, Poetry, Philosophy, and Law, into which the whole of science was divided by the scholastic tradition.

There was nothing novel in the use of these ideas as themes for decoration. The method in which they were generally represented was familiar to Raphael from his earliest days in the decoration of Federigo's library at Urbino. It consisted in a simple personification of the four faculties by figures which symbolised in their characters and attributes something present in the conception of each science. The task was, however, new to him, for unless the *Vision of the Knight* be reckoned he had only once, in the predella to the *Entombment*, attempted to clothe in flesh and blood any of the numerous personifications of his age. But examples were numerous. Maidens served in Florence from the earliest times to represent the sciences as they did the virtues and, in the simple personifications which he placed in the four lunettes at the centre of the ceiling, Raphael's conception differs very little in essentials from representations, in marble or in paint, which are too numerous to need specification. He made little attempt to characterise his four figures, or, in the true spirit of allegory, to suggest by their types of face, figure, and posture differences of nature corresponding to their attributes. The words written in scrolls upon the figures are required in order that they may be distinguished; for their differences of nature are scarcely expressed by divergences of type, and their poses and gestures are arbitrary, and do not in any way arise from the character of their general forms.

In other words, these figures, together with their attendant putti, are primarily decorative. Their first

71

object is to fill space pleasantly, and since in those days it was not enough to fill the space with a pleasant pattern, and figures were required, the figures are also decorative and pleasant in their form and bearing. If they do not succeed in conveying the allegorical idea which is stamped upon them by their attributes and inscriptions, they do not in any way contradict it, and they do, at least, so far correspond to the ideas for which they stand that they convey an impression of dignity, grace, and fair proportions, as befits the great branches of intellectual activity which they represent. So much Raphael might have learned from Perugino or any Florentine master of the fifteenth century. But in his choice of the human figures to embody these qualities he had moved from his masters, for, while in their spirit and in their general ineffectiveness of character, the four *Sciences* [101, 103, 106] recall the *Saints and Sibyls* of Perugino—the figure of *Jurisprudence* is especially Peruginesque in its weakness and incoherence of movement—the freedom in the perspective, their poses, the lighting and the modelling of their bodies and limbs, the simplicity of their drapery, all show traces of a newer, freer, and broader style. Of this style Michelangelo's *Sibyls* in the Sistine Chapel are the greatest example. Since Raphael had not, according to all accounts, yet seen that work, the character of these frescoes and the difference between them and all their predecessors prove that the relation between the two painters was that of a common spirit rather than of direct imitation. If there is direct imitation, it is to be found in the resemblance between these lunettes and the *Holy Family* which Michelangelo painted for Angelo Doni. There, the drapery of the Madonna is flowing and classic as in the *Jurisprudence*, the foreshortening of limbs and body is bold, and the children are sturdy and heavily modelled in broad planes of light and shade. The curly hair and free poses of the children in this medallion recall Michelangelo's types, and the infant to the right of *Jurisprudence* is like a freakish memory of a figure in the *Holy Family*. At the same time the difference of spirit is so complete that to notice these resemblances is to emphasise the least important detail.

A second way of communicating the conception of the four *Sciences* is that of illustration by means of incident. Raphael adopted this means in three of the four rectangular spaces upon the pendentives of the ceiling immediately below the medallions. In the fourth, no doubt because the subject *Philosophy* scarcely lent itself to anecdotal treatment, Raphael introduced a charming caprice which personifies one of its branches, namely, *Astronomy* [106], in a far less conventional and more truly allegorical manner than that of the figures in the medallions above. It is the very genius of discovery which kneels upon the globe and traces with delight the scheme of celestial wonder. The other three spaces contain: above the *Disputa* a representation of the *Tree of Knowledge*; above *Parnassus* the *Victory of Apollo over Marsyas*; above *Jurisprudence* the *Judgment of Solomon* [107, *108, 109*]. In drawing these scenes Raphael has no more attempted to exhaust the dramatic possibilities of the incidents than he had tried to enforce the characteristics of the ideal figures above them. Drama and characterisation would have been as out of place in the decorative scheme of the ceiling as they would be in the carving of a pulpit or the intarsias of a door. He has given nothing more than the general outline of the action, and has represented it with the dignity of form which is appropriate to the heroic story. His manner shows the same broad treatment of light and shade as in the lunettes above, still more boldness in the attitudes, and even more sculpturesque treatment of the human body.

It would be an attractive task to essay to trace the progress of Raphael's style through the different pictures of this ceiling. But while the greatest differences exist between the style of the rectangles and medallions and again of the wall paintings, there is no possibility of tracing in every feature certain and definite sequence. Some critics have placed the rectangles before the medallions, others the whole ceiling later than the *Disputa*. Every view must depend upon some particular details abstracted from the

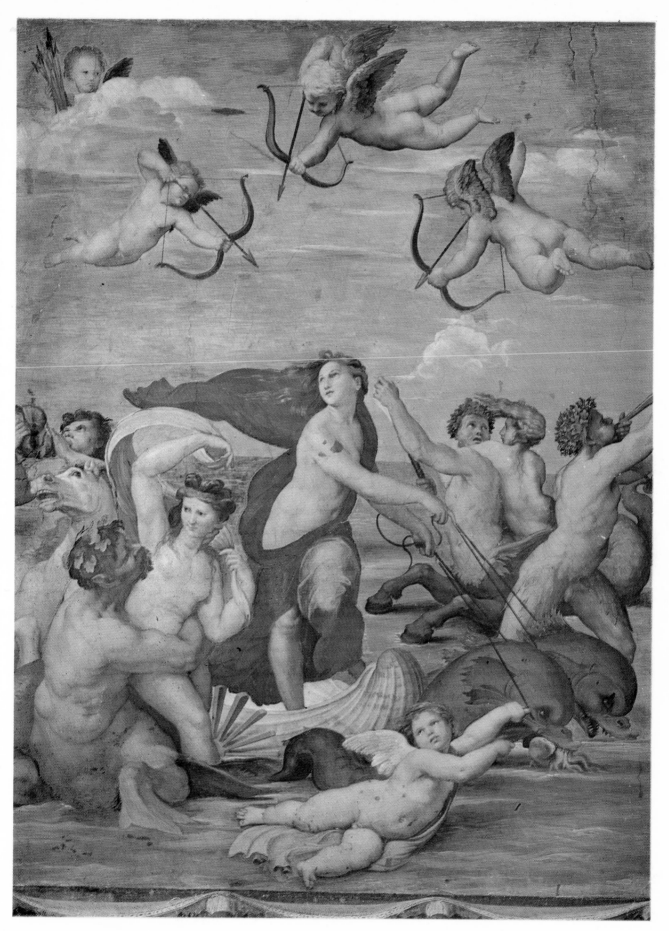

XI *Galatea*. Rome. 295 × 225.

whole. If, with this caution, a guess into the order of their composition may be allowed, it would appear more probable that the execution of each pendentive was closely connected with the wall pictures below them, and it may even have been the case that each was executed after and not before the picture below it. The elongated forms, structureless bodies, and uneasy poses of the *Apollo and Marsyas* are closely paralleled by the *Parnassus*, above which it is placed. The *Adam and Eve* is in strong contrast to the upper part of the *Disputa*, which is nearest of all portions of the fresco to the medallions, while it in its turn forms a transition between the lower part of that fresco and the *School of Athens*. The head and the pose of the kneeling *Astronomy*, which stands above the *School of Athens*, are counterparts of the kneeling youth above Bramante in that fresco; and, finally, the growing drama of the *Judgment of Solomon*, the amplitude of the women's draperies and the pose of the kneeling figure take the onlooker outside the Stanza della Segnatura into the bolder historical compositions of the succeeding room.

2

The ceiling of the room is, however, a mere incident in the decoration of the chamber. The chief embodiments of the intellectual theme and the principal decorative features of the room are the three great frescoes which cover the walls. These are not set, like the paintings above, in gold frames upon a gold background imitating mosaic in order to mark their decorative character, but are placed within a painted frame of columns and arches, and are thus given, at once, a space of their own which is entirely apart from that of the room. In the two earlier pictures, the *Parnassus* and the *Disputa*, the foreshortening of two of the foremost figures bridges the gulf between the imagined and the real space after the manner of earlier painters, and in the *Parnassus* the figures are even worked into the architectural framework of the window. But in the *School of Athens* this device is cast aside. Apart from this detail the whole essence of the composition of all three pictures, their deliberately curving lines bending round inwards at each end so that the figures form the greater part of a circle, is intended to increase the effect of space, while in the *School of Athens* the architectural background, and in the *Disputa* the architectural setting, introduce a widening of the horizon which belongs not to a decorative space but to a new and imaginary world.

Raphael was inexperienced in fresco painting. He may have learned much of the new feeling for spatial decoration by the date of his fresco in San Severo at Perugia, in which he foreshadowed the arrangement of the upper part of the *Disputa* upon these walls. But as that fresco was never completed it is impossible to imagine the effects of space which would have been produced by combining figures on a lower plane with those already painted. In the upper part of the *Disputa* [V, 110–112] the two curves, that of the frame and that of the row of figures, give a domed space in which interest is concentrated upon the figures of Christ and of the Father towering above. In the lower part, two circles of figures lead to the Host upon the altar which, both by the effect of the two rows of figures and by the incidents of the surrounding figures, combines closely with the Christ above, while counter rows of figures, winding off from the extreme ends and disappearing, on one side behind a solid structure, on the other in lessening perspective, produce immediately and without effort the notion of an extended space.

This is in the rough the outline of the pictorial scheme. Its content is a glorification of Theology expressed as a representation of the Trinity among attendant figures, saintly and human, who are actively or passively engaged in praise. The name *Disputa*, attached from early days, has no allusion to a

fancied debate concerning Transubstantiation among the human figures below; if it is applied to the picture with any right at all it is because the word had, in scholastic language, the meaning of a discussion without hostile argument. There is not in the picture a single suggestion of a disputation. There is no drama of debate or struggle nor concentration of opposing force; every figure in its own way catches up its part in the complicated orchestra of praise. Even the scenery in the distance and the accessories of the foreground continue the main idea, for on the left is the building of a church upon the rock, while on the right there are the foundations of the great cathedral which Julius at this time was building. As for the figures; the Patriarchs, Prophets, Apostles and Martyrs in the upper row are seated quietly as participants in the glory; on the lower level Bishops and Doctors of the Church are flanked by men of less importance whose animation gives contrast to their dignity, and whose enthusiasm enlivens and varies the picture, and forms a transition to the mortal sphere.

If any faith could be attached to the many drawings [cf. *113–120*] which bear relation to portions or single figures in this fresco, it might be possible to trace the steps by which Raphael reached his final design. Unfortunately, the few sketches which can make good their claim to have come from Raphael's hand are of little value for this purpose. The others, where they show the most interesting divergences, are probably the work of pupils and imitators who were consciously making variations from the finished picture. An examination of the fresco itself sufficiently illuminates the question of its place in Raphael's own development and in the history of art. The immediate resemblance between the upper portion of the picture and the San Severo fresco[67] gives at once a starting-point for comparison. No doubt the similarity of the subject demanded similarity of treatment, but the divergences are so much greater than the resemblances that the survivals gain an added importance. They are to be found entirely in the single figures. The Christ remains essentially the same, nothing but a greater animation in the legs and a greater softness in the treatment of the light marking either an advance or a decline. Comparison of the faces is rendered hazardous by the repainting of the San Severo figure, but, whatever may have once been shown in that head, the Christ in the *Disputa* shows there the same flaccid and empty sweetness which marks the remainder of his figure in both frescoes. Perugino and Fra Bartolommeo are here, as throughout, the leading influences, and it is worthy of note that in the only other figure of Christ in glory painted by Raphael after this date, that of the *Transfiguration*, the same characteristics are constant. The figures in the upper zone remain also fundamentally similar to those on the walls of San Severo, and the Virgin and St John, though absent from that fresco, are painted and, in the case of the Virgin, drawn[1] with the strongest reminiscence of Fra Bartolommeo's manner.

But, as soon as Raphael escapes from the circle of fixed hieratic forms, his style becomes freer and stronger. The seraphs at San Severo were stiff, overdraped, ornamental accessories, over-expressive in their fossilised attitudes, and over-decorative in the forced lines of their drapery and posture. The angels were bolder in conception and belonged completely to a more recent Florentine cycle. In the *Disputa* the angels have already become so perfectly mastered as a means of expression that they can be imagined in numberless different attitudes and with every degree of foreshortening or action but do not for a moment lose their air of naturalness. In the seraphs every vestige of timidity in the representation of the human figure has disappeared. The convention of flight has been completely assimilated, and the chief characteristic of body and drapery which is required in order that the illusion may be effected—a flowing motion in the drapery and a sense of movement without action in the limbs—has been carried further than by earlier artists, because the body is represented with greater roundness and breadth, and

[1] Milan, Ambrosiana [Fischel, VI, 291]. See for this and other drawings by Raphael in this gallery, Beltrami, *Nozze Gavazzi-Pirelli*, Milan, 1906.

the foreshortening and lighting are more easily handled than in earlier works. Nor is line sacrificed. It is only less obvious because it is not an isolated quality and because the figures serve to do more than merely fill up a couple of corners of the picture with an attractive pattern. They are so contrived as to complete in themselves the illusion of space.

Greater mobility, breadth and ease in the treatment of the human body, are shown in the figures of the Patriarchs, Prophets, Apostles and Martyrs. At San Severo, Raphael could with difficulty construct six seated figures with any variety in attitude, drapery, or lighting. Their immense robes hid their bodies and suggested no movement of the limbs; the lines of their arms and knees repeated each other, and nothing but a slight difference in altitude and stiff formal perspective brought them into their respective planes. Had they been placed farther apart, had the sky been allowed to appear between the outlines of each figure, each would have appeared, as in a picture by Perugino, equally prominent with his neighbour. In the *Disputa*, a freer grouping, a circular construction, the device of bringing the mass of the central figures in front of a part of the circle, and the disposition of the lines of the limbs and the colours of the dresses succeed immediately in establishing the space, while the varied attitudes of the personages themselves give life to the whole group. The intense labour required to secure this varied effect might be represented by a myriad of trial sketches, but, as it is, the figures seem to have sprung at once into their present position.

In their fundamental conception these figures are not different from those of the San Severo fresco; it is only their expression—which is the whole of painting—that is different. Raphael had nothing more to say about their characters, he had only a totally different power of representing them as human figures in action. Dignity and grandeur are still the main attributes of the chief Biblical personages, and the expression of these qualities must still be found in somewhat unmeaning and inconclusive gestures. It is different with the figures on the lower level: the Bishops towards the altar may still be fundamentally the same beings as the elderly fathers who watched in ecstasy the coronation of the Madonna in pictures of the fifteenth century, but they have been infused with a new blood from the observation of their successors at the Vatican. Realism was founded in the fifteenth century upon the painful reproduction of accidents observed in actual life; it was based with Raphael, as with Michelangelo and Leonardo, upon a thorough comprehension of the really vital features in the human figure; upon a mastery not of anatomical detail, but of the general structure and habits of the human form. The advance was not made in a day. Each real master of the earlier ages had seized some central characteristic of the human body, some note of lightness or of solidity, of strength or of elegance, which gives their work real value in the eyes of the discerning amid all the conventional and extravagant accidents which have now succeeded in attracting the vulgar. Successive steps had brought the artists of Italian schools to a level of achievement at which they could look upon and appreciate the mature works of classic art, themselves the outcome of a long and precisely similar evolution. It is thus not easy to decide in any picture of the Renaissance how much is the result of Italian tradition, how much the result of personal observation, and how much the effect of the daily discoveries of classic art. In the *Disputa* of Raphael, for the first time in his history, all the three tendencies appear to have converged.

It is clear that he owed to no one his ease of distribution upon the various planes. Concentration upon a central incident and variation of grouping had been the characteristic distinguishing him from Perugino in days as early as those in which he painted the *Coronation* and the *Sposalizio*. Nor could he have learnt from Perugino the art of representing figures in a consistent and unified space. Something may have been learnt from Pinturicchio, whose frescoes in the library at Siena are connected with Raphael by tradition. They show, with painful stiffness, a deliberate attempt to produce a spatial effect

by means of a circular arrangement of the figures. But the chief influence must have come from Florence and from the two great cartoons which have themselves disappeared, but have left traces upon every significant work of art which was produced after their exhibition. Another work of Leonardo's, upon a smaller scale, and in itself most obviously the greatest of a long series of similar compositions—the *Adoration of the Kings*, which is in its unfinished state at the Uffizi—has left definite marks on Raphael's style. Here, as in many earlier Florentine pictures, the long cavalcade of the King's retainers sweeps round unfinished buildings and diminishes into the distance. The figures of the youths to the left of the altar recall, with their vehement bending movements and their curved lines, certain figures in that picture. Perhaps the cartoon for this fresco showed a still more marked resemblance to Leonardo's style, as does that for the *School of Athens*, which still exists [*122*]. Michelangelo's influence is less clear, but it was perhaps through him that Raphael learnt to attempt the daring foreshortenings which recall the work of Signorelli, and to cast his figures in the large heroic mould which made its appearance, before Signorelli, in the prototype of all Renaissance art, the frescoes of the Brancacci chapel.

So great a gulf is placed by modern art criticism between the works of the high Renaissance and those of its darling Quattrocento that these resemblances with their evidence of direct continuity are scarcely estimated at their true valuation. Men point to them, in default of admiration, with some disparagement of Raphael's inventiveness, as though they had discovered in one who pretended to make an innovation clear signs of dependence upon those whose work he wished to supersede. It is necessary to discard completely this notion of a fresh beginning, a virgin-birth in art, in order to appreciate the pictures. Contemporaries, indeed, had no illusions. It was no doubt of this picture that the Pope was thinking when he spoke of Raphael's work as Peruginesque. In the upper part the connection is obvious, but in the lower it exists no less. The colour, with its predominant greens and blues and its equable light, is that of Umbrian art as shown, in the Vatican itself, in the Borgia apartments. So, too, is the scale of the crowded figures, some of whom even show in their poses and their forms direct resemblances with Peruginesque types. So, too, is the intellectual conception of the scene with its mass of attendant personages. To a contemporary they meant no less and no more than the attendant groups which filled the wall spaces of Florentine churches, gesticulating, posing, or standing with dignity around the Manger of Bethlehem or the performance of a miracle. Even the old habit of introducing contemporary portraits is maintained. So gradual was the advance in the representation of such figures, their movements and their groupings, that a change of style occurred almost without being perceived, and the qualities which now are most evident in the *Disputa* as proofs of a novel art may easily have been recognised and appreciated without seeming to have changed the character of the whole. The more retrograde qualities are most conspicuous in the *Disputa*, but they are not absent from any of the paintings in this room, save from those on the pendentives of the ceiling and those on the fourth wall.

3

In the *Parnassus* [VII, 129–133], which is generally considered to be the second in order of composition among these frescoes, the primitive features are only less evident than in the *Disputa* because there are fewer works with which it can be compared. But in reality they are infinitely more pronounced. In the matter of space and atmosphere, wherein lay the greatest advance of the *Disputa*, this picture is not only flat but actually unsuccessful in its obvious attempts to escape from flatness. This failure amounts to a virtue in modern eyes, for modern taste demands flatness from a fresco, and time and discoloration

which do no harm, and even improve a painting without relief, ruin completely, by distortion of the values, the whole effect of a picture with a space and atmosphere of its own. Moreover, this fresco has another obvious feature which hides its imperfections as a composition. It is cleverly adapted to the irregular space of the wall, and the critics and public can see at once that a difficulty has been overcome. In reality a plain space is harder to decorate than an irregular, because of the very fact that no pattern is suggested by it as inevitable. But success in an irregular space gives the spectator an immediate notion of fitness, and failure is equally immediately excused by the recognition of the difficulty; it may even be welcomed, because the spectator enjoys his own judgment in having discovered the cause of the trouble. But these considerations are foreign to true criticism of the picture. It is clear that the effect of flatness is the very contrary of Raphael's own intention, and that he took infinite pains to produce the same illusion of space in this fresco as in its neighbours; but the fact that most of the figures are in one group, and that discoloration has reduced the whole to a greenish tone, have hidden the realisation of a result which at best was imperfectly attained.*

As in the *Disputa*, gradually diminishing figures encircle a central group. The whole is set within a frame which is outside the picture, with again a second frame, beyond which two of the foremost figures protrude into the room. The receding circles of figures start from these two and wind upwards until they disappear behind Apollo and his immediate group. But the effort to represent a hummock as a hill is vain; the eyes waver in comprehending the reduction in the size of the figures, which is too slight for a mountain, too sudden for a mound. Moreover, the effect of space is still further lessened—in fact, is positively destroyed—by the mistake in the tone of one dress. The laurel-crowned poet (Sannazaro) to the right of the averted muse should be definitely standing at a lower level than she. The line between his dress and hers is sharp, as it should be, but a mistake in the lighting which places him in shadow produces a wrong effect of values, and his dress looks as if it were cutting off a part of hers from the vision instead of being hidden itself. To some extent the same mistake occurs at the opposite corner in the figure of Dante, but there Homer's outstretched hand places the distant figure in its true place.

These faults are not alone. A general spirit of light-hearted gaiety runs through the whole picture and gives it a unity of feeling such as the Quattrocento could attain, and in its general arrangement of lines the composition, as were theirs, is not inharmonious. But the grouping is lumpy and forced. Each group of figures stands alone, with but a mechanical connection with its neighbours. Raphael's power of concentration is for the moment wanting. Even the three central figures, pendants as it were to Christ, the Virgin and St John in the *Disputa*, are separate from the rest. The two large figures in the foreground, fine though they are in themselves, are scarcely more than ornamental 'supporters'; the small boy with crossed legs, recalling figures in the *Scuola*, is awkwardly placed, and the muse standing with bared shoulder is in no sort of relation with her sister at her feet. With these faults of composition there occur a mechanical rigidity of attitude, a tendency to draw in full face or profile, a want of foreshortening, and a repetition in four places of the motive of bared shoulders. The youth on the extreme right stands preciously, with out-turned foot, like figures in pictures of the Perugian period, and his attitude is more appropriate to the angel of the Annunciation than to an auditor of a poet. Numerous hardnesses in the outlines of the faces and in the features, a general want of strength in the limbs, incoherence and conflict in the minor lines of intersecting limbs and drapery, the prevalence of a greenish colour, are all features which recall the weaknesses of the *Entombment*. There is even in the face of the

* The Stanze frescoes were cleaned after the last war.

muse to the right of Apollo a distinct resemblance with that of the bearer in that picture, and as these features occur with greater appropriateness in one of the male figures of the *Disputa*, it would seem that there is some reason for placing the *Parnassus* intermediate in date between these two, and so making it the earliest of the frescoes in this room. The figures grow in strength from the top to the bottom; but even the lowest, with their protrusion into the room, an effect modified in the *Disputa* and never again repeated, suggest, for all their Michelangelesque grandeur and classic solidity, a less practised hand. Argument, however, from general inferiority of style is exceedingly unsafe, and it would be foreign to the purpose of this book to attempt to establish this hypothesis as a fact. So, too, for the present it can only be suggested that in the character of the female faces, in the general composition of the groups, and in the sleek and snaky bonelessness of the female limbs and the emasculate Apollo, Raphael shows the influence of Sodoma, who is generally represented by tradition as having been associated with him in the decoration of the chamber, and that he in his turn was affected in his later work by the influence of this fresco.

4

In the *School of Athens* on the third wall [VI, 121, 123–4, *122, 125–8*] every trace of immaturity has disappeared, and the characteristics of the earlier style are caught up and transformed in the qualities of the new. The figures are so grouped that they occupy the wall and fill the space of the imaginary court in which they stand without suggesting that there is the least cunning in their arrangement, that they are not merely placed at hazard where their occupations have taken them. The groups fall naturally together, and partly by the symmetry of their arrangement, partly by the unity of their action, they succeed in drawing the eye onward from one to another without a gap or an error to create the impression of a false move. Each figure is large, characteristic, and simple; each attitude is self-contained, independent, and necessary; and yet there is no figure which does not serve to lead to the next and through him to the two central figures. These are themselves almost rigidly simple, and owe their emphasis entirely to the architecture of buildings and of men in which they are framed.

The fresco represents Philosophy, depicted not as an allegory, but by a collection of imaginary figures who are the great philosophers of Greece. Critics have analysed the picture to discover hidden intellectual and symbolic meanings in each figure, in each group, in the whole arrangement. Such criticism has naturally proved its own doom, for it soon found better employment in deciphering the artificial symbols of primitive hieratic art, which were painfully pieced together, and can be as easily resolved into their constituent factors. Raphael's figures are not like these, but are the representation of a world of living and breathing men, who show their characters in the complex forms in which nature clothes qualities of mind, and who are more real than those of the world around because they are more perfect. If he placed portraits in the group—Bramante as Archimedes, the young Duke of Urbino as the boy standing, to the left of the picture, between the seated writer (Pythagoras) and the standing disputant with a book (called Xenocrates)—he did so because their characters and their features resembled in his eyes those of the prototypes whom he imagined. As the figures suggested themselves, the group, expressing by its dignity, animation and intentness, and by its very breadth and depth and concentration, the ideal character of the activity which it represents, fell into a natural symmetry and significance, and the whole scene found its setting in the vast architecture which proclaims as much as any of the figures the emotions which at the moment were deep in Raphael's heart.

This vividness of conception gives the picture its living force. The critic in his detachment can piece

out coldly the different elements which were fused into the whole conception, and can point, for one reason or another, to single, isolated incidents of interest. He can note that in the original cartoon for the fresco, which is still happily preserved at Milan [122, 128], the large figure of Diogenes writing upon a slab was absent from even the penultimate form of the picture, and that throughout the cartoon a likeness to Leonardo's drawings is manifest. But in doing so he fails to take into account the heat of inspiration which told Raphael that just such a figure was required in order to complete the decorative scheme which expressed his ideas, or the exact unanalysed condition of mind which prompted him to use something of Leonardo's forms as appropriate to his idea. The critic can note that the stooping figure of a boy below the column writing upon his knees is a reminiscence of the boy writing in the *Parnassus*, and can mark the increased skill which brings this figure into a harmony with its surroundings such as the other failed to achieve. Were they not so intent upon tracing Raphael's indebtedness to other men the critics might have also pointed out two signs in this picture of the continuity which is ever present throughout his miraculous progress. The architectural setting of the whole fresco, in spite of its immense and classic vaulting, and its two niches with their towering statues of pagan deities, derives directly from the modest early-renaissance octagonal temple which served as a background for the groups of figures in the *Sposalizio*. Similarly the effect of light, which is the keynote of the whole fresco—the radiance from the sky, which enters from behind the shaded architecture, and gives prominence to the central figures—has its primitive counterpart in the circle of sunlight which illuminates, from behind the temple, the head of the high priest in the predella of the *Presentation*. But whether they be proofs of outside influence or of continuity the mere establishment of the facts scarcely does more than touch the fringe of a true account of the picture. The main element is the meaning, the emotion, the creative force which enlarged and changed each detail, from wherever seized, and wove it into the web of the general conception. Earlier pictures of his own, pictures by other men may have been consciously present to Raphael's mind when he evolved this creation, but they were scarcely as influential in determining its form as the lighting and character of this fresco itself would appear to have been influential in inspiring Velasquez with his picture of the *Spinners*.

In this picture, perhaps for the first time, Raphael shows that no problems of technique puzzled and preoccupied his mind, and prevented him from giving free expression to his imagination. He could use technical devices to suit his ends, keeping his mind intent upon his central purpose, just as he had learnt to use his knowledge of the human figure when he executed the *Disputa*. The dominating influence which at once enlarged his power of expression and gave colour to his thoughts is his new passion for the freedom of antique minds. It was learnt, perhaps, partly from the association with scholars, poets, and philosophers, but it was revealed to him more intuitively and directly through its expression in antique art. In the *Parnassus* his idea of antiquity is still that of the fifteenth century, a world of studied and curious grace, such as, in the main, it had appeared to Piero di Cosimo and Botticelli. Residence in Rome, contact with a larger life of men who acted and were concerned in great affairs, the mighty activities of the centre of the human universe enlarged his whole nature and gave an ennobled sweep to his brush. Other men found expression in great undertakings, Michelangelo in the studies for Julius' great tomb; Bramante in the designs for the new temple of all Christendom; Leonardo in vast designs for penetrating the secrets of the universe and conquering the elements of water, air and fire. Raphael himself was to be caught up in the whirlwind of this vast activity and to throw his energy into the scheme of restoring the magnificence of ancient Rome. But for the present he gave his work in another direction, and through his forms, lights, groups, and spaces gave expression to the sense of the grandeur

of humanity as it was in his day, and as he saw it, written even more large, in the history of an ideal antiquity.

Figures, groups, and architecture alike breathe this spirit of antique grandeur. But there is another characteristic, smaller perhaps, but no less vital to the true understanding of Raphael's art. In all three paintings in the Stanza della Segnatura, but chiefly in the *School of Athens*, the subsidiary figures fall into groups of listeners and admirers who hang upon the words of a master and are intent upon some common thought. The unity which these groups attain singly and together is the whole secret of these pictures. It is not, as all seem to think, a merely formal and decorative matter arising from cunning arrangement of line and mass and space, at best a kind of meaningless music attached to the figures from outside. It has its origin, rather, in one of the most characteristic features of Raphael's nature. Raphael had throughout his life the strongest sense of comradeship or discipleship; finding himself always among bands of enthusiastic friends until in the end he was the leader and not the loyal follower. It was not his nature to live in solitude as a single gloomy figure, like Michelangelo, brooding over his own and the world's wrongs, crucifying himself with troubles and disappointments, but to live in unity with others, enjoying what they found good, strengthened by their association, and living and learning with them. The intensity with which a scene embodying these ideas would appeal to his whole nature raised merely formal qualities to a higher and more genuine level. The group, as a group, appealed to him as the single figure appealed to Michelangelo; he saw and felt instinctively the motions of each of its constituent members, and threw them, by the force and vigour of his sympathy, into the attitude and position in which they would most effectively play their parts. The sense of symmetry and harmony in the figures is only the articulate expression of the real unity of the group, just as the outward appearance of the figures themselves is not a merely external creation of abstract beauty, but an indication of their nature, and the wide space and embracing architecture visible symbols of the dignity and breadth of their whole life.

5

In the decoration of the fourth wall of the Stanza della Segnatura Raphael departed from the scheme which he had utilised in the other three. The wall space before him was pierced irregularly by a large window which was not in the centre. A precisely similar wall in the next room was used for a single composition, but in this case he did not attempt to compose one large scene which would occupy the whole wall. Nor did he, as would an artist of the age immediately preceding, satisfy himself by cutting up the space into three contiguous fields and filling each of them by a separate picture. Instead of this he carried still further the elaborate architectural scheme, which he had already used to frame the frescoes on the other three walls, and made it the basis of the decoration of the fourth. He divided the wall above the window transversely by means of a heavy painted cornice and set two painted niches one on each side of the windows, using each in such a way that it might seem a portion of the architecture, and that it and the figures, for which it served as a background, might appear in perspective and so mask the diversity in the size of the walls on which they were painted. Above, in the lunette between the cornice and the painted arch of the ceiling, he placed a single row of life-sized figures which he painted as though they stood solid against a background of real sky.

In this decorative scheme, Raphael was acting on precisely the same principles as was Michelangelo in the adjacent Sistine Chapel. Michelangelo had to convert an unimposing roof of a chapel into a vast vault; Raphael an irregular and meanly proportioned chamber into a worthy meeting-place for the

Papal Court. Both succeeded by the use of imaginary architectural ornament and structure, and by decoration with semi-statuesque forms and inset pictures. The conception of a large and dignified space which underlies both decorations is identical, and, making due allowance for the purpose of the rooms and the position of the decoration to the spectator, both aim at producing much the same effect by the character of their figures. If the current stories as to the secrecy with which Michelangelo worked in the chapel have any truth, Raphael can have owed nothing to his example; indeed, the absence of anything like direct imitation has caused the general truth of the story to be universally accepted. But the resemblance is too striking to be allowed to pass unnoticed, and it is a proof that both men in their decorative ideas were merely carrying forward a development in the course of painted decoration which followed necessarily as soon as painting began to represent depth as well as height and breadth. It belongs to exactly the same logical progress of ideas as the conception, most often connected with the name of Leonardo, of a single and imaginary space for each architectural field of decoration, and like this idea it did not spring upon Italy as something totally new. The idea is already present in the roof of this very chamber, for it follows precisely the model of ceilings by Pinturicchio. But, in the case of this wall, a new impetus and example may have been given by the discoveries of Roman wall decorations where imaginary architecture and figures set against a painted sky are features of one of the most popular forms. Classical works had been present throughout the history of the Italian Renaissance, but it was only when the native artistic development had reached a certain stage that the whole spirit of the models could be caught and reproduced.

The subjects chosen for decorative treatment are as much akin to, but no more scrupulous in their uniformity with, those of the other walls than is the treatment itself. The semi-historical, semi-allegorical imagination of the other groups is here split into its two components, and while the figures of the lunette are purely allegorical, the subjects of the side pictures are taken from history. They represent the foundation of Civil and Canon Law, that on the left showing *Justinian presenting the Pandects to Trebonianus* [136], the other, *Gregory* IX *delivering the Decretals* [137]. These are the first purely historical compositions which Raphael painted, and it is due to the nature of the subject that the frescoes are comparable with later work rather than with earlier, there being nothing either in the colour, which is richer and hotter than that of any other painting of this room, or in the strong simple portraiture to mark their date among all the pictures which Raphael painted until the end of his life. The quiet and dignified postures of all the actors and the clear outline and sharpness of feature in some of the heads, the delicate gradations of tone, and the success in lighting and relief all show to what extent Raphael had made himself master of the chief characteristics of Florentine fresco style. Others of the heads in the fresco of Gregory, notably those on the right, carry the beholder forward into the days of the Tapestry cartoons. The portrait of Julius II, with a beard, as Gregory, dates the picture with certainty after June 1511, when, in pursuance of a vow, he returned to Rome from Bologna with a beard, and thus the fresco becomes of capital importance as the first dated document of Raphael's art in portraiture. This does not in any way exhaust the value of the fresco as a work of art. It does not receive its due consideration as a supreme example of simple and dignified heroisation of a historic theme without exaggeration, fantasy, or emphasis. The other picture has suffered so greatly that it can receive less notice, but, apart from the excessive skill of its utilisation of space, it is remarkable for the suavity of its line and the combination of its figures. Possibly the decay of the colour is alone responsible for the awkwardness of the seated Justinian, but this same cause has emphasised a curious and characteristic resemblance between the standing figure on his left hand and the unfinished Madonna in the Esterhazy picture. This resemblance, which appears to have been overlooked, not only suggests a

date for the latter picture, but shows the pre-occupation with exquisiteness of posture and flow of line which was present in Raphael's mind when such historical groups were composed.

The interest of the subject causes the lunette to overshadow the lower frescoes. In it Raphael returned to the spirit of personification which had produced the figures in the medallions of the ceiling, and he showed *Moderation*, *Prudence*, and *Strength* as maidens [135], the one with her traditional attributes, the reins and bit, the second with two faces, the third in armour, with an oak branch, and all surrounded by the meaningless *putti*, who were introduced as a matter of course into all decorative works. The comparison of the subject renders the advance in freedom of conception and execution so noticeable, and Raphael here attains so completely all that he was merely struggling for in the medallions of the ceiling, that it becomes remarkable that he did not tear it all down in order to begin afresh. If he had, not only would the medallions of the ceiling have fallen, but also the greater part of the *Parnassus*, for these figures recall many of the incidents and gestures of figures in that fresco. The legs of *Prudence* are disposed like those of the Muse to the left of Apollo; her left arm, and to some extent her head, suggest those of the Muse on the right. *Moderation* is a free version of the Sappho, and *Strength* might be studied from a model in much the same position as the old man at the right foot of the *Parnassus*. But in no case are the figures mere repetitions; they are free, amplified versions, stronger and more significant in pose, bolder and more effective in their perspective, and simpler in the disposition of their draperies.

The freedom from all pre-occupations of complicated grouping and composition in space allowed Raphael to direct his energies solely to the execution of the three figures and to their harmonious arrangement in mass and line. The result is one of the most complete examples in all his work of his sense of rhythm and motion in the human figure, and his appreciation of the subtle beauties which the most complex of all living structures is capable of assuming. There are faults in detail but they are scarcely worth recording; figures and drapery alike are treated with ease and naturalness and surety of selection, and the whole group is large and dignified with the very spirit of the goddesses whom it represents. This is the true essence of allegory and personification and not the choice of attributes and the gesture of the central figure, which are merely taken over from traditional art and rendered insignificant by the greater importance of the general treatment.

6

Of the subject pictures which were completed during the period in which this chamber was being painted, there is nothing but internal evidence to tell the date. The *Esterhazy Madonna* with its sudden outburst of careful decorative elegance and subtle, somewhat unmeaning, arrangement of body and limbs has already been mentioned. Another painting of the Madonna with the two children seems to belong both in conception and execution to the period in which Raphael was passing from the so-called Florentine to the Roman stage. It is the much damaged *Madonna of the House of Alba* from the Hermitage [now in Washington] [138, *139–142*]. The flowing classical dress of the Madonna, with its loose folds upon the breast, is closely related to those of the figures in the lunette of *Justice*, and is totally distinct from the tightly-painted garments of such pictures as the *Cardellino* and the *Belle Jardinière*. These features are anticipated in the female figures of the *Entombment*, more especially in that on the extreme right. Here as there the influence under which the picture was painted may well be Michelangelo's, and a model for the painting of the classical dress may be found in the *Pietà* of the

Vatican. Something of Michelangelo also exists in the sprawling posture which is infinitely weaker and more prominent than in the allegorical figures, and there is even a recollection of his manner in the features of the face. These are not unlike those of *Moderation* in the fresco, where they approximate more closely to the dark, large-eyed type which became Raphael's favourite and his most characteristic creation during the Roman days. In this early period, however, as the frescoes in the Camera della Segnatura show, Raphael was casting about in many directions for varied and beautiful forms of the head. Space is too limited and vocabulary too restricted for a thorough consideration of his progress in this detail.

There are other pictures of the Madonna which may, from the evidence of their style, date from this or the immediately succeeding period. The Madonna in the National Gallery which is called the *Garvagh* or *Aldobrandini Madonna* [143] is painted in a hard and somewhat unluminous manner which is paralleled by that of the *Vision of Ezekiel*, and these pictures are therefore assigned in their execution away from Raphael by the majority of modern critics, who would credit his pupils with the invention of every feature which they find anomalous in Raphael and unpleasing to themselves. As a matter of fact, this technical detail is not far removed from Raphael's early manner as shown in the small *Cowper Madonna*, and it is not difficult to imagine that features in the work of so important a predecessor as Lorenzo di Credi seemed either to his patrons or to himself worthy of reproduction or imitation. Nor is it plausible, in general, to assume that his pupils introduced features which were not present at least in germ in the works of the master. But apart from the hard colouring, this little picture deserves infinitely more admiration than it now receives. It possesses all the concentration of grouping, tenderness of feeling, and unconscious significance of pose which mark the *Belle Jardinière* or the *Cardellino*, and it has the same simplicity and absence of forced or superhuman effect that belonged to those early essays in the portrayal of the human Mother and Child. But with these qualities it joins the studied appreciation of beauty in form and gesture, and the harmony of line and attitude which belonged to the *Esterhazy Madonna*. In the combination neither element loses in the least of its particular value. Less magnificent than the *Sistine* and less poignant and concentrated than the *Madonna della Sedia*, this picture is the most successful of Raphael's efforts to represent the Virgin with the lightness and animation which he had shown in the Florentine group. In its elements the infant St John carries the picture back to the *Belle Jardinière*, while the Infant Christ recalls the infant figure in the *Madonna Alba*; but the head-dress of the Madonna suggests that of the *Sedia* and her face is that sublimation of unassertive beauty which belongs to the late Roman type of the *Sistine Madonna* and the *Galatea*. It is almost exactly reproduced in the altar-piece of the Prado called the *Madonna del Pesce*. With these contrary indications it is not possible to assert a date with any certainty, but the evidence of the facial type is the strongest, and therefore the picture should more properly be placed at a later period than that of the Segnatura Stanza. The fact that the conception of the group stands halfway between the humble Madonnas of the early days and the grandiose groups of the later is no proof at all that the execution dates from the middle of Raphael's career, for, in the absence of external corroboration, any theory of consistent development in Raphael's style is purely imaginary.

There is, however, definite evidence for placing at this stage of his career the first of his important portraits, that of *Julius II* whose picture, existing in three rival versions in the Uffizi [97], the Pitti, and the National Gallery, is clearly synchronous with the cartoon of *Gregory* in the Camera della Segnatura. Raphael's earlier portraits are either too conjectural in their attribution or too much damaged in their condition to be seriously considered in their place among his works. Two for which Vasari is testimony, those of Angelo and Maddalena Doni [II, 94, 95], were discovered early in the nineteenth century, but

in so ruined a state that no judgment can be passed upon the present restorations.[1] The portrait of the lady has become in fact so much a creation of the restorer, that it represents a woman of many more years than Maddalena can have possessed when Raphael was in Florence.[2] The portrait of an old man in the Hermitage[*] and the so-called *Donna Gravida* of the Pitti [96], have suffered equally, while they and the many other portraits attributed to Raphael at this time are his merely by conjecture. It is unfortunate that this should be the case, because nothing could have been more interesting than to compare Raphael's advance in the treatment of the real living face with his progress in giving life and expression to, and in constructing the features and build of, the imaginary face of the Virgin. But by the time that the last frescoes of the Segnatura were painted Raphael had already evolved so great a mastery in the representation of the actual face and so unhesitating a certainty in the selection of features characteristic of his sitter that his simple and direct methods can scarcely be called a style. The *Portrait of Julius II* has the same qualities. There is nothing to seize upon but the character of the Pope himself: analysis of the picture is a history of the sitter. There is no jugglery of paint, no startling achievement of likeness or texture by means obviously displayed and miraculously successful, such as attracts in modern works, no beauty of tone in atmosphere and surface such as enchants in Velasquez' *Philip*, no great harmony of colour as in Venetian portraits or in some of Raphael's own, and lastly no special trick of attractive expression such as belongs to Venetian or Florentine portraiture, and appears at last to be drawn over the face like a well-fitting glove. There is not even the keen and arresting glance of the fixed eye which occurs in almost all Raphael's portraits, and forms the one consistent link between the many early pictures which go by his name. There seems to be nothing in the picture but the Pope himself; for all the processes of selection which went to build up both the reading of the character in the face and the pose of the body in the chair have reached so perfectly their result that there is no sign left of the processes themselves. The old Latin tag that *Ars est celare artem* is out of fashion, but no stronger proof of Raphael's greatness can be found than that in these days when portraiture is the most living branch of painting, his portraits are ranked among the highest, just as in other days some or other of his other works, early or late, have always placed him among the greatest. The same qualities which exist in the portraits are shown in his frescoes, his cartoons and in his easel pictures, and perhaps the appreciation of these will follow naturally upon the love of his portraits.

Of the three versions of the portrait which are best known that in the Uffizi appears to be the authentic or the earliest picture. Harder in outline and in surface and less fluid in colour than that of the Pitti, it is more in keeping with his style at this date. There are differences in detail as well as in technique between the pictures, and a difference in preservation which may be more telling than either. There is a strong indication in the method by which the richer and more transparent colour of the Pitti portrait is reached, namely that in certain places, as in the eyebrows, it is washed over pencilling in greenish paint, that it is a rapid and successful copy of the more thorough painting in the Uffizi. Whether the replicas are by Raphael's hands or not is a question which has never been settled, and those who are unconvinced by the self-satisfied efforts of the higher critics to apportion the various works assigned to Raphael among his various assistants, and to credit them with portions of his authentic works, are justified in pointing to these three portraits as proofs of the impossibility of arriving at certain conclusions. In any case the nearness with which they here approach to all the

[1] Gruyer, *Raphaël, peintre de portraits*, I, 103.
[2] Davidssohn, *Repertorium*, XIII, p. 21.
[*] Gronau-Rosenberg, Plate 208.

excellences of the master is alone enough to demolish any credit in theories which assign all that the critics dislike to assistants and leave the merits to the master.[1]

<div align="center">7</div>

In the Stanza of the Segnatura Raphael had given proof of his power to fashion and combine human figures in dignified allegorical groups. This was one branch of the painter's art as understood by the Italians. There was with them, as with the Greeks, their masters, another branch. From the first, painters had attempted to depict scenes and incidents, tragic in their character, violent in their action, and painful in their effect. The less capable the painter had been to represent the human body in its structure and action the more inclined was he to exaggerate the posture of his characters, and to emphasise the expression of their faces. In this way they produced the tragic effect. Others, more intent upon the study of the human figure in its many attitudes, used scenes of anguish or violence for the sake of the difficult problems of movement or foreshortening which could only be presented in this way. The latest of the great pictures of violent action and the most famous of all time was by the greatest master of the figure in repose. Leonardo's cartoon of the Battle of Anghiari had marked a date in Italian art. Raphael appears to have known it well, and during his years in Florence he studied the drawing and the composition of its several groups, and appears to have himself put sketches of similar character on paper with an eye perhaps to future use. But no work of his own save the *Entombment* showed any result of this study before he came to Rome. Opportunity no doubt was wanting, but with his arrival in Rome he came upon the example and the fame of Michelangelo which were alone enough to compel his patrons to demand the like from him, and he met, besides, with works of the classic age in which themes of this type were displayed.

But when he was faced with the problem how to decorate with scenes of action the walls of the second Stanza, Raphael had already achieved a style of his own. The wall spaces were precisely similar to those in the room just finished, and in the first of his compositions, the *Legend of Heliodorus* [IX, 147, 148, 152, 149-151, 153], Raphael naturally conceived a scheme of decoration upon the model of the *School of Athens* which occupied the same space in the other room. As the rooms were nearly square the focus of interest would naturally be found in the centre of each wall, and Raphael had learned that the eye could best be led towards such a focus by diminishing groups leading in a semicircle inwards, and by a vast architectural setting with its centre of line and light above the principal figure. This scheme is adapted with slight changes to the *Legend of Heliodorus*. The Pope, whose prayers led to the destruction of the infidel and who embodied in himself the glory of the Papacy which Raphael was intent to celebrate in the fresco, occupies the position which Plato and Aristotle, the summit of Greek intellectual activity, had occupied in the *School of Athens*. The groups in the foreground are subsidiary to him in the decorative sense, and their action on one side issues from him, and, on the other, in part (through the figures upon the column) leads up to his.

From this point, however, divergences occur. In the frescoes in the first room the scene is of general and typical action; the unity is consequently distributed throughout the picture and depends upon the simplicity of the single spirit penetrating every figure. Here on the contrary the scheme is based upon a

[1] I have not seen the replica of the portrait of Inghirami which has gone recently from Volterra to a private collection in America [239]. To judge from the reproductions its superiority to the example in the Pitti [C.I. 113; D. I. 34; PV. 113] is doubtful.

<div align="center">85</div>

definite incident in which a single moment is a climax and a crisis. Yet it is not upon the figure of the Pope who occupies the central position that interest centres. His action may be supposed to be of some duration and the essence of his whole attitude is external quiet and internal tension. Interest passes him by in spite of the centralness of his position and naturally fastens upon the group in the right-hand foreground. There a huge horseman accompanied by a flying angel has struck down the intruder, while his attendants fly shrieking with the booty which he had ordered them to collect.

Recognising that this was the real centre of the picture Raphael made an effort to carry the eye directly towards it from the groups on the other side of the picture. The women point frantically towards the catastrophe forgetful, all but one, of the presence of the Pope. This is the sole touch of promise in the picture as a composition, for it foretells a recovery of Raphael's powers of concentration. But in this picture whatever might have been gained by this incident is destroyed by a third motive, imposed no doubt from without, but whatever its origin, entirely annihilating the picture as a scene. In the very foreground of the left-hand corner corresponding to the position of Heliodorus himself on the right, Raphael has introduced a third centre of interest in the portrait group of Julius II and his bearers.

The result is a medley, unintelligible without full consciousness of the historical conditions of the picture. Raphael had achieved unity in his pictures in the other room, but he had not yet learnt to invent the proper form in which to display an incident. The imagination of the picture is still half submerged in the convention of the fifteenth century; its three main incidents are as separate and scattered as the incidents in a picture by Botticelli or Filippino Lippi. This could cause no offence to contemporaries, who saw even less than he did the inconsistencies in which his own advances had placed him. They could admire whole-heartedly the portraits of Julius, the figure of the Pope, the vigorous drawing and foreshortening of the rider, the angel and Heliodorus, and, quite separately from this, the grandeur of the architecture, the perspective of the columns and the cunning of the mixture of lights, and they would never appreciate the failure to combine these qualities into a consistent whole.

There were still other qualities in the picture which required a contemporary mind for their appreciation. It is an old hypothesis that in this fresco, for the first time in Raphael's career, the work of assistants can be traced in several portions.[1] Re-painting—the picture is in a sad condition—may be responsible for much, but the heaviness of the modelling, the violence of the contrasts of light and shadow, and certain of the facial types show such differences from other portions of the same picture and the frescoes in this and the preceding room, that it is natural to imagine a difference in the hand that executed them. But since this is not a work left unfinished by the master and carried out without his direction by his pupils, the hypothesis of different hands only shelves and does not dispose of the real difficulty. Undoubtedly pupils may and must have worked upon the fresco with the master, for the labour of fresco-painting necessarily involves the assistance of many journeymen, but it is impossible to suppose that they worked upon some parts only and those among the principal, and it is uncritical to find their handwork in the bad and to reserve to Raphael all the good. Since he was responsible for his whole picture are we to suppose that Raphael did not notice inequalities of work which are so patent to modern eyes? If he was less sensitive than we are to these faults in his pupils, he would have been less sensible to them in his own work, far less so, indeed, if he was constituted as other men. He would have been far more likely to excuse imperfect work from himself than from pupils whose work was to pass under his name. Nor is it probable, as has been said with regard to other pictures, that any exagger-

[1] Bellori (1695) already found it necessary to combat this opinion (*Descrizione*, ed., 1751, p. 75).

ations would have been made by pupils which were not already present in the Master's work, and such as occur in this fresco are so much less marked than in the pictures of the succeeding room, so little more evident than they are in the *Entombment*, and, as regards the method of painting the face, in the *Parnassus* that their occurrence here is by no means incompatible with Raphael's authorship.

Another explanation must therefore be sought for. It appears at once when the pictures are looked at in their proper historical perspective, and the artificial gulf is removed from between the Quattrocento and the Renaissance. Contemporary eyes were accustomed to over-expression, hard outlines, and imperfect modelling in pictures where dramatic scenes were depicted. They were for the painters of the Quattrocento the natural means of emphasising the suggestions of terror and fear, and men would find no cause of offence in their employment in pictures by Raphael in which, like the general want of unity, they are due to the imperfection of the means as yet attained to achieve the result desired, and it is only the more advanced scheme of the whole that renders the failure of the parts a visible imperfection.

In certain respects, moreover, this fresco marks the beginning of a new art and shows Raphael in the character of a 'primitive' and tentative innovator. Its ruddy colour, vivid and diversified in the groups to the left, is toned to fit into a general scheme of warmth which is dramatically apposite to the luridity of the tragedy depicted. But, besides the colour, the actual lighting of the picture is brought into connection with the general intention and made to play its part in the emotional scheme. There is no longer the broad open light of the frescoes in the Segnatura which was reminiscent of the sunny simplicity in the *Sposalizio*, but the architecture breaks up the sunlight into heavy spaces of light and shade, artificial light is made to appear in the recesses, and shadows give solidity and force to the more active figures on the right. No doubt the effect is but suggested in the fresco and as yet unrealised; but, obviously placed there by intention, it marks a stage beyond that of the Segnatura Chamber towards a conception of art in which, pure, flat, decorative line having been abandoned, lighting and composition in space are the pictorial factors in producing emotional effect.

The contrast between the *Expulsion of Heliodorus* and the *Mass of Bolsena* [VIII, 155, 154], the fresco upon the next wall of this room, is so marked that it is possible to imagine a deliberate renunciation by Raphael of the dramatic form of art which he had just essayed. He has chosen—or was given to illustrate—a legend of the Church which told of a doubting priest and his conversion by the miraculous appearance of blood upon the Host; and the moment which he has selected for his illustration is the very instant of the miracle. The priest is in the act of raising the Host, which even the spectator can see to be marked with a cross in blood. The spirit of the *Heliodorus* fresco or of the cartoons which were shortly to follow would have marked the miracle by the abject recoil of the priest before the Host and by the excited consternation of all the bystanders. In the fresco there is no trace of this. The priest is quietly turning over the leaves of the missal with his right hand as he elevates the Host with the left; his face is reverent but impassive, neither that of the doubter nor of the doubter confuted. Nor are the other figures of the fresco more dramatically treated. The Pope is undisturbed in his prayers; the choir-boys and acolytes are attending to their ceremonial duties with the light-hearted unconcern which is characteristic of their kind; two idlers are watching the ceremony and the attendant priests and bearers are taking part with quiet dignity in the proceedings, while in the foreground women are playing with their children, as they do to this day when not immediately taking part in the service. Only a group to the left, representing the populace, shows signs of eagerness and animation, but their animation is not more marked than that of some of the groups in the *Disputa*, and is so much more significant of appeal and adoration than of surprise or consternation that it might well be taken to

represent nothing more sensational than the eagerness of a congregation at the moment of the supreme miracle of their faith.

Indeed the character of the picture suggests that Raphael had in his mind far less the legend of Bolsena with its incident of the confutation of an unbeliever, than the representation of the glory of the Church by means of its most central ceremony. The fresco therefore becomes separated from the others in this room, and is much more nearly allied to those of the Camera della Segnatura in its treatment. The simplicity of the grouping and the complete ease of the poses, the sobriety and fine portraiture of the heads, bring it into close connection with the two historical frescoes which were placed on the last wall of that room. It, too, is a combination of the graver Florentine tradition of fresco-painting with no little of the Florentine feeling for touches of almost naturalistic observation. But the chief features of the fresco are in its rich and harmonious colouring, the fluid ease of the painting and the dignified form and concentration of its composition. It is a small point that the irregular position of the window in the wall is cleverly masked by the utilisation of its upper line in the top step of the altar, a problem which was shirked in the decoration of the corresponding wall in the preceding room. But it is of the essence of the picture that the lines are strong and restful, the planes simple, the groups and the architecture conceived in their true relations, and the figures brought into full prominence and into close contact. It is important, too, that with the new colour-scheme a greater use is made of effects of light and shade. These are simple and dignified, fitting the manner of the *School of Athens*, and there is no attempt, as in the *Heliodorus* picture, to produce a powerful emotional effect by means of strong and mysterious shadows. A hint of Raphael's growing love for curious problems of light is given by the introduction of the torches carried by the acolytes. At the same time, though the dramatic is studiously avoided, the group of the populace shows with what ease violent action could now be represented, and, further, the whole treatment of the composition, if on a less magnificent scale than that of the pictures in the earlier room, bears witness to an increasing power in Raphael of conceiving a single incident. The *Heliodorus* had drama, but failed in concentration. In this fresco there is all the concentration of the other frescoes devoted to a more restricted group. Only drama is wanting.

The chief effort in the decoration of this room was probably reserved for the third picture, the *Repulse of Attila* [156, 157–159]. In it not only was the divine favour of the Church to be represented by the overthrow of a barbarian, as in the *Heliodorus*, and a single pictorial incident to be dramatically treated, but a whole scene was to have been shown of a mighty army descending upon Rome through regions which it had devastated, and brought to a sudden standstill by the appearance of a mightier force. It was a subject which older painters might have treated in their dry way, suggesting the number of the invaders by a multitude of evenly painted figures, and placing somewhere in the centre or at the sides the central incident of Attila's overthrow. But Leonardo in his cartoon at Florence had shown that a battle could be treated in another way. Raphael seems to have determined to surpass him in his attempt to depict the scene with all the grandeur of figure, and breadth of space and atmosphere which a more critical taste demanded in order that emotion might be aroused. To attain this end the formal treatment which had failed in the *Heliodorus* was discarded. Attila was brought into the centre and well into the front. A few figures in the foreground advanced diagonally towards him, setting him into his proper position in the space. To the right the massed troops were placed in apparent confusion. They disappeared into the distance behind the hills with the same effect of space as was used in the *Disputa*. To the left a few scattered figures broke up the line of Attila's advance, again suggesting confusion and carrying the eye partly to him and partly to the two figures of the flying apostles who were, with Attila, the centre of the picture. In the middle distance, set in a calm landscape and below a clear

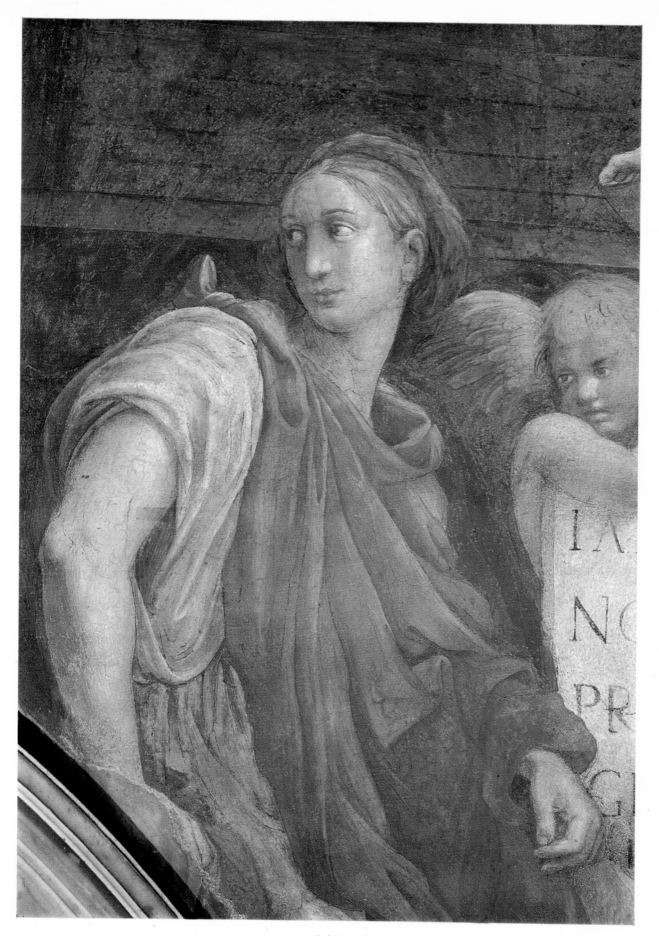

XII *Sibyl*. Rome.

sky, the Pope knelt with his following in prayer, a counterfoil in his own character and that of his surroundings to the barbarian hordes, the mountains, the tempest and the fires upon the other side.

This is the conception of the picture. Unfortunately it is only embodied now in the copy of a drawing by Raphael preserved in the Louvre [158]. In the picture itself two evil influences have found their way to render the original conception all but invisible. Time, or the imperfect methods of fresco, have dulled the colour and destroyed the aerial perspective, until, in the general flatness of greens and greys and yellows, nothing meets the eye but the heavy figures of horsemen in the foreground and the unbalanced weight of the attendant figures. The army of Attila has all but disappeared, the effect of the crowd is lost, the fire and the tempest are merged in one general confusion. Even more harm is wrought by the intrusion of the Pope into the foreground. No doubt Leo, who ascended the pontifical throne while this picture was being painted, was justified in demanding the same prominence in this fresco as had been accorded to Julius in the *Heliodorus*; but his intrusion was even more fatal in its consequences. Julius was content with claiming a large space for himself as a spectator of the scene; he left the figure of the older Pope in its original position. Leo insisted not only upon personating his namesake but also on the mutilation of the whole design, in order that he might have the chief place in the person of his predecessor. Dignified and well painted as are his figure and those of his retinue, they annihilate, with the overweighted solidity of their own persons and of their horses, the whole balance of the composition, and by repeating the motive they render otiose and supererogatory the two flying Apostles who were originally the keystone of the whole structure and of whose existence they seem themselves to be entirely unaware.

The attempt to represent a dramatic incident upon a great scale failed. Upon the last wall with its more limited space Raphael now depicted an incident with fewer figures but with more concentrated drama. He was helped by his subject and possibly by the example of the paintings already on the wall. The desire to make an allusion to the release of Leo III from captivity by the French is supposed to have caused him to substitute the *Release of St Peter* [X, 160, *161*, *162*] for a *Vision of St John the Evangelist*, which he may have originally planned for this position. A resemblance between the central group and the *Vision of Constantine*, by Piero della Francesca, at Arezzo, has been thought to indicate that this painter—who is said by Vasari to have painted in this room—had already decorated the walls with a similar subject and influenced Raphael first in his *Vision*, and finally in the *Release*. It is more certain that the figures on the right side are suggested by Filippino's painting of the same subject in the Brancacci chapel at Florence, while figures from many paintings of the Resurrection supplied prototypes for the sleeping guards.

Its central idea, the depiction of three scenes from the same incident, is arranged in accordance with the new precepts of decoration formulated by Leonardo in his notebooks. Italian taste until the very end of the fifteenth century accepted, without question, the custom of dividing walls into several spaces, either horizontal or perpendicular, and filling them with totally disconnected scenes. As long as these scenes were merely flat decorative representations the division caused no offence. But when it was discovered that a flat space could be so treated as to have an atmosphere of its own, a separate space and a distinct illusion, the contradiction and the unrest caused by placing several such distinct spaces in close juxtaposition became apparent. The maxim that one undivided wall-space should contain one scene became axiomatic. But the discovery was not immediately followed by a recognition that each scene should be historically and logically a unit. The requirements of the narrative historical style could not have been satisfied by such purity. Hence, by a compromise, the only unity demanded was the visual

89

unity which required that, whatever contradictions of time and place the mind might discover in the picture, the eye should remain content that the scene before it was homogeneous and possible.

Raphael had followed this axiom both in the *Expulsion of Heliodorus* and in the *Repulse of Attila*, as originally sketched. But in these pictures it was possible for all the incidents to coexist at the one moment. In the *Release of Peter* this was not possible. The waking and astonished soldiers to the left might be looking upon the miracle of the centre, but the escape of the Apostle over their recumbent bodies could not be synchronous with either of the other scenes. It remained possible to combine the incidents in such a way that their continuity should not come upon the spectator as a shock, and, aided partly by the irregular configuration of the wall-space, Raphael so contrived the lighting of the various groups and the architectural setting of the scene that the spectator naturally accepts the pictures as a series when his attention is called to it, and as naturally as a single incident when he is merely observing the disposition of the figures.

Dealing with a smaller quantity of figures, Raphael, in this picture, succeeded in attaining a success of which he had fallen short in the other paintings in the hall. Mere decorative composition is cast aside, or, rather, is so hidden that the figures while performing their own actions seem to fall naturally into the required positions upon the walls. The few figures are carefully chosen for the expressiveness of their attitudes, and the skill and selection in their postures is no less complete and far less emphasised than in any of the pictures in the Stanza della Segnatura. The figures are enlarged until they fill the whole decorative space—a lesson gradually learnt in the course of the decoration of this room, and one of the principal features, which marks the abandonment of Perugino's traditions for Michelangelo's— and the drama of their action is closely bound up with their composition. But besides these marks of progress the picture shows others, and of greater importance. Just as the *Attila* was a strenuous attempt to realise the whole outward appearance of the scene portrayed, this is an effort, almost realistic in its character, to reproduce the whole visual accompaniment of the actual scene. It was not enough for Raphael to suggest the darkness of the night by a black sky or a circular disc representing the moon, as though he had written 'This is Night' in large characters upon the wall. He required to give the whole effect of night upon the figures, the mystery of the obscurity, the uncertainty of the artificial light and the wonder of the supernatural radiance. Close study, after the manner of Leonardo, in a field which had attracted his attention since the early days when he surrounded St Michael with the flames of a Gothic Hell, enabled him to portray the night with its changing effects, to follow the light of moon and torches upon armour, and that of a blaze, as of a fire, upon dungeon walls and bars. With these he decked the old subject, adding to the eternal wonder of the incidents which he depicted the actual emotional thrill which a realisation of all its circumstances would necessarily convey.

Nor is the picture in any way a mere work of naturalistic tendency. As such it is, even more than the *Heliodorus*, the beginning of a new art which led through the 'Neri' of later Italy to Honthorst and to Rembrandt. But it is also the culmination of an earlier period during the whole of which men had striven inch by inch to represent the actions of heroes with fitting simplicity, and with the grandeur which imagination demands in the figures of its creation. There are feeblenesses, no doubt, in the fresco, but, upon the whole, each figure stands out as a man fit to be taken as a model of his race for dignity, solidity, and force. Nothing but the most thorough knowledge of the human form could attain this end, a knowledge which rendered the imagination of the figure and the gesture easy, and mastered the actual model until both it stood itself in the attitude which was needed, and the painter could take from it exactly what he required, leaving the rest untouched. Earlier men had glimmerings of the truth, but, faced with the actual, their eyes faltered, and they were bound, through incapacity to

seize what they required, to reproduce anything or everything which struck them in what they saw. In such frescoes as this Raphael is enabled to discard all the petty reproductions of natural actions, the yawnings and the stretchings, which earlier art had needed in order to express their intention, because he had so seized the general character of his action that he could convince of its whole truth without dwelling upon and underlining its accidental features.

With the increase in power of selection there came a growth in the grandeur and nobility of the imagination. It is already a step to have disregarded the reproduction of irrelevant and merely realistic or amusing detail, and to have reached a stage at which reality of effect is produced, not by the insertion of mere detail, but by the general knowledge and accuracy of the delineation of the human figure and its position among its surroundings. But it is a more important achievement to have replaced the prettiness, choiceness, and piquancy of early efforts by a magnified conception of the human race. The earlier performances at Florence, where they were not distinct steps towards the achievement of Raphael, were playful and light-hearted representations. Compared with Raphael's Peter and the Angel, those of Filippino in the Brancacci chapel are exquisite vignettes. Elsewhere in Italy the seed sown by the more serious artists of Florence fell on more favourable soil, and Padua, with Mantegna, arrived at a conception of human dignity which Raphael could not surpass. Here, besides the Florentine, the influence of classical antiquity was powerful, and at Rome again the Greek world revealed itself. To Paduan dignity a classical fullness and solidity were added, and, having both of these, Raphael brought the work further by his appreciation of the pure painter's qualities in nature—light, colour, atmosphere and space.

8

Grandeur and vigour in the human form are still more notably the whole intention of the four panels on the ceiling of this room which represent four scenes from the Old Testament [146]. In three of them the key-note is the grandiose flying figure of God the Father which recalls the figures of the *Creation* in Michelangelo's roof of the Sistine. So great, in fact, is the debt owed to that example, extending even to the reproduction of one of the faults of that ceiling—the coincidence in the same decorative position of figures of different scale—that the four decorations may almost be summed up by the comparison. Clearly Raphael was swept off his feet by the revelation of Michelangelo's conceptions, and found for the moment no forms in which he could express his own ideas but those which had been perfected by his contemporary. But, even so, there is no startling gulf between Raphael's work here and that which had preceded it. The growing weight and majesty of his figures had marked the Stanza of the Segnatura, and even the decorative realism in the scheme of the ceiling, the effort to fit the paintings to their architectural position by representing them as tapestries stretched on nails across the roof, is paralleled by the cunning realism of the fourth wall of the Segnatura.[1]

For the *Isaiah* [163] upon a pillar of Sant' Agostino which appears to belong to this same moment of Michelangelesque obsession, and is cited by Vasari as a proof that Raphael surreptitiously entered the Sistine Chapel, there is no insignificant a forerunner in the Diogenes of the *School of Athens*. Almost as much as the *Isaiah*, this figure shows the closest resemblance both in its general bearing and in detail of

[1] The allegorical scenes and ornaments in the ribbing between the tapestries are traditionally ascribed to Baldassare Peruzzi. To him also Dr Dollmayr attributes the four principal panels ('Raffaels Werkstätte', *Jahrbuch der Kunstsammlungen des allerhöchsten Kaiserhauses in Wien*, XVI, 1895, p. 244). I regret that the scope of this work does not allow me to refer fully to this the most considerable effort of modern criticism concerning the later work of Raphael and his school.

its action to the *Jeremiah* of Michelangelo, and yet, in its own place upon the wall, it shows no discrepancy with the other figures. There is nothing dramatic or sudden in this acceptance of Michelangelo's forms, nor is there any attempt to hide the resemblance. Where the subject called for treatment in the manner of Michelangelo, Raphael naturally followed his example. Had any man pointed in adverse criticism to the resemblance, his answer, which applies to the generality of modern art historians, would have been in the words of Brahms to the man who charged him with using a theme of Beethoven's—'Any fool can see that'.

But when the subject came to Raphael in a light other than Michelangelo's, he could show that he had not only experienced an influence, but had also thoroughly mastered a style. In the *Sibyls* of Sta Maria della Pace [XII, 164], which may be placed at about this date (it is noticeable that the flying seraphs are closely akin to the angel holding back the hand of Abraham), the influence of Michelangelo shows itself merely as a similar form of language used to express quite other thoughts. These figures of women, familiar now to Raphael through the ceiling of the Segnatura and the lunette of *Justice*, were to him, as to his predecessors, musical instruments through which every idea could be conveyed. They had no definite individuality like the *Prophets* with whom they were combined, but, abstractions of the Virtues, personifications of the Arts, they were creatures of no real existence, vague ideals of form and action. To earlier Florentines they were creations of curious elegance and subtle charm, to Perugino more solid and more sweet, to Michelangelo emblems of strength and thought. Raphael combines something of each stage, in no way defining their personality more closely, or approaching nearer to a realisation of their character as sibyls, but leaving them as inarticulate imaginations with dignity and grace and force of attitude, and vague large movements of inspiration.

These figures are a natural development from those in the fresco of *Justice*. Here, too, the freedom from any dramatic or narrative requirements enables the figures to produce an unimpeded effect of emotion, while the almost complete absence of spatial character has caused injury and restoration to detract little from the immediate impression. Consequently this fresco remains for us, as for Vasari, one of the greatest monuments of Raphael's power, and the best of his secular pictures to act as an introduction to some of the dominant tendencies of his genius. The figures show in its clearest form the real value of his decorative gift and of his power to use decorative line as an expression of emotional meaning. The fresco is not a whirl of bewildered and contrary movement, but an ordered advance, sweeping the eye along from point to point, and, while delighting it with simplicity in the complexity, with large curves and balanced spaces, calling up in the mind suggestions of grandeur and of freedom, of superhuman force and ease. Into this scheme the figures fit with such completeness that it and they are clearly part of the one mental conception. Form and content together spring from one emotional idea. Not only are the figures themselves charged with all the qualities which the painter has chosen for personification, but they move naturally into their places in the pictorial field with no more suggestion of attitudinising or self-consciousness than has the most simple of his Florentine Madonnas. Heads, limbs, and bodies follow in one movement; whatever the figures are doing, they do entirely. Consequently their actions are embodied thoughts, and as they fit into the general united action of the whole group their movements and their rhythm suggest some ritual dance in which people of strong emotions express, without consciousness and without analysis, the thoughts and the mood of some great moment. Older art had produced the same effect with its selection of pose and attitude which seldom corresponded to any historical aspect of the scene portrayed, but it required the knowledge and the freedom of Michelangelo and Raphael to typify and represent by means of the human figure the largeness and the grandeur of a superhuman world. If these qualities are seized and understood in the

more or less abstract form presented by the statuesque and isolated figures of the *Sibyls*, it will be found that they are the secret key which leads to the understanding of such larger scenes as those of the *Disputa* or the *School of Athens*.

<div align="center">9</div>

Of the *Galatea* fresco in the Farnesina, which dates from about this time, and shows how Raphael could throw himself from the grandiose and Michelangelesque to the purest expression of his own exquisite sense of grace and charm, more will be said. Similarly, to avoid repetition, the portraits and pictures of the Madonna dating from this time must be considered later. The rough framework of the history of Raphael's development can only be completed by proceeding to the decorations in the room on the far side of the Stanza della Segnatura from the chamber of Heliodorus [170] which were begun shortly after the frescoes of that room. Unfortunately, these frescoes have suffered even more from the effects of time and restoration than those of the other rooms, and, as they owed probably more to the hands of Raphael's assistants, they are now in so hopeless a condition* that they scarcely deserve more analysis than is habitually given to them. Such admiration as they now receive is given solely to the fresco upon the wall opposite the window, on which is painted the legend of a miraculous cessation of a fire at Rome in answer to the prayers of Pope Leo IV [169, *171–174*]. The figures of the refugees from the flames, the suppliants to the Pope, and men eagerly employed in staying the conflagration occupy the whole of the foreground, while the Pope himself with a few scattered figures is placed in the distance, as he was in the *Repulse of Attila* until Leo demanded greater prominence for himself. The picture is the immediate sequel of that fresco and the *School of Athens*, as an effort to reproduce at once the whole outward character of an historical scene with studied heroisation of the figures. The pet theme of flames and artificial light, the contrast of daylight and shadow, and the careful gradation of perspective and stature in order to give the illusion of a real space, recur in this picture. So too the imperfections of the method occur, for while the groups are singly no less dramatic, the tendency begun in the *Liberation of Peter*, to concentrate the interest entirely in the figures of the foreground, is not continued, and therefore in the attempt to comprehend the whole scene something of unity is lost. No doubt this is partly due to the effect of the whole picture being intentionally one of discord and not of harmony, but it is also due to the greater emphasis which is thrown upon each single figure, and to a want of combination in a single direction. There is an air of improvisation and of hasty construction in the whole fresco; figures are interesting in themselves and clearly have part in the general action, but they are added to each other and do not spring naturally as from a single and vivid conception. The woman with hand outstretched above her two children is a clear illustration of this carelessness and want of unity. The group might have served for a representation of the Expulsion from Paradise, and no doubt had done so. Consequently, the picture fails to produce a single impression, and the attention of the beholder wanders from group to group as though he were before a picture of an earlier age. The figures of the foreground are in strong contrast to the small figures in the back, which move easily and gracefully and are painted with flowing and transparent colour. They are over-heavy and immobile, their limbs are stiff and their poses too statuesque. Probably in this the hands of pupils are to be observed, imperfectly reproducing the conception of the master's mind, but through the imperfections the conception remains apparent, and shows Raphael to be now definitely embodying his notion of the human body in the forms of classical antiquity and Michelangelo. In isolated incidents, in the water-

* See note on p. 77.

carrier, for instance, or the man upon the steps, the woman pointing out the Pope to her child, and, above all, in the group of the man carrying his father, even the restoration and the execution of an assistant have not destroyed the vigorous and dignified conception of humanity at its noblest. A circumstance attending the invention of the last-named group serves better than much analysis to illustrate the ideas which underlie this picture. It has for generations been identified with Virgil's description of Aeneas carrying Anchises and leading Ascanius from Troy. Thereby the classic allusion of its form has been made manifest. But it has not been noted that it is also a picture of an incident in the history of Raphael's own family, when his grandfather, Peruzzolo, brought his father, old Sante, and his young son Giovanni from the ravaged village of Colbordolo. Thus a suggestion from actual life became identified with classic story, and the group shows with what reality for Raphael the forms of an ideal past fitted with the ideas of the present.

This room contains another scene of violent action. The *Battle of Ostia* [175, *176*, *177*], originally perhaps painted in some such fluid and oily medium as men were then attempting to use in the place of old methods, has now become a medley of indistinguishable restorations, until even the limbs of the warriors are indefinite and structureless. The other two frescoes are scarcely more visible. They are also historical scenes chosen with allusion to the reigning Pope, and no doubt at the time their interest was largely that of portrait groups. Now they are of interest purely from a historical point of view, for they show better than any other pictures of the time the effort to present such groups of figures with attention to realistic effect. They should be compared with the dry unatmospheric rendering of a similar subject which Pinturicchio had, but five years or so before, painted on the walls of the Library at Siena. The comparison will show both how it was that Raphael could accept such subjects as a possible form of art and, also, what efforts he made to give the subject interest by reproducing the whole external character of the living scene, giving it light and movement, space and colour, and the new-found classic dignity of the human form. One detail in the *Coronation of Charlemagne* [178, *179*] is especially notable. The rows of almost uniform figures which occur in that fresco would be quite unintelligible as a feature in a work of art if it were not for the example of Roman bas-reliefs in which they are of regular occurrence. It is natural enough to find Raphael using incidents from classical remains in such pictures of antique life as the *Battle of Ostia*, or the great fresco of the *Battle of Constantine against Maxentius* in the last of the Stanze, but this use of a Roman convention in a reproduction of a quiet and ceremonial scene shows how completely he was at the moment under the spell of classical art.

10

Excessive fidelity to classical models in these frescoes is but such a mark of momentary inability to assimilate completely an admired example as Raphael had shown before in his imitations of Perugino, Fra Bartolommeo or Michelangelo. In the cartoons for the tapestries of the *History of the Apostles* which Raphael executed for the Sistine Chapel at the same time as he decorated the Sala del Borgo, classical reminiscences occur, but they are caught up and assimilated in the general style as completely as any of the other threads which criticism, with a free command of space, can trace in these works. These tapestries show the successful attainment of all that Raphael had been striving after in the heroic and historic decorations of the Vatican chamber. Unfortunately, bad as is the preservation of those frescoes, that of the cartoons for the tapestries, the form in which they are best known to England, is still worse. To begin with, the cartoons show the decorations reversed, and since the whole effect of the composi-

tion is based, after Raphael's manner, upon the position of the picture in the room, they fail, especially in reproduction, to give the same impression as do the tapestries, or as would the original drawings which would be enlarged for the cartoons by means of reversed proofs.* An example of the damage which is done by reversal occurs in the *Sacrifice at Lystra*, where the outstretched arm of the slayer is monstrous and overwhelming in the cartoon, whereas in the tapestry its line is no longer diagonal and it occupies a natural position. This fault might be removed from the cartoons had they been placed in precisely the reverse of their original position, but their haphazard arrangement at South Kensington [1909] causes the spectator to approach them from a wrong angle, and therefore distorts all the curves and angles in which the whole compositions are thought out. Even greater difficulties in appreciating the designs occur through the ruined condition of the cartoons. Found in pieces and finally placed together in the reign of William III, they have evidently lost the greater part of their original colouring, while the method in which they were painted makes it impossible to distinguish with any certainty the old from the new. One indication should alone suffice to show how completely the original colour has been disturbed. As it stands at present, the robe of Christ in the *Miracle of the Fishes* [182, 183] is white with brown shadows. Yet its reflection in the water below is pink. Obviously it was originally of a reddish colour as it is in the tapestry at the Vatican. Or again, the orange-red colour of Barnabas's dress in the *Sacrifice at Lystra* [187, 188], fine as it is in itself and perhaps restored, is far removed from the dark claret colour of the Vatican example. These inconsistencies could be noted *ad infinitum*. But since there is one piece among all the cartoons which seems to have remained undisturbed, the extreme right-hand strip of the *Sacrifice at Lystra*, it is enough to look upon it to see the difference between the harmonies of the original delicately painted surface with its suggestion of a transparent variegated marble and the staring violence of the other portions. Almost immediately adjoining it there is a hand of brilliant red which differs totally in every respect from the subdued and toned flesh-colour of the head and other limbs. The colour of this strip is more delicate than, but is still comparable to, that of the cartoons by Giulio Romano which once hung above the staircase called 'Escalier Denon' in the Louvre and are almost as unknown as is the wanderer from their number which has somehow reached St Petersburg [Leningrad], and hangs uncatalogued and unremarked in the gallery of copies at the Academy.

A glance at this strip of the *Sacrifice at Lystra* shows, in addition, that the cartoons in their present state cannot possibly be either assigned in their execution to a single pupil of Raphael's, or divided with any certainty among different assistants. Certainly Raphael cannot be imagined for an instant to have painted them with his own hand. Vasari who makes this assertion cannot have seen the cartoons if those at South Kensington are the originals. But probably every boy and man, apprentice and assistant in his large studio had his part in the colouring of these large drawings, and to argue back from them or the tapestries to some hypothetical original drawings which were not by Raphael is to attempt an impossible task. There are resemblances in hundreds between details of these pictures and the frescoes of the Borgo and Heliodorus rooms, the *Spasimo* and other pictures by Raphael, and such cartoons as those just mentioned in the Louvre and in Russia. But they prove nothing, or too much, and the attempt to assign the work to other hands is only made because its value is not appreciated. It is far better to discern the virtues of the designs through the half-obliterated forms of the cartoons, and having done so to forget, as men always forget where they admire, the faults which are only apparent because the whole intention is misunderstood. If the cartoons themselves, even seen through the medium of the 'sacred strip' of the *Sacrifice at Lystra*, fail to make themselves intelligible, it would be well to study such

* Cf. A. P. Oppé, 'Right and left in Raphael's Cartoons', *Journal of the Warburg and Courtauld Institutes*, VII, 1944, pp. 85ff.

specimens of the tapestry as those which are shown to advantage at Berlin or Dresden, or even engravings drawn from the tapestry by men who understood and could emphasise their virtues.

It has been shown that throughout the frescoes of the two later rooms of the Vatican Raphael was attempting to combine at once the rendering of a dramatic incident with a concentrated composition. The attempt failed largely because he sought at the same time to reproduce the effects of a wide space which he had succeeded in fashioning in the frescoes of the Stanza della Segnatura, where the problems of decoration were the same, but where there was no incident to illustrate. The result was that the drama became dissipated, and the composition, however clever in itself, failed to correspond with its context. Only in the *Liberation of Peter* had he, so far, been successful, and, there, the exigences of a treble subject had caused his scene to be unreal. In the tapestries the condition of the material helped him. It was not subtle enough to allow of any but a very bold and rough treatment of space, and therefore he brought all his figures into the foreground, making them the dominant and immediate objects of interest. This is demanded by their heroic emphasis of form, and it should have been made necessary in the preceding frescoes. Nor was the material sufficiently pliable to allow any subtlety of modelling, colour, or characterisation. Consequently the colour and modelling became broad and the expression of the faces strongly marked, and these elements also became appropriate to the heroic conception of his figures. Finally, the exigences of his spaces caused him to vary the centres of his composition, bringing it to the extreme right in the *Charge to Peter* [184] and the *Sacrifice at Lystra* [187], to the right in the *Miracle of the Fishes* [182], and leaving it in the middle in *Ananias* [186] and the *Beautiful Gate* [185]. This no doubt helped him in the concentration of the effect, but it did not cause it, any more than the requirement to place many similar tapestries in one chapel necessarily produced the variety of invention which resulted in the attainment of so many different effects of grouping and space within similar limits and in similar subjects.

But to look at these tapestries merely as compositions is to fail entirely in the perception of their true character. It is of the essence of their perfection as compositions that the composition, as such, does not show. Unity of design is nothing more than the display of an incident (if it be an incident that is displayed) in such a way that its principal characteristics are given their proper prominence and the whole appears without confusion, omission, or redundancy, as if it had appeared to a merely casual eye. The subject should be so adapted to its frame that its adaptation becomes imperceptible. Only by watching Raphael's steps towards the achievement of the tapestries can we appreciate the labour and selection which were required before this end was attained; possibly none but a painter can appreciate it fully, because he alone is capable of comparing the result with the chaotic mass which nature presents. Here the achievement is of absolute simplicity, which shows itself alike in the selection of the groups, and in the massive dignity of the human form. Throughout the series scarcely a figure is placed in a meaningless but decorative or pleasing attitude, such as the earlier painters used in order to mask their failure to discover or to reproduce the appropriate action. There is an instance of this in the legs of St Paul in the *Sacrifice at Lystra* sufficient in itself to point the moral. Every figure is significant, and even such manner as there is in the deliberately classical posture and proportions of the characters has the virtue of all true classic work in its essential truth and dignity.

This search after the significant and the dignified in human action is not merely an adoption of Greco-Roman characteristics, as those who have not been able to comprehend its virtues so commonly assume. It is, on the contrary, the culmination of the main tendency of Italian art which persisted throughout all the excesses and mannerisms of every period. It might be called the centripetal as opposed to the centrifugal tendency which lay in extravagant display and mere decoration, and may be

found in Raphael as well as in the earlier men. Reminiscences of Masaccio, the great precursor of the Renaissance, abound in the heroic standing figures of St Paul, whose outstretched arms are carved in marble, yet never lose their sense of bone and muscle. But earlier than Masaccio, Giotto had laid the foundation of the true classic style. There are in the tapestries not a few resemblances, if not reminiscences, of him. Instead of being simply placed upon the wall to remind the spectator of their existence, buildings are cunningly fashioned in perspective so that their spatial character appears; but this is a minor point, and the intention of placing great scenes among great architecture is Giotto's as well as Raphael's. In one of the tapestries, even, that which contains the *Miracle of the Fishes*, Raphael cares no more than Giotto for the plausible setting of the figures, for the boats are as absurdly undersized as they might have been in any primitive decoration. The greater mastery of the human figure is only a furtherance in Giotto's own direction, the broad simple lines of the figure and of the patterns are invented in Giotto's own manner, even the hard outlines and rigid features of the faces are common to Raphael and to the earliest master. There is a world of learning and achievement between the two, and Raphael's success is less attractive to the erudite critic because it is so much more complete that it requires no cleverness to discover it; but in the ground-principles of the art the two men are the same, and the contrast between Raphael and the so-called pre-Raphaelites is not between these two great figures, but between Raphael and the lesser men who came between. Had the pre-Raphaelites gone back to Giotto, they would at the same time have arrived at a true estimate of Raphael.

The execution of the tapestries was not without its effect upon the decoration of the fourth room of the Stanze [189, 190] for which Raphael was preparing at the time of his death, although it is probable that no part of the actual fresco was begun during his lifetime.[1] It is the largest of the rooms and the only one which offered a great opportunity to the decorator. In its scheme Raphael advanced still further in the direction of imitative decoration, which, in common with Michelangelo, he had essayed in the fourth wall of the Stanza della Segnatura and in the ceiling of the Stanza d'Eliodoro. Unwilling now to utilise a whole wall as a frame for a picture with an atmosphere of its own, he placed large statuesque figures of the *Virtues* on each wall, and between them he had planned to place great painted tapestries. Within this field the picture was painted, and thus both the effect of the picture and the illusion of real architectural decoration were maintained. Of the four pictures only one has any claim to derive from Raphael's mind. It is the huge *Battle of Constantine against Maxentius* [191], an enlarged version of the *Attila* in the next room, and like it also, probably, in being akin to Leonardo's picture of the *Battle of Anghiari*. The failure of the picture to attract the taste of this day suggests that Leonardo is happy in the destruction of a masterpiece which men would no longer accept. For though the touch of the pupils' hands has led to exaggeration in the drawing, and some failure of the colour, or the unhappy desire to reproduce an effect of tapestry, has made the whole picture a rusty brown confusion; the immensity of the visual imagination, the vigour of the action and the variety of the forms, the whole conception of turmoil and violence cause the picture to deserve much more of the admiration which formerly it received than the discredit into which it has now fallen. Men now require in the representation of these scenes either naïve suggestions of their features without reproduction of any of their general visual character such as mark the battle pictures of Uccello or Piero della Francesca, or rapid realisations of the superficial impression such as is given by Goya. The clear-cut representation of the scene through the forms of the actors which was the aim of Leonardo or Raphael and his pupils has consequently lost its meaning.

[1] See Crowe and Cavalcaselle, II, 450; Springer, II, 184.

The epic form of decoration which marks the tapestries and the Stanze of the Vatican did not exhaust Raphael's amazing fertility. At the same time as he was painting or composing these frescoes he was evolving another and an apparently quite different manner of decoration. This manner is as light and graceful as the other is grave and stupendous, but they both have their common basis in the tendency to decorate with forms suitable for architecture, and while one is a logical development from the austere and vigorous art of the earlier period, the other is equally a product of the gayer and lighter side of the Quattrocento. In both, moreover, there is the common feature that the purely decorative is reserved for the ornamental adjuncts while the representation is rigidly significant, and both differ from earlier work in the logic which forbade the two atmospheres, the grave and the gay, to co-exist side by side in one picture. Raphael's art, unlike that of his predecessors, was so sure of its appeal in either key of emotion, that it did not need to combine one with the other in order to produce an effect of reality.

The best-known example of the lighter form of decoration is that of the second storey of the Interior Loggia of the Vatican, which owes its architecture as well as its ornament to Raphael and his pupils [192, 193]. Pillars, walls, to some extent the vaults of the roof are covered with ornamental figures, festoons, medallions, details of architecture, and a general but orderly medley of dainty and attractive details, some painted and some in plaster, which not only amuse in themselves but give a bright pattern of lines and colour. This is the style which is properly called grotesque, because it is based upon a Roman form of decoration which is known to us now from excavated houses at Pompeii, but was then only to be found in the chambers of old Roman houses which were still under the level of the earth, and therefore were known as caves or grottoes. In the vault of each arch Raphael's pupils painted four scenes from the Old and the New Testament. These small pictures are but details in the general decorative scheme, but partly because they embody no little of the virtues of the tapestries, seizing, as they do, with almost too much simplicity the main elements of the incident which they illustrate, and partly because they are unique in giving within a small compass representations of the whole sacred narrative, they attained, before photography ousted engraving as a medium of reproduction, the widest fame as Raphael's Bible [194]. Badly preserved as they are, they deserve more detailed study than space affords for their consideration, and the varieties of treatment which they present would—and no doubt will—justify the existence of a whole library devoted to discussions of their authorship. But in relation to Raphael they are of no more importance than the countless engravings, sacred and profane, which were executed from his studies.

A better, because more concentrated, example of Raphael's excursion in the light and classical form of decoration exists in the chamber called *Cardinal Bibbiena's Bathroom* [195], which was painted shortly before the Loggia in 1516. It is a little antechamber some few feet square upon the third floor of the Vatican. It adjoins the dining-room of a Cardinal, and is kept so completely private that the guide-books make no mention of it. Save for the door, the little window at the other end, and two niches on the side-walls of the same size as the window, it is decorated entirely with panels and arabesques and every form of classical ornament. The ceiling, which has now fallen into complete ruin, is covered with bright patterns, and the walls with three bands of decoration. On the lowest level, reaching to the foot of the niches, are Cupids in chariots painted on a black ground within square frames ornamented with fishes. In the arch of each wall is the fairy architecture which occurs frequently in Roman houses. The chief interest, however, lies in the panels of the middle level, which are set in painted and

decorated frames of gold and red and blue. There are two on each wall, one on either side of the door, the niches, and the window. In each of them, save where some vandalism has torn two from the wall, there is a delicately painted picture of a classical subject with, save in one case, two figures and an open landscape. They are painted in the lightest of colours after the manner of the classic frescoes which they imitate, and the first three at any rate are as exquisite in handling as all are in grace and invention. Those on the side wall to the left hand on entering are the happiest. In the first, Venus or a nymph rides upon a large fish with a panther's head, while a boy rides upon an attendant fish which cannot be a dolphin because it is too long and lithe. The panel is in greens and blues with low-toned flesh colour and grey in the fishes, and there is in the flowing drapery of the nymph a dark red like that of *Galatea* in the Farnesina fresco. The fish rush over the water, the nymph holds firmly on, there are life and movement in the action, and freshness in the figures and in the landscape. The figures of the panel preceding, the *Birth of Venus*, and of the next, a *Wounded Venus with a Cupid* [196], are not less delicate—the latter, especially, with her tapering limbs and the sloping inclination of the figure recalling the over-refinement of Parmigianino and a later school, but they have less of life in the grouping, and serve less well to fill their spaces. Even so, they are immeasurably superior to the remaining three, which are not only inferior in design but are also thickly painted and coarser in the drawing. An alteration in the technical process of the painting coincides with this change in manner, and suggests that after an interval such as is implied by the letter of Bembo to Bibbiena concerning these decorations, the work was resumed by less skilful hands. While the outline of the earlier figures is but roughly indicated by a scratch in the wall, as if the painter had merely wished to fix its position, and had no need to follow its contour, that of the fifth panel is closely pricked out upon the wall, showing that the draughtsman did not dare to trust himself for a moment without the cartoon. In the sixth and last, the outline which is followed closely by the painter is heavy and continuous, and even the folds of the drapery and the muscles of the arm are deeply incised upon the wall. If the whole room was painted by Raphael's pupils, as has been assumed by all writers of the last century, who, with the exception of Dr Dollmayr,[1] never set foot inside it, the latter were clearly executed by men of very inferior powers to the former. But no pupil of Raphael's ever, in the work definitely assigned to him, showed the lightness of touch and the easy colouring of the first three panels, and however busy Raphael may have been, it would have cost him little to execute these small works. He might well have laid aside other commissions to work for a friend; he would certainly have enjoyed the execution of this small room. But whether he actually placed his hand to it or not, he conceived in this chamber a gem of classical daintiness, exceeding his models in the lightness of his fancy, and entering fully into the spirit of choiceness and exquisite triviality which was at once Roman of the old day and Italian of his and the preceding ages.

The bathroom of Cardinal Bibbiena is, however, completely closed to the tourist, and the contemporary enlargements of the central panels—the only reproductions[2] of any value—are now at the Hermitage, and are therefore almost as inaccessible to the general public as are the originals. Fortunately these designs are not alone in showing Raphael's manner in the treatment of a light classical theme. The fresco of the *Galatea* [XI, 197] in Agostino Chigi's villa, now called the Farnesina, contains all these features, and is executed upon a larger scale. If only the room in which it is painted had been completely decorated by Raphael's direction, had it been either alone in the room, or one of a series of

[1] *Archivio Storico dell' Arte*, III, 1890, p. 272. Q.v. for a different analysis of the styles.
[2] From the Villa Mills. These frescoes were engraved in the sixteenth century and reproduced in colour in 1802 by Maestri.

similar paintings, instead of being flanked by blank spaces on one side and on the other by a fresco of Sebastiano del Piombo which is out of scale and out of harmony with it, there would be no need to refer to the consistent scheme of Bibbiena's Bathroom in order fully to appreciate the *Galatea*. Even the ruinous condition of those decorations is not more detrimental to their effect than are the surroundings of the *Galatea*, together with the many imperfections which it too exhibits in its preservation, or perhaps in its execution. By no means all its colour is sound, and some of its forms, especially those of the nymph riding on the centaur, are hard and coarsely modelled like those of the *Incendio del Borgo*. But even as it is, the *Galatea* is the supreme example of the tendency in Raphael's art which showed itself originally in the *Three Graces* and came to adolescence in the Stanza della Segnatura. It is a picture of which either nothing can be said, or the whole philosophy of art must serve as explanation. The obscurity of the subject—it may be Galatea or it may not—proves its unimportance. Any inspiration which the painter may have received from some contemporary poet is as nothing when compared with the inspiration which came to him from the forms themselves. There are no details or incidents, save, perhaps, the rimless wheel of the shell chariot, which are of intellectual interest; there is nothing anywhere to detract from the importance of the figures.

It was of this picture that Raphael says in a letter that the figure is ideal, and so near does it come to the universal idea of human beauty that it is too obvious for much modern taste. Such among earlier works as Botticelli's *Birth of Venus* prove more immediately attractive; to these at first sight the *Galatea* appears to be a complete antithesis. In the earlier work the beauty of the figure is subtle, the technique obvious; in Raphael's the beauty of the figure is obvious, the art which goes to its expression so subtle that it escapes notice. Consequently there is more for the literary mind to seize and expound in the conception and the execution of the earlier work than in those of the later, and the modern taste with its shyness of pure form is satisfied with the earlier. But on deeper analysis the *Galatea* appears as the direct outcome of Botticelli's *Venus*. It has space where the other has only one plane, and a rhythm of intersecting forms where the other has only a play of line. (For this reason Botticelli's qualities survive in a photograph, while Raphael's are only to be appreciated in the picture.) It has ease of movement where the other has constraint, but both are, in their different ways, expressions of delight in the exquisite grace of the human form, and both are poems in honour of the freshness and beauty of the sea. In Raphael's work the colour and the tone of the sea have gone, but its feeling remains in the movement and advance of the figures—not only in the swing and motion of each actor, but in the swirl of the whole composition, from the dragging *putto* at the foot to the four Cupids with their bows and arrows at the top, whose forms by themselves most cunningly suggest the whole space of the picture. These should be taken as the key-notes to the composition, while the conch-blowing Triton on the left with the head of his white horse may stand in the present preservation of the picture as typical of the originally subtle and fluid modulations of the painted form and the exquisite quality of the colour.

Easel pictures painted in the free technique of oils are required to show Raphael's full power in the treatment of classical subjects, but none remain. There are, however, a number of engravings from Raphael's designs which show the same grace and fertility of design, and the same noble conception of the human form as does the *Galatea*. The painted spandrils with the *History of Eros and Psyche* in another room—or loggia—of the Farnesina [199, *200-202*, 203, 204] are akin to these, for in spite of their large scale and the greater skill which was required to present the human figure in life-size, these are still but decorations, and their qualities in their present preservation are exactly those of the engravings. Repainting may be the cause of the hard outlines and coarsened features of many of the figures, or the necessity of

emphasising the forms in their architectural setting may have justified Raphael's assistants in executing work of inferior grace and subtlety. To this cause is due most probably the heaviness of the forms themselves, which are in striking contrast to the litheness of the *Galatea. Psyche rising to the Palace of Venus* [204] is the least solid of the figures, and at the same time her face is the most delicate in its modelling. It is almost universally true that the heads in full face are more delicately painted than those in whole or half profile, and this suggests that the protruding lips and heavy noses are drawn with purpose to give relief against a plain background and are not therefore to be lightly condemned as evidence of pupils' work. But these are minor details in a series of works which are unrivalled in their fertility, in the pure decoration of space, command over the human figure in easy motion and aptness of invention, and finally in their dignity and grandeur in the conception of the human form.

12

From the *Galatea*, which is the most representative among Raphael's works of classical imagination, there is no immense step to the consummation of his efforts in Christian art—the *Sistine Madonna*—which, to judge from the evidence of style, must be placed towards the same undated period of his career. It is completely in accordance with the whole character of Italian art in this and the preceding epoch that the connection between the Pagan and the Christian ideals should be of the closest. The same type of features and of form served for Botticelli or for Michelangelo, as well as for Raphael, to characterise the Mother of Christ, a classic deity or a mediaeval personification. Each was to them the complete ideal of human beauty, and, conceiving the ideal in his own way, each painter embodied it wholly and without division in each figure which it was his choice to portray. There was enough differentiation in the attitudes or in the setting, in the expression and the action, to characterise the subject of the moment, but, apart from this, the figure was endowed with all the beauties of form and figure, of technique and accompaniment which the painter could summon from his mind and hand. Humanity and art alike were single and indivisible, and between Christianity and Paganism there was no barrier.

It is no more surprising then to find Raphael giving to his Madonnas the grace and delicacy, the sculpturesque physique and the easy movements of his *Galatea*, than to find Botticelli endowing Venus with the wistful look, the exquisite extremities or the serious elegance of his Madonnas. Raphael had already moved in this direction in the *Esterhazy Madonna*, which was a pagan picture painted before ever he touched pagan subjects. In the Madonna called *of Loreto* [212, *213, 214*], which was painted as early as 1512 for Julius II, and was placed with his portrait in the church of Sta Maria del Popolo, but exists only at this day in several copies, the same elegance of pattern and ease of movement are employed with greater concentration of effect. The old subject of the Mother raising the veil from the recumbent Child becomes a vision of lightly poised limbs, of supple forms and of simple flowing drapery, all beautiful and valuable in themselves and expressing, as the sound of verse expresses its meaning, the tenderness and sweet joy of the action. Here, as everywhere in Raphael, the beauty and expression of the face is not required in order to make clear the emotion of the whole figure; but here, as in the *Garvagh Madonna*, Raphael gives to his Madonna the pure oval face, the large downcast eyes, the small, delicately modelled nose and the subtle mouth—each with its rounded shadow just emphasising its position upon the cheek—which best fit the character of his forms and the emotion of his composition.

In this picture a dark background, a high light and the most skilful use of shadow prepare the way for a series of pictures of the Madonna which will fall to be considered later. In others which have some community in subject, whatever be their date, the treatment of the Madonna and Child is more picturesque, in the sense that the principal figures become centres of a landscape composition, as here they are centres of a world of light and shade. The *Madonna of the Diadem* at the Louvre [215], which exists, like the *Madonna of Loreto*, only in the form of many replicas, belongs to the large circle of Raphaelesque pictures which seem to derive from sketches by his hand but owe nothing in their final form to him. They are free versions of Florentine themes, on occasion* preserving even the conventions of landscape which belong to the period of the *Madonna del Prato*, while other examples like the *Madonna of the Diadem*, with its restless lines and overpowering classical surroundings, show features of the compositions which belong to the latest period. The Louvre picture also has something of the careful contrasts of light and shade which mark pictures of that period, while its thick painting and bright colour bring it into contact with the *Garvagh Madonna* and the *Vision of Ezekiel*. The recumbent infant is the one feature of the conception which shows care and appreciation.

A further example of the picturesque style which is akin to these pictures both in the execution and in the uncertainty of its date is the *Madonna del Passeggio* [216]. Of the many replicas of this picture, that from Bridgewater House is said to be the best, but even this cannot be said with any certainty to be more than an arrangement of Raphaelesque material. If an example existed in which the hardness of colour did not conflict with the atmospheric intention, it would be of all Raphael's pictures the most perfect development of the simple picturesque style, in which an almost Peruginesque motive is made a part of a real landscape, and the incident of the chief group is made familiar and human. The Madonna stands with the two boys, who are older than is customary, in an attitude of complete unconsciousness, and the figure of St Joseph disappears with his burden on his back, like that of any peasant farmer of the hills. So much more is seen and heard of the grandiose and majestic character of Raphael's Roman Madonnas that this half romantic and half realistic picture, with its unaffected combination of landscape and figure, must be made much of as a necessary corrective to a current opinion. If it owes its existence entirely to Raphael's pupils the tendency which it displays is still more characteristic, for they did not reap seed which the master did not sow. But the whole conception of the picture is the same as that of the groups in interiors, and of such portrait pictures as those in the Camera d'Eliodoro, for it consists entirely in an effort to give full visual reality to themes which had always their naturalistic basis, but had hitherto failed to approximate to the character of the forms represented.

The *Madonna of the Fish* in the Prado [219, 220, 221] is an attempt to combine this realistic conception of holy subjects with its very antithesis, the hieratic presentation of the Virgin enthroned among attendant saints. As the purely picturesque treatment of the *Passeggio* became common in Venetian painting, so this manner of representation became fashionable in Florence. Some necessity of religious observance, totally inartistic in its character, gave Raphael the theme. He attempts to connect the young Tobias and the Archangel who guides him with the Virgin and the Infant, but St Jerome and his lion remain as they would have been in any early picture. The result is frigid, and the animation of the various characters becomes uneasiness. The picture seems hurried and ill thought out, and only certain of its details have beauty when taken by themselves. The chief of these is the Virgin herself. Her figure provides an illuminating contrast with another Madonna of this circle, that of the *Candelabri* [222], in which the arrangement of Madonna and Child is obviously derived from the same drawing. The picture [of which a variant copy, now untraced, once belonged to Charles Newton Robinson] shows a

* E.g. the *Westminster Madonna* (Gronau-Rosenberg, Plate 77).

certain cleverness of arrangement and an interest in the painting of metal work and artificial light which is no novelty in Raphael's work, but its chief feature is the introduction of meaningless details which follow necessarily upon the merely mechanical process of its origin. As the Madonna is brought from left to right and the motive of her action is dispensed with, her arm becomes entirely supererogatory. It rests without purpose, with violence even to Nature, upon the Infant, instead of being, as in the original picture, the essential feature of her action. Similarly one of the Infant's hands becomes otiose and has to be hidden away. Nothing could show better than this contrast, the difference between significant composition and meaningless disposition, and the existence of these two variants upon one theme illustrates better than much analysis of the handling of different pictures the methods of picture production which ruled in Raphael's shop. A precisely similar variation from an original picture exists in the *Madonna della Tenda* of Munich [229], in which the elements of the *Madonna della Sedia* are freely adapted and, through hasty misunderstanding of the position of the Child upon the Mother's lap, the right arm becomes more than purposeless, even monstrous.

The *Madonna of the Fish*, with its memories of Quattrocentist combinations, was an unfruitful experiment, and stands alone in Raphael's work. The only possible result of the effort to give full naturalistic accompaniment to arrangements which were impossible in Nature was a divorce between the two. Where the whole scheme was artificial, as in earlier art, the two tendencies could only exist side by side, without, in our eyes at any rate, creating any effect of inconsistency or contradiction. But when naturalism had ceased to consist in the faithful representation of a few details, and had become a complete method of vision and imagination, it could not co-exist with an equally coherent and systematic conception of the supernatural.

The *Madonna of Foligno* [223, *224–226*] is the picture which presents the first steps towards a complete emancipation of the hieratic conventional group from semi-naturalistic bonds. Its date may be about 1512, the year of the Heliodorus fresco, for its richer colouring and certain characteristics of the painting of the heads suggest a contemporary origin; while an old tradition connects the picture with Sigismondo Conti, whose portrait as the donor stands in the picture, and who died in 1512. But neither its date nor that of the *Madonna of the Fish* is established with such precision as to provide any ground for establishing an historical sequence between the two. The presence of the donor in this picture alone among the whole series of Raphael's altar-pieces marks its conventional character. Three saints who were chosen for no artistic reason but from some arbitrary association with the private cult of the patron are placed with him, and an angel holding a tablet is introduced with no more meaning than were the *putti* in the frescoes of *Justice* and the *Sibyls*. Frankly facing the artistic problem of combining within one frame totally irreconcilable figures, Raphael represented the Virgin as seated upon the clouds in intellectual and symbolic connection with the other characters, as an object of their thought, or as an element in the spectator's conception, but with no terrestrial bond, such as was supplied by the canopied throne in even so recent a picture as the *Madonna del Baldacchino*. The landscape also, which was a customary feature in the convention, is retained. It no longer, however, serves as a mere touch in the background to enhance, as a kind of accompaniment, the sentiment of the principal figures, but becomes important in itself. All the elements of the conventional altar-piece therefore remain, but they are resolved from self-destructive literalism, and while each becomes in itself more freely treated as a representation of nature, the whole is united in a scheme which is completely supernatural. Possibly the arrangement of *Assumptions* or *Coronations of the Virgin*, which was familiar to Raphael from his earliest days in the studio of Perugino, was responsible for the conception of this picture, but the adaptation of the arrangement for another purpose is the logical outcome of the whole tendency of Raphael's art.

It is not, of course, the case that the main elements of the picture are merely flung upon the canvas with such hints to their intellectual combination as a purely primitive altar-piece might have presented, although here, as in the case of the Tapestries, Raphael shows a distinct tendency to revert to a characteristic feature of earlier art. Such frank conventionality would have been impossible, both for acceptance by the general taste of the day and for assimilation with the developed style of each of the component parts. A theme of symbolic character, unusual in Raphael, serves as a pictorial vehicle to convey the intellectual association. Much no doubt is still effected, as it would have been in a primitive picture, by the upturned gaze of all the four figures and by the uplifted arm of St John, which recalls, through the figure at the altar in the *Disputa*, a whole series of frigid Perugian Assumptions. This is a mere relic of the convention which was in general being disregarded, and it is largely responsible for the imperfection of the effect. The true unifying idea in the picture is the vast imaginative glory, half halo and half sun, which rises behind the figure of the Madonna and casts its radiance throughout the picture, including, even, as arch-shaped rays piercing through the clouds, the landscape of wood and water and town, and touching with its golden light the curls of the angel in the foreground. A spot of orange-yellow in the landscape, which seems somehow to be connected with the golden glory, has been taken generally to represent either a meteor or a bomb (the critics do not know which), and a story has been invented that this picture records the salvation of Conti at some siege of Foligno, in which he is supposed to have taken part. But the town is not Foligno, nor do the peaceful shepherds in the middle distance suggest either a siege or the approach of an aerolite, and the story may be dismissed as an irrelevant fabrication which only serves to detract from the real interest and beauty of the conception.

The *Madonna of Foligno* marks, however, only one stage in the direction of the picture which is acknowledged to be the supreme embodiment of Raphael's mature mind and art—the *Madonna with St Sixtus and St Barbara* [XIII, 227], which was originally painted for an obscure chapel at Piacenza and is now at Dresden. Raphael's rigid logic had shown itself in the choice of decorative forms for the Stanze and in the purely human treatment of the Madonna and Child, whether they were set in a country landscape or the interior of a room. Here it succeeds in eliminating from the representation of the Madonna in Glory every remnant of the conventional grouping and leaves nothing but the central idea of the vision. The adorers of the *Foligno Madonna* are partly swept away and partly translated themselves into an imaginary sphere. With this, the artifice of the golden glory disappears, for the Madonna and Christ have become in themselves so central and enthralling that they can suffuse and penetrate through the whole picture without requiring any artificial harmoniser in idea or colour. The angels, also, whose heads and bodies composed the sky in the *Madonna of Foligno*, as they do in the *Disputa*, close in upon the Madonna and at the same time recede into the distance, while the *putto* at the foot becomes less definite and less obtrusive until only two angel heads remain at the very edge of the painting as a decorative touch and as a key-note in the representation of the space. Nothing then remains in the picture but the Virgin and the Child themselves, two attendant saints, a vague background of angels and two *putti* at the foot. Thus the vision of the earliest painters of all returned to art, comprising nothing but the essential elements of the conception, and disregarding all the elaborate scaffolding of accessory and detail which had enabled the intervening ages to lead up to such perfection as finally rendered them unnecessary. How far Raphael had the conception of the *Sistine Madonna* in his own mind from the days when he first imagined vaguely the visions which he wished to paint, we cannot know; but as in the history of an individual the power of maturity only gives form to ideas which were present from the rich days of impotent youth, so in the history of art the ultimate

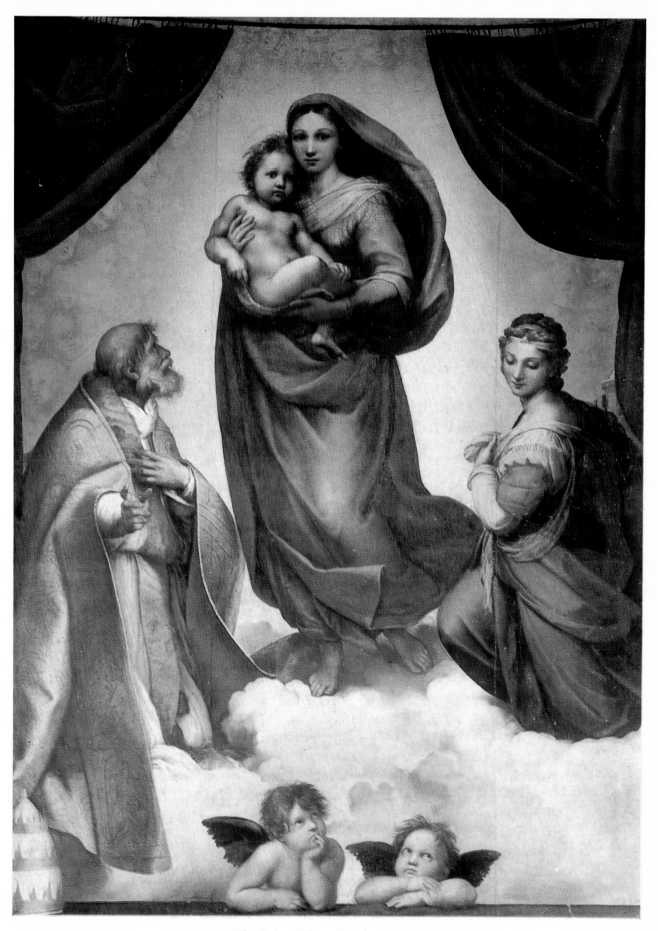

XIII *The Sistine Madonna*. Dresden. 265 × 196.

expression is but the consummation of intentions which were crudely put forth in the first days of all. It is no disparagement of Raphael to say that there is not in the whole *Sistine Madonna* one element, one material ingredient that is new, but the greatest praise of both his and the whole range of Italian art that he was produced by it, and that he in turn was enabled to give it so complete and masterful an expression.

It stands to reason that the Virgin and Child, who by themselves so completely dominate this whole conception, should exhibit in their forms all the majesty and dignity of which in Raphael's eyes the human figure was capable. In the *Madonna of Foligno* the Madonna and Christ are merely the graceful mother and child of Florentine imagination. Sweet and serious, animated and full of Raphael's elegance, they do not force the attention of the spectator from the figures of the saints or the donator, the *putti* or the landscape. Even if they had possessed the mysterious fascination which belongs to the conception of the true Florentine artists they would still not have adequately filled their position in the picture. In the *Sistine Madonna* a standing attitude replaces the seated, and the two figures, instead of being occupied with some playful and trivial action, rest in a firm and enduring position. The absence of momentary occupation suggests an occupation of eternity. Their minds, intent on no visible action, seem brooding over the actions of all space and all time. Their eyes, always with Raphael the seat of life in face and figure, though usually in his Madonnas cast downwards in unconscious meditation, look forward above the heads of the spectators. No less than those of the primitive Madonnas of Duccio and his group, they are the centre of the whole picture, the secret of its unity and the dominant expression of its mood. Through them and the worlds of unuttered thoughts of which they hint, Raphael in this picture assumes within himself the depth and mystery which he had formerly failed to accept from the leaders of an earlier age in Florence, and he adds to their virtues a majesty and a force which they had never succeeded in achieving.

Compared with the eyes, the actual features of the face are artistically of less importance, for the face is capable of infinite variation. One man's standard in this matter is as good as another's, but Raphael's choice of regular and unobtrusive feature, of sensitive mouth and delicate nose is not so much the elimination of significant characteristics as the discovery of the totality of female beauty. There is no reason to doubt that this is an ideal and imaginary face brought together by a mind so conversant with the human form that it could fashion the features of the face as it could mould the body, according to its mood and will. The gradual appearance of this type among others essayed, and then discarded, would be enough to make this evident to any one familiar through and through with Raphael's work, but, besides this, it is not perhaps a mere trick of fancy born of too much study of the painter, to discover in these features more than an echo of, even direct descent from, the early and almost entirely conventional lineaments of the *Connestabile Madonna*. Apart from the features the shape of the skulls, and still more the manner in which the heads rest upon the neck, are characteristic and expressive. These show the transitions of line and tone which make life in painting; they are the secrets of perfect comprehension and easy representation. More still, the whole body of the Infant, the shoulders, the breast and the arms of the Madonna; their easy and purposeful lines and their consummate rendering of structure and surface, the significance of their movements, the amplitude of their forms make the centre of the picture the adequate expression of a thought which is not only the painter's imagination, but is the truth of an universal human conception. The human body is not only the most varied and subtle of all natural objects which art, as the mere delight of the eyes, can find for its exercise, but is also the richest and most delicate orchestra for the conveyance of emotional ideas. Every characteristic of form which Raphael chose for his two protagonists communicates a reading of character and of life and tells

of a conception of humanity, for which he found the best embodiment in the ideal form of the Mother of his God. If the heads of these figures were wanting they would still rank with the Parthenon pediment as the noblest among man's conceptions of his own excellence, and it is the greatest tribute that can be paid to the heads to find in them an adequate complement to the figures which they surmount. Complete as they are, there is but one work of art which reaches the same height of majesty and tenderness, the *Pietà* by Raphael's master, Michelangelo. To deny Raphael's greatness before the *Sistine Madonna* is to condemn the whole of art and to destroy all nature.

As must necessarily be the case, the remainder of the picture is of less supreme importance. It was Raphael's problem to place the figures of the Madonna and Child where they could at once be the whole centre of interest and yet be remote enough from the spectator to suggest their appearance in the distant heaven and their identity with the sky itself. Obviously, while to place the figures far away would have given the effect of distance, it would have failed to represent the vision, for it is of the nature of a visual impression that the object of focus occupies the whole field. Much is heard in these days of the impressionism of light and colour, but the impressionism of form and figure which was Raphael's consummate achievement, is not recognised as a part of art. Yet only by some such idea as this can the greater part of the work be understood. In this picture the large, broadly painted drapery of the Madonna not only adds to the magnitude and dignity of her body, but they act as a pedestal throwing into prominence the power and glory of the upper part. As the lower part is itself of less importance, or, in other words, because it was of less emotional interest to the painter, he could be satisfied with a less significant attitude of the legs, and he drops in fact into a reminiscence of his very earliest days in Perugia when he adopts the half-standing, half-walking posture which was for Perugino the last word of human elegance. So little does it conform with the conception of the upper part of the body that this attitude combined with the bareness of the feet has a halting, heavy appearance, and is no doubt largely responsible for the impression which many critics have received, that there is as a basis for this Madonna a reminiscence of some peasant maiden from the Campagna. In its position, however, in the picture this slightly disconcerting detail becomes intelligible, and the effect would of course be lessened and probably would entirely disappear, were the picture placed over an altar or at the level above the heads of the spectators for which it is clear from its foreshortening that it was originally intended.

Concentration of attention upon the central incident of the picture also explains the figures of the two attendant saints. In spite of their admirable painting, the ease of their postures, the amplitude and flowing lines of their drapery, these figures are somewhat wanting in significance of feature and attitude. The reason is simple enough. They are not intended to be of any capital interest in themselves; they were not objects of any deep thought on the part of the painter. But just as in the primitive prototypes of this picture the attendant saints were of importance chiefly as part of the pattern, delighting in themselves by the arrangement of the lines and masses, and leading the eye upon the single plane of the picture to the central figure of the Madonna, so here the two saints have no profound intellectual significance, but serve by their position on the canvas and by their lines and planes to emphasise the central figures. They are as it were the ladders by which the eye ascends to the heads of the Madonna and the Child, and having their part as such in the fundamental conception of the picture, their character as human beings or saints has but a secondary importance. Even so they are far from being devoid of interest or empty in significance. They possess, each according to its character, dignity and grace; their lines are decorative in themselves, their draperies flowing and ample, and their bodies moulded with the delight in the movements and the structure of the human form which is

shown in the fresco of the *Sibyls* or the lunette of *Justice*, or, best of all, in the central figure of this picture itself. The hands of St Sixtus, the head, shoulders and arms of the St Barbara, painted in the broad and solid style of the period, are the counterparts in their plastic excellence of the exquisite outlined forms which suited better the more delicate tracery of earlier conceptions. Moreover the whole character of the figures belongs as completely to the general intellectual conception of the picture as they do to the visual. Their grandeur is essentially an element of the superb vision. Not less, the happiness of their attitudes and faces springs necessarily from the radiance and glory of this triumphant appearance of the Virgin, and tells, as clearly as the song of a Greek chorus, the emotion which the painter felt at his own creation and therefore conveys to the spectator.

The final touch in the consummate unity of this conception is given by the green curtain. It has at once a definite and an indefinite position in space. It opens from in front of the Madonna, and therefore casts her back into the distance. It falls behind St Sixtus and St Barbara, and therefore brings them into the foreground, while the clouds which surge up and hide their feet throw them again into the imaginary space of the vision. The introduction of the rod and rings at the very top of the picture (most often absent from the reproduction) is not a mere piece of frigid realism, but an essential element in the conception, for it not only gives precision where precision is required, but also allows the sky to reach to the very edge of the frame, which is a necessity in order that the whole breadth of the heavens may be suggested. The old-fashioned curtain which occurred in the majority of pictures of the Virgin was merely a background setting off the modelling of her figure, or the colour of her draperies, and in such pictures as the *Madonna del Pesce* or the *Madonna della Tenda*, it renders the space enclosed and the picture heavy. In the *Sistine Madonna*, where all the conventional features are transformed, the curtain also becomes a living part of the conception, and if something of the artificial and rococo is introduced through the employment of such a feature in order to emphasise the momentariness and completeness of the vision, the fault is inherent in the feature itself, whose triviality only becomes evident when it is allowed to show itself in full.

There are still other elements in the picture which call for notice. The heads of the angels, now reduced to a mere note at the foot of the picture, supply a decorative and spatial feature, as they had done from the beginning of art, and with their strong forms and rapt serious gaze touch the same chords as the principal figures above. Their faces show repainting which might perhaps also be evident in other parts of the picture (notably in the blue of the Madonna's robes), were there opportunity to inspect the whole surface as thoroughly as the bottom portion. The balustrade upon which they rest their arms, and the Pope's tiara in the corner are mere details in the illusion of space already produced by the curtain. There is a greater importance in the colour of the whole picture, for it is as integral a portion of the general conception as the forms or the delineation of space. Hitherto in this book little has been said of the colour of the pictures which have been described, partly because a mere catalogue of the names of colours is always valueless for descriptive purposes, and partly because in most of the pictures and frescoes the colour scheme chosen by Raphael is of the kind which is least of all capable of description. Where a harmony of a single tint or tone is dominant and the whole picture is based upon the foundation of one tone, description is possible. But where the harmony is of bright and variegated tints, as is customary with Raphael, description becomes a mere catalogue of bad colour terms which are only completely significant to painters, or of similes which, however illuminating in themselves, are puzzling in combination. The *Sistine Madonna* is no exception to this rule. Clear brilliant tones of red, blue, green, and yellow occur as freely as in the works of primitive painters, who thought, like children, that the more variegated and bright the surface the better the result. But Raphael, who knew

already in the days of the *Sposalizio* how to combine and harmonise colours of the highest tone, uses here no crude colours nor surfaces of opaque pigment. By the skilful use of shadow and still more by the unanalysable subtlety of comprehension and execution which marks off the true colourist from all others, he gives to each surface the transparent radiance of colour under light, and while suggesting the actual surface of the coloured substance, uses his own pigment with the fluidity and multiplexity of living colour. The whole is harmonised in the cool silvery shimmer of the flesh and painted with so subtle a brush that the eye looks in vain for the methods which were followed. All this is no mere display of qualities which are valuable only to painters and are indifferent to the general public. On the contrary, the brilliance of this colour scheme in its total effect, the number and force of the colours, and the general harmony of all within the simplest and most unemphatic unity of light gives to the vision of the picture an effect of totality, of real and clear light and atmosphere such as a more obvious and easily intelligible unity of any single hue, however attractive in itself, would have been powerless to convey. In the colour, as in the general arrangement, Raphael transformed the conceptions which were handed down to him in the universal practice of his predecessors. But where they showed fields of uniform clear and enamel-like tint brought into harmony only by the brilliant gold of the background, he melted and varied his colours and gave them unity by the clear light of day. It is not of course the light of the bright sun that he used, but the cooler light of the day towards the evening or in the north which gives the colour itself its utmost brilliance and allows the form to show unimpeded, as is required where the whole significance of the picture is to be communicated through the character of the forms.

13

The *Sistine Madonna* is the final embodiment of Raphael's conception of the Madonna in Glory, the last step in a series which produced the *Ansidei* and *Sant' Antonio* altar-pieces, the Madonnas of the *Baldaquin*, of the *Fish*, and of *Foligno*. The *Madonna della Sedia* [230] is its counterpart in the purely human representation of the Madonna which had occupied Raphael throughout his life. Similarities in form both in the Madonna and in the child bring the two pictures close together. The shape of the Madonna's head, her hair, ears, eyelids, and the robust limbs, chubby features and tousled hair of the Infant are almost identical in the two pictures. It is of more importance that both pictures show the same delight, for their own sakes, in the strength, amplitude and subtlety of the human form, the same joy in draperies which are not merely decorative but significant and living, and the same thorough understanding of the body, not as a combination of exquisitely shaped parts, but as a breathing and moving envelope of the soul. There is also in the *Madonna della Sedia* the wonderful sense of pattern in the composition of the limbs which marked each figure of the Sistine altar-piece, the power of placing each member of the body where its lines and masses follow complex but ample curves without ever suggesting that the figure is in any position but that in which it is thrown by the immediate purpose of its action. These are the similarities between the two pictures. The differences are equally obvious, for the *Madonna della Sedia*, being a rapid representation of an observed fact, shows more of portraiture and less of careful selection, both in the features and in the choice of attitude. There is none of the refinement of either the *Sistine Madonna* or of the Child in that altar-piece in the faces of the Matron and bold Infant of the *Sedia*; their attitudes are frankly a denegation of all dignity, and even the painting, though masterly and even miraculous in its rapidity and ease, has not the same transparency nor the colour the same harmony against its artificially effective background of black. The modelling

of the Madonna's face is wanting in delicacy, and the St John, apparently thrown in as an afterthought for the sake of the design, is either painted in a totally different key or is completely repainted. These contrasts arise through the difference in the conception of the pictures. The *Sedia Madonna* is a swift and frankly realistic portrait of a mother with her child, palpitating and breathing with the hot life of the Roman sun, and though as such it is the culmination of the whole tendency of Italian art to find in the Madonna the incarnation of human motherhood, the logical conclusion of the tendency proves to some extent its ruin. It is absurd to suppose that in painting the picture Raphael was either more or less governed and impelled by what is called a 'religious' motive than were the earlier Florentines who portrayed the Madonna in the likeness of a human mother. But the sheer fullness and joy of life which dominates his whole mind and penetrated into every detail of his expression, while it was for him as natural an attribute of the divine mother as any of the qualities with which the earlier men had endowed their ideal, is, in fact, too completely human to satisfy as the fitting clothing of a divine figure. Every man in the presentation of his ideal must take his fortune in his hands and strive honestly for realisation whether he is to hit or miss an ideal which other men can share. To some extent Raphael has done that in this picture, but by exerting all his immense powers to make the Madonna human, he has necessarily ended by making her too much a woman.

The interpretation of ideal types depends so much upon the individual taste that, were it not for the other representations of the Madonna and Child which Raphael himself produced, it would be hyper-critical to find fault with the features of this picture. There is no need to import general conceptions as to the proper method of representing the Virgin into the appreciation of the group. Had the faces been ugly or depraved they would have recommended themselves to the *élite*. As it is, they may be ignored if they are not liked, accepted if they satisfy. They do not interfere in the least with the virtues of the painting as a sheer delineation of human action. Where, as in the *Sistine Madonna*, excellence of human form can be welded with significance of superhuman character, so much the better. But where, as here, the portrayal of a human action remains purely human, the emotions from which it springs are too valuable to be quenched by any sense of comparison or loss. The art of the *Madonna della Sedia* may not be the highest art, but it is after all the art of by far the greatest number of painters, and there is, besides the superb power of fashioning and displaying the beauties of the human form, so much of Raphael's own dignity, breadth and largeness in the choice of the forms themselves, that it is supererogatory to regret that the tenderness of the human mother and the wonder of the human child are not combined with a greater reserve and loftiness in their attitude. For these qualities it is possible to go to earlier Madonnas of Raphael's. Here, just as in the *Sistine Madonna* the idea of the supernatural appearance burst open the conventional bonds of earlier hieratic pictures and produced a culmination of mystic visual effect, the human qualities of Raphael's earlier groups proved too strong for their modest setting and, for once only, ended in a riot of purely human emotion.

14

The counterpart of the *Sistine Madonna* among Raphael's portraits is not to be found in any of the pictures of women which are attributed to him, but in the bust of his life-long friend Baldassare Castiglione [228] which is now in the Louvre. Painted about 1516, if it be the picture referred to in a letter from Bembo to Bibbiena, and not one of the other portraits of the same man which are spoken of in contemporary and later documents, it would be of about the same date as the *Bathroom of*

Bibbiena and perhaps the *Galatea* fresco, and its date may possibly be taken as fixing that of the *Sistine Madonna* itself. In any case the portrait shows the same qualities of colour and of easy handling that occur in the *Sistine Madonna*, while the colour scheme of delicately toned greys and blacks against a grey background is so completely in the modern taste that this portrait has become almost the favourite among all Raphael's pictures. But, remarkable as it is in its colour and modelling, these are not the only qualities which give the picture value or make it characteristic of Raphael's work. Its simple lines, full drapery, easy disposition, and above all the absence of any studied effect, either of sentiment or of posture, make it an epitome of all Raphael's artistic qualities. Castiglione was not like Julius II in possessing features which overwhelmed the picture and only needed adequate representation in order to inspire a masterpiece. His face, while it was handsome, kindly and witty, had not the marked characteristics of feature or of expression such as the painter habitually loves in a sitter because they can be seized readily and form an immediate motive which dominates the whole. His face might appear, as the portrait would appear, commonplace, and far too human for the artist to rejoice in. This was Raphael's opportunity, for art to him never meant the odd or the out of the way, but always the complete and the universal.

Apparently without the least consciousness of the magnitude of the task before him, Raphael attacked his subject with perfect simplicity. He makes no effort to reduce his sitter to any formula of portrait painting, nor seeks among his many moods for an expression which is striking and characteristic. He sets forth to paint the whole man, as others see him, even, perhaps, as he sees himself. The excellence of the picture as a portrait is attested not only by Bembo's words—they indeed state that the lost portrait of Tebaldeo far excelled this—but also by Castiglione's own epigram[1] upon the picture. Naturally, therefore, he portrays his sitter in a moment of complete external repose, when all the moods and characteristics of the sitter are in potentiality or subdued activity. All action in art is a limitation of character, because to make a moment permanent is to give it over-emphasis, and no motion of so complex a being as man can be an action of the whole. The eyes are wide open and pensive, the lips are closed in a slight smile; no words are passing, and the thought that is at work behind the eyes is indeterminate. These were the characteristics of the Virgin's head in the *Sistine Madonna*, for, there as here, Raphael was searching for an expression which might be complete, and giving to the ideal head of the woman the same universality as he finds here in the features of his friend.

To appreciate the exact quality of the brownish skin, the brilliant blue of the eyes, and the tender modelling of face and hair and feature (note especially the oblique setting of the eye), it is necessary to study the picture itself. But, in general, the pictorial qualities which belong to the portrait are those which correspond most closely to its intellectual conception. This is everywhere the case with Raphael, and it is the secret of his paramount position among painters, but it can nowhere be so easily observed as in this portrait, because nowhere else is the field at once so limited and so familiar. The broad, simple colour scheme, subdued, but frank and clear, is the translation into the music of colour of the expression of the face, the harmonious and easy line the counterpart of an open character. The cool and uniform light is the fitting atmosphere for the presentation of a character when nothing is to be hidden and nothing over-emphasised. But chief of all, the broad and dignified treatment of the head, the easy transitions from light to shadow, the strong, simple modelling, the absence of all insistence upon detail, with at the same time the utmost delight in the play of structure and surface—all the qualities, in short, which mark off the 'Grand Style' from the haphazard, the affected and the obscure—belong immedi-

[1] Passavant, II, p. 154, from the works of Fulvia Morata (Venice, 1534).

ately and entirely to this thorough comprehension of the whole character of the sitter and the perception, through him, of all that is enduring and dignified in the creation of which he is a part.

The classic breadth of the portrait of Castiglione recurs in the slightly later picture of the two Venetians, Navagero and Beazzano [231], which is in the Doria collection at Rome, where it passed for long under the anachronistic title of Baldo and Bartolo. There, in spite of beauties of colour and unparalleled mastery of paint in dress and background, absence of the fluid painting and a certain darkness of flesh-tints have caused the picture to be assigned away from Raphael by many critics. The development, however, towards a tighter and more solid texture is quite in keeping with the other pictures of Raphael, and if the technique of the *Sistine Madonna* and the *Castiglione* were to be demanded as a *sine qua non* from the authentic pictures of Raphael, his paintings would dwindle in number until they scarcely exceed the admitted canvases of Giorgione. He seems, however, if the portraits alone are taken into account, to have varied his method of painting with his subjects, as freely as a mastery over all the manners of his predecessors would allow him. Another portrait of a man, the *Unknown Cardinal* of Madrid [232], is in its manner intermediate between the Castiglione and the Doria pair. The excess of scarlet, and the absence of all relief in the body, which were necessitated by the robes, diminish the general attractiveness of the picture, but the head with its seriousness of expression, firm modelling and dignified treatment is remarkable even in the Gallery which is the shrine of Velasquez himself. At the same time this portrait, though more immediately arresting than that of Castiglione, has not the same universal value. There is something of a formula in the treatment of the eye-balls. They look straight at the observer while the face is turned sideways. This attitude occurs in almost all Raphael's portraits from the earliest of all, that of himself, and is so far independent of the character of the sitter that it would be possible not to recognise the portrait were the eyes downcast or veiled. In this detail lies the whole difference between a characteristic which is universal in the abstract and one which is both universal and relative; but so apposite does it appear in this portrait of the Cardinal, so well suited is the stern glance to the powerful nose and firm thin-lipped mouth, that it is scarcely possible to say whether the formula was applied because it was a cunning and easy way of communicating life to the picture or because the painter had found the occasion in which above all others the formula was a strict representation of fact. In the touch of sun in the eye-balls, and in the modelling of eyes and lips, though all these details are represented in a similar manner in the Castiglione and in the Doria portraits, there is no appearance of the mere application of a formula because the drawing and the painting are completely without mannerism and are nothing but the signs of honest comprehension and straightforward expression.

The portrait of Leo x with Cardinals Giulio dei Medici and dei Rossi [233] has suffered from the effects of time. Vasari describes it with ecstatic admiration for the details of still life, the velvets, damasks, silver bell and the ball of gold on the chair, and these details still remain to show the scrupulous care which Raphael could exhibit himself or, quite probably, demand from Giovanni da Udine or another assistant when they were required for the purpose of his commission. But these are small matters—though they make up the whole picture for modern commentators as well as for Vasari—compared with the painting of the heads and the general disposition of the picture. Here time, by darkening the shadows and throwing the lights into too great a prominence, has injured the modelling of the heads, and has so far ruined the atmosphere of the picture that the three heads start away from the background with too marked a violence, and with too little relativity of values among themselves. The effect, therefore, becomes that of the portrait frescoes in the room of the *Incendio del Borgo*, where the accessories, especially the objects of metal, are also painted with scrupulous care, and

III

time has ruined the total effect. Relief, which is the one general quality noted by Vasari, clearly must have been the central intention in this picture, marking it as an advance upon the very similar arrangement in the fresco of Gregory. But it has disappeared entirely save from the still life in the foreground, and through the loss of atmospheric quality the figures have become hard and wooden. They appear now as though they were arbitrarily brought together into one frame, and their studiously quiet attitudes and the absence of all communion in their gaze or their postures make them appear as separate portraits. Light would have brought their figures into harmony, and thrown their characteristics of form and feature into a single group of cunning concentration, and the beauties of detail in the dresses and the accessories would have shown but as minor incidents in a scheme of receding planes and masses which ended in the vague obscurity of the half-lit chamber. It is worthy of investigation whether judicious cleaning of the picture might not bring it forth in all its original splendour, but, if not, this portrait, which is of the most capital importance both for the intrinsic interest of the sitters and its attempts to bring three figures with all the luxury of their dress into one solemn architectural setting, must stand with the frescoes of the Vatican and the *Transfiguration* as instances where the very greatness of the effort has caused its own destruction.

Precisely the same fate has befallen the portrait of Giovanna of Aragon [236] which was painted in 1518 for the King of France, and for the same reasons, to which must be added that, like all the pictures by Raphael which were in the collection of Francis I, it has suffered the further injury of restoration. Here too the intention of the painter was to give the figure its place in and relief against an architectural background, and thus to produce the warmth and breadth of real light and space where formerly either the background had been left blank, or its features cold and as prominent as the principal personage. This tendency will be further considered before the subject-pictures in which it is exhibited, but the portrait of Giovanna of Aragon, with its rich detail of stuff and jewellery in the dress, its high light on the face and its colonnaded background with receding passages of light is, in its small scale, an admirable example of a novelty in treatment which was the origin and foundation of the whole of modern oil painting. It is principally indeed in this respect that the picture is noteworthy, for, beautiful as Giovanna's features are in themselves, her face shows something of hardness and want in comprehension, which is due, no doubt, to the fact that the picture was painted, as Raphael said himself, from a drawing by one of his pupils, and has not therefore the unity and the life of either his purely imaginary heads, or the portraits of men whom he knew. The hands also with their schematic elegance and the dress and accessories may have been, as Vasari states, executed by Giulio Romano.

Several other portraits are recorded to have been painted by Raphael, and several of all periods are ascribed by tradition, or attributed by critics to his hand. By far the most important of these is the bust of a woman in a white dress with a veil thrown back over her head and shoulders which is in the Pitti Gallery at Florence under the name of the *Donna Velata* [234]. Morelli first attributed the picture to Raphael partly on the strength of some documents which have not come to light. More still, the resemblance of the head to the type which Raphael chose for the *Sistine Madonna*, to the Magdalene of the *St Cecilia*, even, in his eyes, to the *Fornarina* of the Barberini palace, caused him to divine the hand of Raphael in a picture which he acknowledged to owe all but the head to some pupil, and the present state of the head itself almost entirely to the restorer. His attribution has been almost universally accepted by recent writers, who find with him in this picture the portrait of the lady who served as a model for his Madonnas, and whom, as a natural inference, they identify with the mistress spoken of by Vasari, and the 'Fornarina' of obscure tradition. Certainly the resemblance exists and the *beaux yeux* of this fine head may well have fascinated the most scientific of higher critics into forgetting the caution

of his method. But the resemblance between this head and that of the *Sistine Madonna*, apart from the hair and the veil, is less noticeable than that between the *Sistine Madonna* and such heads of the Virgin as those in the *Madonna of Foligno*, the *Madonna del Pesce* or the *Garvagh*. Moreover a resemblance in type is the very poorest of reasons for inferring a community of authorship, since a portrait showing a resemblance with a noted picture may very well have been painted by another man under the influence of the picture, and in the head itself in spite of the close parallelism of many of the forms with those of heads in Raphael's pictures, there is a want of structure in the modelling and a protrusion of the lips and eyes, which remove the picture, if not from the circle of Raphael's work, at any rate from the level of achievement reached in the *Sistine Madonna*. The likeness to the Magdalene in the *St Cecilia* is hard to discover—it is noticeable that the forms of the ear in the two heads are different—while even the divination which saw Raphael's hand below the work of the restorer is surpassed by the miraculous power of vision which found a likeness in the picture to the *Fornarina*. On the whole therefore it is necessary to suspend judgment as to the authenticity of the picture. If it be Raphael's, it is at any rate necessary to beware of identifying, as a portrait of any lady whom tradition may have coupled with his name, a head which, as it left his hands, can only have been a sketch upon a panel without body or hands.

A strange feature of this picture is that the general position of the body, and in particular the attitude of the hands, are repeated in other contemporary portraits of women. The *Dorothea* of Berlin, which was once assigned to Raphael, and now rests more securely under the name of Sebastiano del Piombo, not only shows these details in common, but also has some decided resemblance in the features of the face. Direct imitation of Raphael would not be surprising in Sebastiano, but such fidelity to the creation of a pupil—for the hands and dress of the *Donna Velata* cannot on any hypothesis be credited to the same painter as the face—is almost unthinkable. As far as it goes this resemblance suggests the existence of a common prototype, and this theory derives more probability through the repetition of the attitude in the *Fornarina* in the Barberini Palace [235], which, though it is inscribed with Raphael's name, and therefore has secured itself a better pedigree than any other painting by Raphael not mentioned by Vasari, is rejected from the list of Raphael's work by the common instinct of every layman and critic. Even in the seventeenth century Fabio Chigi found the lady ugly. She is more than that. Whatever the painting may have once appeared before the background of green leaves and the touch of a sky in the right-hand corner had become discoloured into an uniform black, it now shows nothing but a repulsive hardness of feature, outline and expression, with no touch of delicate painting save in the right arm and hand, and in certain passages of the breast and abdomen. Nothing could be less plausibly attributed to Raphael. Yet as the whole picture remains unexplained and entirely foreign to our taste, it is impossible either to reject it as not his or to assign it to any other painter. It always remains possible that he painted it in some mood or as some experiment which has failed to make itself clear in the painting, and until the cause of the strange phenomenon has been explained it must remain as an isolated anomaly. Certainly the attribution to Giulio Romano—*facilis descensus* of every writer upon Raphael—is not convincing, at any rate not if the somewhat similar picture in the Hermitage, which was also once given to Raphael, is his, as the complete resemblance to his other work would suggest. But it is quite possible that the whole mystery of the picture is due to no other cause than to the inferiority of the painter, and he may have been one of those converters of well-known portraits into nude figures who were responsible for the repeated versions of the *Mona Lisa* as a leering courtesan, undraped. In that case the prototype of both this and the *Donna Velata*—for the two pictures are connected not only by the attitude of head, shoulders, and arms, but even by so significant a detail as the hanging jewel in the hair—must be sought for in vain among the pictures that are now lost.

The attribution to Raphael of the many other portraits which exist under his name, or their definite rejection, depends entirely upon the general conception which each critic forms as to his character and development as a painter. Such heads as that of the *Violin Player* in the Rothschild collection, or the traditional *Fornarina* of the Uffizi [237] are now confidently dismissed from the catalogue of Raphael's works and assigned to Venetian painters, preferably Sebastiano del Piombo. But the general voice of tradition which persists in assigning to Raphael portraits of a Venetian character is not to be disregarded so lightly, and if once a slight alteration in the current view of Raphael were accepted, and something more of a Venetian moment were hypothetically admitted in his history, the balance of evidence would again turn the scale against Sebastiano, and these pictures would return with a rush to Raphael. Certainly the two men worked in a common circle of ideas for long, and the influence of Venice upon Raphael, which may be observable in the change of style during the painting of the Heliodorus rooms, may be attributable either to his influence, or to that of the many other Venetians whose work was known to Raphael. Giovanni da Udine came to him from Giorgione's side, and is credited by Vasari with the superbly coloured and richly-toned accessories in the altar-piece of *Saint Cecilia*, and it is impossible that the close friend of Titian's patron, Bembo, could have been unacquainted with Venetian portraits. His pupils went to Venice for the colours, and he who searched in Roman grottoes and among Greek ruins, corresponded with German artists, and found everywhere lessons to be learnt in the furtherance of his art, is not likely to have overlooked the fact that more than the raw pigment could be found in Venice. Certainly, while his combination of colour with chiaroscuro was not a lesson learnt from Venetians but rather a development of Leonardo's practice which he in turn imparted to Venice, his essays in the simpler effects of harmonious colour such as that of the portrait of Castiglione or the *Sistine Madonna* seem based on Venetian models. If that is the case he may well have exhibited at times a liking for Venetian forms which was not confined to the colour alone, and among the innumerable portraits which issued from his studio more or less as the work of his hands many may have shown such approximation to Sebastiano's type as that of the *Violin Player*.

It is quite possible that the link between Venice and Raphael required on this hypothesis may be discovered in a practically unknown portrait at Petworth [238]. It is the head of a youth traditionally described as a portrait of Guidobaldo of Urbino, and is stated to have been bought about the beginning of the nineteenth century from the Albani collection of that town.* It shows a head and shoulders turned slightly to the left (of the picture); the man is clothed in a black hat, a black dress open at the neck, and a white frilled shirt. There is a gold button on the dress and three more on the hat, and the one hand is placed at the breast and wears a grey glove. The background is green. The definitely Raphaelesque character is the attitude of the eyes which look straight at the spectator from the half-averted face, exactly as do those in the majority of his portraits and in the *Violin Player*. This characteristic is here joined to the long upper lip, which in the *Violin Player* is taken to be a mark of Sebastiano's manner, although such a feature may well be characteristic of the model rather than of the painter, and Raphael's own practice could vary from the thin lips of the *Cardinal* of the Prado to the full and protruding lips of Giulio dei Medici in the *Portrait of Pope Leo*. None of these characteristics, however, would suggest Raphael to be the author of the picture were it not for the traditional ascription and for a further fact which corroborates the generally Raphaelesque appearance of the picture. The description of the sitter as Guidobaldo is obviously incorrect, but the head has sufficient likeness with that of the standing youth in the *School of Athens*, which has been traditionally identified with Guidobaldo's

* A marginal entry of Oppé's of 1920 here notes: 'No. Francesco Maria della Rovere. Picture bought from Ozias Humphry who bought it, as such, in Italy. Correspondence in vol. VI, 48 etc. of the letters at the R.A.'

successor, Francesco Maria,★ to make it not impossible that the name of the Duke only is wrong, and that the picture is a portrait of Francesco painted by Raphael in his early days at Rome. It is far from the purpose of this book to attempt to lay down such an hypothesis as a fact, but if the picture should be accepted as justifying the theory—and no proof but acceptance is possible—no little progress would be made in following the course of Raphael's development. In any case, it is among the so-called Venetian portraits that lost Raphaels will probably be found. The game of 'attributions' is at present pleasantly occupied with pictures of the primitives who answer readily to its conventions and laws. But when it is played with pictures of a later date it will be among the portraits of Raphael's school which are scattered through galleries and private collections that some of the hottest contests may be most confidently expected.

15

The true opportunity for the full expression of Raphael's Roman art would most naturally have been afforded by large subject pictures which he could have painted in oil. Fresco gave the necessary largeness of scale, but the rapidity of execution which it demanded, the summary methods required by its medium, prevented it from being accomplished with the refinement of touch and the depth of light and colour which are noticeable in certain of the simpler Madonna groups and in the portraits. This fact was well known to Raphael and his contemporaries, but instead of abandoning fresco as a medium, they devoted their energies to engrafting upon it the means and methods of oil painting. Something of an experiment in this direction is already to be noted in the Sala dell' Incendio; the hall of Constantine was to have been completely painted in oil, while in the church of San Pietro in Montorio Sebastiano did actually carry out a wall-painting entirely in the new medium. If the large *Triumph of Bacchus* which Raphael had promised to paint for the Duke of Ferrara and was upon canvas had ever been executed, it might have filled the gap. But as it is, the lesser commissions for altar-pieces were somewhat disregarded, and they now exhibit as many shortcomings through the execution of pupils insufficiently supervised by the master, as the frescoes have suffered through the ill effects of time. Nor has time spared these since, as in the case of the portraits of Leo and Joanna, some, and those the most characteristic, have lost as much through discoloration as even the frescoes. The greatest of all, the one picture in which Raphael was to have summed up the whole course of his power at this date, the *Transfiguration*, has suffered in this respect almost as much as it has through the untimely death of the painter which left it incomplete.

One of the easel pictures, uncertain in its date, but painted for the Count Vincenzo Ercolani of Bologna, appears from its general character to be the reproduction on a small scale of a design intended for a fresco. This is the *Vision of Ezekiel* now in the Pitti Gallery [XIV, 241], a small picture whose miniature technique and opaqueness of colour go far to destroy its true qualities. Malvasia, the historian of artists at Bologna, states that the price paid to Raphael for the work was eight ducats.[1] If this be not as much an error as the date (1510) which he assigns to the transaction, the smallness of the price would go to show that the picture was not regarded as an independent work but only as a coloured sketch. But as it is, even the smallness of the scale cannot hide the greatness of the conception, and, hard

[1] *Felsina pittrice*, I, 44. For the coloration of drawings see the letters of the Bishop of Adria to Alfonso d'Este (quoted above) of 21 September 1518. Raphael prays the Duke not to have the cartoon of the St Michael coloured.

★ A second marginal note of Oppé's, undated, here reads: 'See above. This was noted at the time. O[zias] H[umphry] had a copy made of the fresco.'

though the colouring may be, it is quite sufficiently capable to serve its main purpose of giving light, shade and solidity to figures which require these qualities above all others for their comprehension. Relief is of the essence of this composition, for the directions of the lines, the incidence of light and shade, the disposition of the masses, all make up a solid pyramid of interlacing figures which floats high above a broad landscape and is set within a bold and luminous sky. This is a fitting pedestal for the towering figure of the deity, whose forms have all the majesty which classic art had found in the maturity of man, and whose head has a benignity such as both mediaeval and classic art combined in attributing to supreme omnipotence. Few compositions could stand the strain of reproduction upon a colossal scale, but this design could cover satisfactorily by itself even so prominent and immense a field as the east wall of the Sistine chapel. With the grandeur of its forms and the freedom of the movement, together with the depth of its relief which is necessary for the full display of these qualities, the picture is an embodiment of the 'Grand Style' such as, with the exception of Michelangelo's creations, no other painting can present, for in it alone the subject is adequate to the manner of the representation.

A comprehension of the relief of the picture is again required for the proper understanding of the altar-piece showing *Saint Cecilia among attendant saints* [240]. Here some repainting and discoloration, but more still the removal of the panel from a dim chapel lit by a light above to an open gallery have obscured the effect of concentrated space, which is the first visual quality of the picture. The large size and heavy shadows of St Peter and St Magdalen afford the necessary key, and if they are not enough to bring the eyes to the proper focus, the cunning introduction of the black eagle where a deep shadow is required should be sufficient. With these preliminary steps made clear—and so much have modern eyes become accustomed to the comparative flatness of Quattrocento art, that these details demand explanation—the way is set free for the direct appreciation of the more obvious qualities of the picture, the grandeur of St Paul—recalling both the *Disputa* and the tapestries—the refined head of St John, and the ease of pose and rapt expression of St Cecilia herself. Much of Peruginesque tradition remains in her upturned gaze; she is indeed a later and richer counterpart of Raphael's own *St Catherine* [IV, *88, 89, 90–92*] in the National Gallery, and there is more than a little of Perugino's arbitrary arrangement and lack of unifying action in the group of figures. But all that colour and form could lend to increase the force of the figures, and all that light and shade could do to bring the actors into a unity of real vision, have been brought into the picture from Raphael's richer art. Qualities which marked off his *Coronation of the Virgin* from Perugino's treatment of similar subjects are here brought to fruition; and, since the faults of the picture are common both to him and to his predecessors, the virtues which mark his advance can be observed in this place more clearly than in other works where they are joined to qualities which are foreign to the earlier painters. Nor is it alone in the principal figures that Raphael is his true self here. The instruments in the foreground, richly toned and fluid in surface without bright or emphatic colouring, may be, as Vasari says, the work of the Venetian, Giovanni da Udine. The blue sky has apparently suffered repainting which has destroyed the whole of its quality and gone far to ruin the atmospheric effect of the whole picture, but the choir of angels above, though somewhat damaged, shows how completely Raphael could preserve the graceful movements and choice imagination of an earlier epoch while adding the new qualities of free open action and fluid transparent colour.

The greater number of altar-pieces commanded from Raphael had for their subject the Holy Family with attendant figures from their immediate circle. These pictures fall into two groups, according as the figures are represented as standing in the open air or within a chamber. The pictures of the Prado called *The Pearl* [242], and the *Holy Family under the Oak* and the *Little Holy Family of Francis the First* at the Louvre [247], belong to the first group; the *Madonna dell' Impannata* of the Pitti [244, *245, 246*]; the

Madonna of the Rose and the *Madonna del Divin' Amore* [248], which occur in many repetitions, and the *Large Holy Family of Francis the First* [243] belong to the second. In either group the main characteristic is the full pictorial treatment of the scene; in the one the deep, carefully composed landscape, with its light and shade on foreground and on broad hill, river and forest behind; in the other the rich shadow of the interior, with its light penetrating through a window and falling upon the heads and drapery of the figures within. Schemes which were as old as Italian art were rethought in terms of actual atmosphere and space, and the careful composition and choice of effective incident which had marked the earlier attempts to group the figures, the accessories, and the features of the landscape, were here employed again in the new medium and with greater wealth of effect. The pictures are the culmination of a tendency which had already shown itself in Raphael's Florentine period, the *Impannata* showing a transition stage from the comparative coldness of the *Orleans Madonna* to the warmth of the *Divin' Amore* and the landscape compositions following in unbroken series from the Perugian to the ripest Roman days. The warmth of colour and the depth of the effects of light and shade enter with the Heliodorus fresco, and show perhaps the combination of some Venetian influence, such as is observable in the portraits, with the sense of dramatic relief, of chiaroscuro, which was foreign to Venice at that time, and is merely a development of a true Florentine tendency which found its most powerful expression in the work of Leonardo.

In both groups there is a further common characteristic in the air of excessive animation, and in the restless uneasy lines of the figures. The suave flowing lines and equable dignified poses which are the mark elsewhere of Raphael's more characteristic pictures are here present only intermittently, and are drowned among the busy limbs and tortured drapery. To a very great extent this feature is due to the discoloration of the pictures, and to repainting, which have, as in the portrait of Leo X, thrown the shadows and the lights out of relativity, and produced discords of tone where, clearly, the uttermost delicacy of gradation was intended. But these causes are not alone. The restless animation which shows itself principally in the figures of the children, in the disposition of the Madonna's legs and, in the *Large Madonna of Francis the First*, in the figures of the two attendant angels, is a studied effect springing from the essential conception of the groups. Here again there is no new development, such as is commonly and superficially supposed, of Raphael's latest and more careless days at Rome. The *Madonna of the Lamb*, with its date of 1507, is not very secure evidence of the existence of these characteristics in the earliest Florentine days. But there are not only sufficient traces of this restlessness of pose in the *Canigiani Madonna* and others of Raphael's authentic work to show that the tendency was permanent in Raphael himself, but also, as has been said in connection with these works, it was so constant a feature in preceding art, both at Florence and Perugia, that it was natural and even necessary in its occurrence in Raphael's style. To make the Madonna and her attendants appear living, and to give her the graces of the human body in motion, was the whole object of one important school of Italian painting, and, though Raphael could impart life without apparent effort in the quiet ease of his figures, he necessarily attempted the more varied effects of his predecessors and contemporaries. A considerable touch of floridity was always a mark of the Italian taste, and lively over-emphatic gestures are as proper to the inhabitants of the southern countries as they are repugnant to the northern. Possibly had his life been longer Raphael might have discarded as unnecessary the air of troubled vitality, and have been content to pursue, in the direction already shown in the *Perla* and the *Divin' Amore*, the effort to construct a living group with the quietness and dignity of his single figures, but as it is, he was still accepting without question the ideas and conventions of his age. No stronger illustration of unmeaning activity will be found than the two attendant angels in the *Large Madonna of Francis the First*, one of whom

stretches over St Elizabeth to crown the Madonna with flowers, while the other bends with crossed hands and looks with adoring eyes out of the picture. Yet both of these are merely conventional figures: the latter recalling a work of Leonardo, the former being nothing more than an extension of the crowning angel who was placed as a matter of course in Botticelli's tondos and in hundreds of other compositions of the Quattrocento. Apposite there, because the whole conception is imaginary and outside all place and time, these figures are unnecessary intrusions among the general realism of Raphael's work, and they would, in all probability, have been flung out of the picture by the logical force of Raphael's imagination, just as the saints of the *Madonna di Foligno* were crushed out of the *Sistine* by the power of the central figure, had the conception of the Holy Family ever reached with Raphael the ultimate expression which was given to that of the Madonna in Glory.

Discoloration and repainting detract also from the effect of the *St Michael* of the Louvre [249], in which passages only of delicate fluid colouring in the flesh and much force in the painting of Satan and the background remain to show that originally the picture, which was for over a year on the stocks in Raphael's studio, was no careless production of other hands. This picture, like the *Holy Family* of the same period, is a striking instance of the persistence of Raphael's ideas, and of the changes in visual conception which his ideas underwent during so short a period as seventeen years. The over-graceful figure of the young saint, delicately poised over his recumbent foe, is essentially the same in idea as the boyish *St Michael* who stood over the dragon in the dry early picture, against a background of naïvely-painted burning houses and blissful souls. In this development there is shown the whole advance from the art of the Quattrocento to that of the high Renaissance, the substitution of flesh and blood for a doll-like figure, and of full depth and atmosphere for the mere suggestion in coloured outline of landscape and accessory. One of the abiding features is the touch of floridity which, present only as a mere decorative element in the largely lineal composition of the earlier picture, becomes oppressive and theatrical when joined to full realisation of the human form.

Of the other easel paintings which belong to this period, the *Christ bearing the Cross* of the Prado, commonly called 'Lo Spasimo di Sicilia' [252], is remarkable chiefly for the pathos of the kneeling Christ, a figure said to be inspired by an engraving of Martin Schongauer. It would be interesting to trace German influence not only in this figure and in the crowded restless composition of the group, but also in the over-expressive and somewhat ugly men's faces in this and kindred pictures, and to carry the influence further back to the days of Raphael's youth when Justus of Ghent may have appeared to him as the dominating personality in the Castle of Urbino. But space does not permit of this, and it is enough to note that in this picture crude colour betrays repainting or the hands of assistants; and the restless composition, which now detracts from, instead of emphasising, the figure of Christ, tells not so much of hasty composition, as of a spatial construction which time has ruined. Yet this picture was almost certainly careless in its composition, for figures are repeated from the *Deposition* and the ceiling of the Stanza della Segnatura, and the landscape, which is dry and peopled with small clear-cut figures, is a strange return to the methods of the Peruginesque period. On the contrary, the picture of the *Visitation* (Prado also) [250] shows, like the late Holy Families and the *Madonna del Passeggio*, a rich landscape, thoroughly thought out and composed, while the figures, with their bald haphazard presentation, are as independent of their background as were any of Perugino's worst.[1] The head of the Virgin in this picture is the exact counterpart of that of Giulio Romano's *St Margaret* at Vienna, a picture which shows such resemblances with and divergences from the same subject in the Louvre [251]

[1] Contemporaries were more easily satisfied that this was a work of Raphael. On 2 April 1520, the town council of Aquila—where the picture was—forbade, by decree, any painter to make a copy of it (Pungileoni, *Raphael Santi*, p. 120).

that they may be taken as excellent examples of the methods of reproduction employed among Raphael's pupils at this date. Both these pictures, with the *St John* [254] of which similar variants occur, show the same preoccupation with the effects of a strong light upon the figure against a dark background of hill—one patch of clearer light in the corner—as was to be observed in the Holy Families and in certain of the portraits (the *Fornarina* and *Giovanna of Aragon*). This preoccupation, together with the figure of St John, proves how powerful in its influence upon Raphael was the example of Leonardo.

16

All the qualities possessed by these easel pictures together with the greatest of the virtues of the tapestries and frescoes were to have been summed up in one oil painting. The *Transfiguration* [256, 257–272], painted by order of Giulio dei Medici for a church in Narbonne, should have been the epitome of Raphael's art when freed from the restrictions of fresco technique and the smaller scale of easel paintings. Such indeed it appeared to his contemporaries, but now, through the accident that Raphael's death left it for completion by his pupils, and through the ill effects of time, it stands so much an epitome of all the hostile influences which beset the work of Raphael's later art that more thought and sympathetic reconstruction than is usually given to it in these days must be expended for its true appreciation.

The subject of the picture is taken almost literally from the Gospel of St Matthew. While Peter, James, and John attended Jesus upon a high mountain and there beheld Him transfigured in a white light, holding talk with Moses and Elias, the other disciples were striving below in a vain endeavour to heal a stricken boy of the possession of a devil. The two actions are synchronous in the Holy Story, but they are separate. Possibly painters had already placed the two scenes in juxtaposition; Raphael's characteristic power of unification saw the action immediately as one. As in his early picture of the *Coronation*, as, perhaps, in the fresco of San Severo, certainly, in the *Disputa*, he brought heaven and earth, which had before been separate, into one vast unity of space and interest. All that he had learnt of concentration and of drama in the decoration of the Stanze and in the tapestries was expended in the grouping of the figures below, and the lessons of the *Sistine Madonna* and the *Ezekiel* went to the making of the glory in the heaven above. One scene embracing heaven and earth, a space as wide as the firmament and figures as noble as traditions of classic and modern art could bring into being—these were the elements of Raphael's conception and the worthy epitaph to his own life.

Consideration of the picture must be prefaced with a clear statement that to look for Raphael's hand and inspiration only in the figures of Christ, Moses, and Elias, and to dismiss the remainder as the work of assistants, is to miss entirely and completely the whole intention and purpose of the picture. Nothing but the assumption that the clear tones of the *Sistine Madonna* and the *Castiglione* portrait are the only true and characteristic mark of Raphael's skill is responsible for the conclusion, and this assumption is due to a failure to understand one side of Raphael's genius and therefore to misinterpret the whole of the *Transfiguration*. The secret key of the picture is not in the figures illumined by the supernatural light above, but in the heads and draperies of the Apostles on the left below. Raphael was, according to the tradition, painting this picture in direct emulation of Sebastiano del Piombo, whose *Raising of Lazarus*, the companion to this picture, is now in the National Gallery [255], and there is every sign in Sebastiano's correspondence that, if the story of a direct competition told by Vasari is an exaggeration, the rivalry between the two painters was acute. Yet the pictures have so much in common that the

rivalry was clearly not one of entirely hostile methods of art. Sebastiano shows an attempt to reproduce large spaces by means of figures diminishing in the landscape similar to that of the right-hand corner of the *Transfiguration*, and his direct imitation of Raphael's *Disputa* in certain figures in the centre proves that he desired to adopt all his rival's methods in his attempt to defeat him. It is in other elements that the two painters chiefly competed. Raphael desired to give an exhibition not only of grouping, movement, and wide space, but also of the solid and brilliant delineation of form which was the truest characteristic of Florentine tradition, and the sharpest contrast to the sketchy and structureless creations of Sebastiano's superficial skill. The heads of the Apostles on the left are therefore carefully and firmly modelled with the high lights and well-marked shadows which belong to Leonardo's art. They are the counterparts of such portraits as that of Navagero and Beazzano, and, with their firm but brilliant draperies, carefully shaded, and falling in broad folds, they recall the careful painting and the exquisite modelling of Leonardo's *Virgin of the Rocks*. The blue cloak of one of the Apostles with the ivory light upon his face is by itself a proof of the direction in which Raphael's mind was working at this time.

This corner of the picture gives a further clue to the original intention which only the darkening of the shadows—Raphael's universal bane—has caused to require explanation. The dark background, which was much less dark originally, was meant to act as a counterfoil to the high lights, after the manner, again, of Leonardo, and in the method which Raphael had used in many pictures. The right-hand corner, with its dip in the mountain and its view of sky and landscape, is exactly similar to that of the *St John*. But the main light falls from the supernatural radiance of the bright cloud and strikes more boldly upon the figures of the Apostles as they advance into the foreground. Still tightly painted, with clear emphasis upon each detail of form and drapery, these figures form a vivid foreground, and by their gradual disappearance into the darkness they construct steps of atmospheric values into the brilliance of the upper figures. Nor do their attitudes contradict the essential effect of relief which everything in their lighting and colour is intended to produce. The motive of the repeated arms had been used before by Raphael in the *Deposition*, and in the rows of figures which he placed in tapestries and frescoes, but never with such an effect as here, where it combines with light and shade to carry the eye from the nearest foreground into the centre of the picture. The figures on the right are those which are the least successful, those in the background being perhaps entirely the uncorrected efforts of his pupils, and, strangely enough, coming nearer to Sebastiano's manner than to that of the remainder of this picture. The figure of the father is overstrained, while the mother appears artificial with the reminiscences in her classic pose of the foremost woman in the fresco of *Heliodorus*. But even here, if Time had not darkened all the shadows, the figures would fall so naturally into their place in the general scheme of the picture that it would be superfluous to enquire whether they were the work of Raphael himself or of his pupils. The look of anguish and despair in the father's eyes and the agony of the possessed boy would be not a whit too powerful if the eye swept naturally through the group between the superb figures of the Apostles and the radiance of the space above. But, as it is, even the foreground has become darkened until the tree stump and the once luminous water below the figure of the Apostle in the corner are almost as dark and dead as the shadows of the hill. It is no wonder that the picture falls now into two distinct halves—and the surprising unity of the conception which was remarked by Goethe has so far vanished that at the first view only the dignity and tenderness of a few heads are apparent in the general disruption of the picture—nor that critics can fasten upon fragments and quarrel over their attribution among Raphael's various pupils without reference for a moment to the spirit and intention of the whole.

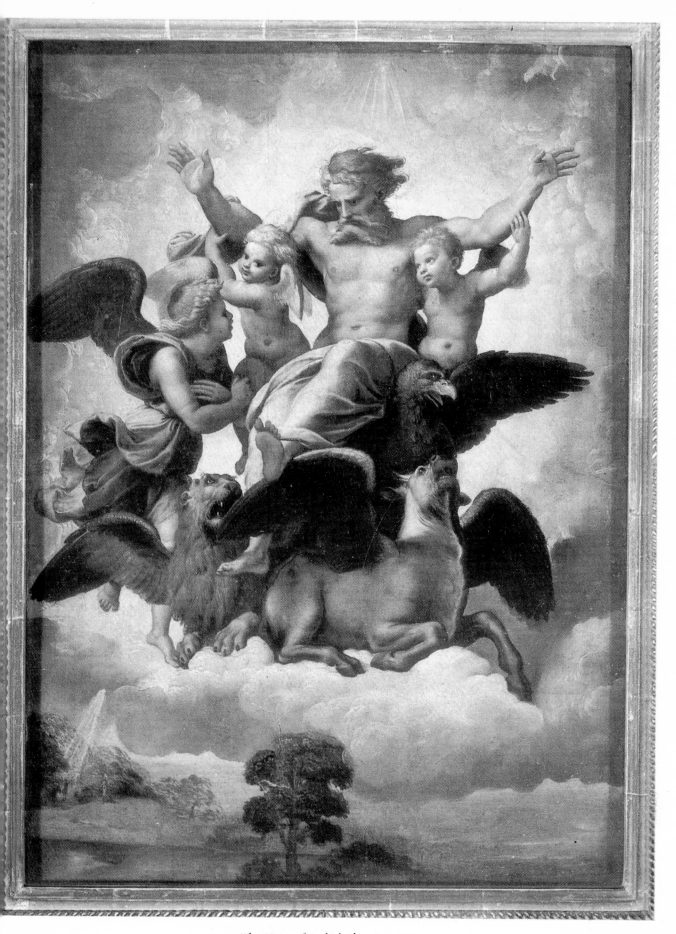

XIV The *Vision of Ezekiel*. Florence. 40 × 30.

But the unity of the picture, once seized by the spectator, becomes the greatest and most resounding note of Raphael's entire achievement. It would be in some respects more appropriate to his genius were his final and consummate work one of those scenes of quiet and general splendour which show his happy temperament in its fullest expression. The *School of Athens*, the *Sistine Madonna*, and the *Portrait of Castiglione* are therefore in many ways the supreme note of Raphael's achievement. But the *Transfiguration* has its centre in such a scene as this, and there is in the picture, besides, the sense of contrast and concentration and the dramatic employment of light and shade which are no less part of Raphael's full genius. Nor is it without a general appropriateness and the necessary note of tragic sadness that the crowning work of Raphael's busy and happy life should have been cut short before it reached completion; that Death should have introduced a jarring strain into the full web of his imagination, and Time dealt hardly with a creation which was too perfect to endure.

Little is known of Raphael's life save for the evidence of his pictures, but those who know Rome—and they alone know anything of Raphael—can feel that when he chose the Pantheon for his last resting-place he was embodying in his choice the full expression of his life and his desires. In the splendour of light radiating through the circles of an expanding dome, in the simplicity of a brilliance proceeding through a single opening from the sky above, and led by cunning steps of shadow and light along the concave walls until it brings the simple circular floor into the likeness of a world as wide as the great heaven above, there is the symbol of his whole nature. Spaciousness, unity, and totality are there; an evenness of temperament that led to an admiration of all that could be admired, and an effort towards a simple comprehensive ideal which would resolve all doubt and multiplicity into an all-embracing universe of perfection. This is the ultimate appearance; but if the dome of the Pantheon is examined more closely, it will be found that the large and simple impression is produced not by the presence of simplicity itself, but by the most skilful use of the most complex means. The rounded canopy of the roof is no pure dome at all, for if it were it would not so appear. It is so small and squat an edifice that from outside it shows no line or mass such as would give a hint of the magnificence within. The whole effect is produced by the subtle use of diminishing panels, each of which is set in a moulding of such varying depth that the light from the orifice at the top cuts across each diagonally, and forms lines of light and shadow which sweep in converging curves from the springing of the dome to its summit. Thus, by subtle knowledge of light and shade the impression of a perfect circle is produced, and within a restricted and ignoble space the art of man has created the image of the most majestic work of nature, the enveloping firmament of earth and sky.

Generations of experience were needed to arrive at the degree of knowledge which was required for the production of this effect, and it needed the supreme glory of Augustan Rome to inspire men with the desire to make use of this experience, and to find expression for their emotion in this architectural form. Similarly Raphael needed the labours of earlier men to lead up to the apparent ease and simplicity of his, in fact, most complicated achievement, and he required for his conception of unity and perfection the proud happiness and glory of the great days of Papal Rome. Alike in this, also, to the perfect sphere of the Pantheon, it is an illusion, this universe of his, in which great men move greatly among magnificence, and large palaces cover their heads from day, or their eyes sweep over broad landscapes in which hills and trees fall into well-proportioned masses and large spaces of light and shade; where colour is clear in its harmony, and form is strong with elegance, and there is no doubt nor indecision, no trouble nor despair. It is an illusion of a great mind moving and living among great minds at one moment in the world's history when there was unity among men. It is an ideal born of

10—R

misunderstanding, but it is a monument not only of a happy moment when Papal Unity seemed, to some few at least of those who lived at the day, the solemn realisation of all that was good and powerful upon the earth, when Christianity and Paganism seemed to combine in one fine harmony of truth and beauty, but it is also, and in this aspect it is no way superficial, a realisation of men's longings and aspirations throughout the struggles and distress of life. Incomplete as the content of the idea may be, imperfect as it is as a picture of the whole of life and of all activity, its form and its endeavour, its freedom and, above all, its essential and permeating happiness are true and everlasting. Michelangelo or Signorelli do better in their glorification of turmoil, distress, or horror, to remind us that when Raphael worked the Papacy was throwing away, through its splendour and luxury, the sympathies of great and grave minds, and alienating from itself all that was freshest and most full of promise in European life; they may hint of the forces, both within the Papacy and without, which were destroying it, and bringing the foreigner into Italy and within the walls of the city itself. Already in such pictures as the *Transfiguration* there is a jarring note, as of failure to bring hostile elements into the general unity of a conception. But in his most characteristic work Raphael was unconscious of the future, and regardless of the evil already present. There seem to be times in the life of nations as in the life of individuals when the greatness of the power and glory blinds with its own serenity and magnificence, when the soul, expanding until it seems to be conterminous with the whole universe, takes no care of the powers around it and above, and through its vices and weaknesses, which seem to be its glory, falls heavily, though no man strikes the blow. If such a man could sing the paean of his greatness, his song would be the picture which Raphael drew of Rome, and though it would be fraught with irony and incompleteness for those who knew the story, it would remain the one great expression not only of human but of universal grandeur which the world has seen.

BIBLIOGRAPHY

1. *Select bibliography* (1909)

A complete bibliography up to 1883 was published by Eugène Müntz in *Les historiens et critiques de Raphael*, Paris, 1883. The recent bibliography of each picture and drawing may be found in the works of Gronau and Fischel quoted below. This list only includes the most important and comprehensive works upon Raphael, or works valuable for the documents contained.

Paolo Giovio. *Raphaelis urbinatis vita*. First printed by Tiraboschi, *Storia della letteratura italiana*, IX, Modena, 1781.

G. Vasari. *Le vite*, ed. Milanesi, Florence, 1878–1885.

J. P. Bellori. *Descrizione delle immagini dipinti da Raffaello d'Urbino nelle camere del Palazzo Apostolico Vaticano*, Rome, 1695. With this may be quoted the seventeenth- and eighteenth-century guides to Rome by Filippo Titi [cf. L. Schudt, *Le guide di Roma*, Vienna-Augsburg, 1930, nos. 280–85] and Agostino Taja (*Descrizione del Palazzo Apostolico Vaticano* [Schudt, no. 1042], Rome, 1750). Their information is included in the *Beschreibung der Stadt Rom* [by Ernst Platner and others], Stuttgart, 1835. Most valuable for indications of restorations, etc.

A. Comolli. *Vita inedita di Raffaello da Urbino*, Rome, 1790. A valueless compilation from Vasari. The notes alone are useful, especially as a guide to the earlier literature.

C. Fea. *Notizie intorno Raffaello Sanzio da Urbino*, Rome, 1822.

Quatremère de Quincy. *Histoire de la vie et les ouvrages de Raphael*, Paris, 1824. Valuable as summing up the traditional knowledge of Vasari before the documentary discoveries of Pungileoni and Campori.

L. Pungileoni. *Elogio storico di Raffaello Santi da Urbino*, Urbino, 1829. Gives for the first time the documents from Urbino. See also his *Giovanni Santi* (1822) and his *Timoteo Viti* (1835).

J. O. Passavant. *Raffael von Urbino und sein Vater Giovanni Santi*, 3 vols., Leipzig, 1839–1858. Revised French edition, 2 vols., Paris, 1860. [English transl., London, 1872.] Remains the foundation of all modern study of Raphael.

G. Campori. *Notizie inedite di Raffaello da Urbino* (Storia Patria . . . per Modena e Parma, I, 1863). French translation, *Gazette des Beaux-Arts*, I, 347ff., 1863.

——*Notizie e documenti per la vita di Giovanni Santi e di Raffaello Santi* (ibid., V, 1870). French translation, *Gazette des Beaux-Arts*, II, 353ff., 1872.

F. A. Gruyer. *Raphael et l'antiquité*, 2 vols., Paris, 1864.

——*Essai sur les fresques de Raphael au Vatican*, Paris, 1858.

——*Les vierges de Raphael*, 3 vols., Paris, 1869.

——*Raphael peintre de portraits*, 2 vols., Paris, 1881.

A. Springer. *Raphael und Michel Angelo*, Leipzig, 1878. The third edition (1895) remains the standard German life of Raphael.

Eugène Müntz. *Raphael*, Paris, 1881. Several later editions in French and English. To be consulted as a picturesque account of Raphael and his times.

——*Une rivalité d'artistes au XVI siècle*, Paris, 1882.

——*Les historiens de Raphael*, Paris, 1883.

Eugène Müntz. *Les tapisseries de Raphael*, Paris, 1897.

J. A. Crowe and G. B. Cavalcaselle. *Raphael*, 2 vols., London, 1882–1885. Biased, unattractive, and unnecessarily long, it persists in holding its place through the completeness of its information.

O. Fischel. *Raphaels Zeichnungen. Versuch einer Kritik*, Strasbourg, 1898. Invaluable as a catalogue of the drawings and a guide to the literature of the subject.

G. Gronau and A. Rosenberg. *Raphael* (Klassiker der Kunst), fourth ed., Stuttgart, 1909. The notes give an excellent summary of modern opinion regarding each picture.

II. *Select writings since* 1909

The most useful guide to the modern literature is Dussler's critical catalogue (1966) of the paintings, murals and tapestries which contains both a comprehensive general bibliography and a special bibliography along with the discussion of each particular work. This must be consulted to follow the movements of modern Raphael scholarship, much of which is recorded in articles rather than monographs. Accordingly, while the following short list is (I hope) fairly synoptic, it cannot be fully representative.

O. Fischel. *Raphaels Zeichnungen*, I–VIII, Berlin, 1913–1941.

A. Venturi. *Raffaello*, Urbino, 1920, Milan-Verona, 1935; Milan, 1952.

V. Wanscher. *Raffaello Santi da Urbino*, London, 1926.

G. Gronau. *Raphael* (Klassiker der Kunst), fifth ed., Stuttgart, 1923.

C. Gamba. *Raphael*, Paris, 1932.

T. Hetzer. *Gedanken um Raffaels Form*, Frankfurt a/M, 1932; 1957.

O. Fischel. 'Santi, Raffaello', in Thieme-Becker, *Allgemeines Künstlerlexikon*, XXIX, Leipzig, 1935 (bibliography).

V. Golzio. *Raffaello nei documenti, nelle testimonanze dei contemporanei, e nella letteratura del suo secolo*, Vatican City, 1936.

O. Fischel. 'Raphael's auxiliary cartoons', *Burlington Magazine*, LXXI, 1937, 167–8.

S. Ortolani. *Raffaello*, Bergamo, 1942; 1946; 1948.

A. P. Oppé. 'Right and Left in Raphael's Cartoons', *Journal of the Warburg and Courtauld Institutes*, VII, 1944, 85ff.

U. Middeldorf. *Raphael's Drawings*, New York, 1945.

D. Redig de Campos. *Raffaello e Michelangelo*, Rome, 1946.

J. Hess. 'Raffael and Giulio Romano', *Gazette des Beaux-Arts*, sixth series, XXXII, 1947, 73–106.

O. Fischel. *Raphael* (English translation, with bibliography, of the 1936 German text by B. Rackham), London, 1948; German text, Berlin, 1962.

A. E. Popham. *Italian Drawings . . . at Windsor Castle*, London, 1949.

D. Redig de Campos. *Le Stanze di Raffaello*, Florence, 1950.

J. Pope-Hennessy. *The Raphael Cartoons*, London, 1950.

W. Suida. *Raphael*, London, 1951.

R. Longhi. 'Percorso di Raffaello giovane', *Paragone*, May, 1955, 8ff.

M. Putscher. *Raphaels Sixtinische Madonna*, Tübingen, 1955.

E. H. Gombrich. *Raphael's Madonna della Sedia*, London, 1956.

E. Camesasca. *Tutta la pittura di Raffaello: gli affreschi*, Milan, 1956; 1962.

——*Tutta la pittura di Raffaello: i quadri*, Milan, 1956; 1962.

K. T. Parker. *Catalogue of . . . Drawings in the Ashmolean Museum*, II, Oxford, 1956.

H. Biermann. *Die Stanzen Raffaels*, Munich, 1957.

W. Schöne. *Raphael*, Berlin-Darmstadt, 1958.

J. White and J. Shearman. 'Raphael's Tapestries and their Cartoons', *Art Bulletin*, XL, 1958, 193ff. and 299ff.

F. Hartt. *Giulio Romano*, New Haven, 1959 (with J. Shearman's review, *Burlington Magazine*, CI, 1959, 456ff.).

S. Freedberg. *Painting of the High Renaissance in Rome and Florence*, Cambridge, Mass., 1961.

J. Shearman. 'The Chigi Chapel in S. Maria del Popolo', *Journal of the Warburg and Courtauld Institutes*, XXIV, 1961, 129ff.

M. Hirst. 'The Chigi Chapel in S. Maria della Pace', *Journal of the Warburg and Courtauld Institutes*, XXIV, 1961, 161ff.

P. Pouncey and J. A. Gere. *Italian Drawings . . . in the British Museum. Raphael and his Circle*, London, 1962.

K. Oberhuber. 'Die Fresken der Stanza dell'Incendio im Werk Raffaels', *Jahrbuch der Kunsthistorischen Sammlungen in Wien*, XXII, 1962, 23–72.

——'Vorzeichnungen zu Raffaels "Transfiguration" ', *Jahrbuch der Berliner Museen*, IV, 1962, 116ff.

R. Wittkower. 'The young Raphael', *Allen Memorial Art Museum Bulletin*, Oberlin College, Ohio, XX, 1963, 150ff.

J. Shearman. 'Die Loggia der Psyche in der Villa Farnesina und die Probleme der letzten Phase von Raffaels graphischen Stil', *Jahrbuch der Kunsthistorischen Sammlungen in Wien*, XXIV, 1964, 59–100.

——'Raphael's unexecuted projects for the Stanze', in *Walter Friedländer zum 90. Geburtstag*, Berlin, 1965, 158ff.

A. M. Brizio. 'Raphael', in *Encyclopaedia of World Art*, XI, New York, 1966 (bibliography).

L. Dussler. *Raffael. Kritisches Verzeichnis der Gemälde, Wandbilder und Bildteppiche*, Munich, 1966 (bibliography).

M. Prisco and P. De Vecchi. *L'opera completa di Raffaello*, Milan, 1966.

M. Salmi (ed.). *Raffaello. L'opera, le fonti, la fortuna*, 2 vols., Novara, 1968, including sections by L. Becherucci on the paintings (7–198), A. Forlati Tempesti on the drawings (307–430), G. Marchini on the architecture (431–492), V. Golzio on the history of Raphael criticism (609–647), and A. Marabottini on Raphael's studio (199–306).

H. Wagner. *Raphael im Bildnis*, Berne, 1969.

INDICES

2. PAINTINGS

PLATES

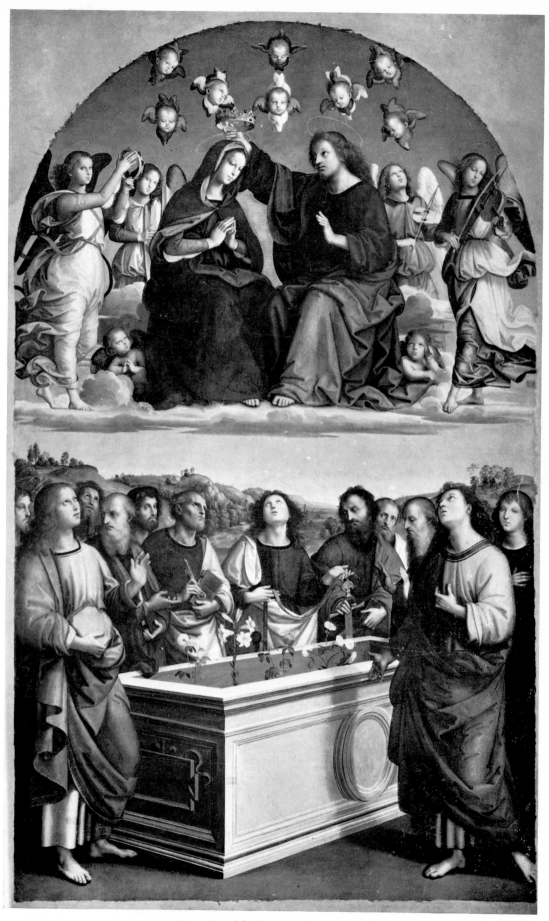

1 *Coronation of the Virgin*. Vatican. 267 × 163.

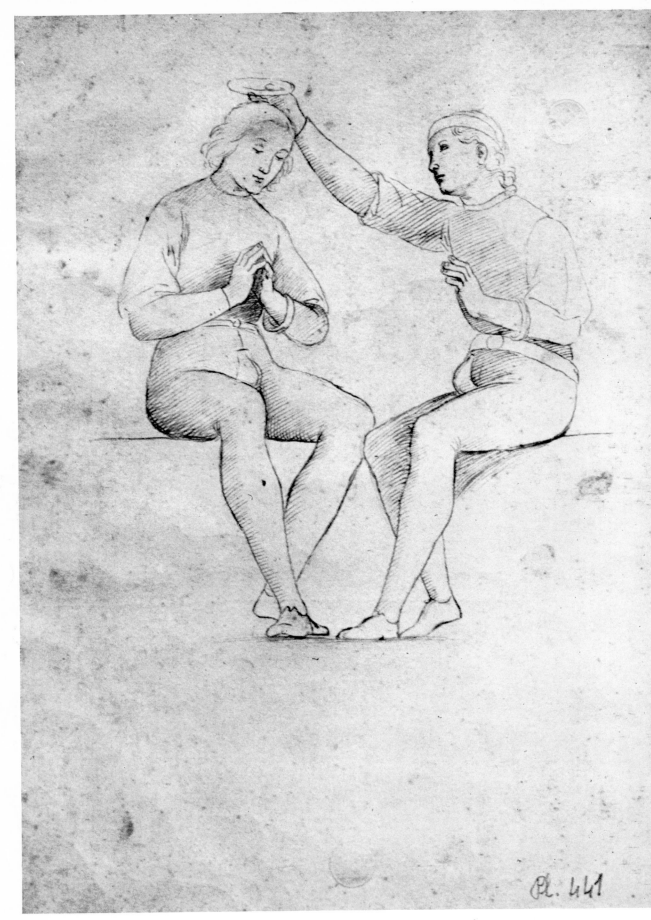

Pl. 441

2 Study for 1. Lille. 24·3 × 17·3.

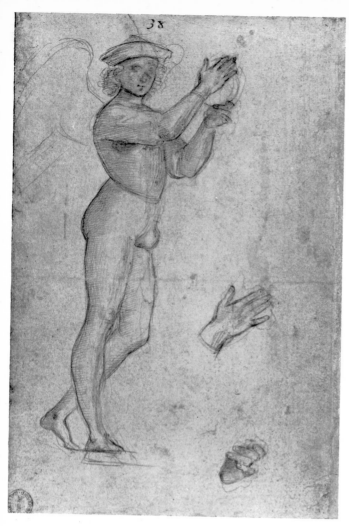

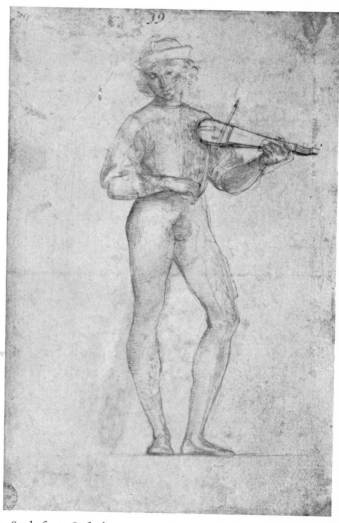

3 Study for 1. Oxford. 19·1 × 12·7.

4 Study for 1. Oxford. 18·9 × 12·6.

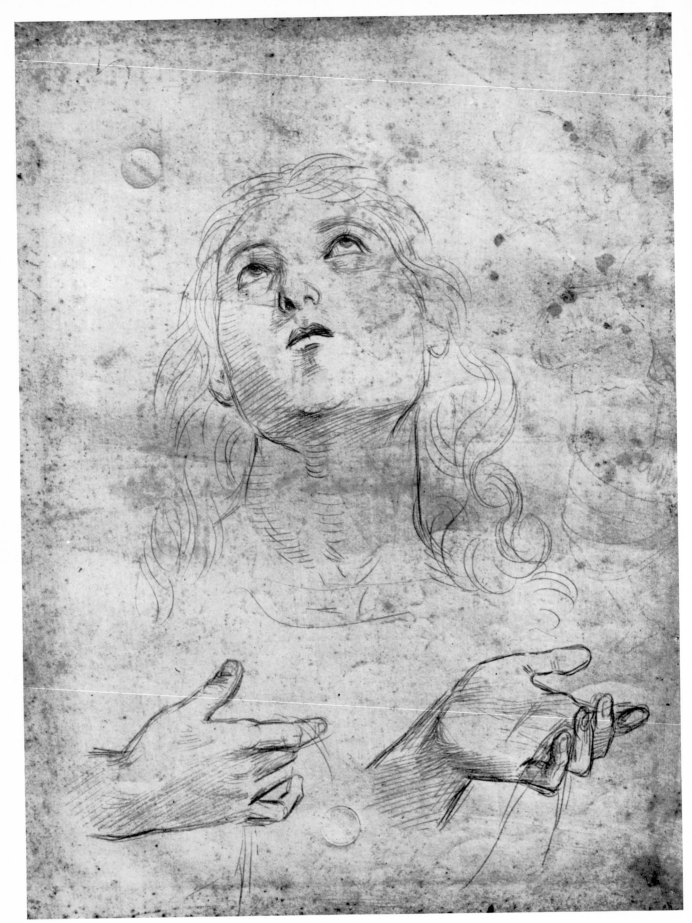

5 Study for 1. Lille. 24·3 × 17·3.

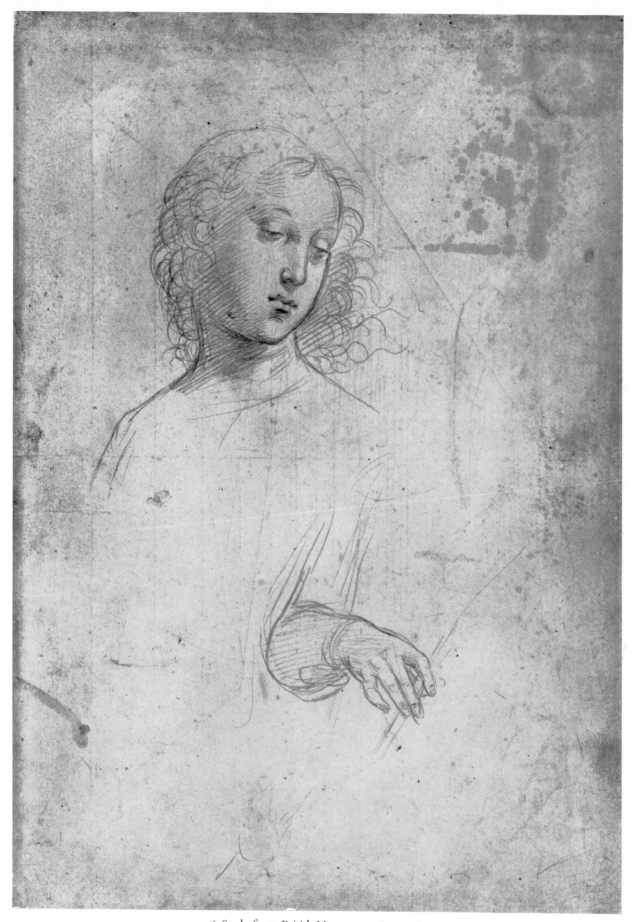

6 Study for 1. British Museum. 27·6 × 19·6.

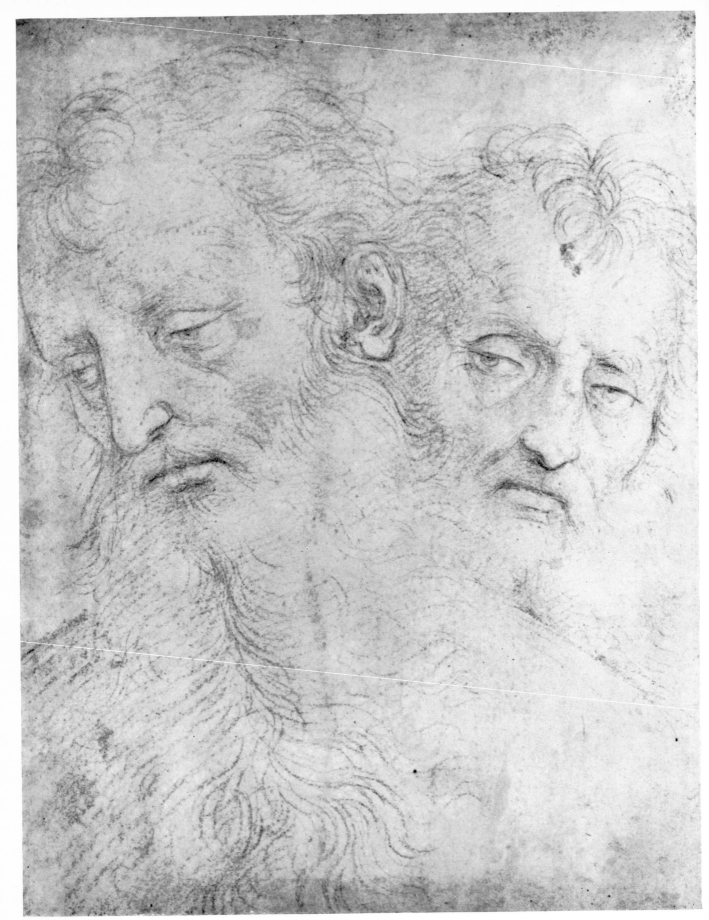

7 Auxiliary cartoon for 1. Windsor. 23·8 × 18·6.

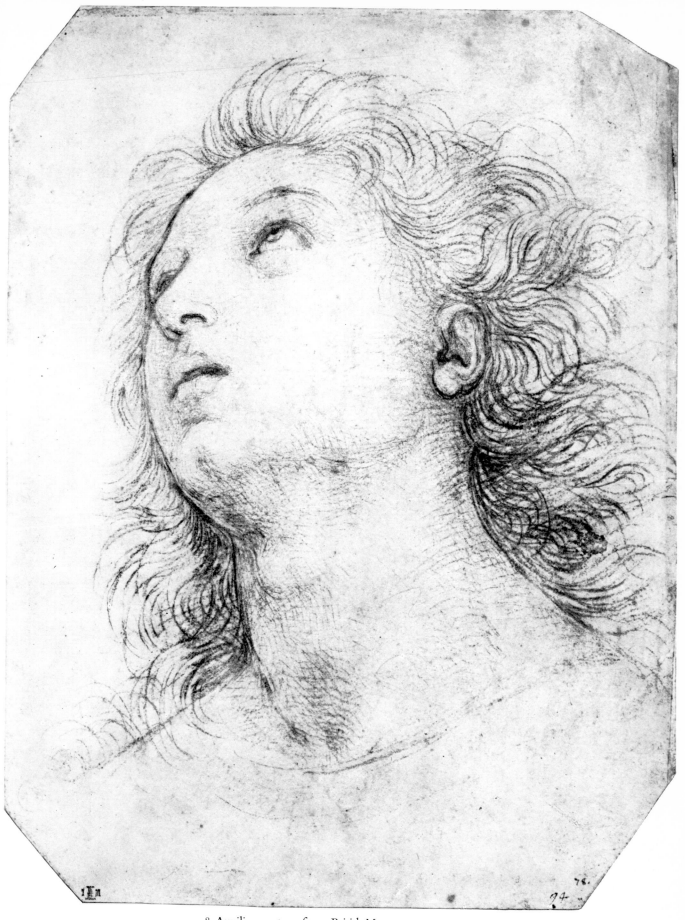

8 Auxiliary cartoon for 1. British Museum. 27·4 × 21·6.

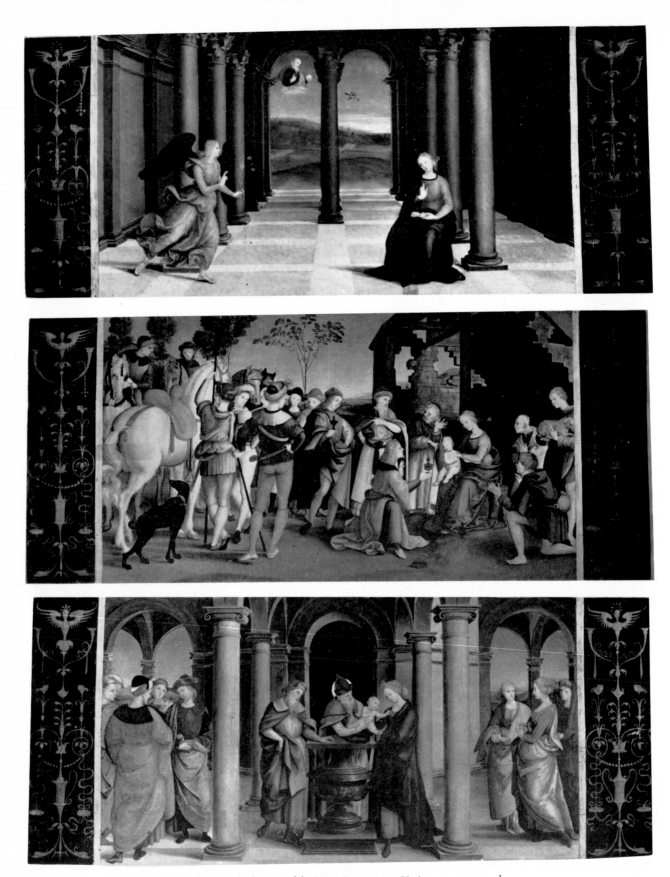

9 *Annunciation, Adoration of the Magi, Presentation*. Vatican. 27 × 50 each.

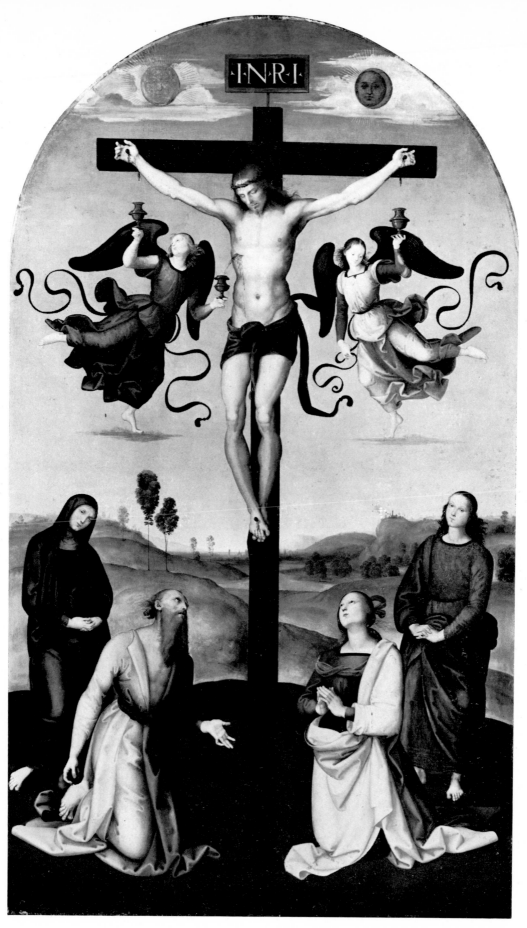

10 *Mond Crucifixion*. London. 280 × 165.

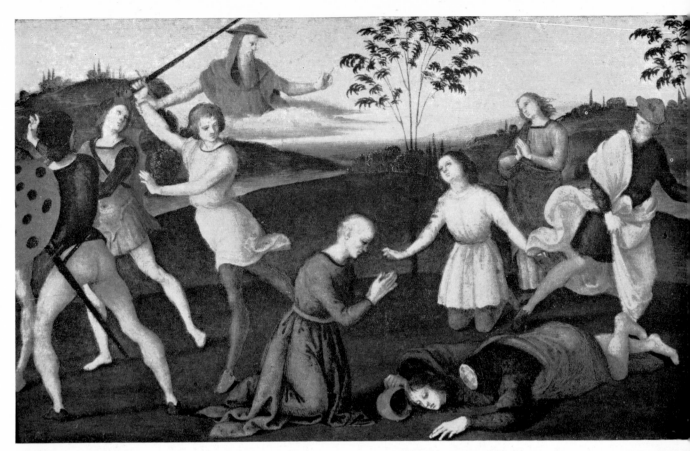

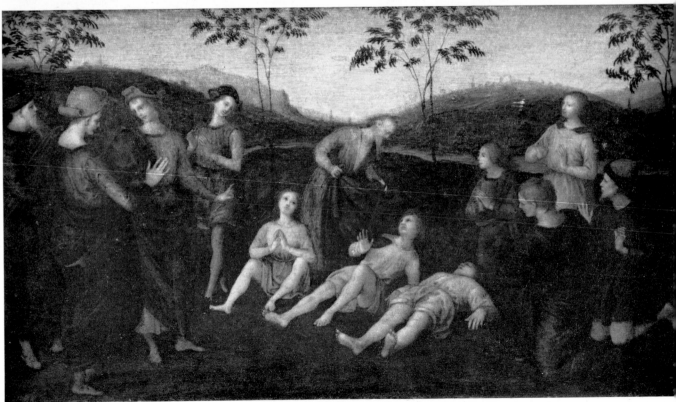

11 *St Jerome and the Heretic*. Raleigh, North Carolina. 23 × 41.

12 *Miracle of St Cyril*. Lisbon. 23 × 41.

13 Detail of 14.

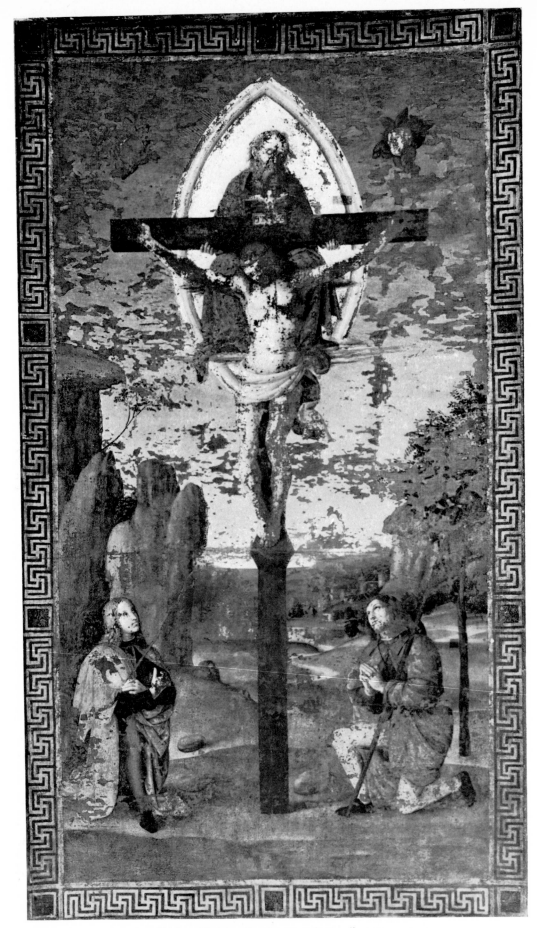

14 *Trinity with Saints*. Banner. Città di Castello. 166 × 94.

15 *Creation of Eve*. Reverse of 14.

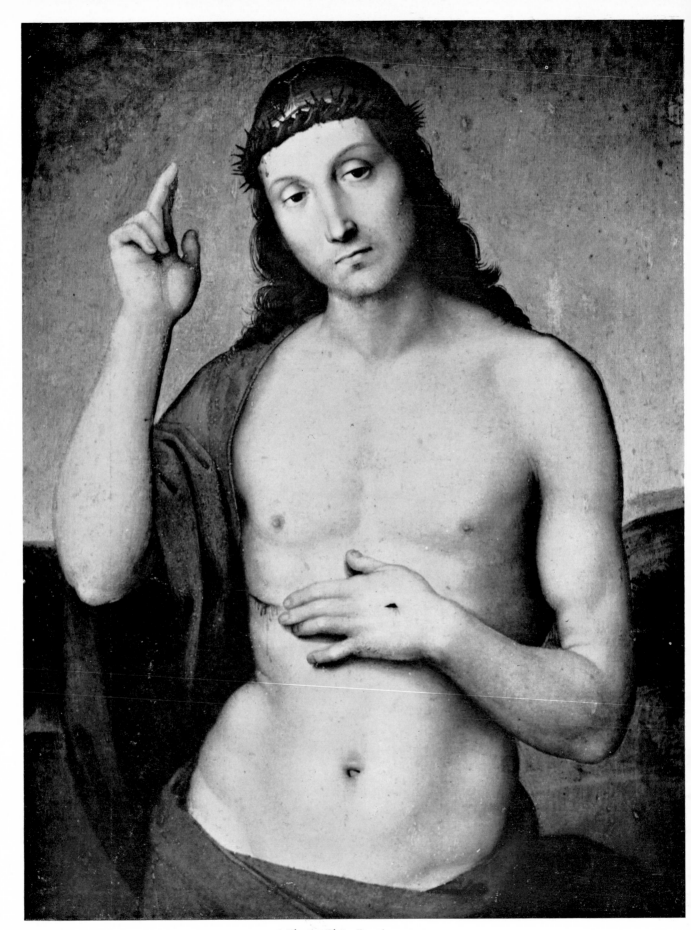

16 *Blessing Christ*. Brescia. 30 × 25.

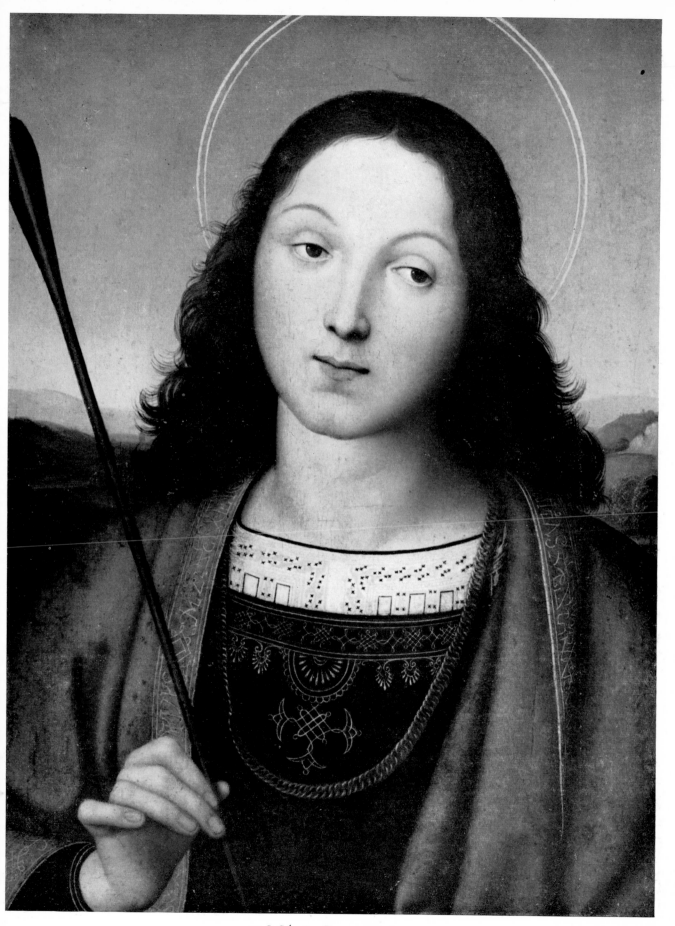

17 *St Sebastian*. Bergamo. 43 × 34.

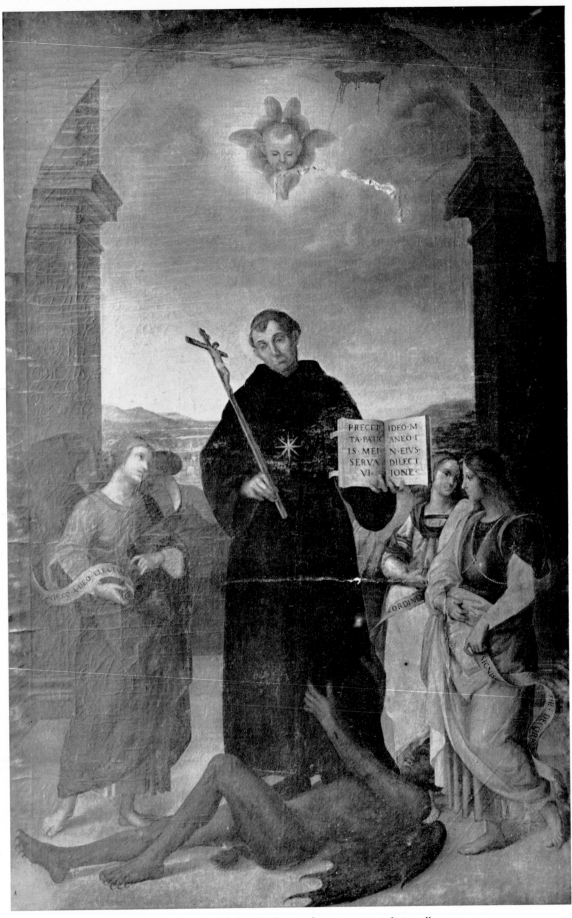

18 Variant copy (1791) of the *Nicholas of Tolentino* altar-piece. Città di Castello. 286 × 177·5.

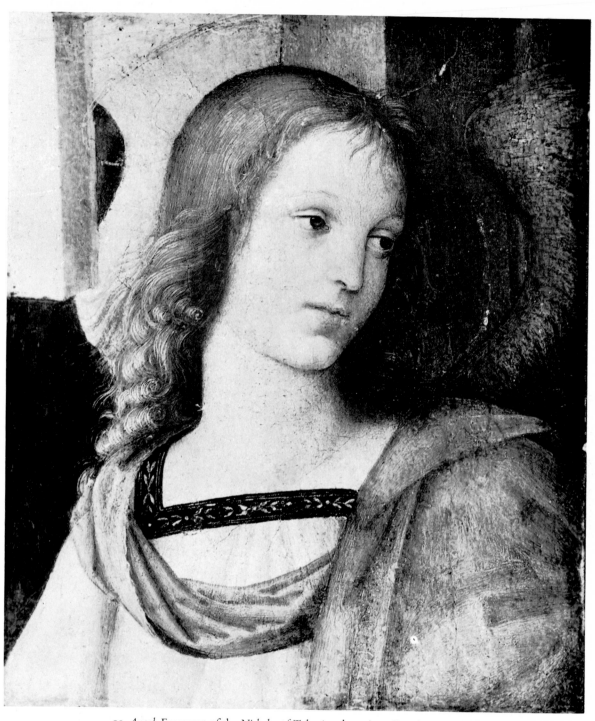

19 *Angel*. Fragment of the *Nicholas of Tolentino* altar-piece. Brescia. 31 × 27.

20 *Madonna* and *God the Father*. Fragments of the *Nicholas of Tolentino* altar-piece. Naples. 51 × 41, 112 × 75.

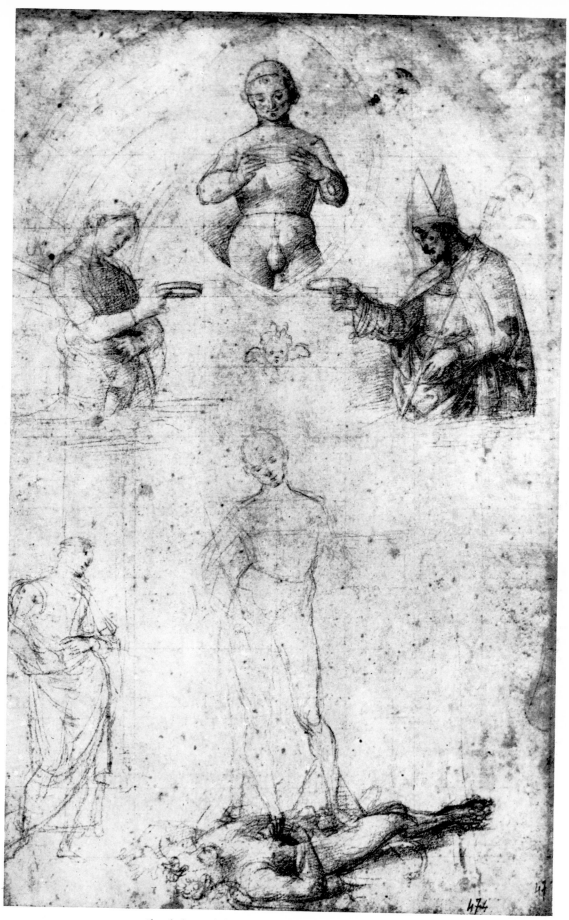

21 Sketch for *Nicholas of Tolentino* altar-piece. Lille. 41 × 26·5.

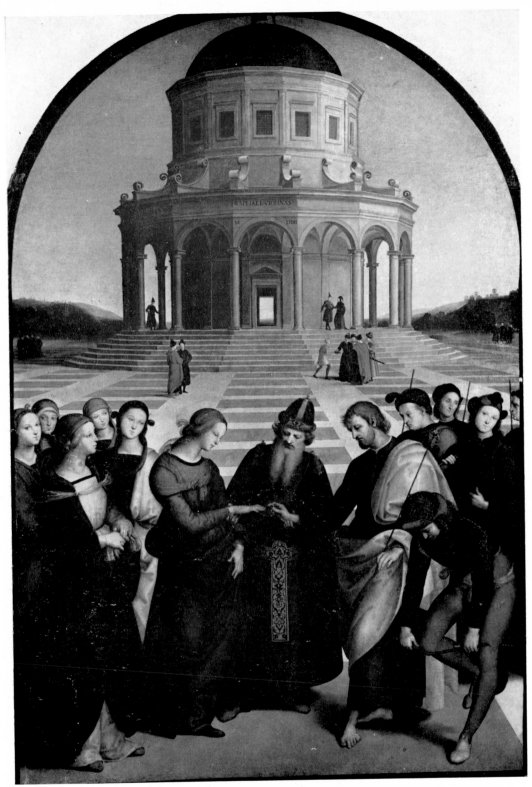

22 *Marriage of the Virgin.* 1504. Milan. 170 × 117.

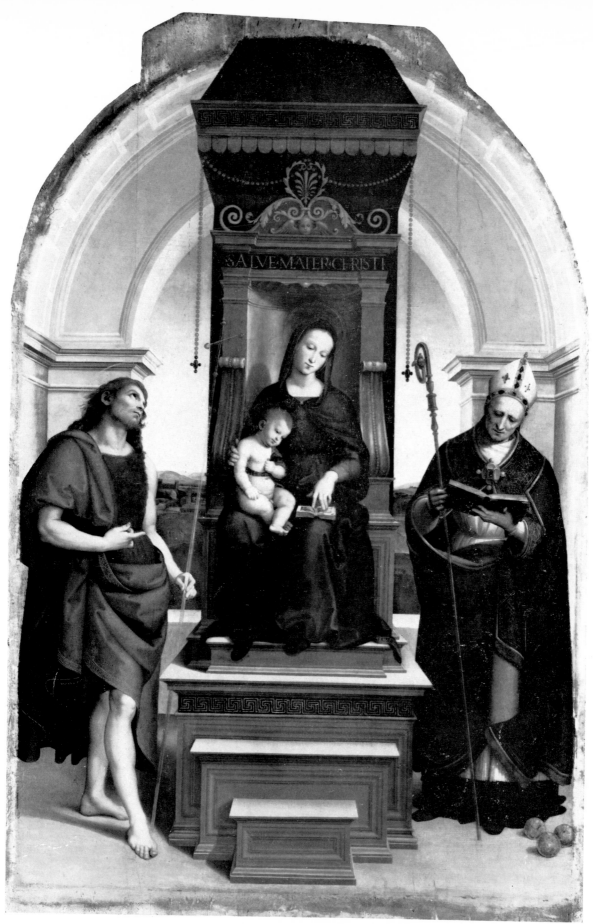

23 *Ansidei Madonna*. 1505–1507. London. 209 × 148.

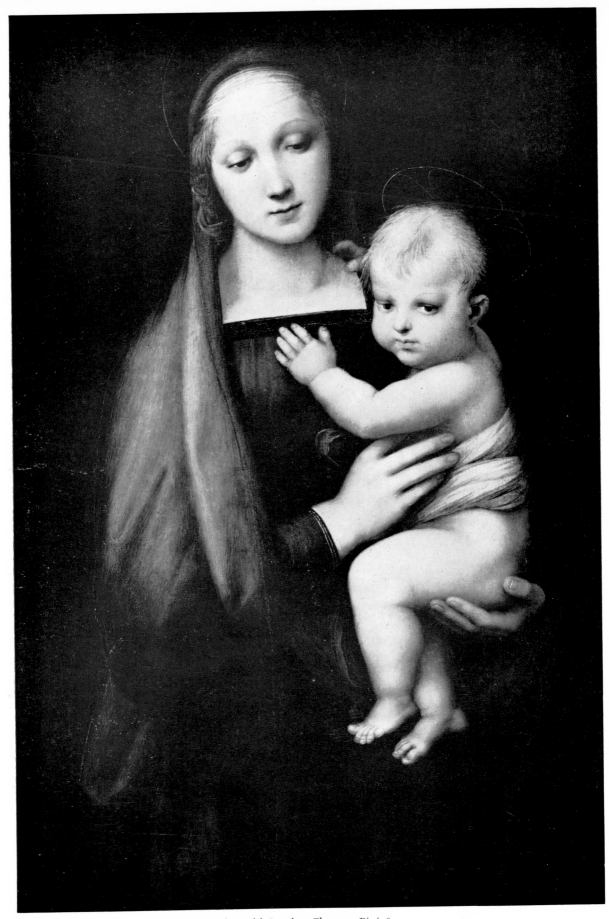

24 *Madonna del Granduca*. Florence, Pitti. 84 × 55.

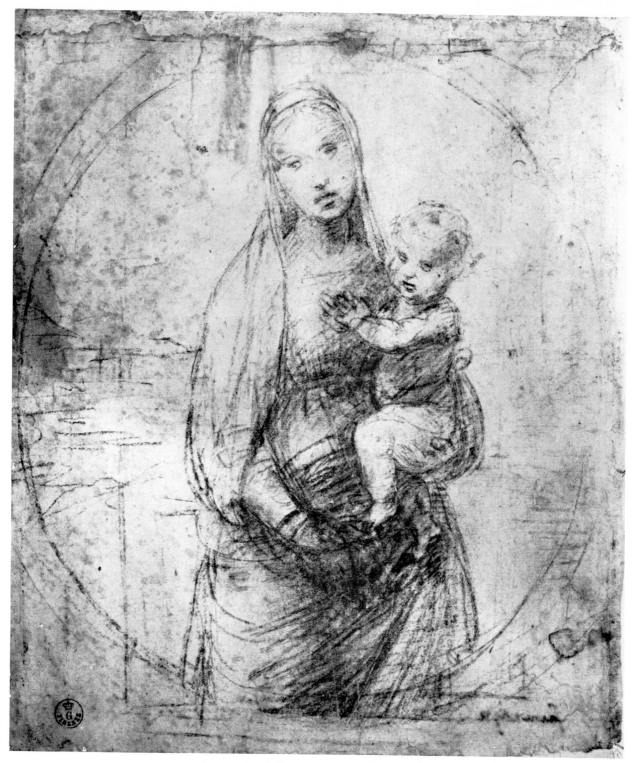

25 Study for 24. Uffizi. 21·3 × 18·8.

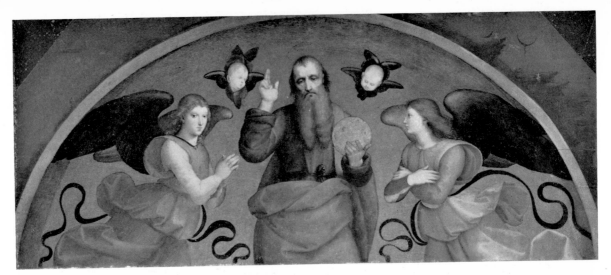

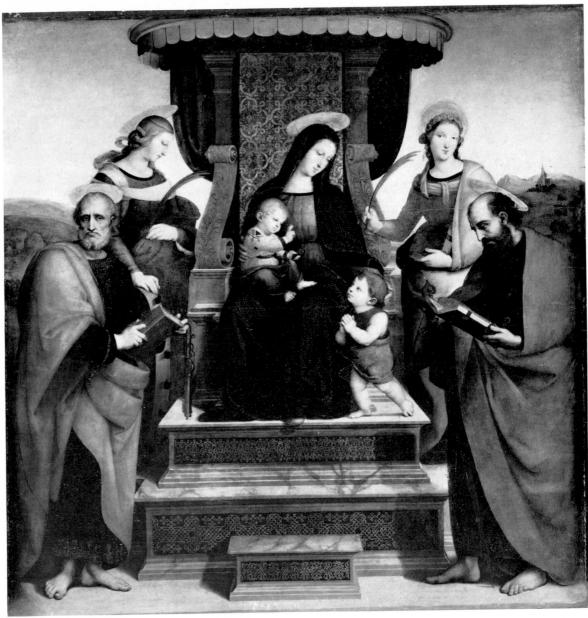

26 Lunette of *Colonna altar-piece*. New York. 76 × 172.

27 *Colonna altar-piece*. New York. 173 × 172.

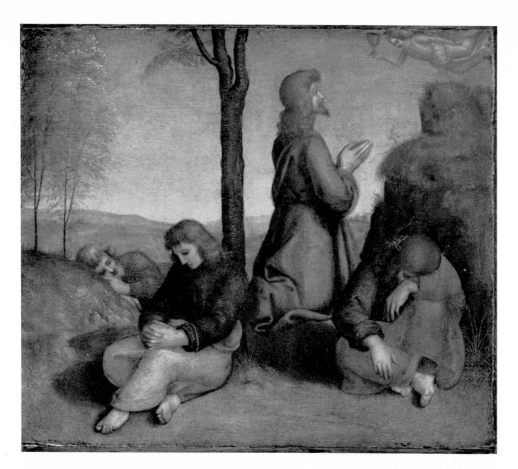

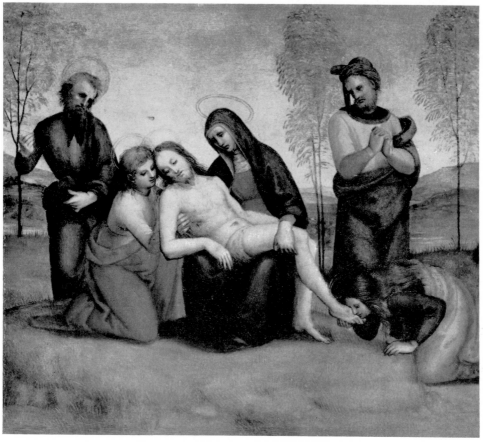

28 *Agony in the Garden*. New York. 24 × 28.

29 *Pietà*. Boston. 24 × 28.

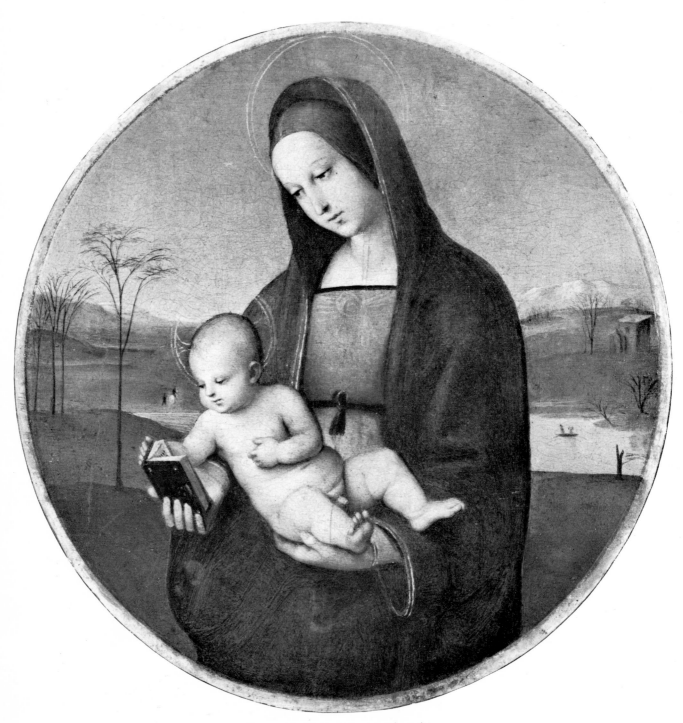

30 *Connestabile Madonna*. Leningrad. 18 diameter.

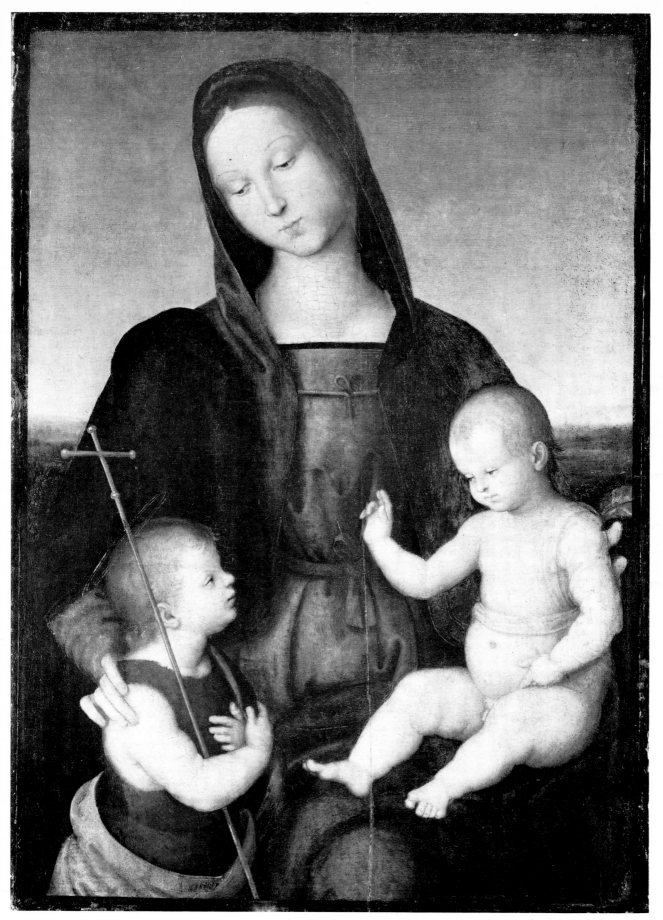

31 *Diotalevi Madonna*. Berlin-Dahlem. 69 × 50.

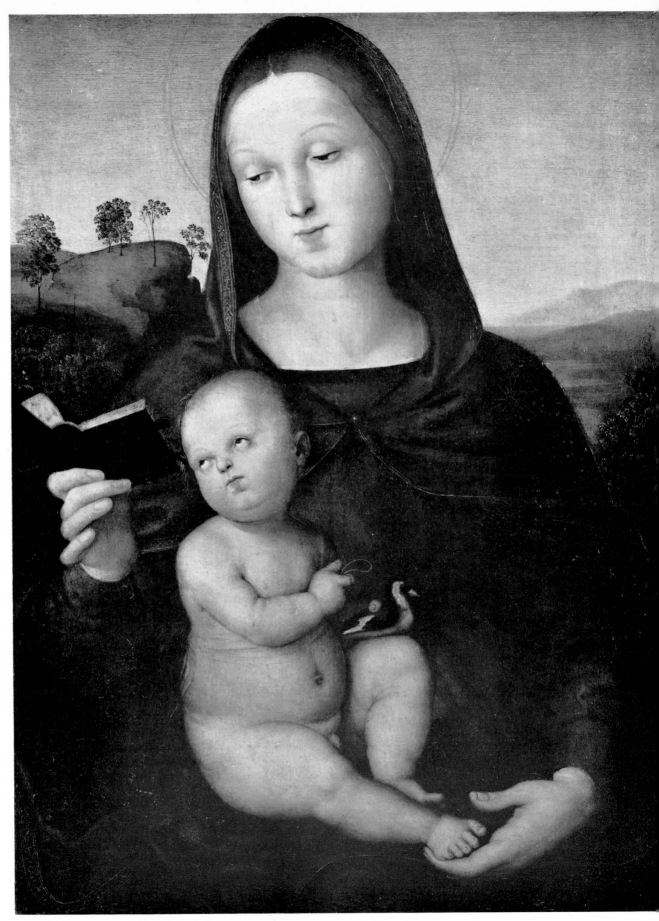

32 *Solly Madonna*. Berlin-Dahlem. 52 × 38.

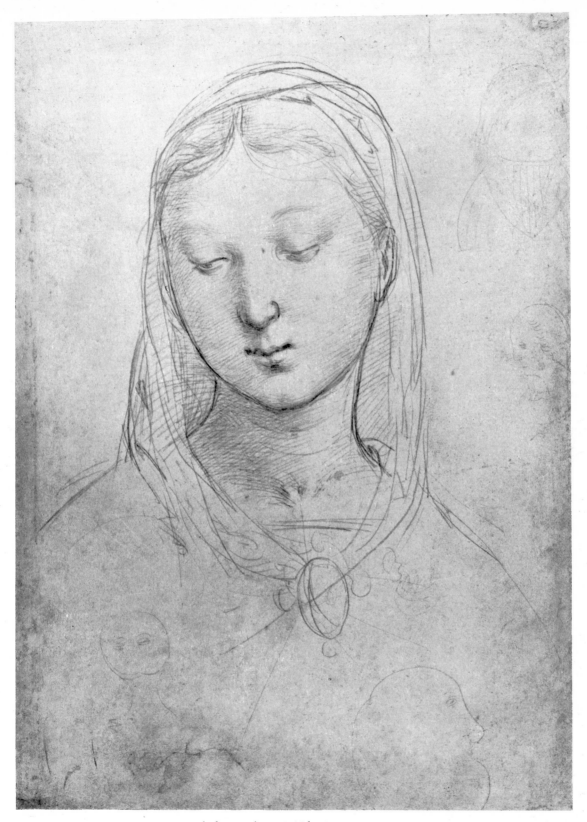

33 *Study for a Madonna*. British Museum. 25·8 × 19·1.

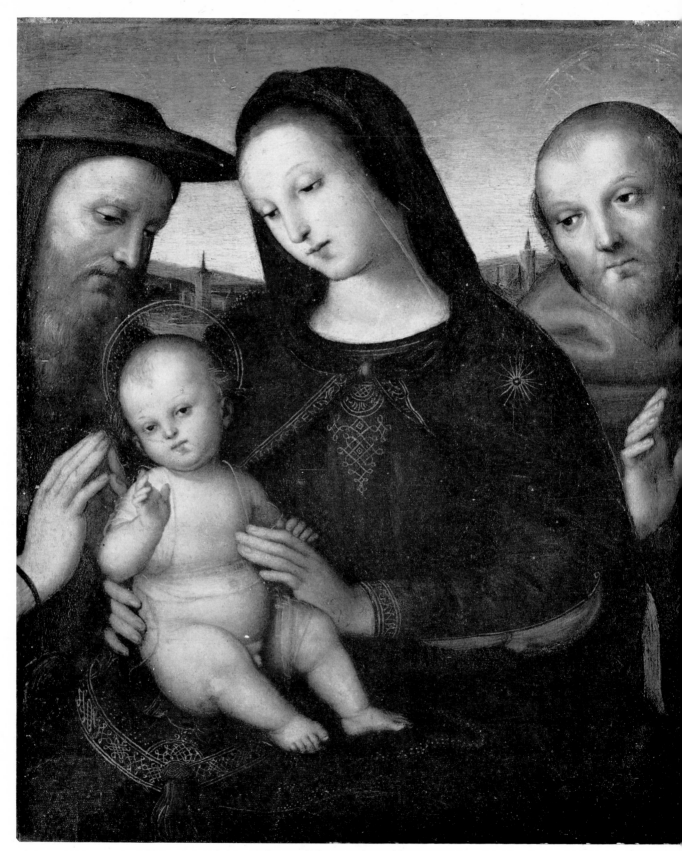

34 *Madonna with Saints*. Berlin-Dahlem. 34 × 29.

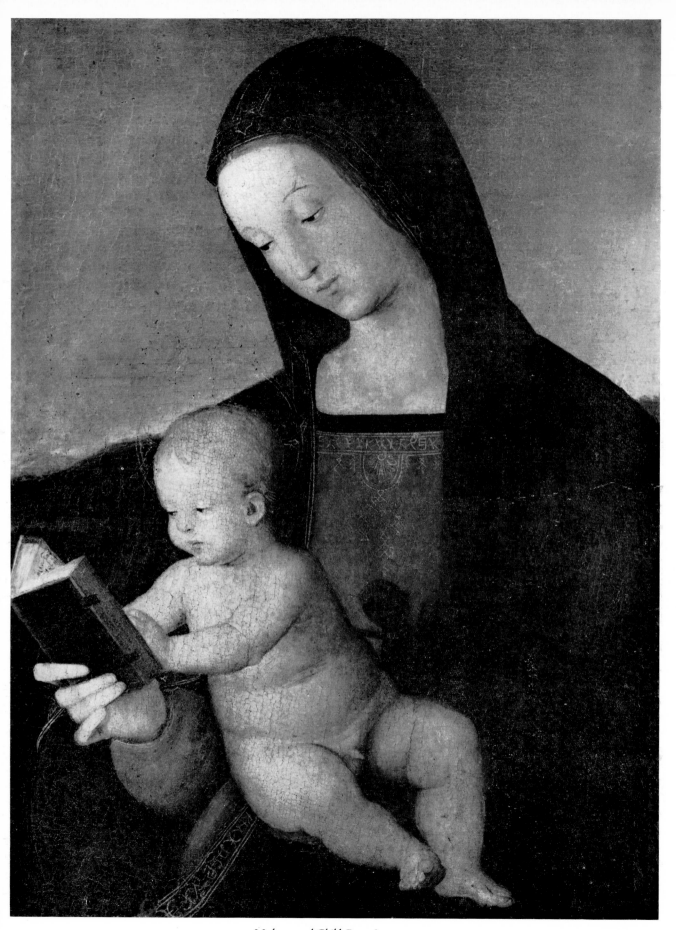

35 *Madonna and Child*. Perugia. 53 × 41.

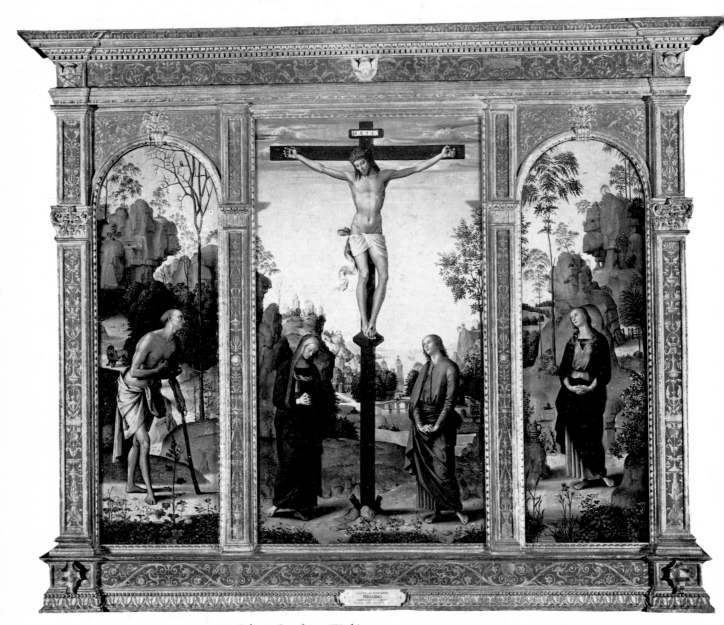

36 *Galitzin Crucifixion*. Washington. 95 × 30, 101 × 56, 95 × 30.

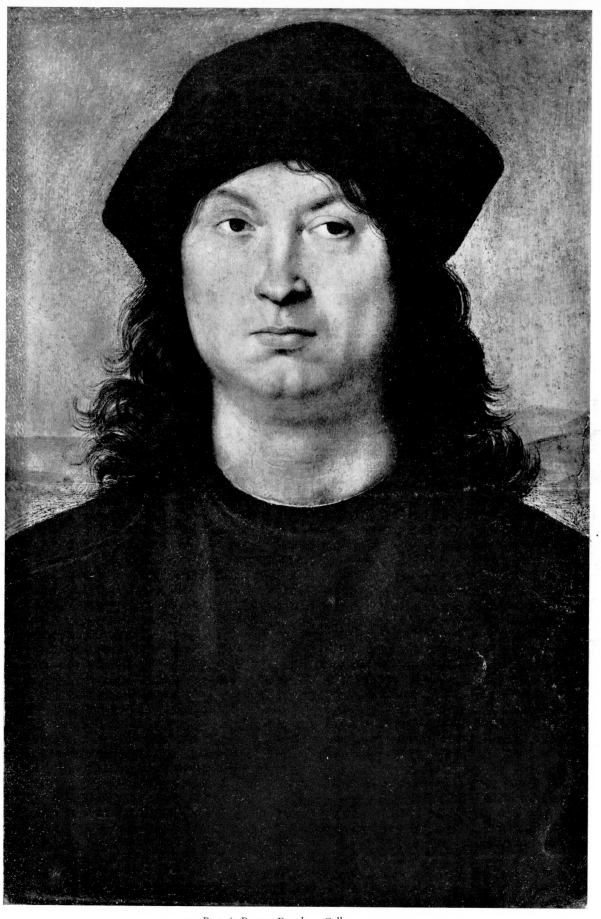

37 *Portrait*. Rome, Borghese Gallery. 45 × 31.

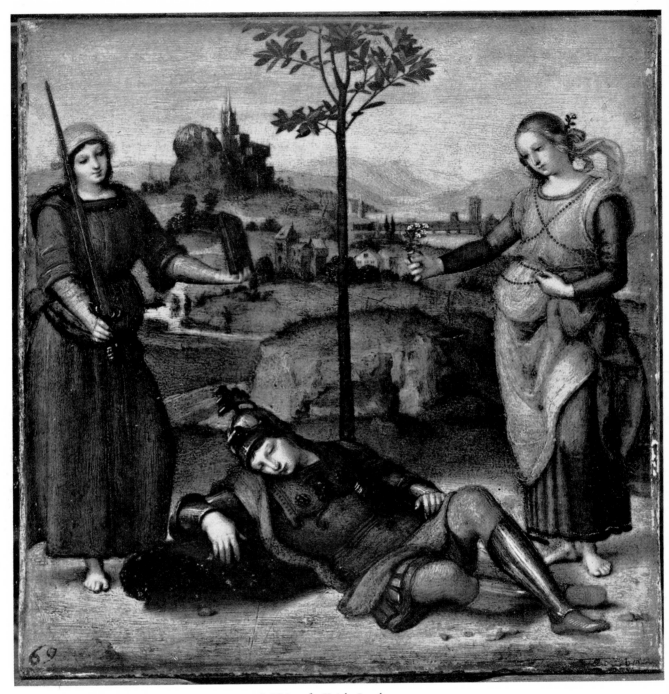

38 *Vision of a Knight*. London. 17 × 17.

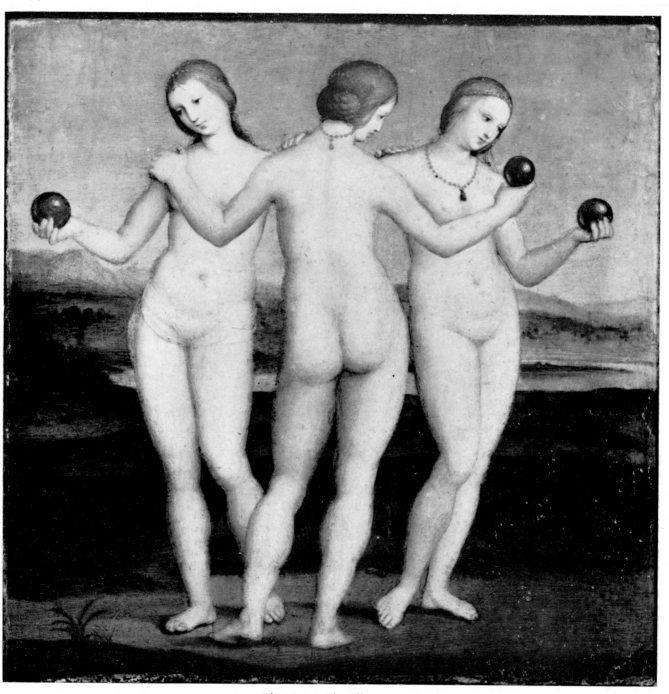

39 *Three Graces*. Chantilly. 17 × 17.

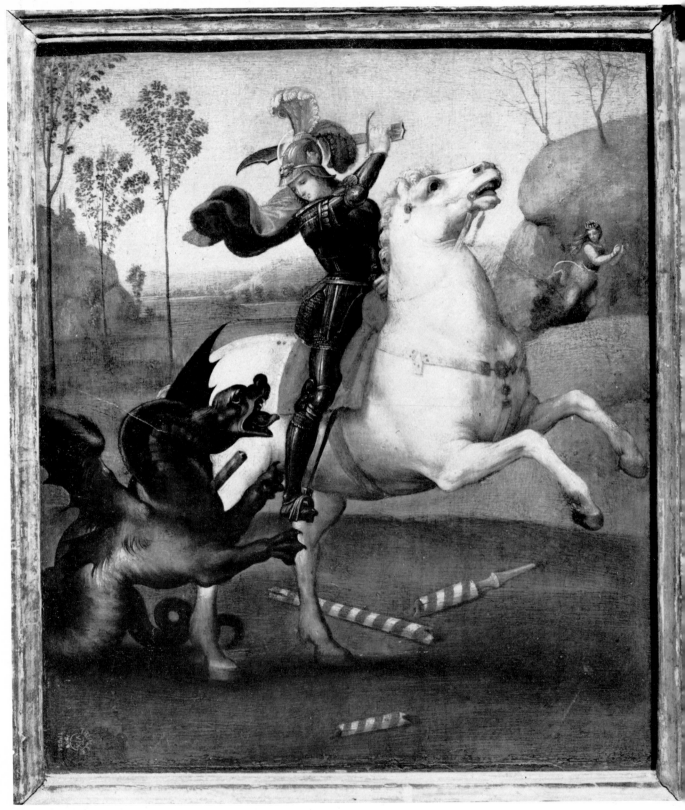

40 *St George*. Louvre. 31 × 27.

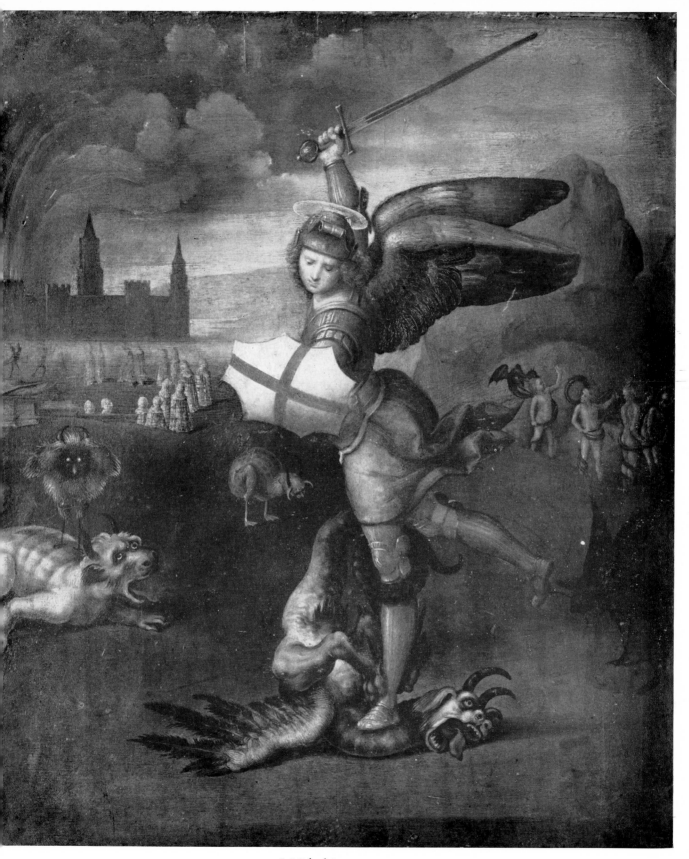

41 *St Michael*. Louvre. 31 × 27.

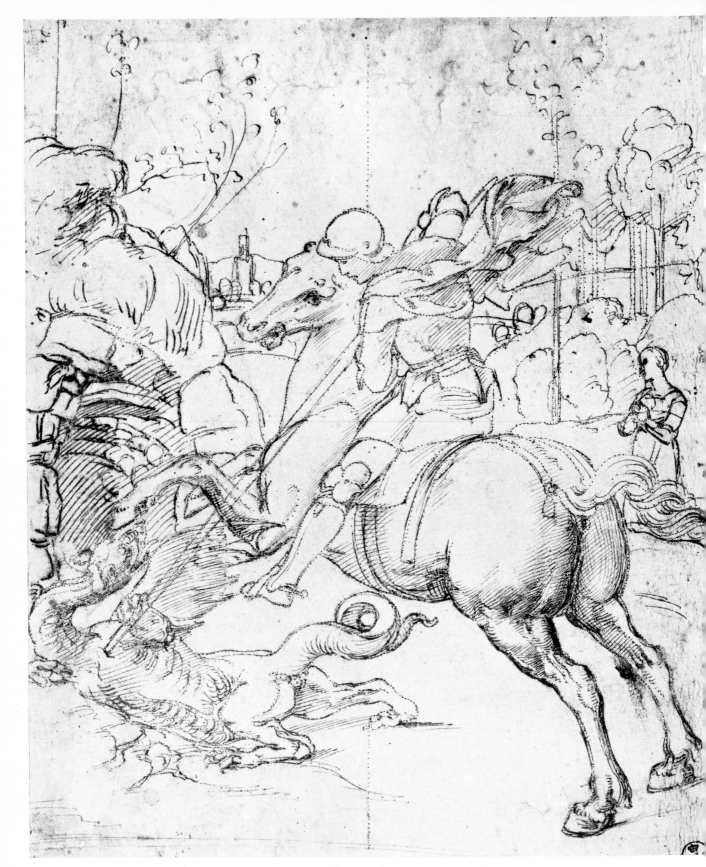

42 Cartoon for 43. Uffizi. 26·4 × 21·3.

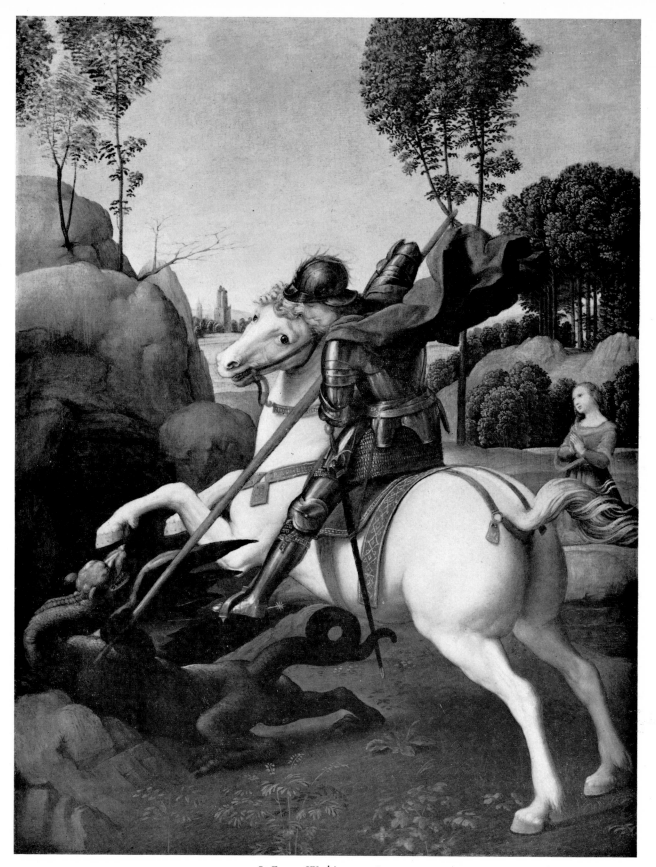

43 *St George*. Washington. 28 × 22.

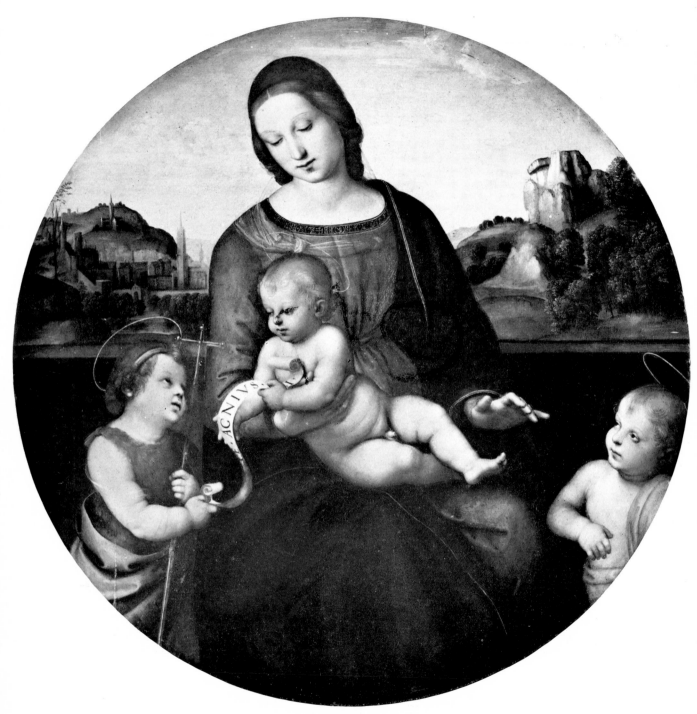

44 *Terranuova Madonna*. Berlin-Dahlem. 86 diameter.

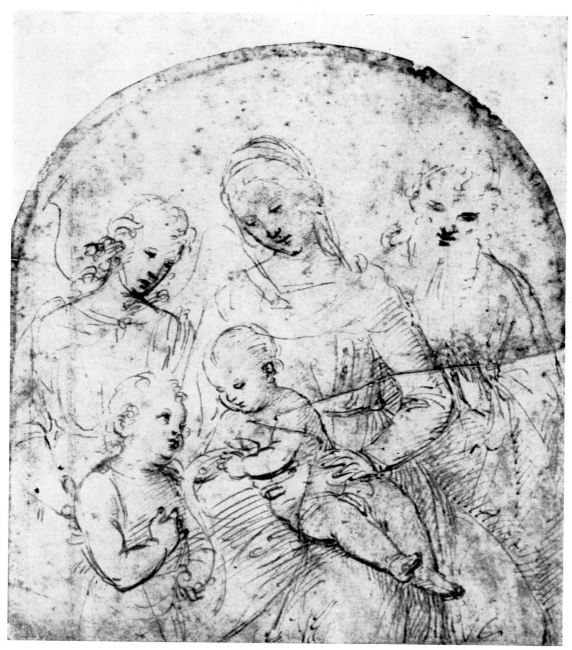

45 Preliminary study for 44. Lille. 16·7 × 15·7.

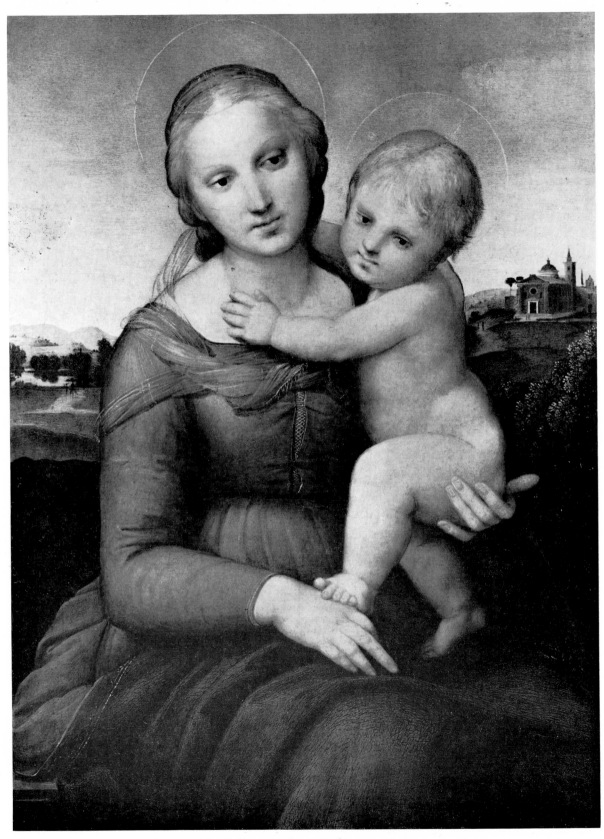

46 *Small Cowper Madonna*. Washington. 58 × 42.

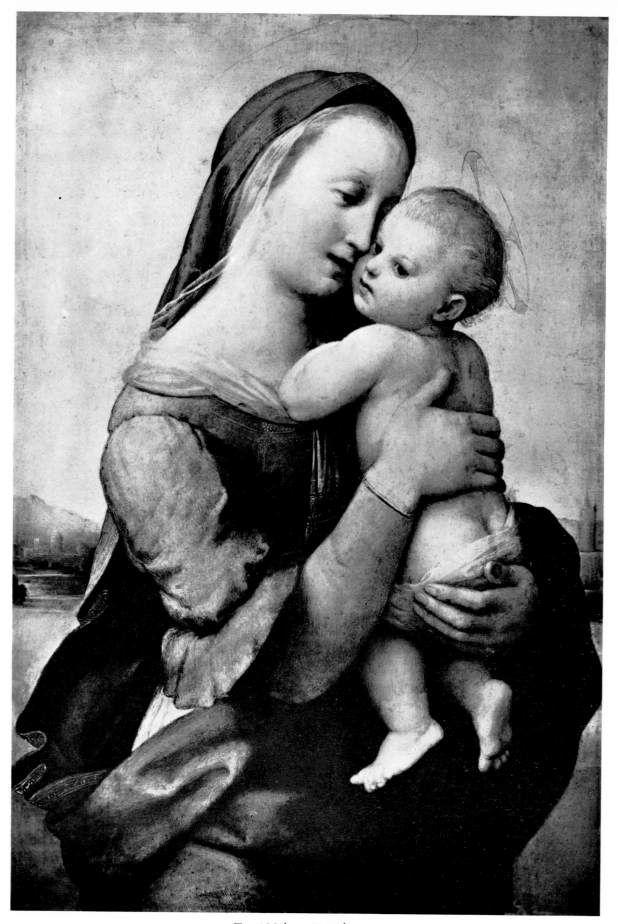

47 *Tempi Madonna*. Munich. 75 × 52.

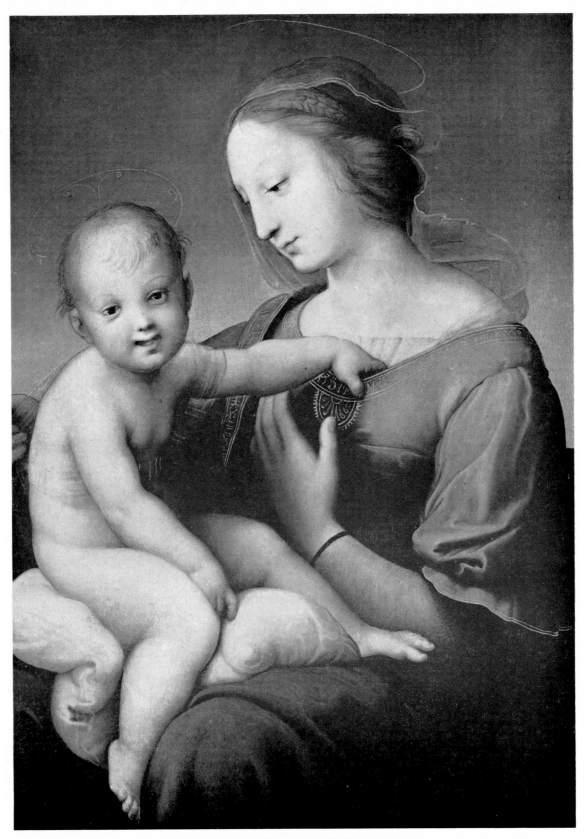

48 *Large Cowper Madonna.* 1508. Washington. 68 × 47.

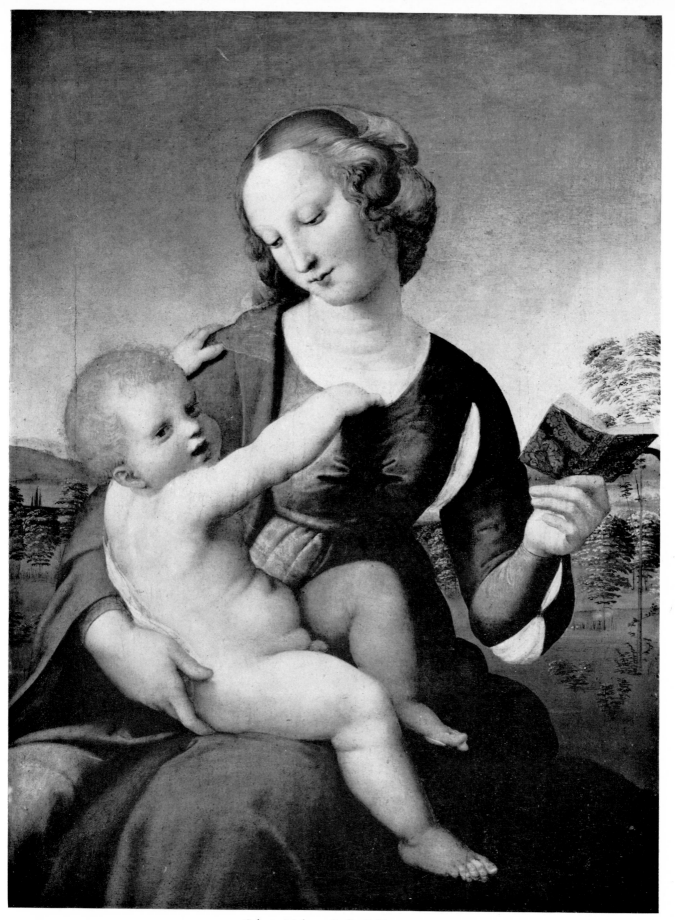

49 *Colonna Madonna*. Berlin-Dahlem. 77 × 56.

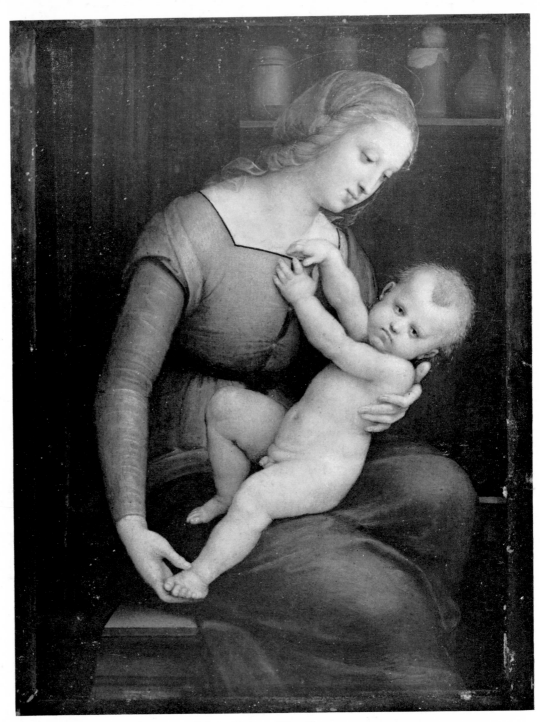

50 *Orleans Madonna*. Chantilly. 29 × 21.

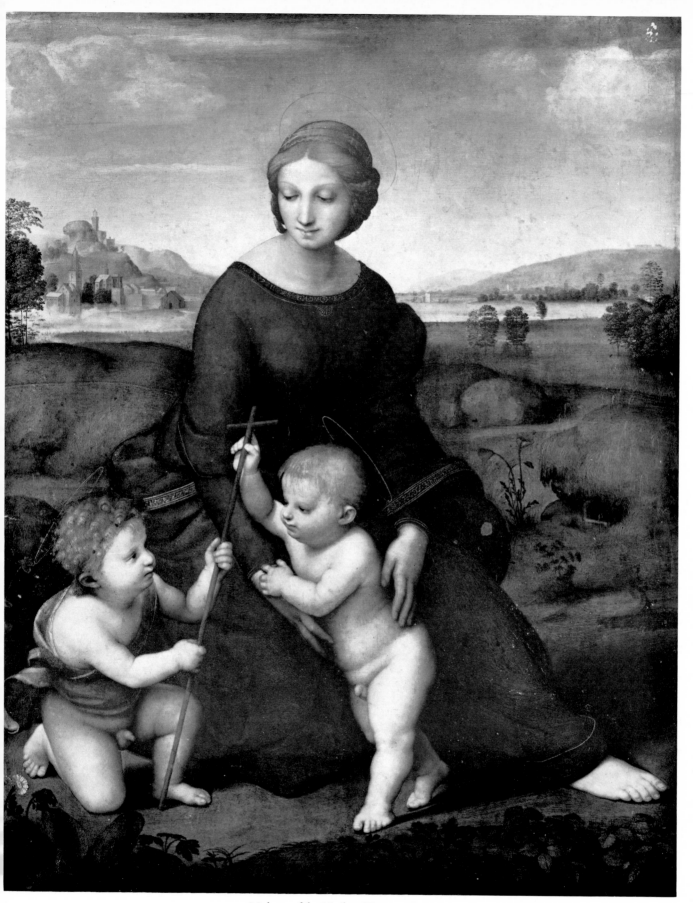

51 *Madonna of the Meadow*. Vienna. 113 × 88.

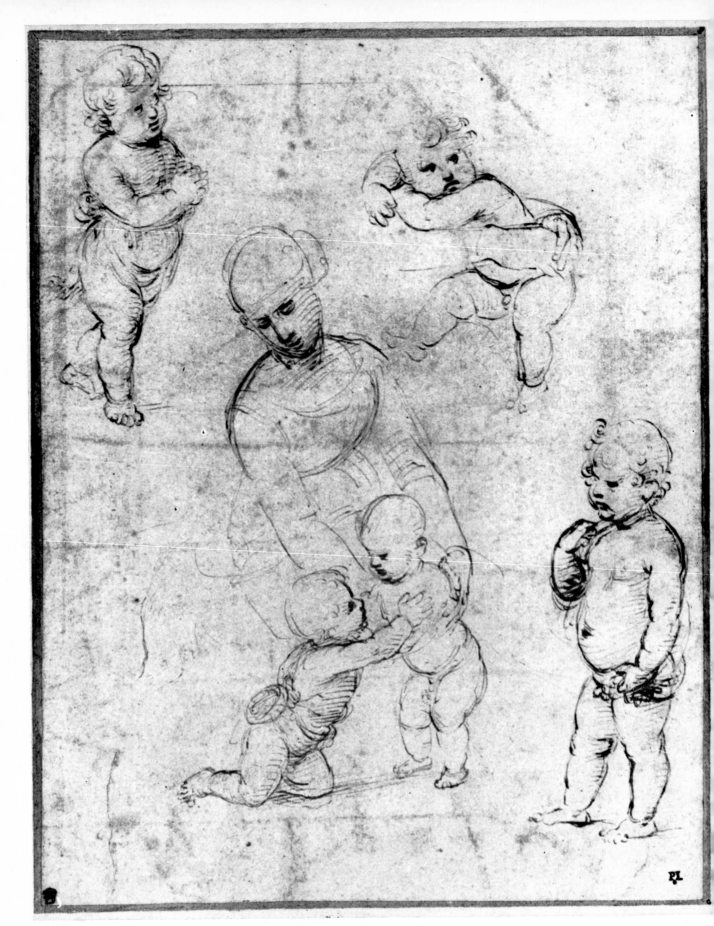

52 Study for 51. Chatsworth. 25 × 19·4.

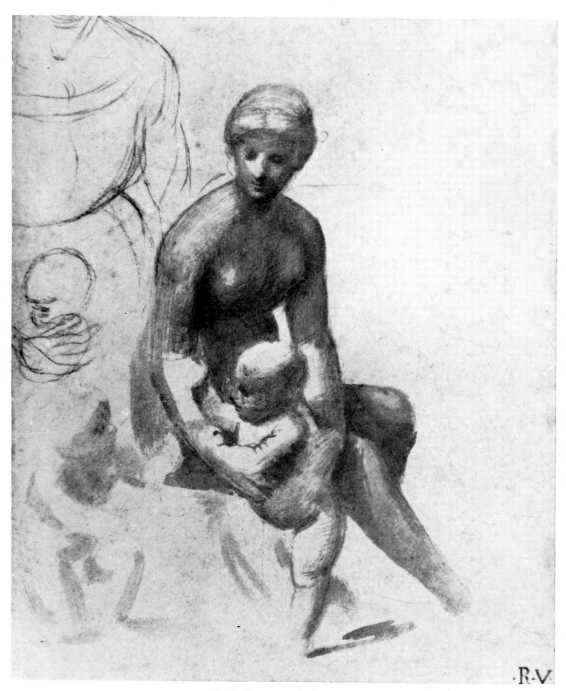

53 Study for 51. Oxford. 21·9 × 18.

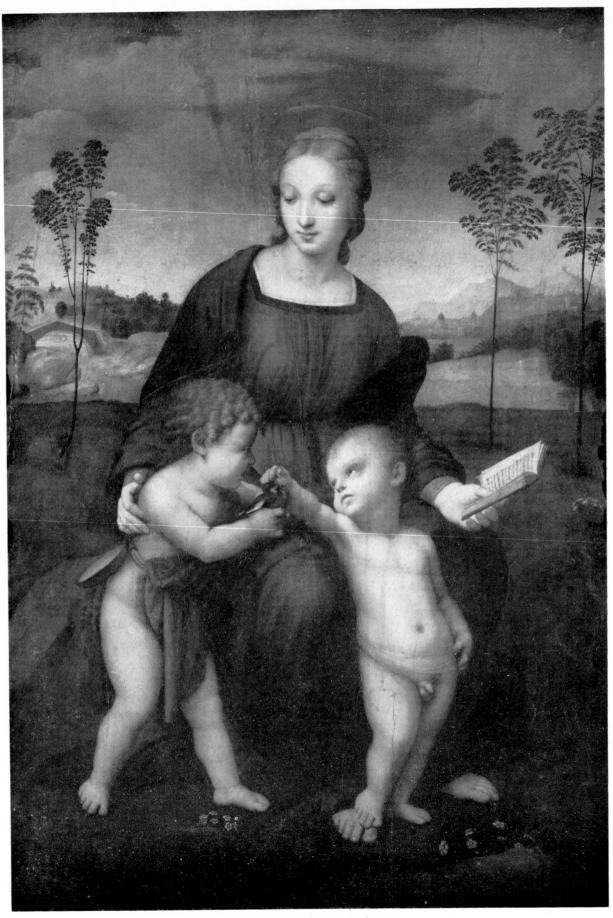

54 *Madonna of the Goldfinch*. Florence, Uffizi. 107 × 77.

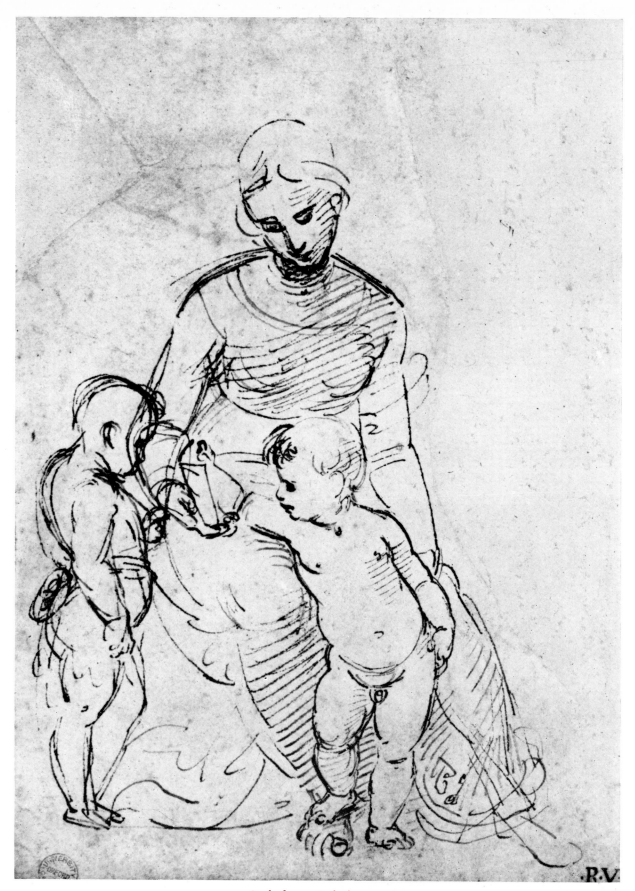

55 Study for 54. Oxford. 23 × 16·3.

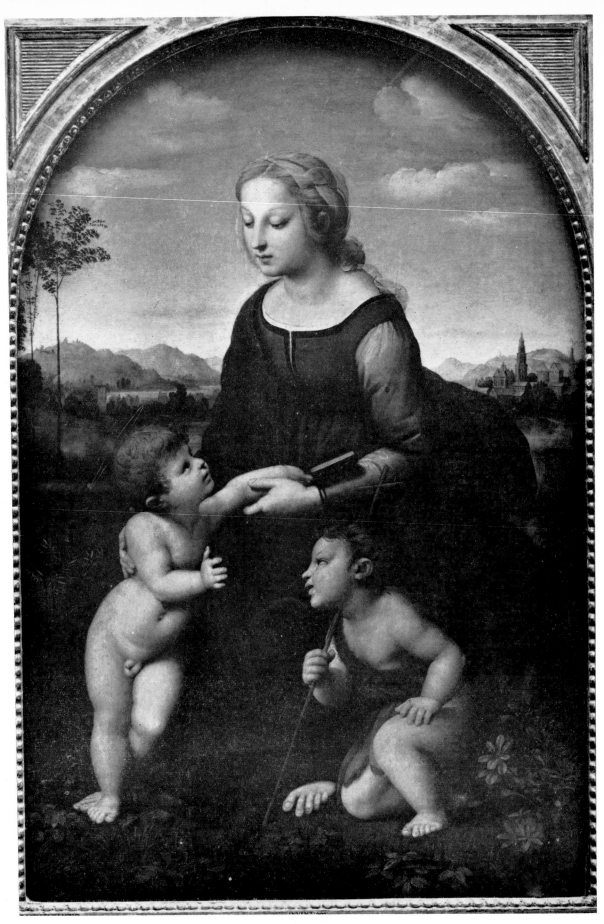

56 *La belle Jardinière*. Louvre. 122 × 80.

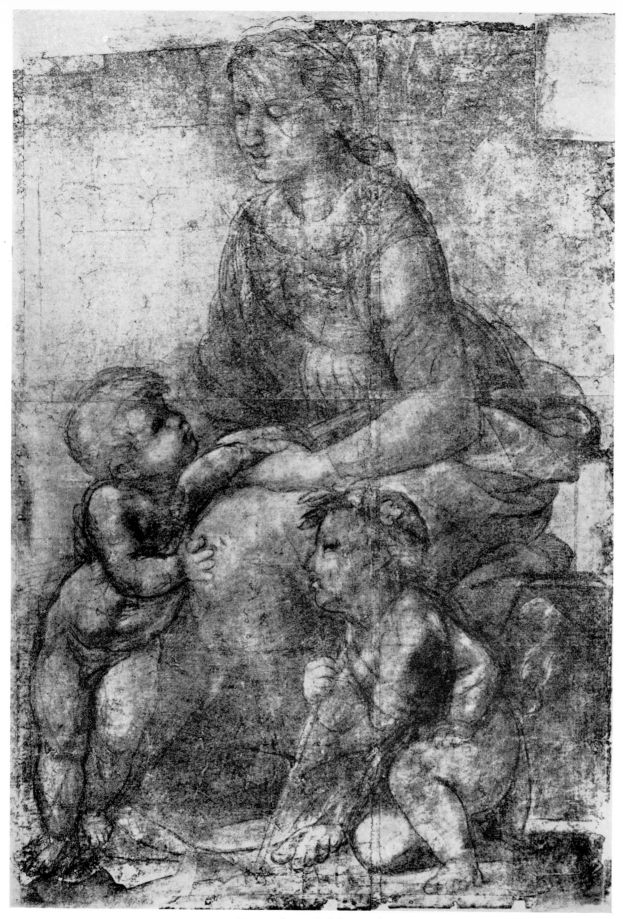

57 Cartoon for 56. Holkham. 94 × 66·8.

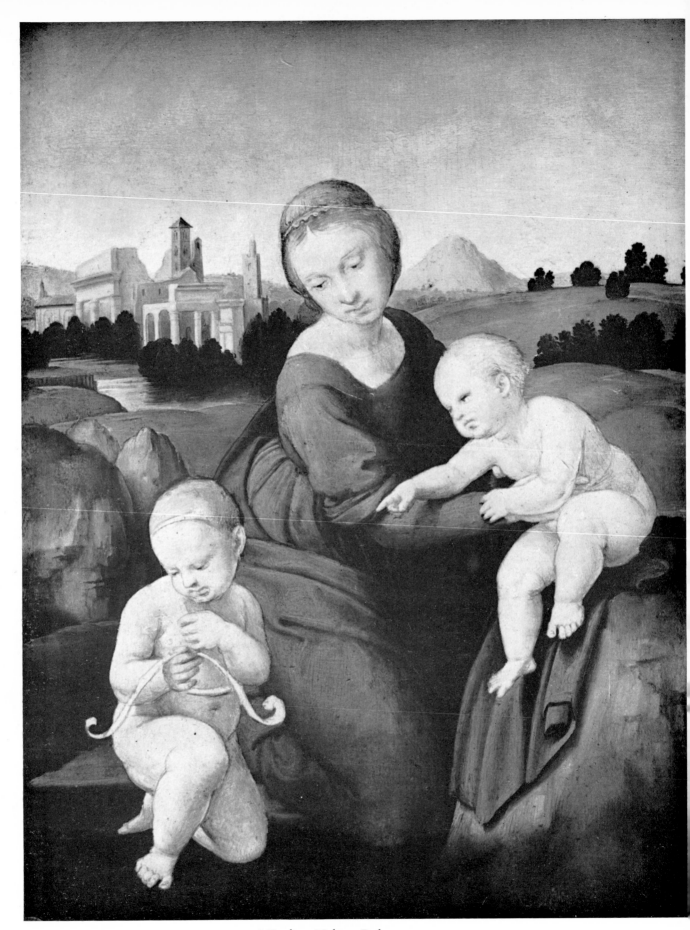

58 *Esterhazy Madonna*. Budapest. 29 × 21.

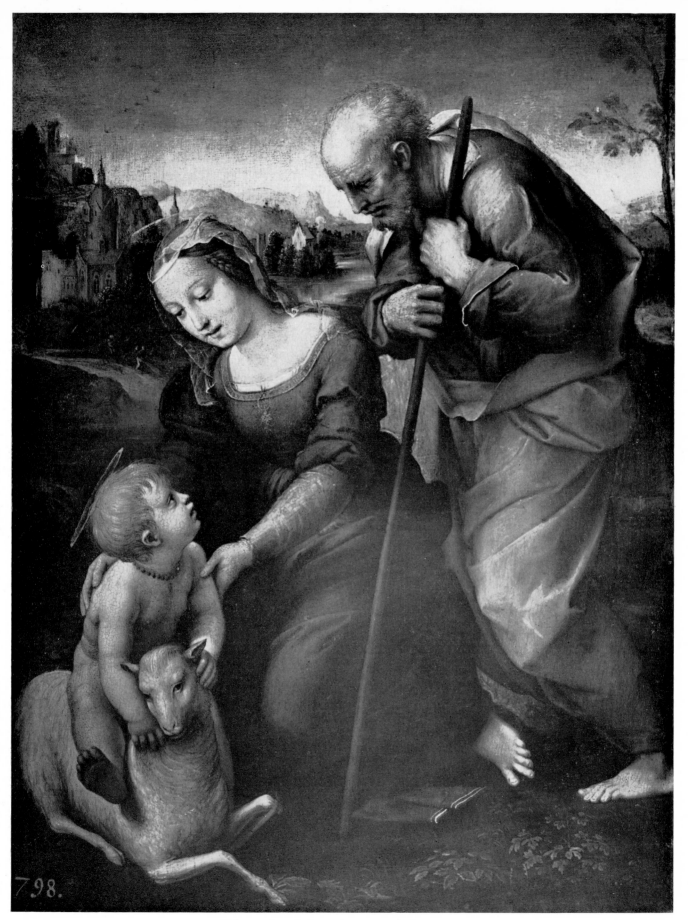

59 *Holy Family with the Lamb.* 1507. Madrid. 29 × 21.

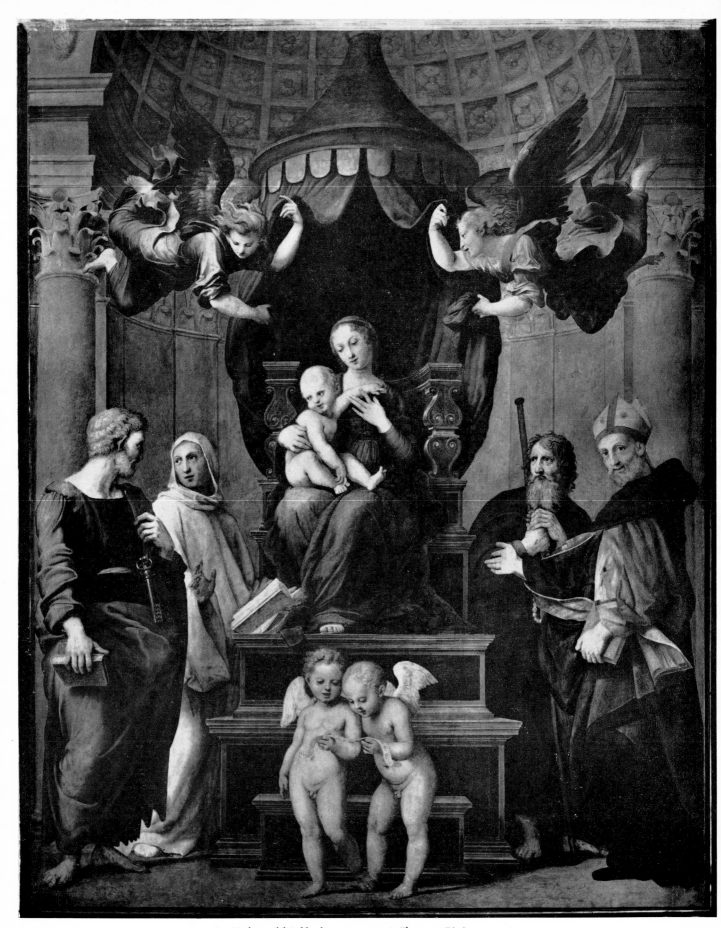

60 *Madonna del Baldacchino.* 1507–1508. Florence, Pitti. 277 × 224.

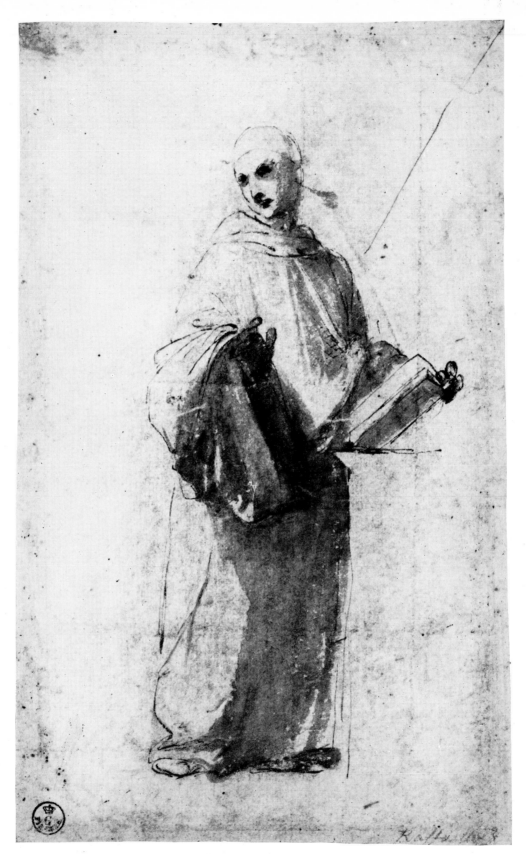

61 Study for 60. Uffizi. 21·9 × 13·3.

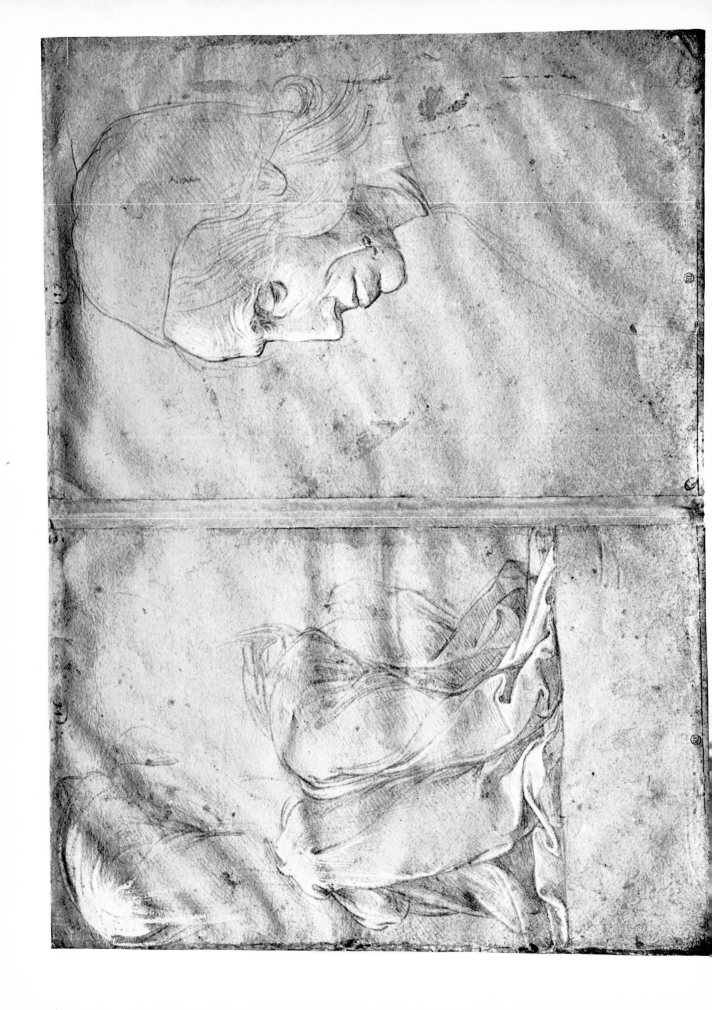

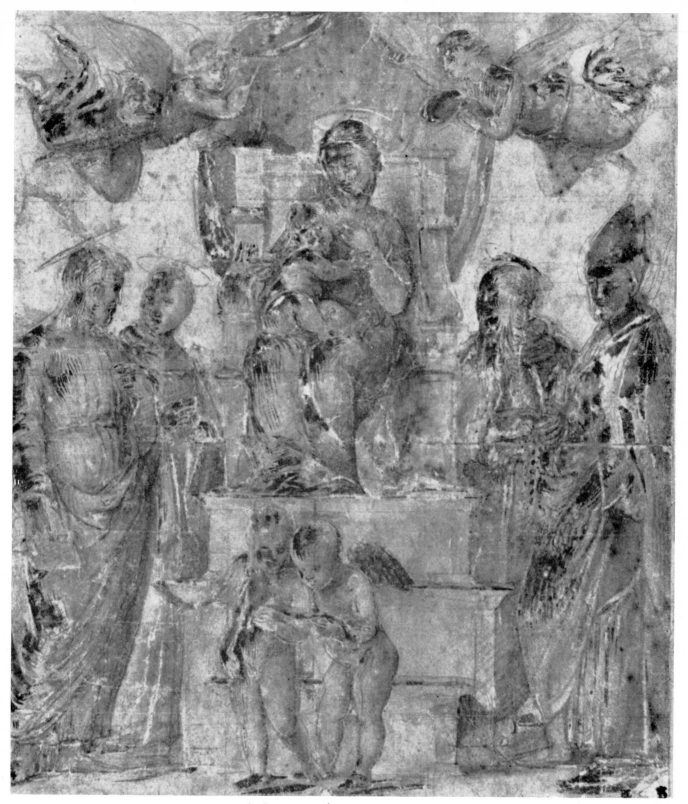

62 Study for 60. Paris, École des Beaux-Arts. 22 × 37.

63 Compositional sketch for 60. Chatsworth. 27 × 23.

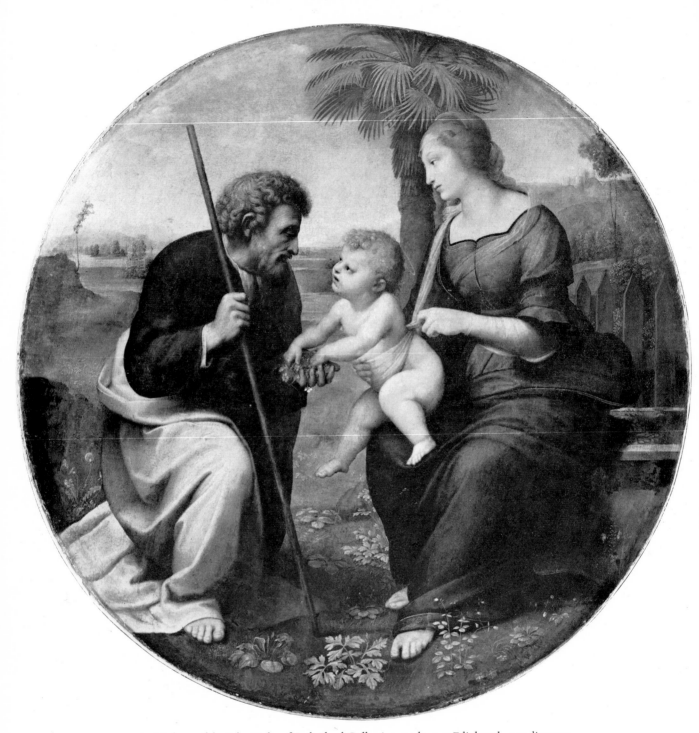

64 *Madonna of the Palm*. Duke of Sutherland Collection, on loan at Edinburgh. 140 diameter.

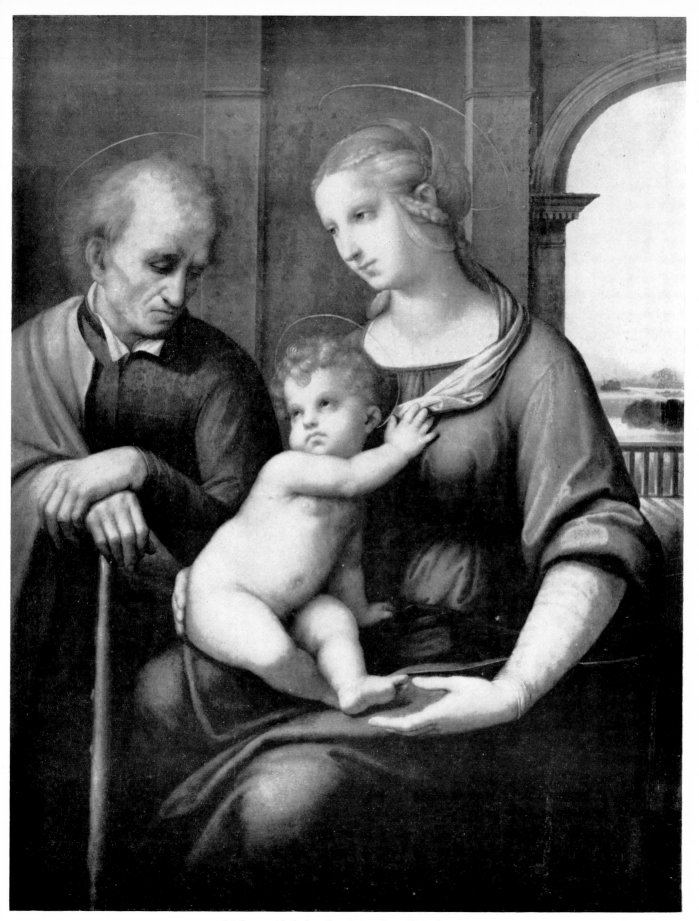

65 *Madonna with the beardless St Joseph*. Leningrad. 74 × 57.

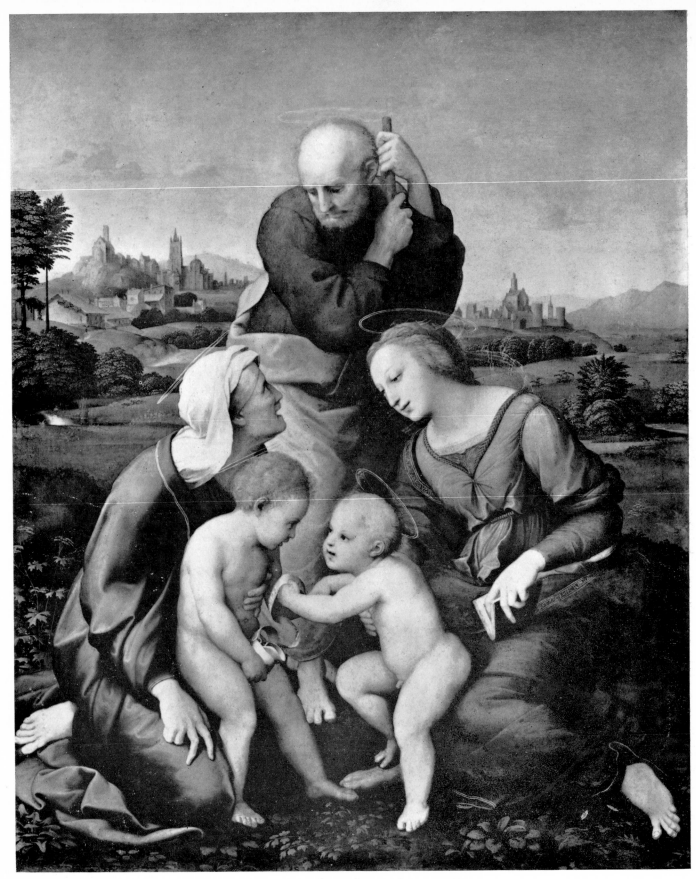

66 *Canigiani Holy Family*. Munich. 131 × 107.

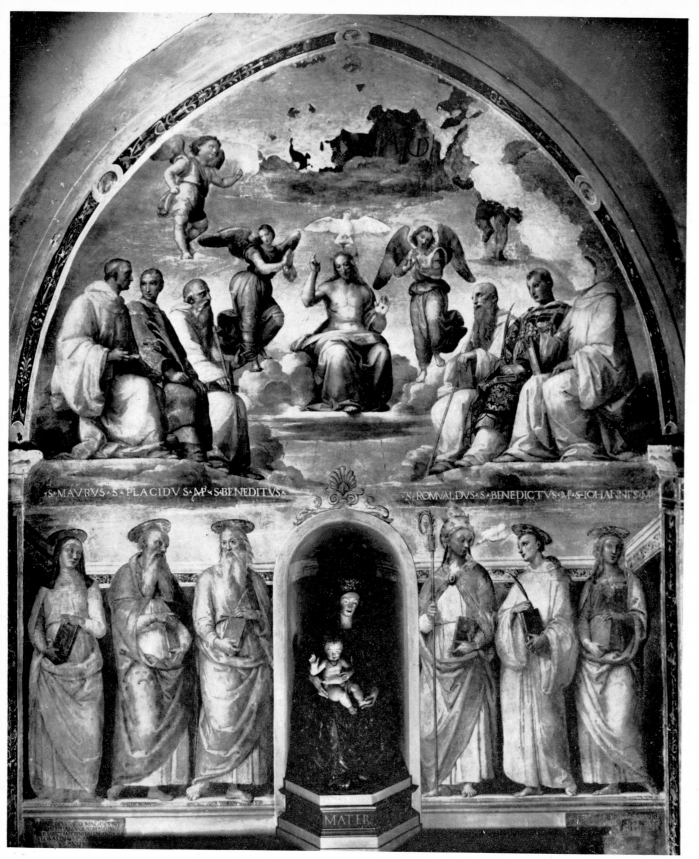

67 *Holy Trinity and Saints*. Perugia, San Severo. 389 wide.

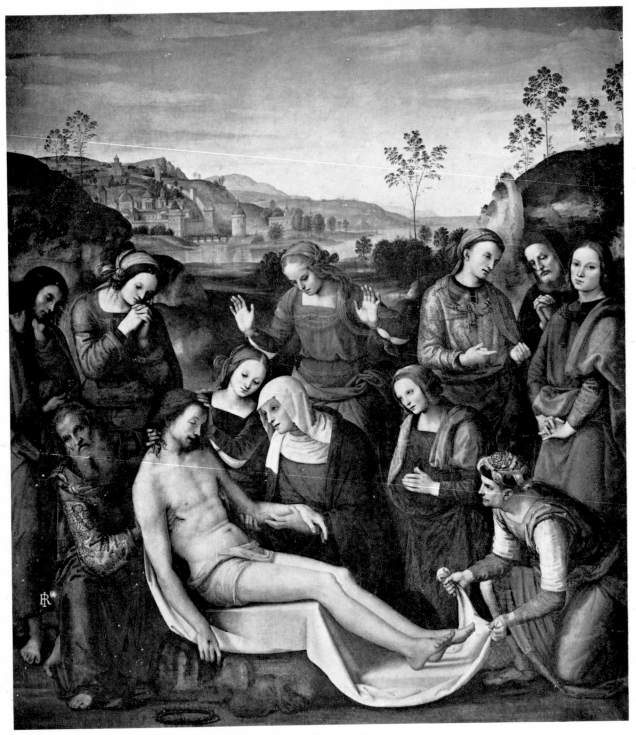

68 Perugino. *Lamentation*. Florence, Pitti. 214 × 195.

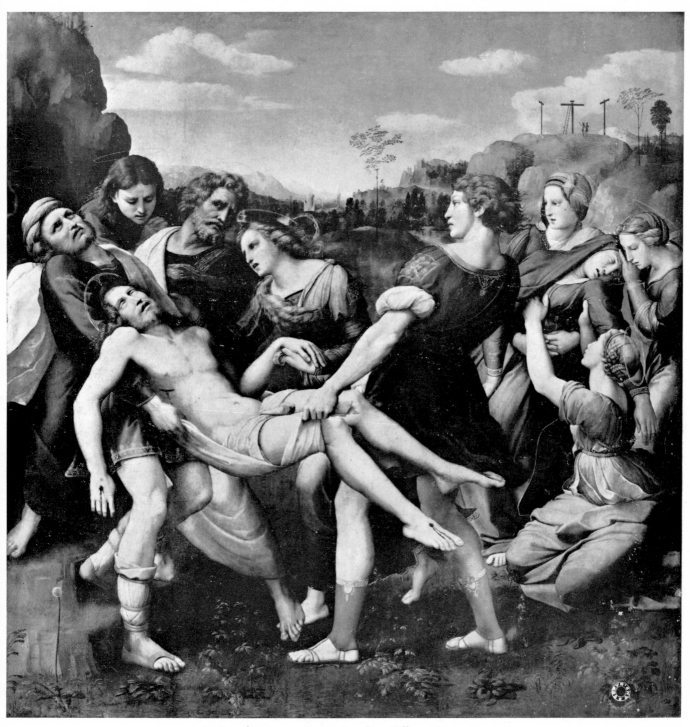

69 *Entombment*. 1507. Rome, Borghese Gallery. 184 × 176.

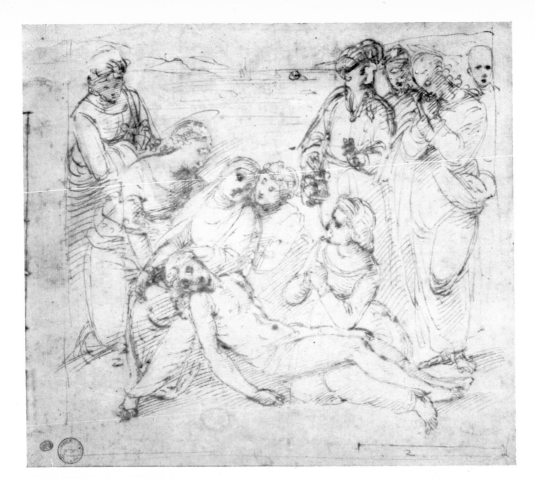

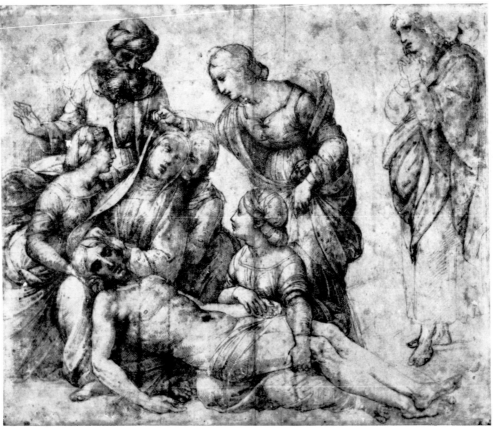

70 Early sketch for 69. Oxford. 17·9 × 20·6.

71 Early sketch for 69. Louvre. 33·3 × 39·6.

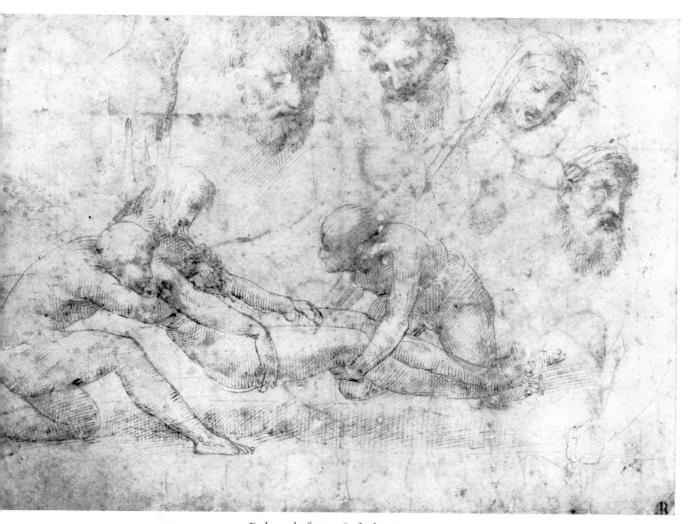

72 Early study for 69. Oxford. 21·8 × 30·7.

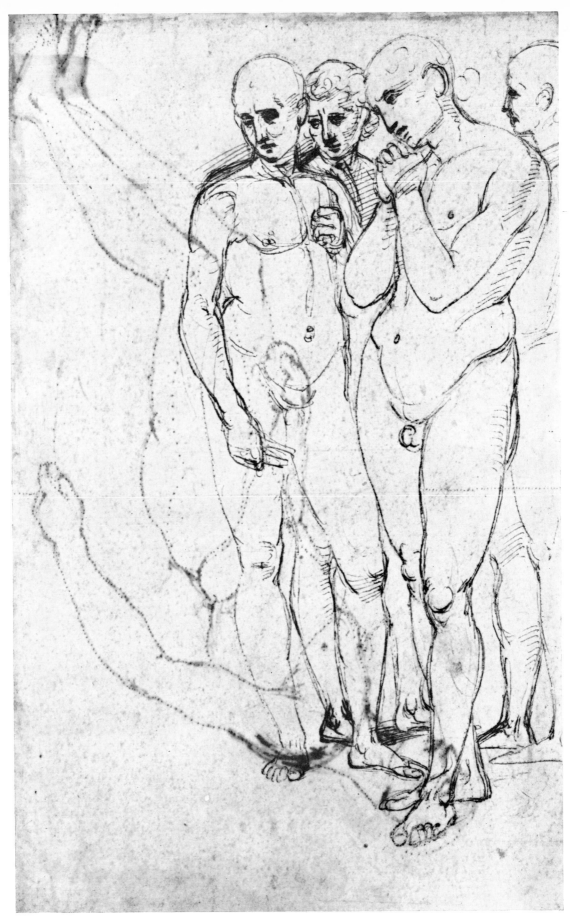

73 Early study for 69. Oxford. 32·2 × 19·8.

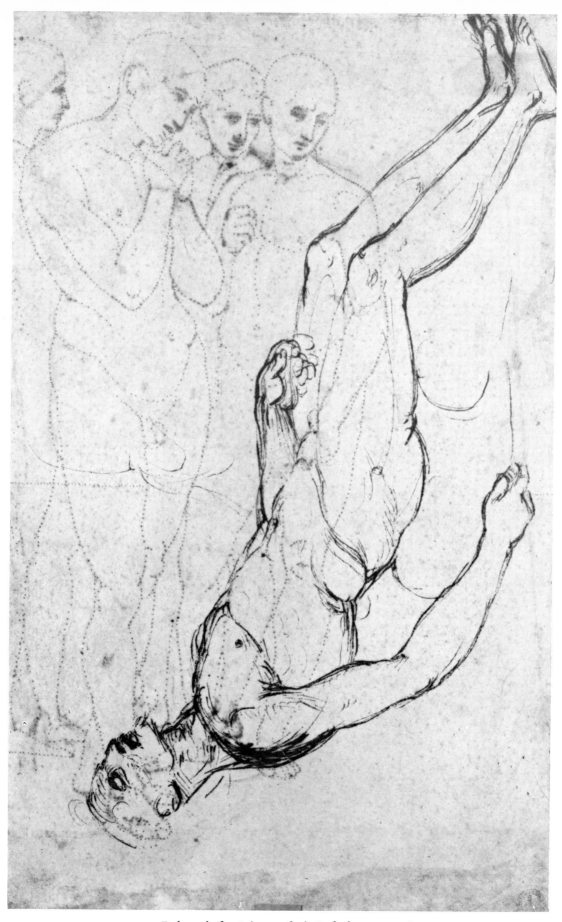

74 Early study for 69 (verso of 73). Oxford. 32·2 × 19·8.

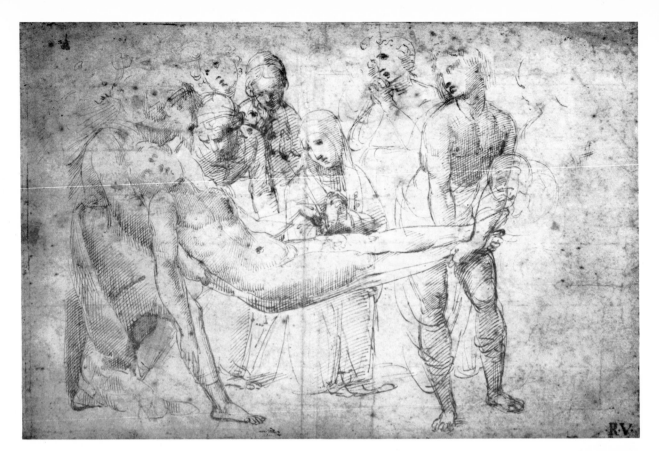

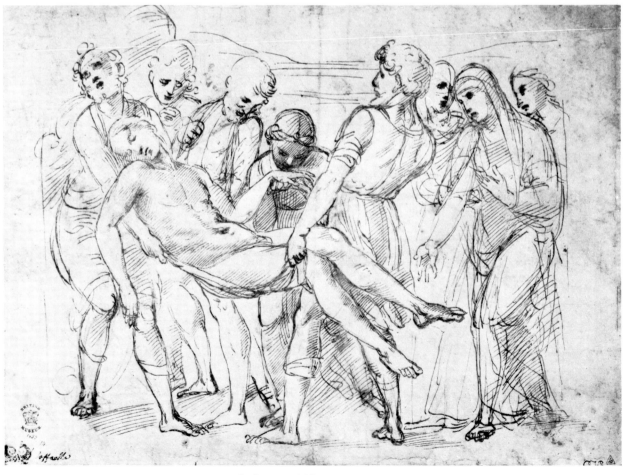

75 Study for 69. British Museum. 21·3 × 32.

76 Study for 69. British Museum. 23 × 31·9.

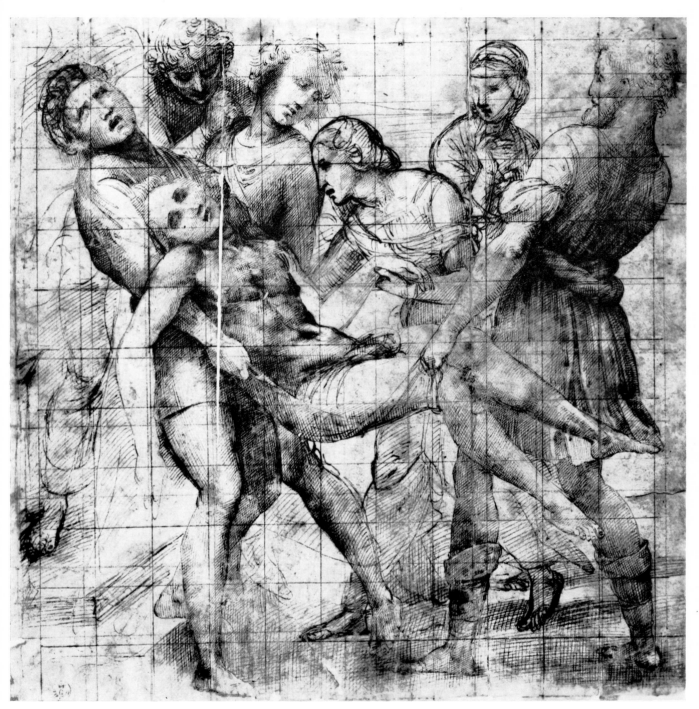

77 Developed design for 69. Uffizi. 28·9 × 29·7.

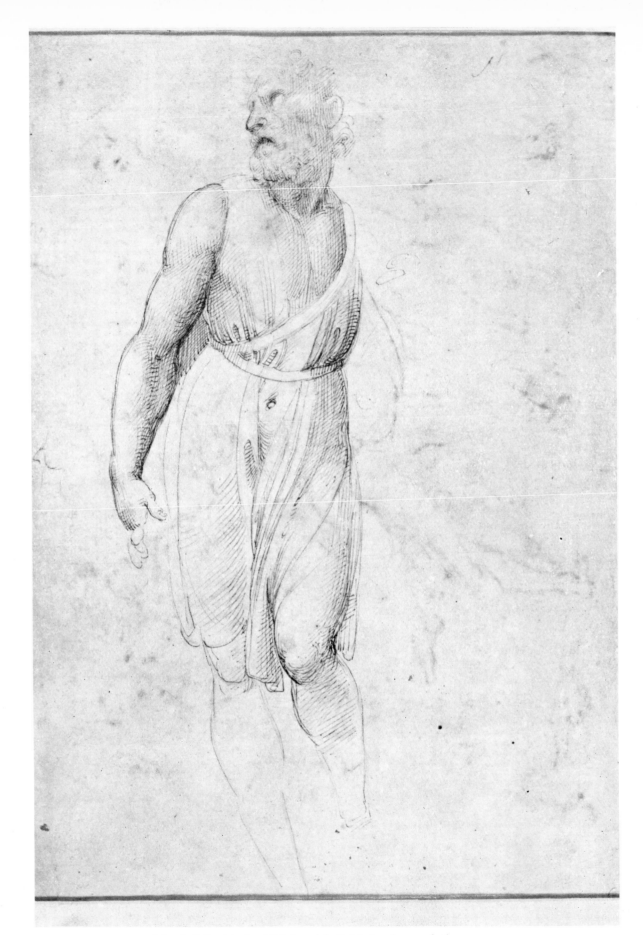

78 Study (? for 69) after Michelangelo's *St Matthew* (verso of 76). 31·9 × 23.

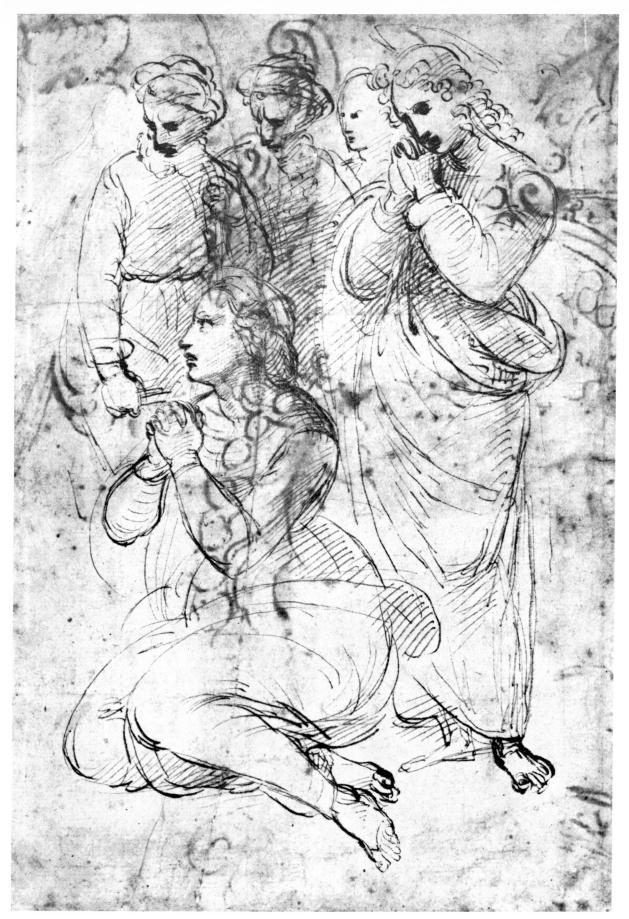

79 Study for 69. British Museum. 25 × 16·9.

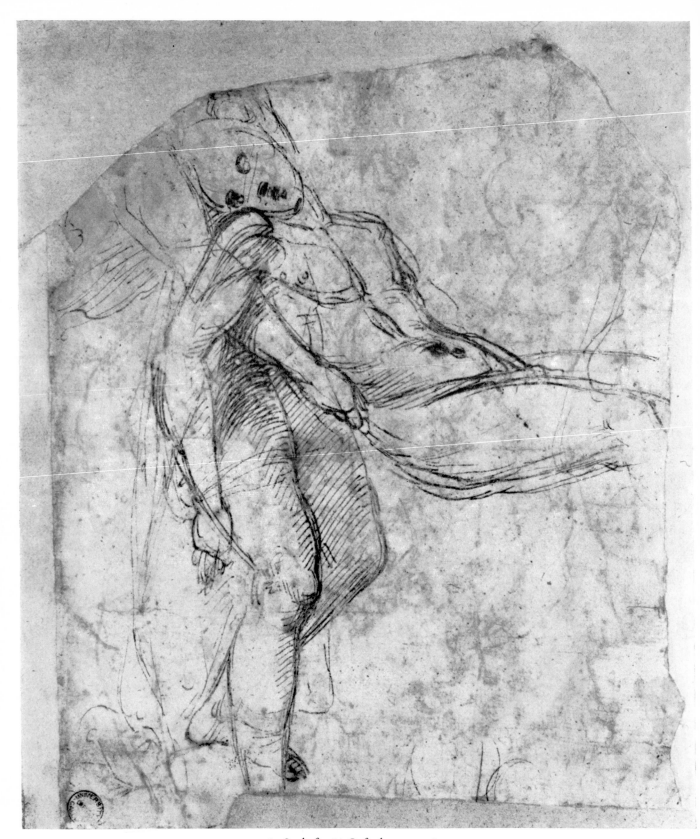

80 Study for 69. Oxford. 23·2 × 18·5.

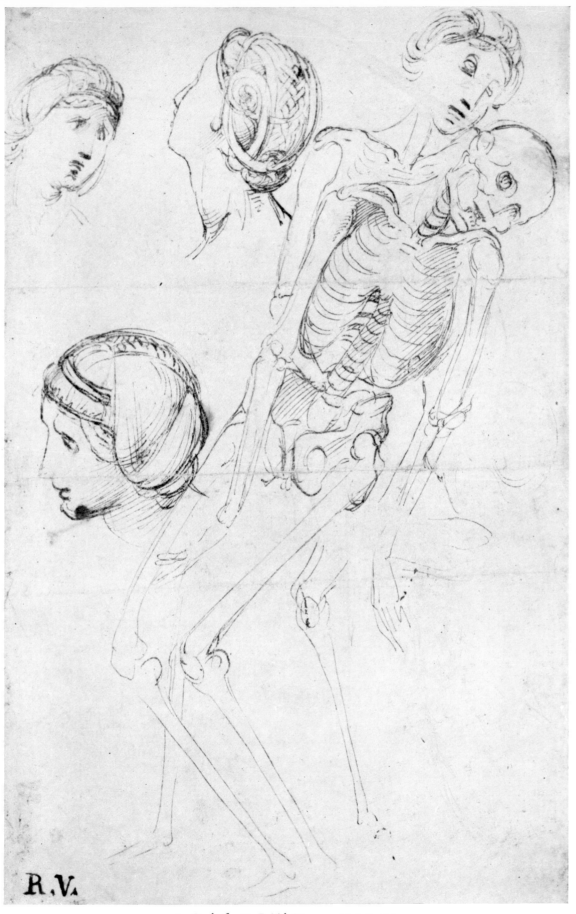

R.V.

81 Study for 69. British Museum. 30·7 × 20·2.

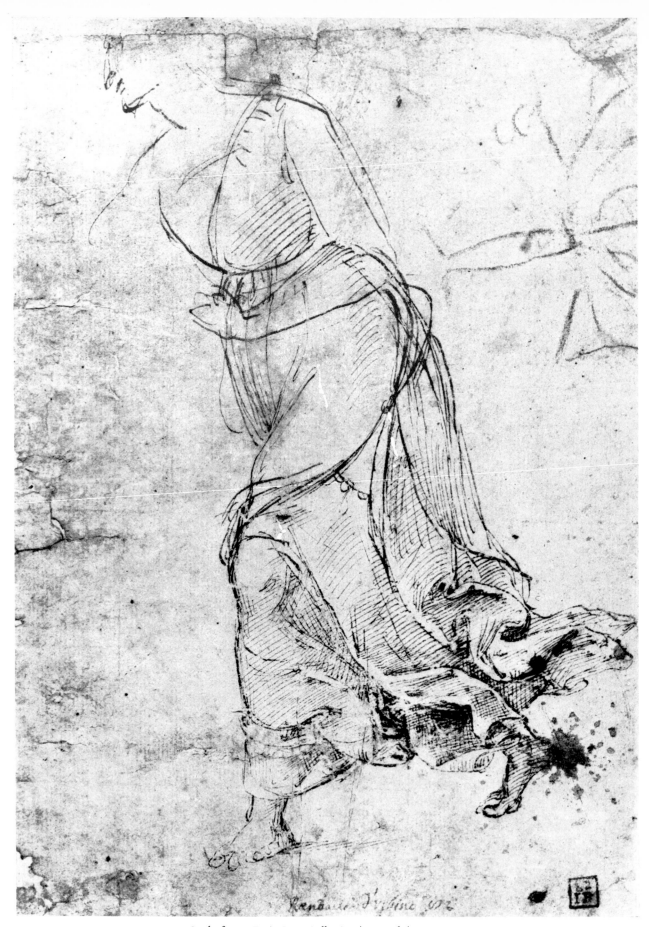

82 Study for 69. Paris, Lugt Collection (copyright). 26 × 18·6.

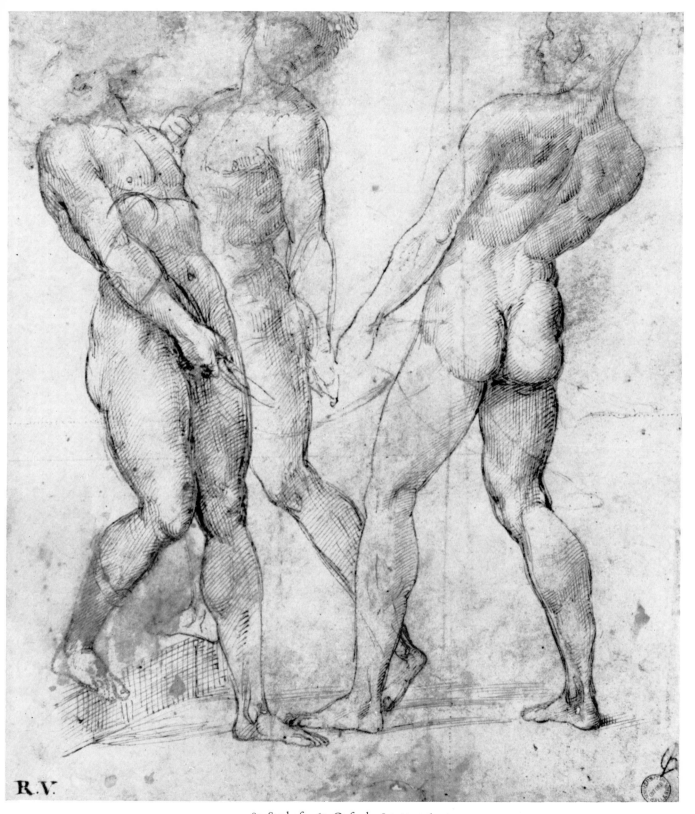

83 Study for 69. Oxford. 28·2 × 24·6.

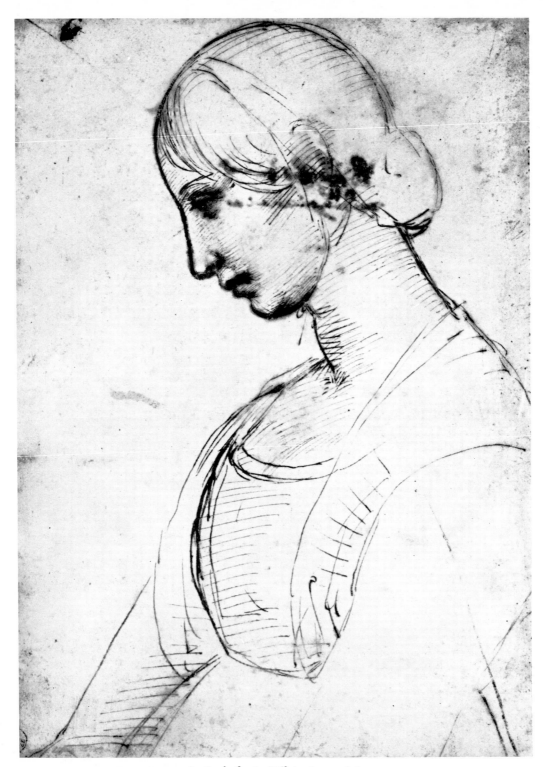

84 Study for 69. Uffizi. 26·2 × 18·8.

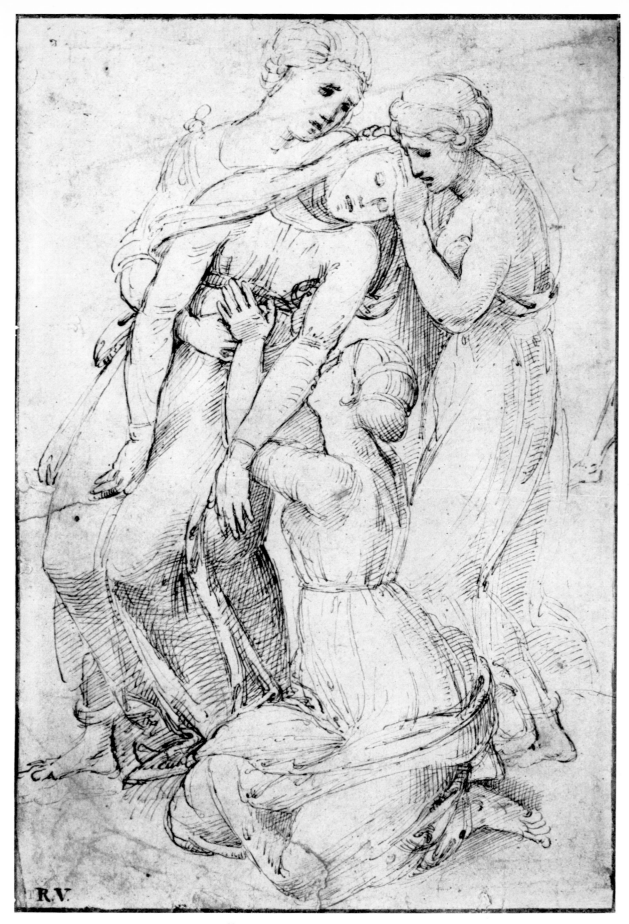

85 Copy of lost study for 69. British Museum. 28·9 × 20·1.

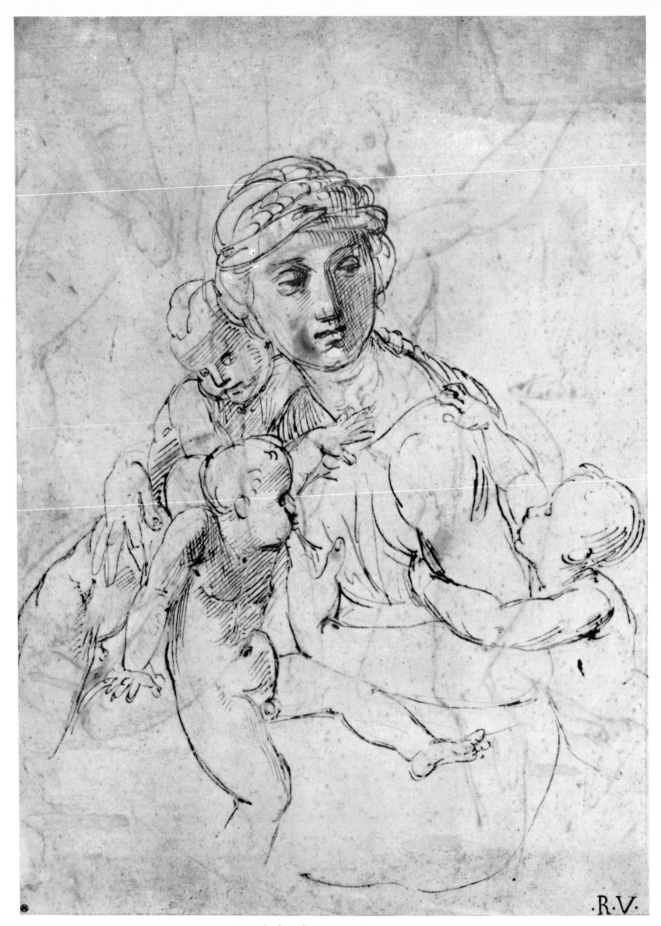

·R·V·

86 Study for *Charity* in 87. Vienna. 34 × 24.

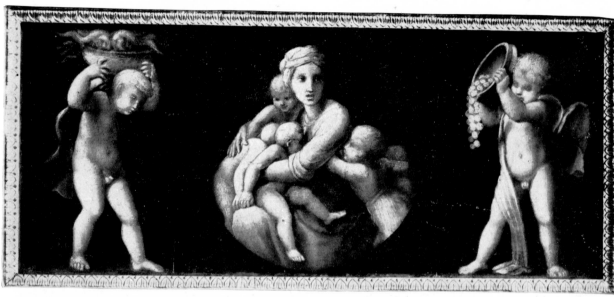

87 *Faith, Charity, Hope.* Vatican. 16 × 44 each.

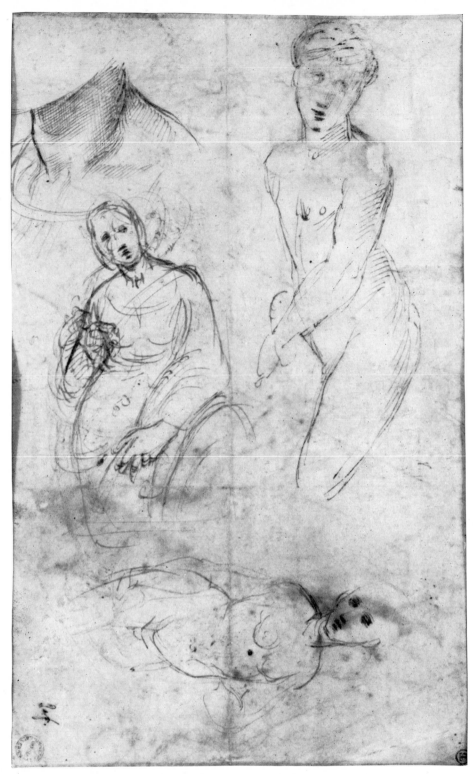

88 Prel iminary sketches for 89. Oxford. 27·9 × 16·9.

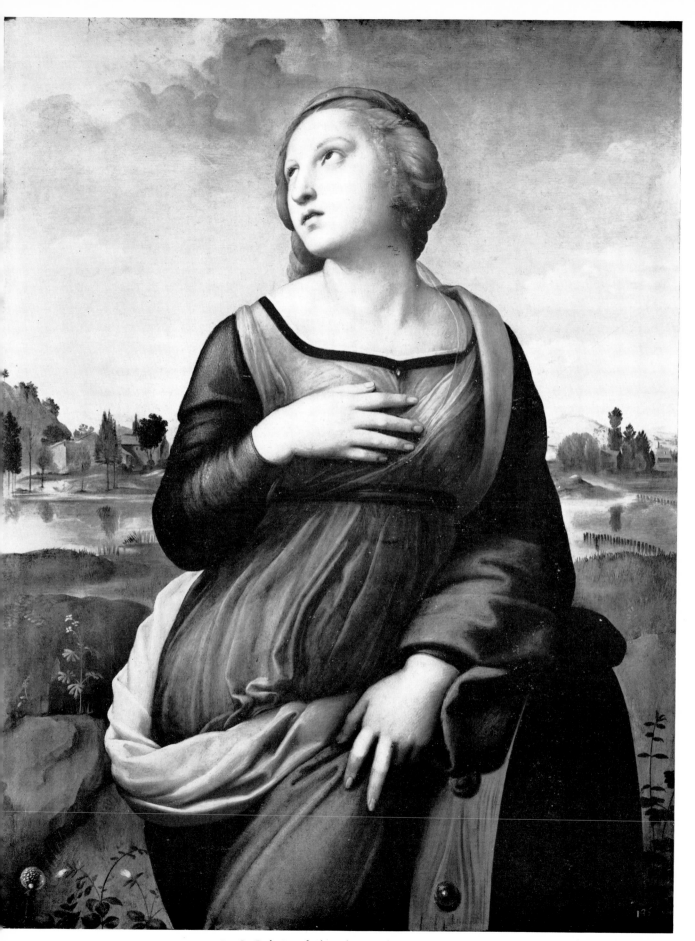

89 *St Catherine of Alexandria*. London. 71 × 55.

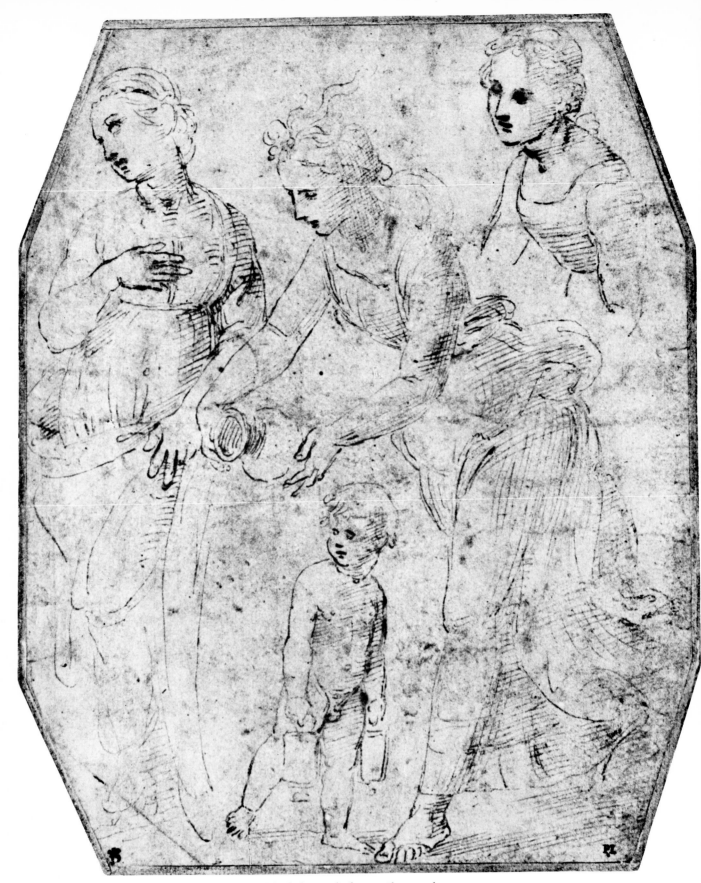

90 Copy (?) of a lost study for 89. Chatsworth. 24·7 × 19·7.

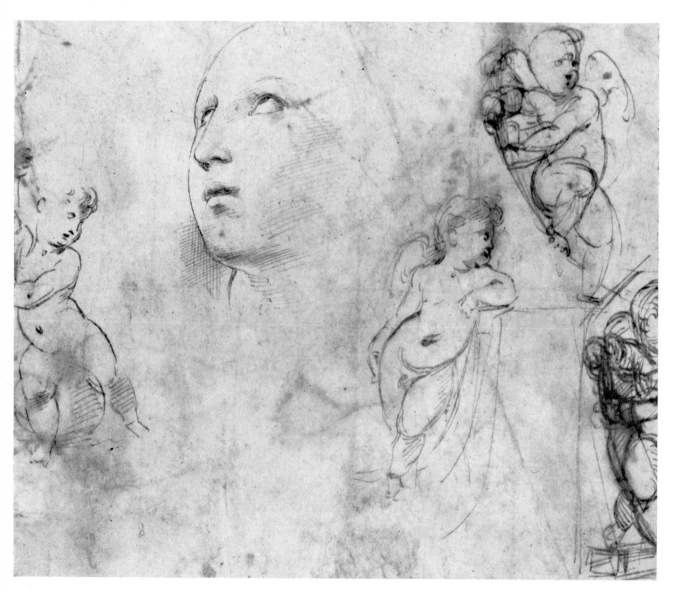

91 Study for 89. (recto of 88; detail). Oxford.

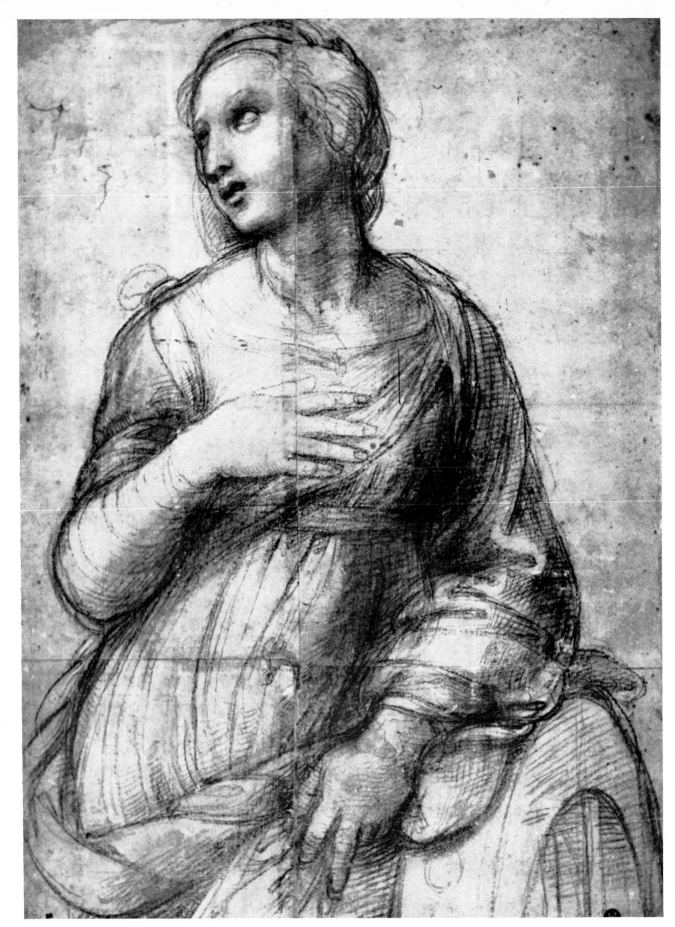

92 Cartoon for 89. Louvre. 58·4 × 43·5.

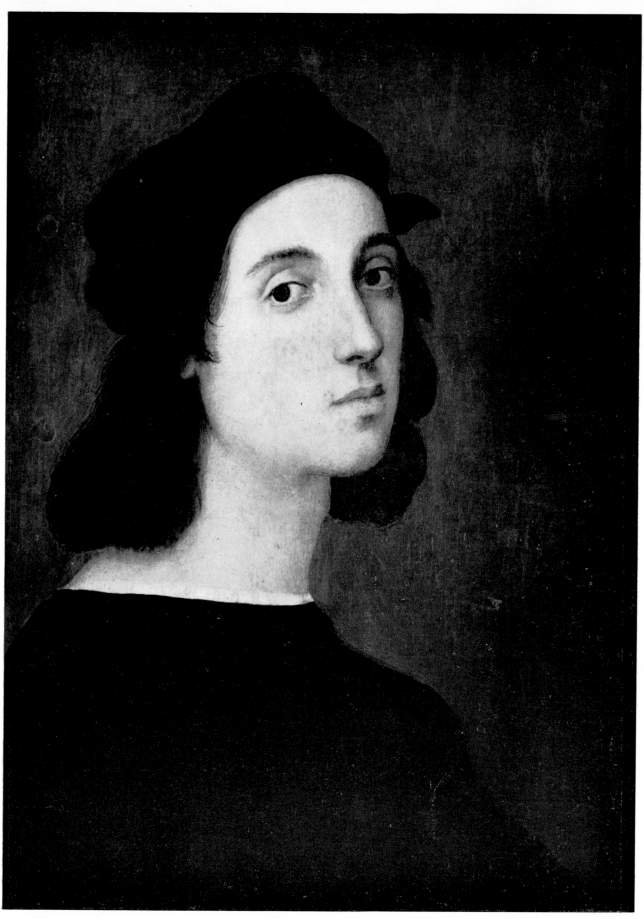

93 *Raphael's Self-portrait*. Florence, Uffizi. 45 × 33.

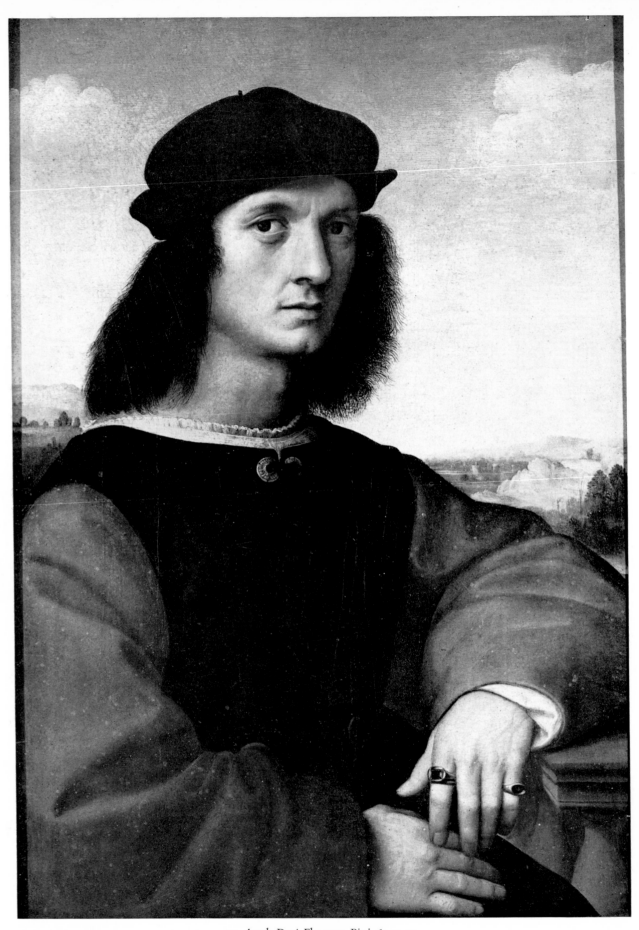

94 *Angelo Doni*. Florence, Pitti. 63 × 45.

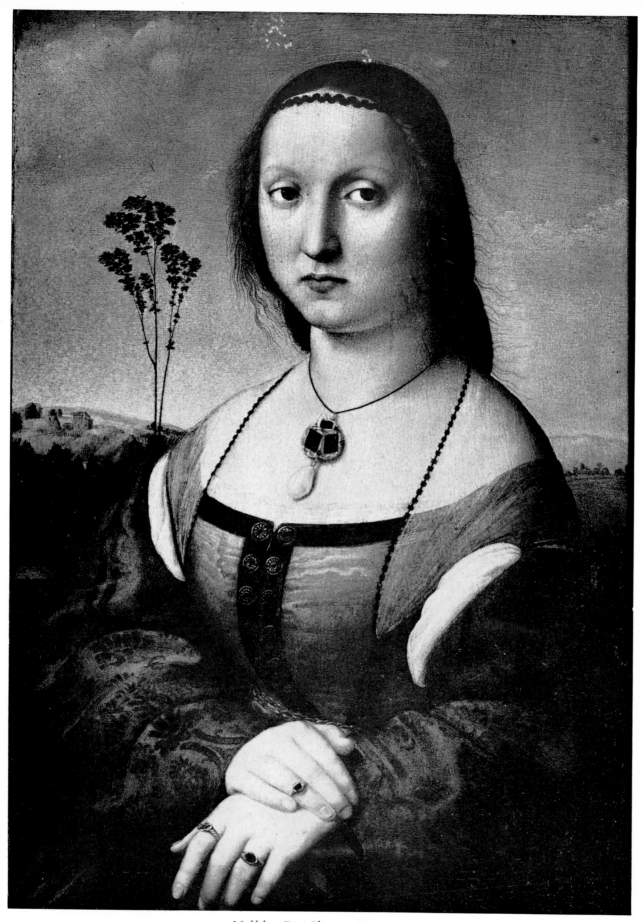

95 *Maddalena Doni*. Florence, Pitti. 63 × 45.

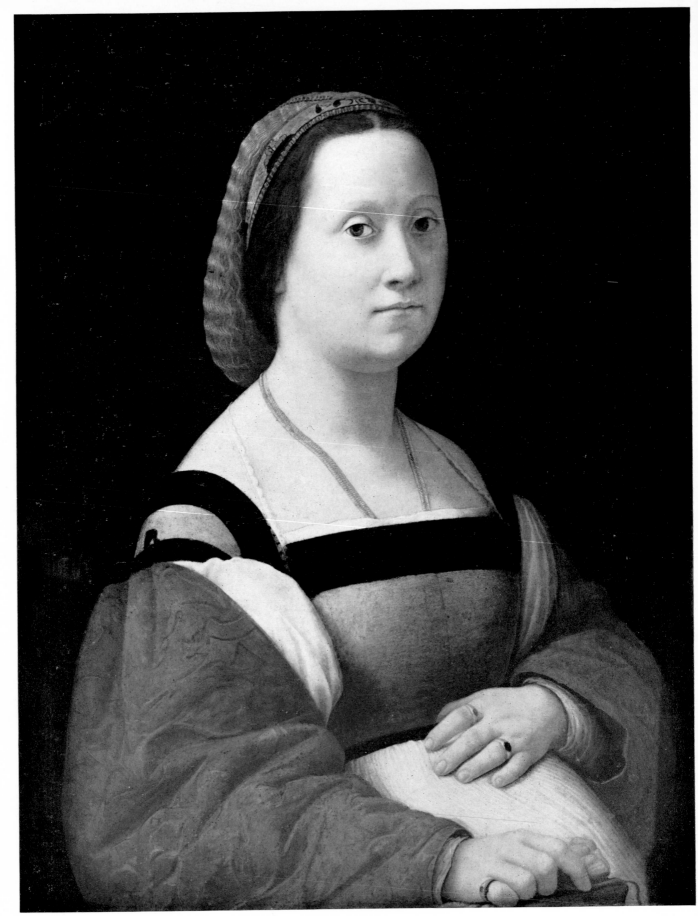

96 *La Donna Gravida. c.* 1505. Florence, Pitti. 66 × 52.

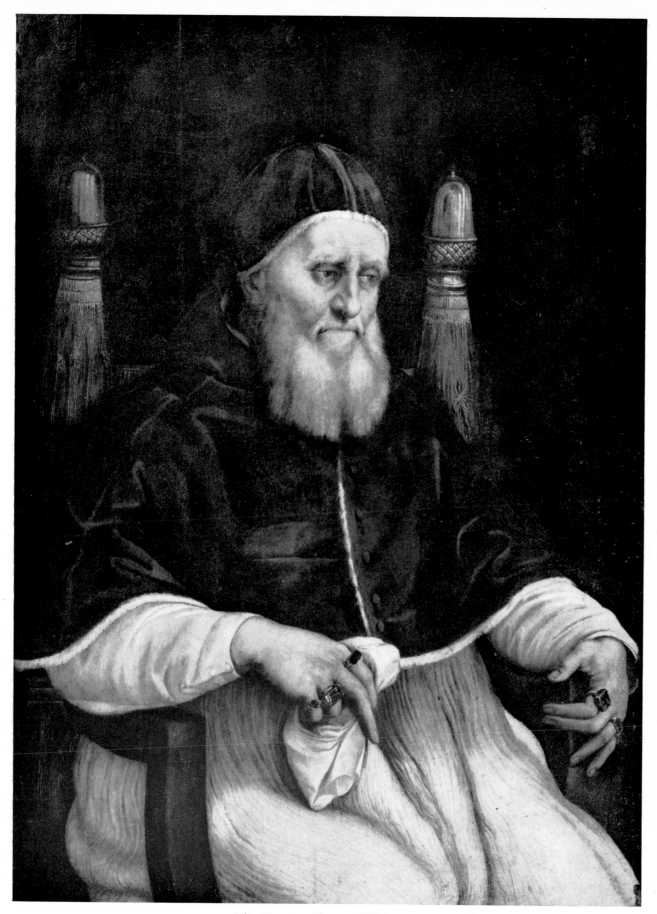

97 Julius II. c. 1512. Florence, Uffizi. 107 × 80.

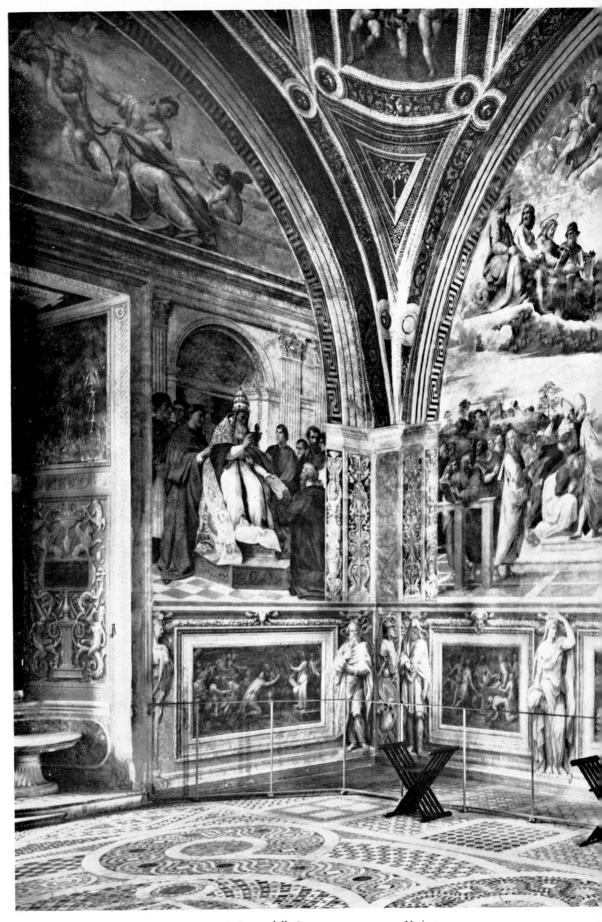

98 Stanza della Segnatura. 1509–1511. Vatican.

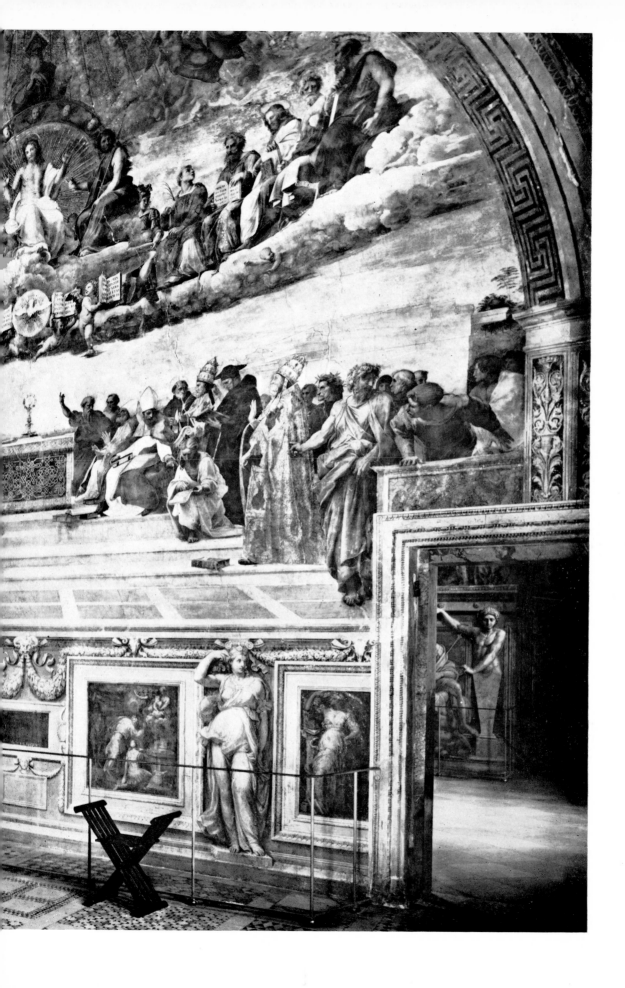

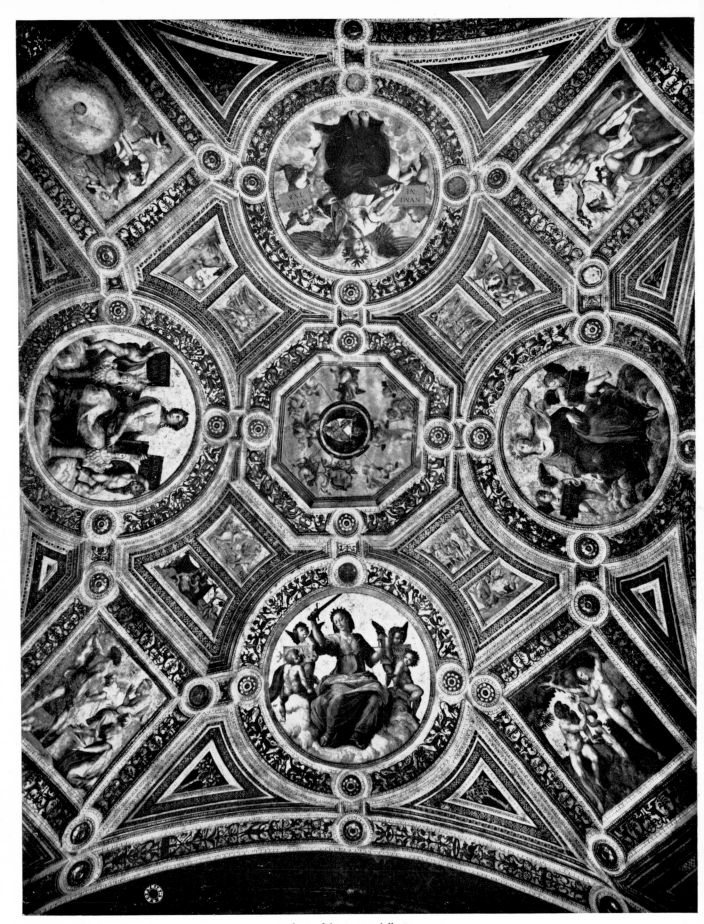

99 Ceiling of the Stanza della Segnatura.

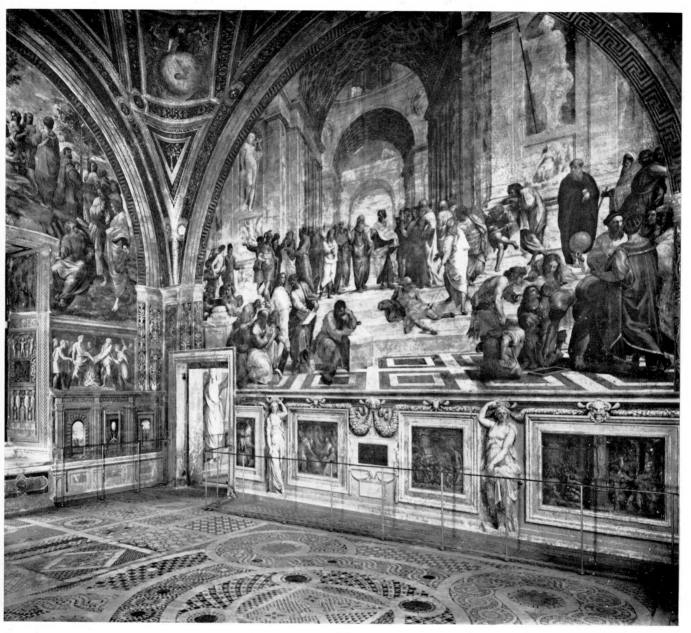

100 Stanza della Segnatura.

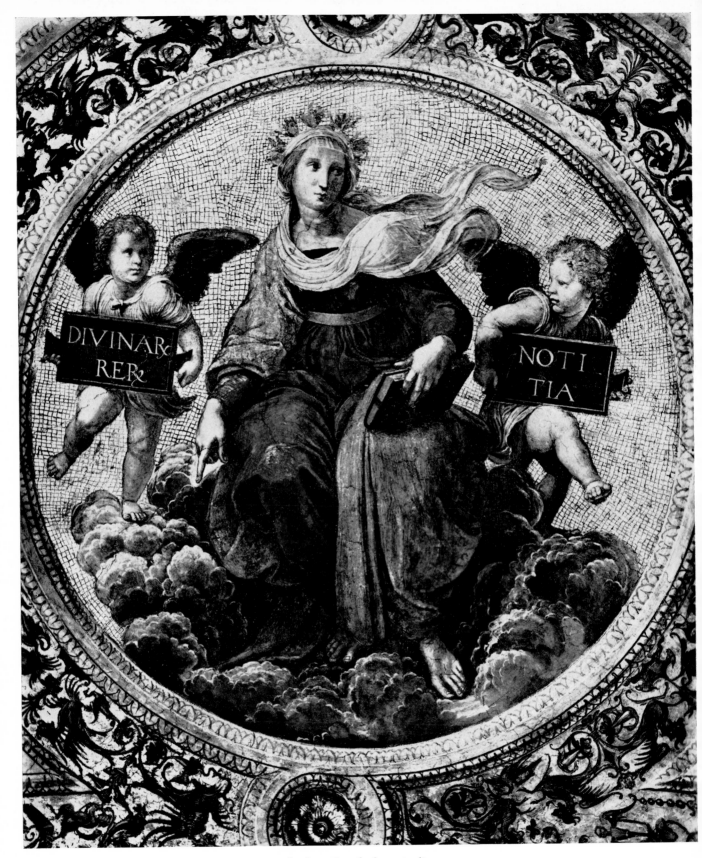

101 Theology. Detail of 99. 180 diameter.

102 Sketch for 101. Oxford. 20·1 × 14·3.

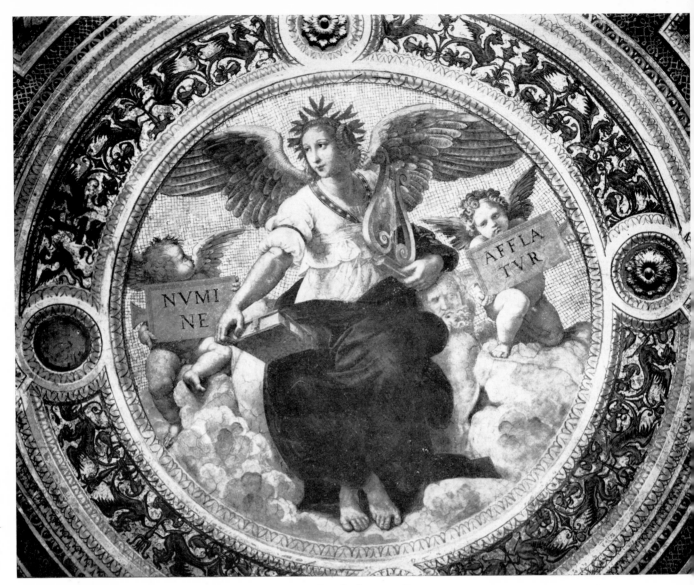

103 *Poetry*. Detail of 99. 180 diameter.

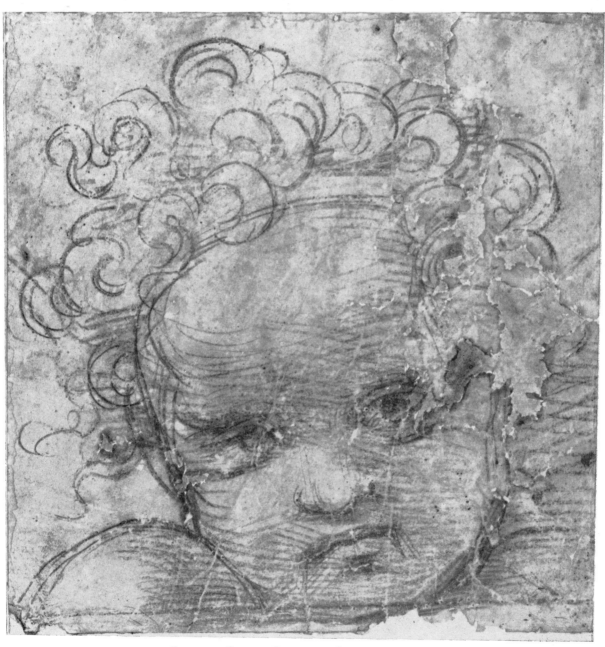

104 Fragment of cartoon for 103. British Museum. 23·4 × 23·2.

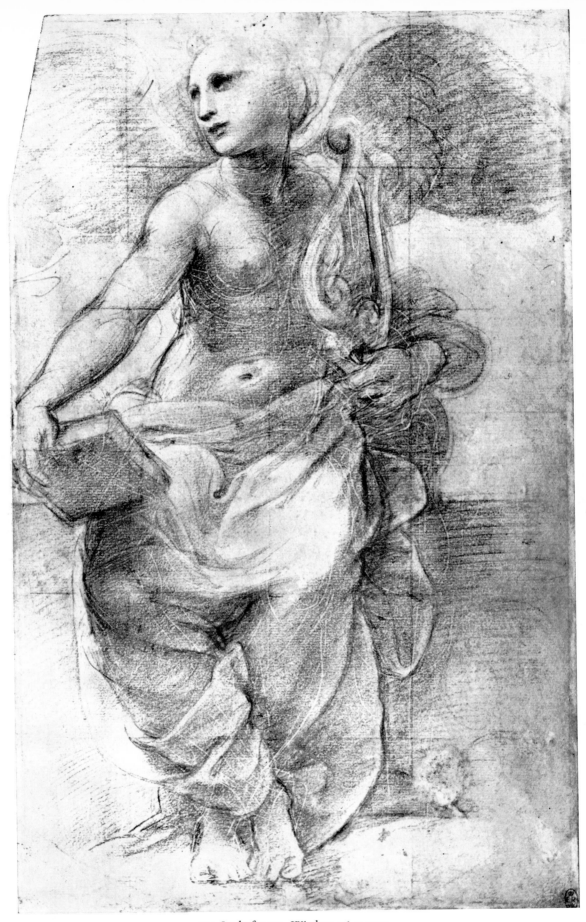

105 Study for 103. Windsor. 36 × 22·7.

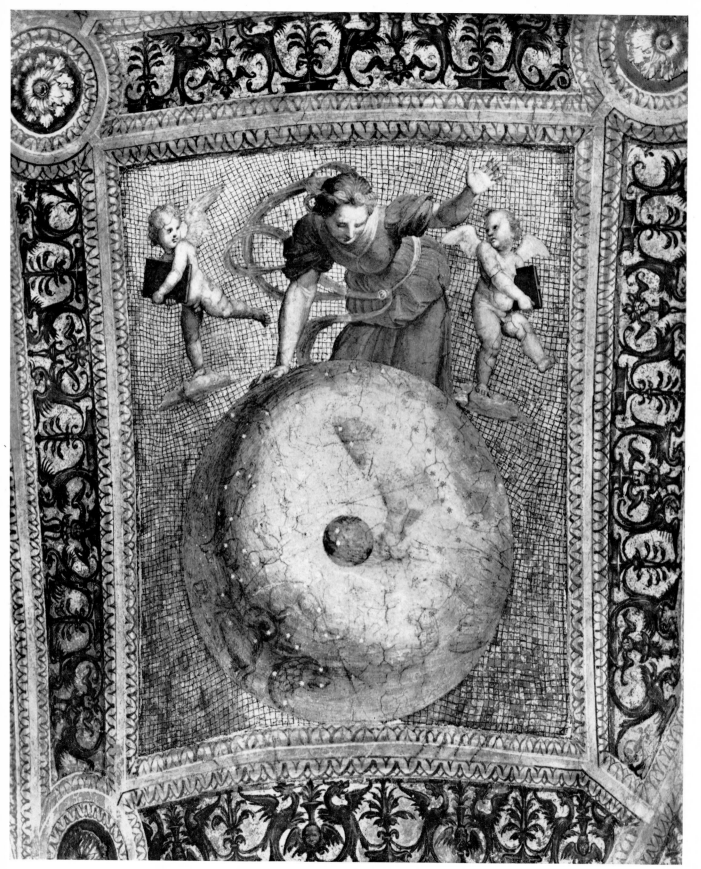

106 *Philosophy* (*Astronomy*). Detail of 99. 120 × 105.

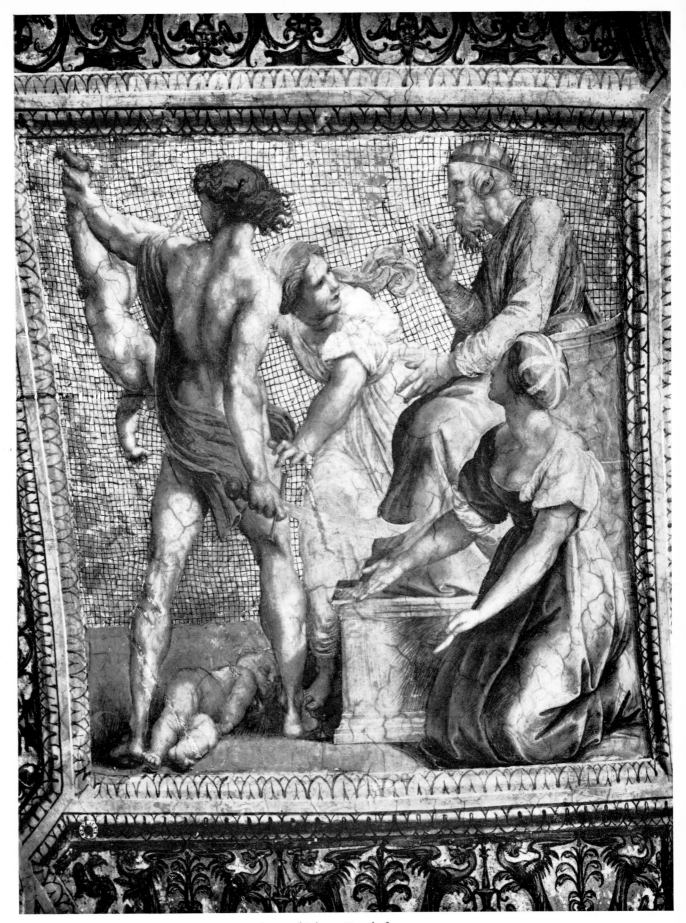

107 *Judgment of Solomon*. Detail of 99. 120 × 105.

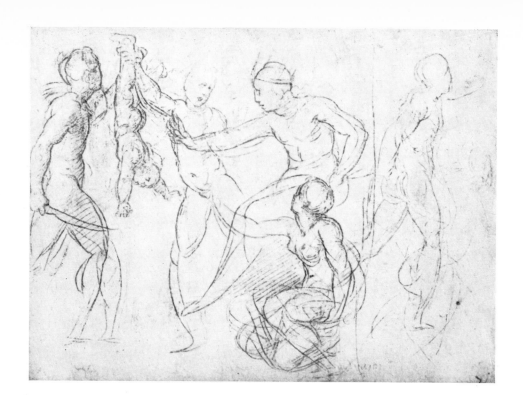

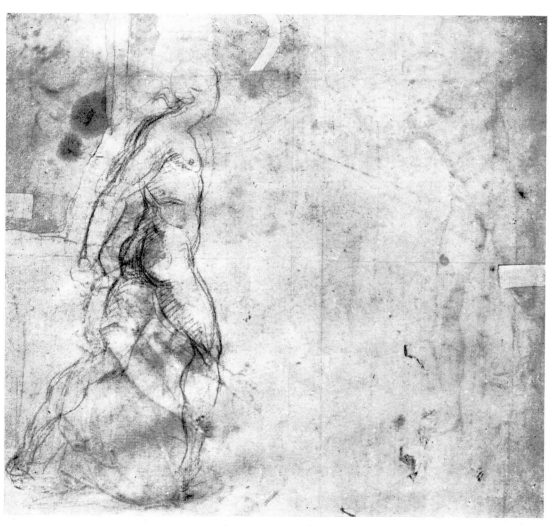

108 Study for 107. Oxford. 10 × 13·7.

109 Study for 107. Vienna. 26·4 × 28·7.

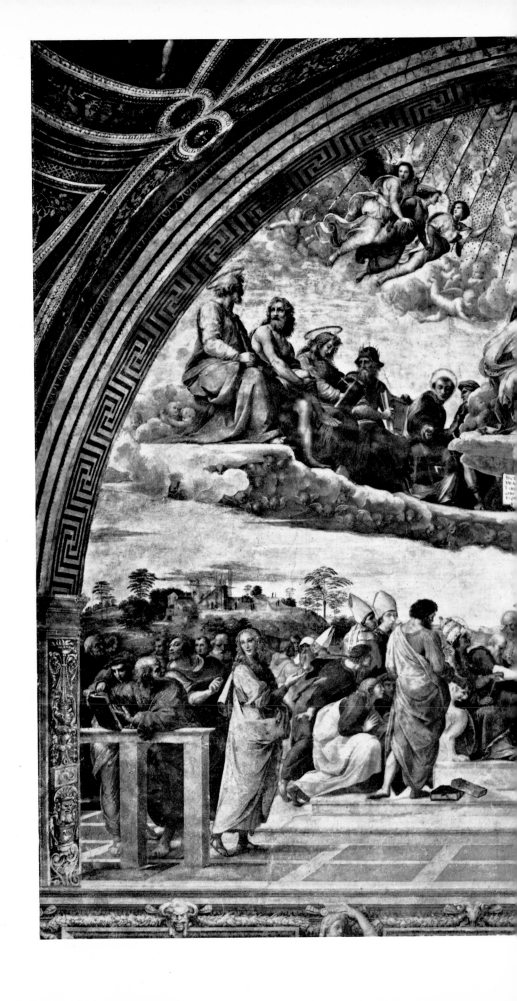

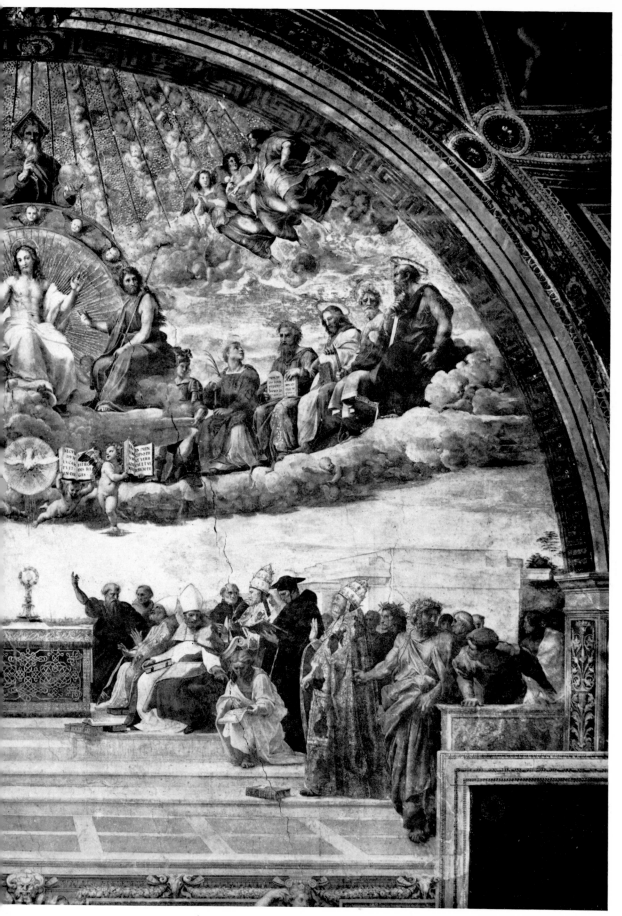

110 The *Disputa*. Stanza della Segnatura. 770 wide.

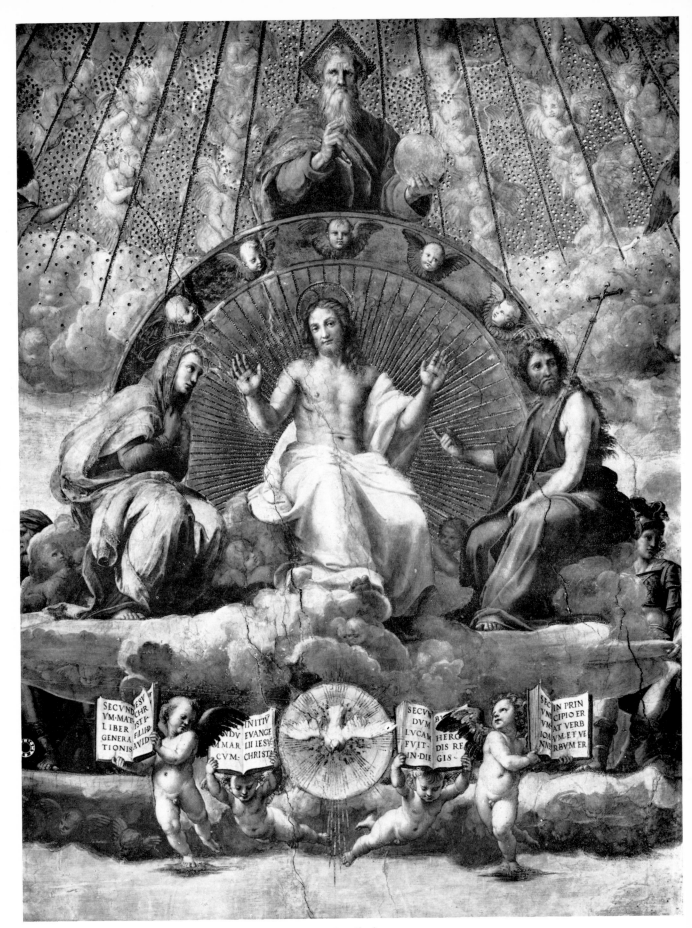

111 Detail of 110.

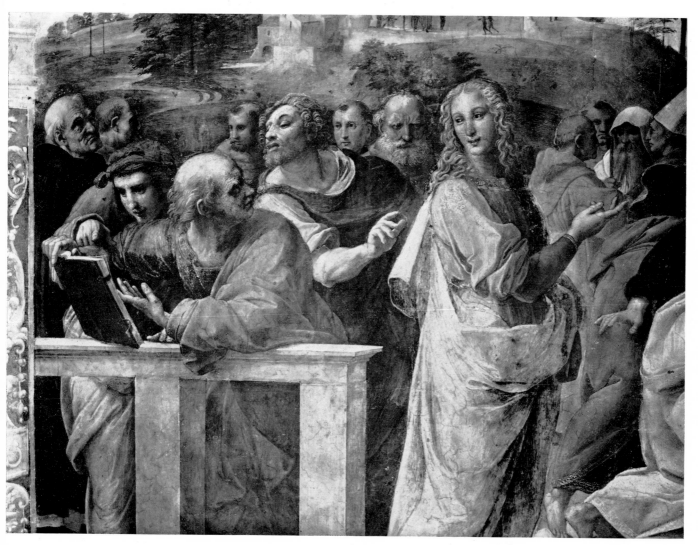

112 Detail of 110.

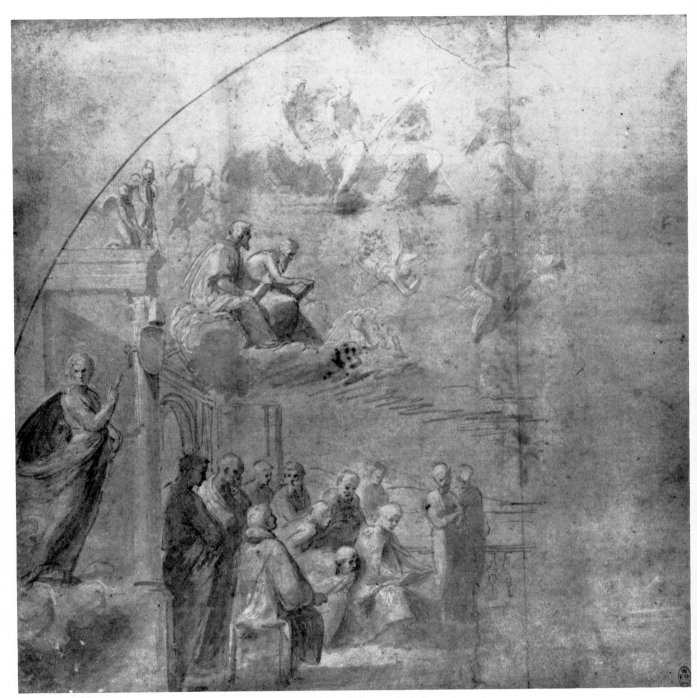

113 Early compositional sketch for 110. Windsor. 28 × 28·5.

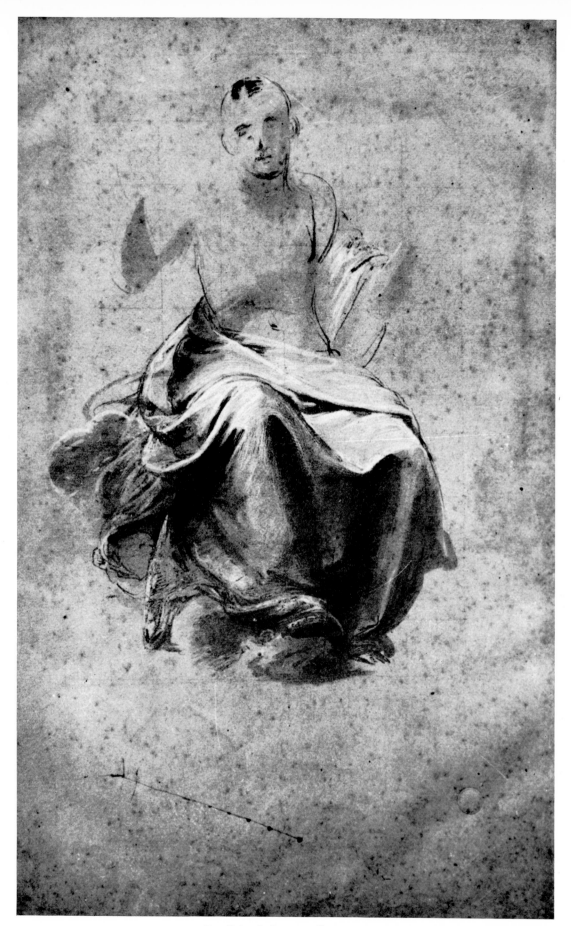

114 Detail sketch for 110. Lille. 41 × 27·3.

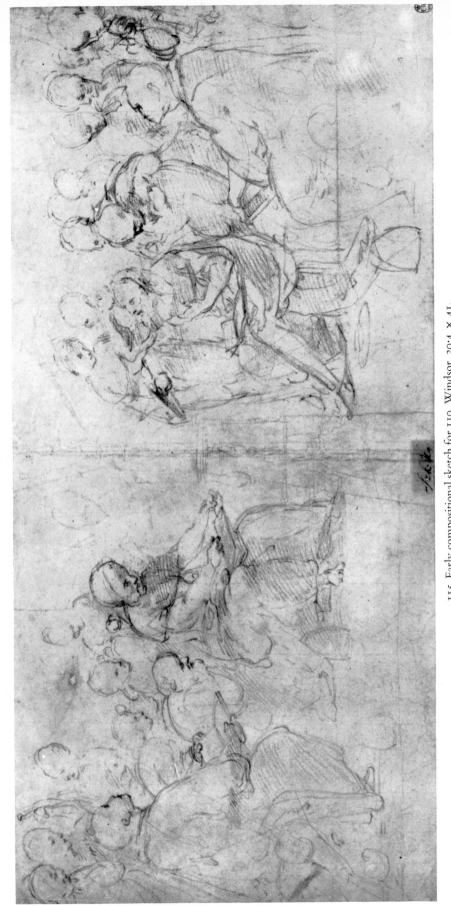

115 Early compositional sketch for 110. Windsor. 20·4 × 41.

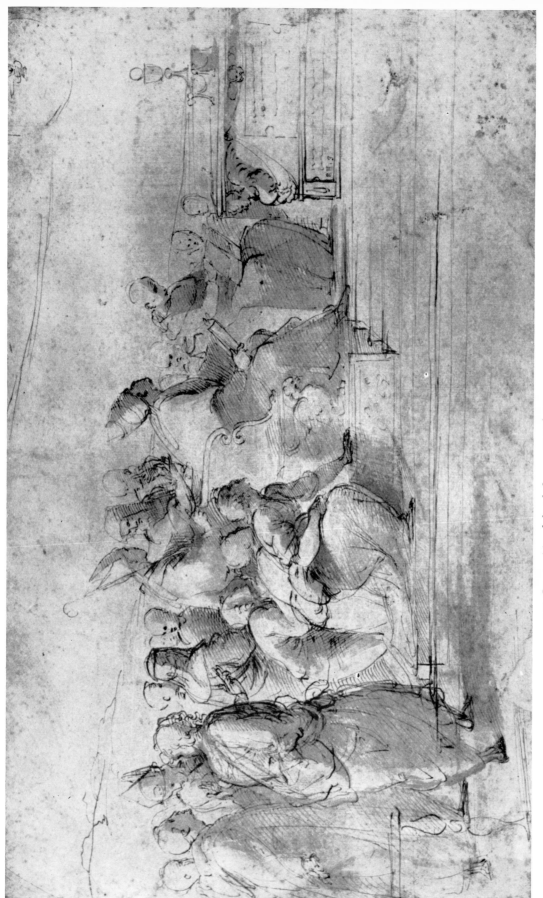

116 Compositional sketch for 110. British Museum. 24·7 × 40·1.

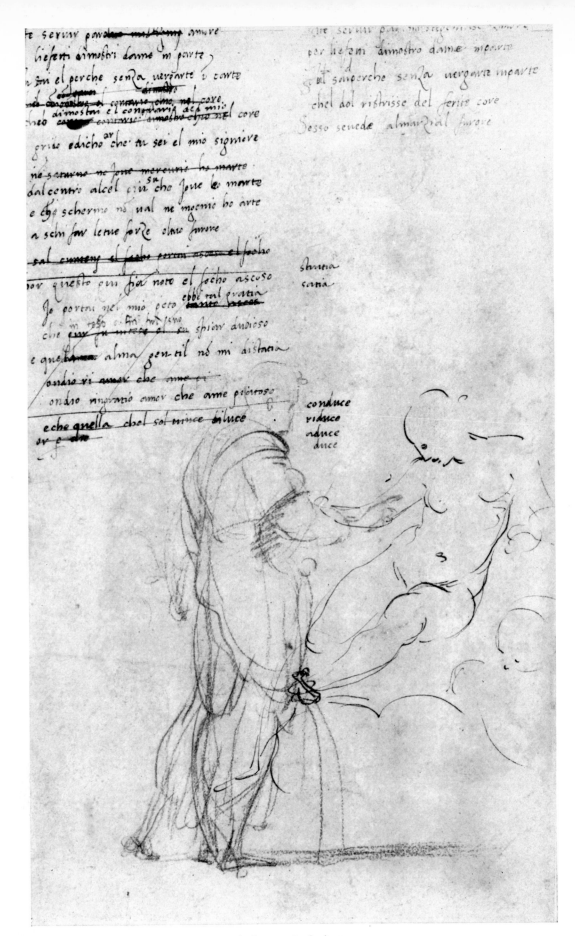

117 Study for 110. Oxford. 38 × 23.

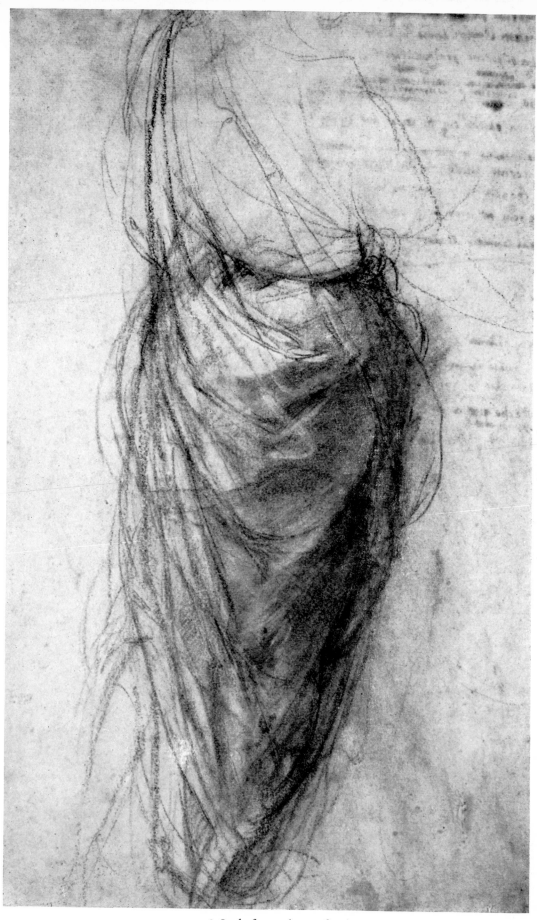

118 Study for 110 (recto of 117).

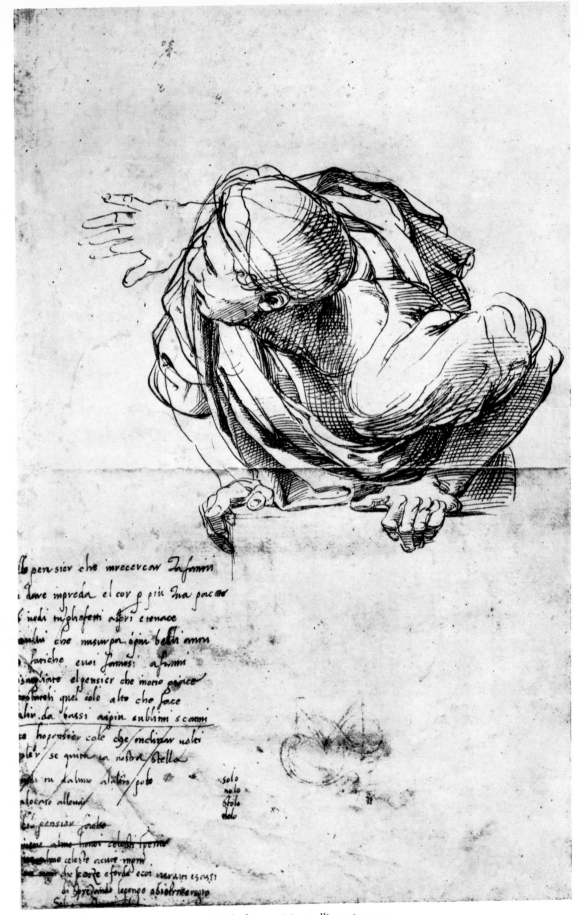

119 Study for 110. Montpellier. 36 × 23·5.

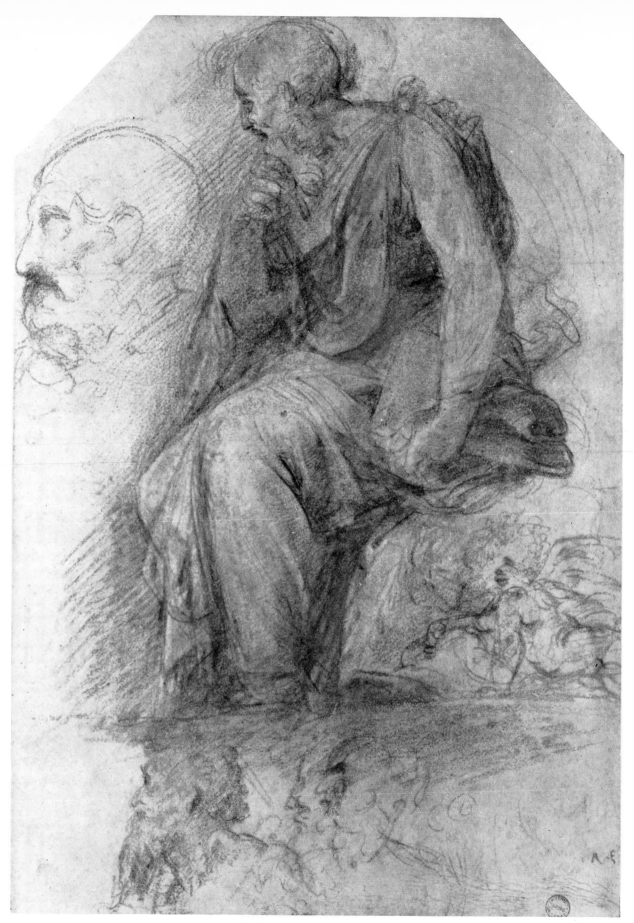

120 Developed study for 110. Oxford. 38·7 × 26·6.

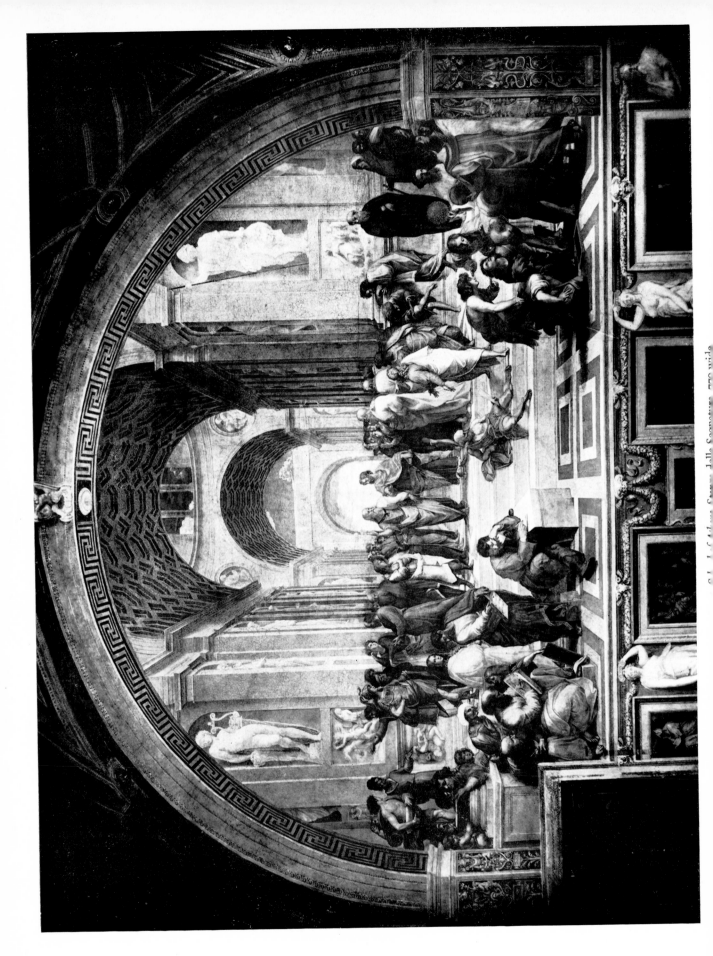

Plate 1. Raphael: Stanza della Segnatura, 772 wide.

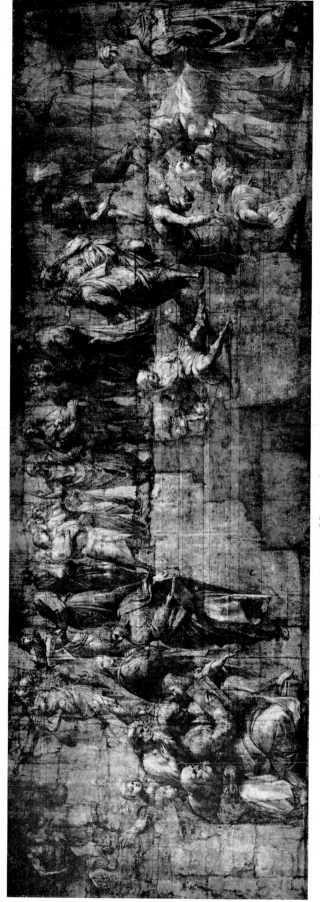

122 Cartoon of figures of 121. Milan, Ambrosiana. 280 × 800.

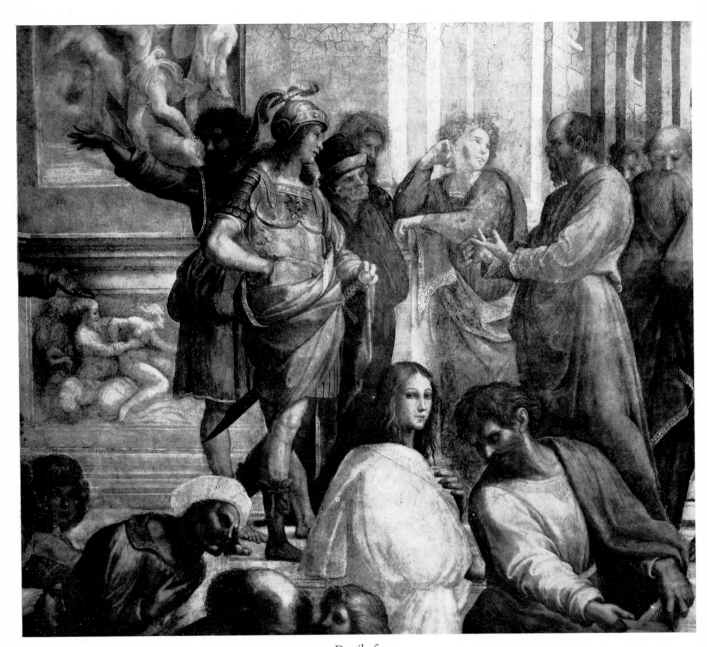

123 Detail of 121.

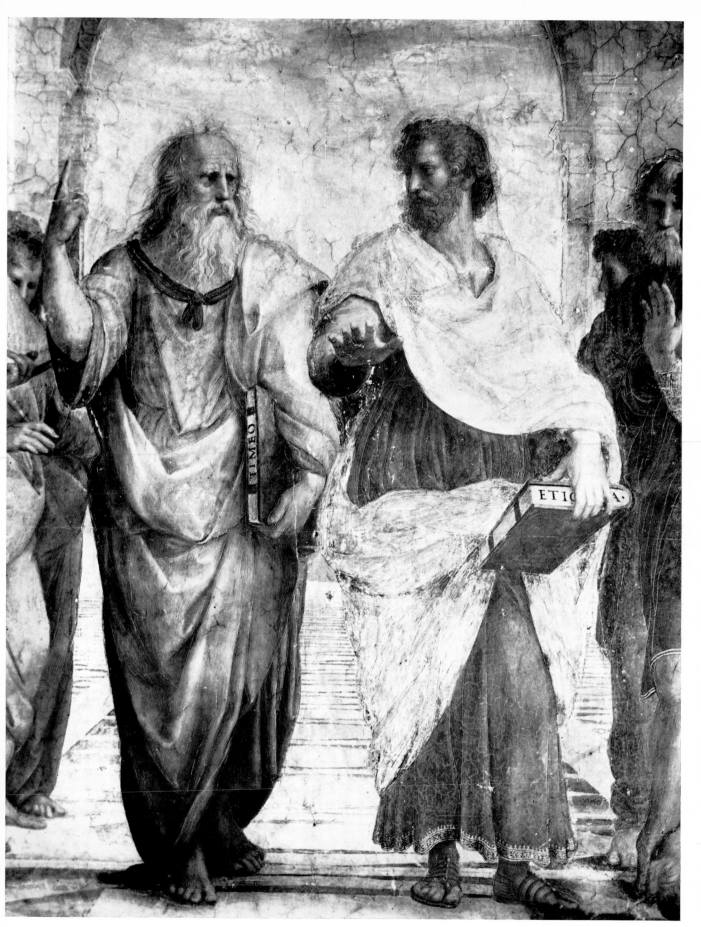

124 Detail of 121.

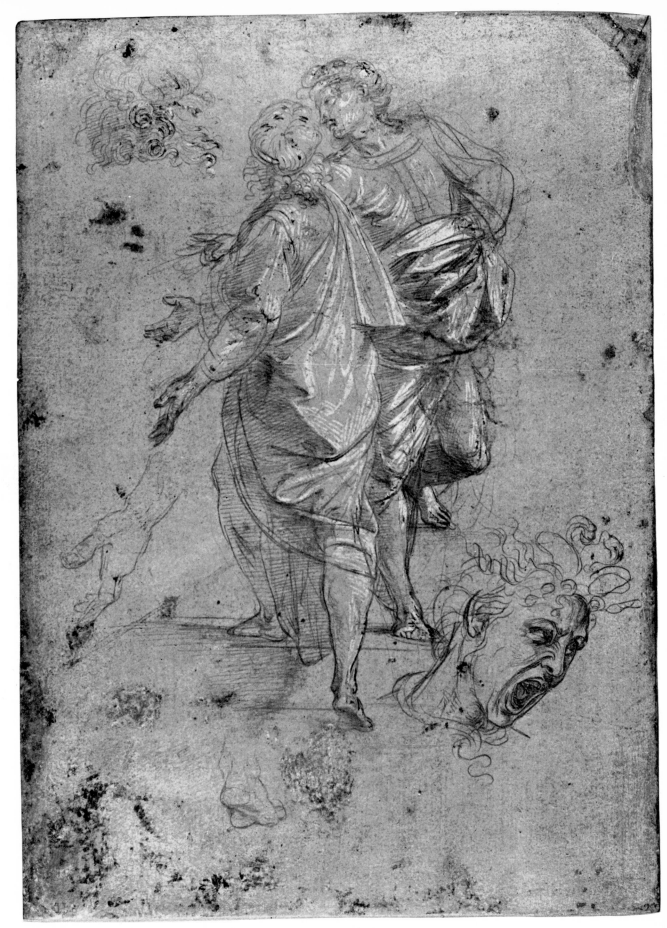

125 Study for 121. Oxford. 27·8 × 20.

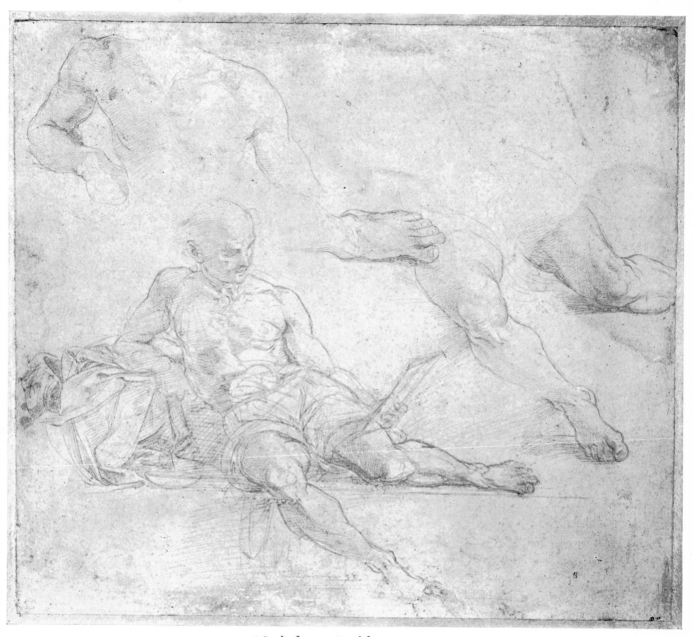

126 Study for 121. Frankfurt. 24·5 × 28·5.

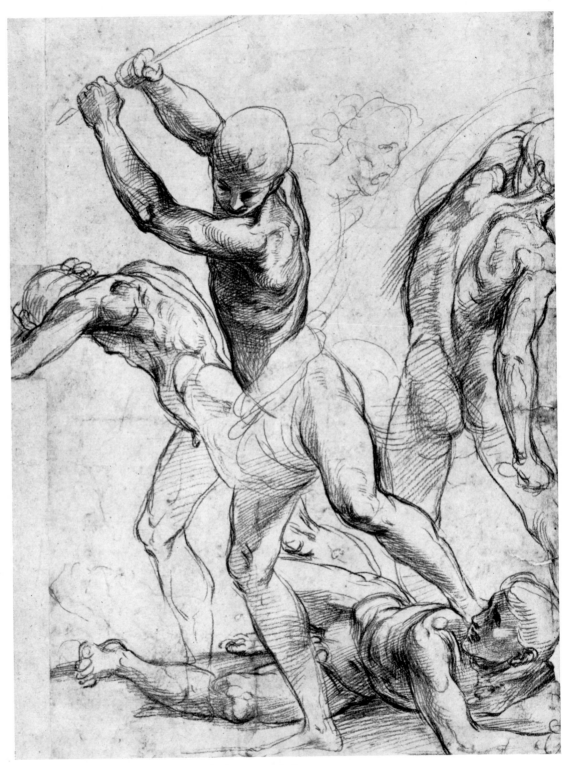

127 Study for 121. Oxford. 37·9 × 28·1.

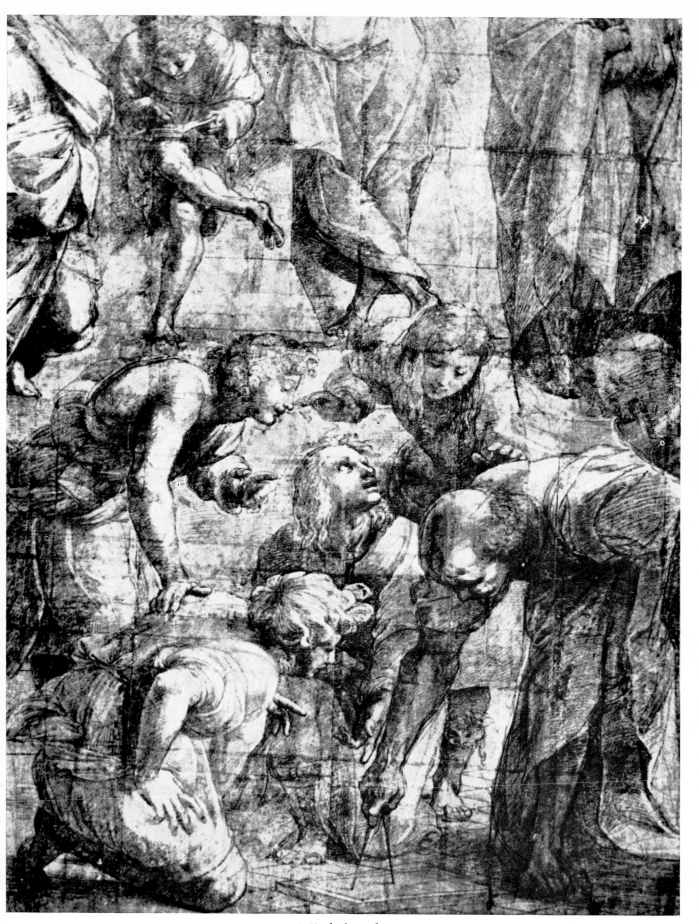

128 Single sheet of 122.

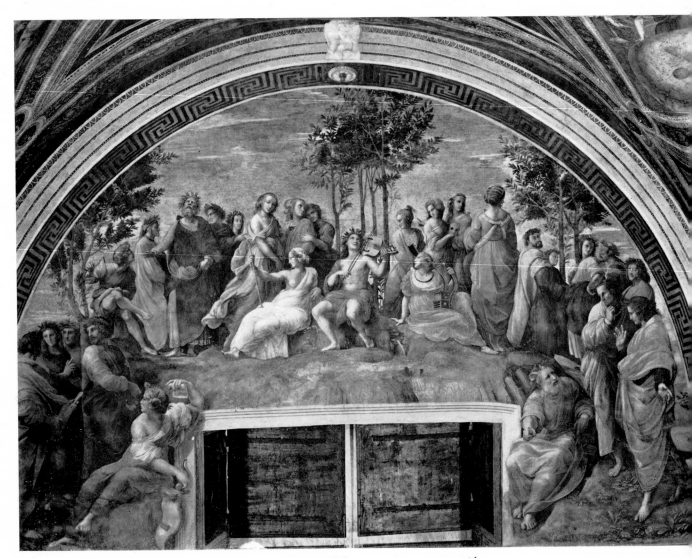

129 *Parnassus*. Stanza della Segnatura. 1511. 670 wide.

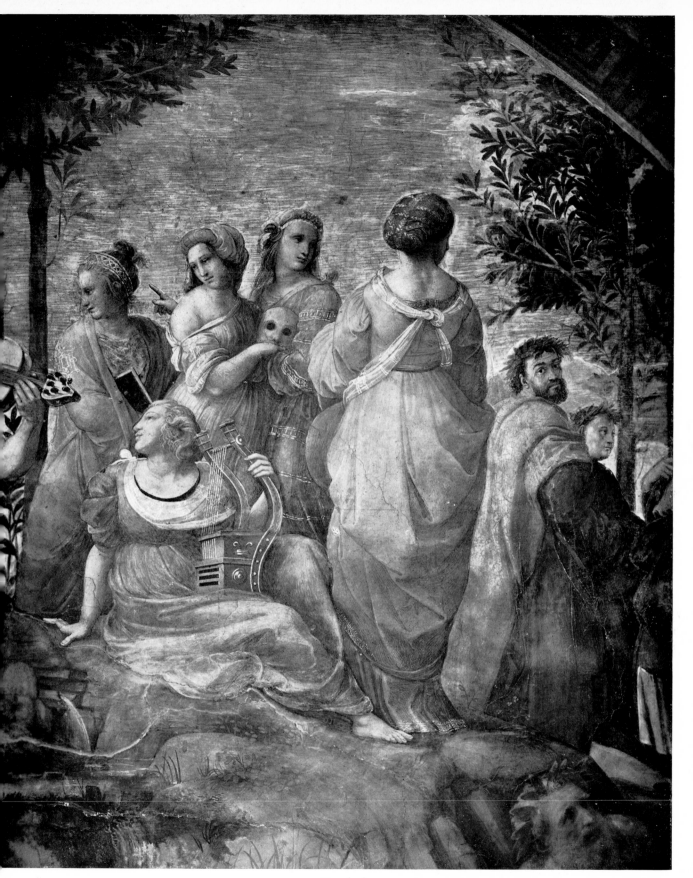

130 Detail of 129.

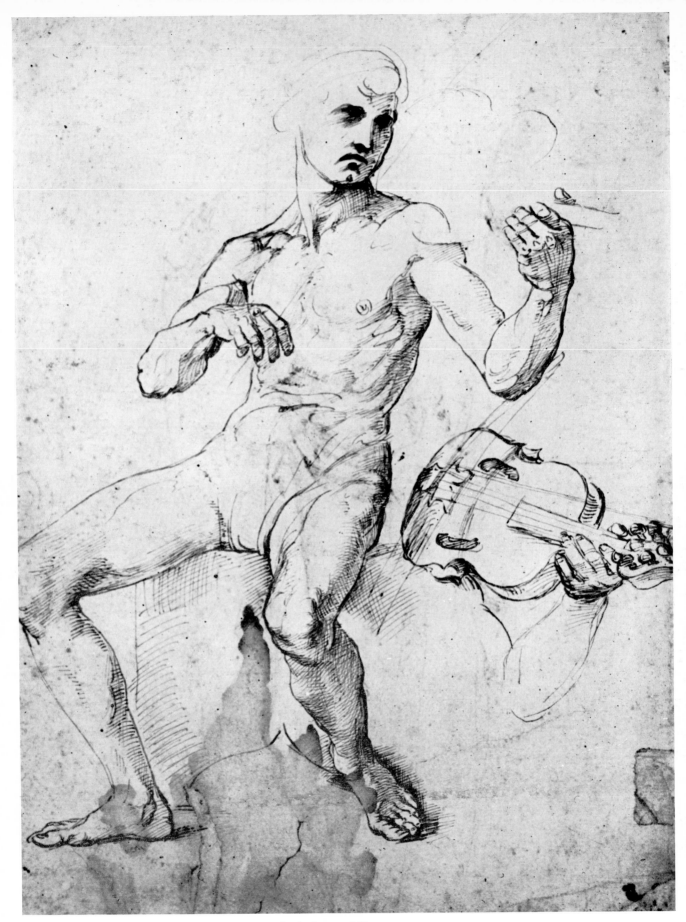

131 Study for 129. Lille. 31·5 × 22·2.

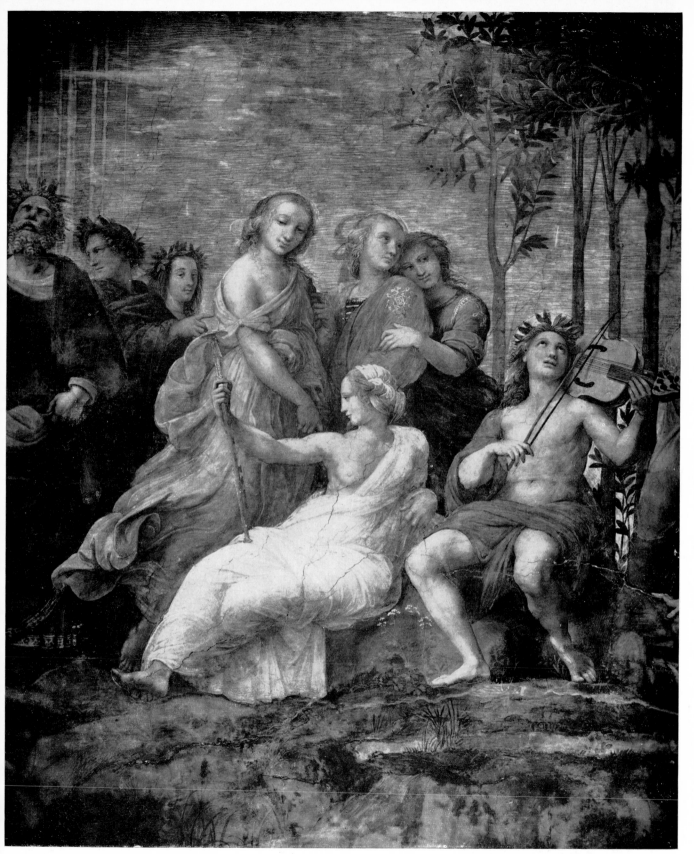

132 Detail of 129.

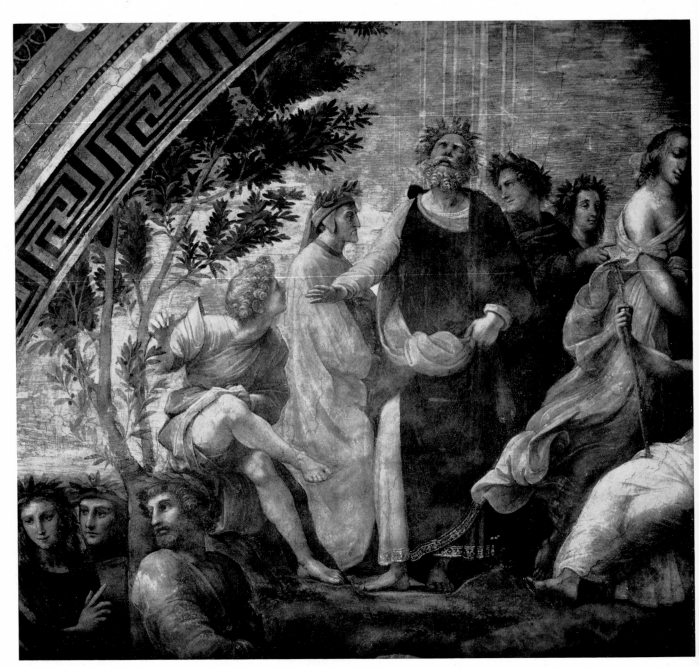

133 Detail of 129.

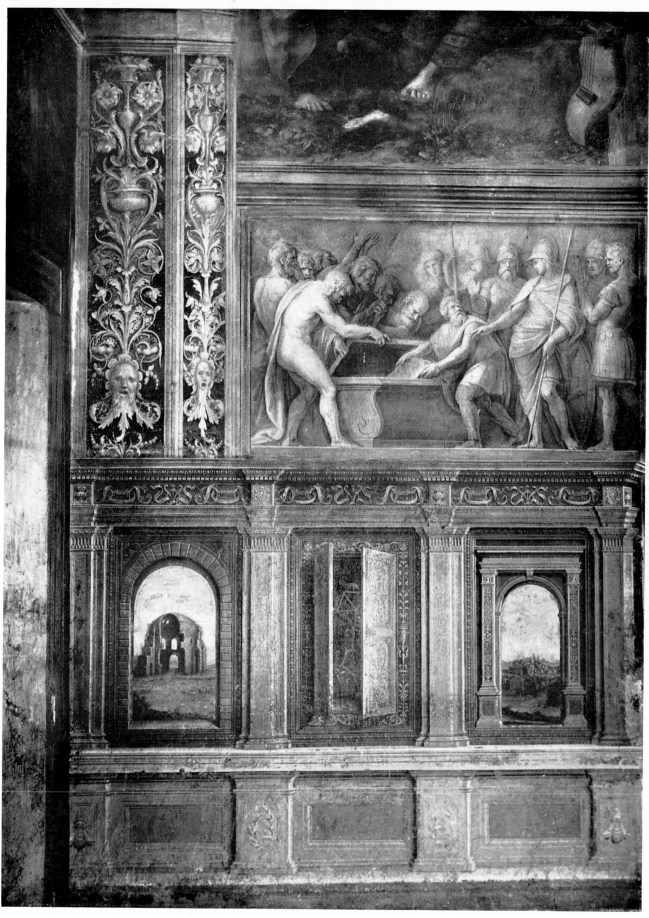

134 *Alexander depositing Homer's poems*. Grisaille below 129. 180 wide.

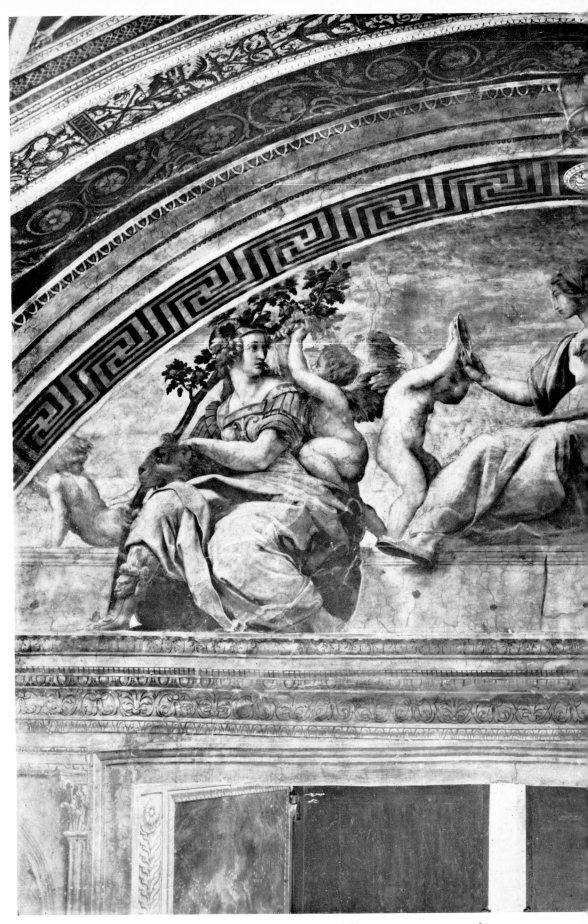

135 *Fortitude, Prudence, Temperance*. Stanza della Segnatura. 1511. 660 wide.

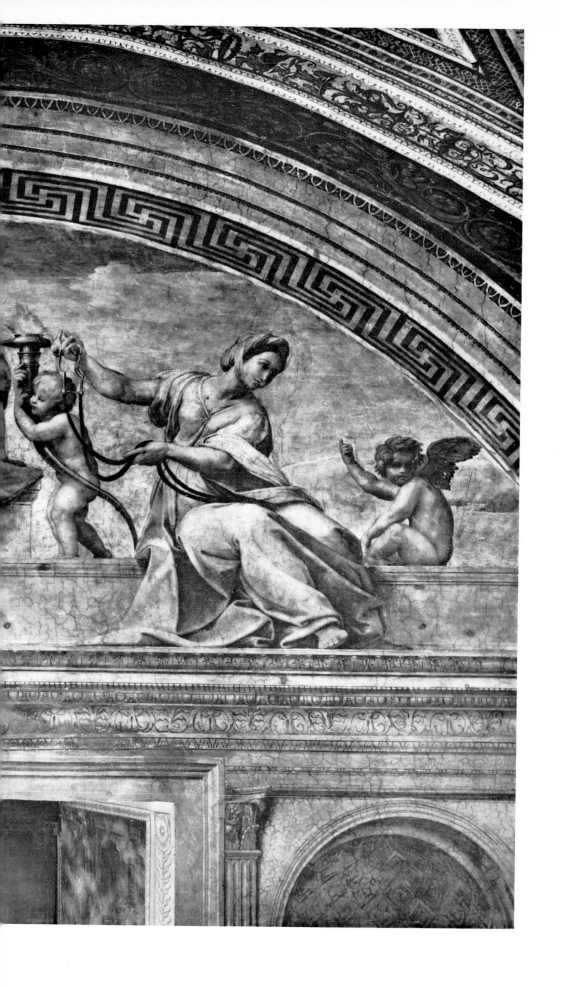

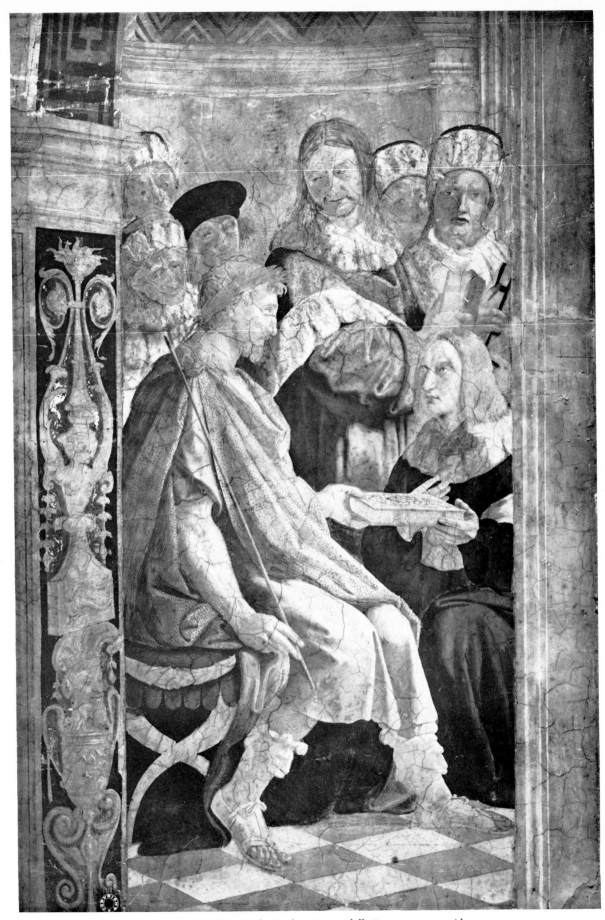

136 *Justinian delivering the Pandects*. Stanza della Segnatura. 220 wide.

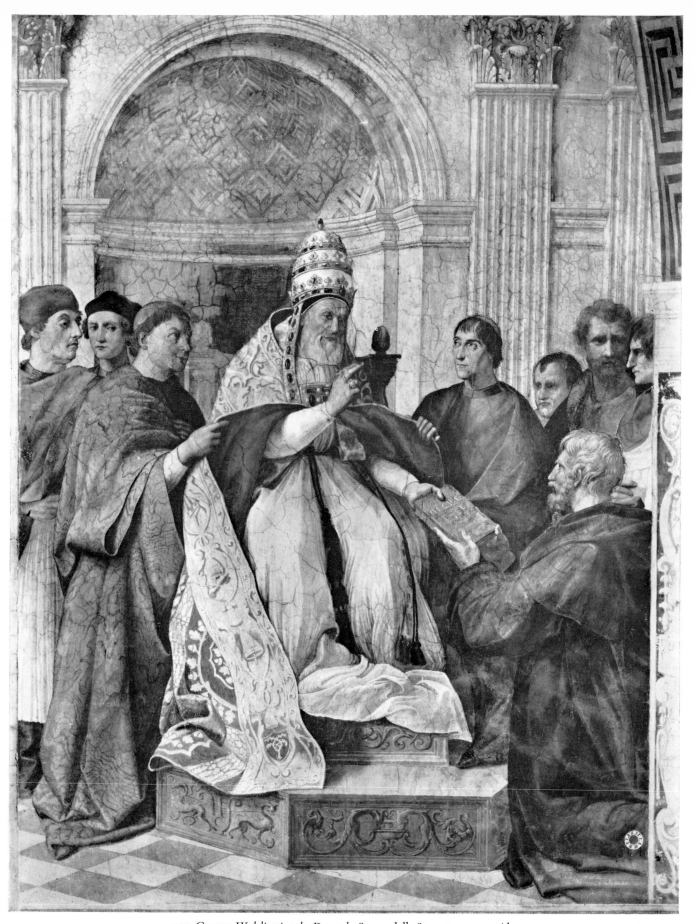

137 *Gregory IX delivering the Decretals*. Stanza della Stegnatura. 220 wide.

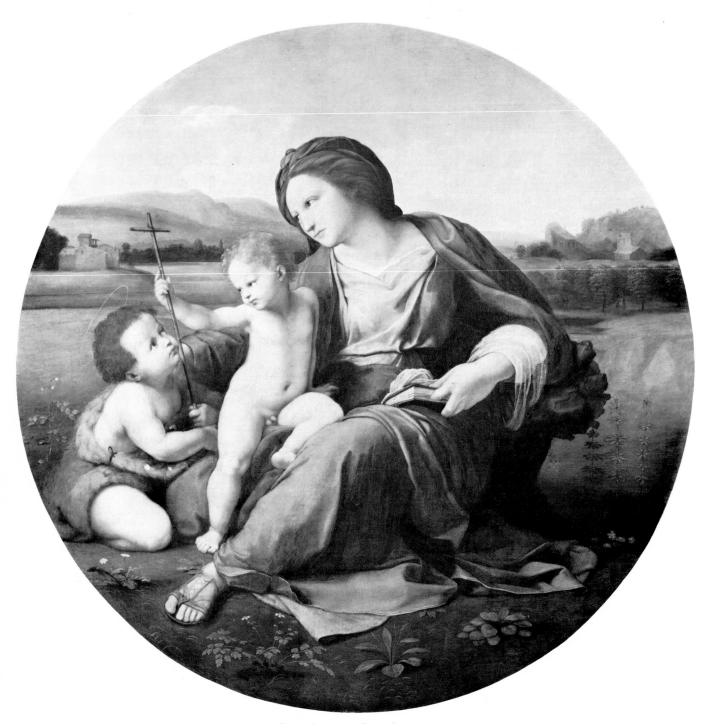

138 *Alba Madonna*. Washington. 95 diameter.

139 Study for 138. Lille. 41 × 26·4.

140 Study for 138 (verso of 139).

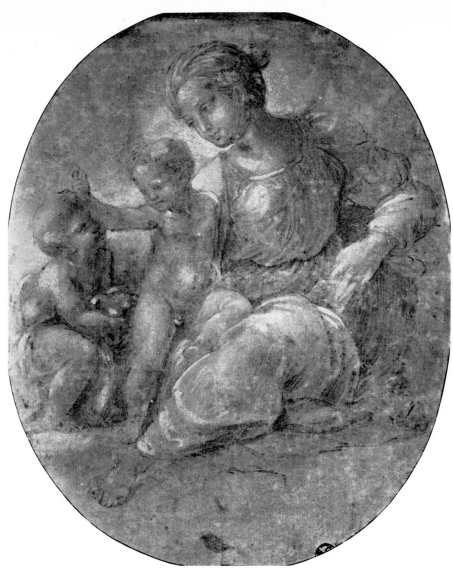

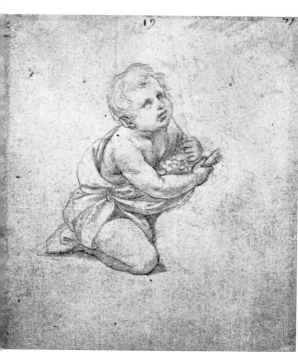

141 Developed study for 138. Vienna. 18·6 × 15·8

142 Study for 138. Rotterdam. 11·7 × 10·5.

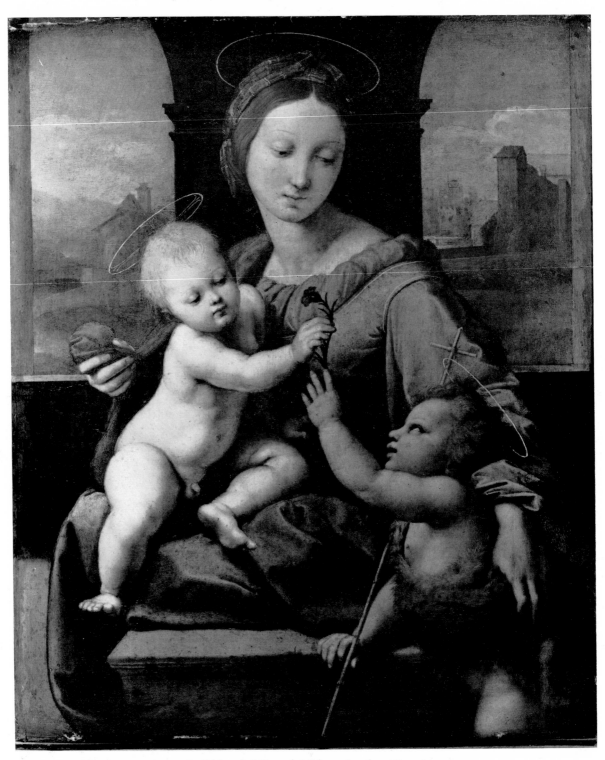

143 *Aldobrandini-Garvagh Madonna*. London. 38 × 32.

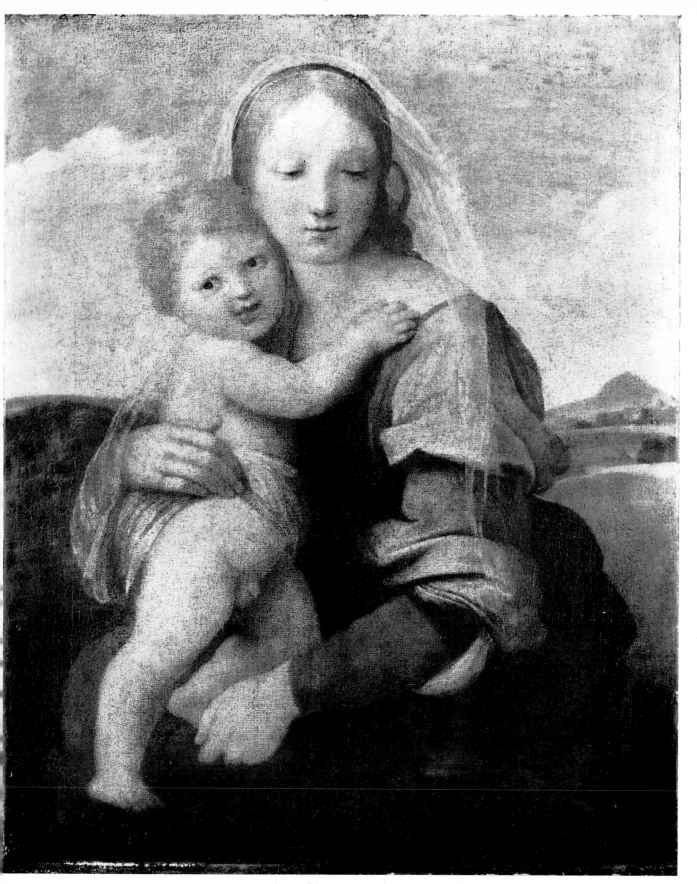

144 *Madonna of the Tower*. London. 78 × 64.

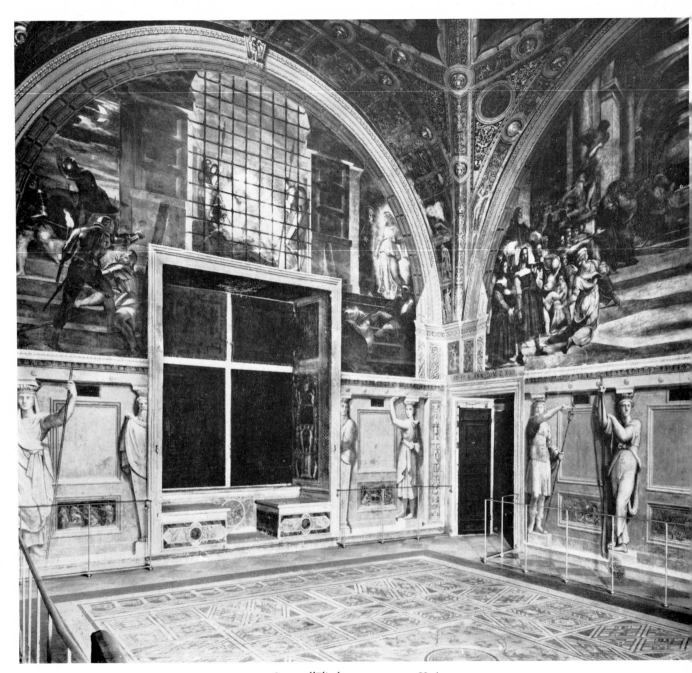

145 Stanza d'Eliodoro. 1511–1514. Vatican.

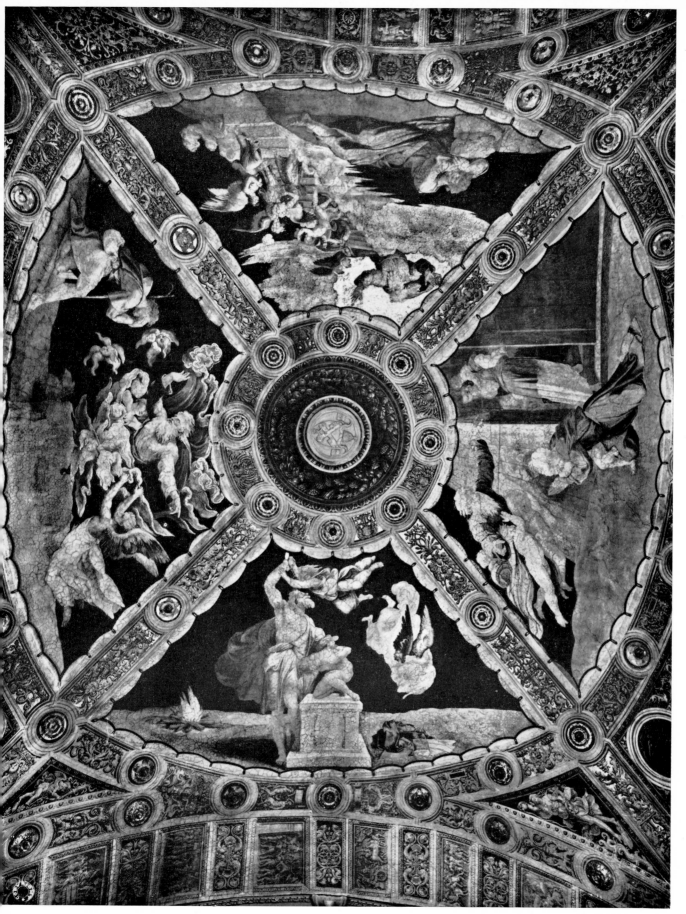

146 Ceiling of 145.

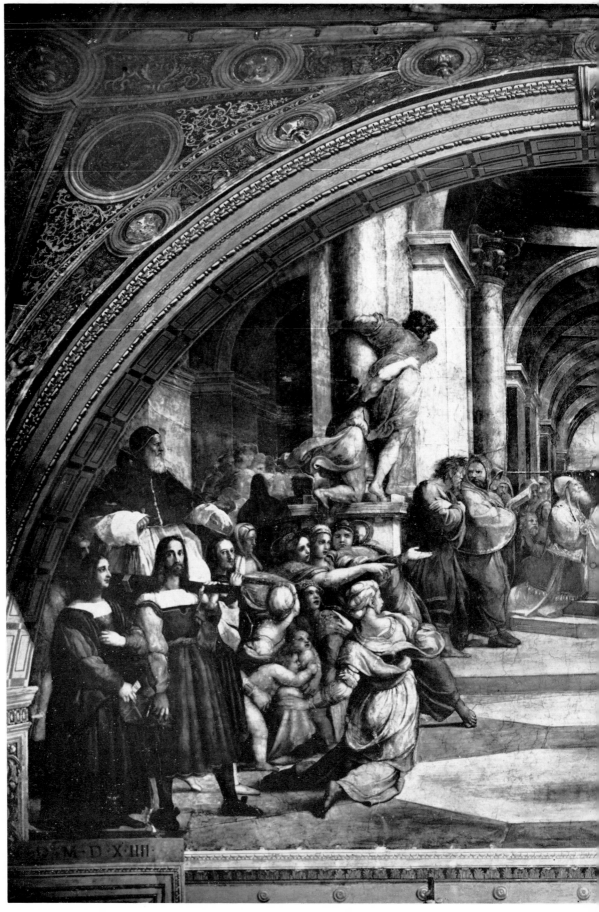

147 *Expulsion of Heliodorus*. Stanza d'Eliodoro. 750 wide.

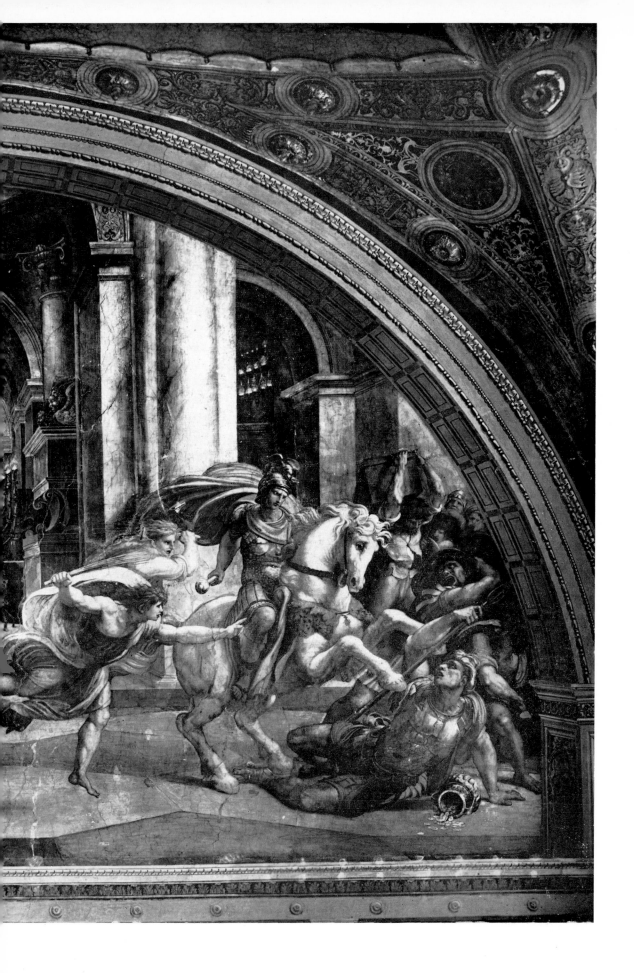

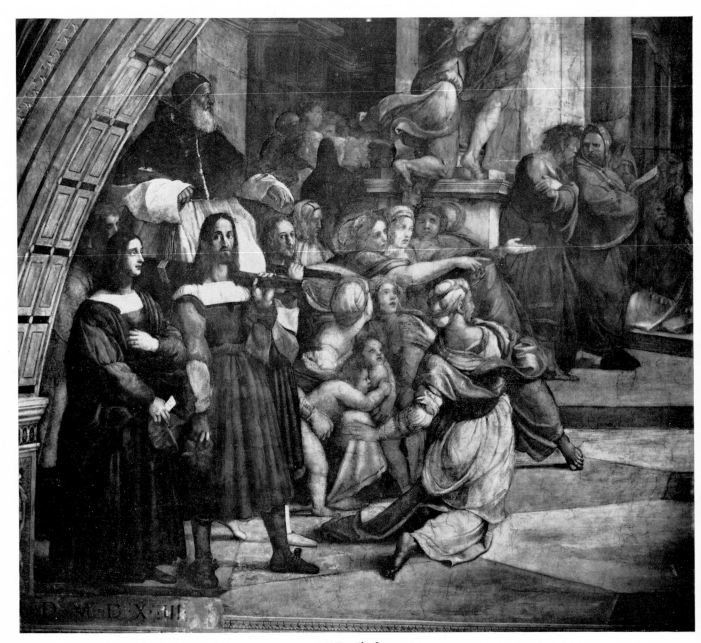

148 Detail of 147.

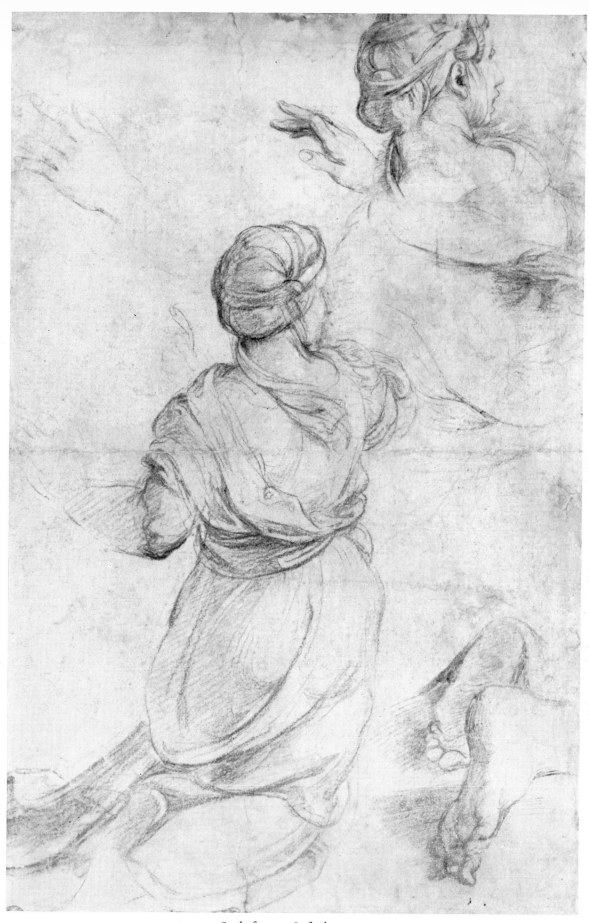

149 Study for 147. Oxford. 39·5 × 25·9.

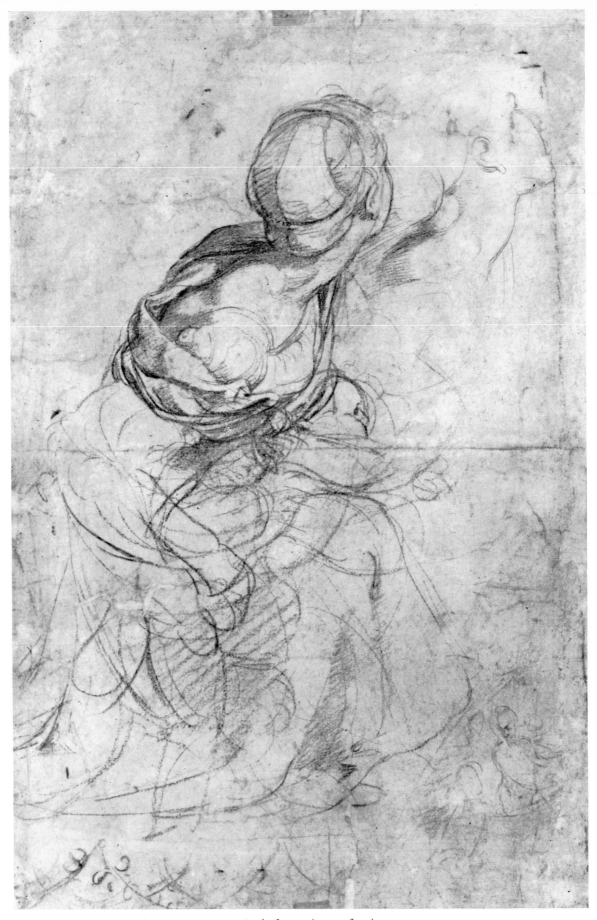

150 Study for 147 (verso of 149).

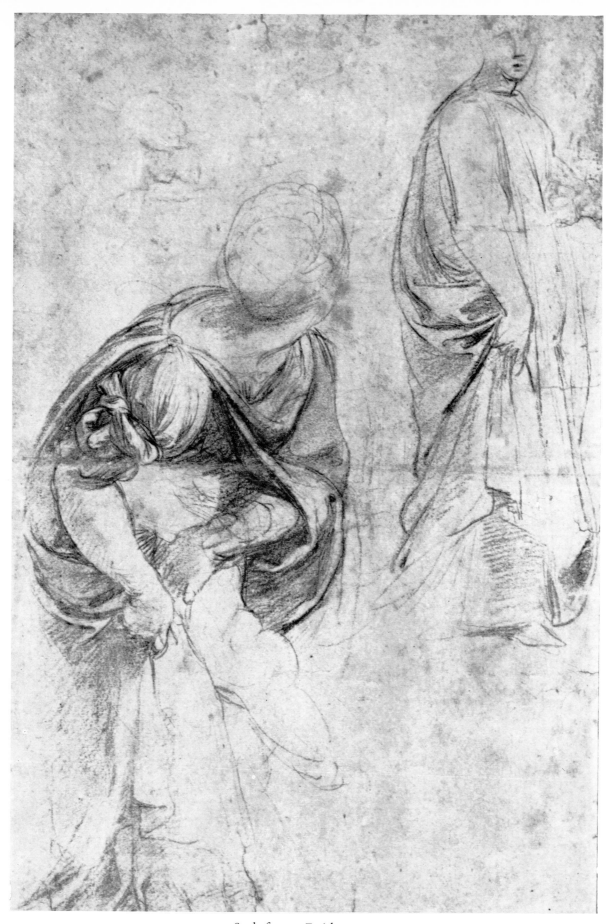

151 Study for 147. Zurich. 40 × 26·6.

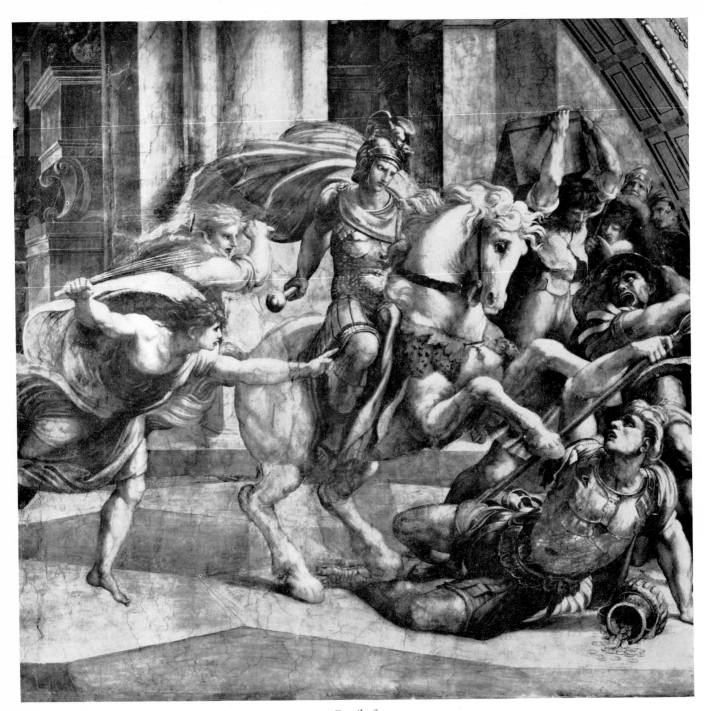

152 Detail of 147.

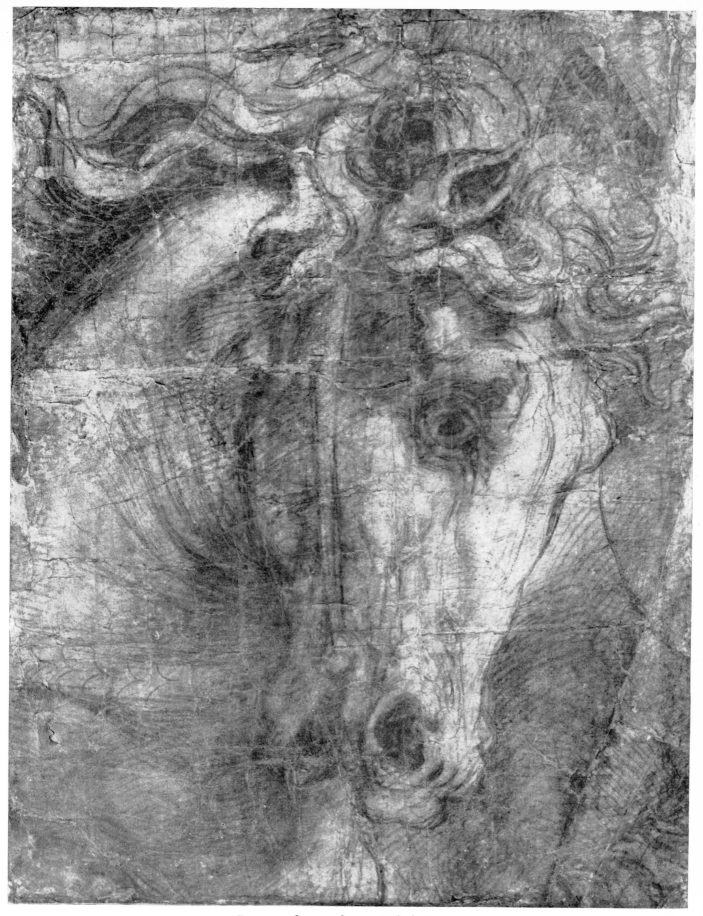

153 Fragment of cartoon for 147. Oxford. 68·2 × 53·3.

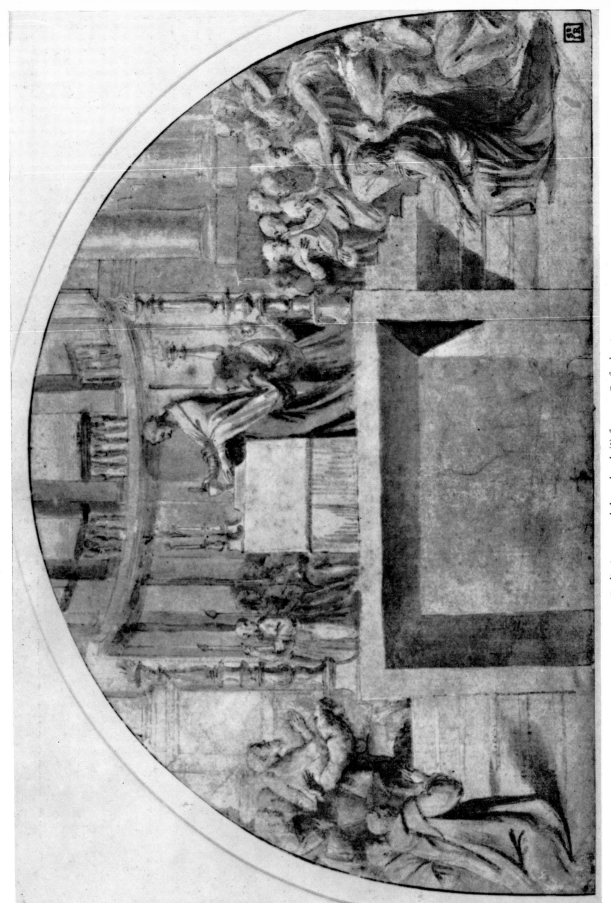

154 Preliminary workshop sketch (?) for 155. Oxford. 26·5 × 41.

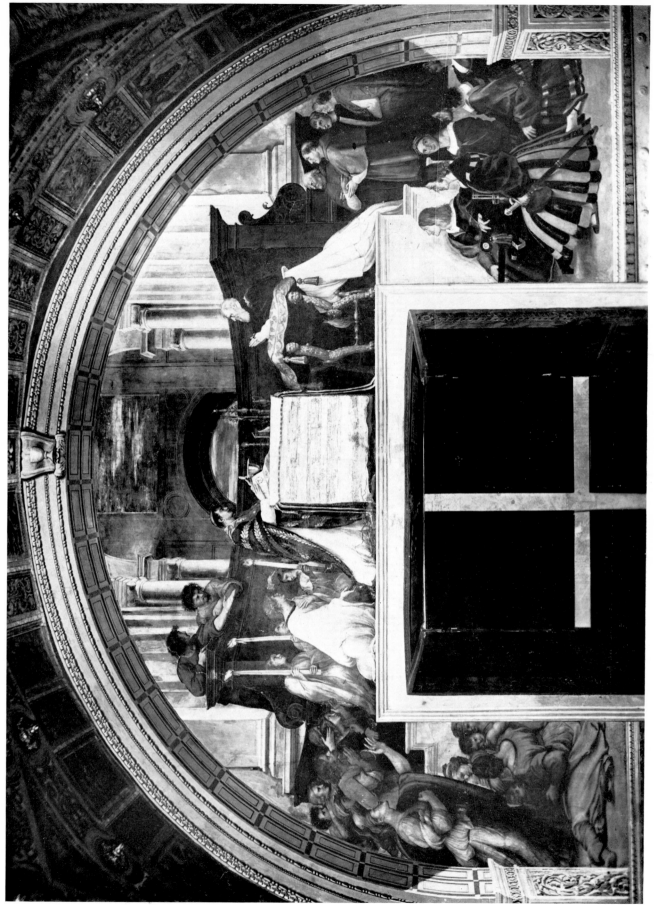

155 *Mass of Bolsena.* 1512. Stanza d'Eliodoro. 660 wide.

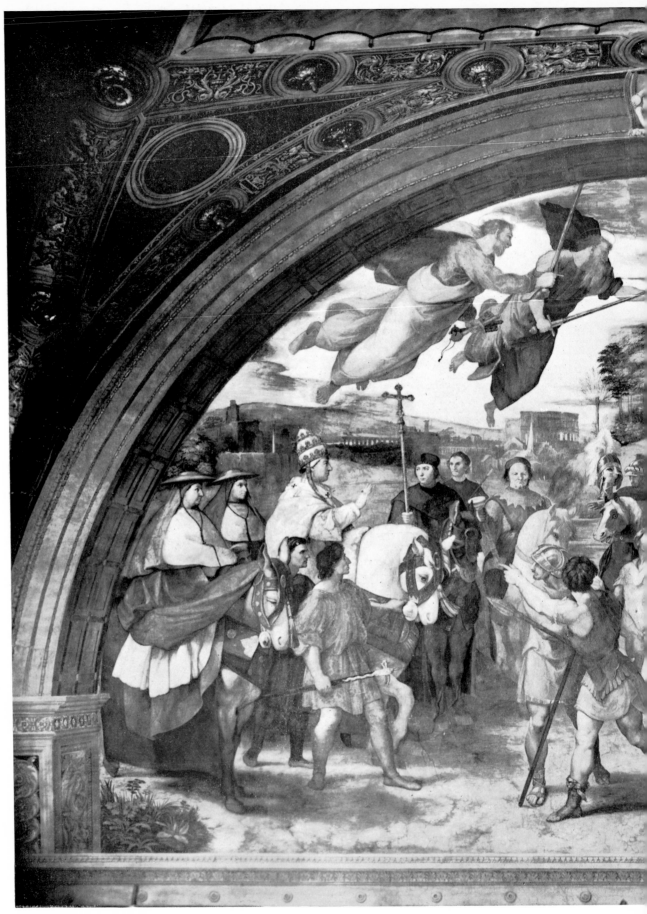

156 *Repulse of Attila by Leo I*. Stanza d'Eliodoro. 750 wide.

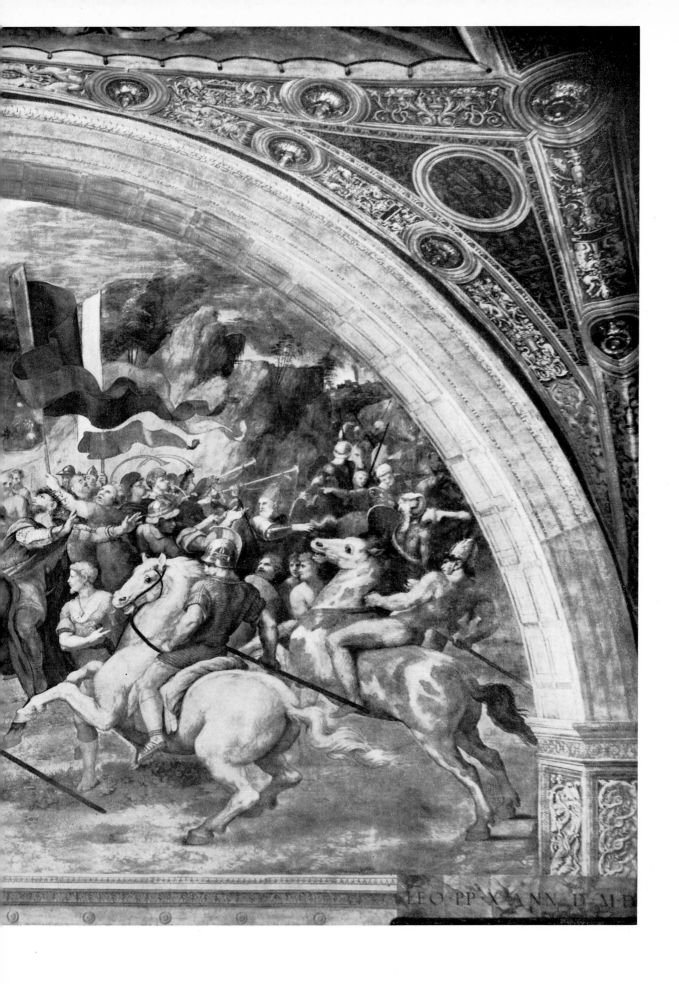

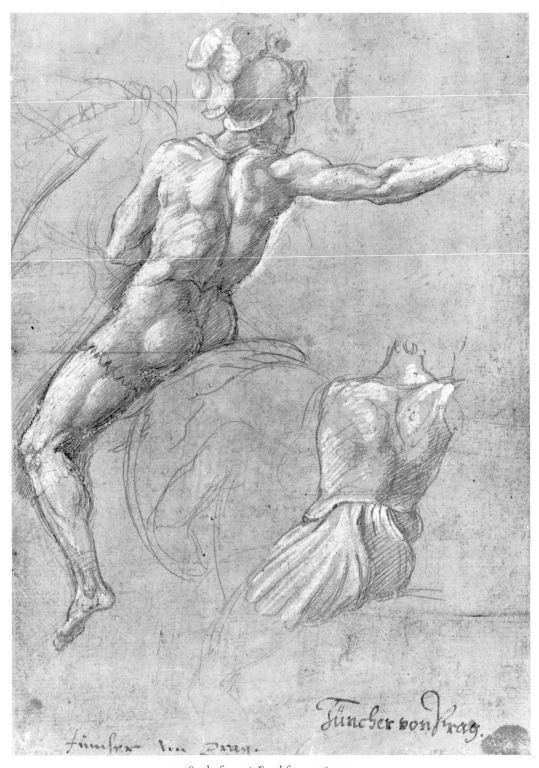

157 Study for 156. Frankfurt. 19·8 × 14·5.

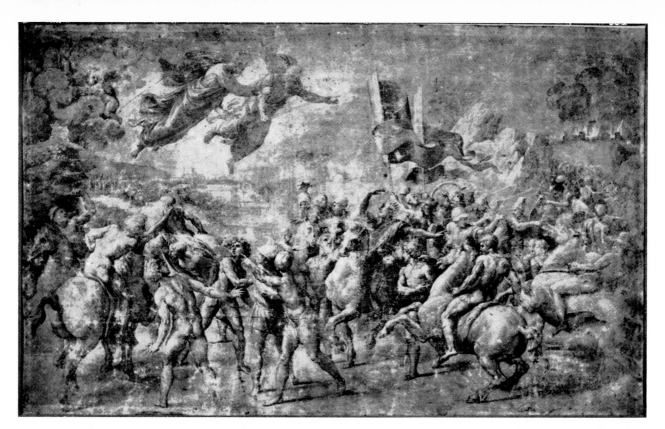

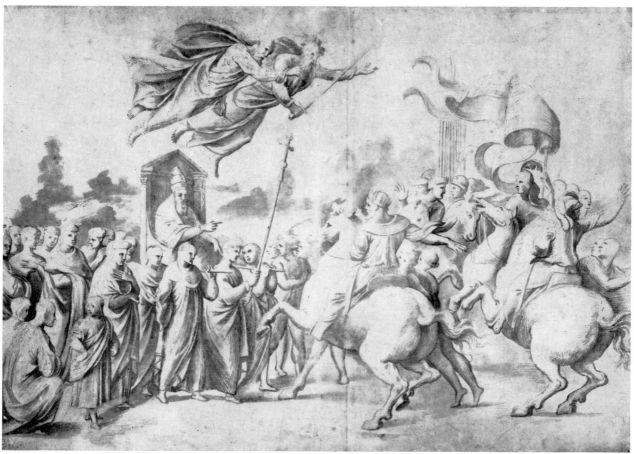

158 Preliminary sketch (? copy) for 156. Louvre. 36 × 59.

159 Preliminary workshop sketch for 156. Oxford. 38·8 × 58.

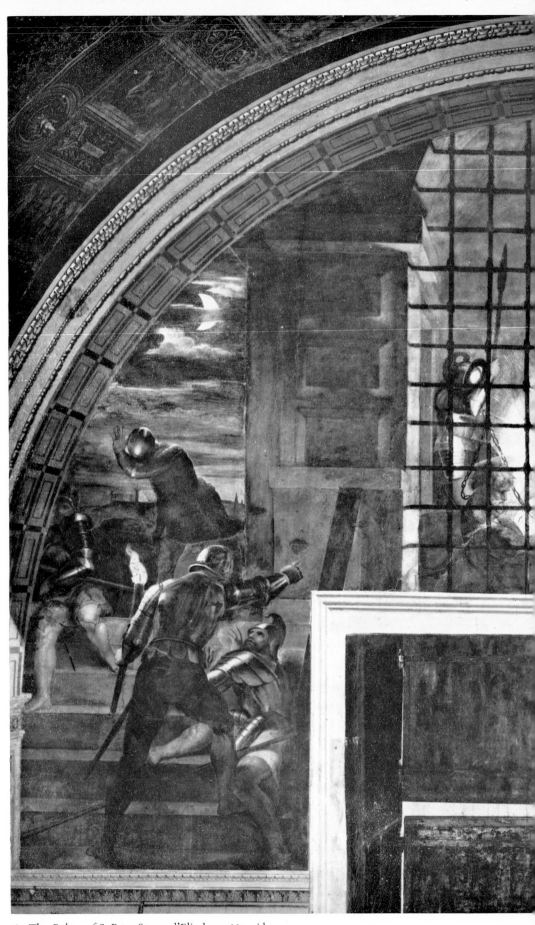

160 The *Release of St Peter*. Stanza d'Eliodoro. 660 wide.

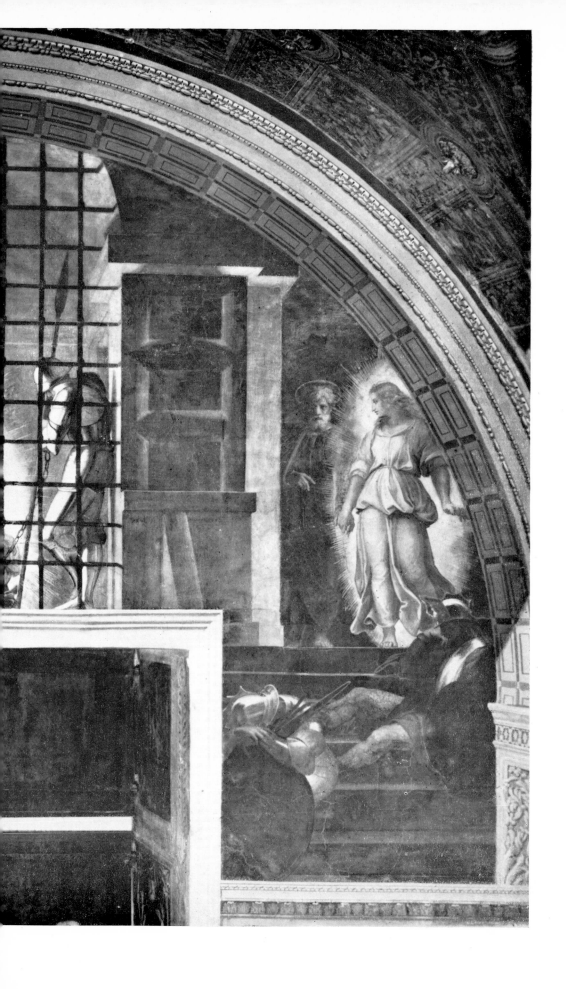

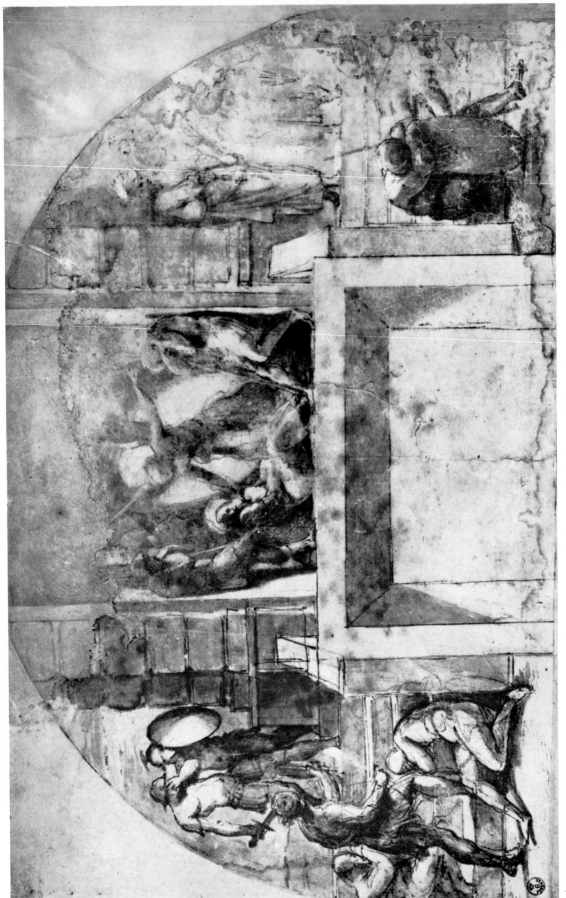

161 Preliminary sketch for 160. Uffizi. 25·8 × 41·8.

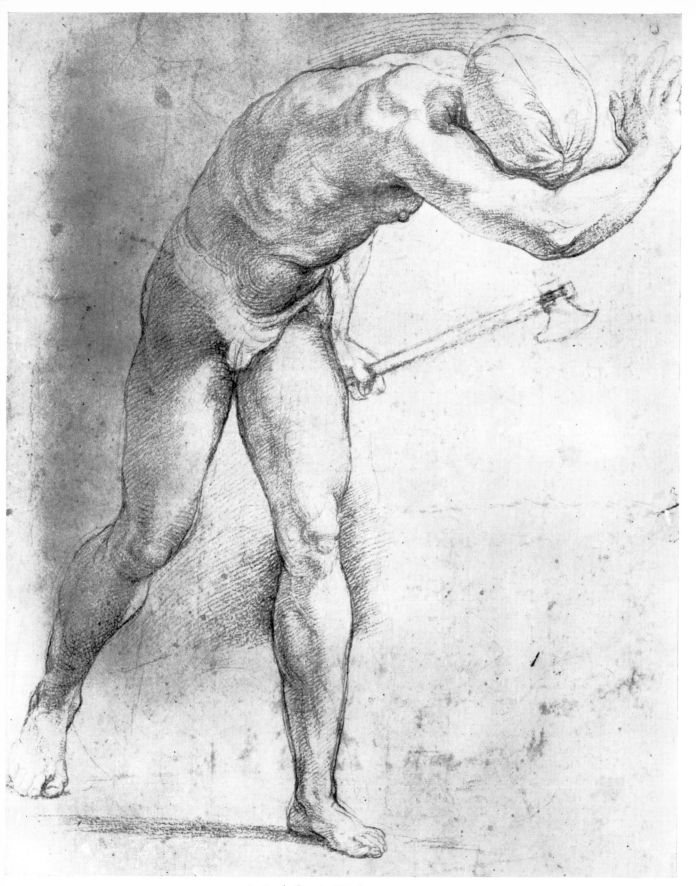

162 Study for 160. Windsor. 32·2 × 25·6.

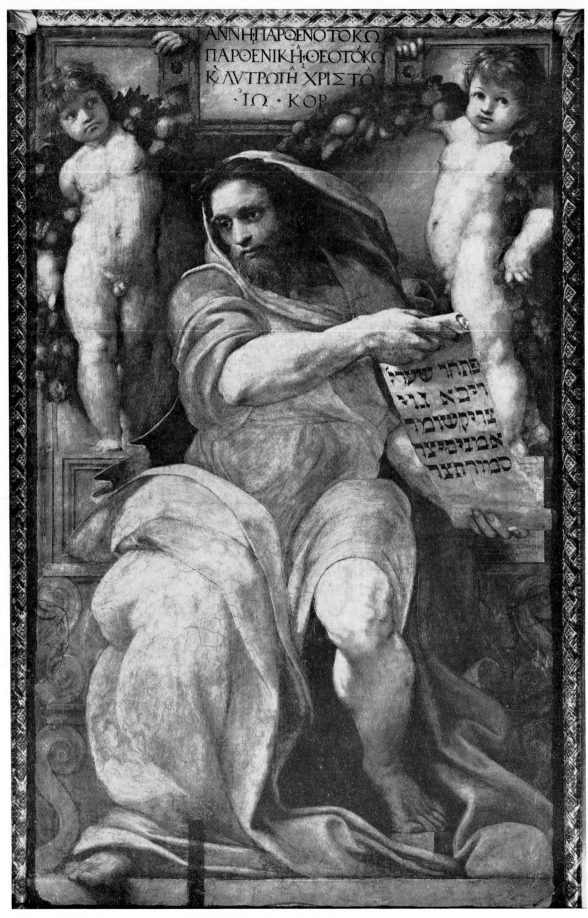

163 *Isaiah*. Rome, St Agostino. 250 × 155.

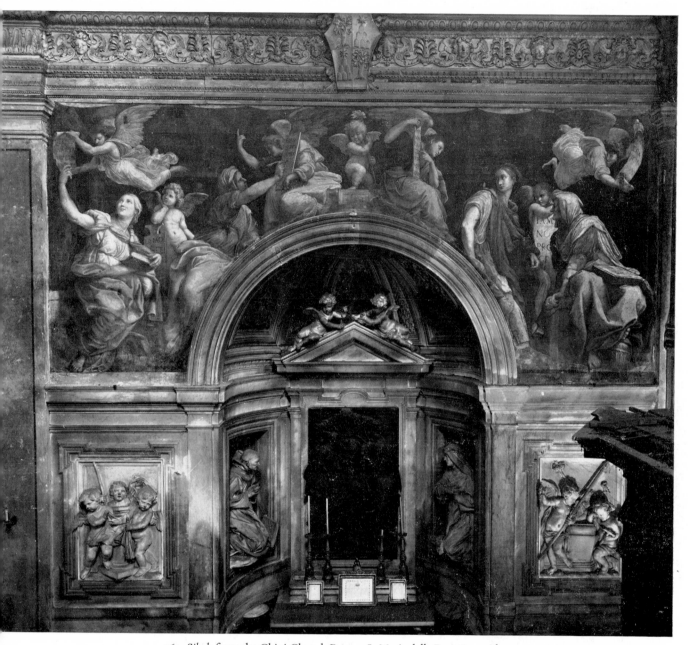

164 *Sibyls* from the Chigi Chapel. Rome, S. Maria della Pace. 615 wide.

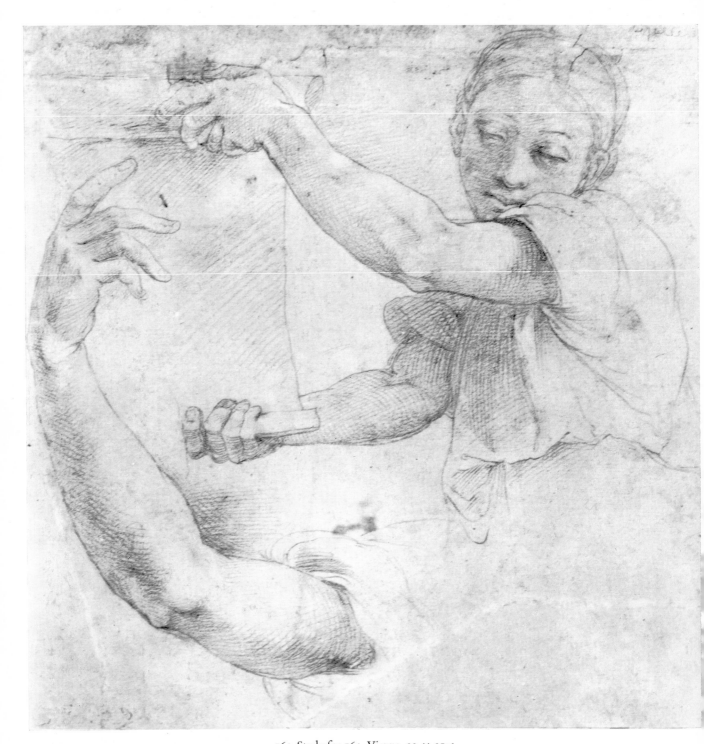

165 Study for 164. Vienna. 22 × 21·5.

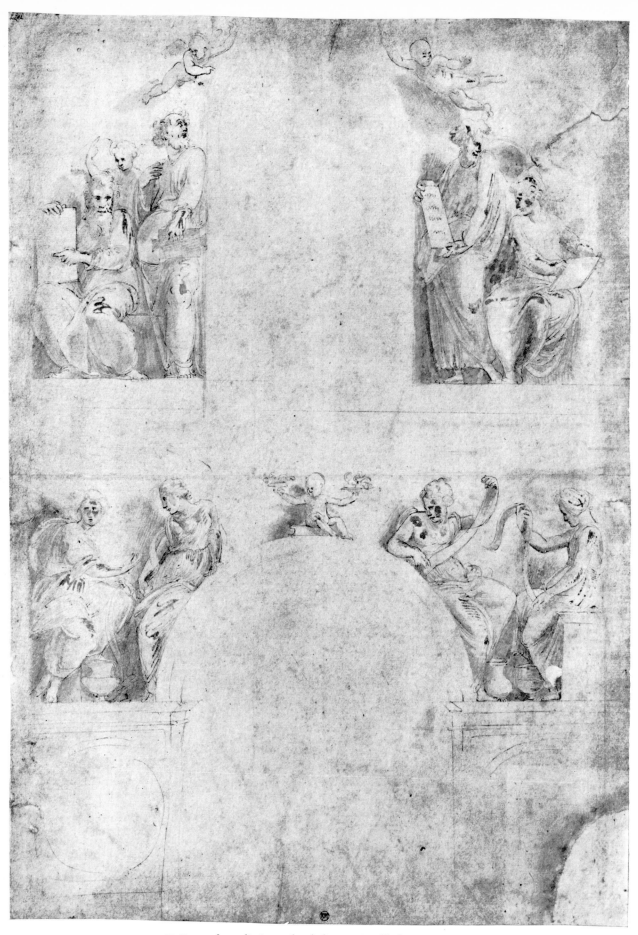

166 Copy of a preliminary sketch for 164. Stockholm. 32·4 × 23·5.

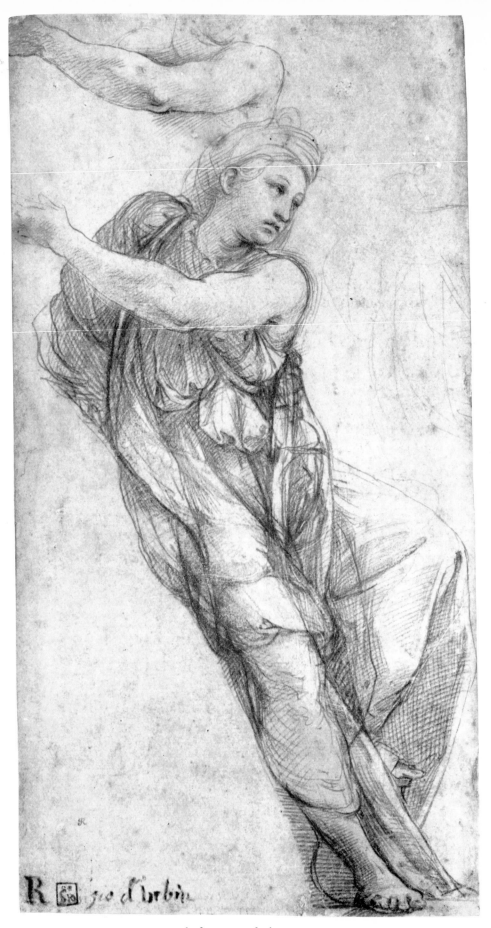

167 Study for 164. Oxford. 36·3 × 18·9.

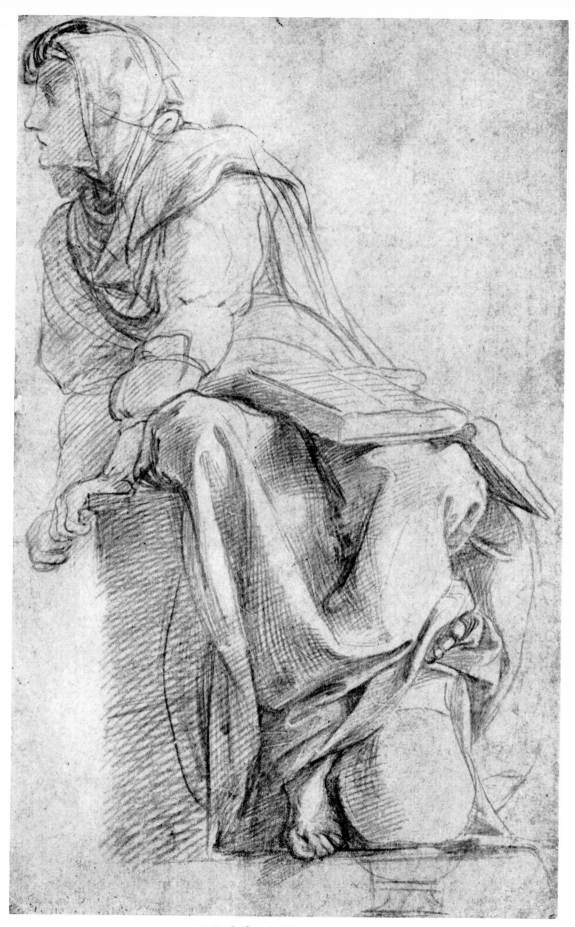

168 Study for 164. Vienna. 27·9 × 17·2.

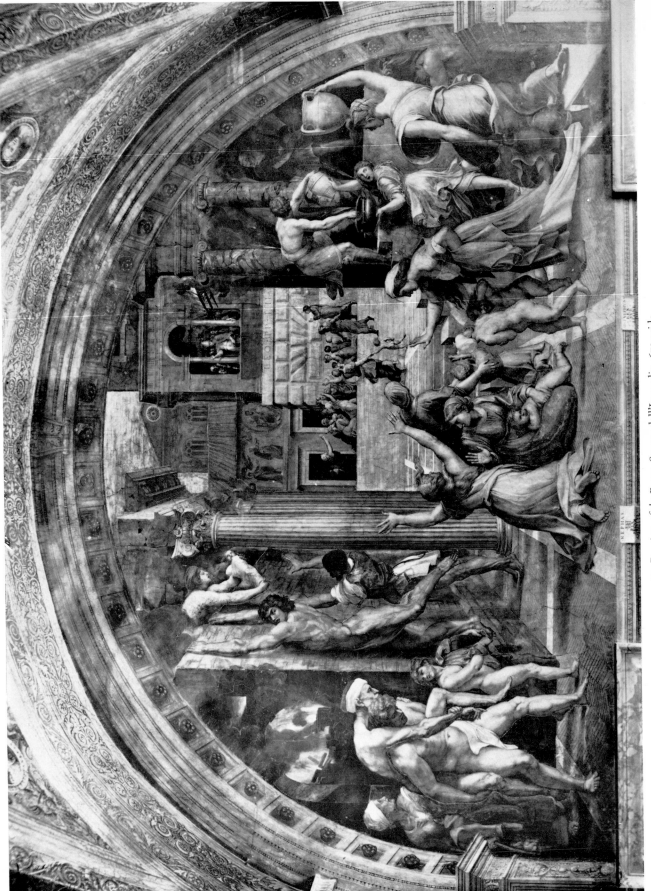

169 *Burning of the Borgo*. Stanza dell'Incendio. 670 wide.

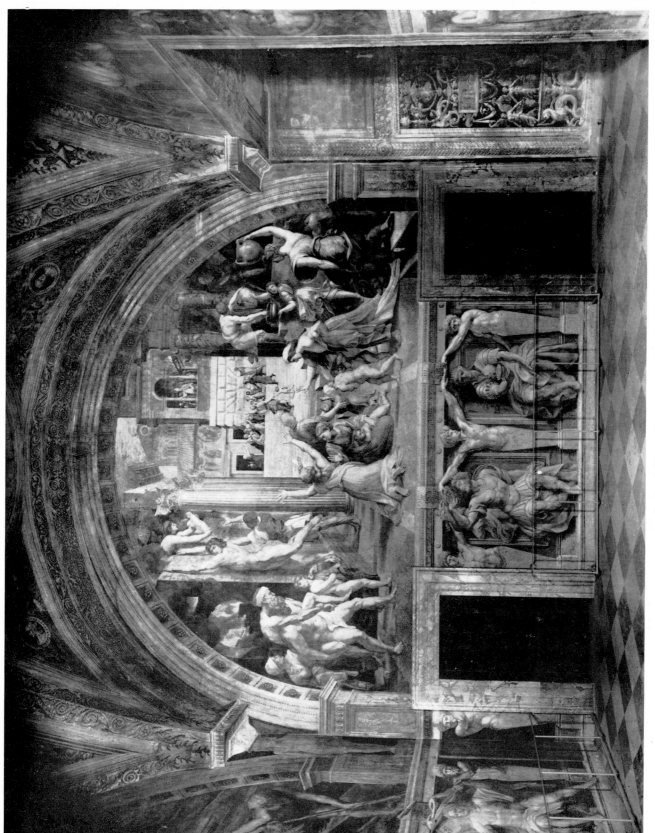

170 Stanza dell'Incendio. 1514–1517. Vatican.

172 Workshop study for 169. Vienna. 36·5 × 16·1.

171 Study for 169. Vienna. 30 × 17.

174 Workshop study for 169. Oxford. 39·2 × 15·4.

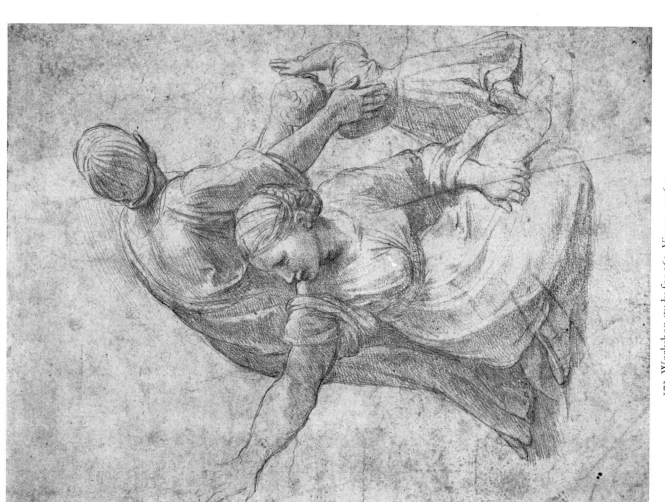

173 Workshop study for 169. Vienna. 33·6 × 25.

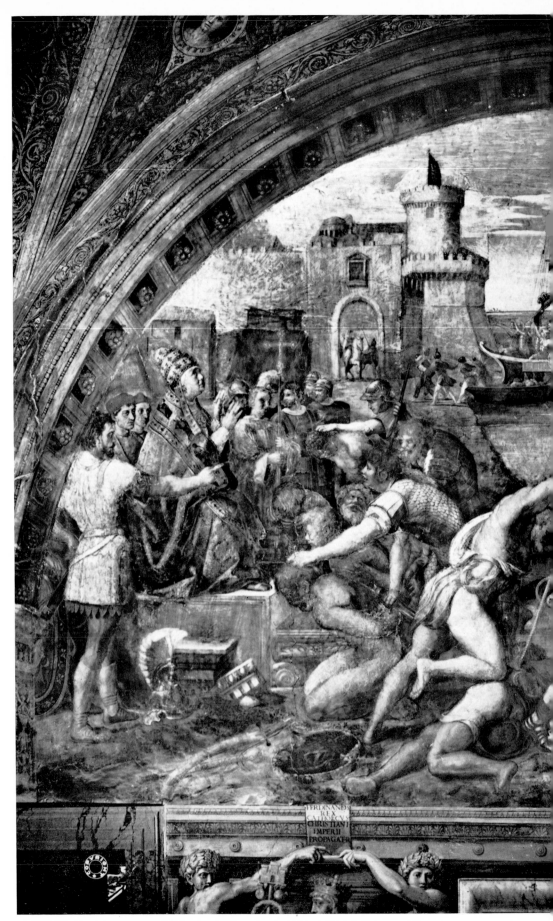

175 *Battle of Ostia*. Stanza dell'Incendio. 770 wide.

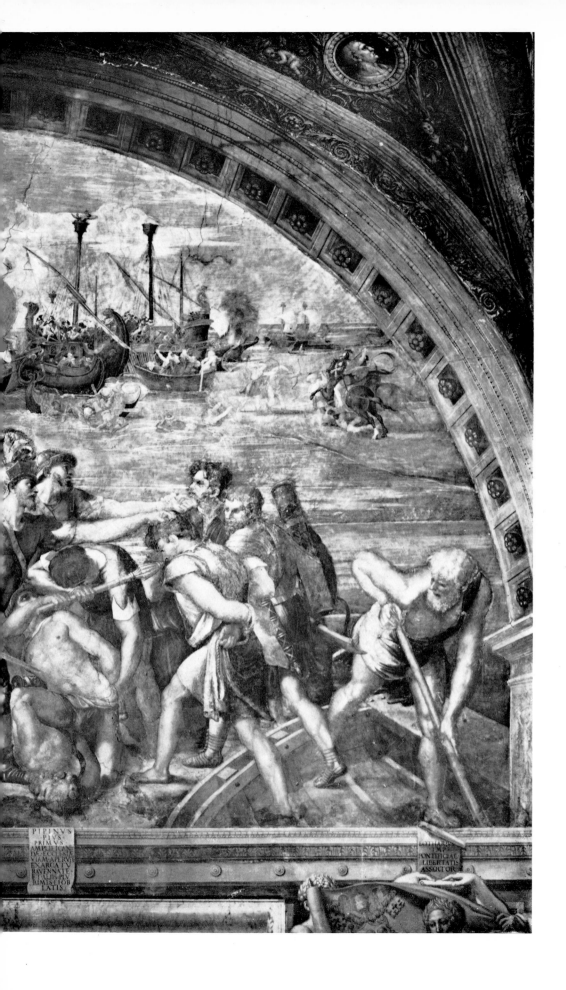

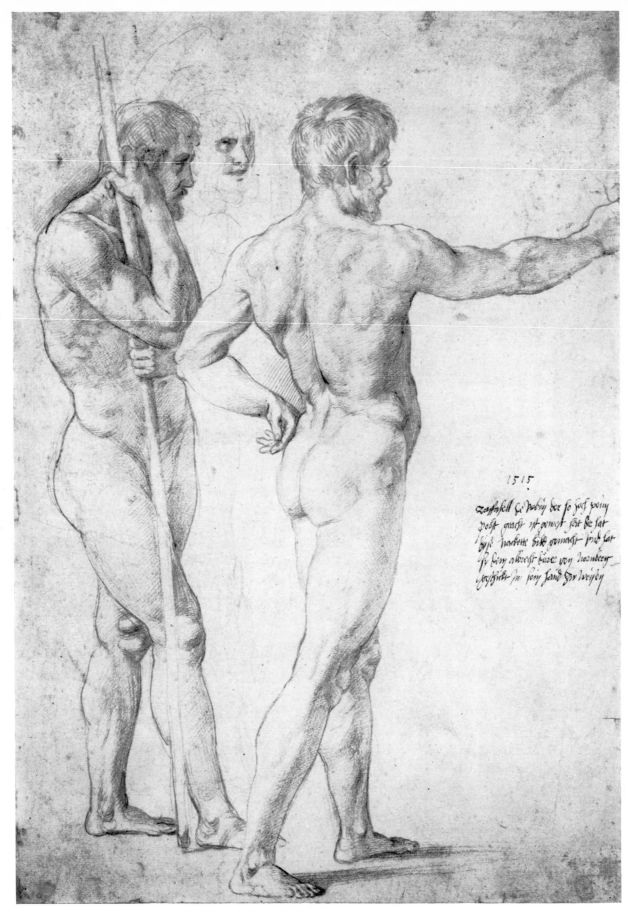

1515

176 Workshop study for 175. Vienna. 40·1 × 28·1.

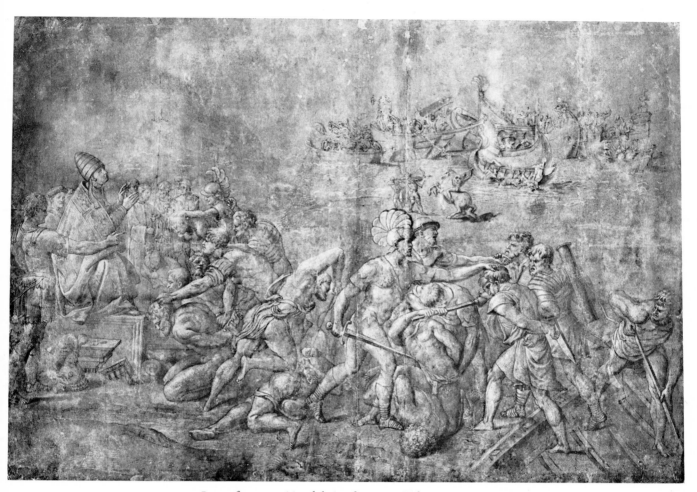

177 Copy of a compositional design for 175. British Museum. 41·4 × 63.

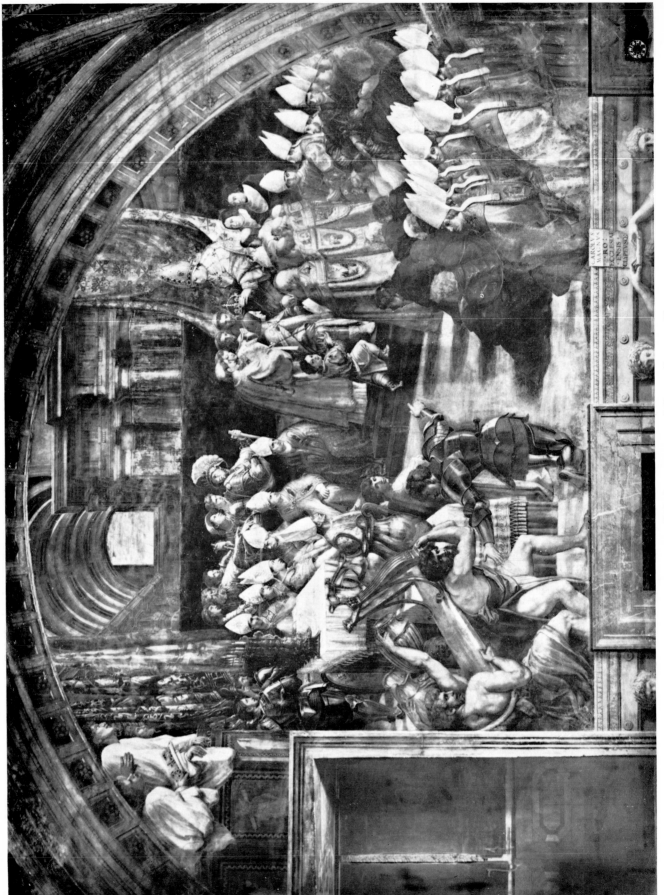

178 *Coronation of Charlemagne. Stanza dell'Incendio. 770 wide.*

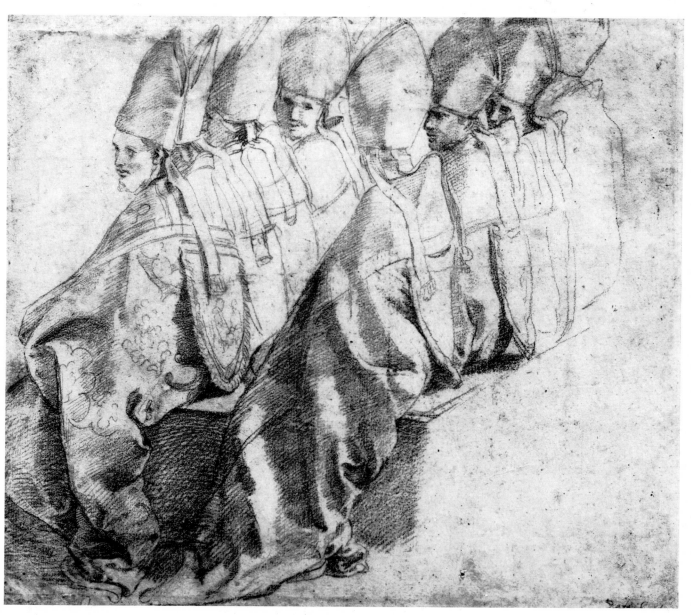

179 Workshop study for 178. Düsseldorf. 26·1 × 31·9.

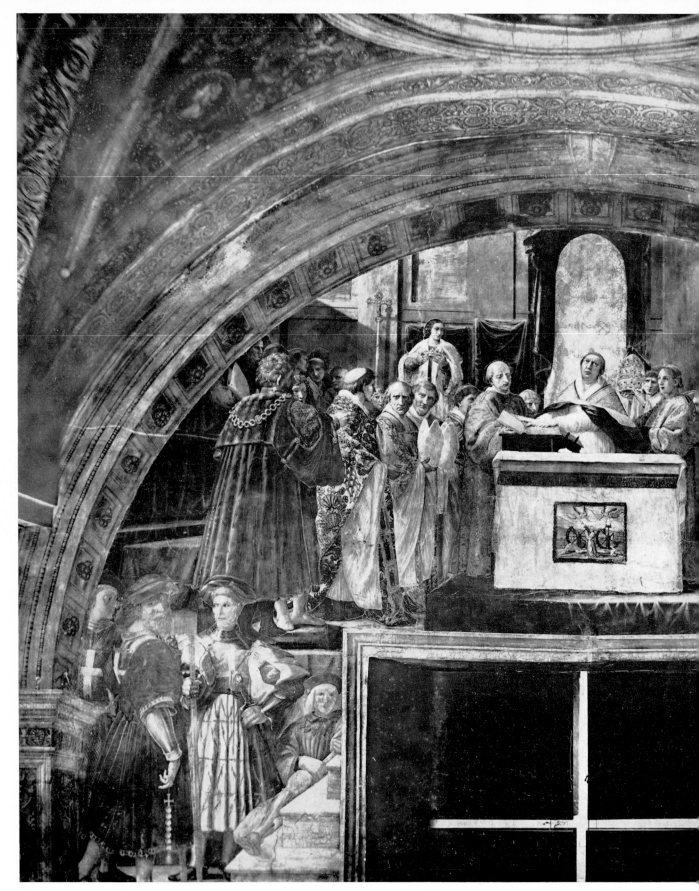

180 *Oath of Leo III*. 1517. Stanza dell'Incendio. 670 wide.

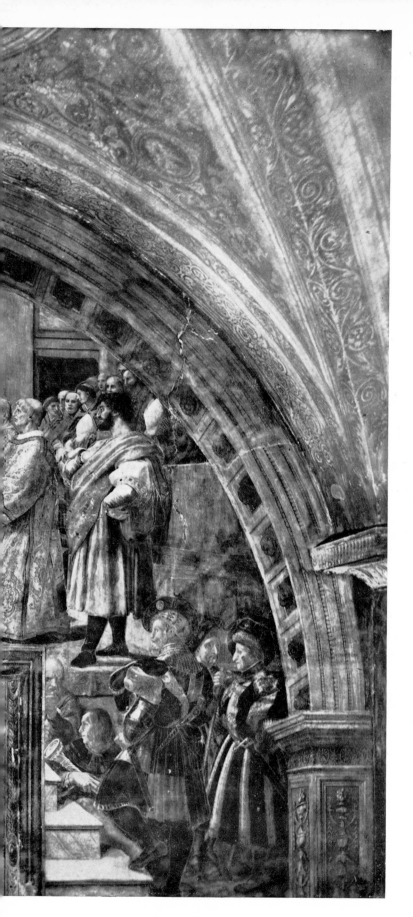

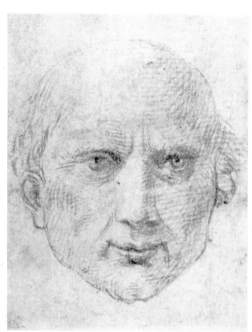

181 Workshop study for 180. Haarlem (copyright).
8·4 × 6·7.

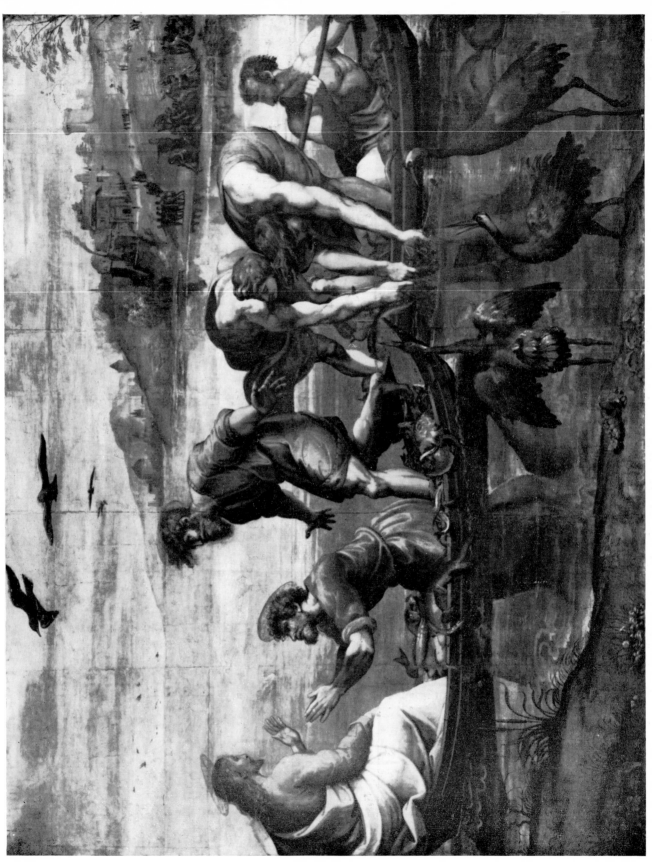

182 *Miraculous Draught of Fishes.* Cartoon. 1515–1516. London, V. and A. 360 × 400.

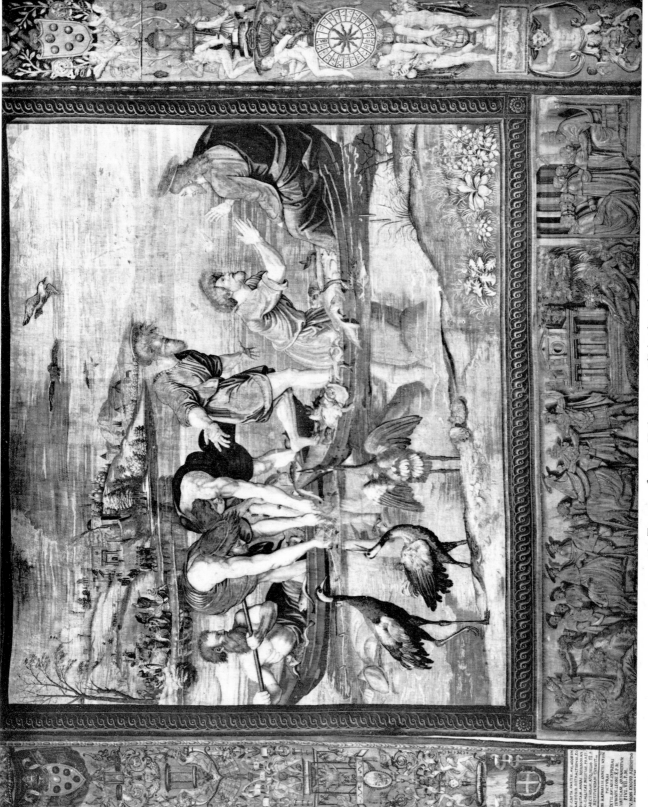

183 Tapestry after 182. Vatican. 440 wide (without borders).

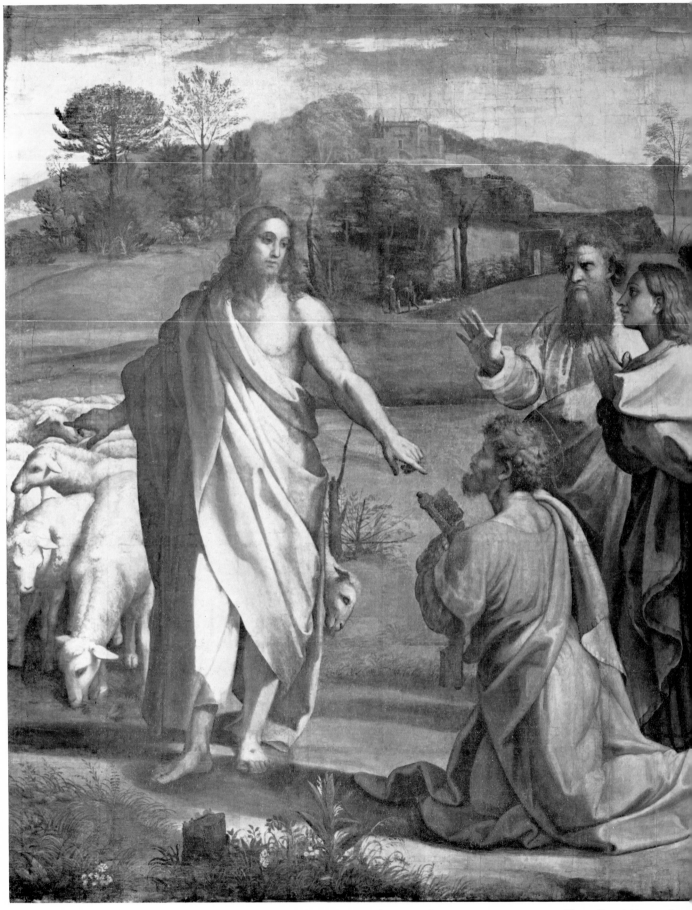

184 *Charge to St Peter*. Cartoon. London, V. and A. 345 × 535.

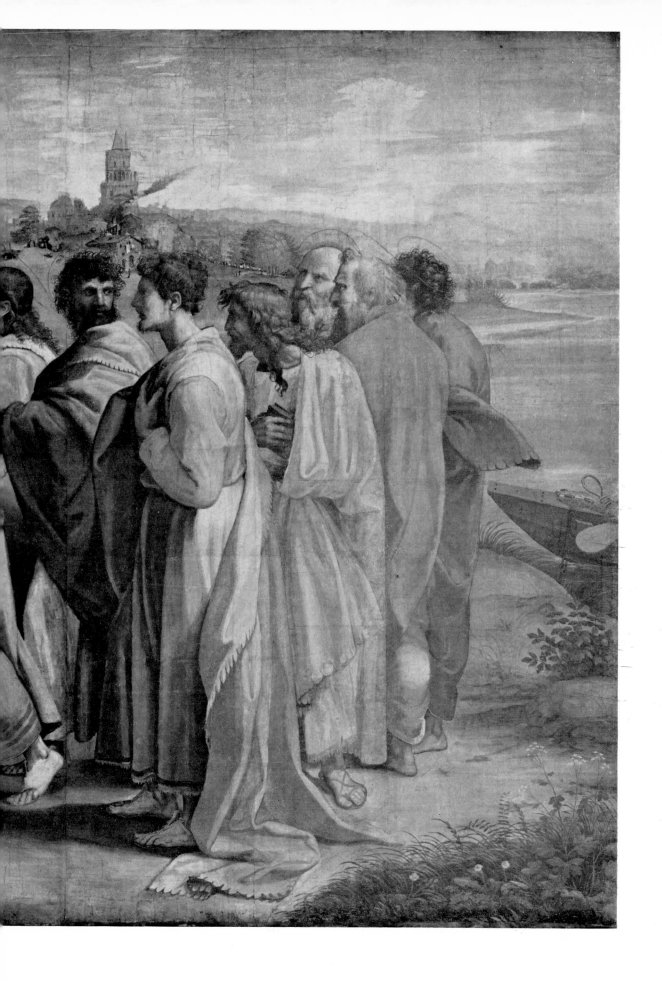

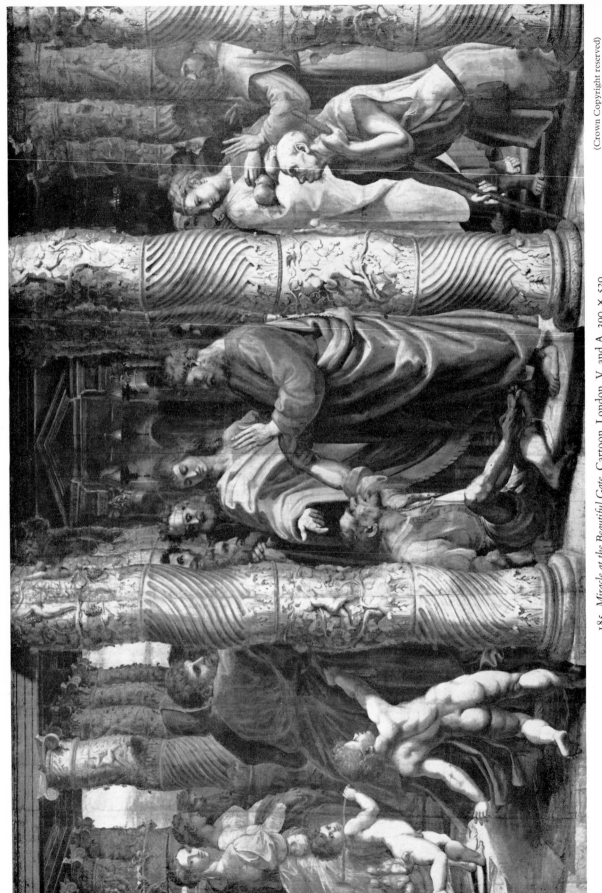

185 *Miracle at the Beautiful Gate.* Cartoon. London, V. and A. 390 × 520.

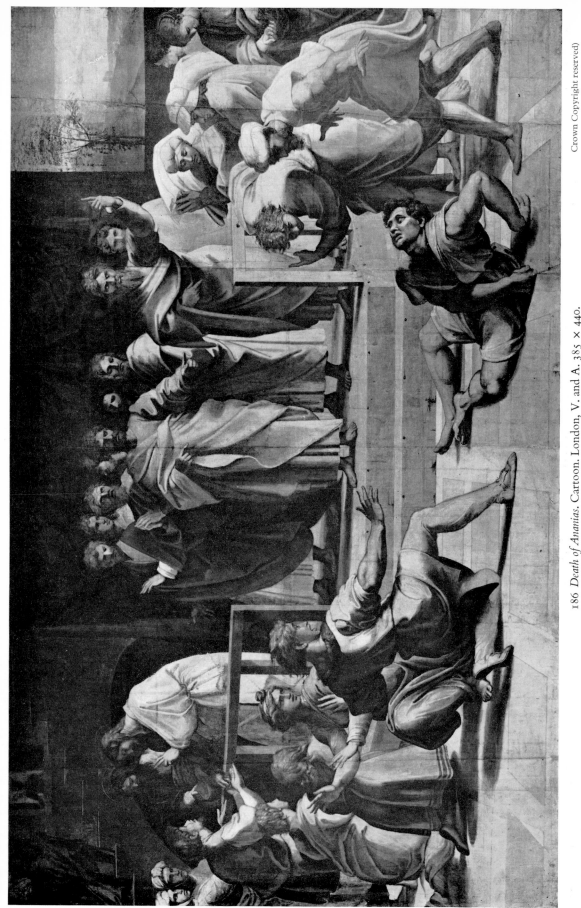

186 *Death of Ananias*. Cartoon. London, V. and A. 385 × 440.

187 *Sacrifice at Lystra.* Cartoon. London, V. and A. 350 × 540.

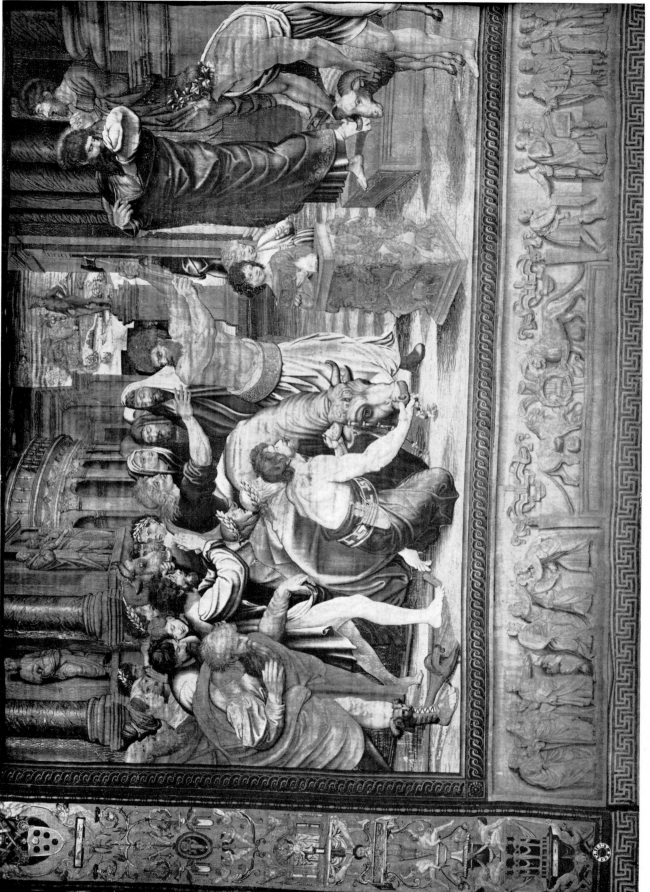

188 Tapestry after 187. Vatican.

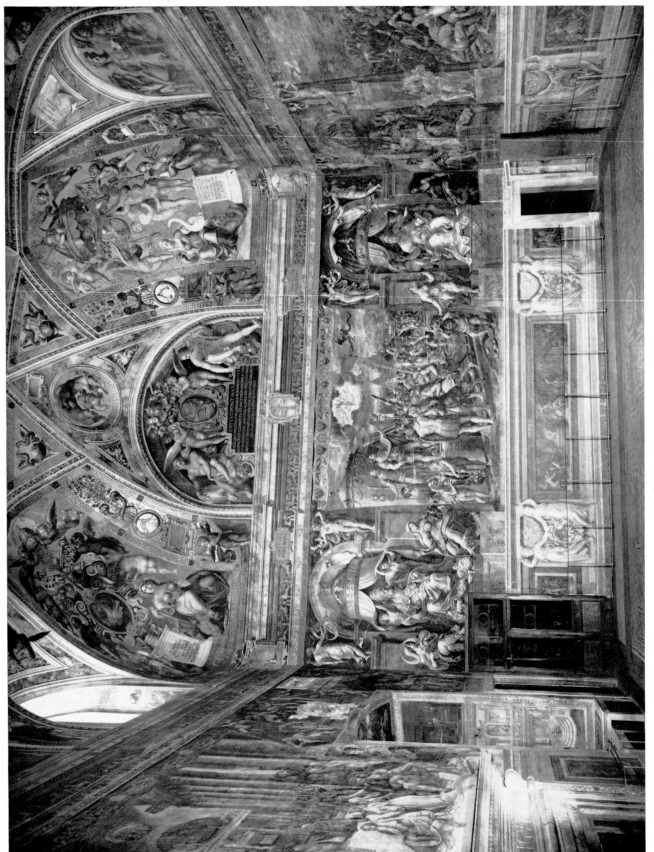

189 Sala di Costantino. 1520-1524. Vatican.

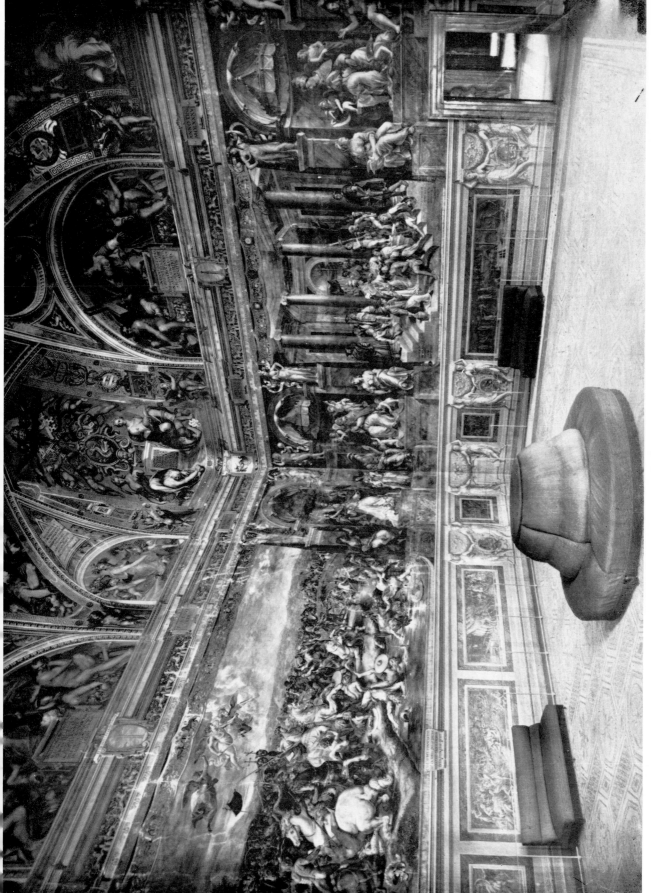

190 Sala di Costantino.

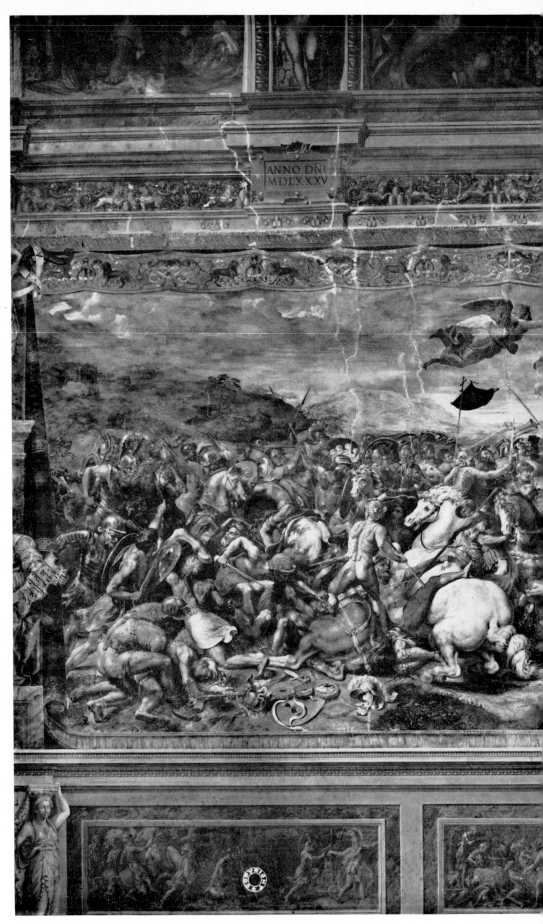

191 *Battle of Constantine*. 1520–1524. Sala di Costantino.

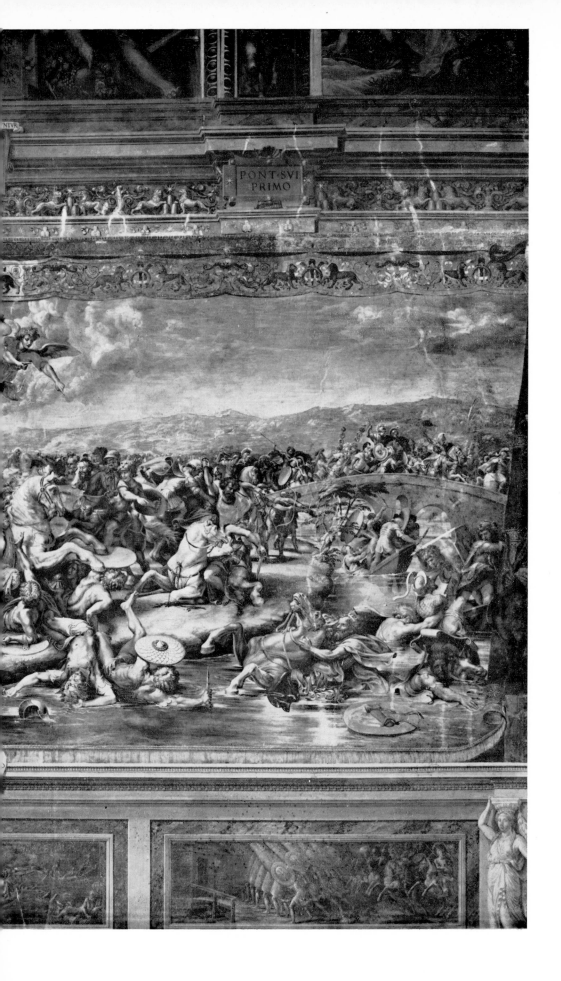

PONT·SVI
PRIMO

192 Grotesque decoration in 193.

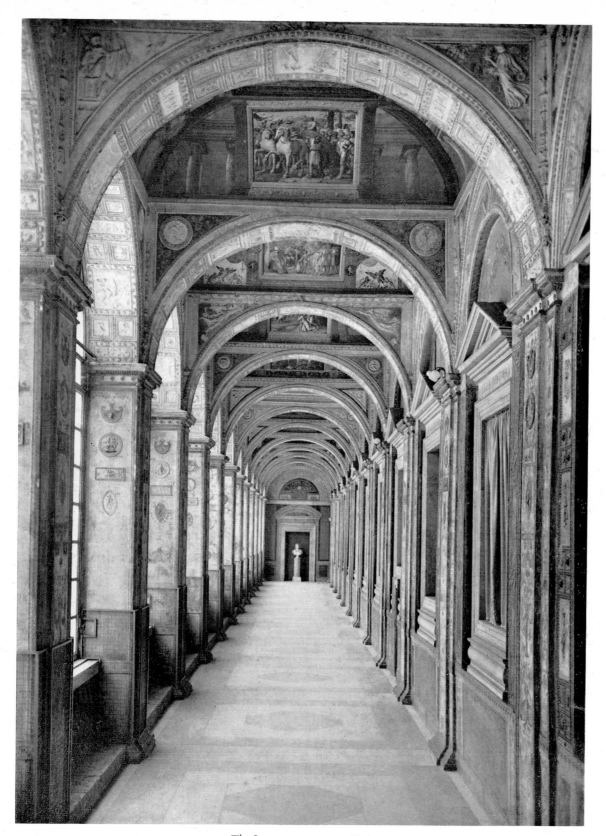

193 The *Logge. c.* 1517–1519. Vatican.

194 Vault of the first bay in the *Logge*.

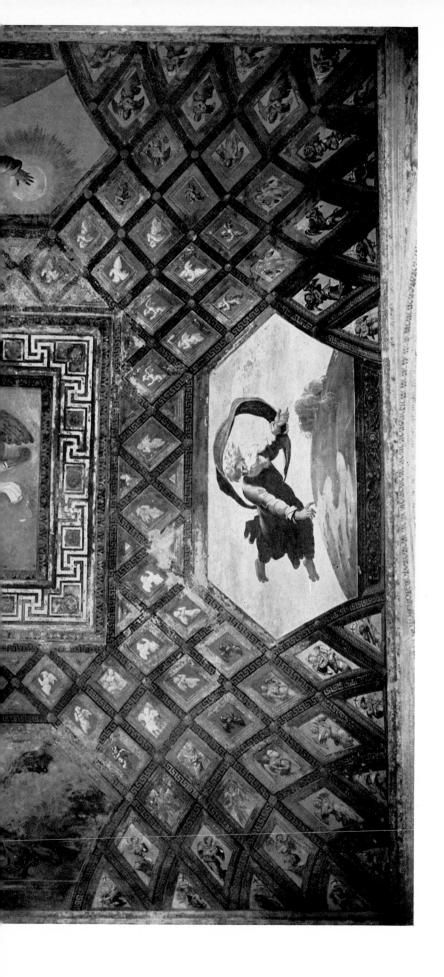

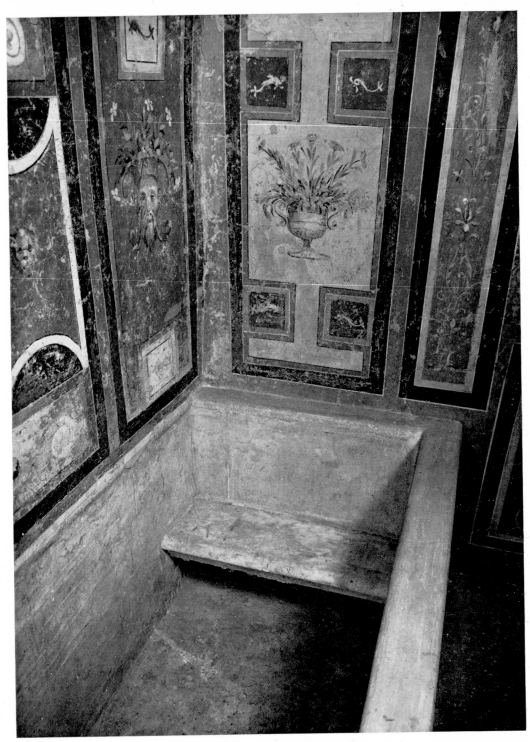

195 Bathroom of Cardinal Bibbiena. 1516. Vatican.

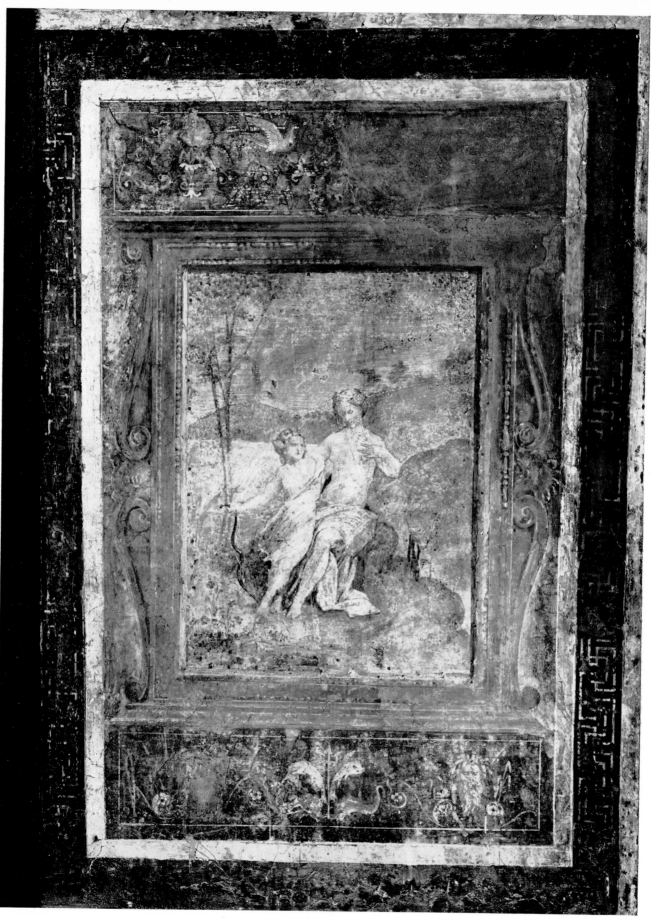

196 Venus showing her wounds to Cupid. Detail of decoration of 195.

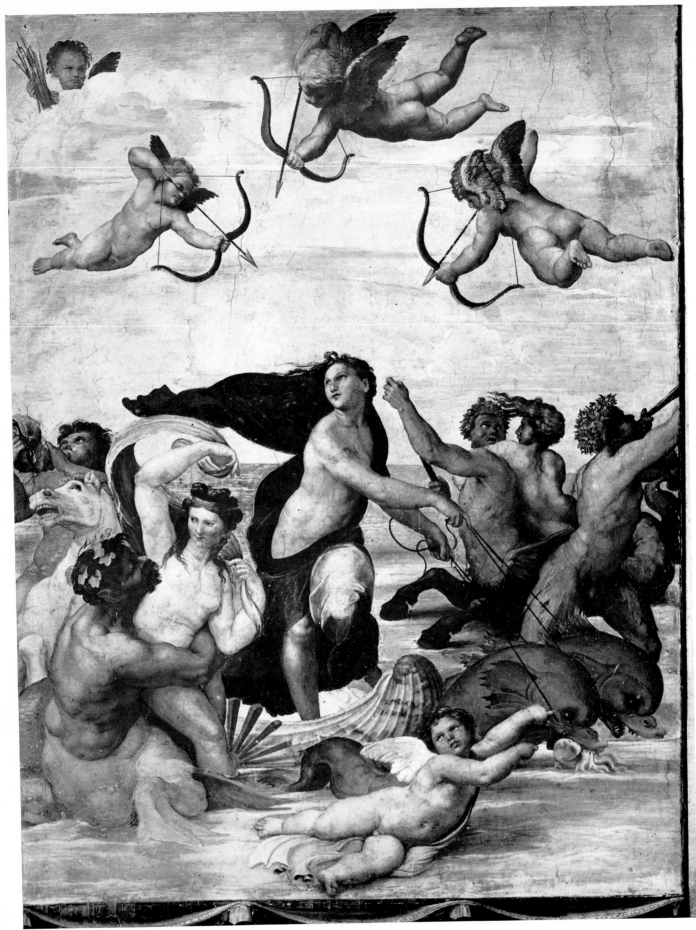

197 *Galatea*. Rome, Farnesina. 295 × 225.

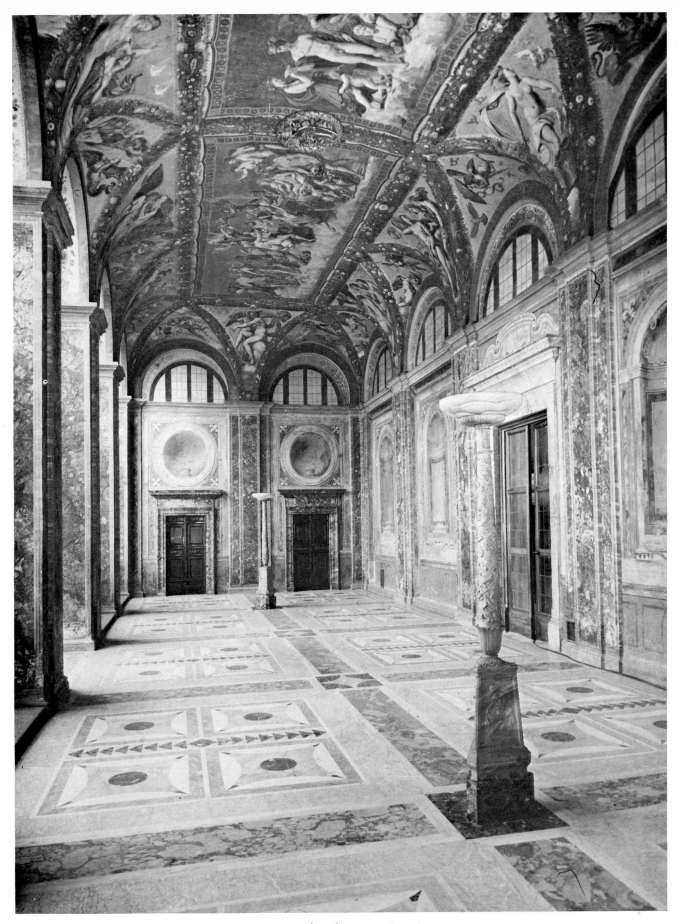

198 *Loggia di Psiche*. Rome, Farnesina.

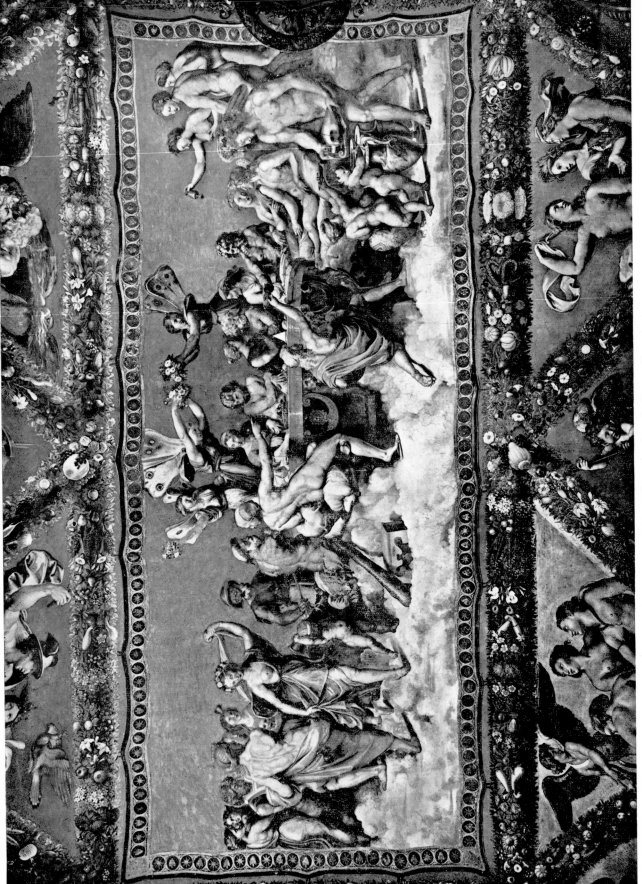

199 *Marriage of Cupid and Psyche.* Rome, Farnesina.

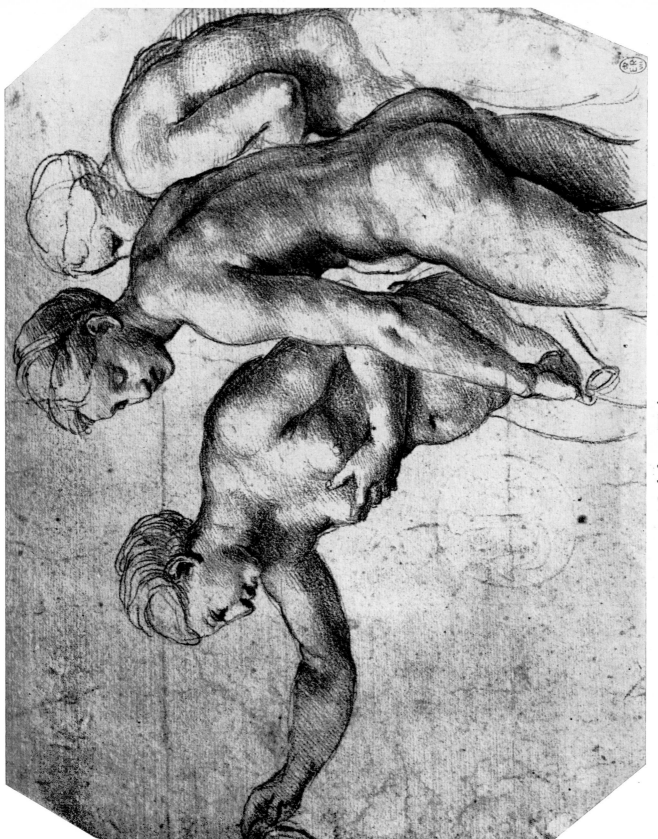

200 Study for 199. Windsor. 20·3 × 26.

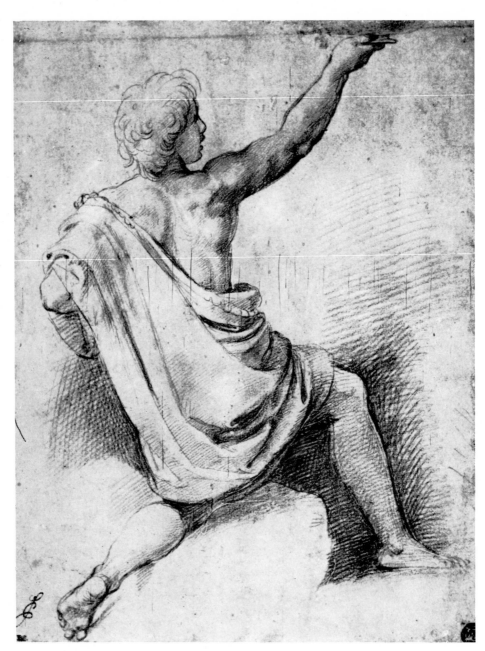

201 Study for 199. Louvre. 28·4 × 21·9.

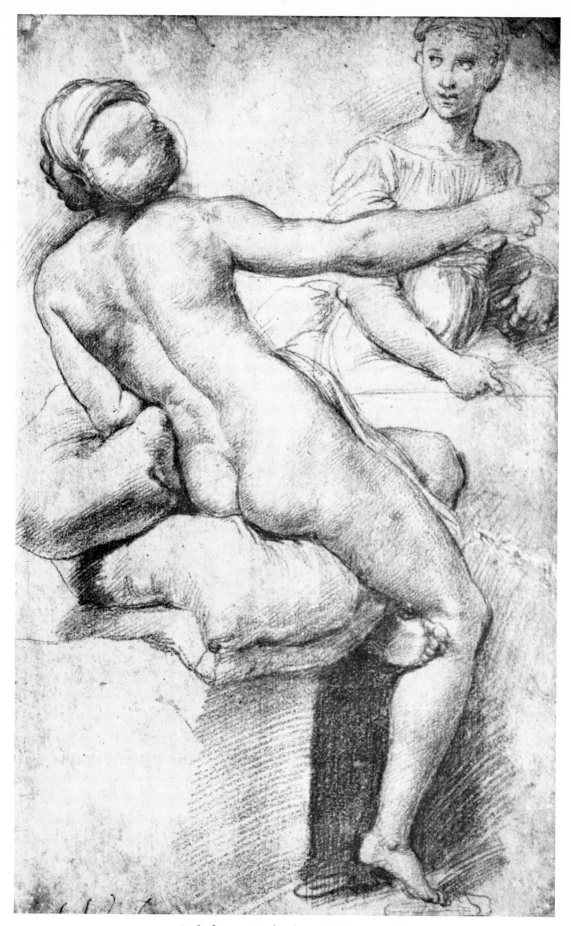

202 Study for 199. Haarlem (copyright). 25·7 × 16·4.

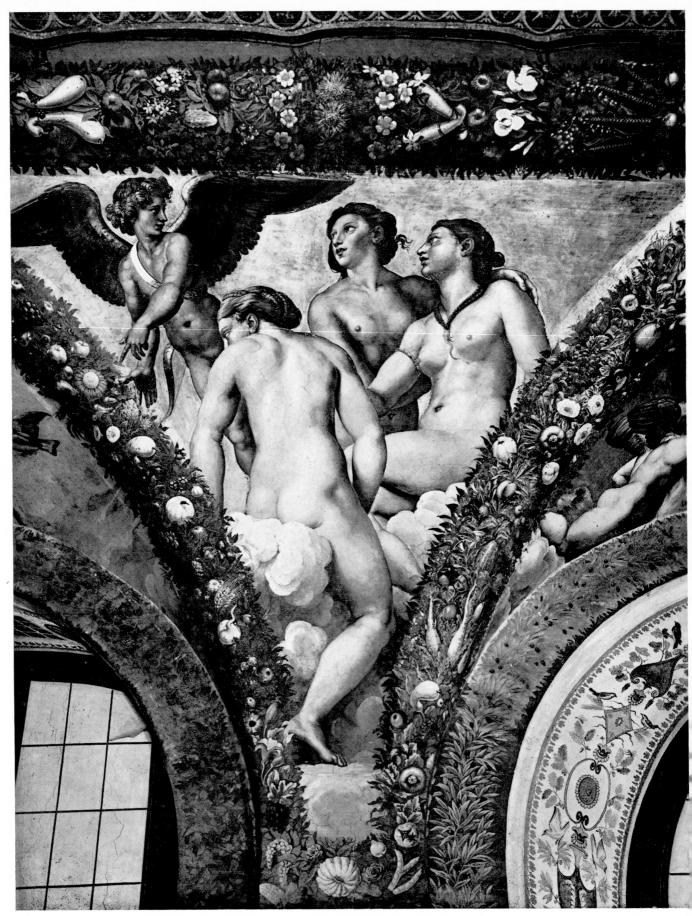

203 *Cupid and the Graces*. Rome, Farnesina.

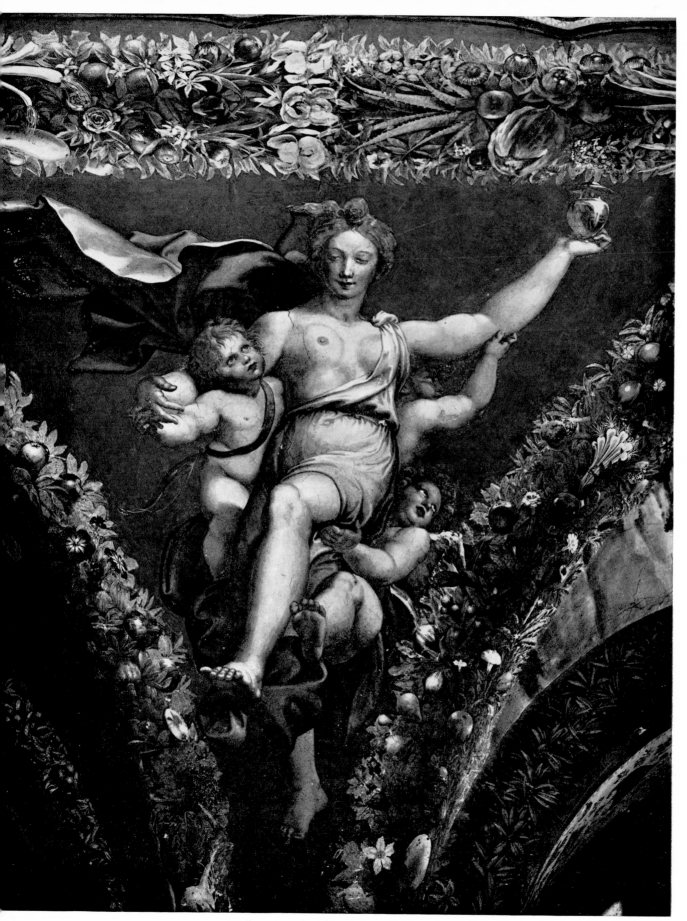

204 *Psyche rising to the palace of Venus*. Rome, Farnesina.

205 Chigi Chapel. Rome, S. Maria del Popolo.

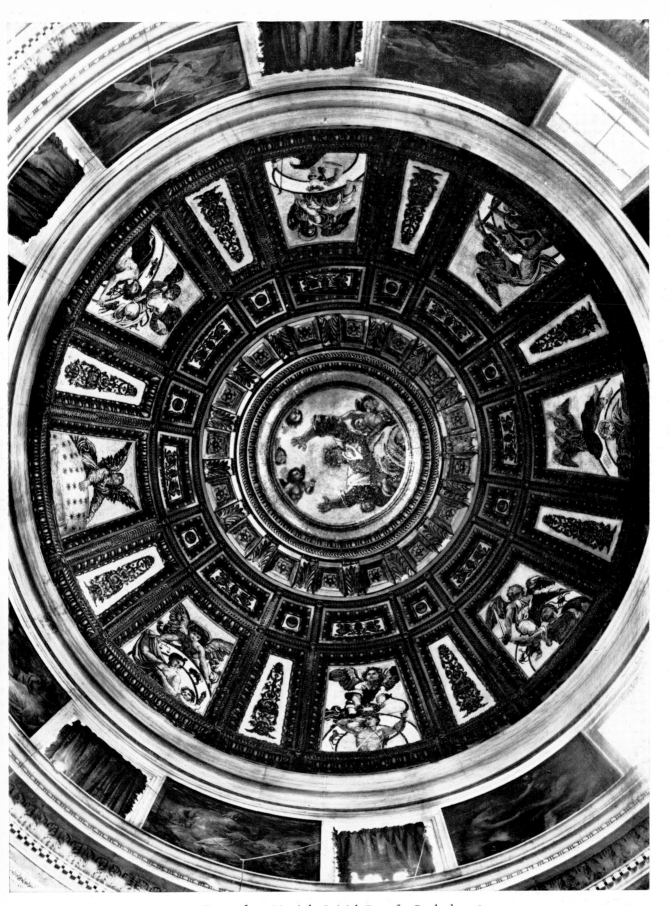

206 Dome of 205. Mosaic by Luigi de Pace after Raphael. 1516.

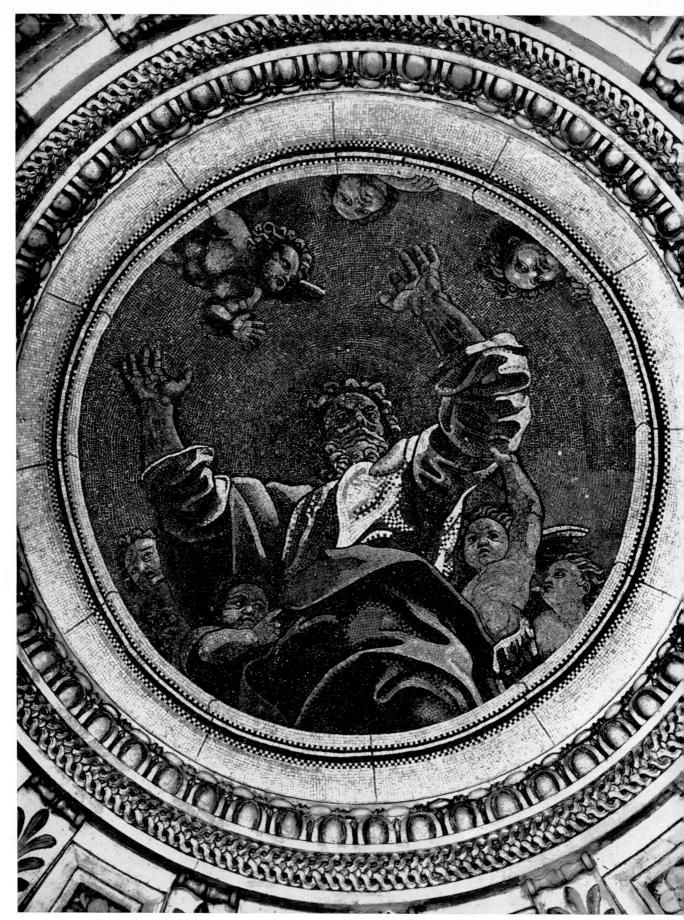

207 *God the Father*. Detail of 206.

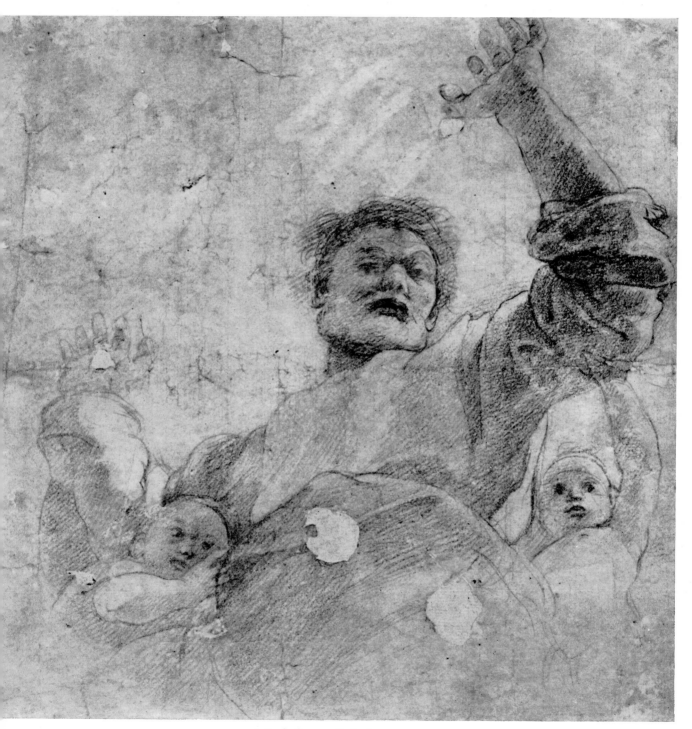

208 Study for 207. Oxford. 21·4 × 20·9.

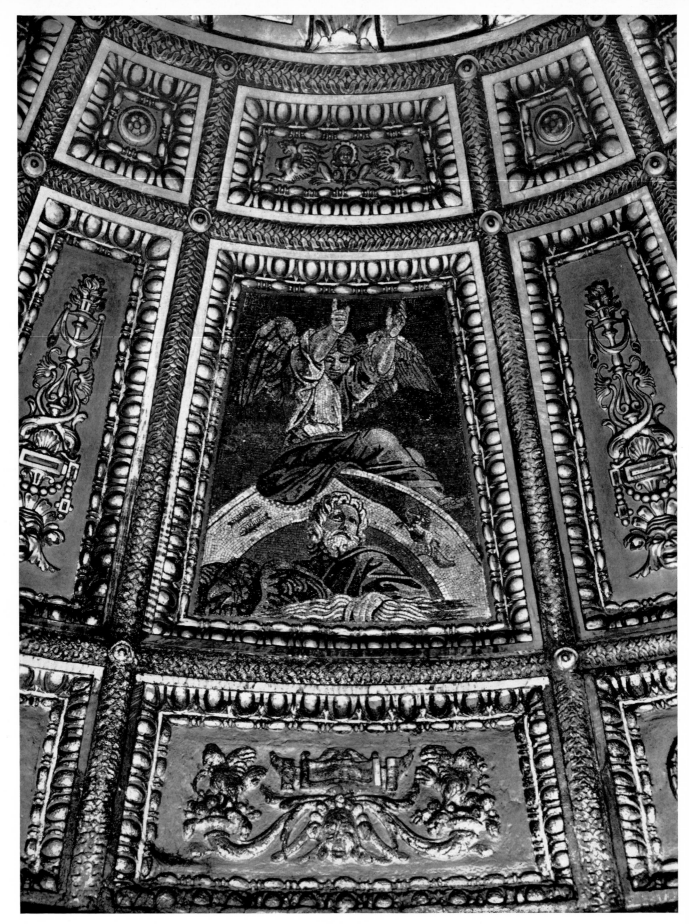

209 *Jupiter* in 206.

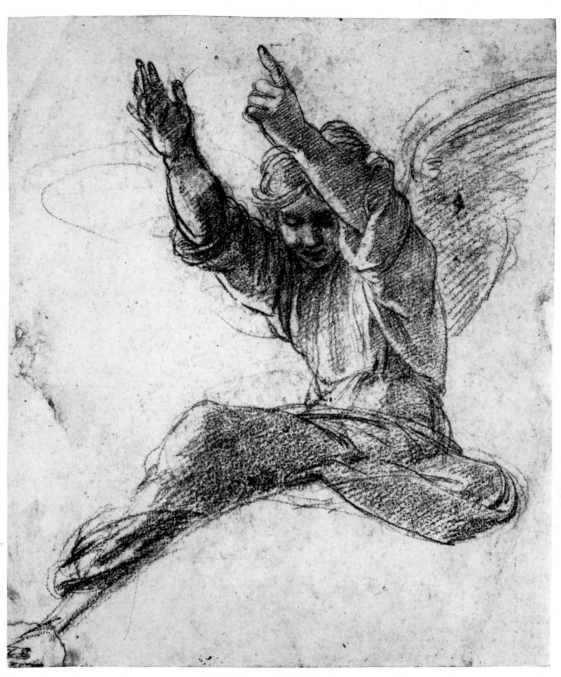

210 Study for 209. Oxford. 19·7 × 16·8.

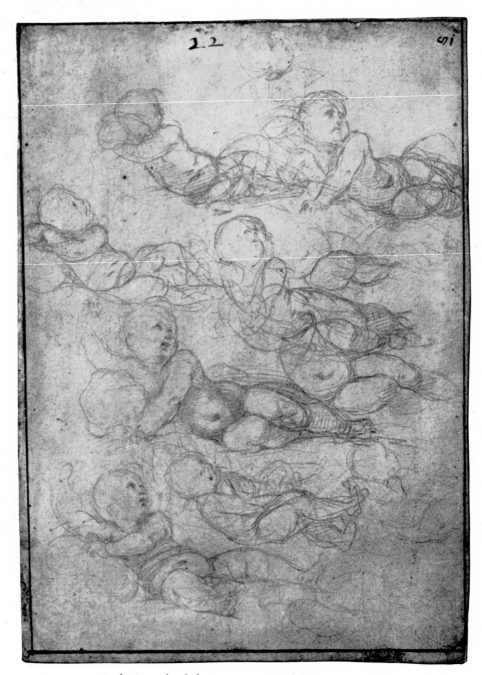

211 Preliminary sketch for 212 or 217. British Museum. 16·8 × 11·9.

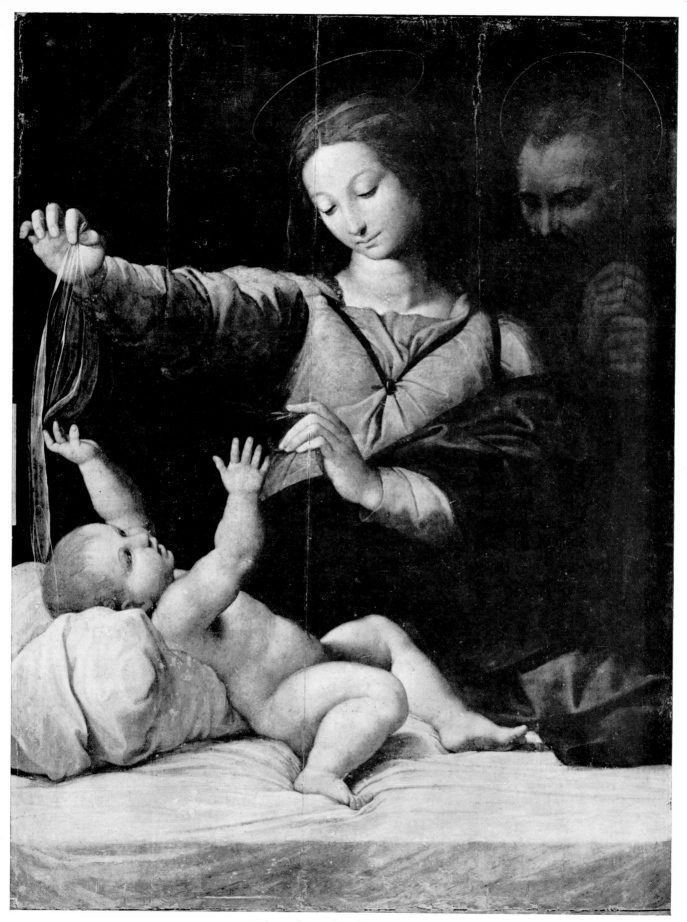

212 *Madonna of Loreto* (copy). Louvre. 121 × 91.

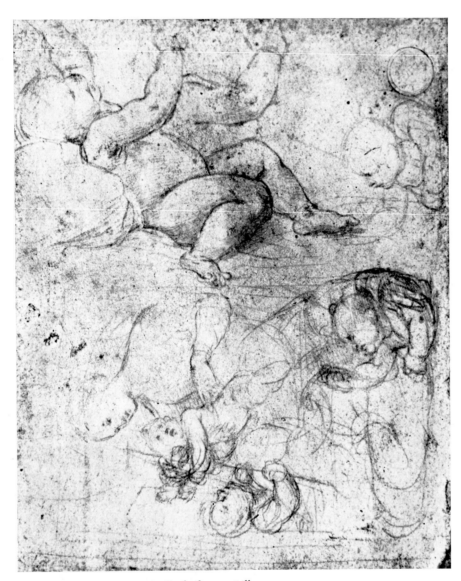

213 Study for 212. Lille. 14·5 × 11·5.

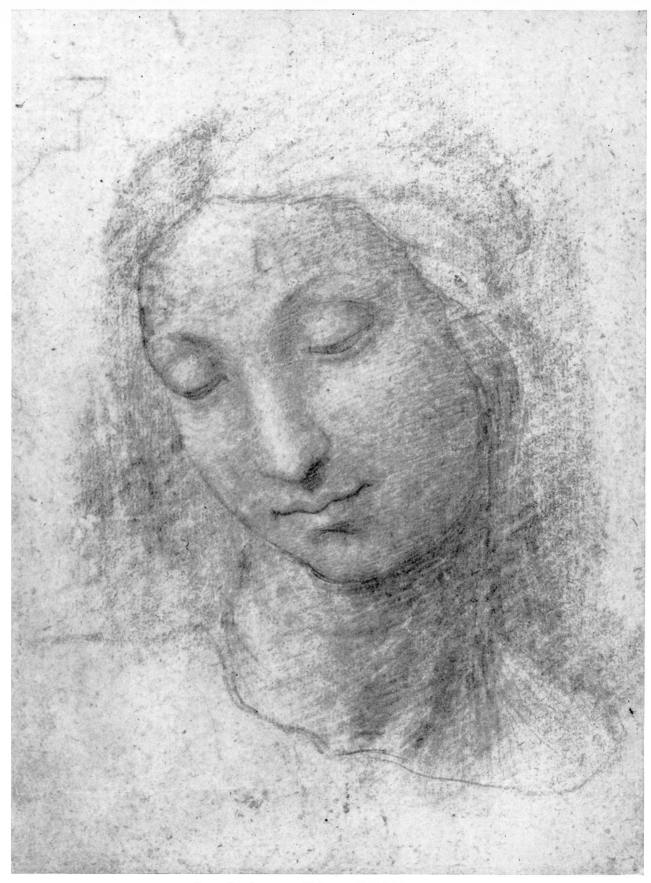

214 Copy after the cartoon (?) for 212. British Museum. 23·2 × 17·9.

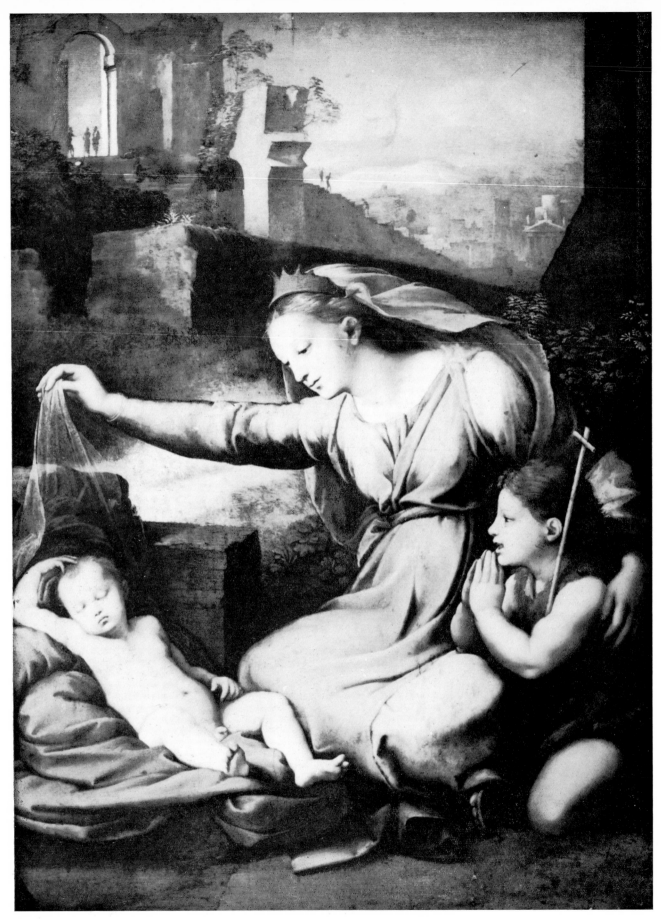

215 *Madonna of the Diadem*. Louvre. 68 × 44.

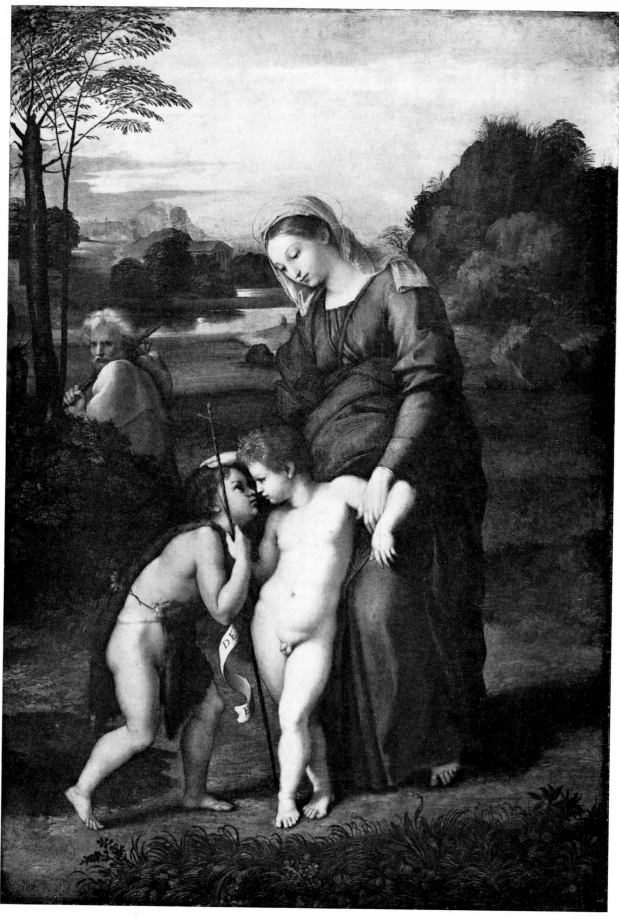

216 *Madonna del Passeggio*. Duke of Sutherland Collection, on loan at Edinburgh. 88 × 62.

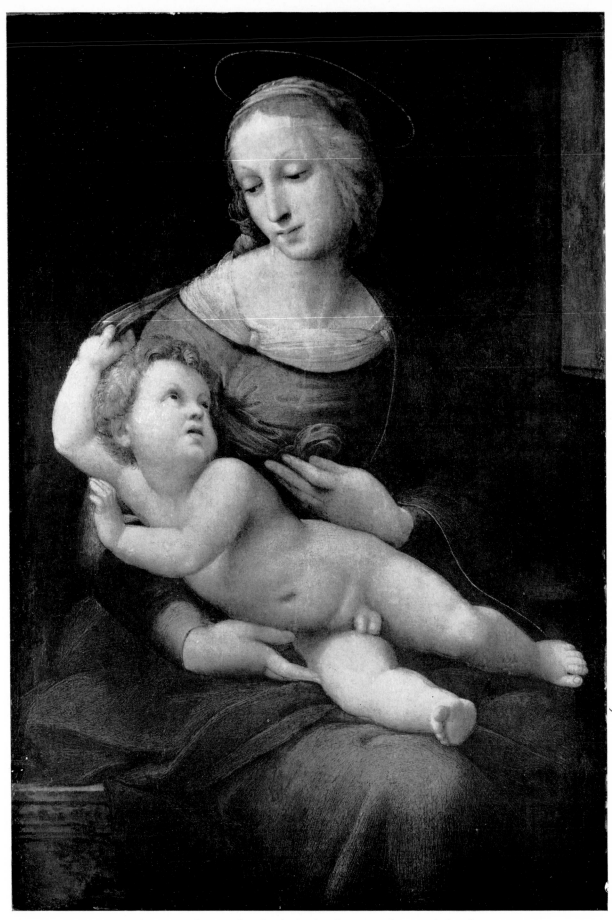

217 *Bridgewater Madonna*. Duke of Sutherland Collection, on loan at Edinburgh. 81 × 56.

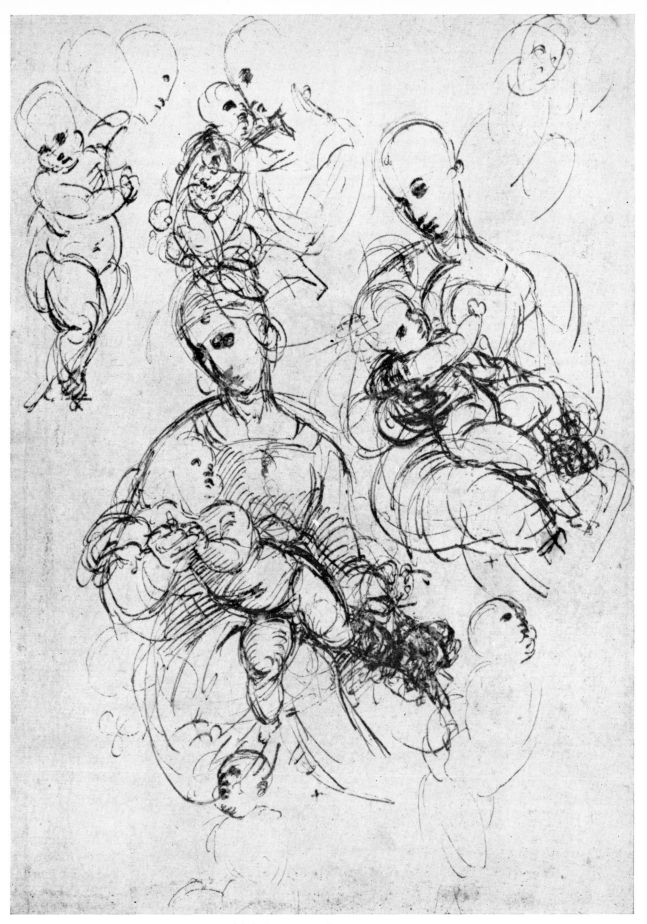

218 Sketch for 217. British Museum. 25·4 × 18·4.

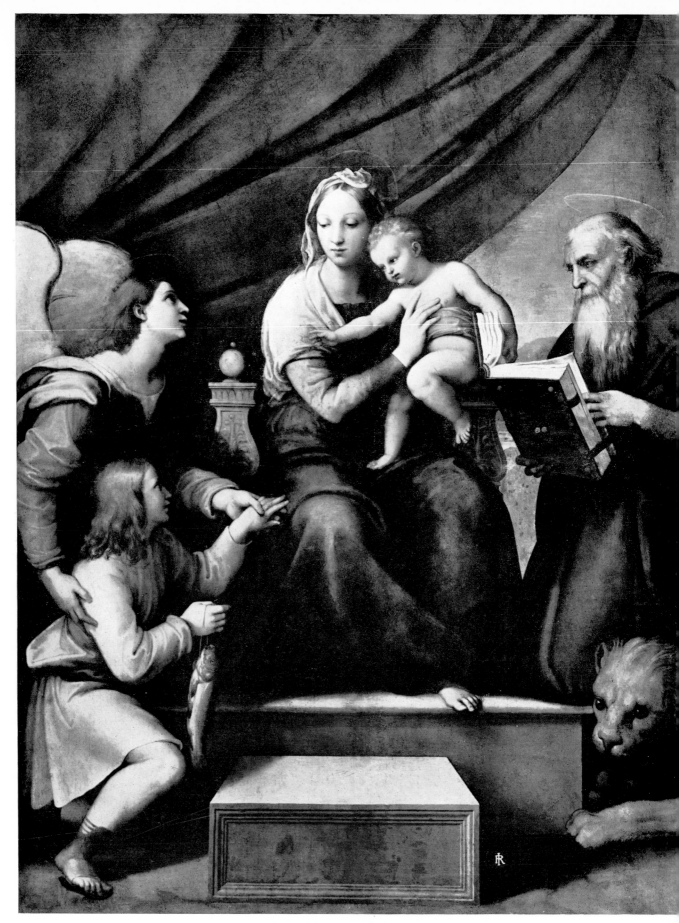

219 *Madonna of the Fish*. Madrid. 215 × 158.

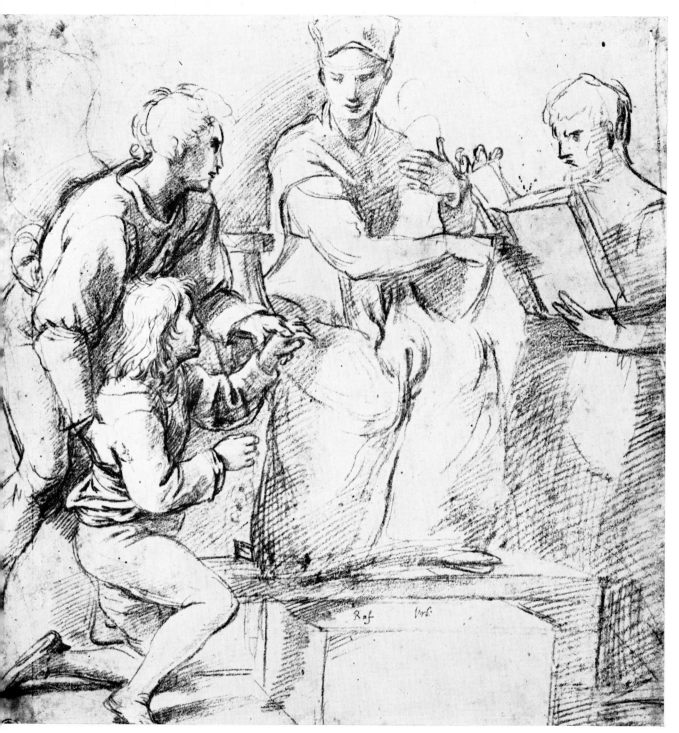

220 Compositional study for 219. Uffizi. 26·1 × 26·2.

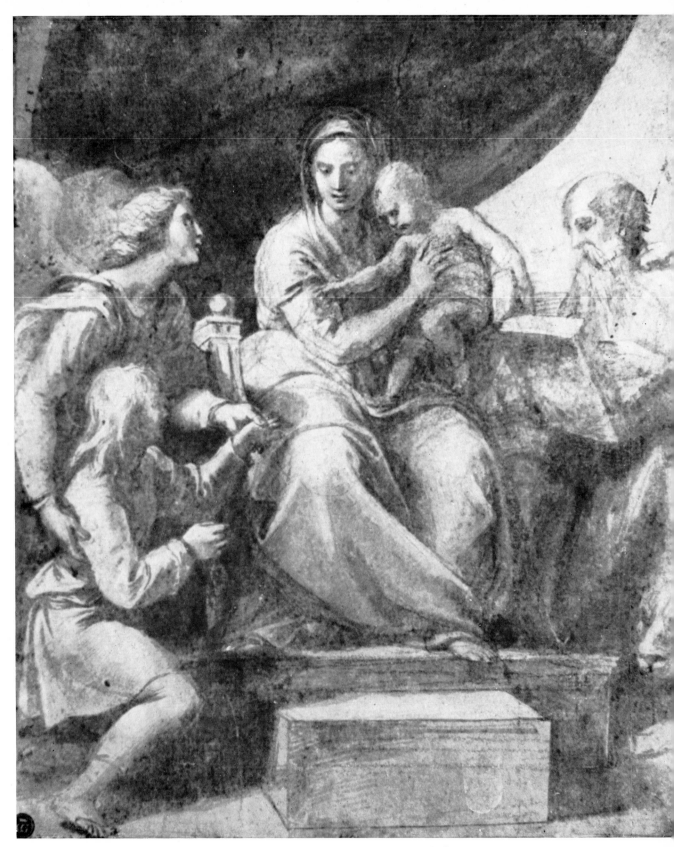

221 Compositional study for 219. London. Norman Colville Esq. 25·8 × 21·3.

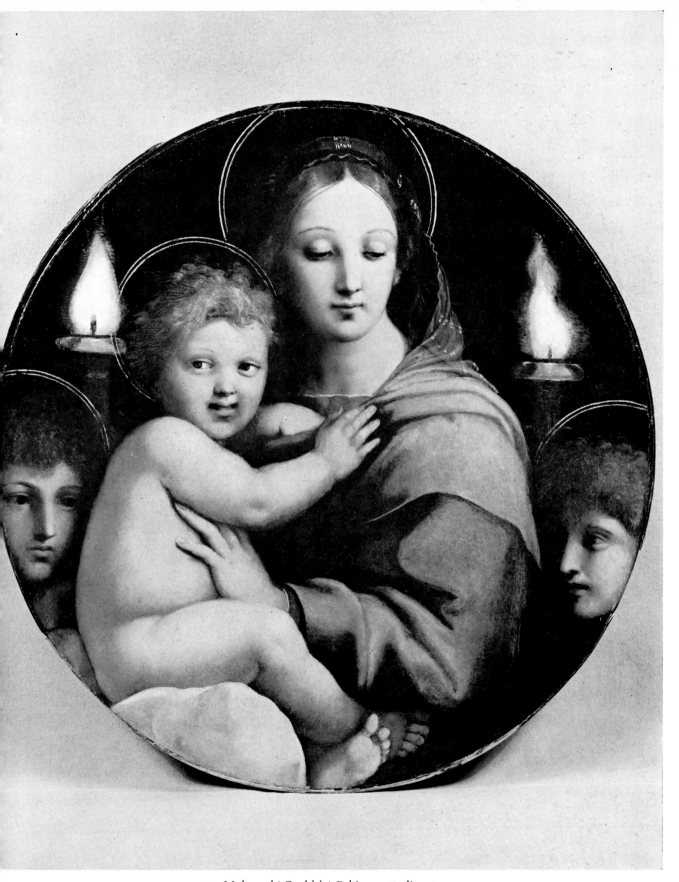

222 *Madonna dei Candelabri*. Baltimore. 65 diameter.

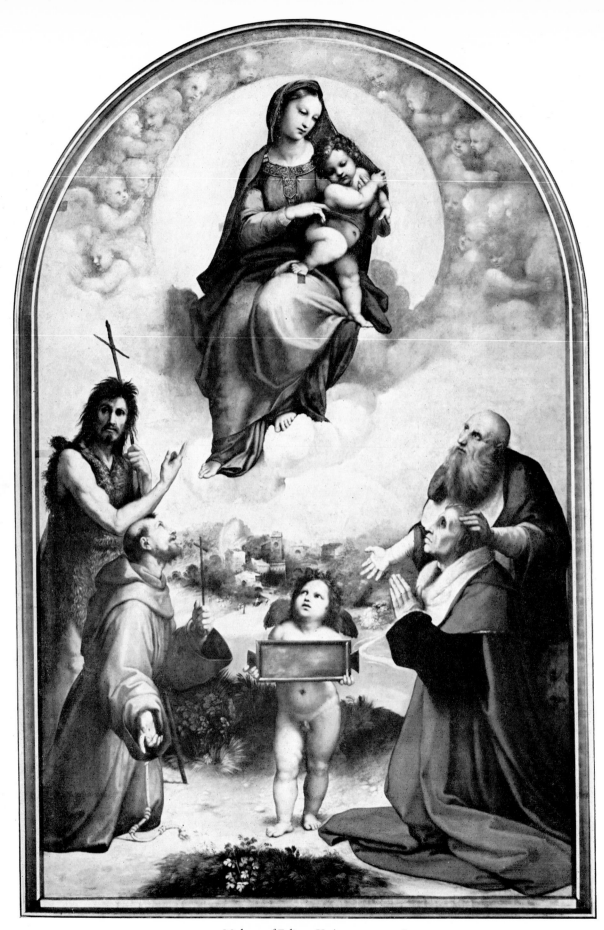

223 *Madonna of Foligno*. Vatican. 301 × 198.

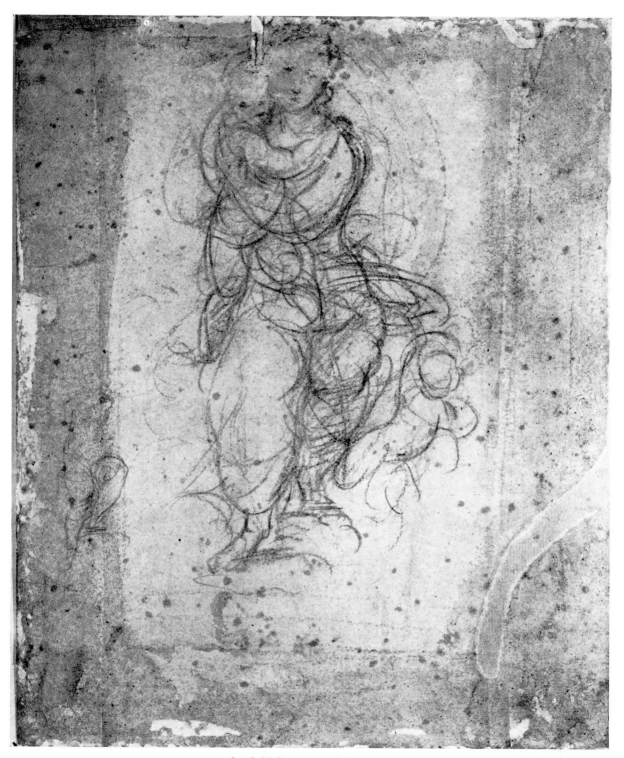

224 Sketch (?) for 223. Frankfurt. 25 × 19·6.

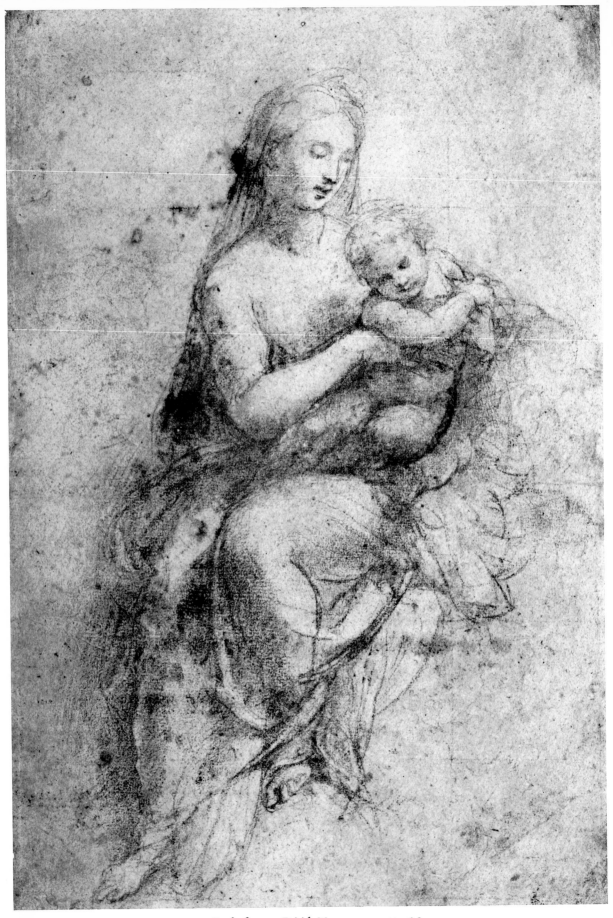

225 Study for 223. British Museum. 40·2 × 26·8.

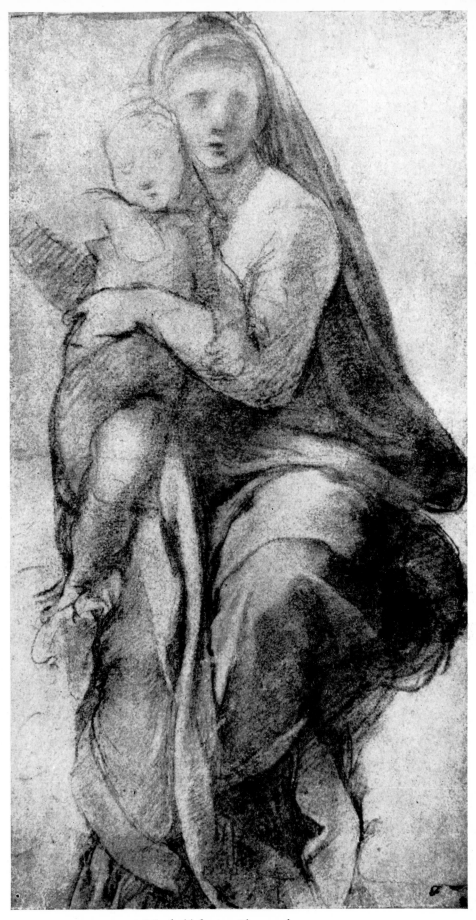

226 Study (?) for 223. Chatsworth. 41 × 22·3.

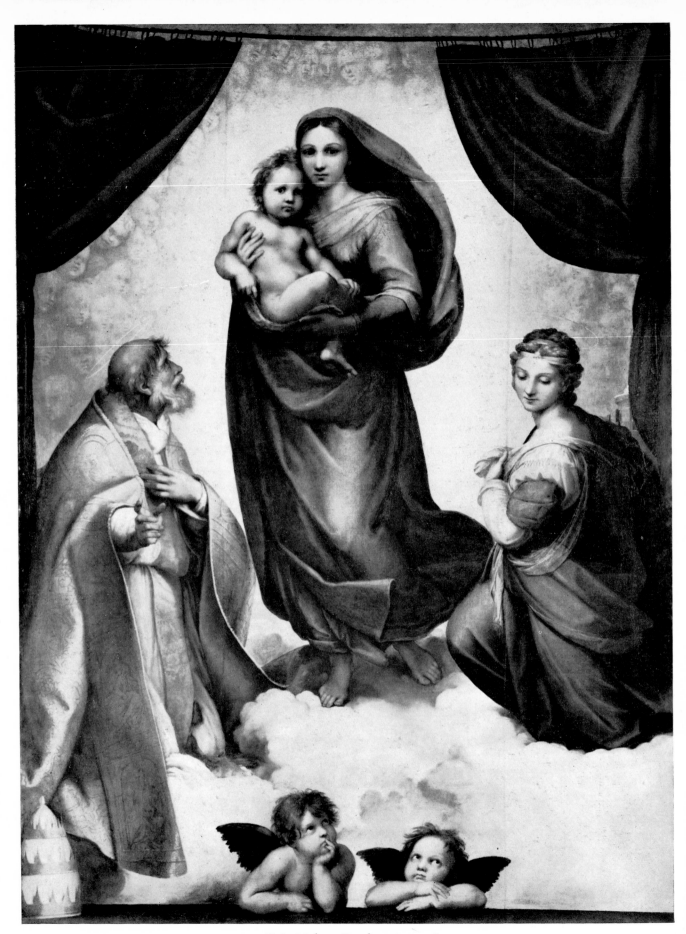

227 *Sistine Madonna*. Dresden. 265 × 196.

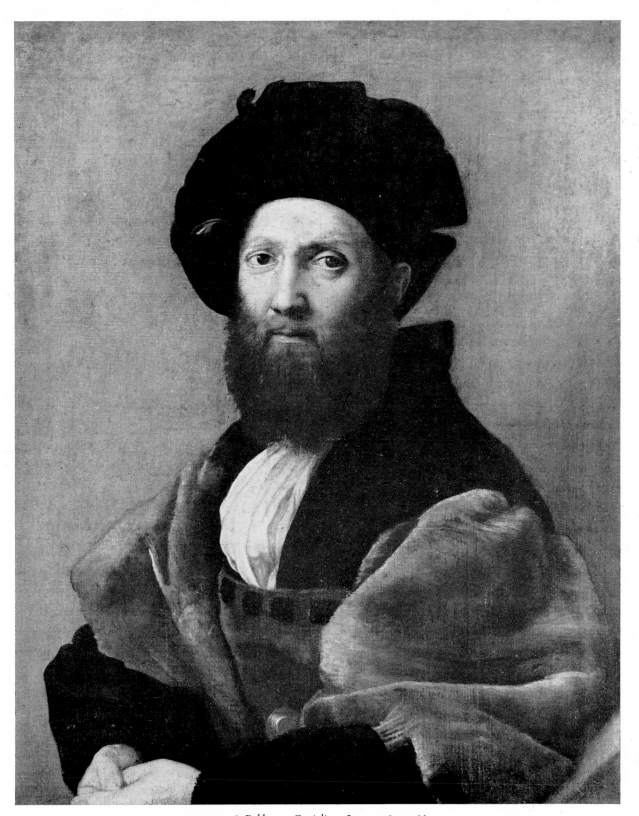

228 *Baldassare Castiglione*. Louvre. 82 × 66.

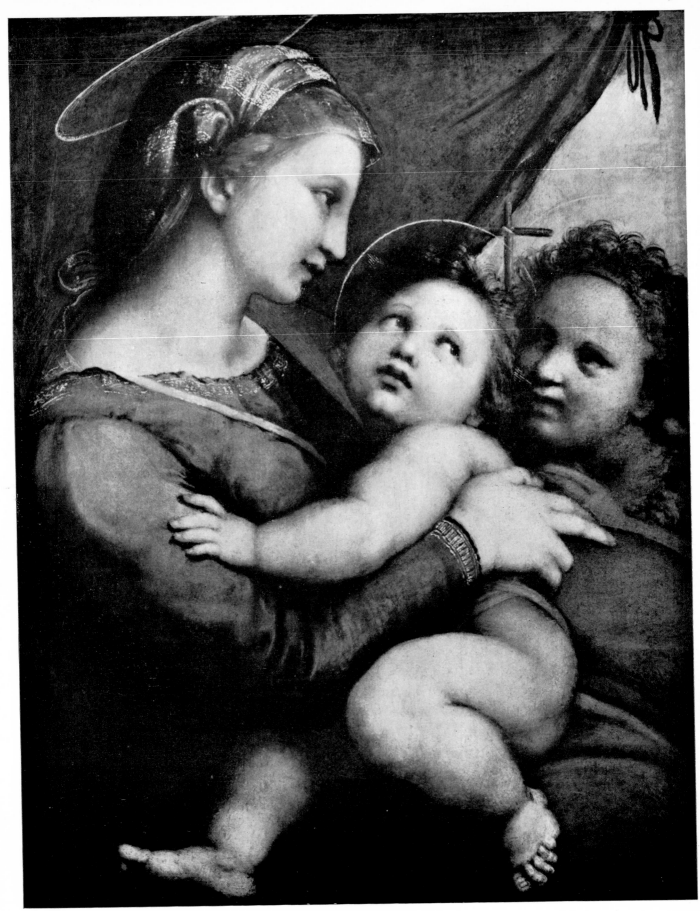

229 *Madonna della Tenda*. Munich. 68 × 55.

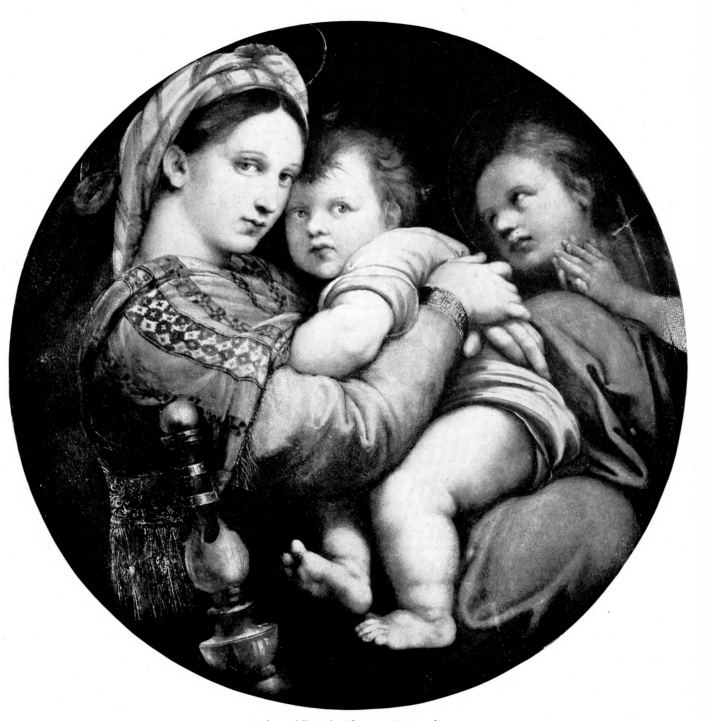

230 *Madonna della Sedia*. Florence, Pitti. 71 diameter.

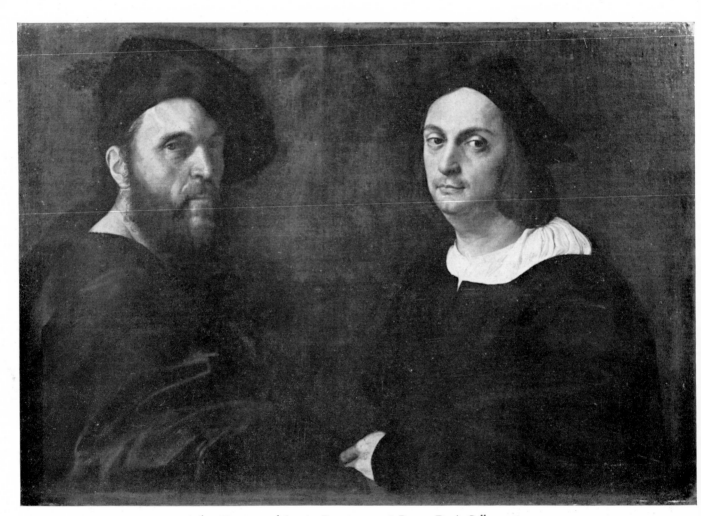

231 *Andrea Navagero and Agostino Beazzano*. 1516. Rome, Doria Gallery. 76 × 107.

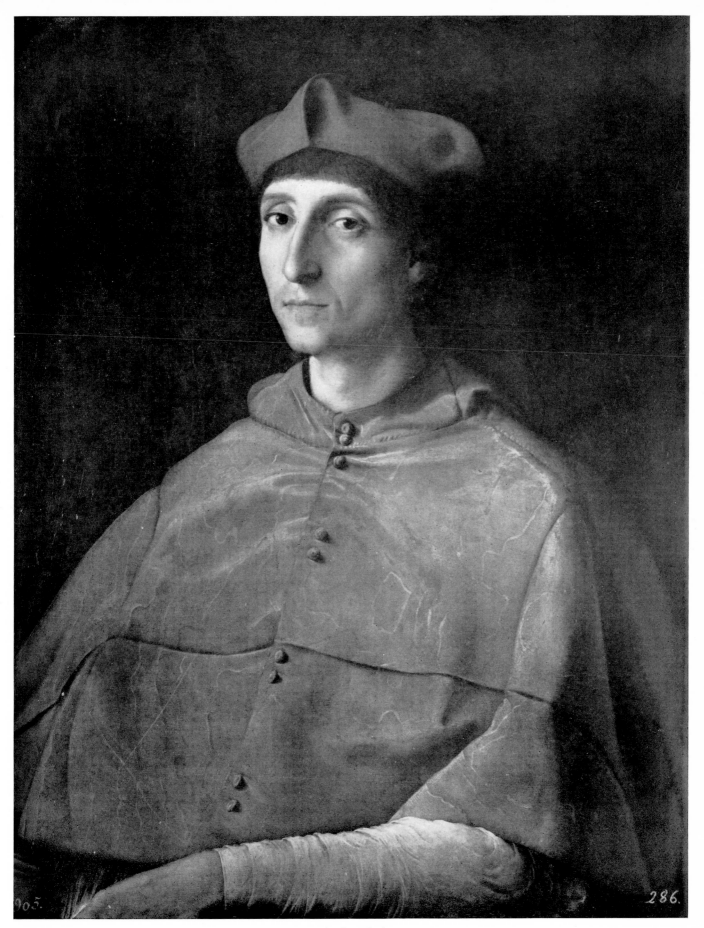

905. 286.

232 *A Cardinal*. Madrid. 79 × 61.

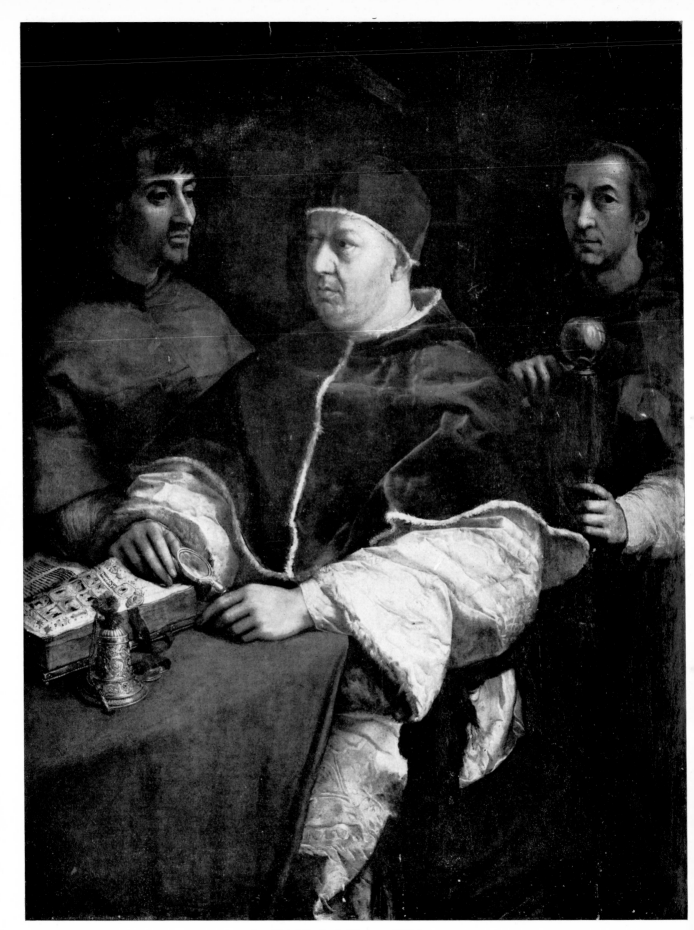

233 *Leo X and Cardinals*. Florence, Uffizi. 154 × 119.

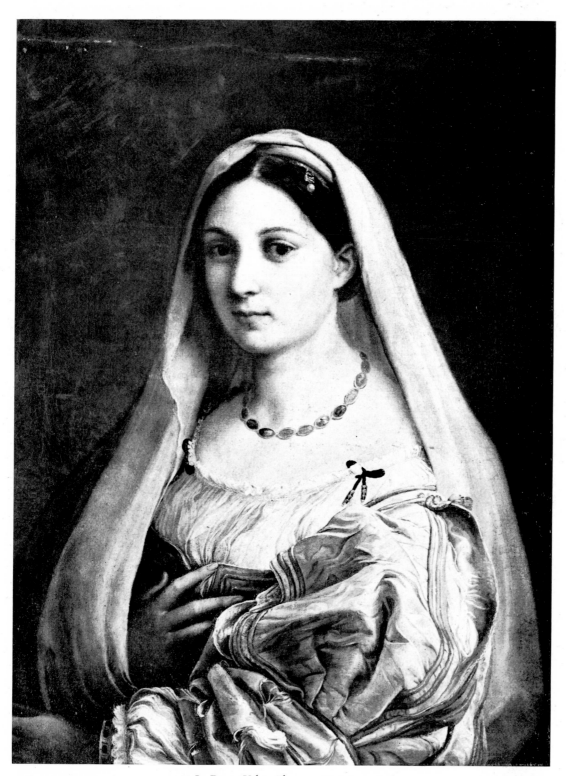

234 *La Donna Velata*. Florence, Pitti. 85 × 64.

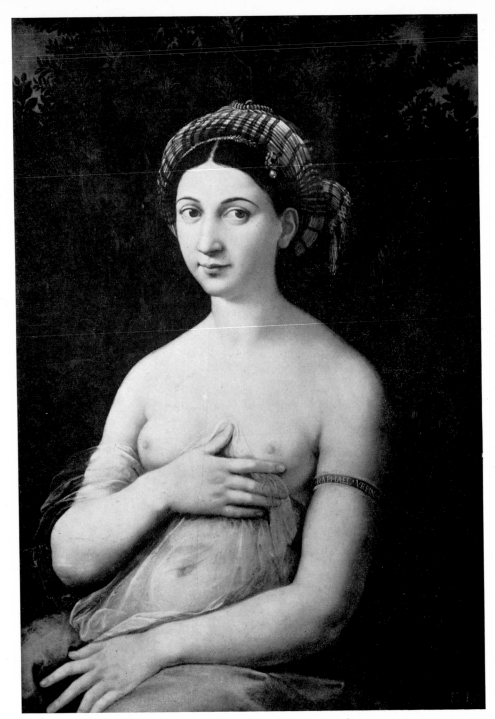

235 *La Fornarina*. Rome, Galleria Nazionale. 85 × 60.

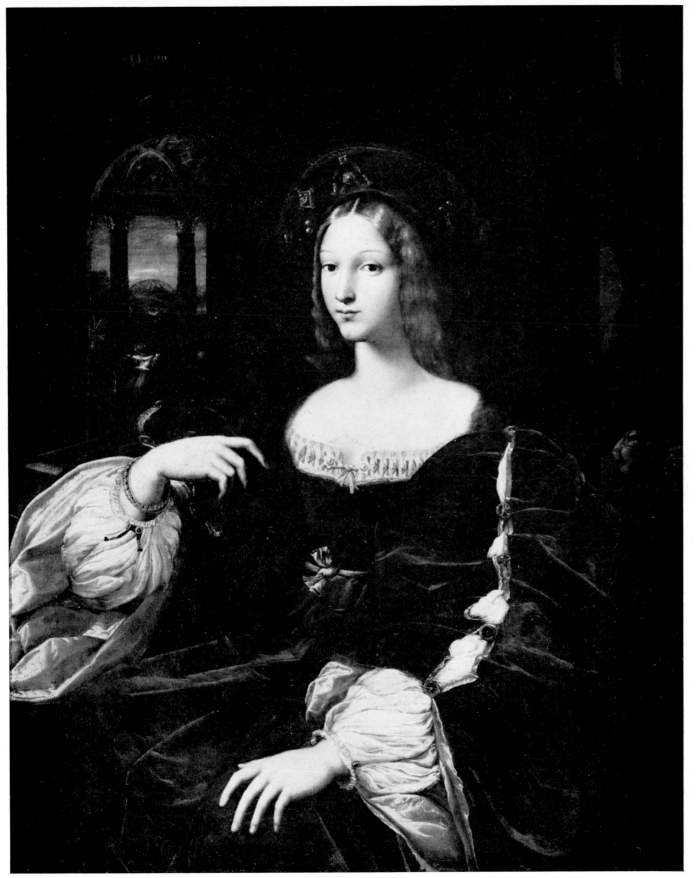

236 *Joanna of Aragon*. 1518. Louvre. 120 × 95.

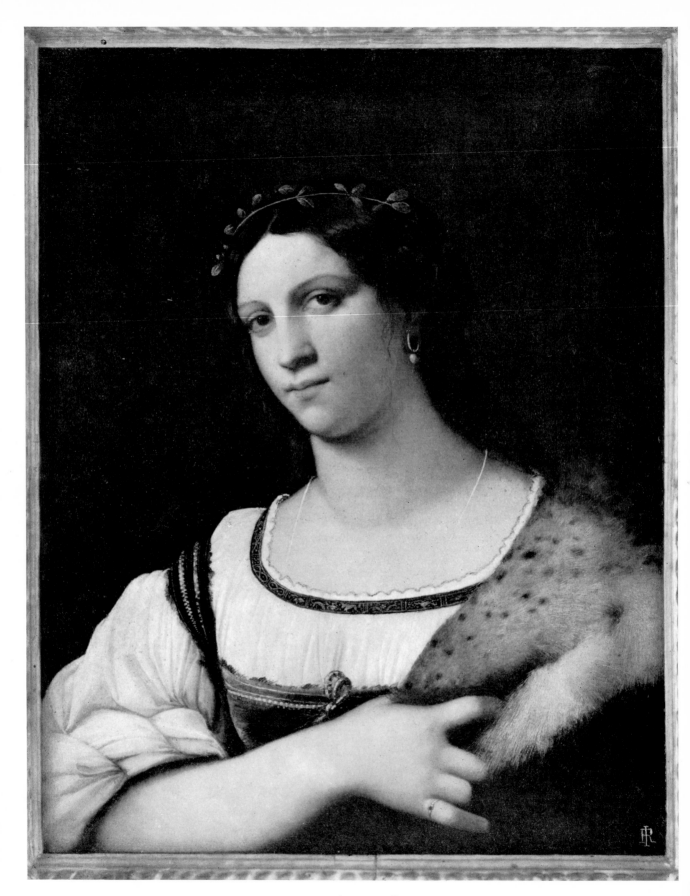

237 *La Fornarina*. Florence, Uffizi. 68 × 54.

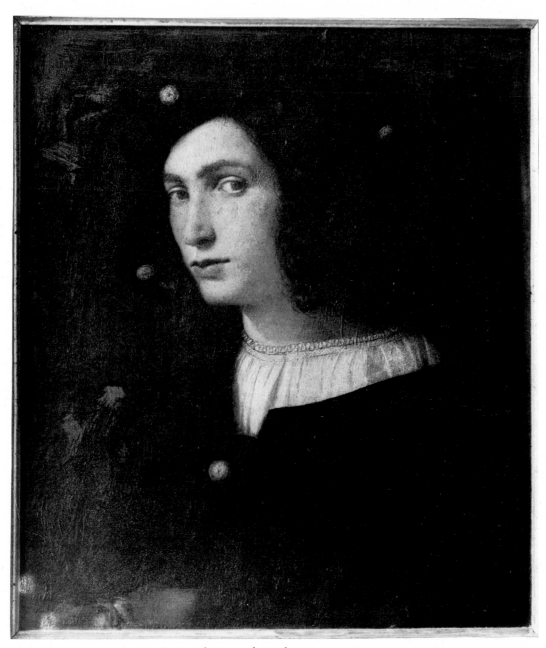

238 *A youth*. Petworth, Lord Egremont. 48·8 × 43·5.

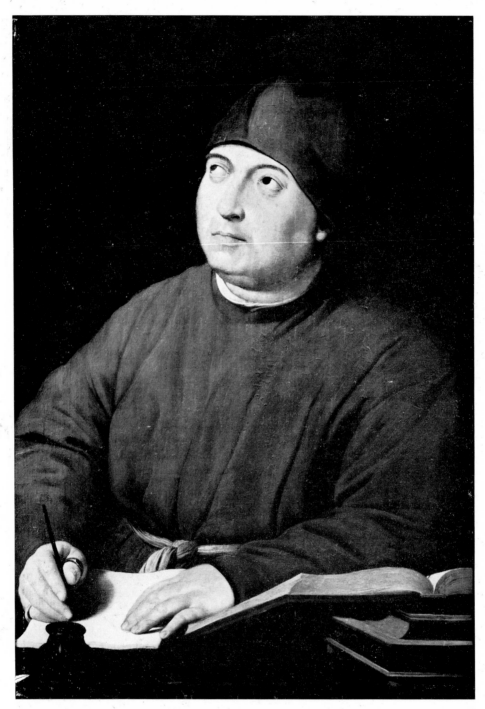

239 *Tommaso Inghirami.* Boston. 89 × 62.

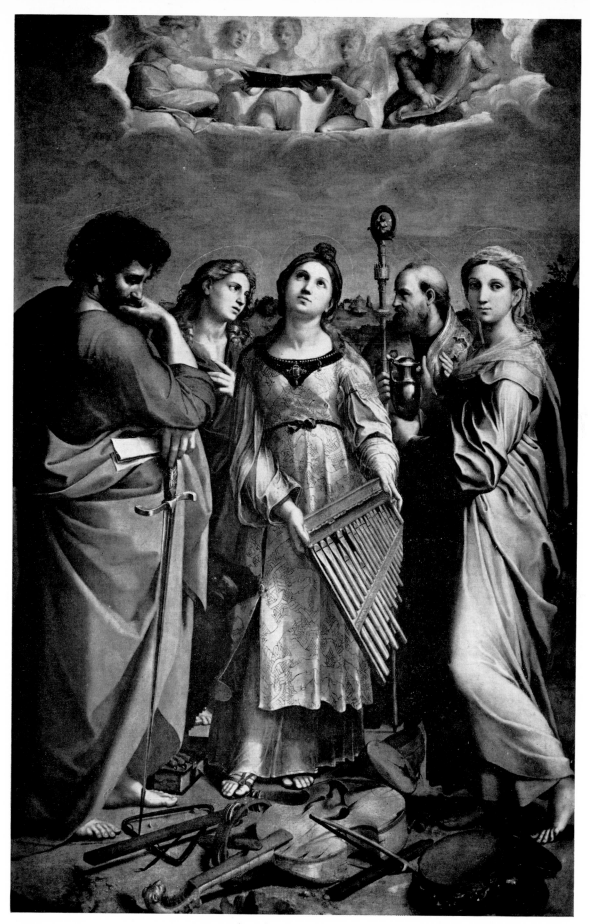

240 *St Cecilia and Saints*. Bologna. 238 × 150.

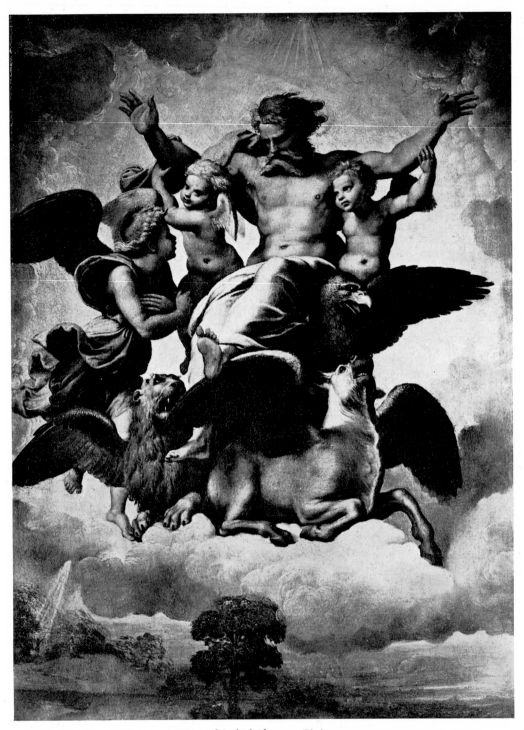

241 *Vision of Ezekiel*. Florence, Pitti. 40 × 30.

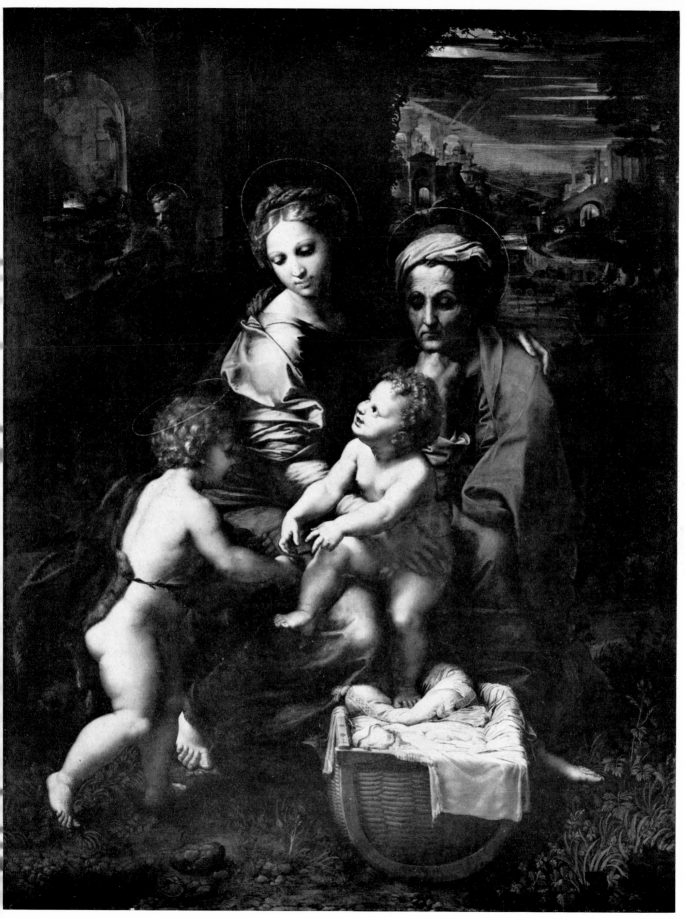

242 *La Perla*. Madrid. 144 × 115.

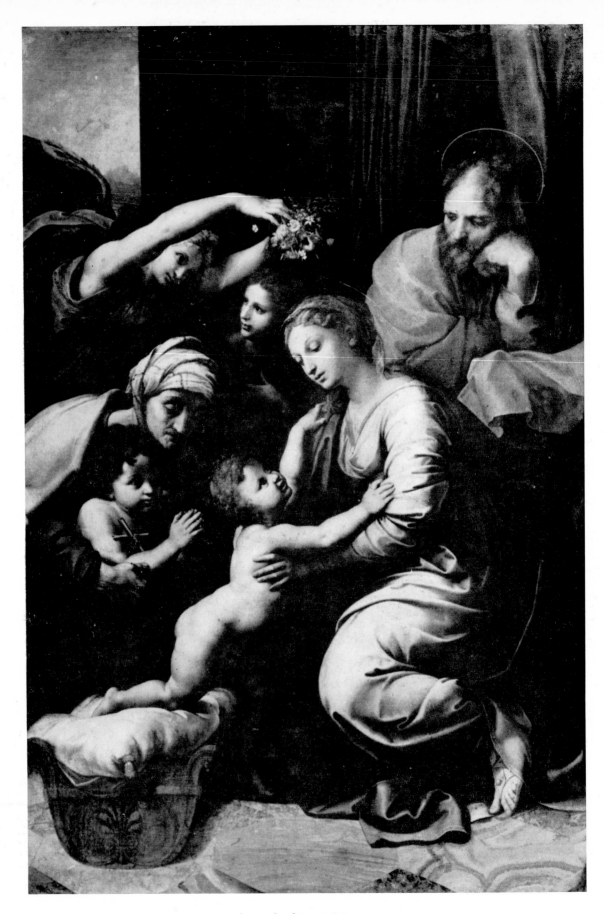

243 *Large Holy Family of Francis I*. Louvre. 107 × 140.

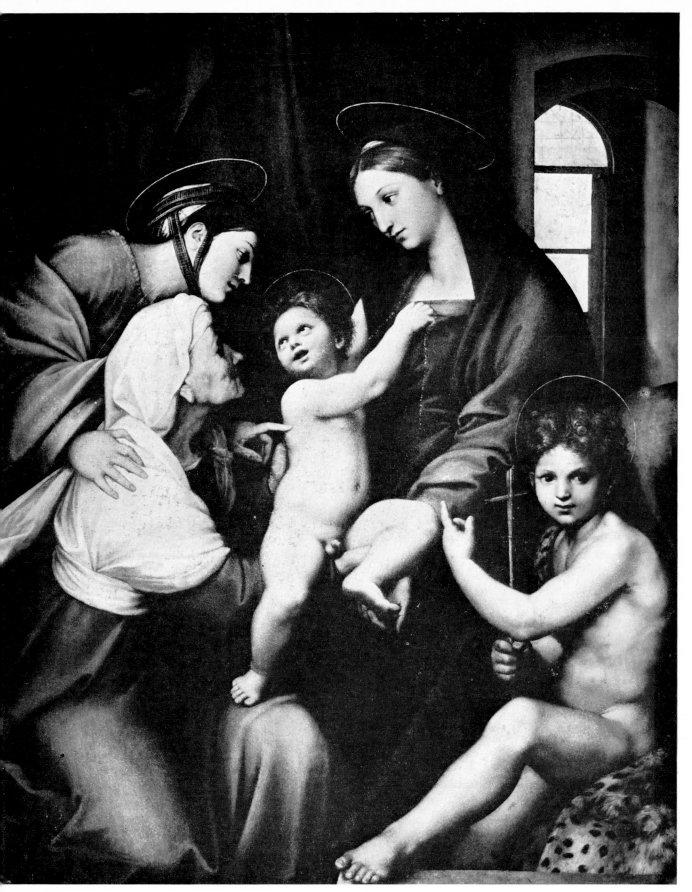

244 *Madonna dell'Impannata*. Florence, Pitti. 158 × 125.

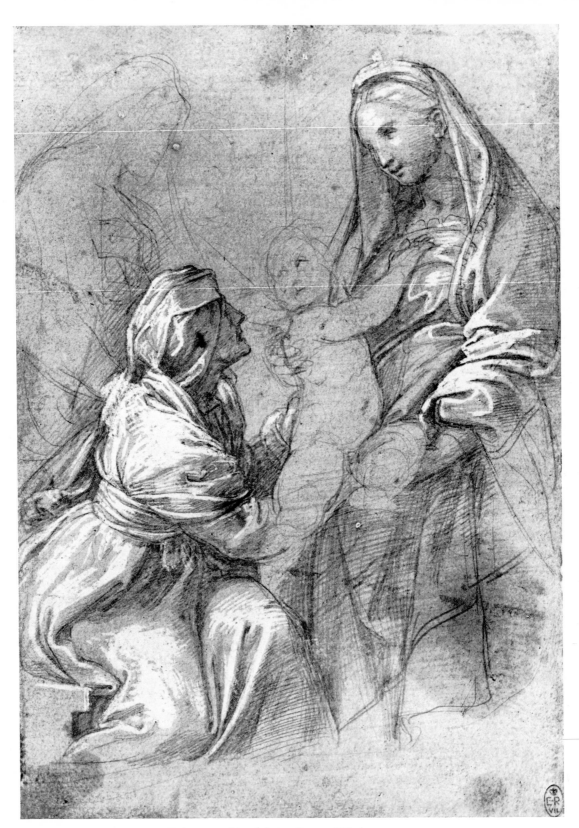

245 Early compositional design for 244. Windsor. 21 × 14·5.

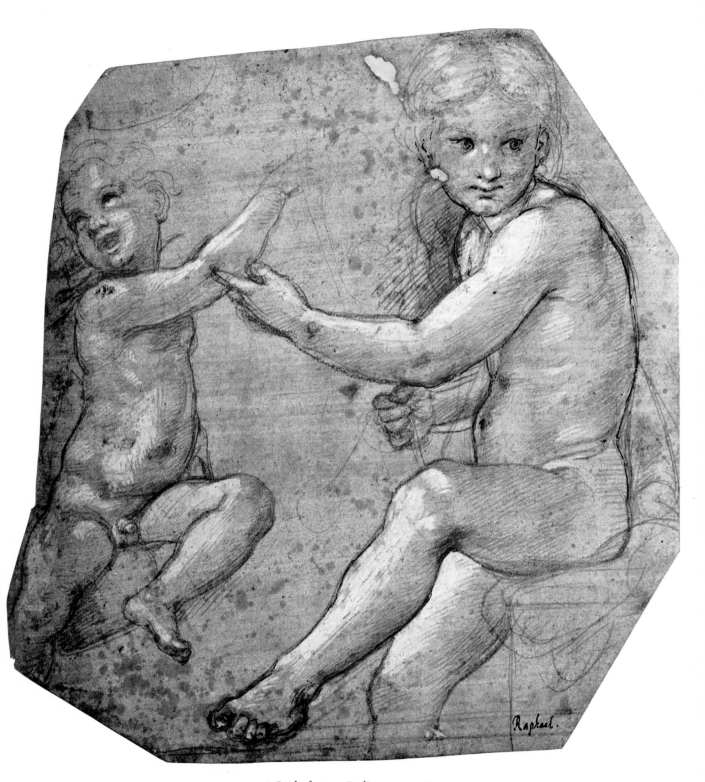

246 Study for 244. Berlin. 21 × 20·8.

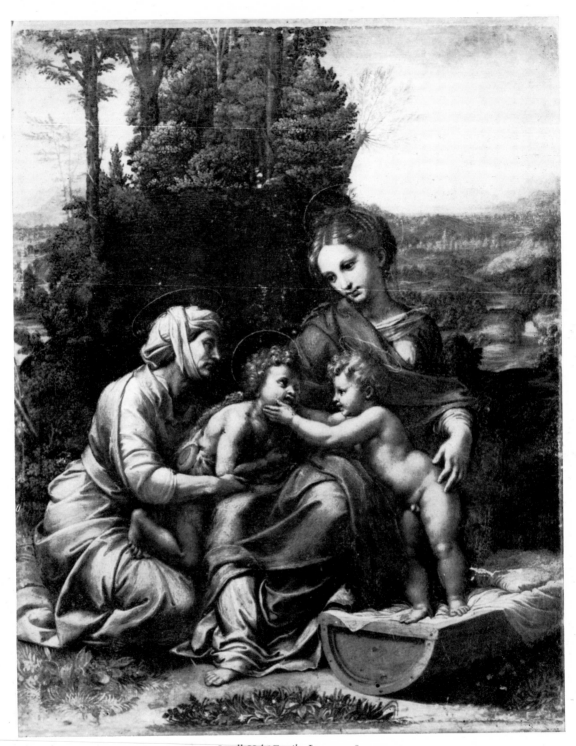

247 Small *Holy Family*. Louvre. 38 × 32.

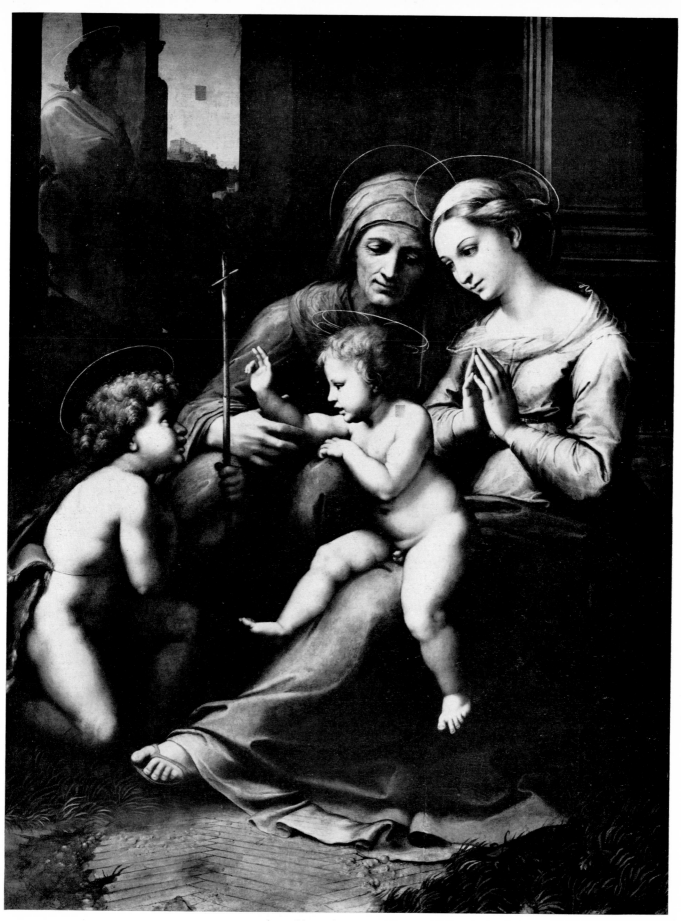

248 *Madonna del Divin'Amore*. Naples. 138 × 109.

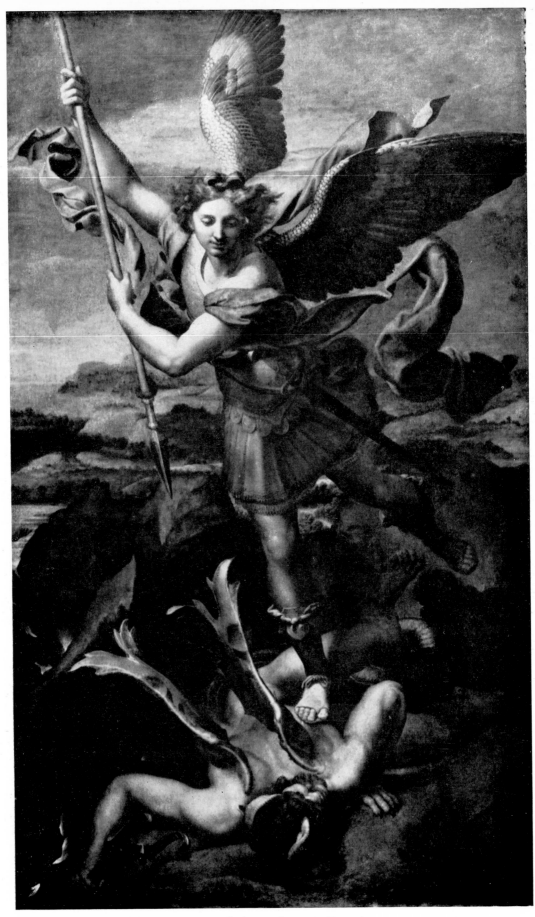

249 *St Michael.* 1518. Louvre. 268 × 160.

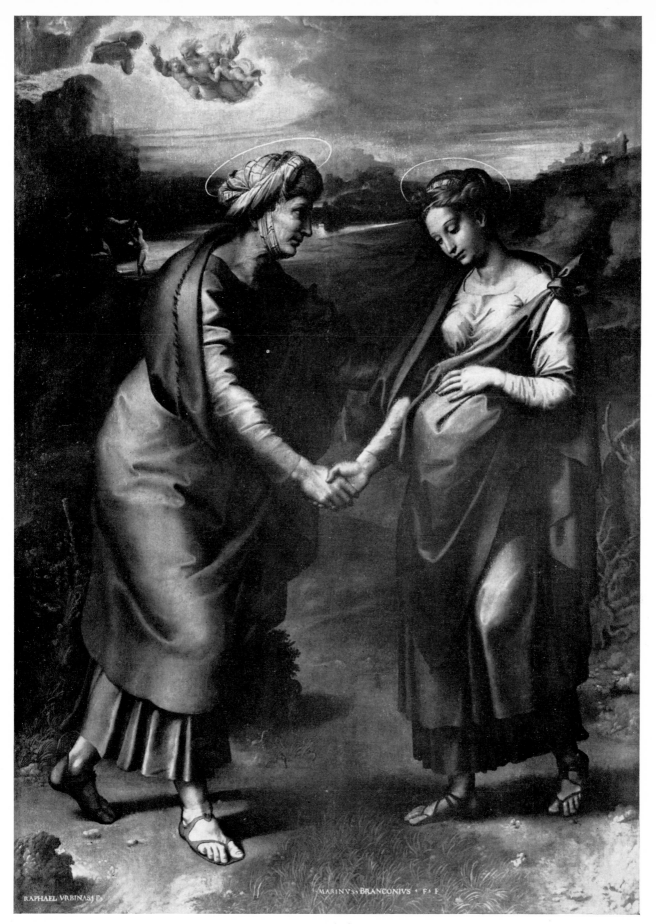

RAPHAEL VRBINAS F⁵ MARINVS·BRANCONIVS·F⁵ F

250 *Visitation*. Madrid. 200 × 145.

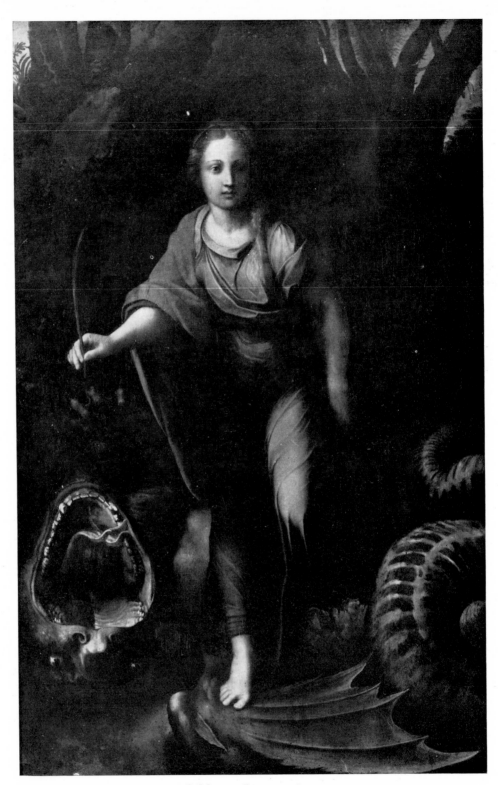

251 *St Margaret*. Louvre. 178 × 122.

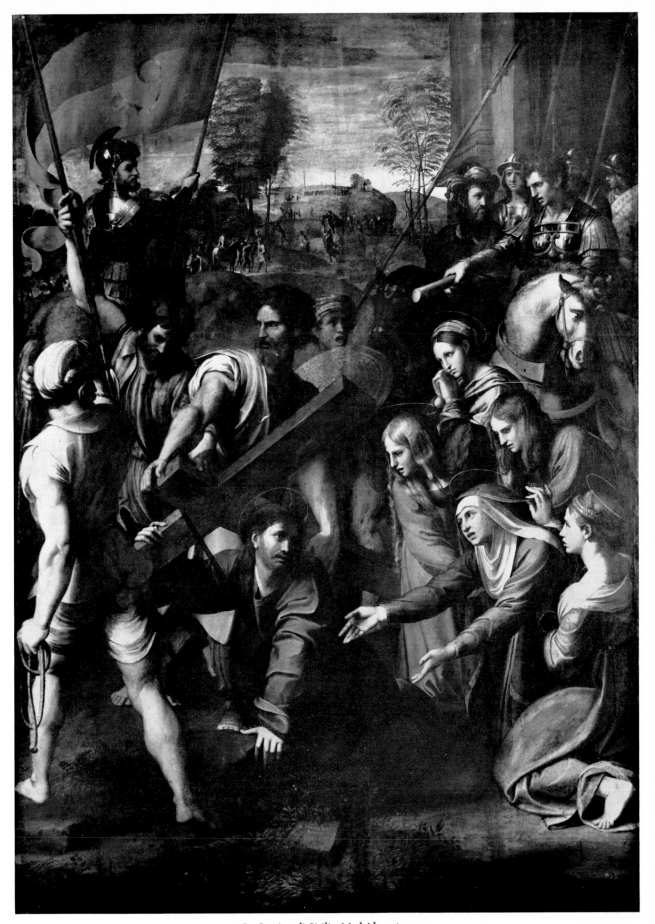

252 *Lo Spasimo di Sicilia*. Madrid. 306 × 230.

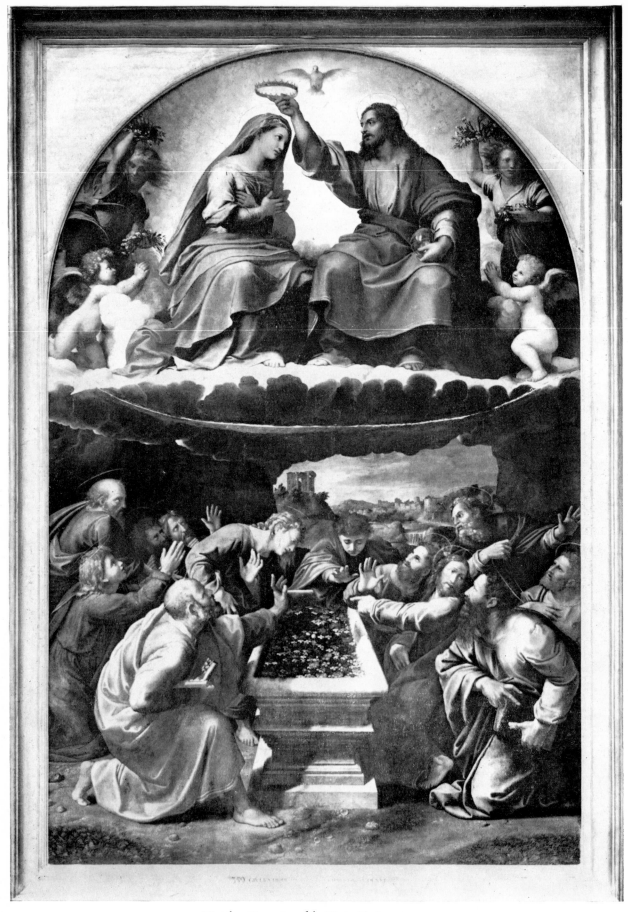

253 *Monteluce Coronation of the Virgin*. Vatican. 354 × 230.

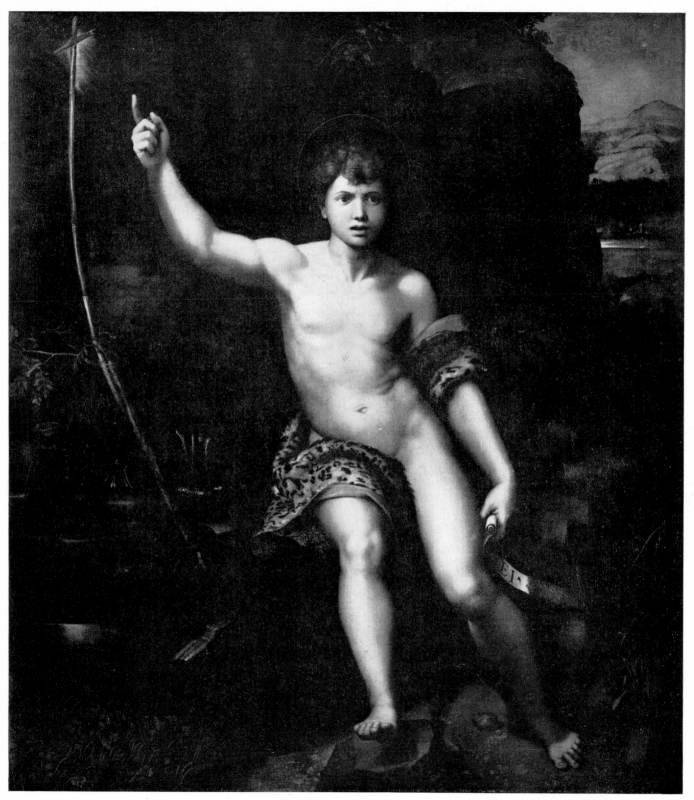

254 *St John the Baptist*. Florence, Accademia. 165 × 147.

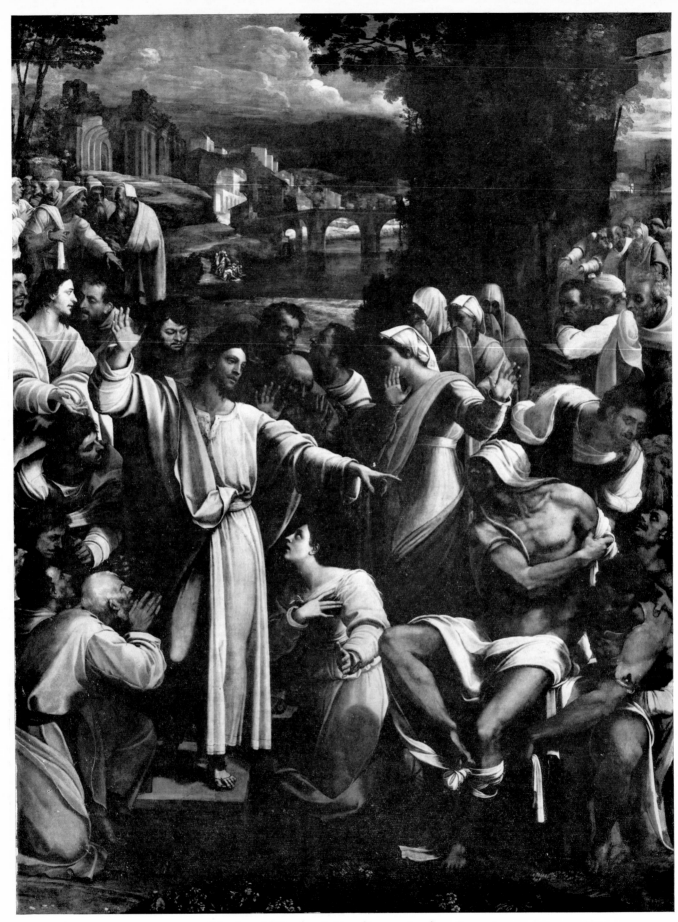

255 Sebastiano del Piombo. *Raising of Lazarus*. London. 380 × 287.

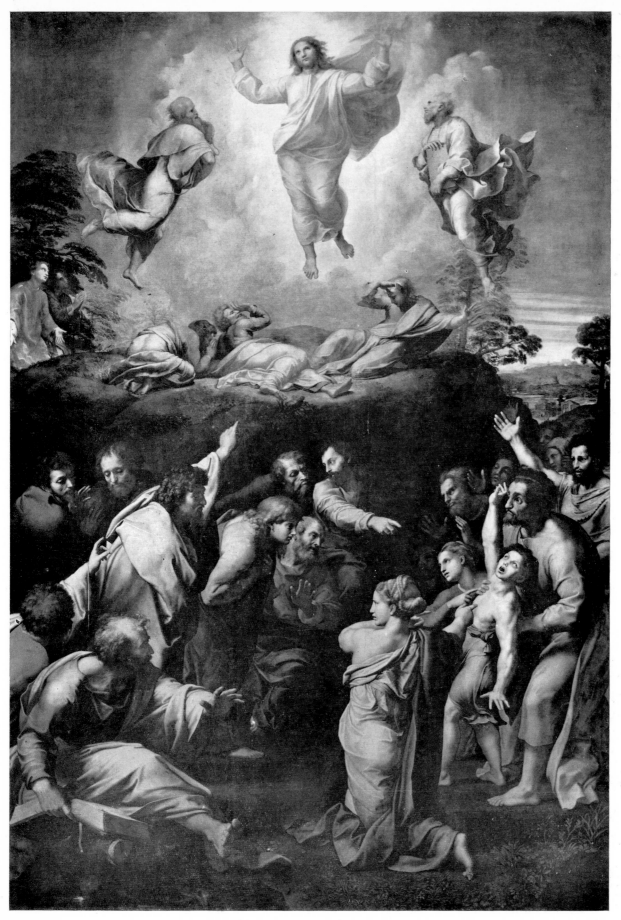

256 Transfiguration. 1518–1520. Vatican. 405 × 278.

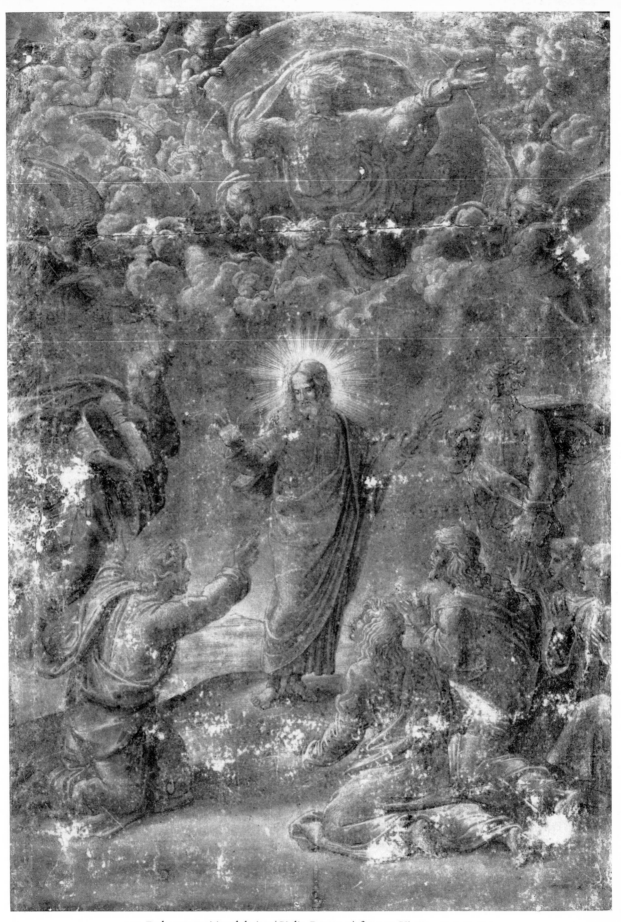

257 Early compositional design (Giulio Romano) for 256. Vienna. 40·2 × 27·2.

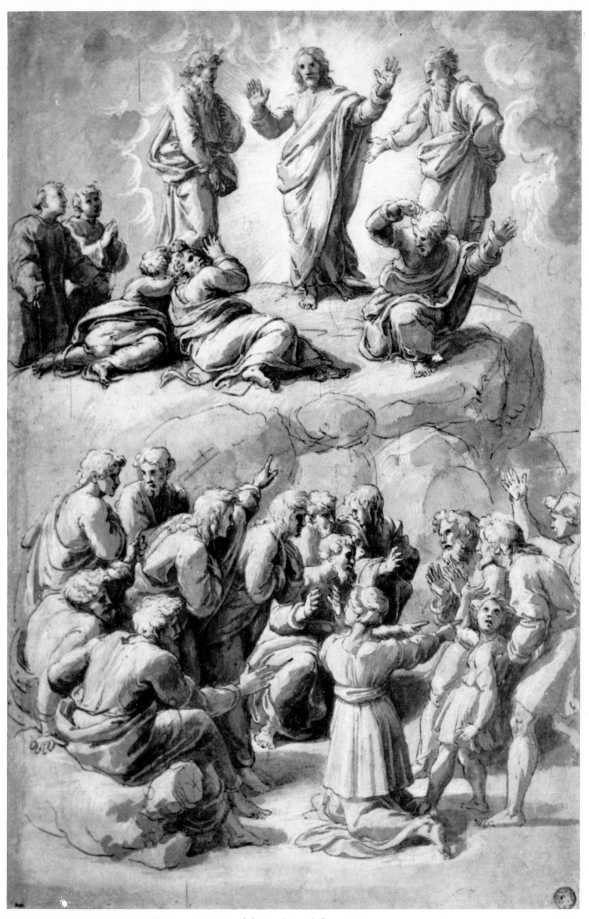

258 Later compositional design (Penni) for 256. Louvre. 41·3 × 27·4.

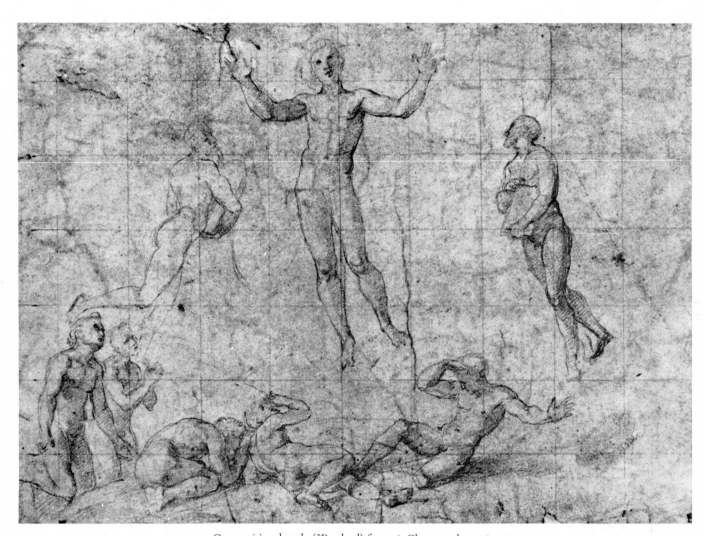

259 Compositional study (?Raphael) for 256. Chatsworth. 24·6 × 35.

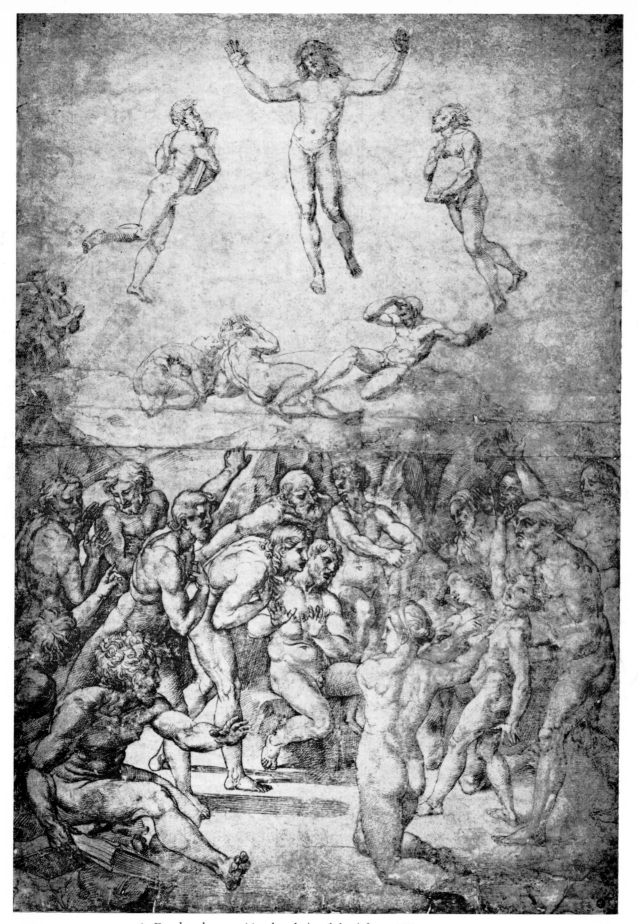

260 Developed compositional study (workshop) for 256. Vienna. 54 × 37·7.

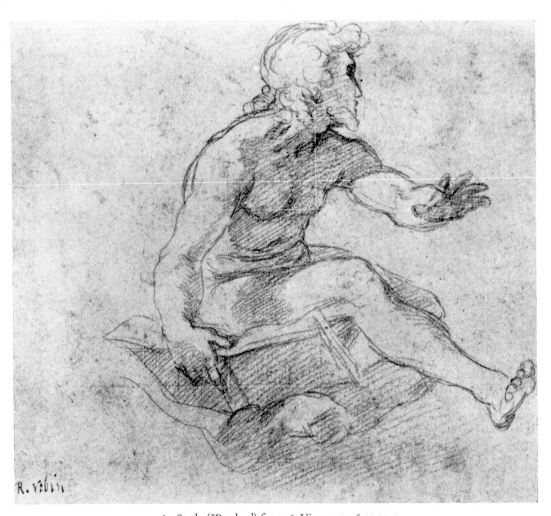

261 Study (?Raphael) for 256. Vienna. 12·6 × 14·4.

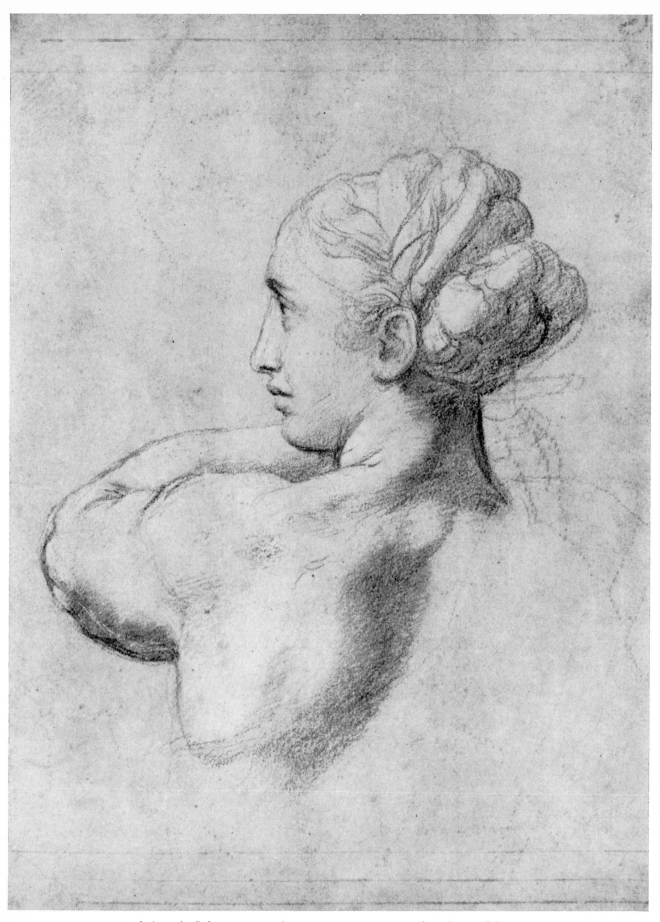

262 Study (?Raphael) for 256. Amsterdam, Dr J. Q. van Regteren Altena (copyright). 33 × 24·2.

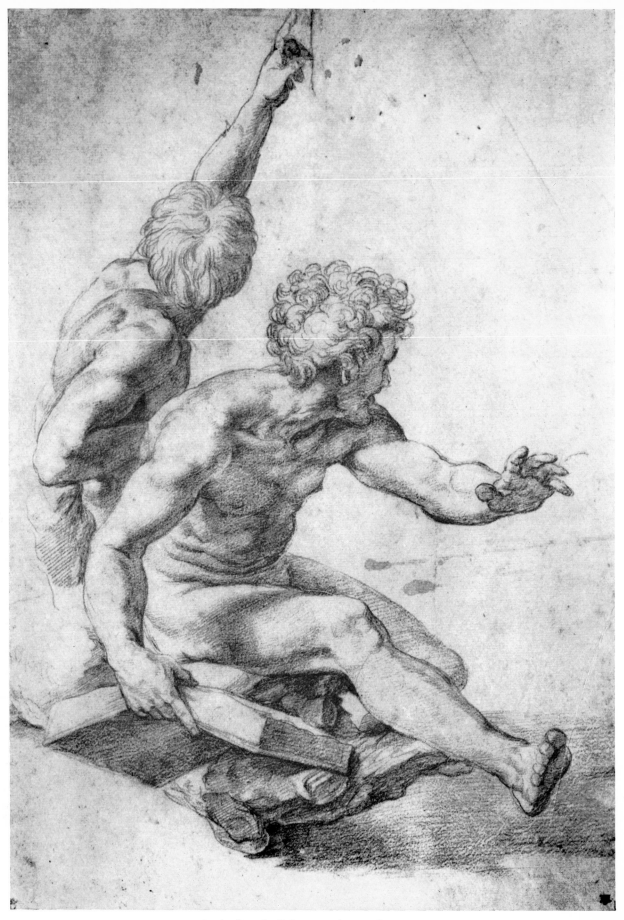

263 Study (?Raphael) for 256. Chatsworth. 32·9 × 23·2.

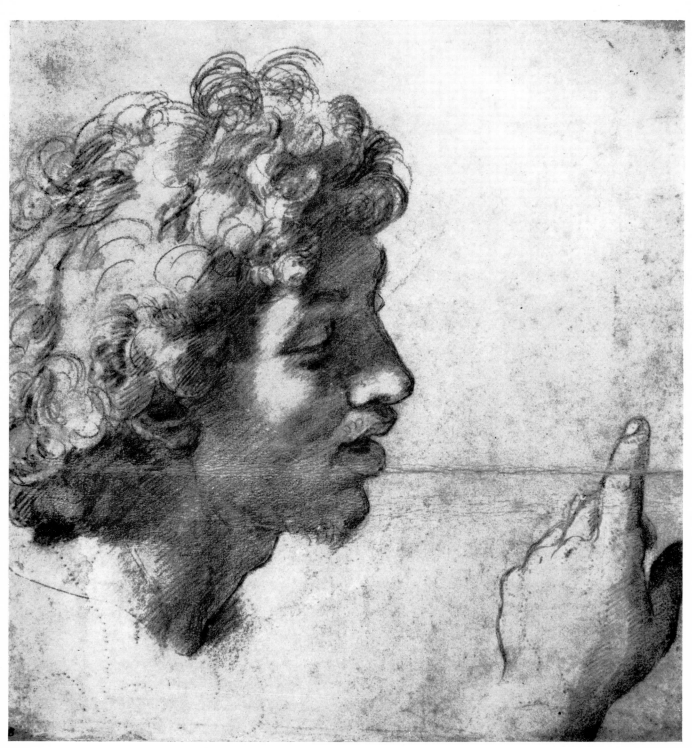

264 Auxiliary cartoon (Raphael) for 256. Chatsworth. 36·3 × 34·6.

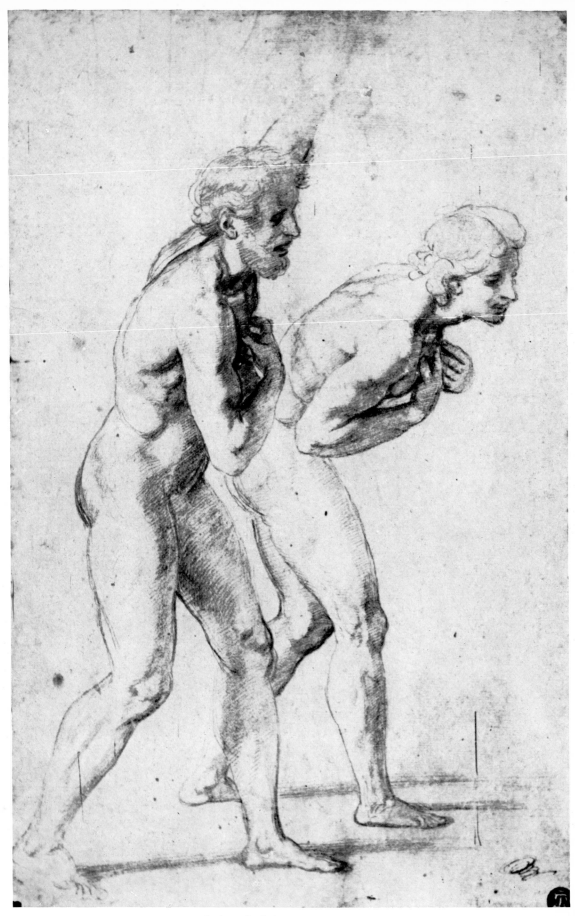

265 Study (?Raphael) for 256. Louvre. 3 ·1 × 22·1.

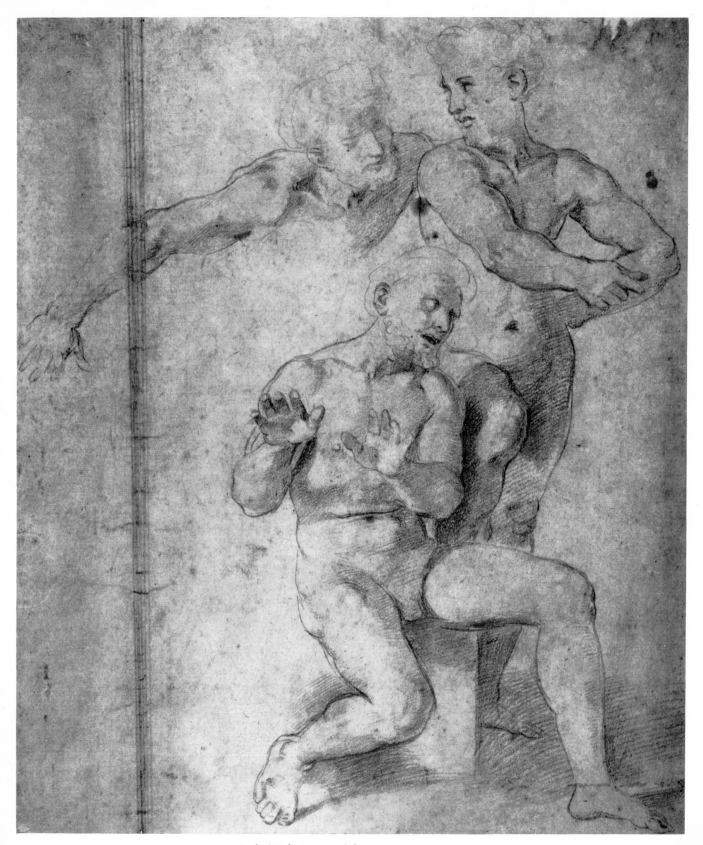

266 Study (Giulio Romano) for 256. Vienna. 32·2 × 27·5.

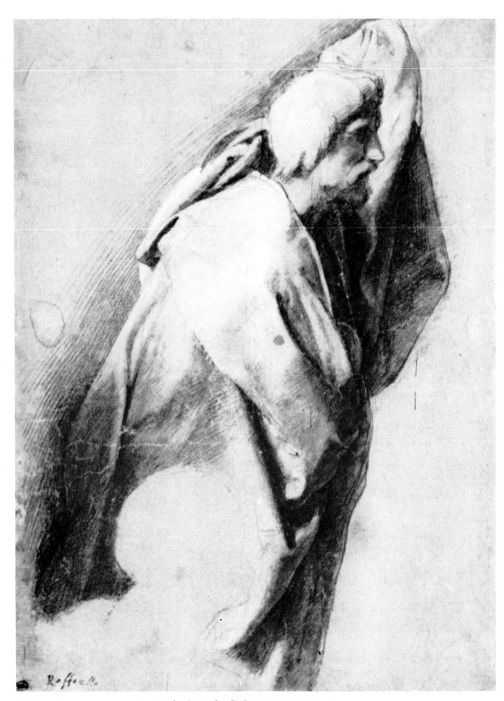

Raffaello

267 Study (?Raphael) for 256. Louvre. 26·4 × 29·7.

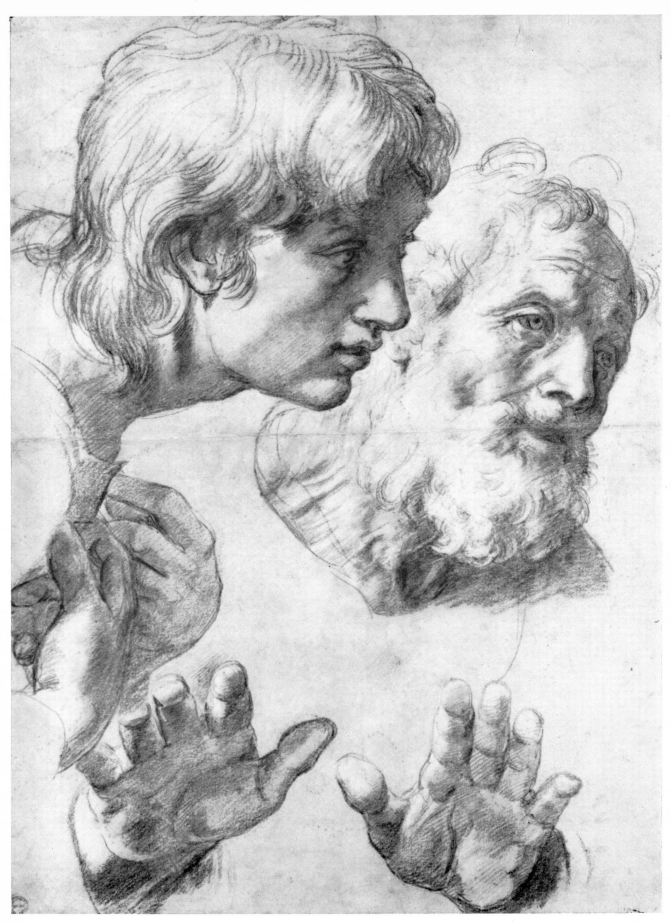

268 Study (Raphael) for 256. Oxford. 49·9 × 36·4.

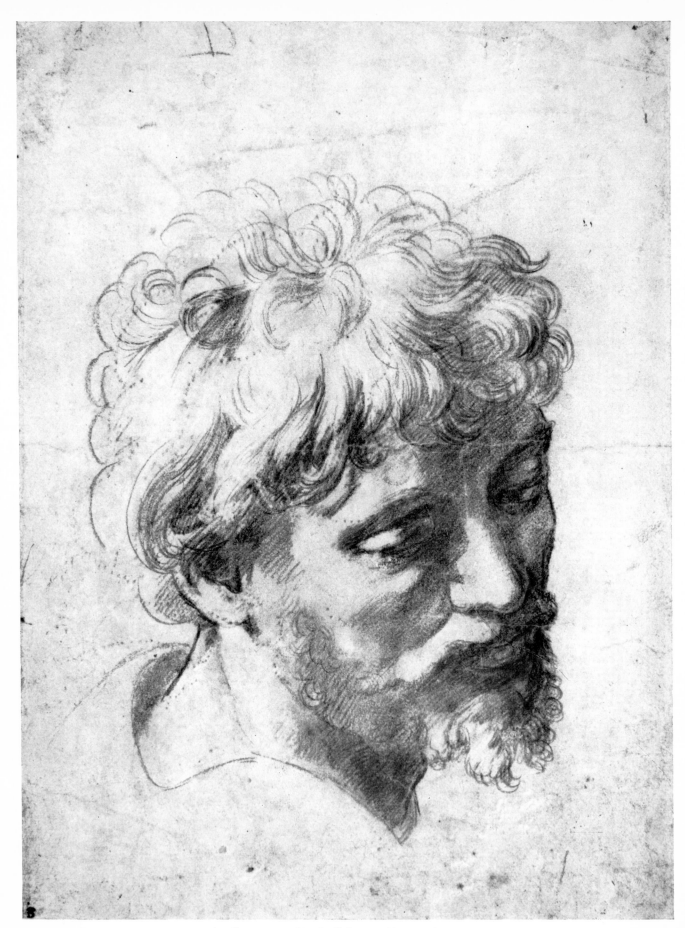

269 Auxiliary cartoon (Raphael) for 256. Chatsworth. 37·5 × 27·8.

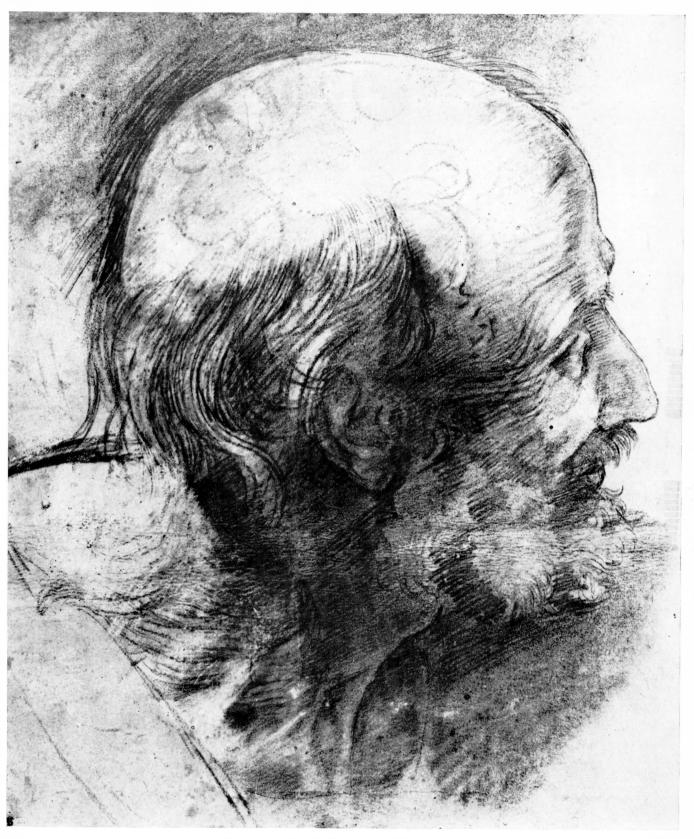

270 Auxiliary cartoon (Raphael) for 256. British Museum. 39·9 × 35.

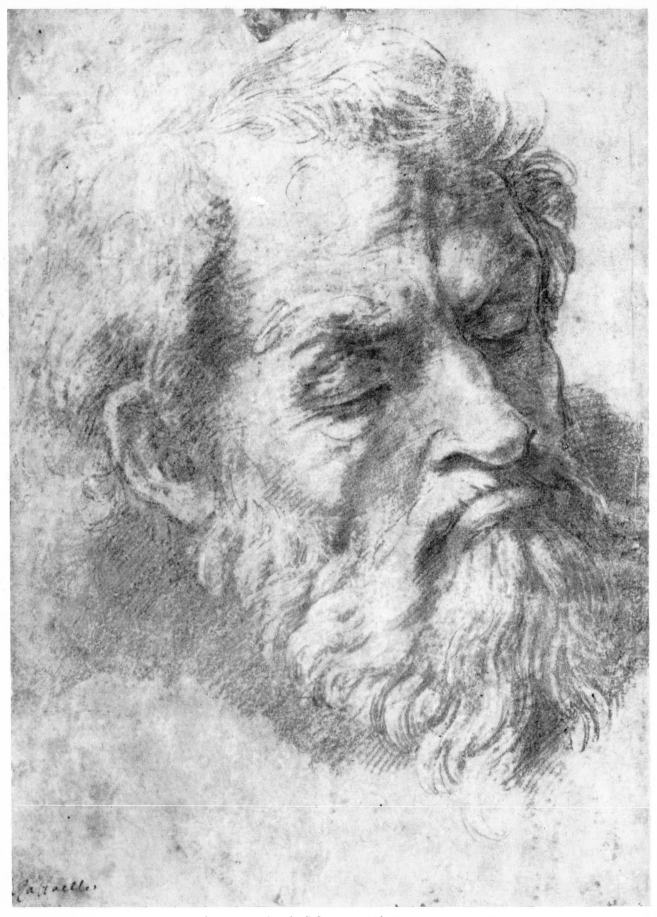

271 Auxiliary cartoon (Raphael) for 256. British Museum. 26·5 × 19·8.

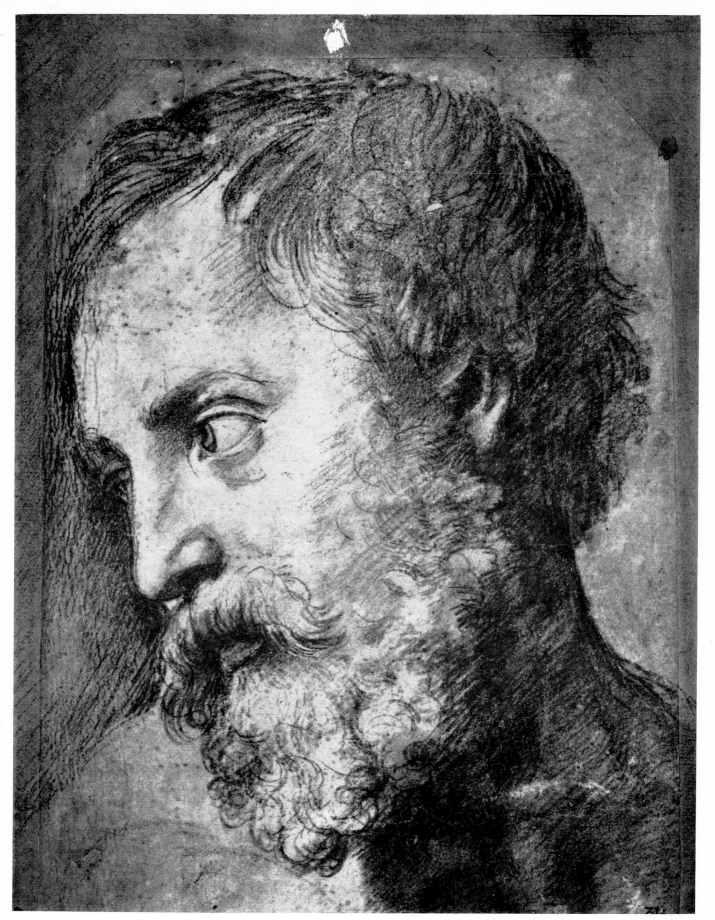

272 Auxiliary cartoon (Raphael) for 256. Vienna. 24 × 18·2.

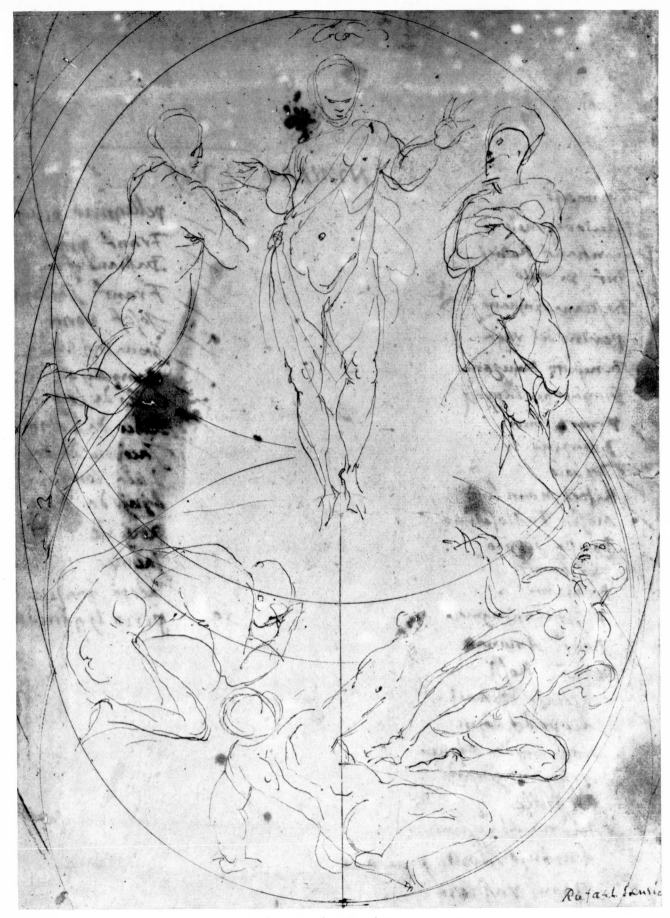

273 Free variant by Vasari of 256. British Museum. 31·2 × 22·5.